reset MODERNITY!

reset MODERNITY!

EDITED BY · BRUNO LATOUR

WITH · CHRISTOPHE LECLERCQ

r·M!　PUBLISHED BY ZKM | CENTER FOR ART AND MEDIA
KARLSRUHE, GERMANY

THE MIT PRESS
CAMBRIDGE, MA / LONDON, ENGLAND

Procedure 3

Procedure 4

POSITION OF THE PROBLEM. Paris, 13 November 2015, two weeks before the opening of the COP21 climate conference: suddenly we find ourselves between two suicidal paths. Militants who believe they are doing something of religious and political relevance commit in cold blood a senseless act that has not the least strategic importance and bears no known relation to religious traditions. As if their destiny and the destinies of those whom they have snatched in their bloody, moronic flight had been completely caught up in the attraction of the great beyond. The last thing desolated citizens should do is try to find meaning in an act of nihilism that has no meaning. "Senseless": this is exactly how it should be characterized.

But this happens just two weeks before another event, when, on 30 November 2015, the people of the world try to obstruct another, much larger, suicidal path, another senseless movement sucked in by the empty domain of the great beyond: the "future," that land of nowhere in the name of which the modernizing frontier seems ready to swallow humans and nonhumans alike, plunging all of them into the midst of a general destruction of the conditions fit for life. This development too is senseless. This too is suicidal. This too is nihilism in action.

Such is our zeitgeist: on the one hand, religious wars for the colonization of a nonexistent afterworld; on the other, economic wars for the colonization of territories that are equally insubstantial. Two situations deeply linked by some strange politico-religious urge to "replace" the world as it is with another world that is transcendent as an ideal yet totally deadly when violently inserted into the world of below. Two forms of criminal intoxication by the beyond that make it impossible for ordinary humans to get back to earth, to become earthly; as if it were impossible to render religion, politics, science, and economics secular again, material, mundane.

So the question for us becomes that of understanding why humans touched by hypermodernism have so much difficulty taking seriously that they are of this earth and thus must stay inside the boundaries they keep pushing beyond. How is it they are able to sacrifice everything to the world of beyond? Through what extraordinarily perverse mechanism has transcendence been transformed into the abandonment and condemnation of *this* world? Modernists seem to keep their eyes turned toward some extraterrestrial land, a land where they could not live anyway, even if by an extraordinary miracle of history they could actually reach it. What is the odd political theology of modernism?

And the tragic thing is that those people who expect a miracle, their faces turned beyond earth, are precisely those who have, for several centuries, debunked all the

religious claims preached from the pulpit by those who wanted to save humans from the plight of this base world! Having shown that supernatural consolations were just a clever ploy by the rich to keep the poor in chains, today they seem to be the ones directing attention to a world of nowhere to keep both the poor and the rich addicted to their deluded expectations.

Those who call themselves materialists and pride themselves on their worldliness seem to be in great need of discovering their materiality once again. Those who have so ferociously criticized calls for a world of beyond with the proud slogans "Stick to matters of fact!" "Religion is behind us!" "The earth is ours!" appear to be in great need of becoming even more material, to consider facts with much greater attention and to get much closer to what their soil is made of. Would it not be a welcome change if we attempted to be mundane once and for all by evicting what we might wrongly take to be the "better angels of our nature"? This might be the time to secularize the secularists, to help the worldly-minded become a little bit more profane, terrestrial at last, with an earth under their feet. Why has it become so difficult for them to register their daily experience as pertaining to the world of below? Why do we seem to have lost our bearings, unable to reset our compass and allow it to register direction again? That's right: time for a reset, time to touch base! As the cover of this book[1] indicates, it is time to document anew the frangible matter on which we rely.

A BAD START IN A DARK CAVE

WHEN YOU THINK ABOUT IT, it's clear that the moderns have inherited a tradition that started badly. What we used to celebrate at school as one of the greatest achievements of Western philosophy is the strange story of cavemen who are kicked out of their cave and end up blinded by the sun because they were stupidly instructed to look at it directly without anything to protect their eyes! What a great parable this is, one that portrays mortals blindly stumbling in the open air instead of staying prisoners in a dark cave below. We have to recognize that such an excursion out of the cave is not terribly good training for those who wish to be earthly-minded.

Everything is bizarre in Plato's allegory of the cave. Not that human beings live in an underground cavern – that is true enough for people who have no world of beyond – but that they are imagined by the philosopher as having been "prisoners there since they were children, their legs and necks ... so fastened that they can only look straight ahead of them," hearing voices echo off the cavernous ceiling yet unable to connect them with any specific mouth (Plato 241). Whose twisted brain could have invented such a view of the unenlightened? Where have you ever

seen people unable to move, to feel with their hands, to talk face to face with one another when puzzled by some state of affairs? In any real situation of collective exploration, normal human beings would have discovered in an instant that those shadows on the wall were nothing but a tricky projection from some clever puppeteers. Such a vision of humanity before it has seen the light outside can only come to someone with a sinister project of emancipation. Humans never sit still like this, silent and in awe, watching shadows. Only a sadistic professor would chain pupils this way so as to have the pleasure of unchaining them later – or to enjoy the masochistic delight of being mistreated by them.

At no point in this "out of the cave and into the great outdoors" fable does the hapless Glaucon protest against such a farce – not even when the emancipated prisoner, having broken his chains and abandoned his fellow cavemen, begins to ascend the stairs of this odd panoramic cinema and slowly accustoms his eyes to the new light, first by looking at his reflection in puddles, then at the moon and stars, and then straight at the sun, not merely as "reflections in water... but as it is in itself" (242). We might expect Glaucon to interject: "But Socrates, the poor fellow will burn his eyes! Stop him before he commits such folly!" But no, when Socrates suggests that the former caveman will come to see the sun as the cause of everything visible: "That is the conclusion which he would obviously reach" (243).

After that, the sad story that we have been asked to admire so much unfolds further: the philosopher returns to the cave (out of what evangelical zeal we are never told) to help his former fellow prisoners get outdoors, in response to which the recalcitrant morons put him to death – not, however, before they have had time to diagnose, quite accurately, that "his visit to the upper world had ruined his sight, and that the ascent was not worth even attempting" (243). How right they are on that score! The whole story is a complete folly from beginning to end. Folly to imagine that humans could be imprisoned in the dark, watching nothing but shadows; folly to imagine that there is some outdoors in view of the sun where some heroic fellow would have unmediated access to the true and the good.

There is something quite strange in this story that is not always highlighted: the protagonists are radically divided by the epistemological break between two entirely different ways of obtaining the truth about matters of fact. Actually, to this day it is this break that explains why it is so difficult to heed the lessons daily experience teaches us about what it means to inhabit the planet. The fictitious prisoners, remember, have no other way to deal with things than to "remember the order of sequence among the passing shadows" in order to "divine their future appearances" (243). In other words, cavemen have nothing to

[1] On this book's cover, see Marzotto and Sambonet (r·m! 42–49)

rely on but tallies and statistics about passing and fleeting occurrences. In contrast, after he has habituated his eyesight, the fully emancipated philosopher has unmediated access to things themselves, namely the sun, without having to be equipped with any instrument, any telescope, without perusing any inscription, any documentation of any sort. Two totally different ways of gaining knowledge are now in conflict – and this conflict is still with us in the daily politics of science.

No wonder the returning philosopher cannot convince any of his fellow prisoners. They have no common ground to reconcile contradictory knowledge: either you see the projected shadows without detecting where they come from, namely the "figures of men and animals made of wood and stone and all sorts of other materials" carried by the puppeteers behind the wall (241), or you see without any shadow straight into light itself. In both cases, what is missing from knowledge production are the artificial concoctions that allow either the projection of images or the screening of the too-brilliant light of the sun so that something can be seen through carefully mounted instruments.

The epistemological break between shadows without things and things without shadows has turned the normal practice of disagreeing about matters of concern (before slowly coming to some agreement with the aid of instruments) into a radical rupture between those who really know and those who simply guess. What has been ruptured is all collective commerce around "artificial" models – ideas, images, theories, scenarios, versions, visions, or puppets – capable of projecting instructive shadows about what really exists. Knowledge can no longer be shared. It has become for the enlightened a sort of revelation the hoi polloi will forever ignore.

Are the cavemen not right in putting to death someone whose eyesight is so irremediably "ruined"? Is not Glaucon totally wrong to assent so meekly to the view that "anyone who is going to act rationally either in public or private life" must have seen "the form of the good" (244)? He should have protested that wisdom in public affairs will be made forever unattainable if such an epistemological break obtains. And yet, today the allegory of the cave is rehearsed every time a scientist sets up an opposition between "primary qualities" (to put it in philosophical terms), which are inaccessible without instruments, and "secondary qualities," which ordinary folks, deprived of instruments, can only tally statistically; the tale is retold every time someone explains to you that the world you experience in color, taste, noise, and depth is but an illusion of the senses, a mere shadow, quickly dissipated by the true nature of what really exists. From this point onward, nature will be taken either as what one cannot see or as what one cannot "see." A "conjecture" or a "dream": that, as Whitehead said, is the choice we are left with (30).

I told you this was a bad start. Instead of giving us, as promised, a parable on "the enlightenment or ignorance of our human condition" (Plato 241), Socrates has trapped us in the dark about the chiaroscuro way of sharing our experience and collectively checking how reliable it is. Those who proudly say "We need no image of any sort to get to the truth" are readying themselves to commit crimes in the name of enlightenment. And does it really matter if they do it in the name of Allah, Jesus, science, reason, or the market? What counts is the way they preach, ignore opposition, and ready themselves to kill. The prisoners, who have been blind from birth, who could have learned to grope in the dark, are being deceived by voluntarily blinded activists turned philosophers.

DIGGING A CROSS SECTION

THERE IS, HOWEVER, another interpretation of this sad origin myth. It is not impossible that the allegory of the cave was written for an innocent Athenian audience easing themselves onto the marble seats of a theater to watch a good comedy, ready to laugh at some buffoonery; or perhaps it's a tragicomedy involving an odd vision of the process of enlightenment taken as a serious description of how cavemen should become philosophers. To interpret it that way, it is enough to remember that Plato is a master artist and a most subtle puppeteer in his own right, a playwright of great renown. As any contemporary playwright could immediately recognize, the story told by Socrates to Glaucon is not a parable about the heroic emancipation and death of a Christlike figure, but an entirely different drama staging the relations between ground and underground, a great experiment in redistributing light, darkness, projections, and shadows.

To get it, you have to add to the audience of fake prisoners the "real" audience in front of which Socrates and Glaucon are talking. The spectators implied by the narrative are seated in such a way that they see every part of the whole stage set simultaneously: the prisoners left in their cinema, the actors holding the puppets in front of a powerful fire, the brightly lit zone above ground, and the fake sun above the scene.

In effect, Plato is presenting on stage something that resembles what you see in natural history museums: a cutout anthill, or a geological cross section of layers of sediment. And now we, the real public of that tale, discover the whole cleverly drawn stratagem. Seen in this way, the ascent and descent follow a different plot: if the projected screen of the cinema where actors play at being prisoners is a fiction, so is the impression of an outdoors created by spotlights and the heroic story of the emancipated philosopher.

If this new version is right, then it becomes quite interesting to deploy the stage set in all its complexity: on the planks are two actors, one playing Socrates, the other Glaucon; they are telling the audience what is happening behind them, as if they were geologists standing in front of some road cut, pointing out layers of sediment. Where is the audience located? Probably seated under the protection of a tarpaulin in the sun – the real one! – or under the stars at night, refreshed by the soft breeze of Attica. The assembled demos listens to a story in which Socrates plays a role just as improbable as the one he played in Aristophanes's famous comedy, *The Clouds*.

Why does the public laugh so loud? Because every aspect of the situation is impossible: that there exist people silly enough to accept being sent to the cave to become prisoners in chains and to unlearn all the skills developed over thousands of years of making sense of the world; that there exists a higher ground where the solitary thinker discovers for himself, face to face, the idea of the true and the good; and that Socrates seems so engrossed with the destiny of the emancipated philosopher put to death, a situation grossly out of joint with everything the people have learned. As for the vicissitudes suffered by the actors blinded first by light, then by obscurity, twice mistaken and twice taken in, they are, for the audience, as hilarious as the meaningless cartoons projected on the wall.

And here comes the lesson of the farce: not that we should believe the emancipator, as Glaucon seems to do, but that neither this kind of "interior" cave of ignorance nor this kind of "exterior" realm of ideas exists anywhere. More exactly, the moral of the tale is that *if there is no exterior bathed in such light, then there is no interior thrown into such darkness either*. Light and dark, above and below are in a totally different relation. Earth is something different. It is not that the prisoners are down to earth while the philosopher is high-minded. It is that both have lost their minds and lost the earth as well. To be within earth is to be positioned somewhere else altogether. The audience cannot but wonder as to what has gone so wrong in the double vision of underground and higher ground.

This strange idea must be the source of the notion that images and models are all delusions of the senses (this, at least, is what the allegory seems to be saying). But what the two protagonists, Socrates and Glaucon, show on stage as the treacherous power of models, projections, shadows, and illusions, cannot but be understood by the play's "real" audience as the only way to give shape to our world. Here is the key to the allegory: on stage, *model* means the real origin, the idea, as opposed to its copies, while for the real audience the word *model*, the *eidos*, designates the most powerful way we have to give a shape to the world we are exploring.

Plato, the artist narrator, imparts an entirely different lesson than Plato the philosopher. The first audience – the fake prisoners – is told that the idea should

be obtained without any image, while for the second audience, without the image there is no idea whatsoever. It is at this point that the public realizes that the whole story of enlightenment is exactly that: a story, a distraction, the sort of spectacle you take your kids to before going back to the real world. A fiction? No, a fiction doubling as a fictitious account of what a fiction is! What we should be taking away from this most famous dialogue is its double and contradictory moral.

Is it our fault if the moderns "speak with a forked tongue"? They have always projected a double narrative: one of emancipation and one of attachment. Iconoclasts put everybody in a double bind. When one says, "Down with all images so that we can more quickly reach the true, the good, and the beautiful," the other says, "Never will you reach the true, the good, and the beautiful without multiplying images, models, fictions, fabrications, and fables" (Latour, "What Is Iconoclash?"). Is it any surprise, then, that young people, unaware of this long, contradictory tradition, become intoxicated by the first ideal and see in the mundane reality of ordinary images nothing but a world to be destroyed? After a bout of iconoclasm, the next step is the assassination of those who are accused of worshipping shadows. So many tears shed for the twice-ruined splendor of Palmyra, "the irreplaceable treasure" (Veyne). So many tears for the mass killings of "infidels." So many tears for the wanton destruction of soils "developed" into desert. How might modernism learn to make sense of its contradictory traditions?

A PROVINCIAL IDEA OF UNIVERSAL EXTENT

YOU MIGHT OBJECT that if the moderns' view of the outside and the beyond is odd, at least they have triumphed in the clear and distinct idea of what the real world consists of, the world of below. Is it not well known that they pride themselves on the solidity, coherence, and efficacy of their materialism? But the tragedy of their history is that the two worlds are linked in such a way that misunderstanding the transcendent world of beyond means risking an equivalent misunderstanding of the immanent world of "mere matters of fact." If priests and preachers have never succeeded in convincing the many cultures they have invaded to turn their eyes upward, scientists and engineers have not succeeded any better in convincing the many cultures they have colonized to live "down below." The oddity of the down is just as great as the oddity of the up. Or more exactly, just as the experience of transcendence was distorted by the allegory of the cave, the experience of immanence has been strangely hidden behind the myth of a "scientific worldview."

As proof that when moderns express their experience of matter, the result is no better than when they try to record their experience of the immaterial,

consider the highly seductive movie shot in 1977 by the Eames Office, *Powers of Ten*. Even though this famous film is supposed to develop the "scientific" worldview, it is the surest way for the poor prisoners to be forever confused about what the world is really like. This time we are asked to believe that there is a plausible continuity in an observer's view that stretches from the farthest galaxy to the smallest particle. A voice-over comments animatedly on this smooth and vertiginous movement through space and time. Here we can witness simultaneously how the enlightened see the outside world and how totally fictitious is the account they provide to give the masses an idea of the "real scale" of their prison.

In the original Kees Boeke booklet that inspired the Eameses' work (see figs. 7 and 9, **r**·ᴍ!59), each successive image was clearly separated from the others by the very medium of the picture book, but none of those hiatuses is visible in the Eameses' movie (see fig. 3, **r**·ᴍ!56, fig.6, **r**·ᴍ!58, and fig.9, **r**·ᴍ!60). The continuity offered by the combination of film and voice-over allows the viewer to imagine that everything from the galaxy to subatomic particles – not to mention the clothing, food, bodies, and cells of the two characters picnicking in the park in Chicago – is not only bathed in the same light but made of "the same stuff." The name of that supposedly universal stuff is "matter."

Of course this "matter" has nothing to do with what the long chain of scientists whose images have been edited together to give the feeling of a single continuous shot would call, each in his or her domain, "materiality." The spurious matter imagined by the film is what Descartes invented in his early treatise *The World* (22–24), which he later named *res extensa*. Today, we would read such a treatise as a work of fiction. You can "expand" *res extensa*, but on the condition of hiding as much as possible what it contains. It is only through the smoothness of the camera's motion that the viewer may begin to imagine (and it is a fancy of his or her imagination!) that every object viewed in this space is also made of no other stuff but this material space itself.

Powers of Ten offers a totally idealistic view of what it means to be material. Spectators are asked to believe that matter in its essence is nothing but what traveling in space allows you to reach. What we know is supposed to be made in how we know it.

Is there a way to twist this film into another scenography? To enchant the prisoners stuck in their seats with another spectacle? After Plato's tragicomic play, the next performance is a movie! Once again things could have become interesting, provided a different spectacle were shown, one that would offer a "realistic" view of materialities totally different from the continuous movement imagined by the Eameses.

This other movement would require us to travel from the astronomer's telescope to the physiologist's laboratory to the great accelerator of the particle physicist, knocking at the doors of many unconnected institutions and learning the skills of the many incompatible trades involved, without omitting the leisurely moment when we would see the reporter chat with the picnickers.

But in following the movements of such a traveling character we would never have left the solid ground of Chicago! The discontinuities between so many different disciplines would not have been erased. The complexity of learning each instrument's true extension would not have been papered over. Each image would have to have been selected from many visual traces. The decision as to which was the right one to focus on would have been shown, and so would the face of the bewildered reporter unable to detect exactly what most of the images mean. Discontinuities would show up everywhere. No one would imagine that everything is made of the same stuff, namely abstract space. The confusion over how we know and what we know would not be so easy to sustain. Materialities would be shown to be clearly different from matter.

Perhaps we have not moved much since the time of the allegory of the cave, even though we are supposed to have gone from an idealistic to a materialistic worldview. Here again, what is supposed to draw the true portrait of the world offers a totally unrealistic vision of that in which we are supposed to reside. What was so implausible in the allegory was the idea of chained prisoners stripped of all their collective cognitive skills and reduced to calculating the passing of shadows. What is impossible in the "scientific" worldview (but attempted nevertheless) is the erasure of all the discontinuous and heterogeneous ways in which many groups of competing scientists are trying to make sense of the world. The continuity of the composition is simply given by the camera, zooming from the very big to the very small and back.

Just as Descartes confused *res extensa* with drawings on paper (Ivins), the chained prisoners forced to watch *Powers of Ten* are asked to believe that they reside in that world – a world of shadows! Once again the act of enlightening the masses generates obscurantism. The material world of those who wish to stick to matters of fact is even more fictional than the outside the philosopher was asking us to reach in order to escape from a world of shadows.

No wonder it is so difficult for those who inherit those two models to find their bearings. The scenography of the outside is just as misleading as the great panorama of the inside. The up is just as fictional as the down. When you are requested to turn your eyes to the higher ground, you are asked to go to the place of nowhere, but when you are asked to cast your gaze downward, that place does not exist either. We are stuck between two utopias. What does it mean to be "earthly" if

both the transcendent world of beyond and the base world of below are seen as a farce, as vaporous as Aristophanes's *Clouds*? Actually, it is the same idealistic rendering of knowledge, the same effort to evict us from the earth.

We need to move to a place that ensures we are never tempted to flee outside, so that we begin to really discern the shape of things inside, and so that we never confuse the inside with Descartes's material world. Such a place will certainly not be lit by the sun, but it might, after a minute of habituation, be bathed in the inner phosphorescence shed by things themselves. Because of the allegory of the cave, the dream of transcendence has given immanence a bad name; because of the invention of *res extensa*, transcendence has been given a bad name. But the contrast itself is misleading. This is the whole moral of those two performances. The mystery is to understand how such a local, historical, provincial idea of what the world is made up of has succeeded in extending itself everywhere, almost to the point of covering the planet, to make it a globe inside which we are all supposed to live. How have we collectively accepted imprisonment in that global cave, simultaneously so vast and so narrow, wrong both on the exact size of where we live and the exact composition of its atmosphere?

We need to focus elsewhere, on a world altogether different, one that has the strange character of being neither immanent nor transcendent, neither so large nor so restricted. The mundane, material, and secular world is not an obscure cave, nor is it made of those famous "matters of fact" that would give the prisoners a good grasp on things. It is neither a dream nor a conjecture. It is made of the provisional conclusions drawn by assemblies of fellow creatures from the provisional traces emanating from carefully designed instruments. A strange counterenlightenment: to see better, we need to shut down the glaring light that blinds us. To get a more realistic view, we must free ourselves from the fiction of an outside that sits atop the underground. We must learn to emancipate ourselves from emancipation. Let us move neither up nor down, but within and along the world.

RESETTING SOME OF OUR INSTRUMENTS

MODERNS ARE THOSE who tell themselves one side of the story; nonmoderns are those who inherit from both. It's the same history, the same sequence of events, but reinterpreted differently depending on whether one accepts the contradiction or denies there is one.

Such is the scene we are trying to construct in this publication as well as in the exhibition *Reset Modernity!* at ZKM | Karlsruhe: on one side of a wall we hear the allegory of the cave told by Plato the philosopher, but on the other side we hear it recounted by Plato the scenographer; on one side we are taken in by movement in a

continuous time and space, while on the other we realize that such a provincial view leaves room for a much more interesting story of science and objectivity; on one side we are given a view of the globe, on the other we are on foot with the localizers.

And at the junction of each of these dual stories we reach an impasse, a moment of puzzlement, perhaps of abandonment: how can we have both? It is a sort of gestalt switch. In one we are moderns (happy or sad to be so); in the other we have never been moderns. In one we are breaking with the other collectives; in the other we are suddenly faced with them and obliged to raise again all the questions of anthropology. The others are no longer others. We are all driven by the same tragedy, trying to get our bearings, entering into a new sort of diplomatic encounter, what we call the middle ground (Latour, "Procedure 7," r·m! 405–19).

What do you do when you are disoriented – for instance, when the digital compass of your mobile phone goes wild? You reset it (Ricci, r·m! 24–41). You might be in a state of mild panic because you have lost your bearings, but still you have to take your time and follow the instructions to recalibrate the compass and let it be reset. The procedure depends on the situation and the device, but you always have to be patient, remain calm, and follow some instructions if you want the compass to regain its ability to receive the signals sent by the arrays of satellites dispersed in the sky, far above your head.

Such is the metaphor we have chosen for our enterprise. As if we wanted to offer the moderns a quiet space where they can reset their instruments and detect a signal again. It turns out that what we are supposed to experience has become increasingly difficult to register because of this strange opposition between a beyond and a below, both scrambled. Yes, it is a darker space than the brightly lit one. Yes, it is much more interior, inferior, mundane, and delicate than both the world of the great outside and the world of the great inside. But remember, no one has ever lived outside, no more than you can breathe in outer space without a space suit, and no one has lived in the cave either. How strange that such a technology-driven civilization remains so unpracticed at calibrating its instruments to detect where it resides and how it can survive. We need all the intelligence, all the skills we have, to develop the right detectors, to place the right sensors, to triangulate the right arrays of instruments. Nothing spectacular, no hype, no grand narrative, no bright future, no new agent of history, but rather a set of simple resetting protocols, just a series of seven procedures – to see where it leads, what it allows, what it permits us to document.

This publication and the exhibition to which it is linked attempt to pursue the work of documentation and instrumentation started with the AIME project (An Inquiry into Modes of Existence), the goal of which is to pluralize the templates with which experience may be recorded (Latour Inquiry; Latour, AIME). What was

21

tried with a paper book, then in parallel with a collective website, then again with many face-to-face encounters, is tried here once again through another medium, the most difficult of all: a three-dimensional space explored by puzzled visitors to a museum in Germany.

Scientists and philosophers are used to what they call "thought experiments," in which they indulge when there is as yet no practical way of mounting a real experiment able to provide some genuine data. Artists, curators, activists, and philosophers can also resort to what, with Peter Weibel, we call a "thought exhibition" ("*Gedankenausstellung*"), a way to anticipate a situation of which there is as yet no real instance. Yes, exactly a fiction, a myth, a fable, a setup, in order to think more freely, to be given space and time to reset our compass.

ON A STRANGE ACCLAMATION: "VIVE LA PLANÈTE!"

ON SATURDAY 12 December 2015, in Paris, a month after the tragic terrorist attack of 13 November, something odd happened on the podium at COP21, on the last day of the conference. Just a few minutes after Laurent Fabius, the French minister of foreign affairs, had banged his gavel, sealing the approval of the Framework Convention on Climate Change, François Hollande, a president not known for his philosophical contributions, exclaimed at the end of his speech: "Vivent les Nations Unies! Vive la planète! Vive la France!"

That a relieved, tired, and proud French president should exclaim "Vive la France" is fairly normal. But what about "Long live the planet"? It would have been ridiculous to say "Long live nature!" or "Three cheers for the laws of physics!" Enthusiastic exclamations such as these are directed at entities that are political, fragile, and, to be precise, at great risk of *not* surviving. You don't acclaim what is wholly indifferent to your wishes and your travails. If you cheer your football club, it is because you know it may lose the next game! Your hurrahs are a performative way to ensure its continuing existence in spite of all the troubles ahead.

To address the planet as something that requires our support transforms the older physical globe into something else: a new form of ambiguous, uncertain, composite entity that is comparable in majesty with other composite bodies – "the United Nations," "France," and the 199 nations applauding in the room. It is in order to triangulate this new corporate body that we need to reset our instruments. If modernity was the discovery of the globe, the new land under our feet is no longer *that* globe, but the earth. Those who will learn to inhabit it will not be called moderns or modernizers. They will have to reinvent themselves – that is, to reset their operating system.

Works Cited

Boeke, Kees. *Cosmic View: The Universe in 40 Jumps*. New York. J. Day, 1957. Print.

Descartes, René. The World *and Other Writings*. Trans. and ed. Stephen Gaukroger. Cambridge: Cambridge University Press, 1998. Print.

Latour, Bruno. *An Inquiry into Modes of Existence: An Anthropology of the Moderns*. Trans. Catherine Porter. Cambridge, MA: Harvard University Press, 2013. Print.

---, ed. AIME: *An Inquiry into Modes of Existence*. FNSP, 2012–16. Web. 17 Jan. 2016. Available at <http://modesofexistence.org>.

---. "Procedure 7: In Search of a Diplomatic Middle Ground." Latour, *Reset Modernity!* 405–19.

---, ed. *Reset Modernity!* Cambridge, MA: The MIT Press, 2016. Print.

---. "What Is Iconoclash? Or, Is There a World beyond the Image Wars?" *Iconoclash: Beyond the Image Wars in Science, Religion, and Art*. Ed. Bruno Latour and Peter Weibel. Cambridge, MA: The MIT Press, 2002. 14–37. Print.

Ivins, William, Jr. *Art and Geometry: A Study in Space Intuitions*. New York: Dover, 1946. Print.

Marzotto, Claude, and Maia Sambonet. "A Process Record from a Frangible Surface." Latour, *Reset Modernity!* 42–49.

Plato. *The Republic*. Trans. Desmond Lee. 2nd ed. London: Penguin, 2003. Print.

Powers of Ten. Dir. Charles and Ray Eames. IBM, 1977. Film.

Ricci, Donato. "Don't Push That Button!" Latour, *Reset Modernity!* 24–41.

Veyne, Paul. *Palmyre, l'irremplaçable trésor*. Paris: Albin Michel, 2015.

Whitehead, Alfred North. *The Concept of Nature*. Cambridge: Cambridge University Press, 1920. Print.

23

DON'T PUSH THAT BUTTON!

Donato Ricci

I DO NOT KNOW if it is still the case, but up until the end of the eighties, in southern Italy youngsters were supposed to spend part of their summer in a craft workshop. My grandfather was a woodworker; so it's normal that I was attempting to learn his art. His voice saying "Arricetta!"[1] came as a relief as well as an annoying signal. The work day was over. Or better said, almost over. Before leaving, I had to see to a last, puzzling, duty. Somebody had to deal with all the tools, the screws, the nails, and the jars of glue left on the work benches, as well as all the wood leftovers and the sawdust scattered all around the workshop. Nothing seemed dumber to me. The next day, I started over, the same messiness having arrived again. Among all the tools to take care of, while doing that *nonsense* activity, there was one that I really liked: the marking gauge (see fig. 1). Built by the master himself, the gauge was used to trace thin guidelines on a surface.[2] For example, it was used to define the baseline of dovetails serving as a firm registration for placing the chisel. In woodworking, where it is wiser to engrave a reference than to draw it, the physical certainty offered by the gauge makes it a humble but extremely precious tool. In fact, for most objects of woodworking, the consistency among parts is more important than absolute measurements. At the end of the day, it was necessary to put back the gauge rulers carefully, hitting the fixing wedge against a working bench in order

DONATO RICCI *is design lead and researcher at Sciences Po, assistant professor at the University of Aveiro, and lecturer at Parsons Paris. Focusing on the role of design practices in human and social sciences, he is involved in projects using new visual approaches for observing social phenomena through digital traces. He followed all the design aspects of the AIME project.*

to release them. Only at the end of this tedious and long procedure under stern gaze of the master, and after planning the duties for the next day, could I finally go out and play with my friends.

During these very same years, the first video-game consoles started to spread. With a mixture of envy and gratitude, I used to join my friends to play on a Nintendo Entertainment System. Seated on the floor, invisibly fastened to the screen connected to the grey box, we spent hours exploring its mesmerizing 8-bit world. There were no memory slots in the NES, so games had only two possibilities: advancing by winning, or losing. When it came down to losing, you had to start over. Through practice we developed a sort of latent skill consisting in detecting, feeling, and understanding from the very first attempts if it was possible to reach a good point in the game or not. It was an ability that had a single scope: to avoid the frustration of playing in a situation, compromised by the errors committed previously, whose only outcome is going

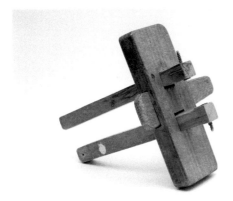

1 The *truschino* (marking gauge), constructed and used in his workshop by master carpenter Donato Ricci Sr. Ca. 1925. Private collection.
The gauge is composed of a wooden rectangle with two square holes through which two wooden rulers, called *segnatoi*, can slide. The end of each ruler was pierced by a screw the tip of which had been hammered to make it like a small blade. Between the holes for the rulers there was a third hole or slot in which a trapezoid fixing wedge was lodged to keep the rulers in the desired position.

25

back to the starting screen. One way to mitigate this was to rely on one of the two buttons jutting out of the plastic box: the reset (see figs. 2a and b). Hitting that button resulted in a short TV flicker, the game reloading, the mistake gone.[3] At that point, before we started playing again, a kind of huddle was expected to debrief what happened while playing, hoping to have gained a little bit more experience to finish the game.

BOXING UP

I'M JUST REALIZING now how these two apparently very different moments of my youth – probably an evident manifestation of what Baudrillard defined as "the great shift from a universal gestural system of labour to a universal gestural system of control" (49) – were indeed two different instances of the same procedure: the reset procedure. Starting with the identification of a moment of rupture: in one case the end of the work day; in the other the feeling of having no chances of success. A procedure that goes on with a sequence of actions: rearranging the space of the workshop in one case; redefining the environment of the room, in the other. A procedure that finds a focus: on the one hand, the wedge of the marking gauge that has to be hit; the reset button to be pressed, on the other. A procedure that finishes with a reflexive moment: planning the next work day in the workshop, and defining moves for the next game. After this set of gestures everything is set for a *fresh start*. It is really quite different from a *new beginning*. Again the experience is still there, I was starting afresh but I was not, in both cases, becoming a newbie again. Thank God!

And yet, usually, when we evoke a reset across this long procedure through harsh metonymic simplification, what we have in mind is a big red button. The trigger has become the procedure itself.[4] It could be seen as ratification of the *button's primacy*, the transformation of the entire procedure in a dyadic, symbolic stimulus-response negotiation. The

[1] The imperative can be translated from the Neapolitan language as: "Put in order! Reset!"

[2] Called *truschino* in Italian.

[3] That was not the only function of the button; in the same situation it could be used for cheating (Consalvo, Altice), till the point that Nintendo, in a game for the Game Cube, Animal Crossing, avoided the gamers profiting by inventing a special character: Mr. Resetti.

[4] This can be easily tested by a quick and dirty method. Try to use an image search engine and query for "reset." By using the keyboard combination CTRL - set the browser zoom to the minimum, reload the page, and a huge repertoire of more or less skeuomorphic buttons will appear. Don't forget to reset your zoom after that, a specific button should appear when using the combination CTRL +.

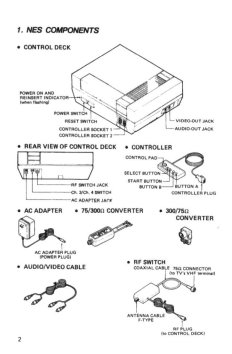

1. NES COMPONENTS

- CONTROL DECK

POWER ON AND REINSERT INDICATOR (when flashing)
POWER SWITCH
RESET SWITCH
CONTROLLER SOCKET 1
CONTROLLER SOCKET 2
VIDEO-OUT JACK
AUDIO-OUT JACK

- REAR VIEW OF CONTROL DECK
- CONTROLLER

RF SWITCH JACK
Ch. 3/Ch. 4 SWITCH
AC ADAPTER JACK

CONTROL PAD
SELECT BUTTON
START BUTTON
BUTTON B
BUTTON A
CONTROLLER PLUG

- AC ADAPTER
- 75/300Ω CONVERTER
- 300/75Ω CONVERTER

AC ADAPTER PLUG (POWER PLUG)

- AUDIO/VIDEO CABLE
- RF SWITCH
COAXIAL CABLE 75Ω CONNECTOR (to TV's VHF terminal)

ANTENNA CABLE F-TYPE
RF PLUG (to CONTROL DECK)

2

2a Page 2 of the Nintendo NES user manual *Control Deck: The Control Deck That Puts You In Control of Incredible Fun!* Redmond: Nintendo of America, Inc., 1988. PDF file.

2b Detail of the Nintendo NES electronic schematic, with reset switch in the bottom right corner. *Schematic Diagrams for Nintendo Entertainment System.* Electronix Corp., 1992. Web.

button alienated from its procedure, and the procedure black-boxed into the button itself, are producing an immediate magic effect, leading from a cause to an effect by a short circuit. The button, thanks to its binary nature, represents, when not activated, an existing state, and when depressed a change in the future of the state. Like any magic object it deserves respect, and we are supposed to use it in case of a firm will of change, placing in it our hopes.

Take, for example, its use in movies (see figs. 3a–c)[5] during different periods. Associated first with craftsmanship practices, then in relation to mechanical and measuring instruments, it becomes part of a discourse on electronics and control, to be, then, tightly connected to the button. The rise of the co-occurrence reset + button can be observed much later on the adoption of consoles in the domestic panorama. How weird is it that this relationship has been consolidated in the era of the disappearance of physical buttons. Buttons are increasingly replaced by a mimicked instance on a flat touch screen, and where the reset button, if not replaced by an awkward simultaneous pressure on a combination of buttons, or regressed into the back of the electronic device, quite often activates by inserting a pin into a small hole. Of the original procedure, in our symbolic panorama, only the magic of a stereotypical, mysterious yet reassuring object remains. An object able to instantaneously wipe clean any error, and able to reinstall, in the thick of any situation, order and homogeneity to any current state.

[5] The visualizations (see figs. 3b and c) are based on the movie subtitle containing the word "reset." They have been retrieved via movies.benschmidt.org and quodb.com. Two sentences before and two sentences after the one containing the word "reset" have been considered as a dialog and retained to compose the final dataset to be analyzed. The main keywords used in a dialog have been extracted manually, by reading the texts and by using a text-mining module, Pattern (clips.ua.ac.be/pattern). The co-occurrence network has been produced by linking together the keywords appearing in the same dialog.

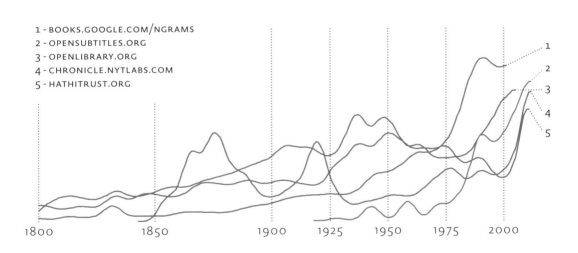

1 - BOOKS.GOOGLE.COM/NGRAMS
2 - OPENSUBTITLES.ORG
3 - OPENLIBRARY.ORG
4 - CHRONICLE.NYTLABS.COM
5 - HATHITRUST.ORG

3a Occurrence of the term "reset" between 1800 and 2015, according to various text datasets (containing digitized books, newspapers, and movie subtitles). The apparent peak around 1850 is due to errors during the OCR conversion (for instance, the misinterpretation of the word "refer" as "reset"), while the peak around 1925 is related to the practice of publishing court judgments in newspapers, which for example referred to thief trials.

QUOTES

THE DIVORCEE
– 1930 –

-I had it <u>RESET</u> for you.

-Oh, it's lovely, darling.

-You like it?

-It's to keep your <u>WEDDING RING</u> company.

THE DEVIL COMMANDS
– 1941 –

-<u>RESET THE GRAPH</u>, please, Richard.

-See how different the wavelengths are?

-Why should this record be so much stronger?

ONLY THE VALIANT
– 1951 –

-If I can <u>RESET THESE FUSES</u>, this mission may still be a success.

-Judging from the ruckus I hear out there, our red brothers are too busy at the moment.

GENRES

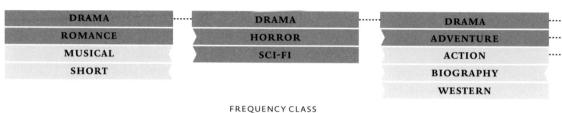

DRAMA	DRAMA	DRAMA
ROMANCE	HORROR	ADVENTURE
MUSICAL	SCI-FI	ACTION
SHORT		BIOGRAPHY
		WESTERN

FREQUENCY CLASS
PER DECADE

HIGH MED LOW

KEY WORDS

DIAMOND

RING

PAGE

TEXT

BANK

GANG

JEWELER

THEFT

GRAPH

CLOCKS

WAVELENGTHS

RECORD

SHIPS

FUSES

YARD

GALLANTS

ORDERS

PLATINS

WHISTLE

WIND

FREQUENCY CLASS
PER DECADE

HIGH MED LOW

50

10

ABSOLUTE *tf*

NORMALIZED *tf*

QUOTES

THE DAY THE EARTH CAUGHT FIRE
– 1961 –

-Slip edition in five minutes. <u>FRONT PAGE NEEDS RESET</u>.

-What's the betting some princess is pregnant again?

SULT
– 1966 –

-It's ten!

-It's two!

-You're wrong, it's ten! You'd better <u>RESET YOUR WATCH</u>, my good man!

STAR WARS EP. V
– 1980 –

-He's all yours, bounty hunter.

-<u>RESET THE CHAMBER</u> for Skywalker.

-Skywalker has just landed, lord.

-Good. See to it that he finds his way in here.

GENRES

DRAMA	DRAMA	DRAMA
ADVENTURE	ADVENTURE	ACTION
ACTION	COMEDY	ADVENTURE
SCI-FI	WESTERN	COMEDY
		SCI-FI
		THRILLER
		CRIME
		ROMANCE

KEY WORDS

DEGREES

BONES

RUDDER

FUSES

MACHINE

PAGE

PATTERN

SONAR

ALARM

WATCH

HEADLINE

BONES

CONTROLS

ELECTRONICS

EMERGENCY

FLIGHT

SHIPS

SWITCH

STOPWATCH

TEST

ALARM

BODY

GAME

TIME

BREAK

TIMERS

COMMAND

CONTROLS

QUOTES

APOLLO 13
– 1995 –

- We've got a <u>COMPUTER</u> restart.
- We've got a ping light.
- The way these are firing doesn't make sense. We've got multiple caution and warning, Houston. We've got to <u>RESET</u> and restart.

NO MAPS FOR THESE TERRITORIES
– 2000 –

- Functional nanotech would pretty much guarantee both of those because there would be, you know, no reason to die if you had sufficient nanotech to keep <u>RESETTING THE LITTLE CELLULAR CLOCKS</u>.

LIVE FREE OR DIE HARD
– 2007 –

- Just hit the <u>RESET BUTTON</u> and melt the system just for fun.
- Hey, it's not a system. It's a country. You're talkin' about people, a whole country full of people, sitting at home alone, scared to death in their houses, all right?

GENRES

DRAMA	DRAMA	DRAMA
COMEDY	COMEDY	COMEDY
ACTION	ACTION	ACTION
CRIME	ROMANCE	SCI-FI
SCI-FI	SCI-FI	THRILLER
ADVENTURE	ADVENTURE	HORROR
THRILLER	MYSTERY	ADVENTURE
	HORROR	ROMANCE
	THRILLER	

KEY WORDS

COMPUTER	ALARM	BUTTON
ALARM	CLOCKS	SYSTEM
SWITCH	SYSTEM	GAME
AUTOMATIC	BUTTON	CLOCKS
COIL	SCENE	DOOR
CLOCKS	COMPUTER	TIME
DETONATION	SWITCH	HIT
NEWS	ODOMETER	PRESS
PROGRAM	GAME	SCENE
	CODES	

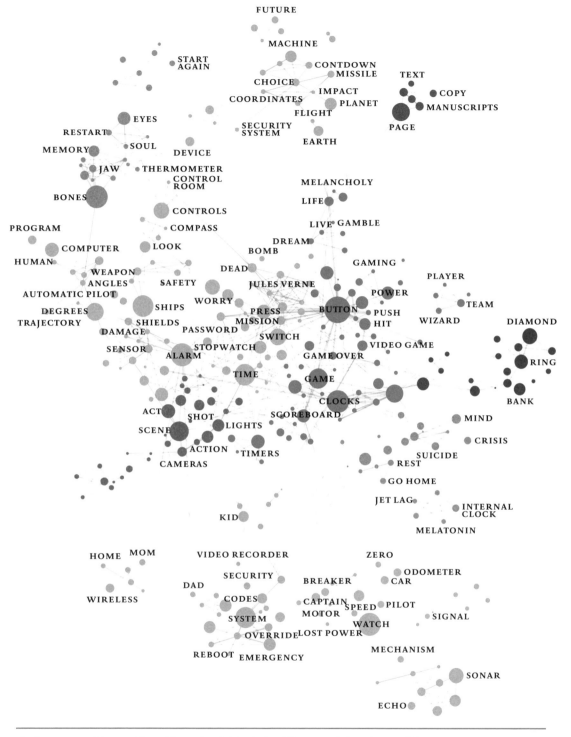

3b Occurrence of the word "reset" in movie subtitles during different periods and genres.[5]

3c Network of co-occurrences to the term "reset" in movie dialogs.[5]

PREPARING A COMPOSITION

IF WE LOOK BACK at the origins of the term "reset" we can rediscover a sense of composition as an active process of selection, adjustment, and transformation done by the grouping and the reconnection of heterogeneous items. By doing a reset, a certain space is carefully prepared to host an event, an action, again. Indeed, etymologically the term is composed of *re* (again, back, anew) and *set*. If we retrace *set* to its Germanic root, it expresses the idea of putting something in place, to fix, to adjust, to group again. Additionally, if we go back to its Latin origin, *cipere* (as an alteration of *capere*), *set* defines the action of taking,[6] hosting, accommodating, and recovering. In this sense, it is also semantically linked to *receipt* and *recipe*, as to devise a series of steps, actions or ingredients of a preparation.

The act of composing is expressed in all its delicacy and importance, in pre-digital typographic practices – in an age when the composing of the pages of a book was extremely labor intensive – aimed at fitting "physically and visually in various combinations" (Drucker and McVarish 80) letterform, graphic ornaments, and images. If a text was reset, for instance, by changing the number of words per line, bibliographers reconstruct the genesis of the texts listing clearly all the changes made as compared with the previous edition. It is a kind of alert for the readers, a warning about possible alterations to the meaning and the sense of the text that may have been introduced by changes to its appearance (see fig. 5). It is with the evolution of mechanics that the term starts to indicate an automatism (see figs. 6a and b), which leads to a terminological

confusion. For instance, in fig. 7 the button used to clear or wipe a wrong combination is called reset.[7] Although the button is part of the procedure to prepare the system's welcoming of a new combination, its main feature is to erase the user's error. Indeed, a real reset procedure is the one offered by many padlocks (see figs. 9a and b), and in general all procedures used to change the authentication of a system are a really good demonstration of how the reset is a long chain of mediation between heterogeneous entities. Whether it is changed through a help desk or by using a self-service application, the user is called upon to run a long script whereby she has to be attentive and patient: to establish that she is human, by completing a CAPTCHA; to provide a proof that she is the real owner of the service for which the new password is required; to compose a PIN sent by e-mail or instant messaging to obtain a one-time password token; and, eventually, choose a new code. The longest 15 minutes of your life if you are trying to reset the password of a hijacked account of yours!

INSTRUCTING A MEASUREMENT

RESET PROCEDURES are more often than not nested in other procedures,[8] but they are of primary importance in scientific observation and measurements (see figs. 10, 11, and 12). Before recording any measurement, thermometers, microscopes, telescopes, sextants, and spirometers have to be calibrated to a baseline through a reset procedure. Among all the recording devices that created an "abstract framework of divided time that became more and more the point of reference for both action and

[6] In this sense the word reset is used to designate the receiving of stolen goods (see fig. 4).

[7] There was the same sort of confusion until some years ago with regard to online forms, when to discarding any information entered in them, the user was supposed to use a button labelled reset, rather than clear. A similar semantic overlap appears in the NASA Space Shuttle manual (see fig. 8). The button MSG RESET "clears ... the ... fault ... Depressing this key will also extinguish all software-driven caution and warning annunciators. ... An ILLEGAL ENTRY message can only be cleared with the MSG RESET key"; while I/O RESET "attempts to restore a GPC's [General Purpose Computers] input/output configuration to its original status prior to any error detection" (2.6–34).

[8] Simple examples are procedures for winemaking or sailing routines.

4 Extract of page 413 from: Robert Pitcairn. *Criminal Trials in Scotland* [...]. 3 vols. Edinburgh, 1833. PDF file.

Common Theft and reset of Theft.

'WILL ELLOT, callit *Woddir-nek;* Petir Trumbill, callit þe *Monk;* and Henrye Blak, in Softlaw, Convict to be HANGIT for Commoun Thift and Commoun reſſett þairof.'

8. An Essay on Man. In Epistles to a Friend. Epistle II. London: *Printed for J. Wilford, at the Three Flower-de-Luces, behind the Chapter-house, St. Paul's.* (Price One Shilling). Folio, uncut, bound with No. 6.

* This is the second edition, with the same collation as the first but entirely reset, with different ornaments. Pp. 13 and 14 of this edition contain 22 instead of 20 lines. This error is corrected on pp. 15 and 16. Otherwise the two editions are page for page. The most notable difference in the two editions is that in this second edition the lines are unnumbered. They are numbered in the earlier edition, though lines 250-270 are mis-numbered 150-170. One copy of this edition is known in which line 175 is numbered. This is sufficient proof that the edition with numbered lines is the first.

5 Extract of page 7 from: Marshall Clifford Lefferts. *Alexander Pope: Notes towards a Bibliography of Early Editions of His Writings* [...]. Cedar Rapids: The Torch Press, 1910. Web.

33

6a Patent announcement for William Biddle's "Trap for Catching Animals." *Journal of the Franklin Institute* 26 (1840): 111. Web.

26. For *Traps for Catching Animals;* William Biddle, Pittsburgh, Pennsylvania, July 12.

This trap is constructed in a manner bearing considerable resemblance to that patented by Thomas Kell, on the 3rd of March, 1838, and the ends proposed are the same, namely, that the trap, after catching an animal, shall reset itself, or be reset by the animal; that the captured animal may pass along a passage leading to a separate compartment, from which it cannot return, said compartment being so constructed as to be readily detached from the body of the trap. The particular devices, of course, differ from those used in the trap above named, or the present patent would not have been granted. The claims are confined to these particular devices, as referred to by letters on the drawings.

6b William Biddle. "Cage Trap." Patent drawing. US Patent 1238, issued 12 July 1839. Web.

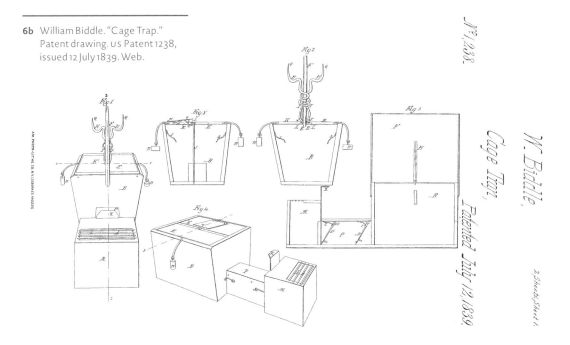

FIG.1 FIG.2 FIG.3 0093666 1/1.

SINGLE KEYSTROKE COMMANDS

FAULT SUMM	SYS SUMM	MSG RESET	ACK
GPC/CRT	A	B	C
I/O RESET	D	E	F
ITEM	1	2	3
EXEC	4	5	6
OPS	7	8	9
SPEC	—	0	+
RESUME	CLEAR	•	PRO

MULTI-STROKE INITIATORS. REQUIRE EXEC AS TERMINATOR.

TERMINATOR FOR ABOVE INITIATORS.

MULTI-STROKE INITIATORS. REQUIRE PRO AS TERMINATOR.

SINGLE KEYSTROKE COMMANDS

TERMINATOR FOR OPS AND SPEC

233

Multifunction Electronic Display System Keyboard Unit on Panels C2 and R11L

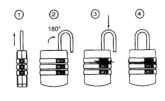

① ② 180° ③ ④

U.S. Patent Feb. 10, 1998 Sheet 5 of 5 5,715,709

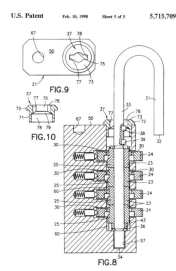

FIG.9

FIG.10

FIG.8

7 Henri Rochman. "Protective device for key-operated door locks." Patent drawing. EP Patent 0093666, filed 28 Apr. 1983, and issued 9 Nov. 1983. Web.

8 Table from page 2.6–34 in: NASA. *Shuttle Crew Operations Manual.* United Space Alliance, LLC, 15 Dec. 2008. Web.

9 Example of key resetting in a lock. Eric Lai. "Combination Lock Construction." Patent drawing. US Patent 5715709, filed 11 Jan. 1996, and issued 10 Feb. 1998. Web.

108 MECHANICS.

should be taken not to set it too far out, as, by so doing, the clew would be lowered, the strain of the sheet fall too much on the foot, and one night, with a strong breeze, might considerably injure the standing of the sail.

No. IV.

REPEATING STOP FOR A SEXTANT.

The GOLD ISIS MEDAL was this Session presented to Mr. T. REYNOLDS, 13, Arbour Terrace, Commercial Road, for a Repeating Stop for a Naval Sextant, which has been placed in the Society's Repository.

IN the sextant, as ordinarily constructed, an observation or angular measurement being made, must be read off and registered before the instrument can be used for a second observation. The only inconvenience attending this, in day observations, is the interval which it necessarily makes between two successive observations. But during this interval clouds may interpose to prevent a second observation; and in all cases where the mean of several successive ones is wanted, the shorter the interval that occurs between them, the more are they to be relied on. In night observations the advantages of expedition are still greater than by day, because the interval between two successive ones is necessarily much lengthened by being obliged to go to a light on deck, or, it may be, in the cabin, in order to read off the result. It is also found, that when the eye is brought from almost

MECHANICS. 109

darkness into a bright light, a certain time is required for that organ to adjust itself before the sight becomes sufficiently distinct to perceive minute objects, and consequently to make an observation and read off its result with the necessary correctness. By means of Mr. Reynolds's repeating stop, which, at a small expense, may be applied to any instrument now in use, five observations may be made in succession without the necessity of reading off, because the bolts in the repeating stop will register the first four, and the index of the instrument will register the last as usual. The only thing, therefore, required for the observer to be aware of, is, that the results of the observations are read off in an order precisely the reverse of that in which they were made.

The invention has received the approbation of the Admiralty, of Mr. Lamont of the Greenock Observatory, of Mr. Lynn, and of Commander Low, R.N., whose testimonials are hereto subjoined, as well as of many professional men, who are at present using it.

Hydrographical Office, Admiralty, September 21, 1827.

SIR,

I am directed by Sir George Cockburn to acquaint you, that you are at liberty to make use of the approbation of the Admiralty for your invention, agreeable to the request you made.

In addition, from myself, I sincerely wish you success in disposing of it, for, though simple, I think it will be of great use to navigators.

I am, Sir, &c. &c.

Mr. REYNOLDS. J. WALKER.

10 J. Walker et al. "Repeating Stop for a Sextant." *Transactions of the Society of Arts Manufactures and Commerce* 47 (1829): 108–11. Web.

caliper legs, but this is not readily done as a makeshift. To measure the inside diameter of a bore having a shoulder like the piece *H*, the inside caliper *F* may also be set as usual and then a line marked with a sharp scriber on one leg, by drawing it along the side *G*. Then the legs are closed to remove the caliper, and are reset to the scribed line. Of course, this method is not as accurate as the previous one, and can be used only for approximate measurements.

To get the thickness of a wall beyond a shoulder, as at *K*, Fig. 7, set the caliper so that the legs will pass over the shoulder freely, and

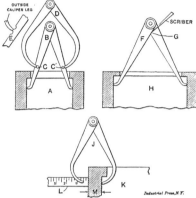

Fig. 7. Methods of Inside Calipering

with a scale measure the distance between the outside leg and the outside of the piece. Then remove the caliper and measure the distance between the caliper points. The difference between these two distances will be the thickness *M*.

11 Page 14 from *Machinery's Reference Book 21: Measuring Tools*. New York: The Industrial Press, 1910. Web.

13 Bert Chapman. "Clock Resetting Device." Patent drawing. US Patent 1830750, filed 14 May 1927, and issued 10 Nov. 1931. Web. 24 Feb 2016.

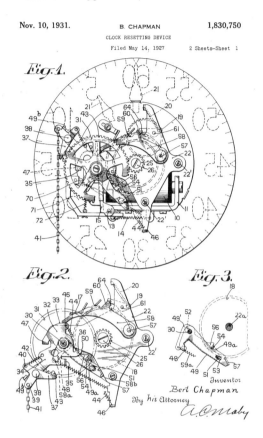

Cyrtometers.

These usually consist of some form of curved caliper provided with flexible arms by which the shape of the outer chest wall may be ascertained and transferred to paper.

Flint's Cyrtometer, as shown by figure 45, consists of a caliper with short steel arms to the ends of which strips of bar lead are attached by means of set screws. These soft, pliable parts form the contact portion of the instrument. A curved bar, or indicator, attached to one arm rests in and slides through a slot in the opposite arm. A thumb screw fixes the arms at any degree of separation. The cross bar is graduated so it can be reset at any given position. By fixing the instrument at the proper width, the outline of one side of the chest may be accurately molded in the lead bars, the set screw released and the instrument removed, after which by replac-

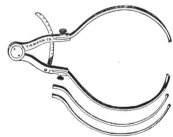

Figure 45. Flint's Cyrtometer.

12 Extract and table from pages 46 and 47 in: Charles Truax. *The Mechanics of Surgery*. San Francisco, 1899. Web.

thought" (Mumford 16), clocks and timers (see fig. 13) are the ones most commonly associated with the reset. The relevance of a technology, in this case the one enabling the precise measurement of time with cogs and wheels, is reflected in the introduction of a series of new metaphors and analogies: "When the mechanical clock arrived, people began thinking of their brains as operating 'like clockwork'" (Carr). Although, we do not have to bother ourselves anymore with resetting our clocks when travelling from one time zone to another – a *daemon*, a *pacemaker*, an invisible script[9] will do it for us by connecting the device to a remote server – we still have to reset our biological clock, our circadian rhythm, the phase of our neurons (see figs. 14 and 15). In this way, thanks to an analogical extension, if the mind and the body are clockwork, the way to control them, quickly, is the reset. Reset, in this case, is the recipe, a magic walkthrough. Query Amazon for reset (see fig. 16): a wall of front pages, where more often than not a big reddish button stands prominently, promising in 7, 14, or 21 days to reset our metabolism, our karma, our motivations or our inspirations, cleanse our body and our mind of stress and toxins. Once again we are witnessing the promise and the premise of a dream, a long procedure becoming a click; a button offering, without any mediators or dispatchers, to erase any lifestyle misconduct, a button equipped with an effective binary logic to disclose an "after" erasing all the errors of "before," with a comfortable action of the finger.

ITERATING A CALCULATION

IT SHOULD COME AS NO SURPRISE that among the book categories most related to the reset there is religion. A book of sermons depicting the Great Flood as the principal scene of all the resets: God inflicting a merciful punishment for a new beginning of the human race. Fictional-religious-dystopic-apocalyptic books depict doomsday as major resets. Close to these gods are other ones, the theo-computational (Bogost) ones, promising stability and perfection, in which, again, the metonymic confusion lets the reset be a button and a clear.

Reset and clears are quintessential in computation. In positional algebraic[10] devices, such as the abacus or the suan pan, to reiterate a calculus as an act of reset was performed by manually sliding the beds along the wires, replacing the swipe and erase gesture of the dust abacus, in other words replacing its blank-state concept. Pascal's machine and Babbage's one (see fig. 19) required massive human intervention to complete calculation cycles (Essinger): annotating the results, moving the drums, gears, and cams to reset them to zero in order to perform a new calculation. Again a long mediation process is visible. The subsequent evolution of calculating machines using electromechanical relais, the flip-flop[11] (see fig. 20), was probably crucial in producing the idea of the reset as an immediate and nonmediated action, recalling the idea of a tabula rasa. Although the ENIAC (see fig. 18) – the first completely programmable Turing machine, a giant of 30 tons wired by

[9] In technical environments, transport systems, or spacecraft a similar operation is performed by Watchdog Timer, Command Loss Timers. These are daemons controlling the state of computers checking, not for the correct timing, but for their correct refresh, generating, in case, timeout signals to start a reset and recovery procedure. They are a kind of automatic Dead Man's Switches.

[10] In an infinite game of lexical and etymological links, it is worth remembering that the word "algebra" derives from the Arabic *al-jabr* or *jábara* that can be understood as repositioning parts whose organization has been disturbed or disrupted, and was also used to designate the treatment of dislocated bones (see fig. 17).

[11] The *flip-flop*, whose name is a vestige of the noise that the electromechanical devices were emitting, are the building block of digital electronics. They are used to count and for synchronizing variably timed input signals to some reference timing signal. They operate with a Boolean binary logic and can be considered circuits with 1 bit memory.

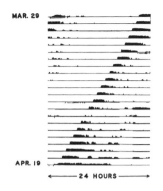

14 Circadian activity rhythm of a
 female mouse kept in constant
 darkness. Table from page 421 in:
 Joseph Altman. *Organic Foundations
 of Animal Behavior*. New York:
 Ardent Media, 1966. Web.

15 Tables from pages 395 and 397 in: Roswitha and
 Wolfgang Wiltschko. "Clock-shift Experiments with
 Homing Pigeons: A Compromise between Solar
 and Magnetic Information?" *Behavioral Ecology and
 Sociobiology* 49.5 (2001): 393–400. Web.

16 Categories of book recommendations by Amazon with the query "reset."

ration of the Nature and End of this Science; for the *Arabic* Verb *jábara* fignifies to refet, and is properly ufed in refpect to Diflocations, and the Verb *bábala*, implies oppofing, or comparing; and how applicable this is to what we call Algebra, the Reader, when he is thoroughly acquainted with this Book, will eafily underftand. As it became better known to the *Europeans*, it received different Names; the *Italians* ftiled it *Ars magna*, in their own Language *l'Arte Magiore*, oppofing to it common Arithmetick, as the leffer or minor Art. It was alfo called *Regula Cofæ*, the Rule of *Cofs*, for an odd Reafon: The *Italians* make ufe of the Word *Cofa*, to fignify what we call the Root, and from thence, this Kind of Learning being derived to us from them, the Root, the Square, and the Cube, were called *Coffick* Numbers, and this Science the Rule of *Cofs*. I fhould not have dwelt fo long on fo dry a Subject, but that it is abfolutely neceffary for the underftanding what follows.

It is a Point ftill difputed, whether the Invention of Algebra ought to be afcribed to the *Oriental* Philofophers, or to the *Greeks*; but it is a Thing certain, that we received it from the *Moors*, who had it from the *Arabians*, who own themfelves indebted for it to the *Perfians* and *Indians*; and yet, which is ftrange enough, the *Perfians* refer the Invention to the *Greeks*, and particularly to *Ariftotle*. Yet, notwithftanding this, it muft be allowed that the Algebra taught us by the *Arabians* differs very much from that contained in the Works of *Diophantus*, the eldeft *Greek* Author on this Art, which is now extant, and which was difcovered and publifhed long after the Algebra taught by the *Arabians* had been ftudied and improved in the Weft. But all thefe Difficulties, which have given fome great Men fo much Trouble, may be eafily furmounted, if we fuppofe that the Invention was originally taken from the *Greeks*, and new modelled by the *Arabians*, in the fame Manner as we know that common Arithmetick was; for this, which is at leaft extremely probable, makes the whole plain and clear,

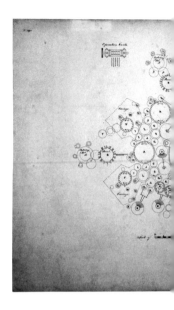

17 Page x in: Nathaniel Hammond. *The Elements of Algebra in a New and Easy Method: With Their Use and Application, in the Solution of a Great Variety of Arithmetical and Geometrical Questions by General and Universal Rules.* London, 1764. Web.

18 Neon lamps associated to flip-flops in the ENIAC for visual control of the operation routines. United States Army, Washington, D.C., and Moore School of Electrical Engeneering, University of Pennsylvania, Philadelphia. *Report on THE ENIAC (Electronic numerical Integrator and Computer).* Philadelphia, 1946. Web.

19 General plan of Charles Babbage's "Analytical Engine." Engraving. 1840. London, Science Museum. Philadelphia, 1946. Web.

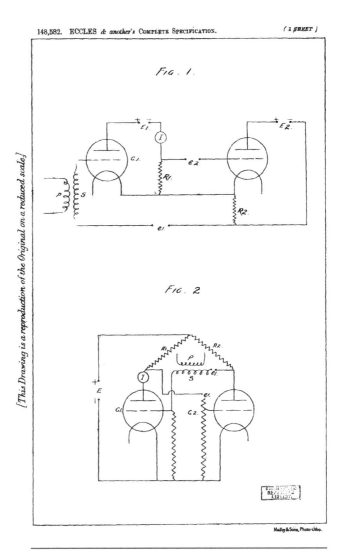

20 William H. Eccles and Frank W. Jordan. "Improvements in Ionic Relays." Patent drawing. GB Patent 148582, filed 21 June 1918, and issued 5 Aug. 1920. Web.

hundreds of cables – still required its programs to be manually inserted and a manual reset of its plugs and switches, it had 1500 flip-flops that gave it the possibility of executing computational cycles like INITIAL CONDITIONS → RESET → COMPUTE → RESET → COMPUTE → etc. Probably, from that moment on, the 0 state, hidden in the flip-flop, invisible to the eyes, and for this reason incorruptible, became an immaculate ideal state from which to start and come back to in case of error.

When the calculation loop becomes "rotten," you have an external reset button capable of returning the machine to its initial state. It is a state that can be invoked and evoked. Nevertheless, inside any computer, blurred by a binary logic and invisible, a long chain of mediation is still active. While reset and refresh processes are running to ensure the stability of the processors, in case of a main system failure an agent is still triggering a long reset procedure: it instructs the CPU to list all the errors, to write a log report, to desperately save the unsaved data, to activate a shutdown process (hopefully not disconnecting itself from the power source) that in turn imparts the order to clean the memory.[13] At that point by using a *reset vector* the CPU will find an address where the first instructions are stored that it will perform after executing a reset: the *re-boot*.

REMEDIATING AN IDEAL

THIS CHAINED ASSEMBLY of techniques and algorithms that is anything but neutral (Gillespie), stays invisible. What is left is the button, used as narrative expedient in storytelling – the reset button technique – and used clumsily in international political affairs.[14] Buttons are everywhere because they initiate immediate actions, because they are seductive, because they are a potential for interaction. But they are always working under the regime of analogy and metaphor: rare are the buttons nowadays acting on steel gear and lever by transmitting the force of a body to the metal components. They relentlessly select and hide part of the system by casting a light on other ones. They are the wireframe of a situation. But still, as a vestige of mechanical connections, they are trustworthy because we presume that we can predict what will happen after being pressed: "they always precipitate the same action" (Pold 32). While they try to remediate their old analog existence (Bolter and Grusin) by offering something easy and well known, they detour our common limited understanding of the human–machine–society assemblage. We should know that by clicking, double-clicking, hitting, and pressing, we are manipulating several layers of symbolic instances (Johnson), but we ignore it. It is easy to describe what we do when accepting the terms and conditions of any web service or software: just click. But in that case either you accept the terms or you don't,

[13] A long chain of mediation is active also outside the computer, think for example about the moments when the reset button is activated because the system is not responding, you will call a help desk, a fiend, look on your mobile for a forum searching for a troubleshooting procedure, describing in this way one of the most common socio-technical assemblages. This example describes the reset procedure for a classical personal computer, other personal devices as reset procedures are intended the ones trying to put back the device to the factory settings, that to some extend is linked to more extreme actions like formatting.

[14] In 2009, United States Secretary of State Hillary Clinton and Foreign Minister of Russia Sergey Lavrov, after a diplomatic meeting pressed a symbolic red button (see fig. 2, *r*·M! 382; Kharkhordin, *r*·M! 381–86). The button had two words on it: one in English, and one in Russian. Lavrov explained to Clinton that the Russian words used stand for "overcharge" and not for "reset." Besides mentioning the translation error, the *New York Times* technology columnist J. D. Biersdorfer commented: "[R]eset, as in *reset button* – that's a nice, comforting physical switch you find on everything around the house from electrical outlets to video game consoles. Push that button, and everything is supposed to be all right. Everyone wants the magic button" (Safire).

no middle ground is on offer. Nevertheless, the buttons make you feel in control by compressing part of society, technical knowledge, mediations, and transformations in a ready-to-be-run package. They do that also in a noncomputer related environment, when there is no ideal state or normal condition to go back to. So better not push that button but still rely on the reset, as a long, calm, patient, and puzzling procedure.

This is why, in spite of the complicated history of those technical devices, evolving from the mechanical to the digital, from the mundane to the highly sophisticated, from the esoteric to the cliché, we have chosen this ambiguous term for the title of the book and the exhibition. The reason has to do with its nice contrast to "tabula rasa," "revolution," and "iconoclasm," which are frequent tropes in modernist discourse when talking about a clean break. A reset does not break anything; on the contrary, reset is a somewhat fresh term for something that does not refer to critique, simply to embarrassment, accumulation of bugs, and excessive complication. It also has the advantage, especially in its mechanical examples, to be close to the key notion of *procedure*, which we have been using throughout this entire book. Finally, it may help readers to get used to the odd situation of mild panic generated by the requirement to reset their recording instruments. There is nothing direct, instantaneous, easy, in the apparent simple movement of pushing the reset button, especially when modernism is at stake!

Works Cited

Altice, Nathan. *I Am Error: The Nintendo Family Computer Entertainment System Platform.* Cambridge, MA: The MIT Press, 2015. Print.

Baudrillard, Jean. *The System of Objects.* Trans. James Benedict. London: Verso, 1996. Print.

Bogost, Ian. "The Cathedral of Computation." *The Atlantic.com.* Atlantic Monthly Group, 15 Jan. 2015. Web. 13 Dec. 2015. Available at <http://www.theatlantic.com/technology/archive/2015/01/the-cathedral-of-computation/384300/>.

Bolter, Jay David, and Richard Grusin. *Remediation: Understanding New Media.* Cambridge, MA: The MIT Press, 2000. Print.

Carr, Nicholas. "Is Google Making Us Stupid?" *The Atlantic.com.* Atlantic Monthly Group, July–Aug. 2008. Web. 13 Dec. 2015. Available at <http://www.theatlantic.com/magazine/archive/2008/07/is-google-making-us-stupid/306868/>.

Consalvo, Mia. *Cheating: Gaining Advantage in Videogames.* Cambridge, MA: The MIT Press, 2007. Print.

Drucker, Johanna, and Emily McVarish. *Graphic Design History: A Critical Guide.* Upper Saddle River: Pearson Prentice Hall, 2009. Print.

Essinger, James. *Jacquard's Web: How a Hand-Loom Led to the Birth of the Information Age.* Oxford: Oxford University Press, 2004. Print.

Gillespie, Tarleton. "The Relevance of Algorithms." *Media Technologies: Essays on Communication, Materiality, and Society.* Ed. Tarleton Gillespie, Pablo J. Boczkowski, and Kirsten A. Foot. Cambridge, MA: The MIT Press, 2014. Print.

Johnson, Steven. *Interface Culture: How New Technology Transforms the Way We Create and Communicate.* New York: Basic Books, 1997. Print.

Kharkhordin, Oleg. "Resetting Modernity: A Russian Version." *Reset Modernity!* Ed. Bruno Latour. Cambridge, MA: The MIT Press, 2016. 381–86. Print.

Mumford, Lewis. *Technics and Civilization.* 1934. Chicago: The University of Chicago Press, 2010. Print.

NASA. *Shuttle Crew Operations Manual.* United Space Alliance, LLC, 15 Dec. 2008. PDF file.

Pold, Søren. "Button." *Software Studies: A Lexicon.* Ed. Matthew Fuller. Cambridge, MA: The MIT Press, 2008. Print.

Safire, William. "Reset Button" *The New York Times Magazine.* New York Times, 1 Apr. 2009. Web. 13 Dec. 2015. Available at <http://www.nytimes.com/2009/04/05/magazine/05wwln-safire-t.html?_r=0>.

A PROCESS RECORD
FROM A FRANGIBLE SURFACE

Claude Marzotto and Maia Sambonet (òbelo)

LET'S OPEN A 1920S Encyclopédie Larousse at the entry "Diagram": "Figure graphique, propre à représenter un phénomène déterminé. (Syn. de GRAPHIQUE.)" [Graphic image specifically representing a particular phenomenon. (Syn. of GRAPHIC.)] (see fig. 1). Let's place this definition side by side with the Diagram of Forces by László Moholy-Nagy in a 1939 photogram, (re)presenting the impression of a creased piece of paper – an example of the "space-time diagrams" that the author of Vision in Motion (1947) came to recognize in every line of a drawing, every vein of a leaf, or every crack of peeling paint – (eventually in any visible configuration) (see fig. 2). Let us then expand our visual reservoir to include the series Phenomena (Les Phénomènes), the extraordinary "atlas" of lithographs produced by Jean Dubuffet between 1958 and 1962, a collection of impressions sur le vif including soil, rocks, wall textures, and incrustations (see fig. 3).

As the safety distance of drawing collapses, the graphic surface may turn into a receptacle of intended or accidental collisions and rubbing of matter. This gives way to another kind of diagram, made of imprints that report some hidden characteristics of a physical interaction on its planar surface. As, for example, in Max Ernst's frottages, where the printed outcome, although it may be faithful to its origin, may also disclose the wonder of an unexpected landscape.

CLAUDE MARZOTTO, designer, and MAIA SAMBONET, visual artist, live and work as a designer duo in Milan. Their studio ÒBELO is the space where they conduct an open inquiry into the processes of image production. Since 2012, they collaborate on editorial, visual identity, and graphic design projects. Ongoing experimentation with tools and languages provides them with material to share through academic teaching and workshops for adults and children. òbelo is graphics, workshop, and research.

This is the ground we moved on when we were asked to release the telluric image of cracked soil to embed this publication's cover.

Now let us take from our desk a European standard A4 sheet of paper, lay it on a wooden board, and build a frame around it by nailing some crossbars along its sides. It's now time to move the sheet across the board and keep multiplying the frames until we achieve a grid that covers the entire working area. We can then prepare some cement paste and pour it to fill the internal spaces of this foundation. Looking for a sundry outcome, we vary the mixture for every casting by blending each time different quantities of sand and other aggregates: dust, filaments, soil, dirt, debris. The A4 areas start to take shape.

A few days later we remove from the open timber frames a series of A4 sheets, solidified into irregular

diagonal, e, aux adj. (du gr. *dia*, à travers, et *gônia*, angle). Se dit d'une droite qui joint deux sommets non consécutifs d'un polygone. N. f. Cette droite : *les diagonales d'un carré, d'un rectangle sont égales.*

diagonalement [man] adv. En diagonale.

Diagoras [*rass*] **de Mélos**, philosophe grec, surnommé *l'Athée* (vᵉ s. av. J.-C.).

diagramme [*gra-me*] n.m. (gr. *diagramma*). Figure graphique, propre à représenter un phénomène déterminé. (Syn. de GRAPHIQUE.) *Bot. Diagramme d'une fleur*, sorte de plan où sont représentés le nombre et la disposition relative des pièces de ses verticilles.

diagramme [*gra-me*] n. m. Genre de poissons acanthoptères, famille des pristipomatidés, renfermant de nombreuses espèces, de taille moyenne, à livrée argentée, habitant toutes les mers chaudes.

diagraphe n. m. (du gr. *dia*, à travers, et *graphein*, dessiner). Instrument qui permet de reproduire, sans connaître le dessin et d'après le principe de la chambre claire, les objets qu'on a devant les yeux.

A, B, diagonale.

43

1 "Diagram" definition. *Larousse universel*. Paris: Librairie Larousse, 1922.

2 László Moholy-Nagy. *Diagram of Forces*. 1938–43. Gelatin silver print, photogram. Museum of Fine Arts, Houston, Texas, USA / Museum purchase funded by the S. I. Morris Photography Endowment / Bridgeman Images.

and frangible double-faced objects. The next step is to put some black printing ink on a smooth tile using a rubber print roller. The roller collects a thin layer of ink from the tile and then is rolled over the concrete plate. Its pressure breaks the surface along the lines of weakness, which have been determined by the casual distribution of the aggregates within the cast. While releasing a layer of color on the elevations that it rubs on its way, the roller retains some of the dust and particles delivered from the concrete's breaches. Like in offset printing, the cliché does not come into direct contact with the paper: it is the rubber roller that retains the impression of the original surface and transfers this information to the new terrain.

The roller's capacity and memory is confined to the cylinder's surface area, which is slightly smaller than A4. At the second turn of the roller over the paper, a fainter image is repeated after the first in a fading sequence. On the other hand, every time

the roller moves on the cliché, it alters irrevocably its anatomy by breaking it into different lumps and eventually destroying it.

Rather than a mechanical reproduction from one original to many copies, the combination of the material's fragility with the roller's mechanics set a peculiar transmission scheme, performed *una tantum* and from one to one only. "It seems that the prints can only be referred to in the plural, precisely since it seems only to exist *in particular*: particulars, such as every place in which the print is operative (according to the material, texture, plasticity of the substrate); particulars, such as every dynamic, gesture, operation in which the imprint happens" (Didi-Huberman 11; Trans. òbelo).

The roller touches without seeing anything. The image it returns after each time it travels over the surface is a faithful graphic restitution of the contact points resulting from a tactile relief. Like a satellite, telescope, or microscope view, the visual data

produced by this manual tool are elicited at an unfamiliar distance and thus elude an univocal interpretation, while offering in exchange its own principles of order and measure. In the blind spot of vision, at the highest contact point, images are free to evade the control of the mapping eye (see figs. 4–15).

3 Jean Dubuffet. *Lithographies: série des Phénomènes.* Book cover. Paris: Berggruen, 1960.

Works Cited

Didi-Huberman, Georges. *La ressemblance par contact: Archéologie, anachronisme et modernité de l'empreinte.* Paris: Éditions de Minuit, 2008. Print.

Larousse universel. Ed. Claude Augé. 2 vols. Paris: Librairie Larousse, 1922. Print.

Moholy-Nagy, László. *Diagram of Forces.* 1938–43. Photogram.

Moholy-Nagy, László. *Vision in Motion.* Chicago: Paul Theobald, 1947. Print.

Dubufett, Jean. *Les Phénomènes (Phenomena).* 1958–62. Prints.

4-9 A4 concrete plates.

10–15 òbelo, *Concrete diagrams*. 2015.
Monoprint series, offset
printing ink on coated paper.
A4 size.

As Peter Sloterdijk has instructed us to do, whenever we mention the word *globe* or *global*, we should start to look around to see *where* we actually reside and *what* we can actually touch with our fingers. Most of the time, a "globe" is what we look at when we are comfortably seated in a room and flatten out a 2-D map of some part of the world or make a 3-D spherical contraption turn on its axis. It may happen that, if we look up at the ceiling, we realize that we are sitting under a dome, as is often the case in a universi-

ty auditorium, in a library, or under some Greco-Roman architecture, but in all these cases we never reside outside, nor are we able to really grasp the whole world from *nowhere*. As Donna J. Haraway would say, knowledge is always "situated."

Procedure 1

RELOCALIZING THE GLOBAL

To be inside and to have a limited view of a certain set of inscriptions, traces, or screens, connected or not to many states of affairs, is the condition from which there has never been any escape. And this is true of science as well as of politics. Thus the first procedure to reset our compass is fairly straightforward: it consists in *relocalizing the global*.

No one has done it in a more striking manner than Caspar David Friedrich when he hinted that the terraqueous globe might actually be situated not in outside space viewed from above but, on the contrary, literally embedded in one of the meanders of the Elbe river (Latour, *Face*). As Joseph Leo Koerner comments (**r·m**!68–73), this is what creates the fascinating visual puzzle in Friedrich's *Large Enclosure*. Is it the earth seen from the impossible site of a satellite? Did the painter want to render a curvature symmetric to that of the sunset sky above? What is certain is that when this marvelous painting was interpreted by Johann Philipp Veith, the plausible reading of it as an earth sunk into the earth was erased: Veith turned the mysterious scene into a most banal landscape (see fig. 15, **r·m**!66, and fig. 16, **r·m**! 66–67). It is much more interesting to read Caspar David Friedrich's painting as a lesson in the impossibility of seeing the earth except as a muddy place seen from a muddy place!

Localizing the global means becoming attentive to the situated places where one lives. The *Dasein* is not so much thrown "in the world" as it is located somewhere, most of the time in some variety of *designed* architecture. You may go from one architecture to another, but not from an inside to an outside. Even the "outside" is a highly designed and carefully staged "interior" called "Nature" or "wilderness." When you move from one space to the next, you always pass through a set of vestibules, locks, and connecting zones. Never "up." Just *sideways*. The master of this resistance to the "global view" is the artist Armin Linke (Latour, "Armin

Linke," r·m! 74–77) because of his highly peculiar way of showing interior spaces and obsessively sticking to this sort of "insideness." One of the peculiarities of

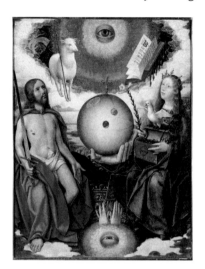

resetting our compass to the local is that, thanks to him, we are enabled to detect the changes of scale to which a human actor is always subject. When you consider an inscription, for instance, the map of a building, you are a giant, but when you shift to a place that has been built by the engineers, architects, and workers who followed this very same master plan, each of them the same size as you, you become a speck compared to the gigantic scale of the architecture. Traveling through society is being subjected constantly to a roller coaster ride. You never follow the trek upward as the emancipator[1] does in Plato's allegory of the cave.

1 Jan Provoost. *Christian Allegory.*
 Ca. 1510–15. Painting, 50 × 40 cm.
 Musée du Louvre.

Have you noticed the hand gestures people make when they talk about the "whole of society" or the necessity to "see the big picture," "consider the whole earth," or "think globally"? What they draw with their hands is never bigger than a reasonably sized pumpkin! That's about the real size of "the whole." Even when activists plan to destroy "capitalism," in practice they always designate a local site that may be connected to many other places through many different instruments, institutions, canals, channels, and dispositifs – or, on the contrary, not connected at all. Connected or disconnected does not have the same topography as big and small. If it is difficult not to be intimidated by those who talk constantly of considering "the big picture," watching their hands might be a good recipe for resisting the temptation to "think big."

Such resistance is all the more important when people talk about "the whole earth." Even on the cover of the *Whole Earth Catalog*,[2] the "blue planet" image is a composite made of many pixels. To the point where one could doubt that the "blue planet" image is a scientific image. Rather, it is a new instance of a much older globe, that of Christ holding in his hand the

2 Elifsu Sabuncu et al. "PrP Polymor-
 phisms Tightly Control Sheep Prion
 Replication in Cultured Cells." *Journal
 of Virology* 77.4 (2003): 2696–700
 (here 2698).

orbis terrarum of the Roman emperor (see fig. 1). The problem with the global is that you always enclose what you say too quickly in its spherical shape. You cannot resist thinking that what you say is actually "bigger" than the tiny local trace that you are holding in your hand. You are confusing the viewing of a 360-degree panorama with actually being up and outside – that is, unsituated for good.

One of the exercises that could cultivate the habit of resisting globalization and globalism is actually to look at scientists and scientific images. The cascade of inscriptions of different styles is of great help in foregrounding the many hiatuses, the many discontinuities that have to be inserted in any scientific demonstration. The very visual layout of scientific papers multiplies the gaps that, ultimately, end up showing for good that what you say and what you show are the same – provided referees and readers have been convinced.

The more you peruse the scientific literature, the more you learn to slow down and localize knowledge production. Localizing the slow composition of any global view is a great exercise in learning the exegetic skills necessary to combine, interpret, push aside, and focus on the many contradictory traces that are called, though much too quickly, *data*. Those exegetic skills are exactly what the emancipated philosopher in Plato's allegory of the cave lacks, and the reason why he cannot share knowledge with those he has imprisoned in the cave.

This cascade, so routinely present in scientific papers (see fig. 2), this race of sorts through discontinuities of many kinds, which are called "chains of reference" in the AIME project (Latour, "Chains"), is exactly what is being erased and smoothed over in the film *Powers of Ten* (see fig. 3, *r*·M!56, fig. 6, *r*·M!58, and fig. 9, *r*·M!60), mentioned in the introduction (Latour, "Let's Touch Base!" *r*·M!17 and 18–19).

It is a great paradox of contemporary culture that what is proudly called "the scientific worldview" bears no relation whatsoever, even visually, to the way scientists actually assemble knowledge. One reason is that the position of the observer is impossible (it is the view from nowhere, a view from an outside that is inaccessible); another is the disappearance of all the gaps and hiatuses across which the path of demonstration has to move for knowledge to be validated, have disappeared (Daston and Galison). What is left is not even a popularized, dumbed-down, and simplified "view." It has nothing to do with objective knowledge. But the worst thing is to pretend that, if you were such an all-seeing ideal creature, you could actually zoom in and out, at any scale, in a smooth continuous way (Latour, "Anti-Zoom"). It is on the basis of this pretense that you imagine yourself residing out in space.

[1] Concerning his interpretation of Plato's allegory of the cave, see Bruno Latour's introduction to this volume ("Let's Touch Base!" *r*·M! 11–23).

[2] The *Whole Earth Catalog* was a magazine and product catalog published by Stewart Brand between 1968 and 1972. See Diederichsen and Franke, also Grevsmühl.

It is true that resisting the zoom effect and being made aware that the "scientific worldview" is but a shadow (literally a film, a panorama) is difficult, all the more so because of the ease with which we now have access, through the Internet, to sliding movements like those imposed by Google Earth.[3] Still, it takes only a minute of concentration to become aware of all the little discrepancies, oddities, and slowdowns of even the best staged cartographic digital mapping. Then we quickly realize that we don't live in Google Space but are actually shifting from one data set to another. The cartographic ideal was very powerful in shaping the modern idea of the globe, but through a strange twist of history, its further extension through digital implementations leads to its eventual breakdown and shows that it is one extremely implausible way of staging, arraying, and disposing data sets. The very megalomania of the visual ambitions of Google and the rest reveals how the idea that we live in Euclidean space is just that: an idea. Or rather the ideal rendering of how an idea actually functions.

This is what makes the theatrical experiment of Andrés Jaque, *Superpowers of Ten*, especially effective (r·m! 78–89). He and his company took the *Powers of Ten* as a well-known emblem, but by copying as exactly as possible the trajectory of the film from a Chicago park to some outer galaxies and back, before then zooming down to the smallest particle, they show the complete implausibility of such a move. Every shot needs a new set of equipment, a new staging, and a new description, and obliging both actor and spectator to refocus on what is to be seen and, especially, on how to *align* the various props used to describe views at every scale. In a comedic way, the theater piece offers a more realistic demonstration than the apparently more "scientific" and "pedagogical" film shot by Charles and Ray Eames. Truth and objectivity depends on how many discontinuities are being *foregrounded*, not on how many are being smoothed over.

Try for yourself and see whether this first procedure helps you to reset your compass and position you safely in some locality, able to follow connections without jumping too quickly to the "big picture." Earth is not visible as long as it is hidden behind the globe.

[3] Note that the "inventors" of the virtual 3-D globe Google Earth were initially inspired by *Powers of Ten* when they were looking for a convincing demo for a virtual reality system in 1996. (They would go on to found Keyhole, Inc., in 2001, which was later acquired by Google in 2004.) See Leclercq and Paloque-Bergès; also Brotton.

Works Cited

Brotton, Jerry. *A History of the World in Twelve Maps*. London: Lane, 2012. Print.

Daston, Lorraine, and Peter Galison. "The Image of Objectivity." *Representation* 40 (1992): 81–128. Print.

Diederichsen, Diedrich, and Anselm Franke, eds. *The Whole Earth: California and the Disappearance of the Outside*. Berlin: Sternberg, 2013.

Grevsmühl, Sebastian Vincent. *La Terre vue d'en haut: L'invention de l'environnement global*. Paris: Seuil, 2014. Print.

Haraway, Donna J. "Situated Knowledges: The Science Question in Feminism and the Privilege of Partial Perspective." *Feminist Studies* 14.3 (1988): 575–99. Print.

Jacque, Andrés / Office for Political Innovation. "SUPERPOWERS OF TEN." *Latour Reset Modernity!* 78–89. Print.

Koerner, Joseph Leo. "Caspar David Friedrich: Earth Life Art." *Latour, Reset Modernity!* 68–73. Print.

Latour, Bruno. "Anti-Zoom." *Olafur Eliasson: Contact*. Ed. Suzanne Pagé. Paris: Flammarion, 2014. 121–24. Print.

---. "Armin Linke, or Capturing / Recording the Inside." *Latour Reset Modernity!* 74–77. Print.

---. "Chains of Reference." AIME. FNSP, 19. Aug. 2013. Web. 15 Jan. 2016. Available at <http://modesofexistence.org/aime/voc/51/>.

---. *Face à Gaïa: Huit conférences sur le nouveau régime climatique*. Paris: La Découverte, 2015. Print.

---. "'Let's Touch Base!'" *Latour Reset Modernity!* 11–23. Print.

Leclercq, Christophe, and Camille Paloque-Bergès. "Les artistes face aux services de cartographie Web." *Nouvelles cartographies, nouvelles villes: HyperUrbain.2*. Ed. Khaldoun Zreik. Paris: Europia, 2010. 199–210. Print.

Sloterdijk, Peter. *Globes: Spheres Volume II: Macrospherology*. Trans. Wieland Hoban. South Pasadena: Semiotext(e), 2014. Print.

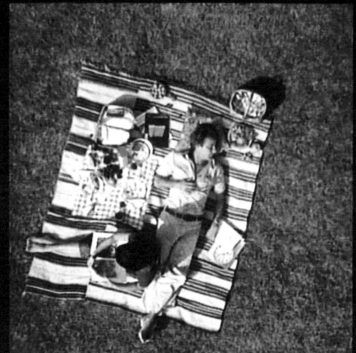

3 *Powers of Ten.* Dirs. Charles and Ray Eames. 1977. Film still.

4 Andrés Jaque /
Office for Political
Innovation
Superpowers of Ten.
2013–15.
Architectural
performance.

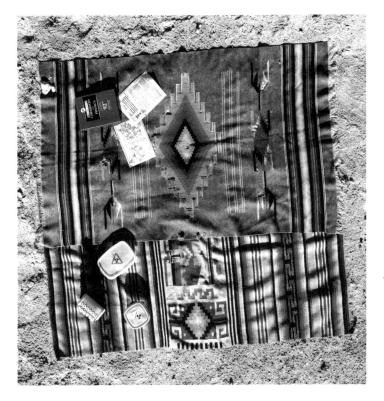

5 Peter L. Galison. 10^{25}, 10^4, 10^7, 10^{80}.
Photograph, dimensions
unknown. 2012. In *A Variation on the
Powers of Ten*, by Futurefarmers.
Web project. 2012.

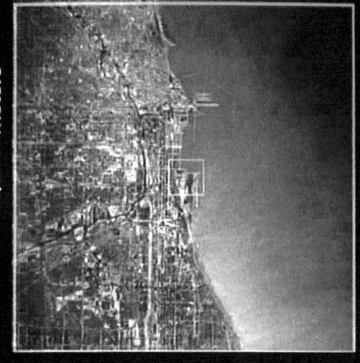

10,000 meters

10^4 meters

6 *Powers of Ten.* Dirs. Charles and
 Ray Eames. 1977. Film still.

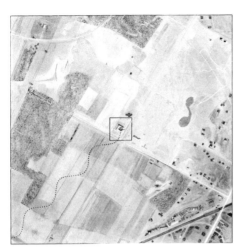

4. It is surprising that already in this fourth illustration the child, who filled the greater part of the first picture, has completely disappeared. The reason, as we said in the introduction, is that each time we jumped upward, we had to go ten times higher than we were, in order to produce an image at a scale one-tenth that of the one before. If we viewed the little girl from a height of, say, 5 meters in picture 1, we had of necessity risen to 50 meters to see #2, to 500 meters for #3, and now we look down from a height of 5000 meters. That is higher than Mont Blanc, Europe's highest mountain! No wonder that the huge whale can now hardly be distinguished. We notice a strange wavy line reaching the school building. We wonder what that is. The next drawing will show.

1 cm. in picture = 10,000 cm. = 10^4 cm. = 100 m. Scale = 1:10,000 = 1:10^4

9

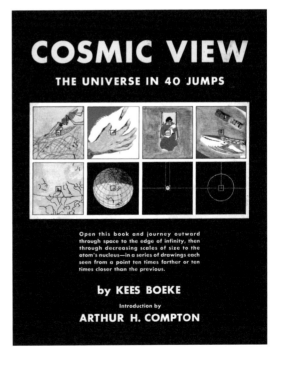

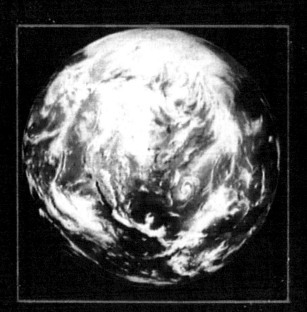

10 million meters

10^7 meters

9 *Powers of Ten.* Dirs. Charles and
 Ray Eames. 1977. Film still.

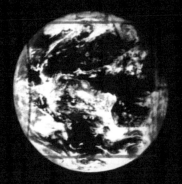

10 A Rough Sketch for a Proposed Film
 Dealing with the Powers of Ten and
 the Relative Size of Things in the
 Universe. Dirs. Charles and Ray
 Eames. 1968. Film still.

11 Sarah Sze. *Model for a Weather Vane*. 2012. Mixed media, stainless steel, wood, stone, acrylic paint, archival
prints, 345.4 × 381 × 142.2 cm. Courtesy the Artist and Victoria Miro, London.

12a *Weapon To Fight Cancer: The Harvard Cyclotron.* Dir. David Rosenthal. 2001. Video, 6:57 min. In *The Wall of Science*, by Peter Galison, Robb Moss, and students. 2005. 6-channel video installation.

12b *Locomotion in Water.* Dir. Hanna Rose Shell. 2003. Video, 8:00 min. In *The Wall of Science*, by Peter Galison, Robb Moss, and students. 2005. 6-channel video installation.

12c *Looking.* Dir. Rajesh Kottamasu.
2003. Video, 14:30 min. In *The
Wall of Science*, by Peter Galison,
Robb Moss, and students. 2005.
6-channel video installation.

12d *Tom & Yen.* Dir. Abby Paske.
2003. Video, 11:20 min. In *The
Wall of Science*, by Peter Galison,
Robb Moss, and students. 2005.
6-channel video installation.

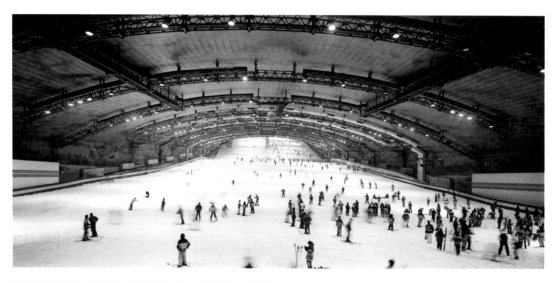

13 Armin Linke. *Ski Dome, Tokyo Japan*, 1998.

14 Armin Linke. *Cargo Lifter, air-ship construction hangar. Brandenburg (Berlin) Germany,* 2001.

15 Johann Philipp Veith (after Caspar
David Friedrich). *Evening on the Elbe*
(*Abend an der Elbe*). 1832. Engraving.

16 Caspar David Friedrich. *Large
Enclosure* (*Das Große Gehege bei
Dresden*). 1831/32. Oil on canvas,
73.5 × 102.5 cm.

CASPAR DAVID FRIEDRICH: EARTH LIFE ART

Joseph Leo Koerner

HOW WOULD THE ROMANTICS have respond-ed to the Anthropocene? What poems, plays, and paintings would they have created, what songs with-out words composed, knowing that human beings have so influenced the earth as to inaugurate its new-est geological epoch? It was, after all, a new though perhaps opposite sense of the world that dawned on them. Mesmerized by the enigma of geological time, the Romantics – among them neptunists and vulcanists alike – were among the first to respond creatively to the realization that the earth was not a fixed order that could be read like scripture, but was instead an ever-changing spectacle that mu-tated on a scale incommensurate with human life and human understanding. What would they, these explorers of nature's radical otherness, have made of earth affected globally and permanently here and now, through human actions, artifacts, decisions and indecision?

The paintings of Caspar David Friedrich are today the principal icons of Romanticism. Their ruined churchyards, moonlit evenings, and halt-ed travelers are displayed whenever that nebu-lous movement or sensibility requires expression. This is not only because of the ubiquity in Friedrich's art of "romantic" motifs and moods: for example, Gothic ruins that bespeak the root word "romance" as tag for the vernacular languages and literature of the Middle Ages; summit crosses and wayside

JOSEPH LEO KOERNER *is an art historian and filmmaker. He is the Victor S. Thomas Professor of the History of Art and Architecture and a Senior Fellow at the Society of Fellows, Harvard University. His books include* Caspar David Friedrich and the Subject of Landscape *(1990),* The Reformation of the Image *(2004), and* Bosch and Bruegel: From Enemy Painting to Everyday Life *(2016).*

shrines that affirm religion as the Romantic reviv-alists did, as subjective sentiment and nostalgia for innocent piety; fog-engulfed distances that turn landscapes into sites of longing, of Romanticism's longing for longing – including the yearning for what Romanticism itself is or should be; and land-scape itself, Friedrich's high subject, not merely as replacement for history painting as the craft's high-est form, but as emblem of History with a capital H, understood as (among other things) the unfolding of nations and, for Friedrich's exclusively terrain, of a united "Germany" in particular. Friedrich's paint-ings are icons of Romanticism most of all through their structure. In them "world" is set ineluctably *apart from* the human subject who, gazing across the divide, can only yearn, and live life as melancholic longing, ontological division, world-alienation.

The turned-away wanderers that people so many of Friedrich's pictures are the clearest emblems of Romantic separation. They diagram what remains

distinctively modern in this movement and what it feels like to live under the modern constitution that states: "there shall exist a complete separation between the natural world … and the social world" (Latour 31). This is roughly what the French sculptor David d'Angers intimated when, visiting Friedrich's ascetic studio in Dresden in 1834, he exclaimed, "Voilà un homme, qui a découverte la tragédie du paysage!" (Carus, *Lebenserinnerungen* 172). For nearly two centuries that tragedy has been our condition. But what would Friedrich have made of the new tragedy, that of landscape wounded permanently by us? What communicative resources might his remarkable artistry still furnish as we try to reset the modernity built into it?

The so-called *Large Enclosure* is arguably Friedrich's last great masterpiece (fig. 16, *r·m!* 66–67). Painted around 1831, four years before the artist suffered a debilitating stroke, it was acquired in 1832 by the Art Association of Saxony, which put it on auction at its December charity raffle. Unlike many of Friedrich's landscapes, this canvas constructs its palpable sense of the world without the presence in it of any human subject over whose cold shoulder, as it were, the artist asks us to peer vicariously. Instead, we stand alone, while the watery conditions of the foreground – those reflective meandering rivulets flowing towards us and the boggy high points in between – make our standpoint seem unreachable by foot or boat. (The heavily loaded barge sails on deeper waters than these.) From the prospect we have of the distance, and measured by the elevated view we have on the foreground, we seem to float impossibly in midair above the earth's surface. As the late Richard Wollheim put it:

> Any attempt to connect up landscape and viewpoint, or to offer a naturalistic explanation of how the viewpoint arises out of the landscape, is rejected, and the hiatus between what is seen and where it

is seen from is emphasized." The result is not only that we feel the landscape somehow to run on "under the point which it is represented"; having indicated a view divorced from a terrestrial site, Friedrich "goes so far as to render the phenomenal curvature of the Earth" (136).

Wollheim refers to the sense that all those rivulets limn a curved surface with its outer edge just below where the barge sails, and with its bits of bog reading like continents of some foreign planet viewed from outer space. Granted, this effect is fugitive. The seeming recession of forms on a sphere could be a mere artifact of the water's meandering course into whose random patterns we – our imaginations informed by photographs of planet earth – read the figure of a terrestrial globe. It remains unclear whether, from crafted globes, projective maps, or views taken from mountaintops or balloons, Friedrich could have arrived at such a precociously global viewpoint. When the Dresden printmaker Johann Philipp Veith engraved the composition for the Art Association of Saxony to document its acquisition, he straightened out the rivulets, making them into conventional orthogonals of perspectival representation and thus eliminating the globe-like effect (see fig. 15, *r·m!* 66). Whether that effect was intended or not, however, many who look at the painting as it hangs now in Dresden's Albertinum have felt it. In charcoal and pencil drawings executed on ledger book paper, William Kentridge in 2014 redrew the *Large Enclosure*'s foreground curve with a compass and sketched himself ceaselessly walking that unwalkable planetary edge (see figs. 1 and 2). The ledger forming the drawings' ground served as the 1906 cashbook of Johannesburg's Central Administration Mine. In our time, Kentridge reminds us, landscape is always already humanly excavated, wounded, and inscribed, here through the inhuman mine economy that treats workers like chattels.[1]

[1] On Kentridge's drawings and on the ledger books that are their support, see Kentridge and Morris.

Already in their own day, Friedrich's landscapes were criticized for severing foreground from background and for placing their viewer in an impossible point in space. Detractors of his most controversial early work, known as the *Cross in the Mountains* (1807), understood that the painter wanted to endow the scene with an inner-worldly sublimity corresponding to its otherworldly subject. But they rejected Friedrich's inflated and fragmented depiction of world. They argued that, just as figure painting sought to capture the coherence of the human body, landscape painting should aim at rendering continuities between and among bodies and at harnessing the visual manifold into an artful whole.[2] Friedrich sought totality, but of a new and different kind. In him, world outmeasures human space and time not only at infinity, in the vast distances and colossal mountains he marvelously paints; infinities occur close up, as well, in unremarkable objects that, painted as if they were possessed of life-and-death urgency, terrifyingly turn their back to us. The small canvas titled *From the Dresden Heath II* (1828) features nothing but bare alders in the snow (see fig. 3). It can be construed as depicting what someone wandering the land shown in the *Large Enclosure* might stop to observe in winter and bring back as fragment, or episode, "from" the heath – a cryptic epiphany of the whole.

In the *Large Enclosure* inhuman immensity begins already in the foreground, in the erratically shaped and discontinuous patches of primal humus receding from view like islands of an archipelago viewed from an orbiting satellite. Vastness is immediate and mundane, it is right there under one's feet. Friedrich underscores this by echoing the foreground shapes in the cloud formations of the evening sky. Resembling orthogonals in a perspectively constructed view (as Veith's corrections showed), the patterns of earth and sky converge at separate horizons. Sky converges at the vertex of the obtuse v of the clouds; earth at the place in the river where the barge sails. Between the far and the near vanishing points stands a strip of world resembling landscape before modernity.

A friend of Friedrich, and one of his best public champions, named the new totality towards which the painter strived. Carl Gustav Carus was a physician, a naturalist, and a talented amateur landscape painter in his own right. His Friedrichesque canvases now hang in major museums around the world. Carus moved to Dresden in 1814 and quickly fell under Friedrich's spell. What fascinated him was Friedrich's endeavor not simply to represent a beautiful world as a continuum of things wherein we live and act, but to paint in nature a mood "corresponding" to "a certain mood of mental life" (Carus, *Nine Letters* 91). Friedrich asserted, and Carus recorded the assertion, that "a picture must not be invented but felt" (Carus, *Lebenserinnerungen* 207). In two epistolary books, Carus went on to sharpen the idea by indicating that what expressed mood or feeling in nature was specifically its life.[3] In contrast to science's understanding of nature as multiplicity of objects set forth before human subjects for observation and use, the Romantic concept of *Naturleben* (life of nature) posited nature as a dynamic, evolving, organic whole. Carus reports that his feeling for Friedrich's art had been prepared during his medical studies in Leipzig, where he encountered in the writings of Friedrich Wilhelm Joseph von Schelling the notion of the *Weltseele* ("world-soul").[4]

Naturleben and *Weltseele* seem like mere anthropomorphisms born from a disappointment with Enlightenment critique. But they were a

[2] On the controversy sparked by Friedrich's *Cross in the Mountains* as it relates to the artist's compositional "system," see Koerner 117–25.

[3] In addition to his *Neun Briefe über Landschaftsmalerei* (*Nine Letters on Landscape Painting*), Carus published *Zwölf Briefe über das Erdleben* (*Twelfe Letters on the Life on the Earth*).

[4] Carus, *Lebenserinnerungen* 181; on this point, see Bätschmann 1–6 and passim.

1 William Kentridge. *Untitled* (43). 2014. Part of a set of five. Charcoal and pastel on ledger book paper from the Central Administration Mine Cash Book 1906, 42.5 × 61.5 cm. Goodman Gallery, Johannesburg.

2 William Kentridge. *Untitled* (39). 2014. Part of a set of five. Charcoal and pastel on ledger book paper from the Central Administration Mine Cash Book 1906, 42.5 × 61.5 cm. Goodman Gallery, Johannesburg.

3 Caspar David Friedrich. *From the Dresden Heath* II *(Aus der Dresdner Heide* II). Ca. 1828. Oil on canvas, 31 × 25.5 cm. Galerie Neue Meister, Staatliche Kunstsammlungen Dresden, Dresden.

4 Caspar David Friedrich. *Evening Star (Der Abendstern)*. Ca. 1834. Oil on canvas, 33 × 45.2 cm. Freies Deutsches Hochstift, Frankfurt am Main.

productive response to the dawning sense of the world's otherness that Enlightenment thinking believed could be eliminated through reason and technology. Carus, and far more profoundly and influentially Alexander von Humboldt, posited the world's unity neither as fact nor as mystical faith but simply as an *Eindruck* ("impression") that the life of the world can be shown to make on the life, or experience, of the human subject. In Humboldt, the chief vehicle for this impression was the book he published under the title *Cosmos: Sketch of a Physical Description of the World*. The book's true purpose, Humboldt explained in 1841, was "to float above the things we know, in 1841."[5]

Carus's vehicle for the impression was a new form of painting, one that he first found in Friedrich and that he would name *Erdlebenkunst*, which means, literally, "earth-life art." *Erdlebenkunst* expressed the life of the earth, its dynamic structure and history, through, for example, the legible development of mountains, the visible effects of water over time, and the manifest growth and development of plants. *Erdlebenkunst* utilized both the mimetic capabilities of art and the knowledge achieved through science. Its purpose was ultimately rhetorical: to demonstrate nature's being

to human being. Humboldt's fascination with the great earthquakes in Cumaná and Caracas rested in how, in these disasters, heaven and hell could enter the human lifeworld suddenly and apocalyptically: "The people screamed aloud in the streets" (Humboldt, *Reise* 47). Humans suffer the life of nature; before the advent of the Anthropocene, they do not alter that life; but they already unite with inhuman life in the impression that life makes on them.

The terrain depicted in Friedrich's canvas is that of the Ostragehege, a former floodplain spread along the southern bank of the river Elbe as it flows into the city of Dresden. From 1820 until his death, the painter lived and worked at Haus An der Elbe 33 – for this prodigious walker-painter an easy stroll to the Ostragehege and to a spot where an evening view not unlike the painting's could be enjoyed. Not unlike, because the trees featured in the painting in fact derived from a sketch the artist made in 1801 somewhere near the town of Breesen in Mecklenburg. This was Friedrich's working method. He observed and meticulously recorded in pen or graphite singularities in nature – this tree, this pair of boulders, this tiny bit of coastline and no other – in order to gather and unite them in a painted view created in the shuttered space of his studio. The Ostragehege

[5] Translated from a letter to Varnhagen von Ense (*Briefe* 92); cited and discussed at Blumenberg 285.

was nearby, but the trees in the picture come from elsewhere, near-photographic impressions synthetically brought into the experience of Dresden's enclosure by the productive imagination of the artist who experienced them. More than an accident of the artistic process, the temporal and spatial distance of those trees (30 years, 500 kilometers) belong to what, for me at least, is the painting's most moving feature.

Beyond that foreground treated as a microcosmic planetary globe, and underneath that gigantic sky that, filling most of the canvas, veers (through the stripes of clouds) towards a perspectival infinity inside a merely suggested cosmic one, Friedrich sets forth, in narrow panorama wherein everything is distant, a beautiful place in human scale: his own beloved Dresden setting, with its groves, river, hills, and verdant clearings. Sandwiched between the two immensities, this, the lifeworld, becomes the unattainable object of Romantic longing. Such longing is in part that of the subject-painter and – by the extension Friedrich masterfully constructs – of ourselves, who see "home" only across an unbridgeable divide. But Friedrich also makes this longing look partly like nature's own yearning, the Weltseele's ache to become one with itself.

In another canvas made around the time of the Large Enclosure, Friedrich introduced human forms to dramatize this yearning. Evening Star places us again just outside Dresden's walls, again with that naturally apocalyptic evening sky (see fig. 4). But here he puts a little boy with arms raised as if somehow to catch the vanishing afflatus of lived experience. It is Gustav Adolf, the painter's only son, born when Friedrich was 50 years of age. It is of course only from the artist's viewpoint that the boy's doffed cap hovers just there, at the edge of heaven's radiance. And only from where the artist stands does that rising foreground mound of earth – another planetary curve – conceal all of Dresden except its spires. Nature's full immensity cannot be grasped, neither by the boy nor by the painter. Yet painting can capture nature's Eindruck, here mediated also

biologically across time, from father to son. It can almost perform what we must endeavor to do today, to grasp the global in the mundane.

Works Cited

Bätschmann, Oskar. "Carl Gustav Carus (1789–1869): Physician, Naturalist, Painter, and Theoretician of Landscape Painting." Introduction. Carus, *Nine Letters* 1–76.

Blumenberg, Hans. *Die Lesbarkeit der Welt*. Frankfurt am Main: Suhrkamp, 1981. Print.

Carus, Carl Gustav. *Lebenserinnerungen und Denkwürdigkeiten. Nach der zweibändigen Originalausgabe von 1865/66 neu herausgegeben*. Ed. Elmar Jansen. Vol. I. Weimar: Kiepenheuer, 1966. Print.

---. *Nine Letters on Landscape Painting, Written in the Years 1815–1824: With a Letter from Goethe by Way of Introduction*. Trans. David Britt. Los Angeles: Getty Research Institute, 2003. Print. Trans. of *Neun Briefe über Landschaftsmalerei, geschrieben in den Jahren 1815–1824. Zuvor ein Brief von Goethe als Einleitung*. Leipzig, 1831.

---. *Zwölf Briefe über das Erdleben*. Stuttgart, 1841. Print.

Humboldt, Alexander von. *Briefe von Alexander von Humboldt an Varnhagen von Ense aus den Jahren 1827 bis 1858*. Ed. Ludmilla Assing. Leipzig, 1860. Print.

---. *Reise in die Aequinoktial-Gegenden des neuen Kontinents*. Ed. Hermann Hauff. Vol. 2. Stuttgart, 1859. Print.

Kentridge, William, and Rosalind C. Morris. *Accounts and Drawings from Underground: The East Rand Proprietary Mines Cash Book, 1906*. Calcutta: Seagull, 2015. Print.

Koerner, Joseph Leo. *Caspar David Friedrich and the Subject of Landscape*. 2nd, rev. ed. London: Reaktion, 2009. Print.

Latour, Bruno. *We Have Never Been Modern*. Trans. Catherine Porter. Cambridge, MA: Harvard University Press, 1993. Print.

Wollheim, Richard. *Painting as an Art*. London: Thames and Hudson, 1987. Print.

ARMIN LINKE, OR
CAPTURING / RECORDING THE INSIDE

Bruno Latour

BRUNO LATOUR is a professor at Sciences Po Paris and head of its Médialab, specializing in digital methods and digital humanities, and has recently published An Inquiry into Modes of Existence (2013), whose contents are replicated on a digital platform accessible via modesofexistence. org, and Facing Gaïa (2015). All the references to his work in this volume and most of his papers are available at bruno-latour.fr.

Originally published in: Armin Linke. *Inside/Outside*. Rome: Roma Publications, 2015. 42–44. Roma Publication 235.

Bruno Latour **Armin Linke, or Capturing / Recording the Inside**

The work of Armin Linke follows the traces, wherever he is given access, of a very special kind of human activity. Do not expect pretty pastoral pictures or portraits, or else highly eccentric ones; nor any lofty perspective; nothing that evokes an all-seeing eye; no images, so to speak, "from outside". Linke, as his name indicates, is an analyst of the concealed places of *connectivity*. A philosopher of interior envelopes and confined spaces, inside which, unbeknownst to us, our destinies are cast. But a philosopher who has at hand, instead of a pen or keyboard, a superb optic and, behind him, an immense digital archive.

For about twenty years, he has put together an impressive database of enclosed spaces within which, from the early twentieth century, most human activity has taken place, at least in what we still dare to call "developed countries": research centers, laboratories, scale models, trading rooms, banks, courts of law, parliaments – in short, places that have, in and of themselves, no aesthetic value, no sparkle to catch the eye, so many spaces of bureaucracy, administration, and expertise, of which Armin, almost on his own, manages to grasp the banal and irreplaceable originality.

More remarkable still is the fact that Armin records these usually invisible locations, with a sure eye, while following no pre-conceived plan. This is no social science research project, nor an ethnography of techniques and sciences. Never has he set out to systematically document the locations of concealed power, which rest on the establishment of intellectual technologies. He is an artist through and through. And yet, over the ten years that I have been engrossed in this archive, I can't help but think that this artist has been secretly directed by a kind of zombie researcher, who has pointed him toward everything that needed to be captured to provide an accurate portrait of modern institutions. The result is an archeology of accumulated sediments which gradually delineate the nodes and networks of contemporary infrastructures – which the concept of "fields" (economic, legal, scientific, political, etc.) fails to capture.

One would have to spend a long time wandering this labyrinth to reconstitute the underground research project that Armin's sites have tirelessly pursued: there is a whole expanse on the ruins of socialist modernity, from Russia to North Korea; a vast survey of the way the Alps are made visible in locations that are always enclosed (the remarkable film *Alpi*); a long exploration of deserted islands in the Mediterranean; an inventory of parliamentary and legal architectures; an infectious obsession with "oligoptics" – those sites of surveillance, analysis, observation, and processing that revolve around computer screens and more or less alert technicians; and more recently, and again through film as much as photography, investigative work on the Anthropocene, a concept that seems to have been developed by geologists with Armin in mind! In this outsized project, the photographer becomes a stratigrapher.

Who other than Armin would think of filming, in order to document what we know of the Anthropocene, a building in Berlin which houses the computers that produce climate simulations; and not just the computers, but the cooling systems as well? And who else would, for good measure, take us to the roof to have a good look at the fans that provide for their ventilation? All that Armin is about is in that impulse: if the art of photography has any purpose, it is to prevent the notions we may have about the world from dissipating into the thin air of ideas. You are talking about modeling climate change? Then tell us where such work is being carried out, at what address, in what office, what does it take in terms of staff, computing power, and refrigeration? Show us, and even though it may be trivial, show it to us in all its magnificence (and, as an extra telling detail, is it not irresistibly ironic to learn that the building that models global warming is the most energy-intensive of the whole capital city?).

And Armin is off again, camera on his back, to investigate, with no preconceived plan, anything that *localizes* and therefore *focalizes* attention. I find myself looking for a word to describe the consistently amused, emotional, and precise tone of his voice-over commentary of the images he has gathered: "wry" might be right. Yes. That's it, Armin, the wry photographer.

What I find most fascinating in the multifaceted work of this photographer is how he teaches us to localize what usually hovers without ties or links. The economy is paralyzing and intimidating – but if we could only analyze a trading room in detail, then we could, literally, put our finger on what had until then escaped us. This is the purpose of one of the works commissioned by the Sciences Po Library. A fine example of collaboration, midway between artistic exploration and sociological examination – since the analysis of the economy in-the-making is also part of the research agenda of this institution. This is where the work of art focuses the often-distracted attention of the researcher.

How is one to talk about the Alps "as a whole"? Seemingly impossible, at first. Unless we follow Armin's solution: to reconstitute the series of originally disconnected locations, from which "the Alps" are made visible. You are not likely to see the Alps from above, from the outside; no chance of breathing the mountain air or of being treated to postcards of Heidi's countryside. Rather, you are going to visit the laboratories, the tourist board meetings, the military checkpoints, the national weather stations, and even the museums where paintings of snow-capped summits are on display; in short, all the *insides* into which the ever elusive *outsides* are absorbed. With Armin, it is as though actor-network theory had been invented only to provide his work with a guiding thread. "Localizing the global" could serve as a description of both the field of science studies and the archive of this photographer of connection.

But there is much more to the artist's exploration than the researcher's meager means of inquiry. Indeed, the question of the right *distance* must be resolved. The aesthetic developed by Armin is intriguing in that it manages to avoid ever grasping things from the outside, and yet never appears to add anything personal or subjective to them either. Yet, at first glance, if I were to tell you that we are going to photograph bureaucrats, civil servants, lawyers, court bailiffs, secretaries, as well as their cabinets, files, computers, and desks, you would either start yawning or look for some sort of hidden irony. Is it not, after all, the role of art to criticize, deconstruct, or at least

transform? No, not at all. No critique. Yes, there is transformation, but it is that of a remarkably distinctive gaze, which seizes insides from the inside, without objectifying, embellishing, or dimming them.

One would need to be a photographer oneself to provide a detailed account of the technical solution Armin has found, but the result – the only aspect a mere amateur such as myself can appreciate – is that the places inside which he transports us are, every time, splendid. No aestheticization, no value judgment, no derision. There are very few characters – interior landscapes, rather – but entirely devoid of reverie. Armin manages – through a process of extraction, intensification, and distillation – to render magnificent a trader's computer terminal and a hydrologist's scale model. How does he do it?

77

It is precisely because he restores beauty to these invisible sites – a beauty that resembles no other – that we can begin to reconstruct, little by little, and thanks to the multifaceted archive he assembles, the workings of the contemporary world. In the face of his works, we realize to our amazement: "Yes, it's true, he's right, it is *here* that it all happens."

If any recent work of art deserves to be featured at the heart of an institution devoted to academic research, it is that of Armin Linke. And here again, the point is not to adorn or amuse! No, the work or art says to budding researchers, slaving away in the library: "*Look*, and now follow the path I have shown you and try to understand what you can!"

SUPERPOWERS OF TEN

Andrés Jaque / Office for Political Innovation

INTRODUCTION

IN 1977, RAY AND CHARLES EAMES produced *Powers of Ten: A Film Dealing with the Relative Size of Things in the Universe and the Effects of Adding Another Zero*. An exploration of daily life at different scales – from within a molecule of skin to beyond the edges of the Milky Way – the Eames' film was beautifully designed and produced for decades has been used as an educational tool in schools across Europe and the United States. Yet the selective framing and narrative of *Powers of Ten*, which centers on a couple having a picnic on Chicago's lakefront, presents a linear progression of scenes and images in which abrupt jumps in scale and the interaction between genes, bodies, societies, and technologies appear frictionless and apolitical.

Developed by architect Andrés Jaque and the Office for Political Innovation, SUPERPOWERS OF TEN is an operatic, large-scale performance that offers a reinterpretation of the Eames' *Powers of Ten*. In the performance Jaque and the Office for Political Innovation reenact the film, revealing alternative narratives, political conflicts, and forgotten historical events. New characters such as Kodak's "Shirley Card," polio, and the transgender pioneer Flawless Sabrina are invited to star together with the picnickers, clusters of galaxies, and human DNA that are featured in the Eames' original film. SUPERPOWERS

OFFICE FOR POLITICAL INNOVATION is a Madrid/ New York-based architectural firm that explores the role of architecture in the making of societies. Among its projects are COSMO, PLASENCIA CLERGY HOUSE, House in Never Never Land, IKEA Disobedients, TUPPER HOME, PHANTOM. Mies as Rendered Society, and ESCARAVOX. In 2014 the Office for Political Innovation received the award for Best Research Project at the 14th Venice Biennale.

ANDRÉS JAQUE is an architect and the founder of the Office for Political Innovation. He is Professor of Advanced Architectural Design at the Columbia University Graduate School of Architecture, Planning, and Preservation, and visiting professor at Princeton University's School of Architecture. Jaque's research work explores the potential of the traditions of science and technology studies and cosmopolitics for architectural practices.

OF TEN critically denies the possibility of framing daily life as contained by a universe automatically accountable through science, to reclaim the beauty of multiverses constructed out of politics.

SUPERPOWERS OF TEN

AN ALTERNATIVE version of *Powers of Ten: A Film Dealing with the Relative Size of Things in the Universe and the Effects of Adding Another Zero*, made by the Office of Charles and Ray Eames for IBM in 1977.

ACT 1 — SCENE 1

FEMALE VOICE. In 1977, the L.A. office of Ray and Charles Eames made the movie *Powers of Ten: A Film Dealing with the Relative Size of Things in the Universe and the Effects of Adding Another Zero* available to the public. This movie was the second cinematographic version that the Eames made of the book *Cosmic View: The Universe in 40 Jumps*, a work that had been made public in 1957 by the Dutch architect, pedagogue, and reformer Kees Boeke.

Kees Boeke promoted his work through the implantation of sociocracy, a form of collective government which establishes itself as an alternative to democracy. Democracy is based on granting representation to differences and producing the commonplace through dispute.

By contrast, sociocracy places good government on how the agencies that compose society vow not to object to the path set forth by GENERAL CONSENSUS. Many say that the sociocratic methods generate proficiency and keep societies CENTERED.

Both the Boeke book and the Eames' movies were beautifully designed, produced, and broadcasted as projects that were simultaneously architectural, political, and pedagogical. For decades they were used as education aids in schools all over Europe and the United States and contributed to focusing the collective gaze, as a linearity in which the jumps in scale and the interaction between genes, bodies, societies, and technologies were seen as automatic, nonproblematical, and apolitical. We are fans of the *Powers of Ten*, just as we are fans of The Smiths, and that is precisely why we inhabit its conflicts.

Just like a song in karaoke or a costume at a party, every past discourse is available to respond to current challenges, and we can use it as the means for positioning ourselves vis-à-vis present-day conflicts. Welcome to our version of POWERS OF TEN.

ACT 2 — SCENE 1

SAMPLED MALE VOICE. The picnic near the lakeside in Chicago was the start of a lazy afternoon early one October.

We begin with a scene one meter wide, which we view from just one meter away.

Now every ten seconds we will look from ten times further away and our field of view will be ten times wider.

This square is ten meters wide and in ten seconds the next square will be ten times as wide.

Our picture will center on the picnickers, even after they have been lost to sight.

One hundred meters wide, the distance a man can run in ten seconds.

Cars crowd the highway, powerboats lie at their docks, the colorful bleachers are Soldier Field.

This square is a kilometer wide, one thousand meters, the distance a racing car can travel in ten seconds.

We see the great city on the lake's shore.

Ten to the fourth meters, ten kilometers, the distance a supersonic airplane can travel in ten seconds.

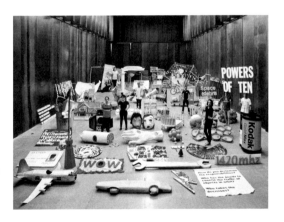

1 Andrés Jaque / Office for Political Innovation. SUPERPOWERS OF TEN. 2013–15. Architectural performance.

We are able to see the whole earth now, just over a minute into the journey.

The earth diminishes into the distance, but those background stars are so much farther away that it half-crosses the tilted orbit of the moon.

Now we mark a small part of the path in which the earth moves around the Sun.

Ten to the fourteenth, as the solar system shrinks to one bright point in the distance; our Sun is plainly only one sun among many.

Giant steps carry us into the outskirts of the galaxy and as we pull away, we begin to see the great flat spiral facing us.

The time and path we chose to leave Chicago has brought us out of the galaxy along a course nearly perpendicular to its disk.

Ten to the twenty-second power, a million light-years. We pass the big Virgo Cluster of galaxies, among many others.

One hundred million light-years out, as we approach the limit of our vision, we pause to start back home.

This lonely scene, the galaxies like dust, is what most of space looks like.

This emptiness is normal; the richness of our own neighborhoods is the exception.

The trip back to the picnic, on the lakefront, will be a speeded-up version, reducing the distance to the earth's surface by one power of ten every two seconds.

Every two seconds we will appear to cover ninety percent of the remaining distance back to earth.

Notice the alternation between great activity and relative inactivity, a rhythm that will continue all the way to our next goal, a proton in the nucleus of a carbon atom, beneath the skin on the hand of the sleeping man at the picnic.

Ten to the ninth meters, ten to the eighth, seven, six, five, four, three, two, one, we are back at our starting point. We slow down at one meter, ten to the zero power.

Now we reduce the distance to our final destination by ninety percent every ten seconds, each step much smaller than the one before.

At ten to the minus two, one one-hundredth of a meter, one centimeter, we approach the surface of the hand.

In a few seconds we will be entering the skin, crossing layer after layer from the outermost dead cells to a tiny blood vessel within.

We enter the white cell among its vital organelles, the porous wall of the cell nucleus appears, the nucleus within holds the heredity of the man in the coiled coils of DNA.

At the atomic scale, the interplay of form and motion becomes more visible. We focus on one commonplace group of three hydrogen atoms, bonded by electrical forces to a carbon atom.

Four electrons make up the outer shell of the carbon itself; they appear in quantum motion as a swarm of shimmering points.

At ten to the minus ten meters, one angstrom, we find ourselves right among those outer electrons.

Now we come upon the two inner electrons, held in a tighter swarm. As we draw towards the atom's attracting center, we enter into a vast inner space.

At last, the carbon nucleus, so massive and so small.

This carbon nucleus is made up of six protons and six neutrons. We are in the domain of universal modules; there are protons and neutrons in every nucleus, electrons in every atom, atoms bonded to every molecule out to the furthest galaxy.

As a single proton fills our scene, we reach the edge of present understanding. Are these some quarks in intense interaction?

Our journey has taken us through forty powers of ten; if now the field is one unit, then when we saw many clusters of galaxies together it was ten to the fortieth, or one and forty zeros.

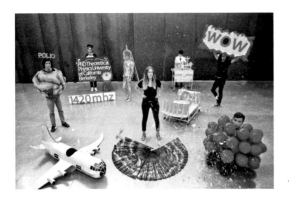

2 Andrés Jaque / Office for Political Innovation.
SUPERPOWERS OF TEN (Act 3, Scene 1). 2013–15.
Architectural performance.

ACT 3 — SCENE 1

FEMALE VOICE. The scientist Philip Morrison was sixty-two years old when he agreed to be the narrator of *Powers of Ten*.

It is his voice that tells the story.

The voice that tells us of the picnic, of the atom, of how "empty" outer space is and, also, the one that tells us of the richness of "our" neighborhoods.

He contracted polio when he was four years old and the effects of the disease caused him mobility problems for the rest of his life.

He never really believed that outer space was as empty as his voice made it sound in the movie, or that the wealth of our neighborhood was an exception within the galaxy.

Morrison became famous by defending the idea that sooner or later humans would find a way to communicate with extraterrestrial beings.

In 1942, Morrison resigned from the Communist Party and in 1943 began working on the Manhattan Project.
He at first worked in the Metallurgical Laboratory of the University of Chicago, less than 20 km away from the setting of the fictitious picnic that he would narrate 35 years later in *Powers of Ten*.

He joined a work team comprising of scientists

from various fields that oversaw the design and construction of the reactors at the Hanford Site, Washington state, the world's first full-scale plutonium production facility, which supplied the uranium and plutonium for the bombs that were dropped on Trinity and Nagasaki.

On July 16, when FAT MAN, a new model plutonium implosion device, was first tested near Socorro, New Mexico, Morrison described the explosion as "a sight never seen before."

Twenty-four days later, Morrison personally loaded the plutonium bomb Little Boy into the plane that took off for Hiroshima.

This is what he said later, when he visited Hiroshima as a member of the commission of scientists analyzing the effects of the bomb on the terrain:

"The public must realize that the atomic bomb opened a door to fear, expense, and danger rather than just end the war" (Sartori 6).

From that moment onward until he died Morrison became one of the most outspoken activists against the development and use of nuclear weapons. He was one of the founders of the Association of Los Alamos Scientists, which defended the importance of publishing and making available all of the clandestine knowledge regarding the weapons.

The problem was not only the atomic bomb but the way in which the bomb, both as a scientific and everyday reality, had stayed out of the discussion.

In front of 380 scientists, some of the members of the association declared in a joint lecture: Any conversation on the 'secret' of the atomic bomb eludes the fact that there really is no such secret. Other nations, Russia included, know its basic principles. The compulsion for atomic secrecy will wind up undermining the structure of the democratic government.

At 11:17 on the night of August 17, 1977, the same year in which his voice narrating the cosmos began to resonate in American suburbs, the Ohio State University Radio Observatory, known as "Big Ear,"

with its large radio telescope Morrison's ideas on interstellar communication helped to develop, picked up the signal 6EQUJ5 (aka the Wow! signal), which appeared to have come from the northwest of the Sagittarius constellation.

It was the first extraterrestrial message detected in the history of humankind.

The Big Ear's radio telescope was pointed at outer space, but, paradoxically, in 2015 it looks like the tennis courts that one finds in clubs and resorts in residential areas.

Who has not imagined how great it would be to have extraterrestrial friends? Morrison also thought of extraterrestrials as colleagues, scientist colleagues. This is why he believed the best frequency to contact aliens would be 1420 MHZ, the frequency that resonates in hydrogen, the most common element in the universe.

What earthling or extraterrestrial scientist would mistake this gesture?

The Wow! signal is the name given to the strong

3 Andrés Jaque / Office for Political
Innovation. SUPERPOWERS OF
TEN (Act 3, Scene 2). 2013–15.
Architectural performance.

radio signal detected by Jerry R. Ehman while working on a SETI program at the Big Ear Ohio State University Radio Observatory, who circled it on the computer printout and wrote "Wow!" in the margin. Thus the name does not refer to the signal's content, but is the reaction of the scientist who heard/saw it for the first time.

After the initial euphoria, it was discovered that the Wow! signal was not a reply sent by extraterrestrials, but merely the reflection of signals sent from earth bouncing off space junk.

ACT 3 — SCENE 2

FEMALE VOICE. It is estimated that at this moment there are about 6,000 tons of space junk in orbit around the earth.

International television, global surveillance, militarism, the social construction of geography, or even meteorology are all possible thanks to satellites which will become space junk in the near future.

The – to us on earth – invisible circle of 6,000 tons, more than 500,000 pieces, orbiting a population of TV viewers, netizens, and victims of cyberespionage is also a product of the global village and of the globalism that confronts it.

Less than 1,000 km above geostationary orbit, begins the graveyard orbit, where most of the satellites that lose their functionality go to die.

More than 5,500 abandoned satellites are evidence of the already long history of our presence in the frontiers between land and space.

The Japanese space agency JAXA has proposed removing the debris by means of a kilometer-wide web of carbon nanotubes. Others have proposed destroying debris with laser beams, which would reduce its speed and send it tumbling down over the earth.

The earth's urbanisms do not disappear as we move upwards. Space is just another suburb consisting of trash, television, international conflicts, and surveillance.

4 Andrés Jaque / Office for Political Innovation.
SUPERPOWERS OF TEN. (Act 3, Scene 3). 2013–15.
Architectural performance.

railway network (sound of trains), up to 82% of the meat consumed in the United States was processed in the industrial complex of Union Stock Yards. Mass production systems that anticipated Taylorism and the scientific organization of labor were developed there.

The production and distribution of meat was the predecessor to assembly-line automobile production and of the automobile culture that has rebuilt the surface of the land.

The term veganism was coined in 1944 and referred to a movement of people who, for ethical reasons, abstain from products of animal origin. Currently, 4% of the population in Europe is vegan, and in countries such as India it is around 40%.

Veganism provides an alternative to the centrality of speciesism and anthropocentrism making way for a cosmopolitical sentiocentrism, that recognizes the rights of all sentient beings (Recarte Vicente-Arche).

A cortex gazing inwards, where Beyoncé video clips mingle with drone control, which will eventually be atomized and fall like soft rain, bouncing off our neighborhoods like Wow! did on Big Ear.

ACT 3 — SCENE 3

FEMALE VOICE. Sausages are made by grinding various animal tissues so that, mixed with blood and fat, they have a maximum exposure to salt, which delays their decomposition.

Atomization, together with the blending and salting, diffuses the flavors and textures of each component into a homogeneous mass that erases heterogeneity.

In 1900 the Chicago River was permanently reversed to prevent, amongst other pollutants, that decomposing blood from the massive meat production center in Union Stock Yards reached the city and contaminated the waters of Lake Michigan, which were the inhabitants' water supply.

Separating the places in which food was consumed from those where it was produced was a priority of modern and reformist urbanism during the late nineteenth and early twentieth centuries.

Thanks to the development of the national

ACT 3 — SCENE 4

FEMALE VOICE. It would be hard to narrate the history of color photography without talking about Charles and Ray Eames. They contributed to the spread of Kodak film and were given the task of publicizing the alternatives proposed by Polaroid.

Since the popularization of color photography during the 1940s and 1950s, labs all over the world have used the so-called "Shirley Cards" in color calibration processes.

It is thought that "Shirley" was the name of the first Kodak employee who agreed to be photographed as a global chromatic reference.

A Caucasian woman, a redhead with blue eyes, was eventually replaced by new Shirleys, all white and Caucasian, whose photographs hung from the walls of photography studios all over the world, like a mixture of pinups for chemical normativity and Caucasian Madonnas.

In everyday life, it is commonly believed that

83

photography objectively and equitably frames the reality it represents.

For Kodak, the color film market was the Caucasian population of the world.

In the 1970s the exclusion triggered by the films became evident.

The growing diversity of people from different ethnic backgrounds in colleges and universities in the United States turned graduation group photos into frames of exclusion.

Photographs became landscapes of black blurs surrounded by smiling men and women with pinkish skin and blue eyes.

In 1970 Caroline Hunter and Ken Williams formed the Polaroid Workers Revolutionary Movement[1] and accused the company of collaborating with the apartheid politics of the South African government.

The Polaroid ID-2, developed for the South African market, included a button that increased the flash intensity by 42%.

A device that, curiously, allowed cameras to compensate the chemical imbalance that blurred the faces of people with dark skin.

The name of the camera, ID, stood for the initials of Identification Camera.

The South African Pass Laws Act forced black people to carry identification papers with their photograph at all times.

The flash adjustment had the object of including the dark skinned population in a new control frame.

It wasn't until the 1980s when Kodak commercialized the Vericolor III and Gold Max films, which, in the words of Richard Wien – Kodak's director – could "photograph the details of a dark horse in low light" (Roth 121–22).

According to Jim Rice, a former Kodak technical sales representative and marketing manager, the new films were not developed in order to include black users in the frame, but because of the complaints

from publicists in the chocolate industry and the growing interior decoration magazine market, who every day faced problems because of the impossibility of photographing chocolate bars and dark furniture (Roth 119).

The digital sphere has turned into an arena where the Shirley Card is discussed and challenged.

Adobe produced an excluding frame in their

5 Andrés Jaque / Office for Political Innovation. SUPERPOWERS OF TEN (Act 3, Scene 4). 2013–15. Architectural performance.

6 Andrés Jaque / Office for Political Innovation. SUPERPOWERS OF TEN (Act 3, Scene 5). 2013–15. Architectural performance.

84

[1] Information about this movement has been collected from the African Activist Archive Project. http://africanactivist. msu.edu.

adjustment cards with a fake Latin Carmen Miranda, but with a skin as pink as Shirley's.

Nowadays the production of multiracial Shirley Cards in which a multitude of people with different skin tones are arranged in multiple compositions has become a graphic genre produced and discussed by the Internet community.

ACT 3 — SCENE 5

FEMALE VOICE. Picnics aren't always the beginning of "lazy afternoons."

On September 5, 1882, 1,270 km away from Lake Michigan, twelve small unions mobilized more than 10,000 workers in celebration of Worker's Day. After a long march accompanied by slogans such as "less work, more pay" and "work built this republic, work should rule it," certain spaces in the city of New York were occupied in a monumental collective picnic.

In 2012, Futurefarmers presented the project *A Variation of Powers of Ten*, a discussion format in which scientists like Morrison and his longed for extraterrestrial colleagues are called upon to collectively build arguments regarding the universe and its scales.

The objective of this format is to highlight the way in which knowledge has changed in the course of the thirty-plus years that have gone by since the original Eames' movies were produced.

On June 20, 1989, Otto von Habsburg visited the University of Debrecen. In his address he asked a question: What would a Europe without borders be like?

Two representatives of the Hungarian Democratic Forum proposed answering the question by organizing a picnic at the Austro-Hungarian border.

It was decided it would be held in Sopronpuszta in Hungary.

On August 20, hundreds of people came to the picnic and literally tore down the old wooden gate that separated them from Austria.

On the night of November 9, the Berlin Wall came down.

7 Andrés Jaque / Office for Political Innovation. *SUPERPOWERS OF TEN*. (Act 3, Scene 6). 2013–15. Architectural performance.

At the time of writing, many EU member states are now demanding or reintroducing border controls to constrain the free movement of people as laid out in the Schengen Agreement of the EU.

The expression "lazy" has become a handy weapon that terrorizes, splits asunder, creates new borders, generates revenue streams, concentrates wealth, and fabricates inequality.

ACT 3 — SCENE 6

FEMALE VOICE. Picnics would not be possible if it were not for something that we seldom pay attention to: grass.

Grass is also an arena for differences and the frame in which other types of centrality have been promoted.

It is estimated that there are more than 160,000 km2 of lawn in the United States.

This is three times more than the total area of corn crops, and is thus the U.S.'s single most irrigated crop. Grass surfaces have expanded all over the world parallel to the boom in suburban life. Natural grass is actually a mixture of several kinds of herbaceous vegetation, mostly Gramineae and Cyperaceae.

r·M!

In a wild prairie, in a space 40 × 40 cm, more than 80 different kinds of vegetation can be found.

Prairies are also rich in insects and microorganisms, which fulfill vital processes for carbon fixation and are the nourishment for about a third of all the world's bird species.

For the first time ever the Plant Patent Act of 1930 allowed the patenting of plant species that reproduce asexually.

Monocrops of grass like the one patented as Brilliant have been massively planted on golf courses, in parks, and private gardens all over the world.

Because they are a monoculture with little growth, maintenance costs are reduced.

However, their extensive use leads to the reduction of biodiversity in a large and an important part of the world's surface, the privatization of vegetation, and an incentive to concentrate investments in genetic manipulation.

Brilliant does not have any flowers or dry grass, nor does it contain herbs sensitive to water shortage or high grasses.

In 1968, the year in which the Eames presented the first prairie picnic in their study for *Powers of Ten*, the chemical industry titan Monsanto, entered into a collaboration with the largest producer and distributor of lawn products in the world: the Scotts Seed Company, now Scotts Miracle-Gro Company, in Marysville, Ohio.

That same year they patented glyphosate, a herbicide that since 1973 trades under the name Roundup.

David Barboza wrote in the *New York Times* that the reduction in maintenance time dedicated to trimming and looking after this new lawn was "a suburbanite's dream come true."

When Charles Berger, executive president of Scotts, was asked about the way in which they employed biotechnology as means for biological exclusion he answered: We limit ourselves to make the world more beautiful. I don't think we can call it biotechnology, for us they are nothing but superior plant species.

ACT 3 — SCENE 7

FEMALE VOICE. This is what the narrator, embodied in Morrison, says: "Our picture will center on the picnickers," our description will be centered on the two people having the picnic.

But when the zoom approaches, it is the hand of the sleeping man that occupies the exact center, and it is the account of his tissues, his cells, his genes, and his molecules that are woven into the universe.

The way in which the couple, the male and female couple, negotiate the part that gender plays in the distribution of roles within that relationship. The insistence to impose a fixed gender on the basis of genetics is doubtless one of the arenas where our cultures impose themselves, and argue and subvert each other, now more than ever.

"There won't be a revolution unless it is a feminist revolution." "There won't be a revolution unless it is a queer revolution." "There won't be a revolution unless it is a transgender revolution."

These were some of the more polemic chants coined by the participants in the 15-M protests in Madrid.

1968 is the year of "May of '68," of Pasolini's "the police are sons of the poor," of the protests in London against the war in Vietnam, of the demonstrations in Columbia and Berkeley, of the first version of *Powers of Ten*.

September 7, 1968, was the day on which two simultaneous demonstrations protested against the way in which the Miss America pageant and its television broadcast promoted the hegemony of the female model of the "misses."

400 activists placed a garbage drum in front of the gates of the congress hall in Atlantic City where the pageant was being held, a drum they named FREEDOM TRASH CAN.

In the drum, they dumped bras, eyelashes, pans, mops, and issues of *Playboy* and of *Lady's Home Journal*.

Inside the hall, in front of the television cameras, there was a placard that said: WOMEN'S LIBERATION.

At that same moment, in the Ritz-Carlton Hotel in Atlantic City, a group of activists was crowning Saundra Williams as the first Miss Black America.

J. Morris Anderson, promoter of the protest-pageant, stated: "We're not protesting against beauty. We're protesting because the beauty of the black woman has been ignored. We'll herald her beauty and applaud it" (Duffett).

In 2012, the artist Julia Sherman filmed Jack Doroshow – founder of the Miss Drag America pageant – as he was crowned as Flawless Sabrina in the reenactment of the award he did not receive, nor could have received because of his trans condition in 1968.

Flawless Sabrina acknowledged the reenactment and her recognition as Miss America with the same words that Debra Dene Barnes, the real winner, used in front of the television cameras in 1968.

The artist Julia Sherman depicted the celebration within the conflict of a double frame in which Debby Barnes finally shared her television stardom with Flawless Sabrina.

TV CONDUCTOR. This is what the narrator, embodied in Morrison, says: "Our picture will center on the picnickers", our description will be centered on the two people having the picnic.

FEMALE VOICE. And now, ladies and gentlemen, you know at this moment, a year ago tonight, Debby Dene Barnes sat on this stage, right where these girls are, nervously awaiting what was gonna happen to her: the announcement that she was gonna be Miss America of 1968.

And during her year's reign as queen, she was one of the finest and loveliest queens we have ever had, with charm and with dignity. Now, let us give a final salute to Debby Dene Barnes, Miss America of 1968. With our all special... (Music and applauses).

FEMALE VOICE. Thank you.

FLAWLESS SABRINA. A year ago my somewhere road was miraculously extended to include all the highways and airways of America.

DEBBY DENE BARNES. And my love of America and its people has deepened with every mile.

FLAWLESS SABRINA. And my love of America and its people has deepened with every mile.

DEBBY DENE BARNES. With the help of the U.S.O. my somewhere road has led to Japan and Korea...

FLAWLESS SABRINA. With the help of the U.S.O. my somewhere road has led to Japan and Korea where thousands of servicemen...

DEBBY DENE. ...gave me the satisfaction to know that I was doing just something to alleviate their loneliness.

FLAWLESS SABRINA. ...gave me the satisfaction to know that I was doing just something to alleviate their loneliness.

DEBBY DENE BARNES. As with any worthwhile experience, my road hasn't always been easy.

FLAWLESS SABRINA. As with any worthwhile experience, my road hasn't always been easy.

DEBBY DENE BARNES. But the rough places taught me a lesson I will never forget.

TRANSGENDER VOICE. But the rough places taught me a lesson I will never forget. As I walk this last time off this special place, this special road, I will make way for Miss America 1969 to search for her special road for her special self.

But even though I will be very sad to leave all of my special friends that I made here in Atlantic City my heart will, I am one percent saying this, but 99 percent, gratitude.

8 Andrés Jaque / Office for Political Innovation. SUPERPOWERS OF TEN (Act 3, Scene 7). 2013–15. Architectural performance.

ACT 4 — SCENE 1

FEMALE VOICE. The universe has no center. Yet it surely does not revolve around the hand of one man.

Automatism is only possible once the disputes, the differences, and the protests have been made invisible.

A defined us is not possible without the counteraction of an "out there."

We are configured by otherness.

Professional practices participate in the everyday performatism of political agencies.

Designs such as the Brilliant lawn do not generate superior species but simplified ecosystems.

The ensemble of people, groups, arguments, activisms, cyber activisms, projects, and polemics opposing Miss Universe or socio-technologies like the Shirley Cards are urbanisms which are more exciting and desirable than those of the hegemonies they confront.

Effectiveness, consensus, austerity, and happiness are frames that concentrate societies' actions, but only at the expense of marginalizing everything that evinces difference, that destabilizes granted knowledge, and that burdens with representation the making of decisions.

Architectural practices are a part of this process. We can work on consolidating frames of exclusion. We can work on contributing to making the controversial and diverse appear consensual and homogeneous. But we can also contribute to multiplying frames dedicated to what is relevant, like the problematic, the marginalized, the discredited, and the disputed.

Please gaze through the complexities of our societies.

These are the SUPERPOWERS OF TEN.

Let us herald and applaud their beauty!

Works Cited

Duffett, Judith. "As It Happened: Atlantic City Is a Town with Class – They Raise your Morals While They Judge Your Ass." *Veteran Feminists of America*. VFA, n.d. Web. 9 Mar. 2016. Available online: <http://www.vfa.us/MissAmerica1968 JUNE122008.htm>

Recarte Vicente-Arche, Ana. "The Animal Rights Movement in the United States: Some Thoughts about a New Ethics." REDEN: *Revista Española de Estudios Norteamericanos* 21–22 (2001): 159–82. Print.

Roth, Lorna. "Looking at Shirley, the Ultimate Norm: Colour Balance, Image Technologies, and Cognitive Equity." *Canadian Journal of Communication* 34 (2009): 111–36. Print.

Sartori, Leo, and Kosta Tsipis. *Philip Morrison 1915–2005*. Washington: National Academy of Sciences, 2009. PDF file.

Julia Sherman. *Farewell Miss America 1968 Re-enacted by Flawless Sabrina – Founder of Miss (Drag) America Pageant*, 2012. Video.

Stanley, Kurt E. "Evolutionary Trends in the Grasses (Poaceae): A Review." *Michigan Botanist* 38.1 (1999): Winter, 3–12. Print.

Credits

SUPERPOWERS OF TEN
Andrés Jaque / Office for Political Innovation

Research and Discussion Team (Office for Political Innovation):
Paula Currás, Lubo Dragomirov, Roberto González García, Álvaro Guillén, Andrés Jaque, Irene Kargiou, William Mondejar
With the special participation of the architects and artists: Paula Currás, Eugenio Fernández, Ana Olmedo, Enrique Ventosa, Álvaro Carrillo, Rebeca Hourdaki, Víctor Nouman, Adrián Suárez

Sound Artist:
Jorge López Conde

Set Director:
Roberto González García

Photographs:
Jorge López Conde

Voice actreses:
Susana Correia, Megan Murphy

Superpowers of Ten was developed and presented for the first time as part of *New Publics*, curated by José Esparza for the Lisbon Architecture Triennial 2013 *Close, Closer*, directed by Beatrice Galilee.

89

IF THE FIRST PROCEDURE (r·M! 51–67) for resetting our compass is to re-localize the global, the second is to shift direction sideways by ninety degrees. The reason for such a shift is to change direction and to escape the stifling face-to-face of object and subject that has blocked all possibilities of capturing the experience of being in the world. If we had to relocalize the global, it was because when you pretend to see the globe in its totality you occupy, virtually, a position that is cognitively impossible – that of an unsituated Godlike figure, a position that, because of this implausibility, has been called the "view from nowhere."

Procedure 2

WITHOUT THE WORLD OR WITHIN

But there is something else that renders the apprehension of experience impossible. It is to imagine that you are a subject and that your only job, so to speak, is to *gaze* at what is supposed to be an "object." Everything in such an assumption is highly implausible: that there exists a subject, that there exist objects to be gazed at, and that gazing is the only thing worth doing. This is why we need a new procedure to shift from being "without" a world to being "within" the world.

Historians of science as well as historians of art have long shown the peculiarity of the invention of what could be called the "aesthetic of matters of fact" (Crary). To devise a matter of fact you need to break away from the experience of being within the world and, so to speak, alongside the world, and to transform some of the ingredients making up your experience into a subject by interrupting all other events, producing a sort of stiff, frozen human figure that is reduced to her or his eyes, much like the prisoners in Plato's allegory of the cave[1]. Since Erwin Panofsky, it has become clear that the many contraptions necessary to produce the effects of perspective – from Albrecht Dürer's instructions to projective geometry – have nothing to do with the discovery of a "natural way" to consider the world.

But what is not so often underlined is that you also need to do another extraordinary violence to other ingredients of experience which are also interrupted in their trajectory. The invented subject is bizarre, this is true, but so is the invented object! There is nothing "natural" in molding our relations with things into the not so common form of being an object-to-be-gazed-at-by-some-improbable-frozen-subject. While much criticism has been leveled at the invention of the gazing subject, the "other side," that of the spectacle to be gazed at, has too often been taken for granted. As if it were utterly normal for anything to be freeze-framed and transformed into an object for a viewer.

[1] Concerning his interpretation of Plato's allegory, see Bruno Latour's introduction to this volume ("Let's Touch Base!" r · M! 11–23).

Long before being immobilized into a "still life," cups, oysters, drapes, lemons, and game have a life of their own (Hochstrasser) (see figs. 8 a–d, *r*·M!101).

Such a feat would not have been possible without the medium of painting. The surface of the canvas is what has registered, at least in the European tradition, this invention of matters of fact as well as the "fact" that there is only "matter" in the world. The queerest aspect of the history of the moderns is to take for granted – indeed for the only "natural" way of dealing with the worlds – such an implausible setup. Europeans have the philosophy of their painting, so to speak.

The anthropologist Philippe Descola has called "naturalists" those who transformed this highly peculiar organization of face-to-face between object and subject into an ontology (*r*·M!121–28) – one of the four he recognized in his interpretation of ethnographic literature (*La Fabrique*). In order to try to understand how Europeans, who in his scheme of things were "analogists" until well into the sixteenth century, ended up being transformed into "naturalists," Descola also introduces the visual imagination and the way *res extensa* is apparently being "extended" everywhere (*Beyond*).

Such a shift is nowhere more visible than in a splendid painting-qua-photograph by Jeff Wall titled *Adrian Walker, artist, drawing from a specimen in a laboratory in the Department of Anatomy at the University of British Columbia, Vancouver* (see fig. 5, *r*·M!98). This work concentrates our attention on the strangeness of the situation of drawing realistically: the north light, the arrangement of the dismembered mummy arm disposed on the green felt so as to be rendered an object for the draftsman, the silent, skilled, and meditative male seated less than a meter from what he has to draw (Latour, *What Is the Style* 23–33). Everything is staged. Everything in such a setting is "unnatural." Everything is beautifully familiar (to a European trained eye). It is a great lesson, given by Jeff Wall, that it took a historian of art turned artist to reveal how much of our common philosophy of science actually comes not from gazing at the world, but from gazing at paintings (see fig. 7, *r*·M!100)!

The great virtue of this masterpiece is to make plausible the insertion in the painting of a lateral plane that is not usually visible and that remains virtual even though it is totally necessary for the success of the

1–2 Samuel García Pérez. *Sketch on the Making of the* POV *(Point of View) for the* AIME *Platform: Invention of Realism - A Gallery.* 2012.

staging. It is this virtual plane that is represented in a drawing by Samuel García Pérez (figs. 1 and 2) to insist on the implausibility of the setting. A setting that resulted in the invention of matter of facts (Latour, "Invention"). In order to organize the face-to-face of an object-with-nothing-else-to-do-but-being-seen-by-a-subject and a subject-with-nothing-else-to-do-but-gazing-on-an-object, you need a "choreographer," a stage manager, and an instance of some sort that is "on both sides" of the virtual picture plane and that makes the face-to-face possible.

And that is the great paradox of European philosophy of science: the real practice of generating objectivity never relies on such a face-to-face of object and subject, even if the face-to-face is nonetheless taken as "the" objectivist attitude par excellence. This is explored in a magnificent way by Jeff Wall in another of his photograph/paintings called *Fieldwork. Excavation of the floor of a dwelling in a former Sto:lo nation village, Greenwood Island, Hope, B. C., August, 2003. Anthony Graesch, Dept. of Anthropology, University of California at Los Angeles, working with Riley Lewis of the Sto:lo band* (see fig. 6, r·m! 99). Here objectivity is not obtained by the disinterested, distant, and silent gaze of a draftsman observing a segment of a dead mummified body part, but intimately tied to the collective digging of archaeological remnants that will later be assembled, through many different genres of visual inscriptions, and later published in a monograph.

Such a bodily engagement with the dirt of the excavation offers a totally different rendering of what producing objectivity means. To gain some access to another segment of the trajectory of this past Sto:lo dwelling, the "subject" has to keep moving, in possession not only of two eyes, but also his two arms, a shovel, and the many skills shared with other informants in the depths of the forest. This is the sort of situation that William James tried to introduce in philosophy, unfortunately to no avail. Apparently the visual format imposed by the scopic regime of painting was too strong. This peculiar aesthetic of matter made it easier to deny the lessons of experience.

Once freed from the face-to-face of object and subject, many possibilities are opened. One, of course, is to register at last the practice of science, labeled as reference in the AIME project, liberated from the stifling scenography of the gazing subject. Much like the prisoners in the cave revolted and refused to be stuck on their seats simply watching shadows without being allowed to talk to one another, or to move and touch in order to generate knowledge among themselves (Latour, "Let's Touch Base!" r·m! 11–23), William James revolted against the notion of a view of the world without a world and offered a vocabulary to deal more realistically with how we experience the world. This is what is being attempted, at the end of the AIME project, by a group of philosophers inspired by pragmatism (Debaise et al., r·m! 104–13), and what inspires Pablo Jensen's attempt at rephrasing the

usual debate between epistemology and physics (**r**·m!114–20), or the attempt by
Graham Harman to revive the old notion of occasionalism (**r**·m!129–38).

The main advantage of the orthogonal sideways shift *within* the world is that it
allows the establishment of relations with scientists that are not limited to "adding"
feelings and agency to a "real world" devoid of any activity because it was deemed
to be inert. Only still lifes offer the spectacle of an inert piece of matter. But it is
exactly that, a spectacle – and what a beautiful and moving one! Not the way things
and people move within the world. This discrepancy is visible as well in the narra-
tive provided by scientists (Zalasiewicz, **r**·m!152–58) when describing the ways
controversies about mixing human and nonhumans unfold (Green, **r**·m!139–51).

Such a shift in the role, focus, and position of the gaze is dramatically illustrated
by the magnificent film *Leviathan* by Véréna Paravel and Lucien Castaing-Taylor.
(Neyrat, **r**·m!160–65). Here the issue is not to add a "poetic dimension" to what
would otherwise be a "strictly factual documentary" about fishing in dangerous
waters off the East Coast of the United States. This is not a question of the "lived
world." The attempt by those authors who call themselves adept at "sensory
ethnography" is to start to really register the world sideways by multiplying the
sensors and the positions of the cameras. Not to obtain a more totalizing view,
not by breaking the traditional face-to-face of object and subject, but by "ignoring
it" altogether and literally moving "sideways" within the flow of experience. A
completely new and at first puzzling vision of what is a fishing boat and what is
the body of fishermen, but one which, in effect, is much more realistic than any
obtained by fixing the one-eyed, brainless subject on its tripod!

Once again: try for yourself to see whether such a sideways move helps you in
registering the experience of dealing with the world. Procedure after procedure,
we should be able to reset our instruments for good.

Works Cited

Crary, Jonathan. *Suspensions of Perception: Attention, Spectacle, and Modern Culture.* Cambridge, MA: The MIT Press, 1999. Print.

Debaise, Didier, et al. "Reinstituting Nature: A Latourian Workshop." *Reset Modernity!* Ed. Bruno Latour. Cambridge, MA: The MIT Press, 2016. 104–13. Print.

Descola, Philippe. *Beyond Nature and Culture.* Trans. Janet Lloyd. Chicago: University of Chicago Press, 2013. Print.

---. "How We Became Modern: A View from Afar." Latour, *Reset Modernity!* 121–28. Print.

---. *La Fabrique des images: Visions du monde et formes de la représentation.* Paris: Somogy, 2010. Print.

Green, Lesley. "Calculemus Jasus Lalandii: Accounting for South African Lobster." Latour, *Reset Modernity!* 139–51. Print.

Harman, Graham. "A New Occasionalism?" Latour, *Reset Modernity!* 129–38. Print.

Hochstrasser, Julie Berger. *Still Life and Trade in the Dutch Golden Age.* New Haven: Yale University Press, 2007. Print.

James, William. *Essays in Radical Empiricism.* Lincoln: University of Nebraska Press, 1996. Print.

Jensen, Pablo. "An Ontology for Physiscists' Laboratory Life." Latour, *Reset Modernity!* 114–20. Print. Latour, Bruno. "Invention of Realism: A Gallery." AIME.FSNP, 19 Aug. 2013. Web. 15 Jan. 2016. Available at <http://modesofexistence.org/aime/doc/530>.

---. "'Let's Touch Base!'" Latour *Reset Modernity!* 11–23. Print.

---. *What Is the Style of Matters of Concern? Two Lectures in Empirical Philosophy.* Assen: Van Gorcum, 2008. Print. Spinoza Lectures.

Neyrat, Cyril. "Blood of the Fish, Beauty of the Monster." Latour, *Reset Modernity!* 160–65. Print.

Panofsky, Erwin. *Perspective as Symbolic Form.* Trans. Christopher S. Wood. New York: Zone Books, 1997. Print.

Zalasiewicz, Jan. "Breaking the Surface: Into the Light." Latour, *Reset Modernity!* 152–58. Print.

95

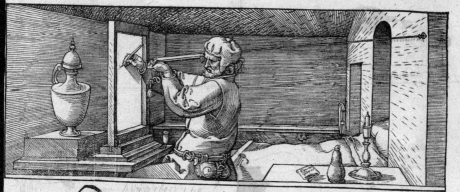

Item noch ein anderen brauch zu Conterfeten/dardurch.man eyn yelichs Corpus mag grösser oder kleyner abconterfeten wie vil man wil/deshalben nutzlicher dañ mit dem glas darumb das es freier ist/ Darzu soll man haben ein ram mit einem gitter von starckem schwartzen zwirn gemacht/die lucken oder sterungen eine ongeferlich zweyer finger breit/ Darnach soll man haben ein absehen oben zugespitzt/ also gemacht/ das man es höher oder niderer richten mag/ das bedeut das aug mit dem.o. Darnach leg hinaus in zimlicher weitten ds corpus so du conterfeten wilt/ rucks vnd peugs nach deinem willen/vñ ger als weg hindersich vnd hab dein aug zu dem absehen.o. negst daran/vñd besich das Corpus wie es dir gefall/ vñ ob es recht nach deinem willen lig/ Darnach stell ds gitter oder ram zwischen dem Corpus vnd deinem absehen also/ wilt du wenig lucken oder sterungen begreiffen/so ruck es dest neher zu dem Corpus/darnach besich wie vil ds corpus im gitter lucken begreufnach leng vñ breyten/ darnach reiß ein gitter gros oder klein auf ein bappir oder tafel darein du conterfeten wilt/ vnd sich hin vber dein aug.o. des spitz am absehen auf das Corpus/vnd was du in yder sterung des gitters findest/ das drag in dein gitter das du auf dem bappir haft das ist gut vnd gerecht/ Wilt du aber für das spitzig absehen ein löchle machen/dardurch du sihest ist eben so gut/solcher meynung hab ich hernach ein form aufgerissen.

4 Matteo de' Pasti. *Winged Human Eye* [reverse].
1446/50. Bronze, Ø 9.34 cm. Courtesy National
Gallery of Art, Washington.

5 Jeff Wall. *Adrian Walker, artist, drawing from a specimen in a laboratory in the Department of Anatomy at the University of British Columbia, Vancouver.* 1992. Transparency in lightbox, 119 × 164 cm.

6 Jeff Wall. Fieldwork. Excavation of the floor of a dwelling in a former Sto:lo nation village,
 Greenwood Island Hope, British Columbia August, 2003. Anthony Graesch, Department
 of Anthropology, University of California at Los Angeles, working with Riley Lewis of the
 Sto:lo band. 2003. Transparency in lightbox, 219.5 × 283.5 cm.

7 Thomas Struth. *Musée du Louvre* IV, *Paris 1989*. 1989.
Photograph 8/10, 188 × 220 cm.

8a–d *Still Life*. Dir. Sam Taylor-Johnson. 2001. Film stills.

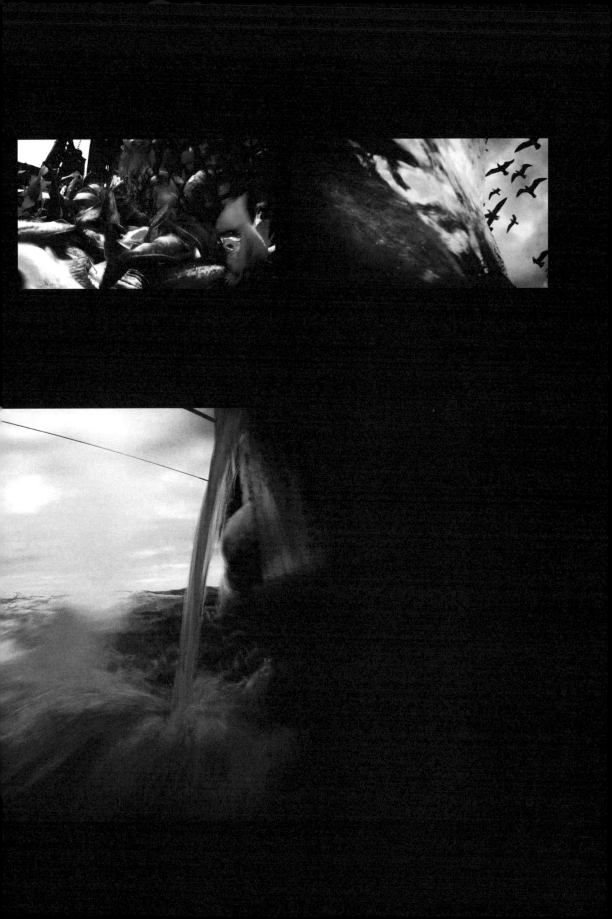

REINSTITUTING NATURE: A LATOURIAN WORKSHOP

**Didier Debaise,
Pablo Jensen,
Pierre Montebello,
Nicolas Prignot,
Isabelle Stengers,
and Aline Wiame**

DIDIER DEBAISE *is a research professor at the National Fund for Scientific Research and the Université libre de Bruxelles, where he teaches contemporary philosophy. His main areas of research are contemporary forms of speculative philosophy, theories of events, and links between American pragmatism and French contemporary philosophy. He has recently published a new book entitled* L'appât des possibles *(2015).*

PABLO JENSEN *wrote his PhD thesis on experimental condensed matter physics and worked for fifteen years on the modeling of nanostructure growth. He then decided to switch to the modeling of social systems. His present work takes advantage of the avalanche of social data available on the Web to improve our understanding of society. To achieve this, he collaborates with "hard" scientists to develop appropriate analysis tools and with social scientists to identify relevant questions and interpretations.*

Originally published in:
Environmental Humanities 6 (2015):
167–74. PDF file.

PIERRE MONTEBELLO is a professor of modern and contemporary philosophy at the University Toulouse – Jean Jaurès and the author of various books and articles on French philosophy. His research has also contributed to reassessing the importance of non-Kantian metaphysics in the direction of a new interbeing cosmology. His latest book, Métaphysiques cosmomorphes, la fin du monde humain (2015), seeks to show how decentering the human in favor of a broader scheme including the others existing in the world, is both a challenge and an imperative for a more substantial understanding of human–earth relations.

NICOLAS PRIGNOT is a physicist and philosopher, and works on questions at the intersection of the struggles tied to the environment and contemporary philosophy. He is a researcher at the Université libre de Bruxelles, within GECO, the Constructivist Studies Group, and a professor of philosophy at ESA Saint Luc and at ERG, the Graphics Research School, both in Brussels.

ISABELLE STENGERS teaches philosophy at the Université libre de Bruxelles. Her work resists the model of objectivity that mimics the theoretico-experimental sciences and silences the diverging multiplicity of scientific practices. In this perspective she has developed the concept of an active ecology of practices, embedded within a democratic and demanding environment. As a philosopher she explores the possibility of a speculative, adventurous constructivism, which she relates to the philosophy of Gilles Deleuze, Alfred North Whitehead, and William James, as well as to the anthropology of Bruno Latour and the sci-fi thinking adventure of Donna J. Haraway.

ALINE WIAME holds a PhD in philosophy from the Université libre de Bruxelles, where she currently works as a National Fund for Scientific Research postdoctoral researcher. She is particularly interested in contemporary French philosophy (Bergson, Souriau, Foucault, Deleuze) and in American pragmatism, and works on topics such as posthumanism and cartographical reason.

r·м!

Environmental Humanities, vol. 6, 2015, pp. 167-174
www.environmentalhumanities.org
ISSN: 2201-1919

COMMENTARY

Reinstituting Nature: A Latourian Workshop

Didier Debaise, Pablo Jensen, M. Pierre Montebello, Nicolas Prignot, Isabelle Stengers and Aline Wiame

Debaise: Faculté de Philosophie et Lettres, Université Libre de Bruxelles, Belgium; Jensen: Institut des Systèmes Complexes, Université de Lyon, France; Montebello: Département de Philosophie, Université de Toulouse II, France; Prignot, Stengers and Wiame: Faculté de Philosophie et Lettres, Université Libre de Bruxelles, Belgium

Translated By :

Stephen Muecke

Environmental Humanities, University of New South Wales, Australia

Translator's introduction

At the end of July 2014 there was a week-long workshop held at the *Ecole des Mines* in Paris, Bruno Latour's former work-place. This was a final workshop, convened by Latour's project, *An Inquiry into Modes of Existence*, which was not only a book, but a website that was an experiment in interactive metaphysics that had been going on for four years.[1] About 30 participants gathered to workshop and rewrite some key contested areas that had been challenged on the site with discussions and counter-examples. One of the round tables working away during the week, occasionally with changes in personnel, was on Nature. Their job (like the other round tables on Politics, Diplomacy, Religion and Economics) was to 'reboot' or reinstitute a concept close to the heart of the Moderns. The assumption was that the traditional concept of nature, as developed through modern European history, would no longer be adequate to a future beset by environmental crises. The main people working on a draft were Didier Debaise, Pablo Jensen, Pierre Montebello, Nicolas Prignot, Isabelle Stengers and Aline Wiame. When they finished the draft, I translated it and it was presented, in French and English, in a final two-day public session at Science Po, to a group of seven international scholars designated as "chargés d'affaires," or "diplomats from the future" whose job was to assess the results of our labours in terms of how they might be met by Gaia, the ur-representative of future planetary crises. The text, originally under the title of *Our "Nature,"* was as follows. ~ Stephen Muecke

[1] Bruno Latour, *An Inquiry into Modes of Existence: An Anthropology of the Moderns*, trans. C. Porter (Cambridge Mass.: Harvard University Press, 2013); see also the AIME website which fully explains the context for the workshop: http://www.modesofexistence.org/. This research has received funding from the European Research Council under the European Union's Seventh Framework Programme (FP7/2007-2013) / ERC Grant 'IDEAS' 2010 n° 269567.

We Moderns are terribly proud of the fact that we can think of "nature" as it really exists, independently of any kind of culture or belief. The experimental sciences have this kind of pride *when they are successful,* when it becomes possible to say, "Nature has spoken." But this pride also appears when it is possible for general, one-size-fits-all, judgements to be uttered about the knowledge of other peoples (often without even knowing them) who are supposed to "mix" nature and cultural beliefs.

But how can we define this nature? Now things get complicated. One could talk about it in the way that St Augustine wrote about time: as long as we are not asked, we know what it is, but when we are asked to define it, we Moderns no longer know. Or more exactly, what we know is how to have ferocious disputes about it.

Nature can be secret, hostile, nurturing, mechanical, sublime, infinite, in danger, or even capable of making humans endowed with reason agree with each other...

In these disputes, philosophy has played a rather dubious role. In one way or another, it has pretty much left the idea of a generally knowable nature alone. Sometimes it has added a layer to it that is supposed to escape from science (nature *naturata*/nature *naturans*, for instance), or, on the contrary, has reduced it to what constitutionally allows for scientific knowledge (the Kantian solution). But in so doing philosophy has only dramatised what Whitehead calls the "bifurcation of nature"—on one side an "objective" nature, blind to our values, indifferent to our projects; and on the other a nature which is the very stuff of our dreams, values and projects. Correlatively, it has created the threatening monster of "naturalisation," which reduces our dreams, values and human projects to blind functions; it has given consistency to a nightmare which feeds the arrogance of some scientists by offering them a carrot, but a poisoned one. And it has constructed, in order to keep this nightmare at a distance, the grand theme of the human exception: go ahead, reduce rabbits to nature, but leave Man alone!

Today, this bifurcated nature partly explains a sort of indifference or scepticism in regard to Gaia. It is as if nature were acting out of character, no longer that which human rationality conquers, but that which plunges us into disarray; it is no longer the backdrop for our human projects, with no project of its own, but is intruding in our dreams, values and projects. How can one not give in to the double temptation of either climatic scepticism, or geoengineering that would put nature back in its place as the thing we should be able to dominate?

Added to the disputes tearing Moderns apart is the fact that, for many other collectives, Nature doesn't exist. It is neither a representation, nor a concept, nor a problem, nor a place, nor a totality. For these collectives we are neither in Nature, nor face to face with it. So by what right do we make our institution of nature the one capable of fixing the problems facing them? The answers to the changes affecting their ways of life do not necessarily proceed through the institution of a universal Nature allowing the determination of rational solutions. If only it were done in such a way that they could go along with it! If only rationality in this case were not reduced to statistical management models, pure calculations, likely to amplify the problems when not creating new ones.

For instance, during our July 2014 discussions we learned from anthropologist Nastassja Martin[2] that, in order to protect Alaskan caribou, a management plan was put in place that decided it would be a good idea to cull, even to eradicate, wolves. To fall into line with this pastoral ideal, the caribou just had to transform themselves into sheep, for which we would be the peaceful and reassured shepherds. We wish to protect and conserve the so-called wilderness, but our own idea of wilderness (sublime, innocent, independent of us, and with a hostile and terrifying power) directly clashes with the indifference of our management towards what the territory is asking of us. We are a long way from the pride of the experimenters when they say, "nature has spoken."

During a preliminary AIME seminar about accounting,[3] we also learned from Lesley Green about the case of quotas on Southern African crab fishing in the Cape. How are we supposed to react to the exhaustion of the crab population, which is panicking the western managers, and impoverishing those who live off the harvest? The Modern reaction is to impose quotas via quantitative modelling, which is blind to the difference between industrial and local fishers. But above all, this modelling is exceeded by the crabs themselves. As a result of global warming, far from confining themselves to the role of resource, or biomass, they become agents who betray the modelling attempts through mass migration and/or deaths.

How can Nature be instituted otherwise, in such a way that referring to it we are not tempted to have those multiplicities of territorial relations, that we have not learned to see, dismembered and destroyed by a bifurcation judgement about what "really," i.e. "objectively," matters and what is "only subjective"? And besides, in such a way that we avoid insulting scientists by denying the specificity of the practices which allow them to claim access to what they call Nature?

Due Attention

We don't want a hegemonic nature, nor do we want a domesticated one waiting politely to be known. So the first important question here for us is how to "institute" a nature which can respect what scientists care about. This requires us to resist two temptations, one that would make such a nature occupy all available space and the other that would assign it a determined place, neutralising it and making it incapable of interfering with other values and other institutions.

We would like to carry forward a proposition of Alfred North Whitehead, a seemingly insignificant one, but one that, if unfolded, will allow us to situate nature without assigning it a place. It will also allow us to diagnose the by-products of the former institution, especially what it failed to protect.

> We are instinctively willing to believe that by due attention, more can be found in nature than that which is observed at first sight. But we will not be content with less.[4]

[2] Doctoral dissertation under the supervision of Philippe Descola, *Métamorphoses des relations entre l'homme et son environnement en pays Gwich'in – Etats-Unis, Alaska.*

[3] Let's Calculate: Reinventing Accounting with Bruno Latour?, AIME Workshop Paris, 5 May 2014 organized by: Martin Giraudeau & Vincent Lépinay

[4] Alfred North Whitehead, *The Concept of Nature* (Cambridge: Cambridge University Press, 1920), 29.

Here the "we" is indeterminate: it concerns non-humans as much as humans, and cannot be reduced to an observing subject. The attention of an animal on the alert, facing possible danger, is testimony to the fact that there are ways of learning "more" about the source of a noise (is it a predator?).

As for "Nature," its articulation with the "more to be found" can satisfy the requirements of experimental scientists—their form of realism. It can happen that if one lends due attention to whatever one is dealing with, more can be learned about it. What these scientists will not accept, what the alert rabbit's ears are witness against, is an erratic nature, the stuff of a kaleidoscopic dream, which takes form or unravels, or metamorphoses itself each time the manner of paying attention to it changes, as if attention was dissolving (or deconstructing) that to which we were willing to pay attention.

Another indeterminate expression is "due attention." We know that this attention is not general, but is, when "nature" is involved, articulated to the possibility of "finding more." But the question as to what attention is appropriate, in one case or another, for learning more, is open, and it is here that we can raise the specific question of the so-called modern sciences.

Bruno Latour has associated experimental sciences with the possibility of accessing "remote" or "distant" things. But this possibility, indeed associated with the experimental origins (Galileo) of modern sciences, does not have to mean that it is the exclusive synonym for the possibility of "learning more." Nor is the question of "due attention" bound to reducing itself to attending to the quality of the chains of reference. Creating stable chains of reference that allow a transfer of "immutable mobiles"[5] is, however, an achievement we want to retain. We don't want to weaken in any way the genuine trust presupposed by the question of this specific kind of due attention, which is especially vital in case of scientific controversy: there would be no controversy if the protagonists did not trust that the remote being which we are paying attention to *may* sometimes be rendered capable of confirming that "more" has well and truly been found.

Experimental sciences, when they succeed, allow us to access "remote" or "distant" things, but it is crucial to emphasise that both remoteness and distance also mean indifference. Indifference is a prerequisite for reference, and, more broadly, for the experimental sciences. It can't be said often enough: the work that produces accessibility assumes the indifference of whatever we are trying to access. Imagine a Mt Aiguille[6] that is sensitive, ticklish, changing its shape every night because it doesn't like the way the trail markers are sticking into it. Or even cooperative, producing by itself a whole lot of markers because that seems to be what is interesting. What we are studying has to be indifferent to our questions in order for us to keep coming back, adjusting, asking "but then?" or "and so?" to whatever we have found.

In contrast, facts in social psychology, for example, have a short life-span—the time needed for the guinea-pigs to understand what is going on in the situation they have been put into and what is expected of them. This is not a matter of a general "limit," but of a signal: we deal with beings for whom the situation they are confronted with matters.[7] In this case, if the

[5] Bruno Latour, *An Inquiry into Modes of Existence.*

[6] Ibid., 74-88.

[7] Isabelle Stengers, "The Curse of Tolerance" in *Cosmopolitics II*, trans. R. Bononno (Minneapolis: University of Minnesota Press, 2011).

point is to "learn more"—and not to obtain extorted obedience for instance the whole question of the kind of "due attention" which is demanded has to be reworked. Any blind extension of experimental freedom, imposing upon what is addressed the situation corresponding to the experimenter's own question, regardless of the meaning of this situation for the addressee, may be characterised as counterfeiting the experimental achievement, obtaining an answer in a way which prohibits "finding more." Such a blind extension is to be resisted in particular when the addressee may be unilaterally submitted to conditions that, postulating its indifference, confront it with a meaningless environment. Ethology is just beginning to accept the hard lesson that one does not learn from beings turned into zombies. The due attention demanded from ethologists thus requires addressing an animal defined as "non-indifferent," an animal for which the way it is addressed matters. "Finding more" means, first of all, finding the questions that are relevant for the animal, the questions which correspond to situations which make sense for it.[8]

In the social sciences, in anthropology, the question of what it means "to learn more" is a matter of relentless debate, and it is especially likely to enter into composition with other preoccupations. Because of its non-innocence, it is all the more important to resist here any hegemony of the articulation proposed by Whitehead between "nature," "due attention" and "find more." We certainly do not want to denounce the crafting of the particular kind of relation, the value of which would be to make it possible to "find more" *about* others. But this crafting cannot claim any privilege compared to the crafting of relations creating reciprocity or the possibility of learning together with.

Retroactively, what we used to call "nature" implied the association of the modern sciences with a general kind of method. Thus, the local and situated success of experimentation, ever since Galileo, has been used as a model for a method that can access any terrain, objectively answer any question, instead of being added to other modes of attention. Galileo himself began the betrayal of what he instaurated—experimental achievement. His method was claimed to be the only way to access "nature", everything else was reduced to a category that foreshadows "relativism": arbitrary fiction or idle chatter.

"Eppur si muove"—this cry should be heard as situated by the problem, that is, as addressed to the long line of astronomers and theologians who came before Galileo and to those for whom the difference between a moving Earth and an immobile Earth at the centre of the world did matter. But it can also be heard as "the Earth is 'really' moving, despite human beliefs." Replacing scholarly geocentric positions with "human beliefs" means that the moving Earth should matter for all humans, whatever the relation they entertain with the Earth. It heralds the figure of Science as opposed to belief. "Really" is then defined "against belief" and should intervene wherever Science claims authority. And since this "really" requires what we may indeed grant to the astronomers' Earth, that its behaviour is indifferent to the way it is addressed, this same indifference must be extended wherever Science has to prevail against belief. Nature must be emptied of everything that does not satisfy the requirement of indifference.

Sciences, in the plural, exemplify the possibility of finding more, and Galileo's moving Earth exemplifies this, as it was the starting point for new questions, new chains of reference,

[8] Vinciane Despret, *Que diraient les animaux si … on leur posait les bonnes questions ?*, Paris, La découverte/ Les Empêcheurs de penser en rond, 2012.

new fruitful ways to pay attention for all those whose practices came to be concerned by what had been an astronomers' quarrel. But the paradox is that Science wants us to accept that there is less, always less to find, to accept that any scientific addition has for its result a sweeping subtraction. For example, finding the molecules correlated with the odour of a particular wine (stabilising an objective and independent mode of access), means adding something new to the world, that allows the reconfiguration of production practices, the training of the palate, etc. The paradox shows up once someone claims that the odour of the wine "is only" the effect of this molecule together with the appalling refrains "you believe, we know" and "that's all it is," destroying all the complexity of the practices associated with wine. The same happens when, from the discovery of incredible neuronal entanglements, a war machine is produced aiming to reduce all experience and all thought to a nasty little naturalism concerning neuronal interaction. The main question for the moderns then becomes synonymous with "naturalisation": either submitting oneself to the narcissistic wounds inflicted by Reason ("Man is only …") or resisting the assaults of "objectivism" devoted to destroying the treasures of a human subjectivity.

III

If only this were a just a mistake … The consequences have been catastrophic, a machine has been unleashed producing arrogant and vacuous scientists, but also an eradicating war machine, directly connected to other machines of appropriation and expropriation. The simple fact of speaking of "nature," including cases of protecting it, keeping it the way it is, "against" humans—a vacuousness peculiar to ecologists full of good faith and good will—can be part of the eradication machine. We are certainly not paying due attention to the hunt for caribou, crucial for the peoples of the American far north. We define this hunt as something that must be eradicated, that threatens declining caribou numbers. Learning more about it would not necessarily have solved the problem, but it would at least have avoided the indignity of suggesting to these people that they become farmers planting winter-resistant GM potatoes. This vacuousness of so-called rational solutions is coupled with a vision of nature as wilderness (mirror, some say, to our own savagery), always independent of humans, which should be protected from them, that is, needing to be redefined for the caribou to survive protected, scrutinised, their predators removed, in short, "humanised."

It is not only in the encounter with other peoples, for whom what we understand by this word, "nature," is (unsurprisingly) hard to understand, that this problem arises. At the heart of modernity, we live in the midst of a cemetery of practices sacrificed on the altar of hegemonic method. Today, any practice is just a surviving one, threatened by eradication. Even the "due attention" cared for and nurtured by experimental scientists is threatened by the objectively evaluated imperative for finding something publishable or patentable.

In reinstituting nature we are obliged to make the question of due attention a crucial one. We have to resist the temptation of making nature something that can be defined once and for all. We don't want to give up the possibility of learning more about it, but this is no authorisation for judging that learning something new is the destiny and duty of humanity …

Civilising Nature: We Belong to the Earth
Rethinking the institution of nature is all the more urgent as we must address the consequences of the intrusion of Gaia in our all too human scenography. We have to resist not only the bad

faith of climate deniers but also the well-meaning search for direct answers, that is global ones, mobilising Mankind, demanding that peoples "under attack" forget spurious bickering.

If Gaia translates our knowledge that the climatic disorders that we are experiencing are part of a process that will get increasingly worse, then this knowledge relates to the work of the specialists in the Working Group 1 of the Intergovernmental Panel on Climate Change (IPCC). As such, we can say that Gaia is an example of "finding more," in relation to the earth's climate, and thus is part of nature. But the relation between science and nature takes on a particularly singular appearance here, in the sense that the fact of finding more, which is generally communicating with the fact of being able to do more, is in this case likely to frighten "the finders," forcing a whistle-blowing role on them. The models are "neutral" in the sense that what they are talking about is well and truly indifferent to them, but they speak of a direct relation between the disorder that is threatening and human activity (characterised in a neutral language in terms of greenhouse gases emissions).

The temptation to be resisted here is that the alarm be transformed via other institutions into a new type of power, or of duty, that of imposing the reference to Gaia on other peoples of the Earth. Then the disarray of the moderns would turn into a new legitimate demand that all bow to the consequences of our new knowledge—"Nature has spoken." This is not, of course, a matter of the other peoples being ignorant. Everywhere on the earth, from Amazonia to the far north, from the vineyards of Burgundy to the Cape Town crabs, an increasing number of situations are witness to an undeniable disorder. It is a matter of refusing to affirm that these disorders that affect humans and non-humans would have for their only truth the same universal natural cause, demanding from everybody anywhere on the earth recognition and compliance with one "rational" course of action.

The knowledge regarding the intrusion of Gaia comes from global models, models that can only be global. It is thus a knowledge that as such is doubly silent. First, it is silent on the disorders that affect and will affect different earthly localities, precisely because the global variables do not authorise local derivations (example: neither the local distribution of the temperature rise nor its ecological, human and economic consequences in a given place can be derived from the global model). But also and above all, these variables have nothing to do with the way in which humans and non-humans can respond to these disorders. The only response that this type of global knowledge can provide would be in the order of a "simple" reduction in greenhouse gases. Such a response implies such an abstract universality that it can only correspond either to a statistical bureaucracy which would thus make nature into a universal institution, or into the sorcerer's apprentice's geo-engineering dream.

Civilising the institution of nature implies a strong distinction between nature and earth. On nature, we will say that it is related to the possibility of "finding more," and that it is what we are dealing with in this modality. On the Earth, we will say we belong to it, just like all other collectives. Thus Gaia is not another name for the Earth. Gaia is what the IPCC models and numbers teach us about (reinstituted) nature.[9] In other terms, we must resist putting the Earth under the sign of a globality that belongs to the scientific modelling which allowed us to

[9] On Gaia, see Bruno Latour's Gifford lectures, available online; or Bruno Latour "Waiting for Gaia: Composing the common world through arts and politics." Lecture at the French Institute, London, November 2011. Available online: http://www.bruno-latour.fr/sites/default/files/124-GAIA-LONDON-SPEAP_0.pdf

find more. The signification of Gaia is that of a question that intensifies relations in all earthly localities, but in no case is confused with the common truth of the problems put to human and non-human terrestrial collectives. Gaia does not have the power of unifying these localities, nor of unifying the manner in which the response will be given to these local disorders. That could be our chance: Gaia's demands constrain us to go back to earthly practices, these alone being able to deal with local, situated and complex configurations. Earthly practices mean due attention to territories, to the various ways all beings, human and non-human, populate and indeed co-produce the Earth through bodily, intra- and interspecific, historical, political, ritual, technical, economical and even mineral practices. Our belonging to the Earth can be more than a fate if we take the risk of associating the needed task of composition with the challenge of learning the demands of radical pluralism regarding each territory, each practice, each being, each collective.

Among these collectives, there are those that belong to the scientific institution. The problem for these collectives is to "find more," certainly, but in such a way that the significance of what they find may indeed contribute to earthly situations, but without ever claiming to provide their rational, or scientific definition. This implies a double constraint. First, the mode of "due attention" to learn more should assert its situated character. Then, this mode should be articulated with other modes of attention, relating especially to other institutions. A current example is that of agroecology, a scientific field whose specialists insist that what they find only has value and significance to the extent that it responds to the knowledges and requirements of farmers, of concrete milieus, of constraints to do with distribution and marketing. It is a case of "slow" science, which the institution, the way it is working at the moment, would readily eliminate, if the concerns of other collectives did not insist on its importance. Among these collectives, particularly crucial are those who pay due attention, not to find more, but to politically address the unsustainable, Gaia-provoking, character of what has been called "development."

Bibliography

Despret, Vinciane. *Que diraient les animaux si ... on leur posait les bonnes questions?* Paris, La découverte/Les Empêcheurs de penser en rond, 2012.

Stengers, Isabelle. "The Curse of Tolerance" in *Cosmopolitics II*. Translated by R. Bononno. Minneapolis: University of Minnesota Press, 2011.

Latour. Bruno. "Waiting for Gaia: Composing the Common World Through Arts and Politics." Lecture at the French Institute, London, November 2011. Accessed 14 April 2015. http://www.bruno-latour.fr/sites/default/files/124-GAIA-LONDON-SPEAP_0.pdf

———. Gifford Lectures, University of Edinburgh, 2013. Accessed 14 April 2015. http://www.ed.ac.uk/about/video/lecture-series/gifford-lectures

———. *An Inquiry into Modes of Existence: An Anthropology of the Moderns.* Translated by C. Porter. Cambridge Mass.: Harvard University Press, 2013.

Whitehead, Alfred North. *The Concept of Nature.* Cambridge: Cambridge University Press, 1920.

AN ONTOLOGY
FOR PHYSICISTS' LABORATORY LIFE

Pablo Jensen

ARE PHYSICS and the AIME project compatible? The answer is not obvious, because physicists are often convinced materialists, while AIME rests on a rebuttal of Alfred North Whitehead's "bifurcation of nature."[1] In other words, physicists frequently argue that only atoms (or more recent "fundamental" particles) exist, the rest being "perceptions" of our mind, while AIME fights that idealism of res extensa and seeks ontological pluralism in things and not in representations (Latour, Inquiry ch. 5). In this article, I summarize my experience as a diplomat physicist[2] involved in AIME and propose a metaphysics compatible with both AIME and physicists' practices.

1. FUNDAMENTALISM

WHAT I WILL CALL physics "fundamentalism" is quite common in the media. For example, The Economist celebrates the opening of the Large Hadron Collider in this way:

> [p]article physics is ... the hidden principle underlying so much else. ... The LHC ... cost about $10 billion to build. That is still a relatively small amount, though, to pay for knowing how things really work. ("Science's great leap")

For brief information on the author see r·m!104.

Unsurprisingly, it is proclaimed by some particle physicists:

> Particle physicists construct accelerators kilometers in circumference and detectors the size of basketball pavilions not ultimately to find the t quark or the Higgs boson, but because that is the only way to learn why our everyday world is the way it is. (Cahn 959)

The importance of particle physics is justified by a "constructivist" hypothesis:

> Given the masses of the quarks and leptons, and nine other closely related quantities, [the current theory of particle interaction] can account, in principle, for all the phenomena in our daily lives. (952; emphasis added)

It is worth reading the whole sentence, which ends with "and in fact, for all the data obtained from experiments at accelerator laboratories around the world"

[1] A detailed analysis of Whitehead's arguments, in line with AIME's project, is provided by Didier Debaise's last book L'appât des possibles.

1 Joaquín S. Lavado (Quino) /
 Caminito S.a.s. Literary Agency.
 1991. Quino. *Humano se nace*.
 Buenos Aires: Ediciones de la Flor,
 1991.

… [accept] without question [that t]he workings of our minds and bodies, and of all animate or inanimate matter are assumed to be *controlled by* the same set of fundamental laws … which we feel we know pretty well. (Anderson 393; emphasis added)

In summary, many physicists[4] share the "fundamentalist" vision: The world is *controlled by* a set of fundamental particles and laws. As the official press release of the 2013 Nobel Prize in Physics puts it:

[E]verything, from flowers and people to stars and planets, consists of just a few building blocks: matter particles. These particles are governed by forces mediated by force particles that make sure everything works as it should.

2. RELIGIOUS ORIGIN OF THE FUNDAMENTALIST VISION

As noted by Bruno Latour in *An Inquiry into Modes of Existence* (ch. 6), this fundamentalist vision is a heritage of the seventeenth century religious world view, in which God's "invisible Hand … wields the vast Machine, and directs all its Springs and Motions" (Atterbury 249). Many human cultures have noticed that the material world is rather stable, showing loose regularities (seasons, fall of objects, and so on). They have often included these regularities in their world views, as in classical China where the world is seen as "regulated" by a constant interplay between polarities.[5] The fundamentalist vision extrapolates these terrestrial regularities to

(952–53). To start elaborating on the vertiginous gap between "fact" and "principle," Nobel laureate Philip Anderson wrote his famous piece "More is different." He showed, using rigorous physics arguments, why we cannot hope to reconstruct the world from the fundamental level. However, somewhat paradoxically for the article that became the antireductionist manifesto,[3] he begins by stating that most active scientists would

115

[2] A physicist, I should add, "tamed" by philosophers, enough to be interested in the project, but a physicist anyway, to remain interesting for the project. Not representing physicists but somewhat representative of them.

[3] Anderson's article has been cited more than 800 times by many different fields (e.g., physics, chemistry, history, and psychology).

[4] According to the first results of a survey I'm conducting, roughly 60% of them.

[5] For a fascinating account of the sophisticated classical Chinese world view, see Jullien.

reach an ideal, literally supernatural territory, where perfect, mathematical laws systematically connect causes and effects. As historians of science have shown (e.g., Cartwright), the idea of laws controlling the world rests on the belief in an omnipotent, transcendent God held by the European scientists that invented this vision in the seventeenth century. As early as 1630, Descartes extrapolated the isolated regularities found by scientists (e.g., Boyle's law on gases, equality of angles in the reflection of light) to proclaim the universality of "laws of nature" in a letter to his friend Mersenne: "Please do not hesitate to assert and proclaim everywhere that it is God who has laid down these laws in nature just as a king lays down laws in his kingdom" (23). The idea of natural laws governing the behavior of all natural bodies gained widespread acceptance in the late seventeenth century, under the impetus of the Royal Society (Roux).

Today, this idea survives without the Divine Character that made sense of it, which leads to many conceptual problems. First, the metaphor of laws becomes rather strange: Where do these perfect, supernatural laws come from? Who created them? How comes that the world is exactly as scientists hoped it to be? (Midgley) Thinking in terms of "laws" seems legitimate for humans that create and respect them because they have a moral sense or fear punishment, but why would things respect them? Second, the very idea of "control" only makes sense for an *external* agent that exerts it on a system, as a supernatural God could do with His invisible hand. [6] Finally, the concept of a fundamental or ultimate level leads into an infinite regression if there is not an omnipotent God to stop it, as the poet Jorge Luis Borges understood long ago.

[THE GAME OF CHESS]

Over the black and white of their path
They foray and deliver armed battle.

They do not know it is the artful hand
Of the player that rules their fate,
They do not know that an adamant rigor
Subdues their free will and their span.

But the player likewise is a prisoner
(The maxim is Omar's) on another board
Of dead-black nights and of white days.
God moves the player and he, the piece.

What god behind God originates the scheme Of dust and time and dream and agony?

(Borges, *Dreamtigers* 59)

3. TOWARDS
A NONFUNDAMENTALIST ONTOLOGY

AT THIS POINT, physicists may argue that, whatever the conceptual problems, in practice they are able, in their labs, to bring out reliably some laws. Can we understand this, and more generally, the possibility of making a successful mathematical science without a hidden God controlling the machine? To start imagining a secular metaphysics and avoid fanciful hypothesis, it seems reasonable to start with a careful description of scientists in action. [7]

[6] According to Leibniz, the idea of God's transcendence states that He is not in the world as a vital principle animating the living beings, but rather as "an inventor … to his machine …, a prince … to his subjects … and a father … to his children" (266).

[7] For an introduction, see Latour, *Science in Action*.

3.1 IN PRACTICE, MATTER IS CONTROLLED BY OUR MACHINES

THE MAIN POINT is that scientists have to tame a wild world in their labs to ensure reproducibility. A helpful image – suggested by Bruno Latour in unpublished notes – is the taming of a tiger for a circus show. Transforming a tiger jumping freely in the jungle into a tiger jumping reliably through a ring of fire in a circus demands a lot of careful, attentive work. And the trainer should never forget that the tiger often dreams of jumping again freely in the jungle. Scientists carry out a similar transformation of the world to stabilize it by trial and error. This work has been summarized by sociologist of science (and former physicist) Andrew Pickering under the name of "dance of agency." Starting with some idea (say, a particle detector), a scientist actively builds a machine, and then becomes passive while the agency of the world, as recorded by the device, takes over. Switching back to an active role, she then reacts to the machine's performance – which is usually not what she expects. This dance of agency continues until an autonomous machine is obtained – something that she and others can use as a reliable tool to do things with, to carry on research. This creative work finds stable "islands," stable material and human configurations which can be reproduced in other places, but need constant maintenance to remain stable. The point is that theories and laws grow on these islands – they do not give them to us.

In these empirical investigations, scientists working at different levels of organization (e.g., molecules, atoms, nuclei) appear to deal with the world independently, like in the parable of the blind men trying to figure out the shape of the elephant by touching different parts. Each observation enriches the description of the world and each blind man

ends with a different (and real) version of the animal. In addition to this experimental work, theorists make connections between the different versions, an important task as it creates "turntables" which guide subsequent investigations, as exemplified by the periodic table of chemical elements or Navier-Stokes equations for hydrodynamics.

3.2 GETTING RID OF THE FUNDAMENTALIST ONTOLOGY

MY SCOPE IS to show that we do not need to assume a world "*already* made of 'objective knowledge'" (Latour, *Inquiry* 90) to allow for the existence of a highly mathematical science as physics. To this end, AIME opposes the "reference" [REF][8] and "reproduction" [REP] modes. However, I find the reproduction mode hard to understand and to distinguish from the "metamorphose" mode [MET]. More importantly, [REP] is difficult to map empirically, as recognized by Latour: "A leap impossible for human eyes to discern" (101), a major drawback for a physicist! Finally, the reproduction mode suffers from problems internal to the AIME project. As noted by Didier Debaise in the AIME workshops,[9] [REP] is not accompanied by the corresponding modern institutions and it sometimes flirts with a general ontology (as in "[beings of reproduction] *precede* the human, infinitely" (203)), tending towards a general metaphysics, common to all humanity, instead of focusing on modern values as urged by AIME.

Here, playing the role of a diplomat physicist within AIME, I propose a different solution, which sticks to the empirical description of physicists at work offered above and may satisfy them. The world is seen as an active entity, in some respects more similar to a living being than to a machine. Of course, since no one has direct access to the world,

[8] For a brief explanation of these abbreviations, which refer to the modes explored in the AIME project, see the glossary in this volume (*r·m!* 543–47).

[9] Most clearly in the workshop held in Porquerolles in April 2014 (available at modesofexistence.org).

world-pictures are not falsifiable, but they can be more or less logically compelling or coherent. They represent a way of connecting our experiences and they make us more sensitive to some aspects of reality while obscuring others, therefore leading us towards different worlds, different political agendas. On this ground, we can examine the differences between the fundamentalist and the active ontologies, on three levels: their conceptual coherence, the feeling of mastery, and the relations of physics with the public.

3.2.1 CONCEPTUAL COHERENCE — Our metaphysics avoids the unverifiable hypothesis put forward by the fundamentalist vision that, before taming, the world is already "made in" mathematical laws, waiting merely to be discovered. Tigers jumping in the jungle are not already tamed "in principle," but it turns out that most of them can be tamed for a while. Our vision extends to the whole world what French philosopher Jean-Paul Sartre pointed out for humans: once we give up the idea of a God predefining essences, it is more coherent to assume that "existence precedes essence." The laws, the properties of the particles, are not the cause of their actions, but their consequences, by which we mean a convenient summary of their (past) actions, always open to modifcation. In a word, laws describe, they do not prescribe. In addition, the active vision does not claim privilege for any level of organization which would be fundamental. It rather sees every level as constituted, defined by a certain scale of intervention and observation (Bitbol). Theorists' work is interpreted as connecting locally different levels, rather than reducing everything to a fundamental level. There are partial "explanations," that is, partial reductions of large-scale diversity to a set of lower-scale entities, but no control anywhere except by the experimental setup.

3.2.2 MASTERY — The fundamental view gives confidence that the world can be mastered, since it is "already" controlled, by God or some hidden laws. This trust certainly played an important role in making possible the scientific revolution. Today, the fundamental view is still appealing for many (theoretical) physicists, who are driven into this science for "ontological" reasons, to discover what the world is really like, something akin to a religious quest. As mathematician Bertrand Russell puts it: "I wanted certainty in the kind of way in which people want religious faith." Russell wanted to discover a truth independent of human existence, and hated those humanists that only pay attention to our "petty planet and the creeping animalcules that crawl on its surface" ("Reflections" 54). I remember having been thrilled by his book My *Philosophical Development* during my student years, as I was also driven to physics by ontological reasons, which may explain why I ended up working with philosophers. Physicists love elegant equations that seem to "contain" many phenomena of the world. They give them a feeling of mastery over a world united by fundamental equations, with no need for those terrestrial approximations engineers have to deal with.

Instead, the active view gives a feeling of uncontrolled liveliness: If you want the world to behave as a machine, you need to tame it by building one. Strictly speaking then, these "law machines" are the only place where laws exist. This vision makes conceptual room for the enormous (and expensive!) technological network needed to purify, standardize the world, and make it reproducible in the labs. It highlights the connection between science and technology and the creativity of manual work, which is often neglected but was decisive on many occasions as shown by historians (Conner). It also helps in understanding the role played by chance in many discoveries. In sum, this vision gives a more lively account of science in the making, for it feels very different to try to uncover a stability, guaranteed by already existent laws, or to try to tame an often surprising world.

As a diplomat, I seek a way of conciliating the active ontology with physicists' libido for simple explanations, because this desire has proved fruitful, as in the case of Einstein's "miraculous year" of 1905. Pushed by his faith in the conceptual unity of physics, he published three papers that solved major puzzles situated at the intersection of different fields (Renn). Confidence in the predictive power of simple fluid dynamics also helped building climate science (Edwards). In my own experience, this conciliation is not easy, at least for "ontological" physicists, because it may seem less thrilling to build "turntables" than to discover how the world "really" works.

PHYSICS AND THE PUBLIC — Finally, the active ontology commands less prestige (and funding) for "fundamental" physics, since it becomes one approach among many others to understand the world. It also clarifies public debates about the relation of physics with society. In a recent paper that generated many discussions within the physics community, Art Hobson states that

> [p]hysicists are still unable to reach consensus on the principles or meaning of science's most fundamental and accurate theory, quantum physics. ... This confusion has huge real-life implications ... [and] quantum-inspired pseudoscience has become dangerous to science and society. (Hobson 211)

He then gives the example of the highly successful "quantum healing," which can allegedly cure all our ills. Hobson's argument suggests that to fight pseudo-science, we first need to close controversies among scientists and then teach "lay" people what we have agreed upon. I doubt the mere possibility of such a strategy: Scientists are (fortunately) reluctant to shut their mouths on these metaphysical issues, as shown by the immediate replies to Hobson's paper, and lay people would not follow anyway. More to the point, I think that the whole fundamentalist approach and its unacknowledged religious background is quite fragile when pitted against pseudo-science. The idea of a single level of supernatural inspiration controlling the whole world is great food for mysticism. When physicists claim that their theories control everything, they legitimate the idea that quantum mechanics could be relevant for health. Instead, a vision grounded in physicists' practice, acknowledging that there is no scientific link between quantum mechanics and health, would help people seeking advice from doctors rather than from quantum gurus. Relativizing the fundamentalist approach – the idea that the world is governed by hidden laws – is even more important in genetics or economics.

4. BEWARE OF THE TIGER!

THE IDEA OF FUNDAMENTAL LAWS controlling the world has so far survived the elimination of God, as a chicken running with its head off. I suggest here a world-picture that avoids those metaphors (control, fundamental level, and laws) which are of religious origin. We may feel a bit dizzy by this bottomless vision of the world. We may also feel unsure in a world that lacks any transcendent guarantee of stability. But this may actually be a blessing in disguise: ecological crises are the sign of too much trust in our mastery of the world. We'd better become more sensitive to surprises, to consequences exceeding the known causes, the previsions. We thought we could get cheap energy by burning coal, oil, and gas, but, unexpectedly, we end up with global warming. We thought we could master the atom, and we end up with Fukushima. Tigers do jump back into the wild.

Works Cited

Anderson, Philip W. "More is different." *Science* 177 (1972): 393–96. Print.

Atterbury, Francis. *Sermons and Discourses on Several Objects and Occasions.* Vol. 1, London, 1723. Print.

Bitbol, Michel. "Downward causation without foundations." *Synthese* 185 (2012): 233–55. Print.

Borges, Jorge Luis. *Dreamtigers.* Austin: University of Texas Press, 1964. Print.

———. *El Hacedor.* Buenos Aires: Alianza, 1960. Print.

Cahn, Robert N. "The eighteen arbitrary parameters of the standard model in your everyday life." *Reviews of Modern Physics* 68 (1996): 951–59. Print.

Cartwright, Nancy. "No God; No Laws." *Dio, la Natura e la Legge. God and the Laws of Nature,* Ed. E. Sindoni and S. Moriggi. Milan: Angelicum-Mondo X, 2005: 183–90. Print. Available at <http://www.isnature. org/Files/Cartwright_No_God_No_Laws_draft. pdf>.

Conner, Clifford D. *A People's History of Science: Miners, Midwives, and Low Mechanicks.* New York: Nation Books, 2005.

Debaise, Didier. *L'appât des possibles.* Dijon: Les presses du réel, 2015. Print.

Descartes, René. "To Mersenne, 15 April 1630." *The Philosophical Writings of Descartes.* Vol. 3. Cambridge: Cambridge University Press, 1991. Print.

Edwards, Paul N. *A Vast Machine: Computer Models, Climate Data, and the Politics of Global Warming.* Cambridge, MA: The MIT Press, 2010. Print.

Hobson, Art. "There are no particles, there are only fields." *American Journal of Physics* 81 (3) (2013): 211–23. Print.

Jullien, François. *The Propensity of Things: Toward a History of Efficacy in China.* Cambridge, MA: The MIT Press, 1999. Print.

Latour, Bruno. *An Inquiry into Modes of Existence: An Anthropology of the Moderns.* Cambridge, MA: Harvard University Press, 2013. Print.

———. *Science in Action: How to Follow Scientists and Engineers through Society.* Cambridge, MA: Harvard University Press, 1988. Print.

Leibniz, Gottfried Wilhelm. *The Monadology and Other Philosophical Writings.* London, 1898. Print.

Midgley, Mary. *Science as Salvation: A Modern Myth and Its Meaning.* London: Routledge, 1992. Print.

Pickering, Andrew. *The Mangle of Practice: Time, Agency, and Science.* Chicago: University of Chicago Press, 1995. Print.

Renn, Jürgen. "Einstein's invention of Brownian motion." *Annals of Physics* 14 (2005): supp. 23–37. Print.

Roux, Sophie. "Les lois de la nature à l'âge classique." *Revue de Synthèse* 122.2–4 (2001): 531–76. Print.

Russell, Bertrand. *My Philosophical Development.* London: George Allen & Unwin Ltd., 1959. Print.

———. "Reflections on My Eightieth Birthday." *Portraits from Memory and Other Essays.* New York: Simon and Schuster, 1956: 54–59. Print.

Sartre, Jean-Paul. *Existentialism and Human Emotion.* Secaucus: Citadel, 2000. Print.

"Science's great leap." *The Economist.* 7 July 2012. Web. 8 Dec. 2015. Available at <http://www.economist. com/ node/21558254>.

"The 2013 Nobel Prize in Physics – Press Release." *Nobelprize.org.* Nobel Media AB, 2014. Web. 14 Dec. 2015. Available at <http://www.nobelprize.org/ nobel_prizes/physics/laureates/2013/press.html>.

HOW WE BECAME MODERN: A VIEW FROM AFAR

Philippe Descola

In the end, the mystery as to what these Moderns have been up to remains intact.
Bruno Latour, "Biography of an Inquiry"

AN INQUIRY INTO MODES OF EXISTENCE is the latest piece in the framework that Bruno Latour has been developing for the last forty years to symmetrize the anthropology of the moderns – that is, to make them as complicated and worthy of interest as the nonmoderns. This framework has become increasingly intricate and powerful over the course of its elaboration, and each new stage of its development has been an event, rightly saluted and appreciated as such by the community of free spirits who value the greater intelligibility of the plurality of worlds. But this enterprise always leaves Latour and his audience wondering: Who exactly are these fabled moderns he discovered in the factories of Côte d'Ivoire and then observed as an ethnographer in the laboratories of the Salk Institute, in the research departments of railway construction companies, in the courtrooms of the Conseil d'État?

At first glance, one might say that Latour's moderns are defined by default – in other words, as not being the moderns they claim to be: they invented a great divide between nature and culture which they never actually respected (Latour, *We Have Never*). Latour argues that in practice, since the mechanistic revolution of the seventeenth century, scientific and technical activity has been constantly creating mixtures of nature and culture within networks of increasing architectural complexity, where objects and humans, material effects and social conventions

PHILIPPE DESCOLA *who initially specialized in the ethnology of Amazonia, focusing on the relationships of native societies with their environment, he holds the Chair of Anthropology of Nature at the Collège de France and is also a professor at the École des Hautes Études en Sciences Sociales, Paris. He is a corresponding fellow of the British Academy and a foreign member of the American Academy of Arts and Sciences.*

mutually "translate" one another. He shows that this proliferation of mixed realities is due to the underlying critical "purification" work of separating humans and nonhumans into two perfectly impervious ontological spaces. In short, to use an expression that Latour is fond of, "White men speak with a forked tongue": they do not say what they do and do not do as they say. How, then, do they differ from nonmoderns? Essentially through the presence of a dualist "constitution" designed to expedite the production of hybrids and make it more efficient by concealing the conditions underlying its actualization. In other words, Latour argues that the moderns have a greater capacity for extending their human and nonhuman networks and making their connections denser, for they have a greater capacity for deluding themselves about what they are doing in reality.

Inquiry gives substance to these ideas by proposing forms of enunciation and regimes of truth with which to describe the originality of what the moderns say and do, in a more relevant way than the old analytics of dualisms (subject/object, nature/culture, universal/relative, etc.), although it is not yet clear just who the moderns are. Their latest Latourian avatars present them, by turns, as producers of enunciations (the semiotic perspective), a pioneering front (the dynamic perspective), a civilization (the culturalist perspective), a project (the constructivist perspective), a legacy (the historical perspective), even a stage of scientific and technological development (the genetic-epistemology perspective, no less!). The result is a construction *en abyme*: Latour sees the moderns, who were once characterized by their positivity – in comparison to the nonmoderns marked by absence (the absence of modernity) – as similar in practice to those to whom they were opposed (since, like the nonmoderns, they mix nature and culture). Yet he also sees them as different from the perspective of comparative ontology, since they do not spawn the same beings, the same procedures of truth, and the same modes of existence. In short, just like everybody else, they produce hybrids, but in their own way.

I would like to contribute to this study on the evanescent identity of the moderns by considering the conditions that made them modern. This entails recognizing that the moderns did indeed become modern over the centuries, and that therefore a few traits suffice to define a modern ontology which differs from other modes of existence. It also entails giving greater credit – having recognized and tested the fertility of a comparative metaphysics approach – to historical circumstances, which is no small admission for the hardened structuralist that I am. I therefore start from the old observation, documented by many historians of ideas, that a fundamental transformation took place in Europe between the end of the medieval period and the latter half of the seventeenth century. What did this transformation consist of? I argue that it corresponds to the gradual development of a new ontology characterized by a twofold assertion regarding the regime of beings: one can detect, in the folds of the world, a discontinuity between humans endowed with a spirit and nonhumans deprived of one, but one can also detect a continuity between humans and the rest of existents in terms of their physical properties. This ontology, which I call "naturalist," is what primarily defines the moderns and forms the framework for the scientific revolution of the seventeenth century. In other words, I take Maurice Merleau-Ponty's comment in his course on nature seriously: "Scientific discoveries did not provoke changes in the idea of Nature; rather, the change in the idea of Nature allowed for these discoveries" (8). There is indeed a difference in nature, and not in degree, between the dominant ontology of the Renaissance, which I call analogist, and the naturalist ontology that followed.

Why this position? First, probably because I am an anthropologist of the nonmoderns, a specialist in institutions and practices that differ significantly from those with which we are familiar in the West, and not, like Latour and most of his colleagues, a specialist in modern science and technology, a field in which I have only the knowledge of a lazy amateur. I am certainly highly critical of the philosophical scenario that was fed to me in my youth, which presented the history of scientific reason as the gradual revelation of truth by a cohort of great minds. Yet having witnessed exotic customs all around the world, I am convinced that what Latour calls the modern constitution was itself something incredibly exotic compared to other ways of doing and thinking, and that its genesis could not have been the result of a simple heightening of the capacity for self-deception. Especially since, if the moderns' main characteristic is that they put themselves more acutely at odds with themselves than anyone else – which has been said by Marx, in a way – should we then think that the nonmoderns

are more transparent to themselves? I don't think so. Having long accused savages and barbarians of being uncompleted rationalists, of being caught up in webs of superstition, of playing the global determinism of magical thinking against the particular causalities of scientific thinking, it would be wrong now to see them as endowed, on the contrary, with some particular lucidity in the form of a reflexive intelligence with regard to the status of the hybrids they harbor – as opposed to the moderns who lost this intelligence, blinded as they were by the evidence of nature to which they had just given birth.

In short, I am somewhat reluctant to cast nature as an epistemological obstacle to the moderns in the same way that mythical thinking once was in relation to the premoderns – to consider nature, that is, as a sort of filter concealing from consciousness the true particularities of the actions in which we engage and the results they produce. That would be like replacing the old "You are failing to purify the hybrids you summon in your rituals because you believe in the authority of gods" with "You cannot see that you are making hybrids in your laboratories because you believe in the transcendence of nature." The second proposition seems too close to the first – which nevertheless has been judiciously critiqued by anthropologists, above all Latour in his reflection on the "factish" ("On the Cult"). Too close, for it replaces an explanation based on erroneous belief now difficult to accept, with an explanation based on something ultimately very similar: what Marxism calls an ideology, understood as a system of ideas that veils the real conditions of action in the collective imaginary.

I therefore prefer to conjecture that there was indeed a change of episteme, as Foucault would put it, a change in the symbolic forms of experience, as Cassirer would put it, a change in the idea of nature, as Merleau-Ponty would put it – and that this created the conditions for the revolution of scientific activity in the seventeenth century. What did this change consist of? In *Beyond Nature and Culture*

I argued that, in a movement that basically runs from Galileo's *Dialogue concerning the Two Chief World Systems* in 1632 to Darwin's *On the Origin of Species* in 1859, we shifted from a primarily analogical mode of identification to a primarily naturalistic one. As these terms are somewhat idiosyncratic, I will briefly consider what they encompass. By "mode of identification," I mean a way of systematizing ontological inferences, each of which is founded on types of resemblance and difference that humans discern between themselves and nonhumans, both physically and morally. For example, I can intuit that an entity present in my environment is animated by dispositions similar to mine: an animal, a plant, a simple "presence" perceptible through its effects, even an artifact or an image. It seems to be driven by its own intentions, capable of autonomous actions, endowed with discernment and able to feel emotions. On the other hand, the physical appearance through which I perceive it differs greatly from mine: covered in fur, feathers, or bark, bearing wings, fins, or branches, incapable of surviving out of water or of moving about in broad daylight, this entity is bound by its material envelope to occupy a certain ecological niche and, consequently, to live a distinct existence therein. In short, I can infer about most beings that they have the following characteristics: their interiority hardly differs from mine, but they differ from me in their physical propensities, in the types of operation that these allow them to perform, and in the contrasting views of the world these offer them. When this attitude becomes generalized and systematized among a group of humans, we speak of *animism*, a common mode of identification among the native peoples of the Amazon and the northern parts of North America, in the Arctic and Northern Siberia, and among populations of Southeast Asia and Melanesia.

Another mode of identification strikingly exemplified by the Australian Aborigines, *totemism*, contrasts with animism in that it holds both interior and physical differences between humans and

123

other existents to be negligible, instead emphasizing a set of qualities shared by a hybrid class comprised of certain humans and certain nonhumans. These qualities, transmitted to each generation through the seeds of an original prototype, relate not so much to the forms of bodies as to the substances of which they are made, the dispositions that inhabit them, and the "temperament" they demonstrate, thus lending more credibility to the idea of an identity relationship between beings with very different appearances. The qualities shared by the members of a class – humans, plants, animals – make them wholly different from members of another class comprised not only of other humans, but also other plants and other animals. Each class is therefore ontologically autonomous, in that it embodies a particular essence situated on a specific site, though it is dependent on other classes on a functional level – at the very least for humans, who rely on those other classes to find a partner and gain access to hunting grounds and ritual services. In this sense, totemism is far more than a classification system that uses contrasts between species to signify contrasts between social groups; it is an ontology that detects and distributes in an original way the qualities perceived in beings and places.

A third formula inverts the second. Instead of humans and nonhumans finding themselves merged within a class because they share a common essence and substances, on the contrary, all the components of the world, all the states and qualities it contains, all the parts that make up existents, are distinguished from one another and differentiated into an equivalent number of singular elements. Much like the *wan wou*, the "ten thousand essences" of Chinese cosmology,[1] or the multiple entities that make up the "great chain of being" in medieval cosmology, this mode of identification relies on the fractionation and individuation of the properties of beings and things. For a world formed of such a large number of singular elements to be conceivable to the humans who inhabit it, for it even to be inhabitable on a practical level without these humans feeling themselves to be at the mercy of chance, all of its constituent parts need to be linked in a network of systematic correspondences. Yet in their most visible forms, these correspondences all rely on the figure of the analogy: this is the case, for example, with the correlations between microcosm and macrocosm established in certain divinatory systems, with the medical theory of signatures, with Chinese and African geomancy, and with the idea that social disorders – incest, oath-breaking unobserved rites – cause climate disasters. We can thus call this ontology of atomization and recomposition *analogism*. It prevailed in Europe from antiquity to the Renaissance, and many examples can still be found among the major Eastern civilizations, in West Africa, and in the American Indian communities of the Andes and Mexico. Given that the world is populated with an infinity of singularities, these then need to be organized into signifying chains and tables of attributes in an endeavor to give order and meaning to both individual and collective destinies.

There is one last mode of identification, the one actualized by the moderns, which inverts, term for term, the premises of animism: while humans are the only ones to possess an interiority – a spirit, an intentionality, the ability to reason – they belong to the large continuum of nonhumans by virtue of their physical characteristics; their material existence is governed by laws from which no existent is exempt. I call this way of inferring qualities in things *naturalism*, for its primary effect, in terms of the architecture of the world, is to clearly distinguish between what relates to nature (a domain of physical realities that are predictable, as they are governed by universal principles) and what relates to society and culture (human conventions in all their

[1] The *wan wou* are still alive in contemporary urban China, as attested by Judith Farquhar and Qicheng Zhang in their recent book *Ten Thousand Things: Nurturing Life in Contemporary Beijing*.

established diversity). The result is a dissociation of the sphere of humans – the only ones capable of rational discernment, symbolic activity, and social life – from the immense masses of nonhumans, bound to a mechanical existence devoid of reflection – an extraordinary dissociation that no other civilization has so systematically implemented.

Let us now return to the origin of modernity and suppose, on the one hand, that the shift from the Renaissance to the late seventeenth century did constitute the beginning of a transition from analogism to naturalism as I have defined it, and, on the other hand, that the naturalist ontology that was starting to gain credibility in some European circles at the time provided the necessary environment for scientific activity to flourish. How should we go about giving these suppositions a semblance of likelihood? Let us start with the transition from analogism to naturalism. Without giving in to the illusion of retrospective coherence, I would argue that traits specific to the analogist ontology facilitated this shift, which, for structural reasons, would have been impossible to envisage if the starting point had been animism or totemism. What happened, in terms of the recomposition of human-nonhuman relations, between the late sixteenth and the nineteenth centuries, first in England and then in the rest of Europe and the United States? The hierarchically ordered segments of the collectives, in their statutory arrangements, came undone, releasing an immense mass of human individuals who had equal rights yet were still separated by concrete disparities, both within the particular communities across which they were distributed and in the formal aggregate that these communities continue to form collectively in the "concert of nations." The mixed cosmos that each collective had tailored to suit itself dissolved into an infinite universe recognized by all those who, independently of their position on the surface of the earth, acknowledged the universality of the nonhuman laws governing them. Most importantly, the City of God fragmented into

multiple "societies" from which nonhumans were banished – de jure, if not de facto – thus creating collectives that were of the same nature and therefore comparable, though they were long thought to be unequal on an evolutionary scale, particularly as some seemed incapable of expelling from the heart of their social life all the kinds of nonhumans which were accommodated there.

How was this new distribution facilitated by the singular characteristics of analogist cosmologies? One of these characteristics seems essential: the nonhumans that analogist collectives recruit into their segments retain their particularities – in contrast to totemism, where they are merged with humans, and, of course, to animism, where their differences of form and behavior are clearly announced, as they are spread throughout monospecific "societies." Analogist segments are therefore not hybrid, but mixed: the entities they mobilize maintain their intrinsic ontological differences – and this is inherent to this mode of identification – but these are attenuated by the multiple relationships of correspondence and cooperation woven between the entities, as they all share the segment's common purposes. The deified ancestor of a lineage is no longer quite human, even if he or she is made present via a mummy or an anthropomorphic sculpture. A mountain is not really human, even if the group of humans who worship it expect it to be receptive to their prayers and contribute to their well-being. The archangel, lion, and unicorn, whose specific positions in the thread of contiguities are subject to the chain of being, all share with humans their dependence on the *ens perfectissimum* that guarantees them a particular identity in the same neighborhood, although they remain clearly distinct from one another. Thus, when the sections of an analogist collective fall apart, each of their human and nonhuman members conspicuously recover the ontological singularities that had been partly concealed, both by the cooperative actions in which they had been engaged and by the formal solidarity induced by the

125

hierarchical structure that had organized their distribution. Humans and nonhumans then become available for the radical differentiations and mass groupings that naturalism is forced to enact in order to organize this chaos of singularities without resorting to a segmentary logic. In the absence of intermediary bodies capable of manifesting its hierarchical stratification, the old cosmocentric order disappears and can be supplanted by an anthropo centric order in which the world and its constituent parts are carved up on the basis of whether humanity is present directly, by proxy, or not at all. In short, the stage is set for nature and society to begin their respective monologues in the light of reason.

However, analogism's tendency to lead to a naturalism conducive to new ways of doing science is not just the product of the ontological characteristics it attributes to the beings whose coexistence it organizes. A role is also played by the practical conditions of analogist collectives' functioning – that is, by the institutions required to efficiently operate the correspondences and couplings between the massed singularities that make up these collectives. For it was these institutions, conspicuously absent in totemism and animism, which, as soon as they were modified and diverted from their primary purposes, provided the social frameworks and intellectual tools for the development of scientific reason. One of the striking features of analogist ontologies is in fact the great instability of the beings populating them. These beings are made up of highly mobile elements, subject to constant recomposition, situated partly outside their physical envelope, and therefore dependent for their fragile equilibrium on an interlacing of determinisms and external influences which humans endeavor to control. And there are only two ways of doing so: anticipating and repairing. Anticipating: in other words, interpreting the multiple indicators signaling an event or a destiny; preventing contact between elements whose combination is thought to be harmful; encouraging harmonious combinations instead; gaining, through

the appropriate rituals, the favors of a given deity or the benevolence of a certain saint, depending on the operation one has embarked on. Repairing: in other words, restoring an upset balance, ultimately using the same methods: deciphering the signs of a diagnosis; rejoining what has been separated and dissociating what has wrongly been brought into association; performing prescribed rites.

In all analogist collectives, in Mexico, China, Renaissance Europe, or West Africa, identical practices can be found, based on similar theories of the dosage of humors and elements, the same conception of predestination, the same respect for the performative effectiveness of well-executed ceremonies. And these practices are entrusted to the same specialists – physicians, seers, geomancers, astrologers, oracles, priests – often gathered into colleges difficult to access, fueled by a strong esprit de corps, and in open competition with one another for the custom of the lay public and the favor of the powerful. These specialists undergo extensive training prominently geared towards mastering complicated intellectual techniques for the computation, memorization, inscription, and storage of information, generally using graphic signs. They are trained to observe and detect regularities and recurrences, both in the movement of stars and the manifestations of meteors, and in the symptoms of suffering bodies, animal behaviors, and events of everyday life. And they know how to extend networks of connections using complex operators like conversion and equivalence tables, algorithms, and miniature models. In short, only in analogist collectives do we find this set of aptitudes, techniques, and institutional frameworks that is needed to integrate and stabilize the singularities populating these collectives. It is easy to see just how immediately transposable they were to the set of aptitudes, techniques, and institutional frameworks needed for the practice of seventeenth-century European science. The shift was not necessarily from a college of seers to a science academy, from astrology to astronomy, or

from African or Madagascan geomancy to set theory, but it would have been absolutely impossible for astronomy to emerge in a world indifferent to the journey of celestial bodies, or for chemistry to appear where there had never been any thought of categorizing substances according to their recognized properties.

This is why I would argue that the physics of sensory qualities that characterizes the analogist theory of the behavior of material bodies, wherever it is found, is far from being a state of knowledge from which modern science brutally dissociated itself. In fact, it was a necessary predisposition for the development of that science. Certainly, analogist physics is simple, at least in terms of its inventory of constituent materials. The litany of sympathies and discordances unceasingly recited by medical knowledge, dietary prescription, and religious ordinance always draws on the same basic substances and the same principles of attraction and repulsion. This is a constraint inherent to analogical systems: the simplicity of their components is probably crucial to their remaining intelligible and manipulable. When each thing appears as a virtually unique specimen, it becomes necessary to be able to reduce its singularity by breaking it down into a small number of elements that might define its nature and explain its behavior towards other things. Drawing on therapeutic practice and on the experience of materials acquired in metallurgy, pottery, or the chemistry of pigments, this qualitative physics actually relies on sound empirical plausibility. How can anyone fail to see that a fundamental continuity exists between analogist and naturalist knowledge, between the Renaissance alchemists' presuppositions and those of the late-seventeenth-century mechanists? Both share the conviction that the elementary materials of the world have the same knowable properties everywhere, and that the different combinations they allow for are valid in all places. In other words, seen from upstream and not downstream, from the perspective of the nonmoderns rather than that of the moderns, from the Han Empire's Astronomical Bureau and not from Laplace and Lagrange's Bureau des Longitudes, it becomes absolutely impossible to go on asking the ritual question of how Kepler was able to be both an astrologer and an astronomer. For hundreds of generations the astrologers of the analogist archipelago observed the revolutions of celestial bodies and calculated their regularities; why did this multimillennial activity suddenly have to be thought of as something entirely new, without any known antecedents, to be purified of all contamination from what existed before?

You must, then, recognize that there is a continuity between analogism and naturalism, some will tell me (Latour already has). And if you agree that the moderns are transformed analogists, why not say that "we" have always been analogists (and therefore never moderns), why not consider that perhaps we still are? Well, precisely because a "transformation" took place, which I have briefly outlined. This structural transformation converted a generalized system of differences into a small core of dualistic oppositions, replaced a cosmocentric stratification with an anthropocentric order, eliminated nonhumans from communal life so that only "societies," resources, and techniques would remain, and dissociated the prediction of fortune and misfortune from the predictability of phenomena. In short, this transformation introduced and consolidated a naturalist ontology in which only a few pale ghosts of past analogism survive as relics. This is why "we" have become modern. And it is also why most moderns still are.

Translated from the French by Liz Libbrecht.

Works Cited

Darwin, Charles. *On the Origin of Species*. Rev. ed. Oxford: Oxford University Press, 2008. Print. Rpt. of *On the Origin of Species by Means of Natural Selection; or, The Preservation of Favoured Races in the Struggle for Life*. 1859.

Descola, Philippe. *Beyond Nature and Culture*. Trans. Janet Lloyd. Chicago: University of Chicago Press, 2013. Print.

Farquhar, Judith, and Qicheng Zhang. *Ten Thousand Things: Nurturing Life in Contemporary Beijing*. New York: Zone, 2012. Print.

Galilei, Galileo. *Dialogue concerning the Two Chief World Systems, Ptolemaic & Copernican*. Trans. Stillman Drake. Berkeley: University of California Press, 1953. Print. Trans. of *Dialogo... sopra i due massimi sistemi del mondo...* Florence, 1632.

Latour, Bruno. "Biography of an Inquiry: On a Book about Modes of Existence." *Social Studies of Science* 43.2 (2013): 287–301, here 299. Web. 11 Jan. 2016. Available at <http://sss.sagepub.com/content/early/2013/02/28/0306312712470751.full.pdf>.

---. *An Inquiry into Modes of Existence: An Anthropology of the Moderns*. Trans. Catherine Porter. Cambridge, MA: Harvard University Press, 2013. Print.

---. "On the Cult of the Factish Gods." Trans. Catherine Porter and Heather MacLean. *On the Modern Cult of the Factish Gods*. Durham: Duke University Press, 2010. Print.

---. *We Have Never Been Modern*. Trans. Catherine Porter. Cambridge, MA: Harvard University Press, 1993. Print.

Merleau-Ponty, Maurice. *Nature: Course Notes from the Collège de France*. Comp. Dominique Séglard. Trans. Robert Vallier. Evanston: Northwestern University Press, 2003. Print.

A NEW OCCASIONALISM?

Graham Harman

EARLY IN BRUNO LATOUR'S book *An Inquiry into Modes of Existence*, we are warned against confusing the modes of reproduction [REP][1] and reference [REF]. This warning renews and extends Latour's secret membership in the occasionalist tradition of philosophy, which is generally viewed as a relic of earlier times though it continues to dominate philosophy from the shadows. Let's speak first about occasionalism, then about how it bears on Latour's *Inquiry*.

1. THE OCCASIONALIST TRADITION

IN ITS BEST-KNOWN FORM, occasionalist philosophy encompasses two distinct theses that usually come as a pair: (a) entities cannot affect each other directly, so that God is the only medium for all relations, and (b) entities cannot endure for more than an instant, but must be continuously recreated by God. Though the term "occasionalism" is often limited to a group of theistic Middle Eastern and European thinkers who accept both (a) and (b), there is a sufficient number of variants on the theory that we ought to use the term more broadly. Some occasionalists accept (a) but not (b), while others conceive of a causal mediator other than God. In what

GRAHAM HARMAN *is Distinguished University Professor at The American University in Cairo. He is a founding member of the speculative realism and object-oriented ontology movements, and a frequent international lecturer. His most recent books are* Bruno Latour: Reassembling the Political *(2014) and* Bells and Whistles: More Speculative Realism *(2013).*

follows I will use "occasionalism" to refer to any philosophy that sees the world as made up of *gaps* that need to be bridged, rather than taking it for granted that everything is already in contact with other things. By this definition God is not central to occasionalism, but is just one flawed solution to the chief occasionalist problem: the apparently *indirect* character of all relation. The problem is found in germinal form with Socrates and Plato, but Aristotle is the ancient thinker who matters most to the history of occasionalism, both for and against.

At the heart of Aristotle's philosophy is the antagonism of the continuous and the discrete, which still haunts the thought of the twenty-first century. His *Physics* is all about continua, which include space, time, number, and becoming. There is no definite number of spatial points between Paris

[1] For a brief explanation of these abbreviations, which refer to the modes explored in the AIME project, see the glossary in this volume (**r·m!**543–47).

For her project (*un*)*earthed*, Sarah Burger buried nine objects made of biodegradable fabric (FREITAG F-ABRIC) and polyester thread in eight different places. Under ideal conditions the fabric disappears within three months. Approximately every three weeks, Burger has gone back to each object, unearthed, observed, and documented it and then put it back into the earth, repeating until all the objects have dissolved.

1 Sarah Burger. (*un*)*earthed*.
 2015. Object No1 in its initial
 shape.

and Karlsruhe, since we can carve up the distance into spatial units as small or large as we please. The same holds for time: is a year made up of twelve parts, fifty-two, or three trillion? For Aristotle there is no definite quantity of instants, but a single yearlong stretch that can be divided however we wish. Nor is there any definite quantity of numbers between thirteen and seventeen, since we can always add countless new intermediate numbers. Finally, there is no distinct number of stages between water and boiling water, since the boiling process can be split up arbitrarily as well. Yet the same answer is *not* given in Aristotle's *Metaphysics*, which teaches the opposite lesson when it comes to primary substances: *there is a definite number of people in any given room*, not just a single humanoid blob to be carved up arbitrarily however we desire. The same holds for all genuine individuals.

Aristotle thus handles the problem of the continuous and the discrete by making a taxonomical distinction between process and substance. Continua allow for easy contact between their parts, since they are really just wholes divided into pieces later by the mind; Zeno's paradox of the impossibility of reaching a doorway is refuted by Aristotle in precisely this way. By contrast, the existence of discrete things turns contact into a problem. In practice, Aristotle sees no problem with one object smashing directly into another. We will see that in Islamic philosophy, this makes Aristotle the ally of those who *oppose* occasionalism. Yet his *Metaphysics* did note a gap between entities in one little-cited case, when considering the relation between objects and the human soul. Namely, Aristotle notes that individual things cannot be defined, since definitions employ universals whereas individuals are always concrete: "For example, if someone were to define you, he would say 'a skinny, pale animal,' or something else that would also belong to some other thing" (148). No bundle of adjectives, however large, can exhaust an individual. Yet for Aristotle this gap between universals and particulars pertains only to the *human mind* and its unique ability to predicate universals of individual things, and is not more widely ascribed to the relations between inanimate objects. While this already contains the famous mind-body problem in germ, it shows no awareness of an equivalent body-body problem.

More extreme models than Aristotle's are possible, and the history of philosophy shows us some. One extreme would efface the problem of contact by claiming that everything is a continuum, including supposed individuals: objects are really just abstractions from a primordial continuous process. This model can be found in such thinkers as Henri Bergson and William James, who thereby miss the lesson of the *Metaphysics*. Another would heighten the problem by saying that everything is discrete, so that even instants of time cannot link up with successors without God's assistance. This is the model of occasionalism, which thereby misses the lesson of the *Physics*. Latour's own solution will prove to be an extreme occasionalism in both senses, though he adopts a more moderate solution than most extremists.

In early medieval Basra, Abū al-Hasan al-Ash'arī (874–936 CE) thought it blasphemous not only to believe in *creators* other than Allah, but even to believe in *causal agents* other than He. All events are ascribed directly to God, whether it be fire burning cotton or the mere continuation of an atom's existence from one moment to the next. His opponents, the liberal-minded Mu'tazilah, pioneered the pro-Greek strain in Islamic thought that reached fruition three centuries later in the work of the Andalusian judge Averroës. An admirer of Aristotle in most things, Averroës upheld Aristotle's model of *direct* causation between things. In his famous work *The Incoherence of the Incoherence*, he targeted his Ash'arite predecessor al-Ghazalī, who adhered to the occasionalist standpoint. In the West we tend to admire the liberal pro-Greek Islamic thinkers such as al-Kindī, al-Fārābī, Avicenna, and Averroës. Yet the metaphysics of the Ash'arite reactionaries was more radical,

and paved the way for modern European philosophy. While Aristotle only accepted a gap between humans and things, the Ash'arites saw the interaction between *any* two things as requiring the mediation of God. And while Aristotle viewed time as a continuum without discrete individual instants, the Ash'arites claimed that the apparent smooth flow of time masked a continuous creation by God. Thus they established the classic twofold doctrine of occasionalism: there are gaps between things, and gaps between moments of time. These same two points will reappear in Latour's *Inquiry* under the names of [REF] and [REP].

It took seven centuries for occasionalism to take root in Europe, by way of Descartes' three-substance ontology of mind, matter, and God. Both main occasionalist theories are here. First, mind and matter are so different in kind that it seems impossible for them to touch directly, thus requiring causal intervention by God. Second, God must continuously create the world in order for time to flow, since each moment is cut off from its temporal neighbors. Descartes only recognized a mind-body problem, not the more sweeping body-body problem in the manner of the Ash'arites. Reviving this body-body problem in Europe was the work of Cordemoy, Malebranche, and other Francophone authors. Elsewhere in Europe it was Spinoza, Leibniz, and Berkeley who developed the theme of God's monopoly on causation. At this point the problem changed form: in the theories of Hume and Kant, occasionalism abandoned God as the global mediator. But rather than abolishing any causal monopoly, they simply transferred it from God to the human mind: Hume rooting cause-and-effect in the habits of the human mind and Kant turning causation into a category of the human understanding.

The 1920s witnessed a bold return to theocentric occasionalism, in the strange but magnificent *Process and Reality* of Alfred North Whitehead, for whom all relations ("prehensions") pass through God in order to objectify other entities in terms of universals ("eternal objects"). A decisive step forward was

taken by Whitehead's admirer Latour. In his 1999 book *Pandora's Hope*, Latour makes the case that a mediator is needed in any interaction, as when the physicist Joliot serves to link politics and neutrons. Latour's philosophy includes the two basic elements of occasionalism: (a) impossibility of direct contact without a mediator, and (b) lack of automatic connection between one moment and the next. Let's call these the "spatial" and "temporal" aspects of occasionalism. Latour makes a point of separating them, and even insists that this separation is the key to understanding his modes of existence.

2. THE CROSSING OF [REP] AND [REF]

IN LATOUR'S CASE there is no avoiding the usual cliché of "early" and "late" phases, though his *Inquiry* is more an expansion than a reversal of his earlier position. The earlier Latour of Actor-Network Theory (ANT) deliberately flattens all beings, refusing a priori distinctions between zones such as "subject" and "object" or "real" and "fictional," instead weighing all things by the single standard of their *effects*. Entities are *actors*: they are what they do, and nothing more. The Latour of the *Inquiry* is newly troubled by this flattening. In describing an imaginary ethnographer who has just discovered ANT, Latour reports that

> to her great confusion, as she studies segments from Law, Science, The Economy, or Religion she begins to feel that she is saying almost *the same thing* about all of them: namely, that they are 'composed in a heterogeneous fashion of unexpected elements revealed by the investigation' (35)

– hence the need for the ANT "expansion module" provided by the *Inquiry*. Actor-networks do not disappear from Latour's new system; they link similar

2–3 Sarah Burger. *(un)earthed*. 2015.
 Object No1 before and after being buried for the first time.

4 Sarah Burger. *(un)earthed*. 2015.
 Object No1 being unearthed for
 the first time.

5 Sarah Burger.
 (un)earthed. 2015. Object No1
 being unearthed for the fourth
 time.

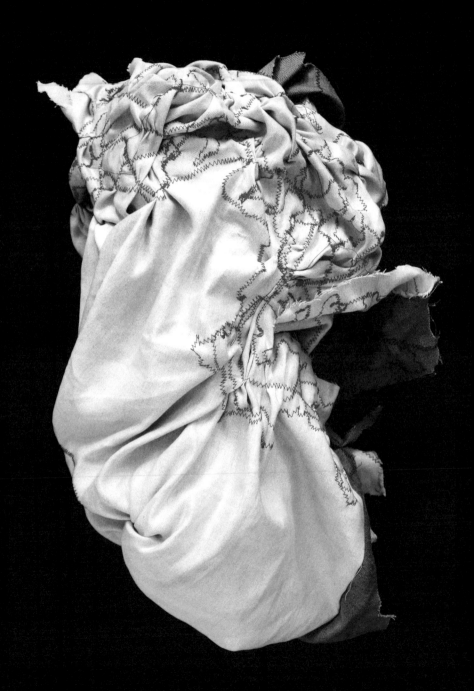

and dissimilar actors just as they always did, in the familiar mode of [NET]. The real shift comes with the second mode, preposition [PRE]. This mode breaks up networks into specific keys, so that legal or religious discourse cannot be assessed in the same way as a scientific or political one. Alongside these two is the black sheep called Double Click [DC], more a category mistake than a mode. Otherwise, Latour gives us twelve modes split up into four groups of three.

When modes interact through a crossing, the result is usually a category mistake: as when someone condemns politics [POL] for not just speaking the truth in clear propositions rather than getting entangled in the various handshakes and backroom deals associated with that mode. Asking [POL] to operate in the manner of scientific reference [REF] simply makes no sense. There are dozens of possible crossings between the various modes, but not all of them are equal. The most dangerous one is the crossing [REP·REF].

> Unfortunately, we cannot sidestep this question: it has to be faced at the start. ... We need it in order to define the means of expression as well as as the type of realism that that this inquiry has to have at its disposal. (Latour, *Inquiry* 71)

If the model of scientific truth is *adaequatio intellectus et rei*, adequation between the mind and reality, Latour interprets this model as a wrongheaded amalgam of [REF] and [REP]. He proposes to drive a wedge between them so as to "register the effects of this category mistake on which ... all the others depend (73).

To explain [REF], Latour deploys a typically brilliant example: the use of a map to hike the Pas de l'Aiguille in southern France. Before beginning, he made sure to obtain a geological survey map. The points on the map bear no resemblance to the mountainous terrain, yet they have somehow been put into alignment with it: "I was helped by the yellow markers that punctuated the route, and by the fact that the tourist office was kind enough to associate those markers with the map so carefully ..." (74). Footprints and donkey manure are further indicators that he is on the right track, as are occasional piles of stones. Despite being in the midst of pristine nature, Latour notes, "I was definitely *inside* a network whose walls were so close together that I chose to lean on them every ten minutes or so..." (75). If there is any loss of continuity in this chain of markers and landscape features, Latour might lose his way in the fog and fall into a crevasse. The links made by [REF] between one entity and the next create continuity between discontinuous things: the occasionalist mission par excellence.

For some, the problem of discontinuity does not exist, due to "a description of knowledge so nonmaterial that it could be detached without difficulty from its networks and attach itself mysteriously to what it knew" (83), as if direct contact were no problem. This is the occasionalist Latour, always insisting on mediation. Yet there is also the anti-occasionalist Latour, who belittles the mind-body problem and the Kantian thing-in-itself, two other examples of gaps in need of being leapt. Latour's strategy is to replace the single chasm between mind and world with an unbroken chain of translations from one entity to the next (78). Instead of a giant gap between mind and object, there is a long chain of mini-gaps. It is reminiscent of an important moment in Latour's *Politics of Nature*. Starting his career as a Hobbesian in political matters, Latour insisted that no knowledge (whether religious or scientific) is permitted to claim transcendence. As if fearing the consequences of "might makes right," Latour now offends Hobbes' ghost by admitting scientists and moralists into the political sphere, giving them the important role of detecting objects and people not currently recognized by the polis. What they achieve is not quite transcendence, but what Latour calls *mini*-transcendence. And now the chains of

7 Sarah Burger. *(un)earthed*. 2015. Object No2 being unearthed for the third time.

8 Sarah Burger. *(un)earthed*. 2015. Object No5 before being buried for the first time.

9 Sarah Burger. *(un)earthed*. 2015. Object No6 being unearthed for the first time.

10 Sarah Burger. *(un)earthed*. 2015. Object No6 being unearthed for the third time. With the support of Ernst & Olga Gubler-Hablützel Stiftung and Dr. Georg and Josi Guggenheim Stiftung.

[REF] seem to entail a mini-transcendence as well, jumping across small gaps in the way that praxis always manages to do, without accepting the gaping chasms that only God can cross.

The other classic occasionalist gap is the one between successive moments of time, viewed by many as a philosophical absurdity. It is so nonabsurd for Latour that he places it at the heart of his philosophy, this time with the name [REP]. This mode allows a cat, for instance, "to exist in time t + 1 after having existed in time t" (*Inquiry* 88). If this endurance of things from one moment to the next were as unproblematic as some readers claim, the mode of [REP] would be completely unnecessary. Instead, it is universal:

> Let us thus use [REP], for reproduction …
> as the name for the mode of existence
> through which *any entity whatsoever*
> crosses through the hiatus of its repetition, thus defining from stage to stage a
> particular trajectory, with the whole
> obeying particularly demanding felicity
> conditions: to be or no longer to be! (91–92;
> emphasis added)

This not only challenges inert Aristotelian substance, but also the Aristotelian continua that inspire contemporary philosophy at a distance.

Thus we have seen that Latour endorses *both* of classical occasionalism's gaps: the spatial gap between different things and the temporal gap between any thing and its slightly different ancestors and successors. One main difference is that Latour's gaps remain *mini*-gaps, which need to be addressed but are finally not difficult to address. Hence his hostility to the Cartesian dualism of finite substances and Kant's utterly unattainable thing-in-itself. Like Hobbes, Latour wishes to remain a philosopher of immanence, with nothing allowed to short-circuit the politics of networks by jumping beyond them into a true world free of networks. The other main difference is his point that [REF] and [REP] cannot be crossed as [REP·REF] without inviting philosophical disaster. As he puts it,

> if you *cross* the two suppositions, the two
> interruptions, and you make the *form
> taken on the side of reference* the thing that
> would ensure *substance on the side of repro-
> duction* … you eliminate all the risks, all the
> movements, all the leaps. (111)

To do this would assume that things retain a single essential form across time, and that this same form is directly known by unmediated knowledge.

Today the occasionalists are misremembered as circus freaks from a bygone theistic era of philosophy, and thus few thinkers feel the need for something like [REP]. Philosophy today does not like gaps, but prefers to speak of lines of flight, pulsating world-wholes, pre-individual geneses, and the like. Perhaps this is why so many readers do not take Latour at his word about [REP], but stress the language of continuity in Latour's new system, forgetting that continuity is what [REP] is called upon to *produce*. As for [REF], the scientific realists who hate Latourian science studies hate above all its emphasis on the mediators between one point of knowledge and another. Yet we still must ask whether the occasionalist Latour respects the occasionalist problem enough. For he is quick to eliminate the modern occasionalist phenomena-noumena split, helped along by the fact that it has almost no defenders. There is good reason to agree with Latour that there is no *unique* gap between humans and everything else. But Latour's problem is not just with the false uniqueness of humans. What bothers him even more is the purported *transcendence* of something lying across a gap from anything else. Though like all occasionalists he insists on the ubiquity of gaps, his point is not that all gaps are just as difficult as the modern human-world divide, but that all gaps are just as *easy* to cross as that between maps and trail markers

once the proper work of translation is done. Latour's gaps between entities are *mini*-gaps just as his political transcendence is a *mini*-transcendence, and thus he finds it a pragmatic rather than philosophical problem when we aspire to bridge the gaps between minds, bodies, gods, hikers, survey maps, or mountains. His occasionalism is just as real as that of his forerunners, but more manageable.

138

Works Cited

Aristotle. *Metaphysics*. Santa Fe: Green Lion, 1999. Print.
Averroës. *Averroes Tahafut Al-Tahafut (The Incoherence of the Incoherence)*. London: Luzac, 1954. Print.
Latour, Bruno. *An Inquiry into Modes of Existence. An Anthropology of the Moderns*. Trans. Catherine Porter. Cambridge, MA: Harvard University Press, 2013. Print.
———. *Pandora's Hope: Essays on the Reality of Science Studies*. Cambridge, MA: Harvard University Press, 1999. Print.
———. *Politics of Nature: How to Bring the Sciences into Democracy*. Trans. Catherine Porter. Cambridge, MA: Harvard University Press, 2004. Print.
Whitehead, Alfred North. *Process and Reality. An Essay in Cosmologie*. New York: Macmillan, 1929. Print.

CALCULEMUS JASUS LALANDII: ACCOUNTING FOR SOUTH AFRICAN LOBSTER

Lesley Green

THE SOUTH AFRICAN West Coast lobster, *Jasus lalandii*, or "kreef" is an iconic species in the Republic of South Africa (see fig. 1). Central to the regional economy, marine ecology, and coastal ecumene in the politically contested Western Cape province, it is a species entangled in multiple attachments and the focus of scientific, culinary, bureaucratic, and activist organization. The rationales attending its catch have been the subject of battles from scientific working groups all the way to Parliament, the Cape High Court, and the New York Federal Court; the last involved a case of massive commercial poaching stretching back to the 1980s, when, under the radar of anti-apartheid economic sanctions, a local commercial company supplied East Coast restaurants in the USA with West Coast lobster from the RSA. *J. lalandii*'s kelp forest ecology, off the Cape of Storms, is a political ecology: the arthropods are embroiled in an ongoing struggle to survive contests over the distribution of rights to harvest lobster biomass.[1]

LESLEY GREEN *is the director of Environmental Humanities South, a research and teaching initiative at the University of Cape Town, where she is an associate professor of anthropology. Her work explores the challenges of decoloniality for the sciences and social sciences in southern Africa and engages with the scientific and social-scientific imaginaries that animate fisheries policy, water management, and plant medicine.*

1 Chip [Andrew Snaddon]. *Che Lalandii*. 2015. Caricature.

At the center of the struggle is the figure of the TAC: the annual Total Allowable Catch – which, in turn, is derived from an accounting of the lobsters as money in a national bank account. Yet that particular lobster logic is bedeviled by the lobsters themselves, who, amid slowly heating waters, growing sewage discharges, decreasing oxygen, increasing corruption, and extreme human predation, have been exiting the bank, both by walking out and dying in the millions on the beach during increasingly frequent harmful algal blooms (see figs. 2 and 3) and, in a significant percentage, by migrating south, against the ocean currents, to an

[1] For a summary of fishers' struggles, see Wynberg and Hauck.

area away from the high-take catch zones where the lobster factories are.[2] The consensus, among marine ecologists and crustacean biologists like Laura Blamey, Eva Plagányi, and Georg Branch, is that the lobster migration has been a "colonization" of a new territory that has resulted in a "regime shift" in the macroecology of the offshore kelp forests in the south. An article in the *African Journal of Marine Science* summarises the extensive research thus:

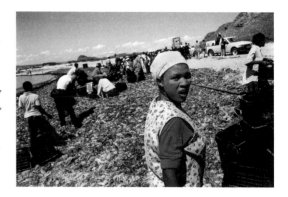

> *Jasus lalandii* experienced severe declines on the West Coast since the late 1980s / early 1990s. This is most likely due to a combination of heavy fishing pressure, reduced growth rates and increased rock lobster walkouts of which the latter two are linked to a change in environmental conditions during this period, e.g. increased low-oxygen water [from harmful algal blooms], El Niño events, and anomalous westerly winds. During the same period, rock lobster abundance increased significantly along the South-West Coast and urchins, a preferred food-source of *J. lalandii*, had virtually disappeared by the mid-1990s. Given that in this region juvenile abalone depend on urchins for protection and additional nourishment, the decline in sea urchin populations had serious consequences for the abalone stock, compounding their depletion by poaching. Some kelp beds once dominated by herbivores and encrusting corallines have become transformed into ecosystems dominated by lobsters and macroalgae. (Mead et. al 411) (see fig. 4)

This lobster-led regime shift, colonization, or invasion – the range of military metaphors in the

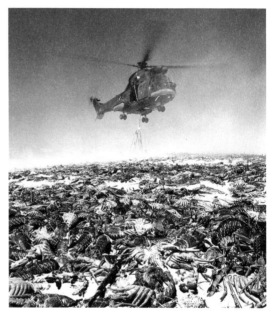

2–3 Lambert's Bay. Western Cape province. South Africa. Hundreds of thousands of rock lobsters lie dying in the sun after crawling out of the sea. This was due to a red tide (a huge bloom of a microorganism) in the vicinity. Red tide leaches the oxygen out of the water, which kills all the surrounding marine life. Increasing occurrences of red tide have been linked to increased water temperatures and the El Niño phenomenon. Once the lobsters have come into contact with the bloom, they are likely to be toxic for humans. The image below shows a helicopter picking up tons at a time to drop them far out at sea, with the intention that some may survive.

[2] Elevated nitrogen levels from sewage discharges into sea water, from the city of Cape Town, are thought to play a role in the increased plankton blooms that periodically deprive sea life of oxygen, resulting in the loss of hundreds of tons of rock lobster along the West Coast (see Griffiths et al. 366). On algal blooms, see Branch, Bustamante, and Robinson.

4 Interaction web of the South-West Coast kelp bed
 ecosystem (Betty's Bay) before and after lobster
 invasion (derived from Blamey et al. 2010, 2012).
 Crosses indicate zero abundance recorded; block
 arrows imply strong effects and line arrows weaker
 effects. The likely positive (+) and negative (−)
 effects are represented as follows: P = predation, G
 = grazing, Cs = competition for space, Sh = shading,
 F = facilitation, R M = removal of competitive algae,
 S = settlement on substratum. Mean wet biomasses
 (g m⁻²) are indicated by numbers and the areas of the
 circles, which are proportional to biomass on a log
 scale. Graphic from Mead et al. 411.

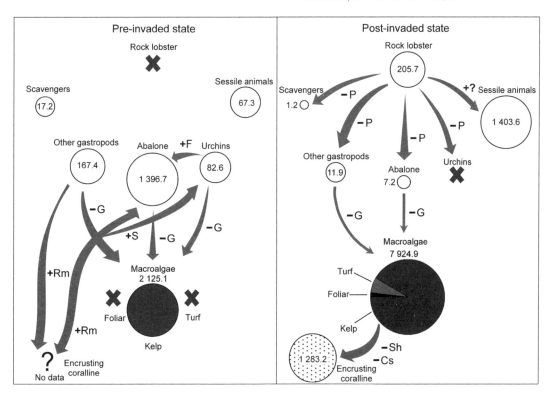

After **5 years, someone <u>MAY</u> have stolen $300 000 from your investment**

You keep withdrawing $50 000 per year

After 5 years, recruitment failure or IUU fishing MAY have reduced abundance by 30%

Catches maintained at 50 000 tons per year

If this event did occur, resource is rapidly reduced

5-7 Doug S. Butterworth. Slides from "Factoring uncertainty into management advice: Have fisheries scientists got their act together?" Keynote address to ICES Annual Science Conference, Reykjavík, 25 Sept. 2013. 14.

ecological literature is startling – was due to adult immigration rather than larval recruitment (Blamey, Plagányi, and Branch). The reasons for the lobster move are not fully comprehended in the literature, although it is known that lobsters can move long distances surprisingly fast when disturbed, and that they can make extended journeys along the coast, against ocean currents. The migration put J. lalandii, in its new location, in the position of top predator in an overfished system.[3] As it has overfished its own new sea urchin fishery and increased its population density, the lobster has changed its diet from high-energy urchins and winkles to sponges, barnacles, and foliar algae (Haley et al. 166). A cuisine change, it is worth noting, is clearly an adaptation that the lobster is willing to make in exchange for becoming the top predator and escaping the zones of red tides and lobster factories.

For marine conservationists, the new regime appears to have settled; predictions are for a new stable state. "These dietary differences have important ramifications not only for the lobster populations," they note, "but also for the structure and functioning of the radically different communities that have developed in invaded areas, reflecting a regime shift induced by lobster predation" (Haley et al. 160).

The regime shift of J. lalandii offers much to think with, for those of us wanting to grasp the

acceleration of ecological mutations [that] will force the inhabitants of the shrinking domains of life into finding out how to compose the common world that they are supposed to inhabit, if not peacefully, at least without exterminating one another. (Latour, "Another Way")

Negotiating that common world, however, requires thinking with the lobsters' new way of life – something that the best ecological science can only model, having yet to fully understand either why or how the lobsters have moved. Lobster motivation is difficult to assess; there is no Sigmund Freud for lobsters

[3] The lobsters compound the risk of the commercial extinction of the abalone Haliotis midae, whose ecology stretches through the kelp forests and fisheries of the Western Cape to the far Eastern via its own network of passions, poachers, permit holders, and aphrodisiac users (Day and Branch).

THE SOURCE OF THE DIFFICULTY

FISHERIES HAVE UNCO-OPERATIVE BANK TELLERS

- **They won't tell you the interest rate, which in any case is highly variable**

 Recruitment fluctuations

- **They will advise your balance only once a year, with a typically +-50% error, and in the wrong currency**

 Surveys are typically annual only, results have high variance, and bias unknown

WHY'S THERE ANY PROBLEM?

Ask the teller for account balance. If this has fallen to $700 000, reduce annual withdrawal to $35 000 ⇒ Sustainability maintained.

BUT

The teller will advise balance only once a year with ±50% error

Resource abundance known only through annual surveys which have large associated errors

– although there used to be: it was none other than a young Sigmund Freud whose work helped to demonstrate that lobster neuronal structures are "basically similar" as neuroscientist Oliver Sacks tells us, to those of mammals – a thread of biological thought cut short by the rise of radical behaviorism.

The "nature" of *J. lalandii*, as currently conceptualized, comes to us through the legacy of a behaviorist biology which, at least in the South African scientific literature, offers two quite different scripts for the lobster.

One is the *J. lalandii* already described above: *J. lalandii* the regime shifter of kelp forest ecology – "Che lalandii," one might quip – enrolled as it is in the ecological imaginaries of invasion biology and conservation policy. Brendon Larson's critique of combat metaphors in invasion biology is apposite: he argues them to be problematic in that they "lead to an inaccurate perception of invasive species ... contribute to social misunderstanding [of what is at issue] ... and ... reinforce militaristic patterns of thought that are counterproductive for conservation" (495). Invasion metaphors both reveal and conceal, and they enlist scholarship in wider militarist rationales.

The other account of *J. lalandii* is offered in the extractive science of fisheries management, where the single-species community plays the part of a capital asset in the national bank, whose growth or decline is projected via the agency of a regularly revised algorithm that in turn dictates how much of the capital asset may be withdrawn. Such a model, too, has very specific conceptual horizons, revealing and concealing, and it enrolls fisheries management in the cosmos defined by the knowledge economy.

The limitations of what can be understood of species managed via the banking model were explored in a witty address by leading South African fisheries scientist and mathematician Doug Butterworth. "Why is fisheries management so difficult?" he asks. His argument, delivered as a plenary lecture at an international scientific meeting, begins with an analogy that shows that it should be so easy: if $1,000,000 is invested at 5% per annum, an annual withdrawal limit of $50,000 will keep the investment sustainably managed. Similarly, if a fish stock is 1,000,000 tons and grows at 5% per annum, good fisheries advice would set the sustainable resource use at 50,000 tons per annum. Why is it not that simple? he asks.

The problem with fisheries, he notes, can be understood in the example shown in figure 5. "After 5 years, someone MAY have stolen $300,000 from your investment. You keep withdrawing $50,000 per year." The accompanying graph shows a devaluation to a small fraction over a period of twenty years.

The key here is the lack of knowledge about whether or not there has indeed been a theft, or

STØTT KYSTAKSJONEN

Aksjon ved Stortinget
Mandag 3. mars kl. 13:00

8 "Support the coastal action! Protest at Parliament."
Poster for a Norwegian fisheries protest against the
individual transferable quota system, March 2014,
circulated by South African fisheries activist group
Masifundise.

perhaps a decline in species reproduction ("recruit-
ment," in the language of fisheries science). The prob-
lem with commercial fisheries, Butterworth quips,
is that they have the most uncooperative of bank
tellers, who don't tell you the interest rate and will
only tell you the balance once a year, with typical-
ly a 50% error, and in the wrong currency – "bias un-
known" (see figs. 6 and 7).

A South African audience would have under-
stood his references to events then current in the
annual cycle of fisheries knowledge production.
National fisheries survey vessels were in 2012 and
2013 the subject of such a major row that the matter
of their management was referred to the public
protector. Amid the squabbles over who was and
who was not fit to run the studies, state fisheries
scientists had enormous difficulty running them,
which put at risk both the annual data series and
the parity of the data sets. As Butterworth puts it

in his lecture, "resource abundance [is] known only
through annual surveys which have large associat-
ed errors." In addition, getting reliable catch data
from fishers – whether small-scale, recreational,
or commercial – is notoriously difficult in a con-
text in which bycatch discards are high, poaching
is rife, the data is recorded manually in logbooks
and then transcribed several months later, and, in
the case of J. *lalandii*, the telephone surveys used
to estimate the catch were recently found to have
been distorted by a major data sampling error that
had gone undetected for five years (Johnston and
Butterworth 1).

Butterworth, however, is pointing to something
different: the success of the model depends upon its
assumed capacity to script a set of relations of com-
pliance between fishers, corporates, government,
and species themselves. The day-to-day experience
of fisheries management, however, is that neither

fishers nor corporates nor politicians (nor, evidently, lobsters) have proved to be particularly compliant with the moralities woven into fisheries accounting (Hauck; Sundström). Clearly, the "bank managers," customers, and governing body are not operating like a bank at all. Moreover, neither is the capital in the bank behaving like capital should. In the scholarly metaphor, the lobster as a creature with lived ecological relations disappears from view in the bank and reappears as dollar-converted "biomass": a figure generated in metric tons after predation and recruitment estimates have been calculated using the best available survey data. But it consistently refuses to behave like capital.

For fishers – presumably the bank customers – the relation with marine life that is permitted in the terms of the allocation of a quota renders the ocean like an ATM from which they may make a specific annual withdrawal; ecological responsiveness disappears from view. The only response-ability (to use Donna J. Haraway's term) that fishers and corporates have, in this approach, is to "take their take" – as depicted in a Norwegian fishers' action poster (see fig.8) that was also circulated on the social media sites of South African fisheries activism. The organizing script of the banking model, therefore, is at odds with the lived relations it claims to describe, and is failing in its own moral imperative to compel all to work together toward the sustainable management of target species. The organizational claim that the banking model makes is that by converting everyone's relation to the sea into dollar equivalents, it will undermine apparently corrupting attachments that might have limited people's capacity to care for coastal ecologies. On the contrary: by seeking to imagine that those attachments can be made to disappear, the bank model sets people up to be criminalized. Hidden from view, in the banking analogy of so many scientific papers, is the "big stick" behind the model: that a bank requires high security since it cannot trust any of its participants. For those who are found to be noncompliant, the courts of law

await, and rather than establishing an orderly bank, the relations around "the bank" require ever more policing (Norton).

Unsurprisingly, the actual negotiations of the annual Total Allowable Catch are acutely sensitive, as scientists, fishers, managers, politicians, and commentators contest the outcome. Several conceptual hiatuses are at work here: while "the science" (of the fisheries bank) is focused on giving a good account of "natural" predation and recruitment, the criticism of the negotiated TAC outcome and associated quotas is expressed via an attempt to reveal the true "bad" account of *social* predation (bribes and kickbacks) and recruitment (the reproduction of racialized interests via nepotism and cronyism). What the "banking" metaphor cannot see is that by separating the social from the natural, and by scripting relations of commodity and control, it is always already enrolled in specific human values and attachments – and as such, its version of nature will necessarily be contested by those who are not followers of the goddess sisters of reason in the knowledge economy: technical efficiency, economic productivity, and scientific objectivity (Latour, "Recall" 14).

The banking analogy is performative: in asserting that an economic nature is devoid of any class interests or human values, it establishes an organizational script (Latour, *Inquiry* 409) in which all become economic actors. The thinking behind the TAC, in the form of the banking model, asserts that the lobster is there for the taking by the fisher in a specific quantity, and that the lobsters themselves will accept the high-take zones as the status quo, and not react. In Timothy Mitchell's words,

> the separation of nature from politics was
> maintained not so much by the authority
> of large-scale science … which monopo-
> lised statements about nature, but by the
> work of economists who laid out the large
> no-man's land between the two. (241)

145

The banking model sets up not only a no-man's land, but a "no-species" land too: the lobster, in this account, is already caught; already all but dead: it is a nonbeing, like a zombie incapable of thinking for itself or voting with its feet.

The TAC, however, has effects in the living world: the catch zones are zones of high predation for a range of species. As evolutionists have taught us for so long, species adapt to the terms of their survival. With the removal of the top lobster predators further south (in terms of TACs calculated for other species and catch zones), the TACs themselves contribute directly to changing the conditions of life for different species. And indeed, it would seem that substantial numbers of J. lalandii are voting with their feet in the Anthropocene, via repeated mass exits from the Atlantic Ocean in response to red tides – the harmful algal blooms that occur with increasing frequency as the oceans warm, the winds change, and the city of Cape Town spews its sewage – and via their migratory regime change from the Cape Peninsula toward the Indian Ocean.

The lobsters' exit is both from the sea and from the "bank" (Cockcroft): their behavior suggests they are more than the scripted parts they have been allocated. Given both moves – the ocean exit, the ocean migration – the terms of the TAC calculation need to be continually revised: not only in relation to the new ecology of the kelp forest, but also in understanding the responses of the creature J. lalandii to the new conditions in which it finds itself trying to survive.

The question arises: are there alternative approaches to biology that might enable us to understand the responses of J. lalandii to new ocean conditions, in a way other than the ecological concept of the lobster-led regime shift and the economic concept of the lobster as there for the taking?

While the two accounts of J. lalandii are very different, they also share a common cause on South African *terra firma*: to insist that theirs are not "political" accounts of nature. Accusations to the contrary are regular, from both fisheries activists and government.[4] As a consequence, despite their deep differences, both mathematicians and ecologists work together on the basis of a shared interest in using the TAC calculation to try to effect a diplomatic political solution for the survival of J. lalandii. The fiction of modernity – that science and politics are separate – begins to lose some of its powers of persuasion. In order to maintain the separation of nature from politics, both are constrained to keep as close as possible to what is currently considered rational: in this case, the assertion that the lobster is a creature capable only of a mechanistic response to stimuli, and not a sentient, responding being. The defense of the TAC, then, and its associated struggles make ever more difficult our escape from the limits of thinkable thought.

Given that both accounts of J. lalandii are having difficulty understanding and accounting for the lobsters' collective actions in the available terms, the task at hand is to consider whether J. lalandii's representation, and its relation to the Anthropocene, might be usefully amended.

Here the interventions of Bruno Latour's *Inquiry into Modes of Existence*, in its two halves, are apposite to the problem of comprehending J. lalandii. The rendering of the ways in which ecological accounts of nature come to be able to claim independence of human values, in part one of the book, offers insights into how J. lalandii comes to occupy the space of the ecological regime changer in an invasion biology that pays too little attention to what its metaphors reveal and conceal. Part two of the book explores how economic accounts of nature come to claim the space of neutrality. Yet the case of J. lalandii offers more than a crash test of the AIME project's ideas: the lobster also speaks back, provoking some ideas

[4] There are so many hiatuses of [REP] and [POL] in South African fisheries sciences that they threaten to subsume the entire project of fisheries management. For a brief explanation of these abbreviations, which refer to the modes explored in the AIME project, see the glossary in this volume (r·m!543–47).

for an AIME product improvement, which in turn might provoke some possibilities for a different kind of negotiation with the lobsters about their survival.

Common to the terms "race" and "species" is a language of biology that performatively scripts actors into relations in terms that they might not recognize themselves – in terms that extract biomass, effort, or labor as services to an economy, in scripts that offer predefined relations of ownership, extraction, and predation. It is worth noting that this radical behaviorism enables relations of extreme cruelty with lobsters, not only in South Africa, but in the global lobster industry (Russell). In South Africa, Premier Fishing exports live lobster to the United States packed in ice gel packs that are just warm enough to prevent death during a trip across the Atlantic in a 14-kg carton ("West Coast") – following the slave routes of old.

The routes their boxes follow are a curious coincidence, perhaps, depending on how one might argue the influence of global economic history in contemporary international markets. Yet while those routes may or may not be spurious coincidence, the form of the relation is not. The historical convergence of decoloniality and the Anthropocene is not a coincidence: both derive from relations of commodification, extraction, expulsion, abandonment – terms that Aimé Césaire grasped in his *Discourse on Colonialism*, where he declares that "colonization = 'thingification'" (42). In that equation, Césaire offers a summation of the modernist knowledge project as one that is invested in transforming understandings of relations of all kinds, in the world, into knowledge objects with which the primary relation is commodification, extraction, and control. Césaire's response to this version of nature was to work with surrealists like André Breton, whose way of working with language could render surreal the realism asserted in colonial logic.

Where the AIME projects offers, in its 2013 iteration, a way of rethinking the claim to representing

a realist scientific nature, feminist and decolonial scholars are exploring ways of reanimating the objectified world in public life and political discussion. As postcolonial scholars before them rejected those scripts for humans, much of the startle factor of the Anthropocene consists in the discovery of the hubris of imagining that other species will not rebel, will not step out of the bit parts of the anthropic script into which they have been enrolled. AIME, one might say, has much to gain from Aimé in engaging the many worldings that fall on the outskirts of modernist realism. To say in American Indian contexts of thought, for example, that the scripts of extraction, predation, and heating that define the *J. lalandii* fishery have been refused by lobsters is not likely to be met with ridicule. To think like a lobster, among South African fishers, is not an outrageous anthropomorphism, but a reasonable recognition that all creatures search out places and spaces that offer well-being. And indeed, lobster fishers along the West Coast are quite insistent that *J. lalandii* is a highly responsive creature that dislikes lobster discards being thrown in the water; an oft-cited sentiment is that "no creature likes its own graveyard." Such an insight is not a surprise to an evolutionary ecologist. Only in the framework in which nonhumans are commodified objects for extraction is it possible to assert that lobsters are incapable of response to the problematic conditions of the Anthropocene – of which monetarized relations with marine life are part.

The great strength of the AIME project is its capacity to gather into view multiple modes of modernist thought, against the claim that there is only one universalist truth that all modernists know. There is more than one way of representing nature. And indeed: once one begins to cast the scholarly net wider than the view of existing *J. lalandii* literature, several different modes of existence may well be required in order to "speak well" of lobsters. Research in ethology suggests both interspecies and cross-species communications between fish

and crustacea about the availability of food and likelihood of predation (Webster et al.; Webster, Ward, and Hart; Laland, Atton, and Webster). The complexity of the crustacean neurological systems that so intrigued the young Freud is evident in studies of lobster neuroethology (Kravitz), their complex social lives as evident in rituals of aggression and dominance (Sato and Nagayama), their capacity for magnetic navigation (Boles and Lohmann), their ability to migrate long distances and adapt to new environs (Bertelsen et al.), and the fear response suggested by their rapid, long-distance movement away from tagging sites in an acoustic tracking study (Atkinson, Mayfield, and Cockcroft). Lobsters, this literature suggests, are far more sentient, and far more intelligently responsive, than the behaviorist approach would allow – an approach with which animal rights activists would concur in arguing for the ethical treatment of lobsters.

In effect, the humble J. lalandii's mass action provokes a restart of a modernist, behaviorist account of its nature (Latour, Inquiry 415): they have confronted the limitations on the potential for objectivist science to represent them in the political negotiations around their survival, and they have challenged the organizational scripts in economic accounts of their nature in which all "stakeholders" are enrolled in the project of their commodification. One might say that in migrating or walking out, they are refusing the scripts of their own unbecoming; they exceed the limits of the representation to which they have been assigned. J. lalandii the ecological regime shifter, and the J. lalandii that exits the high-catch zones deoxygenated by the algal blooms that thrive in the combination of warming seawater and nitrogen-rich sewage disposal, will not be conscripted to the terms of their management. They are making a new proposal, asserting a version of nature that is out of bounds. The continuities of the critique of representation in ethnology, within ethology, begin here to come into view.

The analysis offered in an AIME workshop offers a "route recalculation" by suggesting attention to organizational scripts, attachments, and moralities that are implicit in economic accountings of the environment. The case of J. lalandii suggests that what might yet be usefully added is an *ecology of the relations* that follow the implementation of mathematical and economic models. Attending to this, I want to suggest, requires expanding the conceptualization of [ORG] to include not only the organizing scripts that economic models offer, but also *how the modeled – humans and nonhumans – respond to those scripts and propose new ones*. This returns us to the central question in the AIME project: What might it mean to "ecologize" modernity, to ecologize economy?

To give an accounting of the world in terms that allow us to grasp how people and species respond to their relationalities in a world that has become governed by principles of financial management, we must imagine how different creatures live well together: what kinds of reciprocal moves for survival are to emerge under the amplifications that are a consequence of legislated algorithms? What are the quanta of well-being that the lobster seeks in a slowly warming ocean so close to a city's sewage flows, at a time when the winds that would have blown the sewer water offshore are changing?

The lobsters' noncompliance demands attention to the question of how to model an ecology of relations that refuse the unbecomings (Nhemachena 75) that are simultaneously defined into existence and out of view in the nature-as-a-bank model that has been imposed in the name of ocean preservation. How to proceed with the task of ecologizing economy?

The word "ecology" is a troubling one. The core of the word is the Greek *oikos*, "the household," which has given us "economy," "ecology," and "ecumene." The households have truly divided: "ecology" has come to mean conservation, "economy" commerce, "ecumene" Christianity. Yet *oikos* in the

Greek context – the household – stood outside the polis: it was the space where the excluded – women, slaves, animals – negotiated their existence.

Once one has understood that the *oikos* is a fundamentally contradictory space of both nurture and negation, well-being and dispossession, it becomes possible to imagine an "oikology" that is no longer a quasiromantic green morality clamoring for attention in the polis. Thinking thus of the intimate and animate negotiations necessary for managing mutual dependencies in a wider context of inequity, the idea of the *oikos* can begin to seed a very different form of activism for the Anthropocene: one centered in the the challenges of making a shared home.

To manage a household of species that have a chance of living well together, is, I want to propose, to understand how creatures will negotiate their interests in the adverse conditions we have offered them. The ongoing political drama of ecological regime shift as enacted by *J. lalandii* offers, I want to suggest, a way in to the challenge of thinking about how creatures are going to negotiate the conditions of their survival in altered environs. To think with them, fisheries management requires its own oikological shift – which is to attend first to the relations of well-being in the planetary household, rather than simply accounting what each will produce and consume.

The current means of calculating the TAC and enforcing quotas produces an unworkable moral economy of extraction of life as objects: it establishes an ontology of unbecomings in the name of conservation. The question is, what might a different form of lobster diplomacy offer? The challenge for negotiated solutions like the TAC is to read the chain of scholarly attachments (Latour, *Inquiry* 424–25) from a different direction and ask instead: What do the lobsters think?

Works Cited

Atkinson, L. J., S. Mayfield, and A. C. Cockcroft. "The Potential for Using Acoustic Tracking to Monitor the Movement of the West Coast Rock Lobster *Jasus lalandii*." *African Journal of Marine Science* 27.2 (2005): 401–08. Print.

Bertelsen, Rodney, et al. "Caribbean Spiny Lobster (*Panulirus argus*) Movement and Population Metrics at the Western Sambo Ecological Reserve (Florida USA)." Linking Science to Management: A Conference and Workshop on the Florida Keys Marine Ecosystem. Hawks Cay Resort, Duck Key. 22 Oct. 2010. Lecture.

Blamey, Laura K., and George M. Branch. "Regime Shift of a Kelp-Forest Benthic Community Induced by an 'Invasion' of the Rock Lobster *Jasus lalandii*." *Journal of Experimental Marine Biology and Ecology* 420–21 (2012): 33–47. Print.

Blamey, Laura K., Éva E. Plagányi, and George M. Branch. "Modeling a Regime Shift in a Kelp Forest Ecosystem Caused by a Lobster Range Expansion." *Bulletin of Marine Science* 89.1 (2013): 347–75. Print.

---. "Was Overfishing of Predatory Fish Responsible for a Lobster-Induced Regime Shift in the Benguela?" *Ecological Modelling* 273 (2014): 140–50. Print.

Boles, Larry C., and Kenneth J. Lohmann. "True Navigation and Magnetic Maps in Spiny Lobsters." *Nature* 421 (2003): 60–63. Print.

Branch, G. M., R. H. Bustamante, and T. B. Robinson. "Impacts of a 'Black Tide' Harmful Algal Bloom on Rocky-Shore Intertidal Communities on the West Coast of South Africa." *Harmful Algae* 24 (2013): 54–64. Print.

Butterworth Doug S. "Factoring Uncertainty into Management Advice: Have Fisheries Scientists Got Their Act Together?" Annual Science Conference, Intl. Council for the Exploration of the Sea. Harpa Conference Centre, Reykjavík. 25 Sept. 2013. Lecture.

Césaire, Aimé. *Discourse on Colonialism*. New York: Monthly Rev. Press, 2000. Print.

149

Cockcroft, Andrew. "*Jasus lalandii* 'Walkouts' or Mass Strandings in South Africa during the 1990s: An Overview." *Marine and Freshwater Research* 52.8 (2002): 1085–94. Print.

Day, E., and G. M. Branch. "Evidence for a Positive Relationship between Juvenile Abalone *Haliotis midae* and the Sea Urchin *Parechinus angulosus* in the South-Western Cape, South Africa." *South African Journal of Marine Science* 22 (2000): 145–56. Print.

Griffiths, C. L., et al. "Impacts of Human Activities on Marine Animal Life in the Benguela: A Historical Overview." *Oceanography and Marine Biology: An Annual Review*. Vol. 42. Ed. R. N. Gibson, R. J. A. Atkinson, and J. D. M. Gordon. Boca Raton: CRC, 2004. 303–92. Print.

Haley, C. N., et al. "Dietary Change of the Rock Lobster *Jasus lalandii* after an 'Invasive' Geographic Shift: Effects of Size, Density and Food Availability." *Estuarine, Coastal and Shelf Science* 93.2 (2011): 160–70. Print.

Haraway, Donna J. *When Species Meet*. Minneapolis: University of Minnesota Press, 2008. Print. Posthumanities 3.

Hauck, Maria. "Rethinking Small-Scale Fisheries Compliance." *Marine Policy* 32 (2008): 635–42. Print.

Johnston, S. J., and D. S. Butterworth. "Rock Lobster Scientific Working Group Agreed Recreational Catch Estimates." *Marine Resource Assessment and Management Group*. MARAM, 2010. Web. 18 Dec. 2015. Available at <http://www.mth.uct.ac.za/maram/pub/2010/Fisheries_2010_AUG_SWG_WCRLI9.pdf>.

Kravitz, E. A. "Serotonin and Aggression: Insights Gained from a Lobster Model System and Speculations on the Role of Amine Neurons in a Complex Behavior." *Journal of Comparative Physiology A* 186 (2000): 221–38. Print.

Laland, K. N., N. Atton, and M. M. Webster. "From Fish to Fashion: Experimental and Theoretical Insights into the Evolution of Culture." *Philosophical Transactions of the Royal Society B* 366.1567 (2011): 958–68. Print.

Larson, Brendon M. H. "The War of the Roses: Demilitarizing Invasion Biology." *Frontiers in Ecology and Environment* 3.9 (2005): 495–500. Print.

Latour, Bruno. "Another Way to Compose the Common World." Annual Meeting, Amer. Anthropological Assn. Chicago Hilton, Chicago. 23 Nov. 2013. Lecture.

———. *An Inquiry into Modes of Existence: An Anthropology of the Moderns*. Trans. Catherine Porter. Cambridge, MA: Harvard University Press, 2013. Print.

———. "The Recall of Modernity; Anthropological Approaches." Trans. Stephen Muecke. *Cultural Studies Review* 13.1 (2007): 11–30. Web. 18 Dec 2015. Available at <http://epress.lib.uts.edu.au/journals/index.php/csrj/article/view/2151/2317>.

Mead, A., et al. "Human-Mediated Drivers of Change – Impacts on Coastal Ecosystems and Marine Biota of South Africa." *African Journal of Marine Science* 35.3 (2013): 403–25. Print.

Mitchell, Timothy. *Carbon Democracy: Political Power in the Age of Oil*. London: Verso, 2011. Print.

Nhemachena, Artwell. "Knowledge, *Chivanhu* and Struggles for Survival in Conflict-Torn Manicaland, Zimbabwe." Diss. University of Cape Town, 2014. Print.

Norton, Marieke. "The Militarisation of Marine Resource Conservation and Law Enforcement in the Western Cape, South Africa." *Marine Policy* 60 (2015): 338–44. Print.

Russell, Eric. "PETA Says Maine Lobster Processor Has Cruel 'Kill' Method." *Portland Press Herald*. MaineToday Media, 17 Sept. 2013. Web. 18 Dec. 2015. Available at <http://www.pressherald.com/2013/09/17/peta-says-lobster-processor-has-cruel-kill-method_2013-09-17/>.

Sacks, Oliver. "The Mental Life of Plants and Worms, among Others." *The New York Review of Books*, New York Rev. of Books, 24 Apr. 2014. Web. 18 Dec. 2015. Available at <http://www.nybooks.com/articles/2014/04/24/mental-life-plants-and-worms-among-others/>.

Sato, Daisuke, and Toshiki Nagayama. "Development

of Agonistic Encounters in Dominance Hierarchy Formation in Juvenile Crayfish." *Journal of Experimental Biology* 215 (2012): 1210–17. Print.

Sundström, Aksel. "Corruption and Regulatory Compliance: Experimental Findings from South African Small-Scale Fisheries." *Marine Policy* 36 (2012): 1255–64. Print.

Webster, Mike M., et al. "Environmental Complexity Influences Association Network Structure and Network-Based Diffusion of Foraging Information in Fish Shoals." *American Naturalist* 181.2 (2013): 235–44. Print.

Webster, M. M., A. J. W. Ward, and P. J. B. Hart. "Shoal and Prey Patch Choice by Co-occurring Fishes and Prawns: Inter-taxa Use of Socially Transmitted Cues." *Proceedings of the Royal Society B* 275 (2008): 203–08. Print.

"West Coast Live Lobster: Product and Packaging Information." *Premier Fishing South Africa*. Premier Fishing South Africa, n.d. Web. 18 Dec. 2015. Available at <http://premierfishing.co.za/west-coast-live-lobster-packaging/>.

Wynberg, Rachel, and Maria Hauck, eds. *Sharing Benefits from the Coast: Rights, Resources and Livelihoods.* Cape Town: University of Cape Town Press, 2014. Print.

THE PLANET IN A PEBBLE
BREAKING THE SURFACE:
INTO THE LIGHT

Jan Zalasiewicz

JAN ZALASIEWICZ is a professor of palaeobiology at the University of Leicester. He teaches geology and earth history, and studies fossil ecosystems and environments across over half a billion years of geological time. Over the last few years he has been involved in helping to develop ideas on the Anthropocene, the concept that humans now drive much geology on the surface of earth – and so have changed the course of this planet's history.

Originally published in: Jan Zalasiewicz. The Planet in a Pebble: A Journey into Earth's Deep History. Oxford: Oxford University Press, 2010. 204–09.

millennia away from assuming its unique, individual status, its form as a pebble.

INTO THE LIGHT

The eventual excavation of the pebble – perhaps only a few centuries ago – was brutally efficient. The waves, breaking on the rocks of the newly formed cliff, drove air into the fractures and cavities of the rock, a rock that had been weakened by the growth and then the thaw of long-vanished ice. Those fractures and cavities in turn reflect far more distant events – the formation of the stratal layers on the Silurian sea floor, and then their crumpling, and the refashioning of their texture to form a tectonic cleavage (along which the rock now splits into slabs) – and then the fracturing that formed as the mountains rose. Compressed air, with tons of storm-driven water behind it, acts like a chisel. Applied thousands of times over many storms (and aided and abetted by the boulders also hurled against the cliff by the waves), it eventually loosens slabs of slate, and then finally levers them out – sometimes dramatically, when sections of the cliff collapse.

One of those slabs is the parent of the pebble, released, after a little over 420 million years, back to the surface. Perhaps only a few centimetres thick (though it might be as much as a metre across) its smooth surfaces are defined by the tectonic cleavage, imposed on the strata about 396 million years ago, it lies at the foot of the cliff. It contains within it our pebble, and quite a few others too. To release them – or more precisely to shape them – one needs first to smash the slab.

The storm waves duly oblige, picking up the slab and hurling it against the cliff until it breaks. The now-nearly-pebble breaks off, as a sharp-edged shard of the slab. It has all the features of

its own narrative, that we have followed until now – the stripes of pale and dark rock, the fossils both large and small (or, from a human perspective, small and microscopic), the mineral menagerie and the interwoven chemical and isotopic patterns – but it needs shaping.

The waves can do that too, now washing the more easily transportable fragment along the shingle of the beach, the swash and the backwash constantly jostling it among its countless fellow pebbles along that shoreline. As it travels, pushed along by longshore drift, the thousands of collisions wear it away, smoothing the sharp edges, creating the rounded outline that is just waiting to be picked up – but perhaps not just yet.

For there are another four chronometers to add to the fine tally that the pebble has already acquired. Before we add these latecomer timepieces, let us take stock of the ones already imprinted into the fabric of the pebble. There is the pattern of the neodymium isotopes, which tell us when the stuff of the pebble was released from the Earth's mantle, and when Avalonia was formed: that's one. And then there are the zircon grains, crystallized in magma chambers and deep mountain roots perhaps a billion and more years ago: two. Those sparse rhenium and osmium atoms subsequently bore witness to the falling of the mud flakes on to the sea floor: three. Then, the crystallization of monazite, and the reshuffling of rubidium, deep in the Earth, perhaps as oil was formed and clay minerals transformed: four and five. And after that there was the decay of radioactive potassium in the mica crystals that grew around fossils that were being squeezed by the pressures of mountain-building – that makes six.

This is a conservative tally, for in abbreviating the story of the pebble so that it can fit into one small book and not into

BREAKING THE SURFACE

several weighty tomes, a few chronometers have been missed out (there are ways of dating mineral veins, for instance) – not to mention those hidden in the pebble that we have yet to discover – there will be some of those, undoubtedly. So, with the four newcomers we will have ten in total, at least (it is nice to get into double figures).

Geologists need these chronometers, for they have to deal with colossal amounts of time. To have evidence of things that have happened without knowing when and in what order they happened is a recipe for profound confusion – a kind of a soup of events, well stirred and utterly incomprehensible. Therefore, they have racked their brains to find as many ways as possible to say *what* happened *when*. As racking goes, it has been quite fruitful, all told. And as geology deals with the only-just-yesterday as well as with the deep past, there are other questions that can be asked. For instance, how long has the pebble been a pebble?

Let us allow the pebble to be caught up in another great storm, a 1000-year storm. It is tossed high onto a shingle bank at the back of the beach – so high and so far that normal storms cannot dislodge it to bring it back, by backwash, to the active, continually moving pebble streams of the wave-washed beach. It lies still on the very top of that far shingle bank, exposed to the elements. And three clocks start to tick, while a fourth is due to be activated shortly – in 1945, to be precise.

Now, one clock starts forming on the upper surface, another on its lower one, yet another in one spot – or perhaps two – on its surface, while the means of constructing the fourth one is germinating in human minds. Let us take the upper clock first, as it has a grandeur about it that commands our first attention.

From the sky, a bombardment is taking place. Cosmic rays are constantly speeding across space, and smash into anything

that gets into their way. They are smashing into you and me, and also into the exposed pebble surface where, over time, they do significant damage. When they collide with silicon atoms, the atoms are broken up, with one part of the debris being a short-lived, highly radioactive form of aluminium, while oxygen, similarly mistreated, is transformed into radioactive beryllium. If the bombardment goes on for long enough (a few millennia) then enough of these radioactive by-products accumulate to measure by the marvellous atom-counting machines of today; thus, counting the number of the new atoms gives an estimate of how long that rock surface has been exposed. This is cosmogenic dating. It is a baby technique (not much more than two decades old), but in that short time it has become a standard means of dating landscapes and rock surfaces.

On the underside of the pebble, some atoms are quietly acquiring their own more local damage. The pebble, while it was being washed along the beach, being turned over and over by the waves, was being sunbathed for the first time for hundreds of millions of years. The sun's rays not only warmed the pebble surface: they repaired radiation damage done to the molecular lattices of some of the minerals, notably quartz. This accumulated damage was caused by radiation generated from within the pebble, by its own natural radioactivity. Hide a pebble surface from the sun, and that self-healing mechanism is switched off. The crystal lattices, over centuries and millennia, once more acquire minuscule defects and distortions. Shine a controlled light on them in the laboratory, and the lattices spring back into shape, giving off a tiny flash of radiation as they do so. The size of this flash, carefully measured, is a measure of how long those crystals have been in the dark. Optically stimulated luminescence, it's called, and it's used so

BREAKING THE SURFACE

often by scientists who study the Ice Ages that it has its own acronym, OSL. Very useful it is too, in providing a guide to how long sediment has been buried.

And then there's the most natural, the most *ecological* of dating methods for a pebble surface. Above that exposed pebble surface, high on the shingle bank, spores will be drifting. Some of them will land on the surface. Life will begin to colonise the pebble, getting a grip even on that smooth surface. Lichen – that strange amalgam (symbiosis, more precisely) of alga and fungus – has begun to grow. Lichen grows extremely slowly, at perhaps at a millimetre a year, and steadily, and thus the size of a lichen patch gives an indication of how old an exposed rock surface is. This technique even has its own name – lichenometry. There are ifs and buts, of course. Lichen will probably not begin to grow straight away on a surface; and environmental factors can affect lichen growth – pollution, for instance. But nevertheless it is refreshing to have a dating technique that one can use with a magnifying glass and ruler, rather than with several hundred thousand pounds' worth of *very* delicate equipment.

Then there is another clock, one of our very own making. It started ticking at forty-five seconds and twenty-nine minutes after five o'clock in the morning (local time) in Alamogordo, New Mexico on 16th July, 1945, when the first atomic bomb was tested. That, and the succeeding Hiroshima and Nagasaki bombings, that killed some 220,000 people in total, and the succeeding above-ground atomic weapons tests (before they were banned) – and, more recently, the Chernobyl nuclear accident – produced new, artificial radionuclides that spread around the world. These radionuclides, including plutonium and a long-lived caesium isotope, can be detected in virtually

everything that has been at the surface since that time. There will be some of these new radionuclides, for certain, on the pebble surface – the nutrient-hungry lichens will have been especially effective at scavenging them from the air and from the raindrops.

What a diversity of time, and of events! Now, at last, we come to our brief encounter with the pebble, before we send it on its way into the future. Another mighty storm, and it is dislodged, back to the beach. Washed back and forth once more, it quickly loses its lichen coating (and therefore that particular clock), and the optically stimulated clock is reset too. The cosmic clock, though keeps ticking, as the rays keep smashing in from outer space – oh, and there's no escaping the man-made radionuclide clock, either, anywhere at the Earth's surface.

The pebble, now shiny and patterned, catches one's eye. One can pick it up and sit, for a while, and consider it. It's a nice afternoon. It is tempting to sit on the beach and muse on its history a little, while the Sun is still high in the sky, and one can make oneself comfortable. Time passes.

It's getting dark. Time to go home. The pebble is tossed aside – there are many more, after all. And it still has a destiny. Many destinies, in fact.

BLOOD OF THE FISH, BEAUTY OF THE MONSTER

Cyril Neyrat

CYRIL NEYRAT *is a film critic, essayist, and publisher. After studying political science and film, then teaching film history and aesthetics at the Universités Paris VII and Paris III, he now teaches film at the Geneva University of Art and Design (HEAD – Genève). After directing the publishing company Independencia, he is now in charge of a new company named La Plaine, devoted to publishing books about film and art history.*

Originally published in the booklet of the French and American edition of: *Leviathan*. Dirs. Lucien Castaing-Taylor and Véréna Paravel. Dogwoof, 2012. Film.

BLOOD OF THE FISH, BEAUTY OF THE MONSTER

by CYRIL NEYRAT

〜〜〜〜〜〜〜〜〜〜〜〜〜〜〜

On *Leviathan*,
by Lucien Castaing-Taylor and Véréna Paravel

The first impression upon encountering the visual and auditory splendor of *Leviathan* is of something radically new. After its initial screening in Locarno, many in the press said they had never seen anything like it before. Which is true, but also deceptive: a film like this rises up from the depths of cinema history, surfacing at the intersection of two traditions. Its greatness is due precisely to that rare achievement of coming to terms with a legacy through the most innovative of experiments. At its surface, *Leviathan* stuns us with the power of the totally unprecedented, but it moves us with the feeling of something familiar welling up from the depths of time.

〜〜

FIRST TRADITION: the history of cinema as the conquest of the perceptible tied to an adventure in visibility. In 1895, the first spectators of *Le repas de bébé* were not moved by the sketch of daily bourgeois life in the Lumière family so much as the quiet rustle of vegetation in the background: inside the image, living nature. As early as the 1930s, Griffith famously said that he was sorry that films no longer made you feel the wind in the trees. In the 1920s, the conquest of the perceptible by the French avant-garde privileged the aqueous elements, the stuff of heroic

experimentation with cinematic fluidity. The films of Epstein, Renoir, and Grémillon flow like tragic rivers, roaring and swirling like the tempestuous waters of Finistère. *Leviathan* proceeds from this history, this tradition, reviving it through the new conditions of visibility enabled by digital recording. Think of it as *Morutiers*, Jean-Daniel Pollet's documentary about the Terres-Neuvas of Fécamp, multiplied by *West of the Tracks*.

Wang Bing's epic evokes another tradition: that of the ambiguous partnership between the history of cinema and the industrial, working-class twentieth century. Before he immortalized his nephew's breakfast, Louis Lumière recorded working people coming out of the family factory in the first film ever made. Cinema by turns sang the praises of industry, criticized the alienation and exploitation of laborers, and bore witness to the crises of the working class. Very early on, it also recorded industry's decline and inevitable demise. Watching *Leviathan*, one thinks of another film by Pollet: the poignant *Pour mémoire*, a documentary essay on the words and gestures of workers in the last days of an old foundry in Perche. In the year 2000, a broke young Chinese man without a producer borrowed money from his student friends to buy mini-DV tapes and spent months alone with the workers of a huge industrial complex, chronicling the closing of the factory and the death throes of a world. Balancing between two centuries, *West of the Tracks* inaugurated cinema's new anachronism: tomorrow's technology erecting the funerary monument to yesterday's world. Magnifying the rust and steam, the duration and textures of digital video paid the last tribute to the twentieth century of industry and labor. *Leviathan* takes its place in a similar vein of fantasy inhabiting memory. One of its

directors' primary motivations was to represent an activity threatened by economic development. One of cinema's oldest virtues: part of the world is going to disappear, images of it must be preserved.

~~~

*Leviathan* prolongs the tribute by intensifying the anachronism. Whereas Wang Bing put his DV camera on a tripod and composed his shots like his illustrious documentary forebears, Lucien Castaing-Taylor and Véréna Paravel put their cameras on the ship's slippery deck, attached them to the top of the mast, the sailors' bodies, and the ends of long poles. They surrender control of the frame to the random movements of man and the elements. A decisive gesture, without which *Leviathan* could have descended into technological exhibitionism. But this is far from the case, and rather than the aestheticized and arrogant tour de force we might have feared, Castaing-Taylor and Paravel have composed a dignified, humble, and vibrant elegiac symphony for the Old World. They achieve this by using the latest technology not to increase their mastery of the visible and establish their panoptic control of the world, but to seize the opportunity it offers to share this mastery with the world itself, and share the perceptible democratically with the workers themselves (Jacques Rancière). *Leviathan*'s aesthetic drama is born of this dialectic between conquest and the surrender of control, the gain and loss in visibility, this constantly revived tension between exploit and failure, capturing and letting go. Rarely has a film thus settled in the flesh of the heart of the world, of the perceptible, to upset the conditions of visibility. The world of nocturnal fishing on the high seas secretes its own visual and auditory matter, which the filmmakers collect and organize into an unclassifiable symphonic poem,

somewhere between highbrow *musique concrète* and a hardcore punk outburst for the masses. While *Leviathan* is a monument to the twentieth century, it is not built of marble, but of the very stuff the world is made of.

~~~

"OLD WORLD": one could easily retort that the "Old World" is far from gone and that the era in question is ours. But that is exactly the anthropological and political lesson delivered by *Leviathan*: that the twentieth century survives into the twenty-first century and that yesterday's heroes are also today's, though the dominant imagery relegates them to the margins of the visible world. That suffering continues to be endured and that workers are still exploited at the risk of their lives, not only in the factories of Apple's subcontractors in Asia, but on rusty boats trawling for fish and crustaceans off Melville and Ahab's New England coastlines.

~~~

From Döblin to Fassbinder, from Eisenstein to Franju, the slaughterhouse was one of the aesthetic and political *topoi* of the twentieth century, as well as one of its most powerful metaphors, both before and after World War II. A metaphor for the factory, capitalist exploitation, and the butchery of the Great War, then of the industrial extermination of a part of humanity. An heir to *Le sang des bêtes*, *Leviathan* repeats its double lesson.

On the one hand, the metaphor has lost none of its power, for industrial death has never stopped affecting dehumanized man and anthropomorphized beast. *Leviathan*'s credits randomly mix the names of human and marine animals—producers

and products, victims and executioners. The film pays specific attention to waste, to what falls to the floor before being taken back by the sea, fish heads or beer cans sliding on deck. On the other hand, despite today's great audiovisual porridge and the normalization of spectacular atrocity, cinema can still become a shield of Perseus, as Siegfried Kracauer wrote about Franju's film and the images recorded when the Nazi camps were liberated: a technical detour to face the unbearable, to look petrifying horror in the face and thus overcome it. This is the need met by the sophisticated technical device conceived by the filmmakers: to domesticate the monster, to hold a broken, composed mirror to the *Leviathan*'s formless face.

~~~

Leviathan, "the only appropriate title," according to Véréna Paravel. A title and a name as old as the world, condensing western history. First, *Leviathan* is a sea monster of undefined shape referred to in the Bible (Isaiah, Psalms, Book of Job). A metaphor for a cataclysm, a catastrophe that turns the world order upside down, it is represented in the Middle Ages as the gate of hell, a gaping mouth that swallows souls. In modern times, the term takes on a political connotation. It is the title of Thomas Hobbes' great political treatise, the introduction of which is quoted by Melville at the beginning of *Moby Dick*: "By Art is created that great *Leviathan* called a Commonwealth, or State, (in Latin, Civitas) which is but an Artificial Man." Hobbes' metaphor soon became a literary commonplace. In *Les Misérables*, Victor Hugo describes Paris' sewers as "*Leviathan*'s intestines." The film merges these various eras and meanings, the political and the mythological-religious, into a unique experience: an essay on modern capitalism

crushing workers and threatening their livelihood, a voyage to the ends of the world, into the hell of archaic fears. The montage of sound and image produces a fluid and continuous matter, converting the fishing expedition at the ocean's surface into a blind plunge into the beast. The editing constantly attacks the border between life and death, the organic and the machinic. The killing of animals (can you see life extinguished in the eye of a fish?); the transformation of the off-screen sound of chains into cries of pain. The visual and sound magma eventually embodies Hugo's metaphor: one travels through this film as through the guts of a monster, bright wet flesh of innards and the rumbling of digestive noises.

~~~

The directors simultaneously play with boundaries, limits, and their abolition. Spatial boundaries, limits between the elements: between water and air, surface and the deep. At times the camera—which we perceive is attached to the end of a pole—constantly plunges and reemerges with the movement of the sea: once thrown off the boat and underwater, the waste from the day's catch becomes pictorial matter, composing abstract tableaux, red and white trails streaking the darkness. Sometimes space loses its grip, the sky and the sea trade places. In these infernal visions of a world turned upside down, seagulls fly on their back.

~~~

Some will say: aestheticizing pain, immoral search for beauty on the backs of laborers etc. It's always the same people: puritanical guardians of the documentary temple, fundamentalist priests of the religion of the real who disguise their more or less conscious hatred of art with an immaculate political

BLOOD O
FISH, BE
OF THE
MONSTE

OF THE
AUTY

BY
CYRIL
NEYRAT

ER

virtue. Before thinking better of it, they cried foul at the sight of Pedro Costa's *In Vanda's Room*: "Rembrandt among the poor, how horrible..." But we've known since at least *Pierrot le fou* that blood is also red. Unlike the Pontius Pilates of today, the makers of *Leviathan* do not wash their hands of this paint. On the contrary, they have constructed their film in the heart of this ambivalence, which is no less than the modern avatar of the immemorial drama of beauty and death. They have edited it in such a way to avoid any cosmetic drift and to never seal the flesh of the perceptible in a tableau offered only for aesthetic delectation. The concretions of fish piled in the nets initially appear to be strange sculptures brought back from the depths of time. When the net is loosened, the form comes apart in a viscous swarm of animals promised to the knife. If the filmmakers delay the sight of a human face, it is to reestablish its power of appearance, a tragic counterpoint to the dehumanization of industrial death and its mechanized gestures. When toward its end the film leaves man to follow birds, it does not escape far from the terrible drama, but lets it resonate in the emptiness and silence of a frighteningly indifferent and infinite space-time.

~~~

According to Adorno, the essay is a heretical form in that it aims to reunite what western doxa has always separated: science and poetry. Lucien Castaing-Taylor is the director of Harvard's Sensory Ethnography Lab, Véréna Paravel is an anthropologist. Sailing on a small fishing boat for an ordinary fishing expedition, they came back with the most literally extraordinary audiovisual poem we've seen in...ages. Ethnographic investigation, technical innovation, formal research, cosmic poem, con-temporary adventure ballasted by a vast cinematic, literary, and mythological heritage: combining these heterogeneous aspects in a perceptible experience, *Leviathan* packs the punch of the essay film.

~~~

The essay is intrinsically and indisputably subjective. Any essay expresses the experience of a subject engaged in the world. Who is *Leviathan*'s subject? To say "the filmmakers" would be to overlook the singularity of their gesture, which consists in sharing their authority with the movement and matter of the world in which they are engaged. Let us return to the film's first words, the epigraph from the Book of Job that appears before the first streaks of color disturb the darkness. "He maketh the deep to boil like a pot: he maketh the sea like a pot of ointment. He maketh a path to shine after him; one would think the deep to be hoary." That says it all: the *Leviathan* is a monster and a poet, a monstrous artist, an alchemist of horror and beauty, of darkness and light. This film is his self-portrait.

~~~

*Translated by Nicholas Elliott*

FOR DOING THE RESET, "Procedure 1" (r·m!51–67) consisted in relocalizing the global; "Procedure 2" (r·m!91–103) shifted attention sideways so as to ignore (rather than overcome) the usual scenography of object and subject. We now have to explain how to try out "Procedure 3."

As soon as we agree to flow with our experience of the world, we get quite a different view of what it means to be "in nature." Before, in the eyes of the modernized Westerner, "nature" was distant and outside in two different and contradictory ways: either it was out of which the now free subject had to extract itself to exist as a human; or else it was the "material world" to which everything, including morality, subjectivity, freedom, and poetry, should be reduced. In the one case, to be human meant that you were partially "out of nature," in the other, that you were reduced to a mere chunk of meat among other chunks of meat. In both cases, "nature" was something foreign, alien.

## Procedure 3

# SHARING RESPONSIBILITY: FAREWELL TO THE SUBLIME

But now that we have been prepared to follow the flow of the world, "nature" is simultaneously much more familiar and much stranger than anything we thought before. Agencies are swapping properties in surprising ways: we become unable to recognize either the old ideas of freedom and humanism, or those of matter and reductionism. Responsibilities (that are, as John Cage would say, the abilities to respond to so many calls of experience)[1] are now redistributed.

If, in earlier times, taking materiality seriously was tantamount to taking agency away from subjectivity, and if focusing on subjects meant that you had to push material forces aside, this is now no longer the case. Such a procedure will not have the slightest chance of working (at least for a Westerner) without the sea change in our relationship to the earth summarized by the term "Anthropocene." Introduced by earth scientists into the public discourse, this disputed concept has been seized upon by Dipesh Chakrabarty as the turning point of twenty-first century politics (Hamilton, Bonneuil, and Gemenne; Debaise and

[1]    At the end of his article "Experimental Music" (1957) John Cage coined the expression "response ability" linking this notion to sensitivity rather than accountability:
"Hearing sounds which are just sound immediately sets the theorizing mind to theorizing, and the emotions of human beings are continually aroused by encounters with nature. Does not a mountain unintentionally evoke in us a sense of wonder? Otters along a stream a sense of mirth? Night in the woods a sense of fear? Do not rain falling and mists rising up suggest the love binding heaven and earth? Is not decaying flesh loathsome? Does not the death of someone we love bring sorrow? And is there a greater hero than the least plant that grows? These responses to nature are mine and will not necessarily correspond with another's. Emotion takes place in the person who has it. And sounds, when allowed to be themselves, do not require that those who hear them do so unfeelingly. The opposite is what is meant by response ability." (Cage 10).

Stengers). Leaving aside the many controversies about the proposed term, it is clear that neither the older view of humanism nor that of a "material world" can be sustained (Chakrabarty, r·м!189–99). Far from being the "combination" of geology and humanism, the Anthropocene, as a concept being applied to natural and social sciences as well as to art and humanities, is a thorough "redistribution" of all the agencies composing the world. It is such a redistribution that explains why the very notion of "humanity" has to be redesigned (Hamilton, r·м!230–32), not to mention what the word "humanities" could possibly mean (Muecke, r·м! 224–29) if the new zeitgeist is summed up by the term "geostory."

James Lovelock laid the ground for such a move when he criticized his colleagues in geology and chemistry for arbitrarily limiting the extent and number of agencies present on earth (Lovelock and Obrist, r·м!200–04). Contrary to so many interpretations, his Gaia hypothesis was not the vision of the earth as a single organism (this would anyway have run counter to the first reset procedure of relocalizing the global) but, on the contrary, as a formidable jungle of intertwined and overlapping entities, each of them creating its own environment and complicating the environment for the others. A jungle aptly summarized in Haraway's remark commenting on Lynn Margulis: "complex nonlinear couplings between processes that compose and sustain entwined but nonadditive subsystems as a partially coherent whole" (ch. 2). It is precisely because the earth is no longer an organism, a totality, an overall scheme covering everything, a continuous "material world" stretching without a break from your body to the Big Bang, that it is possible to entertain many alternative relations with its intertwined agencies. Since discontinuities are everywhere, historicity is being generalized to every entity.

No wonder that it had become so difficult for the moderns to feel attached to the earth: either they had to quit the earth to have a soul or, if they stopped having a soul, they became "nothing but" a chunk of meat. Humans are attached to the humus from which they never escaped. "Earthbound" is a term that applies to all entities.

This is what allows for a very different choreography between entities, none of which resemble what used to be "human" or "nonhuman." The dream (or nightmare) of posthumanism was to extend rather enthusiastically the number of objects (technology, prostheses, bioengineering) making up the old fabric of humans. But neither technical artifacts nor elements of the former "nature" ever had the capacity to "reduce," "reify," "objectify," or "naturalize" human souls. On the contrary, they redistribute agencies in so many ways, moving their assemblages as far from the older (Western) view of humans as from the (Western) view of matter. This is clearly visible, for instance, in Tomás Saraceno's exploration of the threads common to spiders and societies (Latour, "Monads and Spiders," r·м!

205–07) as well as to the rematerialization of creation in Antoine Hennion's interpretation of Étienne Souriau (r·m!208–14).

The third procedure has an unexpected consequence: by multiplying "responsibilities" (taking up, as John Cage and Donna J. Haraway would say, more and more "response abilities") it becomes increasingly difficult for the Western subject living in the Anthropocene to enjoy any feeling of the sublime. And for one good reason that Kant had detected early on when he wrote:

> Bold, overhanging, and, as it were, threatening rocks, thunderclouds piled up the vault of heaven, borne along with flashes and peals, volcanoes in all their violence of destruction, hurricanes leaving desolation in their track, the boundless ocean rising with rebellious force, the high waterfall of some mighty river, and the like, make our power of resistance a *trifling moment in comparison* with their *might*. But, *provided our own position is secure*, their aspect is all the more attractive for its fearfulness; and we readily call these objects *sublime*, because they raise the forces of the soul above the height of vulgar commonplace, and discover within us *a power of resistance* of quite another kind, which gives us courage to be able to measure ourselves against the *seeming omnipotence of nature*. (Kant 91; emphasis added)

Every feature of such a situation is now gone. First, our "own position" is no longer "secure": where would you find a safe riverbed from which to look at the spectacle of nature (Blumenberg)? The Anthropocene subject is no longer a spectator because there is no safe place any more. But what is more troubling is that if we begin "to measure ourselves against the seeming omnipotence of nature," you realize, at least if you consider the earth, that you, you the human agent, have become so omnipotent that you have been able to inflict definitive damages on its system (Zalasiewicz). If it is true that there is something beautiful in the view of devastated oil fields, as proposed by Rosa Barba's film *Time as Perspective* (2012) (see fig. 1), fields where metronomic pumps resonate with the obstinacy of some apocalyptic countdown, it is also remarkable that the feeling of the sublime is covered by the lamentations over your own failure to protecting the land from irreversible destruction. This view of the sublime works also for fiction, as is shown by Philip Conway in his interpretation of the film *Silent Running* ( r·m!233–43).

Who has "might"? Who has lost the "power of resistance"? Whose is a "trifling moment"? Such a crushing responsibility is enough to shrink "the forces of a soul" below "the height of vulgar commonplace." And don't believe that you could still enjoy a sort of dark feeling in the face of the sublime generated by the catastrophe you yourself have created, as if you were a sort of Nero witnessing Rome in

flames. You cannot even say *qualis artifex pereo* ("what an artist dies in me"), because there is no spectator left to watch your selfie and celebrate the magnitude of your crimes (Guinard-Terrin, *r*·м!184–88).

To feel the sublime you needed to remain "distant" from what remained a spectacle; infinitely "inferior" in physical forces to what you were witnessing; infinitely "superior" in moral grandeur. Only then could you test the incommensurability between these two forms of infinity. Bad luck: there is no place where you can hide yourselves; you are now fully "commensurable" with the physical forces that you have unleashed; as to moral superiority, you have lost it too! Infinities today seem to be in short supply! You are now entering an "era of limits." The question is no longer to take delight in the contradiction of infinite matters and infinite soul, but to find a way, at last, to "draw limits," this time voluntarily, because the world is no longer a spectacle to be enjoyed from a secure place.

Such is the reset. We are no longer trying to escape from Plato's cave nor limited to the dark recesses of materiality. We are folded in the many-folded world. Slowly learning to respect habits of thought (Cuntz, *r*·м!215–23). Limited, yes, but not in obscurity. Enlightened, yes, but not by escaping outside. There is no outside. Learning to be "inside limits" is what we have been trying to show in the scenography of the exhibition. Earthbound. Earth-abound.

1   *Time as Perspective*. Dir. Rosa Barba. 2012. 35mm film. Film still.

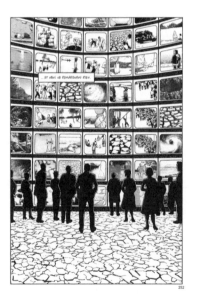

2   Philippe Squarzoni. *Saison brune*. Paris: Delcourt, 2012. 252. Print.

Works Cited

Blumenberg, Hans. *Shipwreck with Spectator: Paradigm of a Metaphor for Existence.* Cambridge, MA: The MIT Press, 1996. Print.

Cage, John. "Experimental Music." *Silence.* Cambridge, MA: The MIT Press, 1966. 7–12. Print.

Chakrabarty, Dipesh. "The Human Significance of the Anthropocene." Latour, *Reset Modernity!* 189–99.

Conway, Philip. "Earth, Atmosphere, and Anomie in Douglas Trumbull's *Silent Running.*" Latour, *Reset Modernity!* 233–43.

Cuntz, Michael. "On the Oddness of Habit." Latour, *Reset Modernity!* 215–23.

Debaise, Didier, and Isabelle Stengers. *Gestes spéculatifs.* Dijon: Presses du Réel, 2015. Print.

Guinard-Terrin, Martin. "Which Sublime for the Anthropocene?" Latour, *Reset Modernity!* 184–88.

Hamilton, Clive. "Reset Modernity: After Humanism." Latour, *Reset Modernity!* 230–43.

Hamilton, Clive, Christophe Bonneuil, and François Gemenne, eds. *The Anthropocene and the Global Environment Crisis: Rethinking Modernity in a New Epoch.* London: Routledge, 2015. Print.

Haraway, Donna J. *Staying with the Trouble. Making Kin in the Chtulucene.* Durham, NC: Duke University Press, 2016. Forthcoming.

Hennion, Antoine. "The Work to Be Made: The Art of Touching." Latour, *Reset Modernity!* 208–14.

Kant, Immanuel. *Critique of Judgement.* Trans. James Creed Meredith. Rev. and ed. Nicholas Walker. Oxford: Oxford University Press, 2007. Print.

Latour, Bruno. "Saraceno's Monads and Spiders." Latour, *Reset Modernity!* 205–07.

---. "Procedure 1: Relocalizing the Global." Latour, *Reset Modernity!* 51–67.

---. "Procedure 2: Without the World or Within." Latour, *Reset Modernity!* 91–103.

---, ed. *Reset Modernity!* Cambridge, MA: The MIT Press, 2016. Print.

Lovelock, James, and Hans Ulrich Obrist. Interview. "We Live on a Dynamic Planet." *Mousse* 48 (2015): 156–63, here 156–59. Rpt. in Latour, *Reset Modernity!* 200–04.

Muecke, Stephen. "Recomposing the Humanities." Latour, *Reset Modernity!* 224–29.

Souriau, Étienne. *The Different Modes of Existence.* Trans. Erik Beranek and Tim Howles. Minneapolis: Univocal, 2015. Print. Trans. of *Les différents modes d'existence.* Paris: Presses Universitaires de France, 1943. Print.

Zalasiewicz, Jan. "The Geology behind the Anthropocene." *Cosmopolis* 1 (2015): 8–12. Print.

172

3    John Martin. *The Deluge*. 1834. Oil
     on canvas, 168.3 × 258.4 cm.

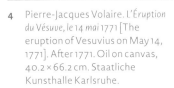

4    Pierre-Jacques Volaire. *L'Éruption
     du Vésuve, le 14 mai 1771* [The
     eruption of Vesuvius on May 14,
     1771]. After 1771. Oil on canvas,
     40.2 × 66.2 cm. Staatliche
     Kunsthalle Karlsruhe.

5   Tacita Dean. *Quatemary*. 2014. 5 framed photogravures in 10 parts on
    Somerset White Satin 400 gr, 239.5 × 709.5 cm.

6 Fabien Giraud. *Tout monument
est une quarantaine (Minamisōma –
Fukushima District – Japan)*. 2012–14.
Photograph.

7 Simon Starling. *One Ton* II. 2005. 5 photographs made of
platinum. Courtesy Rennie Collection, Vancouver.

8 Humble Oil & Refining Company. *Each Day Humble Supplies Enough Energy to Melt 7 Million Tons of Glacier.* 1962. Advertisement. *Life Magazine* 2 Feb. 1962: 81–82. Print.

9 Hicham Berrada. NPA2 *Champ de cristaux, action.* 2011. Photograph, 20 × 15 cm. Courtesy the artist and kamel mennour, Paris.

**10**   Armin Linke. *Ertan Dam, Downstream Side Panzhihua (Sichuan) China*. 1998. Photograph, 50 × 60 cm.

11 Armin Linke. *Whirlwind, Pantelleria, Italy.* 2007. Photograph.

12  Armin Linke. *Italian Climate*          181
    *Observatory Ottavio Vittori, Monte*
    *Cimone, Lab Modena Italy.* 2006.
    Photograph.

- *Brunaspis Enigmatica* -

**14** Jan Zalasiewicz and Anne-Sophie Milon. *Le Mystère du Brunaspis enigmatica, étude du spécimen C-ii-2.* 2016. Colored pencil on tracing paper, 14.8 × 21 cm.

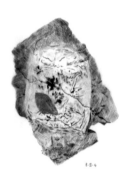

**13** Jan Zalasiewicz and Anne-Sophie Milon. *Le Mystère du Brunaspis enigmatica, illustration du Brunaspis enigmatica.* 2016. Pencil on paper, 14.8 × 21 cm.

**15** Jan Zalasiewicz and Anne-Sophie Milon. *Le Mystère du Brunaspis enigmatica, étude du spécimen B-ii-4/ holotype.* 2016. Colored pencil on tracing paper, 14.8 × 21 cm.

**16** Jan Zalasiewicz and Anne-Sophie Milon. *Le Mystère du Brunaspis enigmatica, étude du spécimen G-ii-2 & G-i-1.* 2016. Colored pencil on tracing paper, 21 × 29.7 cm.

**17** Jan Zalasiewicz and Anne-Sophie Milon. *Le Mystère du Brunaspis enigmatica, extrait de l'installation.* 2016. Mixed media, 120 × 80 cm.

C-I-1

**18** Jan Zalasiewicz and Anne-Sophie Milon. *Le Mystère du Brunaspis enigmatica, étude du spécimen C-I-1.* 2016. Colored pencil on tracing paper, 14.8 × 21 cm.

# WHICH SUBLIME FOR THE ANTHROPOCENE?

## Martin Guinard-Terrin

IT'S FRIGHTENING TO HEAR that geological and human histories have connected in the Anthropocene. How one relates to this process, or sensitizes oneself to it, becomes a key issue. The aesthetic regime of the sublime seems at first particularly appropriate: a mix of fascination and awe in the face of a geological force. But looking closer, the sublime feeling stimulated by the Anthropocene is actually misleading. Indeed, this peculiar aesthetic regime was formulated at a time when the overwhelming spectacle of "nature" was seen as a separate and remote phenomenon from its observer. The current situation, in which humans have themselves become a geological force, undermines this conception: first, because the environmental instability provoked by humans is incompatible with the position of a safe observer, as Bruno Latour outlines in "Procedure 3", (r·M!167–83), and second, because it fosters a set of perverse temptations such as geoengineering and cynicism (Fressoz 48–49). If Latour's third procedure indulges in a paradoxically sublime gesture, it is only to say farewell to it. The question that arises, then, is how to give an account of the tumult of the elements without using the categories that accompany the classical representation of the sublime?

The aesthetic category of the sublime emerged in the mid-eighteenth century, driven by the passion of British tourists encountering the panoramas of the Alps en route to Rome on their grand tours. The

MARTIN GUINARD-TERRIN *has a background in art history and fine arts. He worked as an assistant curator at the Palais des Beaux-arts (Beaux-arts de Paris) with Kathy Allion under the direction of Nicolas Bourriaud before he joined the project* AIME *to work on the exhibition* Reset Modernity!

Lisbon earthquake of 1755 contributed as well, shaking up European thinkers such as Edmund Burke and Immanuel Kant. The aesthetic phenomenon included a cascade of paintings, from Caspar Wolf's rocky mountains to J. M. W. Turner's stormy seas.

In his essay "L'anthropocène et l'esthétique du sublime," the historian Jean-Baptiste Fressoz highlights the prevalence of this grandiose rhetoric in scientific discourses. Indeed, the Anthropocene phenomenon is described by a series of superlatives: the greatest quantity of $CO_2$ in 3 million years, the highest level of ocean acidity in 300 million, the highest rate of species extinction in 65 million (45). Fressoz notes that the "aesthetic of the gigaton and the exponential curve" (44) echoes the vocabulary used by Burke, who stated in *A Philosophical Enquiry into the Sublime and Beautiful* that "greatness of dimension is a powerful cause of the sublime" (71). And descriptions of the cataclysmic outcomes implied by the destabilization of the earth system call to mind the "negative pleasure" that Kant portrays as the "imagination reaching its limits" (Fressoz 47).

Fressoz underlines the ethical and political issues that accompany this mode of perception. When the "fear" and "awe" described by Kant in his *Critique of Judgment* (99–100) intersect with a technological version of the sublime, the way is paved for geoengineering.[1] These movements arise from the belief that the response to such a "grandiose" event must reside in an equally grandiose plan. According to this way of thinking, the climate must be modified, orchestrated, and governed like a giant technological system, despite the incredible risks such changes entail.[2] Moreover, the taste for massive scale tends to dissolve the sense of personal responsibility, potentially fostering a form of cynicism due to an inability to project oneself into the future. Finally, this strident aesthetic, like any sensationalist mode, will in the end lose its ability to shock.[3] Fressoz goes on to conclude:

> Before embracing the Anthropocene, we must remember that the sublime is only one of the categories of aesthetics, which includes many others as well (e.g. the tragic, the beautiful, the picturesque) based on other feelings (e.g. harmony, serenity, sadness, pain, love, modesty) that may be better able to feed an aesthetic of care, of the small, of the local, of control, of the old, and of the involution that ecological action so badly needs. (49; Trans. Guinard-Terrin)

It could be argued that the genres of the pastoral, associated with the domestication of (a fundamentally benign) nature, and the tragic, with its explorations of inexorable fate, would likely produce outcomes similar to those mentioned above (geoengineering and cynicism). But Fressoz is right to point out the necessity to proposing an aesthetic that does not provide an answer to questions formulated more than two centuries ago, since which time the relationship between humans and their environment has undergone a radical shift. In light of this analysis, the trajectory traced by the work of Tacita Dean, Simon Starling, and Fabien Giraud is particularly relevant.

Dean's piece *Quatemary* (see fig. 5, **r·m!** 174–75) was inspired by the Yellowstone supervolcano, a geological formation beneath Yellowstone National Park in the western United States. In a massive photogravure, one sees a harsh and arid expanse of ground, stretching before one, pierced by small craters. Although the foreground remains still and calm, a dark, turbulent fog is swirling behind it. Dean's inspiration was drawn from a documentary, of which she recalls:

> The Yellowstone supervolcano is a blister of a volcano, which has no release. Magma has been gathering beneath the Park's crust for millennia with no means to break through. The surface is noticeably rising and noticeably steaming. Soon, the programme said, the pressure would become so great that the ground would be wrenched apart, causing an explosion of such epic magnitude that several states of America would be as good as wiped out

185

[1]   As David Nye puts it in *American Technological Sublime*: "By implication, this [technological] form of the sublime undermines all notions of limitation, instead presupposing the ability to innovate continually and to transform the world" (60).

[2]   For example, some proposed projects involve using techniques known as solar radiation management and carbon dioxide removal to reduce the planet's temperature (Oxford Geoengineering Programme). For further analysis, see Clive Hamilton's *Earthmasters*.

[3]   Fressoz 49. Both the sublime and the Anthropocene inherit the shortcomings of Enlightenment universalism, as Fressoz reminds us: The sublime regime, which calls for an unsituated point of view, is a typically Western and bourgeois mode of perception, "vilified" by Marxist and feminist critique. Similarly, the Anthropocene, by embracing the whole of humanity, diminishes the responsibility of capitalism, which has disrupted a series of sensitive ecosystems (44–45).

instantaneously, and that it would cause the rest of the world to be covered with an ash cloud, so dense that it would block out the sun and cause an ice age. The human species would become extinct. (Niels Borch Jensen Gallery)

The tone of this statement is, to say the least, not reassuring! And in fact, in 2013 the US Geological Survey discovered that the magma chamber beneath Yellowstone was more than twice as large as previously believed (Witze). This discovery generated an immense amount of attention, including a batch of sensationalist headlines. But according to a 2014 statement from the Yellowstone Volcano Observatory, the situation does not seem to present any unusual dangers. In early August of that year, the activity of the Yellowstone volcanic system was "well within historical norms," and observatory geologists reminded the public that "no volcanologists have stated that Yellowstone is likely to erupt this week, this month or this year." They also took advantage of the opportunity to debunk some of the wilder rumors circulating in the media – for example, that the park had been evacuated.

Unlike the sloppy journalistic research behind such stories, *Quatemary* does not attempt to relate to a specific reference. The title alludes to the Quaternary, the geological period encompassing the Holocene and, potentially, the Anthropocene. But this slight change of spelling brings a sense of personification, the *m* turning the end of the word into the name *Mary*. In the same vein, Dean's annotations act as "stage directions" for the clouds, the dust, and the ground.[4]

Taken in the context of the Anthropocene, the personification operating in the photogravure is not an allegory, since the volcanic terrain does not serve as a concrete substitute for an abstract idea. It is an actor on the geological scale – as are humans, at this point.[5] Following this anthropocentric interpretation, it is relevant that there are no "tiny" humans in the frame looking at the fury of the eruption from afar, as there are in a typically sublime painting such as Pierre-Jacques Volaire's depiction of the eruption of Vesuvius (see fig. 4, *r*·M!173). The viewer (in Karlsruhe in this case) is part of a force possessing a magnitude far too great to be reduced in scale.

In Simon Starling's *One Ton II* (see fig. 7, *r*·M!176), the ground is portrayed as an exhausted surface. The work is a series of five photographs of an open-air platinum mine in Potgietersrus, South Africa. The rich tonalities of the greys portray steep concentric circles cut into rock. These are the roads that allow the mining trucks to access the lower part of the site, which looks like the negative of a mountain.

Platinum is used for making fine black-and-white photographic prints and is known for its ability to give a richer contrast than silver. In Starling's piece, the number of prints has not been left to chance: it corresponds to the exact quantity of platinum that had to be mined to produce them. As the metal is spread throughout huge amounts of ore, a stunning contrast is created: 10 metric tons of ore for about 30 grams of pure platinum, or one ton for five prints. Starling uses the phrase "closed system" (Kaiser C9) to describe this correspondence between the flat surfaces of the prints and the immense volumes of rock pulled out of the ground to produce them.

In this context, the inconspicuous trucks that appear in the vast mine are, again, not really comparable to the tiny human figures portrayed in a state of contemplation in Volaire's painting. As the human presence is, this time, the actor that is exhausting the ground, the "brutally grandiose engineering project that facilitated [the] production" of the prints (Roelstrate 38) causes uneasiness.

[4]   Dean has used this process repeatedly, notably in her series of blackboard drawings.

[5]   In *Eating the Sun*, Oliver Morton compares the 13 terawatts of power used by human civilization to the 40 terawatts of heat constantly flowing from the earth's core (349). In the years since Morton's book was published, human demand has continued to increase; by 2012, according to the US Energy Information Administration, it had reached nearly 16 terawatts.

Fabien Giraud's work (see fig. 6, **r**·M!176) pushes this logic further. His 20 × 15 cm photograph, *Tout monument est une quarantaine (Minamisōma – Fukushima District – Japan)*, has nothing of the massive scale of Tacita Dean's photogravure. It is a sort of *mise en abyme* showing a photo studio situated among dark trees. Powerful lights illuminate a heap of soil on an immaculately white, gently curved sheet of paper. This technique is well known by commercial photographers, as it allows one to draw attention to the object in the foreground while giving a generic tone to the background, as if the subject of the image were unsituated. But the location of the forest depicted here is not insignificant: as the title indicates, it was taken in Fukushima. The paper on which the picture is printed was actually cut out of the piece that serves as a background in the photograph. It is therefore radioactive. Here is another "closed system," where the paper documented and the paper on which it is documented are merged: a toxic feedback loop with a geological catastrophe arising from a movement of the tectonic plates, a tsunami, a nuclear explosion, and an irreversibly contaminated area.

The inventor and scientist James Lovelock played a crucial role in the exploration of this notion of reciprocal action between a living entity and its surroundings. Indeed, he revisited the Darwinist model of evolution, claiming that while species adapted themselves to their environment, they also modified it through a self-regulating process. In the Anthropocene, humans (or at least some of them) have acted upon their environment on such a scale that the other entities composing it have themselves been destabilized. In this context, the envelope that surrounds us does not absorb changes; it is transformed, and in return it transforms the entities within it, leaving us in an unstable set of interactions with what we used to call "nature" (Latour 131–33).

This understanding of the relationship between an entity and its environment highlights one of the major incoherences of the aesthetic regime of the Anthropocene: it relies on a safe observer, separated from his object of contemplation. It is not by chance that Kant described the wonders of nature from a position of "security," excluded from the zone of turbulence (*Critique* 100).

In his *Enquiry*, Burke tried to describe our emotions and their origins by distinguishing between the "pleasure" resulting from the beautiful and the "astonishment" resulting from the sublime. He associated the beautiful with "positive pleasure" and, betraying a gender bias, with feminine attributes, an idea of refinement, and even smoothness, arriving at a conception similar to the painter William Hogarth's "line of beauty" (115). The sublime, on the other hand, is seen as a grand, threatening, "delightful horror" that stimulates a form of fearful admiration and respect (134). Despite these contradictions it is not a clear-cut separation, but rather a fragile distinction.

Immanuel Kant pursued this set of reflections further in 1764, in his *Observations on the Feeling of the Beautiful and Sublime*, and again twenty-six years later in the *Critique of Judgment*. According to the latter book, the spectacle of nature operates in two ways: as a response to the immensity of nature (Kant calls this the "mathematically sublime") and to the violence of nature (the "dynamically sublime") (85–104).

Two and a half centuries later, the Anthropocene, if perceived as a sublime event, presents a number of risks (geoengineering, cynicism, disengagement, etc.). Whereas Dean stages a new set of potential relationships with telluric force, Starling highlights a perverse loop, which Giraud pursues as we enter a system made unstable by humans. Of course these works do not present a ready-made recipe for the total refitting of the perceptual field that is required to sense the "new climatic regime" we have entered. But the transition initiates a movement that will hopefully resist the traps the sublime regime might offer.

187

188

Works Cited

Burke, Edmund. *A Philosophical Enquiry into the Sublime and Beautiful*. Ed. James T. Boulton. London: Routledge, 2008. Print.

Fressoz, Jean-Baptiste. "L'anthropocène et l'esthétique du sublime." *Sublime. Les tremblements du monde*. Ed. Hélène Guenin. Metz: Centre Pompidou-Metz, 2016. 44–49. Print.

Hamilton, Clive. *Earthmasters: The Dawn of the Age of Climate Engineering*. New Haven: Yale University Press. 2013. Print.

Kant, Immanuel. *Critique of Judgment*. Trans. J. H. Bernard. New York: Hafner, 1951. Print. Hafner Lib. of Classics 14.

———. *Observations on the Feeling of the Beautiful and Sublime*. Trans. John T. Goldthwait. Berkeley: University of California Press, 1960. Print.

Kaiser, Philipp. "Interview with Simon Starling." *Simon Starling: Cuttings*. Ed. Kaiser. Berlin: Hatje Cantz, 2005. C1–C17. Print.

Latour, Bruno. *Face à Gaïa. Huit conférences sur le nouveau régime climatique*. Paris: La Découverte, 2015. Print.

Morton, Oliver. *Eating the Sun: The Everyday Miracle of How Plants Power the Planet*. London: Fourth Estate, 2007. Print.

Niels Borch Jensen Gallery. "Berlin Gallery." *Niels Borch Jensen Gallery*. Niels Borch Jensen Gallery & Editions, n.d. Web. 2 Feb. 2016. Available at <http://www.nielsborchjensen.com/berlin-gallery>.

Nye, David E. *American Technological Sublime*. Cambridge, MA: The MIT Press, 1994. Print.

Oxford Geoengineering Programme. "What Is Geoengineering?" *Oxford Geoengineering Programme*. University of Oxford, n.d. Web. 28 Jan. 2016. Available at <http://www.geoengineering.ox.ac.uk/what-is-geoengineering>.

Roelstrate, Dieter, ed. *Simon Starling: Metamorphology*. Chicago: MCA Chicago, 2014. Print.

US Energy Information Administration. "International Energy Statistics." *US Energy Information Administration*. US Dept. of Energy, n.d. Web. 3 Feb. 2016. Available at <http://www.eia.gov/cfapps/ipdbproject/IEDIndex3.cfm?>.

Witze, Alexandra. "Large Magma Reservoir Gets Bigger." *Nature News*. Nature Publishing Group, 28 Oct. 2013. Web> 3 Feb. 2015. Available at <http://www.nature.com/news/large-magma-reservoir-gets-bigger-1.14036>.

Yellowstone Volcano Observatory. "A Short Statement Regarding Recent Rumors." *Yellowstone Volcano Observatory News Archive*. USGS, 8 Aug. 2014. Web. 1 Dec. 2015. Available at <http://volcanoes.usgs.gov/observatories/yvo/yvo_news_archive.html>.

# THE HUMAN SIGNIFICANCE OF THE ANTHROPOCENE

## Dipesh Chakrabarty

## 1. THE ANTHROPOCENE: A NAME AND A CONCEPT

DIPESH CHAKRABARTY *teaches history, South Asian studies, and law at the University of Chicago. He is the author of several books and many articles, including* Provincializing Europe: Postcolonial Thought and Historical Difference *(Princeton: Princeton University Press, 2000; 2007).*

IT WAS THE BRAZILIAN anthropologist Eduardo Viveiros de Castro who first suggested to me that the term "Anthropocene" could be looked upon both as a name – a neologism, that is – and as a concept. [1] What's the difference? A concept is an idea that is rigorously argued for and defended by a series of evidentiary or logical procedures that seek to settle its formal status beyond all dispute. When we say that human-induced changes to the climate and to the body of this planet have ushered us into a new geological epoch called the Anthropocene, we announce, as it were, a formal closure to the universally accepted period of geological time we were all supposed to be in, the Holocene epoch (or "wholly recent" times). Here "epoch" is not a lazy word. It has a precision to it in that it is not a geological age, era, or eon; it is to be counted in terms of millions of years, and more in terms of tens of millions of years than of hundreds of millions of years. And most importantly, it has to be defined following the same rules as were applied in defining other geological divisions of the deep historical time of the planet: by looking for fossilized and other kinds of evidence in the earth's strata.

That is the task that the International Commission of Stratigraphy's Anthropocene Working Group, which has a virtual existence and is chaired by the geologist Jan Zalasiewicz, has set itself, with the aim of formally submitting the name, most likely in 2016, to the full Commission for approval. If the Commission found the term acceptable as the name of a new geological epoch, it would have to make its way through the higher echelons of the world geology establishment in order to begin life as a formally anointed name. The International Union of Geological Sciences would then have to decide whether to ratify the name or not. Such a process highlights the fledgling career of the Anthropocene as a concept. To be accepted as a scientific term, it would have to look like a word whose conceptual connotations had successfully distanced themselves from all the political controversy that has accompanied the expression "the Anthropocene" in its brief career so far.

[1]   Viveiros de Castro; see also LeCain 1, where the same distinction is made.

## 2. WHAT'S IN A NAME?

WHEN WE THINK of "the Anthropocene" as a name and not primarily as the bearer of a geological idea or concept, we act as though a lot were at stake in the very name itself, more than in the verificatory or evidentiary procedures. The focus, in other words, is on the name's immediate implications, political and otherwise. Thus the Swedish academics Andreas Malm and Alf Hornborg ask, in a widely cited essay: if human actions are what has precipitated this collective slide into a geological period that signifies human domination of the planet and even of its geological history, why name that period after all humans or the human species, the *anthropos*, when we know it is the rich among humans, or the institutions of capitalism or the global economy, that are causally (hence morally?) responsible for this change in our condition?

"A significant chunk of humanity is not party to the fossil economy at all," they point out, adding that "hundreds of millions rely on charcoal, firewood or organic waste such as dung ... " (65). Citing the Canadian scholar Vaclav Smil, who notes that "the difference in modern energy consumption between a subsistence pastoralist in the Sahel and an average Canadian may easily be larger than 1,000-fold," Malm and Hornborg argue that "humanity seems far too slender an abstraction to carry the burden of causality [for climate change]. ... Realizing that climate change is 'anthropogenic' is really to appreciate that it is *sociogenic*" (65–66). Thus, they conclude, while "the Anthropocene" might effectively represent a possible polar-bear point of view (since they, the bears, might want to know "what species is wreaking such havoc on their habitats"), "within the human kingdom ... species-thinking on climate change is conducive to mystification and political paralysis" (67).

Analysts of more or less the same mind as Malm and Hornborg have therefore come up with alternative names for the Anthropocene. In an essay of considerable sophistication, Jason M. Moore, a Marxist sociologist at Binghamton University, has put forward the term "Capitalocene" and suggested that we see capital as a "world-ecological limit."[2] Donna J. Haraway has recently argued that more than one name is warranted to capture the multiple kinds of "scale, rate/speed, synchronicity, and complexity" that are at work in current environmental crises, and she suggests that we use, simultaneously, terms like "Anthropocene, Plantationocene, and Capitalocene" (159–60).

Others raise other kinds of objections to the term "Anthropocene." Eileen Crist, for instance, thinks that the name bespeaks "the poverty of our nomenclature" in that it appears to make the force of the Anthropocene inexorable:

> What remains unstated in the trend reifications that characterize the Anthropocene discourse (projections of rising human numbers, continued economic development, expanding technological projects and incursions, and a deepening biodiversity crisis) is the abdication of freedom that reifying the trends affirms: the freedom of humanity to choose a different way of inhabiting Earth is tacitly assumed absent. (138)

Erik Swyngedouw takes the view that if the name "Anthropocene" is made too technical – by making it the preserve of trained geologists only – it would squeeze the space for politics by silencing dissent (on the grounds that such dissent may not be based on specialized knowledge). My colleague Kathleen Morrison, an archaeologist of India, has recently written a short essay striving to "provincialize" the

[2]   Moore, "Part 1" 1; and Moore, "Part 2" 30, 34; see also Luke.

Anthropocene by showing that the term ignores anthropogenic environmental changes over a long period of time in order to privilege a Eurocentric and much shorter-term story of mostly European industrialization.

We may or may not agree with these particular objections, but we see what is at stake in the criticism of the name. When we think of the Anthropocene politically, we think of the present and the immediate future, for we ask: What are the political consequences of this name *now*? Does it hide the role of capitalism? Does it end up legitimizing techno-fixes of the climate and other related environmental problems? Does it therefore lead us to solutions that take us away from the path of democratic politics to a vision of politics driven only by the technological, scientific, policy, and financial elites of the world?

It is clear, however, that this mode of argumentation emphasizes a much shorter period of time than the sense of deep time that informs geological literature. If we contest the name "Anthropocene" in order to foreground the work of capitalism and its privileged stakeholders, we think of humans in the context of a history that is at most about five hundred years old. Debates about the Anthropocene as a name thus have their eyes fixed firmly on the present – the last five hundred years leading to the ever-vanishing present – and on the political consequences of the name in the foreseeable future. In this mode of critique, humans and their institutions are placed in the historical time in which the modern state, global capitalism, and their attendant institutions have evolved, a history of the last five hundred years at most.

## 3. THE ANTHROPOCENE AS A GEOLOGICAL EPOCH: DISPUTATIONS AMONG SCIENTISTS

WHEN ONE THINKS of the Anthropocene as a concept, however – that is, as the geological epoch that comes after the Holocene, which denotes the beginning of the present interglacial phase following the last ice age (ca. 11,700 years BP) – a vista of time opens up that is much wider, vaster, and deeper than the time of capitalism, for it is geological in scale. The very geological argument about the Anthropocene is based on an attempt to work out whether geologists looking at this planet millions of years from now – these geologists may not even be humans; they may be, as Zalasiewicz says in his book, *The Earth After Us*, "hyper-intelligent" rodents (9) – will find evidence in the rock strata of the planet to suggest that the period when humans experienced global warming also marked a break in geological history, which they might recognize as significant enough to denote the end of the Holocene epoch and the beginning of a new epoch – a new epoch that they might (if only they spoke the Queen's language and the language of our geological sciences) term the Anthropocene! There is a certain chutzpah and perversity to the concept, no doubt. For geological periods are usually named long after they are gone. Here scientists are trying to convince themselves and other scientists that stratigraphic evidence already exists for us to be able to imagine the geological history of this period from the point of view of both geologists of the present and those who may come – in human terms at least – in the very, very distant and probably posthuman future.[3]

Thought of in this way, the Anthropocene category becomes a thought experiment among geologists. It is based on stratigraphical evidence, no doubt, but it remains a thought experiment nevertheless and – no wonder – is disputed by scientists themselves,

---

[3]   However, "if global warming and a sixth extinction take place in the next couple of centuries, then an epoch will seem too low a category in the hierarchy" of geological periods (Zalasiewicz, message to the author).

though not always for the reasons mobilized by social scientists. As Bronislaw Szerszynski observes:

> In terms of environmental ethics, one might say that geology is brutally consequentialist – it does not matter what one does, or why one did it, just what consequences it will leave behind. Geological accountability all depends on the account that is laid down in the great book – now not in heaven, but in the rocks of the Earth. Thus geologists – true to geology's semiotic character – talk about the Anthropocene in terms of "signals" laid down for future geologists. (169)

Hence the scientific debate on the Anthropocene is characterized by the search for a distinct lithostratigraphic signal, a distinct chemostratigraphic signal, a distinct biostratigraphic signal, and a distinct "sequence stratigraphic signal" (large-scale sea-level rise), as well as by debates about what Szerszynski calls a "golden spike" – "a particular point in a particular sequence of strata at a particular location." Debates even follow on how one should understand the golden spike itself:

> Is its appropriate position a technical matter, to be determined by objective tests? Or does it depend in some sense on our understanding of the human – of the *Anthropos* of the Anthropocene? Furthermore, to whom is the plaque-like end of the spike addressed, and when is it to be read?[4] If by present humanity, is it a badge of pride or of shame? If by some future observer, is it an invocation, the summoning into being of the God Species, that must grasp the vocation of planetary management? Or is the implied audience an imagined future geologist? (171)

Many of the critical hurdles, both institutional and research-related, that the Anthropocene idea has to clear before it can be formalized have been described in an essay by another member of the International Commission on Stratigraphy, Stanley C. Finney, a geologist at California State University, Long Beach. He explains that the Commission will vote on the recommendation of Zalasiewicz's Anthropocene Working Group, and that this is a process of debate – "all points are presented and all points challenged." The final ratification is up to the Executive Commission of the International Union of Geological Sciences – and that is a process "based primarily on the assurance that the ICS policies and procedures were followed." Finney reminds us that "the recent ICS decision on the formal definition of the Quaternary System and redefinition of the Pleistocene Series followed decades of acrimonious debate." He notes that a "globally distinct stratigraphic marker on which to define the 'Anthropocene' as a formal chronostratigraphic/geochronological unit" would be an imperative, as "such a marker is the only basis on which to define the unit, and the only basis necessary" (23–24). And he proceeds to raise a set of serious questions interrogating the idea of the Anthropocene:

> Is there a well-documented and significant stratigraphic record for the "Anthropocene" on which to base its recognition worldwide and to define a boundary with underlying Holocene strata?
>
> Should the base of the "Anthropocene" be defined on a stratigraphic signal or instead should its beginning be defined on a date in human history?
>
> Is the "Anthropocene" a unit of Earth history or human history, or is it more a

[4]   "Any golden spike is, I think, addressed to our active and living colleagues" (Zalasiewicz, message to the author).

projection into the future? ... Are we so cer-
tain of what future millennia will bring?

What is the usefulness of the
Anthropocene as a material unit to be rep-
resented on geological maps?

Has the change to a human-dominated
Earth system overwhelmed the natural
Earth system, or might geological process-
es both internal and external still over-
whelm the human influence?
[An asteroid impact, for instance, may
obliterate the stratigraphic evidence of
human influence.] ... Considering that
projection into the future is implicit in
the concept of the "Anthropocene," poten-
tial geological events originating within
the Earth system or from outside it should
also be considered. (24–26)

Finney then moves towards a question that would be
of great interest to humanists as well. He points out
that "the argument that formalization recognizes
the immense impact of humans on the Earth sys-
tem and that Earth processes are forever changed
by this human impact ignores the fact that other
organisms have had far greater, longer-term impacts
than humans on the Earth system" – for example,
the evolution of vascular plants, which "dramat-
ically altered $CO_2$ and $O_2$ concentrations in the at-
mosphere and oceans," or the great diversification
of the Middle Ordovician period, which "altered the
nature of marine sediments and biota." And then he
asks, in conclusion: "Why should human impact on
the Earth system be different? Might the desire to
establish the 'Anthropocene' as a formal unit [itself]
be anthropocentric?" (27).

Tough questions. It is not surprising, then, that
the idea of the Anthropocene should be a hotly

debated subject among concerned scientists as well.
One of the most profoundly disquieting aspects
for scientists debating the idea of a new geological
epoch is what may be seen as the novel way the pro-
posed periodization of the Anthropocene has begun
(a problem acknowledged by those in favor of the
idea). Usually, as I have noted, geological periods are
named long after their onset – if not their passing –
whereas the Anthropocene, by the standards of the
geological timetable, has just begun! It is a concept
now in search of evidence that would substantiate it.
Thus Anthony D. Barnosky, a paleontologist at the
University of California, Berkeley, writes:

> Past definitions [of epochs] began with
> recognizing distinctive features of the
> material rock record, primarily the fos-
> sils contained therein and their implica-
> tions for defining biostratigraphic and
> chronostratigraphic units. From those
> stratigraphic entities, geochronological
> units (epochs) were then recognized. The
> development of the Anthropocene has
> gone in exactly the opposite direction.
> An arbitrary unit of time (a geochrono-
> logical unit), characterized as the time
> of intensified human impacts, was first
> proposed, and now the material "rock" re-
> cord – deposits that have accumulated in
> the past few centuries – is being scoured
> for distinctive signs that could provide an
> objective material basis for an epoch.[5]

Indeed, a few years after Zalasiewicz and other scien-
tists had published a statement titled "Are We Living
in the Anthropocene?" in the newsletter of the US
Geological Association, GSA Today, two US geologists,
Whitney J. Autin and John M. Holbrook, posted a
response asking, rhetorically, "Is the Anthropocene
an Issue of Stratigraphy or Pop Culture?" They

[5]   Baronosky 151. Zalasiewicz points out (via e-mail) that his and his colleagues' "reading of the evidence suggests that the
      Holocene may not be very easily visible ... but that the Anthropocene will form quite a striking stratal marker."

commented, somewhat acidly:

> Anthropocene provides eye-catching
> jargon, but terminology alone does not
> produce a useful stratigraphic concept. …
> If there is an underlying desire to make
> social comment about the implications
> of human-induced environmental
> change, Anthropocene clearly is effective.
> However, being provocative may have
> greater importance in pop culture than to
> serious scientific research. (61)

In reply, Zalasiewicz et al. agreed that "selecting an effective boundary is not straightforward, with much anthropogenic change diachronous on a scale of centuries to millennia," but claimed that the potential for the case existed. "Few of Earth's other stratigraphic boundaries represent neatly definable, synchronous changes that can be everywhere precisely located," they added ("Response" e21). Autin and Holbrook responded by saying they were not anti-Anthropocene, but amendment of the stratigraphic code required a formal process, and proposals that did not ultimately provide useful field applications were unlikely to gain traction within the scientific community. "Stratigraphic code," they wrote,

> is explicit in the requirement to establish
> boundary stratotypes with widespread,
> preferably global, correlation significance.
> Recognition of a boundary stratotype is
> a practical requirement. … Neglecting to
> develop stratotypes or deferring the defi-
> nition of boundary criteria to future gen-
> erations should inhibit the acceptance of
> Anthropocene as a practical stratigraphic
> concept. If developing a consistently
> recognizable stratotype is indeed such a
> challenge, then the stratigraphic utility of
> the concept is in question from the onset.
> ("Reply" e23)

Finally, Autin and Holbrook came to a point very similar to the one raised by Barnosky:

> The debate about stratigraphic relevance
> is primarily deductive in that … there must
> be a physical, chemical, or biological sig-
> nal of human alteration consistent with
> the projected exponential rate of envi-
> ronmental change. … This reasoning is
> contrasted with inductive analysis where
> one finds a signal and seeks to explain its
> occurrence. Proposals for Anthropocene
> time- or rock-stratigraphic units did not
> arise because we found a practical, map-
> pable, and useful stratigraphic boundary
> that marks a discrete onset of modern
> human influence to the Earth system. In
> contrast, Anthropocene appears to in-
> terject a conceptual idea onto the strati-
> graphic record. ("Reply" e23)

And they ended with a question whose sarcasm is suggestive of the degree of polemical heat that this debate has generated among some geoscientists: "In the present day of deductive dominance, is the simple scientific reasoning that suggests observations trump theory now considered outdated?" ("Reply" e23). One could argue that the work of Zalasiewicz's working group aims precisely to answer such objections by seeking to collect and present a body of relevant and necessary evidence.

Philip Gibbard, a geographer at the University of Cambridge and a member of the Anthropocene Working Group, and Michael Walker, a specialist in Holocene stratigraphy from the University of Wales, raise an additional but important question about the possible redundancy of the term "Anthropocene," given that the name "Holocene" was invented to acknowledge human impact on the planet. They note that "the term 'Anthropocene' has caught the popular imagination" (35) but raise the following doubt:

The current position is that we are living in the Holocene Series/Epoch, and one of the key justifications for defining a Holocene series, as a separate entity from the Pleistocene, is that humans (*Homo sapiens*) reached critical numbers and began influencing natural systems from the beginning of this time period onwards ... without this unique record of human impact there would be no justification for the Holocene being anything other than an interglacial, in common with all others in the Pleistocene. If the human dimension is accepted as a reasonable basis for a separate Holocene series, as distinct from the Pleistocene, the activities of humans cannot then be used again in support of a discrete Anthropocene division. (32)

Besides, they argue, "the criteria initially used to justify a Holocene Series still obtain," and hence they remain "firmly" of the view, even while "fully accepting the profound and increasing influence of humanity on the natural environment over recent centuries ... that the designation of the Anthropocene as a time unit equivalent to Series or Epoch divisions cannot yet be justified on stratigraphical grounds." At best, they think, "the Anthropocene might become another name for the later Holocene (with a usage similar, perhaps, to 'Dark Ages' or 'Middle Ages'), but in a geological context the term would remain informal" (35).

In this they are largely in agreement with Finney, who also suggests that the Anthropocene, even if not ratified, could remain in circulation as a scientifically accepted but informal periodizing term in the geological timescale, such as "Snowball Earth" (27). Here again, Zalasiewicz's comment (see note 5 above) becomes relevant as a possible answer: "Our reading of the evidence suggests that the Holocene may not be very easily visible in the far future (unless you are a vertebrate paleontologist) but that

the Anthropocene will form quite a striking stratal marker." He further adds:

> The human dimension is not always necessary to justify a separate Holocene Series – it works very well (to a field geologist) as a physical stratal unit (even if one does not see an iota of human influence in the strata being worked on). The Anthropocene isn't founded on evidence of human impact as much as on evidence of change to the Earth system (that happens currently to be largely driven by humans). (Message to the author)

## 4. CONCLUSION

SEEN FROM THE POINT OF VIEW of the human sciences, at the heart of the question of whether we treat the Anthropocene as simply the name of our times or see it as a geological epoch is a larger point: do we see human history simply or mainly in terms of the history of capitalism or capitalist modernity – not more than five hundred years – or do we see humans in the context of geological time? The consequences of these two modes of thinking are very different. If we assume that capitalism has caused devastation to the human environment, and all we need to do to fix the problem is to fight and replace capitalism, we don't need a term like "Anthropocene." We can call our times by names such as "Capitalocene," "Econocene," "the time of global capitalism," et cetera. The geological name "Holocene" can remain in the background. There would be no need to engage with geological *time*, even if we agreed with the paleoclimatologist David Archer that "mankind [we would, from this point of view, perhaps want to replace "mankind" with "capitalism"] is becoming a force in climate comparable to the orbital variations that drive the glacial cycles" (6).

The idea of the Anthropocene, however, cannot be separated from thinking that engages geological time and sees humans in that context. As Zalasiewicz says in the concluding paragraph of a recent essay:

> The Anthropocene – whether formal or informal – clearly has value in giving us a perspective, against the largest canvas, of the scale and the nature of the human enterprise, and of how it intersects ("intertwines," now, may be a better word) with the other processes of the Earth system. ("Geology" 12)

While a distinction remains in the treatment of the term as a name and a concept, there is a certain kind of political focus on the present, a variety of what historians call "presentism," that even scholars who emphasize the geological cannot escape in debating the term. This comes up over the question of where to place the beginning of the Anthropocene. When Zalasiewicz and others argued that the Anthropocene, on technical grounds, could be argued to have begun with the first test explosion of the atomic bomb in 1945, some others contested that date on grounds that were as much technical as they were political.[6] In a subsequent publication, the geographers Simon L. Lewis and Mark Maslin, for instance, placed the beginning in 1610 as a consequence of the Spanish involvement in the Americas, and their argument, as the following excerpt will show, was in part political (though there was a technical side to it too):

> Unlike other geological time unit designations, definitions [of the Anthropocene] will probably have effects beyond geology. For example, defining an early start date may, in political terms, "normalize"

global environmental change. Meanwhile, agreeing [on] a later start date related to the Industrial Revolution may, for example, be used to assign historical responsibility for carbon dioxide emissions to particular countries or regions. ... More broadly, the formal definition of the Anthropocene makes scientists arbiters, to an extent, of the human-environment relationship, itself an act with consequences beyond geology. Hence, there is more interest in the Anthropocene than other epoch definitions. ... Care is needed to ensure that the dominant culture of today's scientists does not subconsciously influence the assessment of stratigraphic evidence. (171–73)

And furthermore:

> The choice of either 1610 or 1964 as the beginning of the Anthropocene would probably affect the perception of human actions on the environment. The [1610] spike implies that colonialism, global trade and coal brought about the Anthropocene. Broadly, this highlights social concerns, particularly the unequal power relationships between different groups of people, economic growth, the impacts of globalized trade, and our current reliance on fossil fuels. ... Choosing the [1964] bomb spike tells a story of an elite-driven technological development that threatens planet-wide destruction. ... The event or date chosen as the inception of the Anthropocene will affect the stories people construct about the ongoing development of human societies. (177–78)

---

[6]    See Zalasiewicz et al., "When"; and Waters et al.

Since geological periods span very, very large, almost inhuman, swathes of time, an error of a few thousand years in calculating when a geological period begins usually does not matter. How would it matter to future geologists studying the evidence in the rocks tens of thousands of years from now as to whether the Anthropocene began in 1610 or in 1945? What is three or four hundred years in geological time? A blink of the eye, or perhaps something even briefer! To future geologists, this difference in time may not make sense (I say "may not" because even millennial events can be precisely determined if the necessary evidence exists).

Surely one important reason it matters today is because *we are trying argue to and with our contemporaries*, not future geologists – even as we try to reason which and what kinds of stratal evidence of human-driven changes to the earth system will survive that long. That is the inescapable presentism built into this debate, which is why the Anthropocene as merely a name and its incarnation as a concept – though analytically distinct – cannot always be separated from each other. Otherwise, think of it: the best stratigraphic proof of the human-driven changes to earth systems for future geologists coming tens of millions of years hence would be a human-driven Sixth Great Extinction. That, some fear, could take effect in a few hundred years, though, as pointed out above, the Anthropocene would then have to be invested with more weight than a mere epoch carries on the geological timescale.[7] But it might not constitute a proof for us *now* and may not in the future! The very name "the Sixth Great Extinction," however, has the history of life on this planet – its geobiological history, that is – built into it. Humanity figures in that history as a biological species, whatever our internal social differentiations.

Timothy James LeCain, a historian of coal in the United States, has nicely argued why, even though he opposes the name "Anthropocene", a geologically grounded view is important to understanding the nature of the present crisis. From a "new materialist" perspective, he recommends the name "Carbocene," which assigns agency to the planet itself in the story of human partnership with coal:

> The Carbocene ... would have the benefit of recognizing the powerful co-starring role played by coal and hydrocarbons like oil and gas in creating our current era. ... Contrary to our naive and often religiously rooted beliefs, the Earth may now be in the process of revealing itself to be deeply inhospitable to intelligent hominid life. ... Perhaps our planet is filled with deadly things that a species with a modest allotment of intelligence and an opposable thumb can all too easily use to destroy itself.[8]

I doubt that the name LeCain proposes would be universally acceptable. But he usefully reminds us as do the proponents of the Anthropocene that the imbrication of human institutions in the geological and biological processes of the planet calls on us to think in terms of *both* the history of capitalism and its inequities, and to place humans on the much larger canvas of geological and evolutionary times at *the same time*. One optic does not come at the cost of the other. Those who say that to think of the history of human beings as that of a species is to forget the history of an iniquitous global economy set up a false opposition; they forget that the two histories operate on different scales and at different levels of abstraction. True, you do not see the human inequality and suffering caused by modern institutions unless you zoom in to the history of the last five hundred years, the history of European empires, of colonies

[7]  See Ceballos et al., as well as note 3 above.

[8]  LeLain 23–24. For an interesting history of the Anthropocene and the alternative names suggested, see Castree.

and modern slavery, of factories and plantations. But equally, you do not see the "suffering" of the earth unless you zoom out to the much larger history of earth system processes (the intertwining of biology and geology on this planet) and see the pressures that human consumption and human numbers are putting on the distribution of life on this planet.[9] Human history, unfortunately, has come to a point where we need to zoom both in *and* out.

## Works Cited

Archer, David. *The Long Thaw: How Humans Are Changing the Next 100,000 Years of Earth's Climate.* Princeton: Princeton University Press, 2009. Print.

Autin, Whitney J., and John M. Holbrook. "Is the Anthropocene an Issue of Stratigraphy or Pop Culture?" GSA *Today* 22.7 (2012): 60–61. Print.

———. "Reply to Jan Zalasiewicz et al. on Response to Autin and Holbrook on 'Is the Anthropocene an Issue of Stratigraphy or Pop Culture?'" GSA *Today* 22 (2012): e23. Web. 15 Mar. 2016. Available at <http://www>geosociety.org/gsatoday/comment-reply/pdf/i1052-5173-22-10-e23.pdf>.

Barnosky, A. D. "Palaeontological Evidence for Defining the Anthropocene." *A Stratigraphical Basis for the Anthropocene.* Ed. C. N. Waters et al. London: Geological Society, 2014. 149–66. PDF file. Geological Soc. Special Pub. 395.

Castree, Noel. "The Anthropocene and the Environmental Humanities: Extending the Conversation." *Environmental Humanities* 5 (2014): 233–60. PDF file.

Ceballos, Gerardo, et al. "Accelerated Modern Human-Induced Species Losses: Entering the Sixth Mass Extinction." *Science Advances* 1.5 (2015). PDF file.

Crist, Eileen. "On the Poverty of Our Nomenclature." *Environmental Humanities* 3 (2013): 129–47. PDF file.

Finney, S. C. "The 'Anthropocene' as a Ratified Unit in the ICS International Chronostratigraphic Chart: Fundamental Issues That Must Be Addressed by the Task Group." *A Stratigraphical Basis for the Anthropocene.* Ed. C. N. Waters et al. London: Geological Society, 2014. 23–28. PDF file. Geological Soc. Special Pub. 395.

Gibbard, P. L., and M. J. C. Walker. "The term 'Anthropocene' in the Context of Formal Geological Classification." *A Stratigraphical Basis for the Anthropocene.* Ed. C. N. Waters et al. London: Geological Society, 2014. 29–38. PDF file. Geological Soc. Special Pub. 395.

Haraway, Donna. J. "Anthropocene, Capitalocene, Plantationocene, Chthulucene: Making Kin." *Environmental Humanities* 6 (2015): 159–65. PDF file.

LeCain, Timothy James. "Against the Anthropocene: A Neo-Materialist Perspective." *International Journal for History, Culture and Modernity* 3.1 (2015): 1–28. Web. 22 Dec. 2015. Available at <https://www.history-culture-modernity.org/articles/10.18352/hcm.474/>.

Lewis, Simon L., and Mark A. Maslin. "Defining the Anthropocene." *Nature* 519.7542 (2015): 171–80. Print.

Luke, Timothy W. "Introduction: Political Critiques of the Anthropocene." *Telos* 172 (2015): 3–14. Print.

Malm, Andreas, and Alf Hornborg. "The Geology of Mankind? A Critique of the Anthropocene Narrative." *Anthropocene Review* 1.1 (2014): 62–69. PDF file.

Moore, Jason W. "The Capitalocene, Part I: On the Nature and Origins of Our Ecological Crisis." *jasonwmoore.com.* Jason W. Moore, June 2014. Web. 24 Sept. 2015. Available at <http://www.jasonwmoore.com/uploads/The_Capitalocene__Part_I__June_2014.pdf>.

———. "The Capitalocene, Part II: Abstract Social Nature and the Limits to Capital." *jasonwmoore.com.* Jason W. Moore, June 2014. Web. 24 Sept. 2015.

Morrison, Kathleen D. "Provincializing the Anthropocene." *Seminar* 673 (2015): 75–80. Web. 22

[9]  Thanks are due to the historian Henning Trüper for conversations on this point. I am also grateful to Jan Zalasiewicz for many conversations in person and by e-mail and for specific and illuminating responses to an earlier version of this essay.

Dec. 2015. Available at <http://www.india-seminar. com/2015/673/673_kathleen_morrison.htm>.

Swyngedouw, Erik. "Whose Environment? The End of Nature, Climate Change and the Process of Post-Politicization." *Ambiente & Sociedade* 14.2 (2011): 69–87. Print.

Szerszynski, Bronislaw. "The End of the End of Nature: The Anthropocene and the Fate of the Human." *Oxford Literary Review* 34.2 (2012): 165–84. Web. 15 Mar. 2016. Available at <http://www.euppublishing. com/doi/abs/10.3366/olr.2012.0040>.

Viveiros de Castro, Eduardo. Message to the author. 14 Sept. 2014. E-mail.

Waters, C. N., et al. "Can Nuclear Weapons Fallout Mark the Beginning of the Anthropocene Epoch?" *Bulletin of the Atomic Scientists* 71.3 (2015): 46–57. Web. 15 Mar. 2016. Available at <http://thebulletin. org/2015/may/can-nuclear-weapons-fall-out-mark-beginning-anthropocene-epoch8295>.

Zalasiewicz, Jan. *The Earth after Us: What Legacy Will Humans Leave in the Rocks?* Oxford: Oxford University Press, 2008. Print.

–––. "The Geology behind the Anthropocene." 2015. TS.

–––. Message to the author. 30 Sept. 2015. E-mail.

Zalasiewicz, Jan, et al. "Response to Autin and Holbrook on 'Is the Anthropocene an Issue of Stratigraphy or Pop Culture?'" GSA *Today* 22 (2012): e21–e22. PDF file.

Zalasiewicz, Jan, et al. "When Did the Anthropocene Begin? A Mid-Twentieth Century Boundary Level Is Stratigraphically Optimal." *Quaternary International* 383 (2015): 196–203. Print.

# WE LIVE ON A DYNAMIC PLANET

## James Lovelock and Hans Ulrich Obrist

**JAMES LOVELOCK** *is an independent scientist, environmentalist, author and researcher, Doctor Honoris Causa of several universities throughout the world, considered since several decades as a one of the main ideological leaders, if not the main one, in the history of the development of environmental awareness. James Lovelock is still today one of the main authors in the environmental field. He is the author of* The Gaia Theory *, and* The Ages of Gaia, *which consider the planet earth as a self-regulated living being, as well as his* Homage to Gaia, *an autobiography published in September 2000. More recently, professor Lovelock published his new book,* The Revenge of Gaia.

**HANS ULRICH OBRIST** *is Codirector of the Serpentine Galleries, London. Prior to this, he was the Curator of the Musée d'Art Moderne de la Ville de Paris. Since his first show* World Soup (The Kitchen Show) *in 1991 he has curated more than 250 shows. In 2009 Obrist was made Honorary Fellow of the Royal Institute of British Architects (RIBA), and in 2011 received the CCS Bard Award for Curatorial Excellence. Obrist has lectured internationally at academic and art institutions, and is contributing editor to several magazines and journals. Obrist's recent publications include* Lives of Artists, Lives of Architects, Ways of Curating, A Brief History of Curating, Do It: The Compendium, *and* The Age of Earthquakes *(with Douglas Coupland and Shumon Basar).*

Excerpt from: Obrist, Hans Ulrich, and James Lovelock. Interview. "We live on a Dynamic Planet." *Mousse* 48 (2015): 156–63, here 156–59. Print.

THE GAIA HYPOTHESIS IS A CAPTIVATING THEORY
ACCORDING TO WHICH THE PLANET, IN ALL ITS
PARTS, REMAINS IN SUITABLE CONDITIONS FOR
LIFE THANKS TO THE BEHAVIOR AND ACTION OF
LIVING ORGANISMS. HANS ULRICH OBRIST MET
WITH THE FATHER OF        THIS         FASCINATING
CONJECTURE, THE
SCIENTIST                                              AND

201

INVENTOR
JAMES                    LOVELOCK,      TO TRACE BACK
THROUGH THE LATTER'S AMAZING   EXISTENCE,
FROM A CHILDHOOD CURIOSITY FOR SCIENCE
TO THE INVENTION OF THE ELECTRON CAPTURE
DETECTOR, THE INVENTIONS FOR NASA'S PLANETARY
EXPLORATION PROGRAM TO HIS LATEST CLIMATE
HYPOTHESES EXPLAINED IN THE RECENT BOOK
*ROUGH RIDE TO THE FUTURE*.

BY HANS ULRICH OBRIST

**HANS ULRICH OBRIST**

It's my dream come true that we are finally meeting.

**JAMES LOVELOCK**

I'm just as much interested in art as in science, so I think we will have lots of interesting things to discuss.

**HUO**

I'll begin by asking you how it all began. Was there an epiphany in which science came to you, or you came to science?

**JL**

What turned me on to science was my father. He was a remarkable man: a survivor and a hunter-gatherer, quite literally. He was born in 1872, and shortly after he was born, his father died, making it necessary for the family to live off the land. Interestingly, they were in the village described in one of Thomas Hardy's novels, *Jude the Obscure*. He said the people and the atmosphere were totally different from Hardy's description, which was a largely political view, and not true. Anyway, when I was four years old, he gave me for Christmas a wooden box containing all sorts of electrical bits and pieces: wires, batteries, bells, buzzers, lights, and so on. He said, "See what you can make." I found it a most fascinating present, and I remember going around asking people, even the postman, "Why do you need wires to send electricity along, when gas or water will go along a pipe?"

**HUO**

Who were your first inspirations?

**JL**

Like most children here, I attended what we called a dame school, which was usually run by one to three intelligent women. They taught the three Rs: reading, writing, and arithmetic, by rote. The whole atmosphere was thoroughly pleasant, and my memories of those days are ones of great happiness.

My mother was an avid reader, and we went weekly to the local library. At first I checked out science fiction books, by Jules Verne and Olaf Stapledon. But then that was not enough; I wanted the hard stuff. So they introduced me to the collection of textbooks on all sorts of things: genes, astronomy, cosmography. Not that I could understand any of it, but the mind of a young child is exceedingly retentive. Even if you don't understand, you remember the words and the context.

**HUO**

And they somehow stick with you.

**JL**

So later on, when science became more practical and I was beginning to understand it, I had this wonderful memory bank of all the terms, a kind of *Wikipedia*, to refer to. This was invaluable.

**HUO**

In your book *A Rough Ride to the Future*, you mention that it was in the novels of Olaf Stapledon that you first encountered the idea that "the Earth itself may have a consciousness, through the presence of our descendants."

**JL**

Stapledon looked on the Earth in fictional terms, and that left a mark.

**HUO**

Also in *A Rough Ride to the Future*, you write about the moment, three hundred years ago, when Thomas Newcomen invented the steam engine, and how that actually created an accelerationism, as one would call it now in philosophy.

**JL**

I've realized since that Newcomen invented not only the steam engine, but in many ways modern economics. Not academically, but in the sense that for the first time an industrial product had a big demand and was sold all over the place. It wasn't long before James Watt came along and vastly improved Newcomen's invention, and it became practical for factories, railways, everywhere.

**HUO**

From the beginning you were an inventor and a scientist!

**JL**

I'm about half and half. Ordinarily you're one or the other. The invention comes first, but intuitively, not rationally. The scientist, usually considerably later, comes along and explains the invention. Look how long it took Sadi Carnot to figure out the steam engine, 120 years after Newcomen, but he did eventually, and he explained it very effectively. Some people are mainly inventors and don't bother about the science; others are mainly scientists who are only interested in the explanation.

**HUO**

That leads us to one of your early inventions, your electron capture detector, which catapulted your work to global fame. Can you tell me about that and how that came about?

**JL**

You never know whether an invention is an invention or not. The secret, really, is that what drives invention is need. Somebody says, "I need a such-and-such. A widget." If you're an inventor, immediately the ideas come flowing to your mind. You can't think of needs in a vacuum.

I was very lucky to be working at one of the best scientific institutes in the world in those days, the National Institute for Medical Research at Mill Hill in North London. I was working with biologists, but I wasn't a biologist, I was more of a physical scientist. They had discovered a way of freezing living cells—whole animals, even—and bringing them back still alive. We trained some of these animals to find their way around a maze, then froze them, and when they were warmed up again they could still solve it.

**HUO**

That is amazing!

**JL**

I found that the critical part of a cell that's damaged by freezing is the cell membrane, which contains a lot of lipids. I was interested to figure out why, so I needed to know the exact chemical composition. It so happened that another scientist there, Archer Martin, had invented the gas chromatograph—he got a Nobel prize for that, incidentally—and I went to him with a sample of my lipids and asked, "Do you think you could analyze them for me?" (That was the way the Institute ran: you could talk to anybody, there were no class distinctions, so to speak.) He said, "Yes, I'd love to. Where is it?" I said, "Oh, it's that tiny drop in this test tube." And he said, "Useless. No, I'd need at least a hundred times as much." My heart sank because that would be three months' more work on a subject that I found rather dull.

Then he grinned, and said, "Or you could invent for me a more sensitive detector."

**HUO**

So that's how it happened?

**JL**

That's how it happened. He voiced a need, and instantly I thought, "That's much more fun than freezing animals." And such was the nature of the Institute that the director was perfectly delighted that I would switch from one subject to another. So I invented a detector which at the time was called an argon detector, and more than a thousand times better than any other then available. It was commercialized, and sold all over the world for about two years until somebody else invented an even better one, which is now the standard.

**HUO**

It was a very important moment because it was the beginning of actually proving that the ozone layer was being depleted. It had a real impact on the world.

**JL**

That particular invention had a huge impact. It got the whole subject of gas chromatography established, which has been invaluable in medicine, in chemical industry, everywhere.

What happened next is what always happens in science. The thing worked beautifully and solved problems for thousands of people, but every so often there was an anomaly. Instead of giving a positive detection, some compound would give a negative one. I realized that the compound was capturing electrons, and then I started investigating that specifically and came up with a detector that was incredibly sensitive— so sensitive that if used properly, if someone in Japan spilled a liter of a detectable compound, and if there wasn't any other of that compound in the world, we could pick it up here in about two or three weeks.

It was used widely to detect pesticides after Rachel Carson wrote her book *Silent Spring*. It was a driving force behind the green movement in many parts of the world.

**HUO**

In chapter seven of *The Rough Ride to the Future*, you propose that we might resolve the problem of global warming by living in giant cities—cities much bigger than anything we ever imagined.

**JL**

Yes, the human equivalent of a termite nest.

**HUO**

I'm fascinated by these cities and how they would look.

**JL**

If termites, which are exceedingly simple things, can build that extraordinary air conditioning tower—they don't live in that, what you see is the air conditioning chamber for the underground nest—we ought to be able to do a lot better.

**HUO**

At a certain moment, you made the decision to no longer be part of an institution to escape bureaucracy.

**JL**

Yes, it's nearly impossible. The brighter scientists must come to work long before anybody else arrives, or stay until some impossible hour like midnight, to do their work, because the rest of the day is interruptions, interruptions, interruptions.

**HUO**

Do you remember the moment when you had this epiphany that you needed to leave the institution?

**JL**

Yes, it occurred about two years before I actually did leave. Up until then, so well was that particular institution run, there was no need. We had nearly total freedom. We could come in at any time, leave at any time, and we were extraordinarily well paid. We had six weeks of paid holiday a year, but almost nobody took it because they found their work too interesting. But the director who was responsible for this wonderful atmosphere was retiring, and I knew things would change. You could see it everywhere, the bureaucracy growing and growing.

In 1958, for reasons unrelated to my work, I decided I didn't like living in London and bought a small cottage in Wiltshire, about a hundred miles away, and tried to commute. Eventually I realized that working from home is much better than working in a laboratory, even a very good one. Then, quite out of the blue, in early 1961, I got a letter from NASA, which was only three years old at that time.

**HUO**

Because of your extraordinary invention of the electronic capture detector?

**JL**

Yes. They needed tiny instruments to mount on their early spacecraft to send to Mars to see what the soil was like, the atmosphere, and so on. A mass spectrometer in those days weighed about a hundredweight, and there's no way that, with their simple rockets, they could carry one.

Having read science fiction as a kid, to be invited by NASA to work on an experimental expedition to Mars . . .

**HUO**

It was a dream.

**JL**

I couldn't refuse!

**HUO**

And through this NASA invitation, which had to do with the Viking program, you became interested in the Martian atmosphere, and life forms on Mars. That research was one of the most important moments in your career.

**JL**

Yes, but it's very complicated. I'm an inventor, mainly, and NASA wanted me for my inventions. They didn't give a damn about my science. So I didn't meet the NASA scientists, I met the rocket engineers, who are a different breed. They are very practical people. Soon they were using my work as a leak detector, because tiny leaks are absolutely fatal in spacecraft.

**HUO**

But you were in fact also doing science there, and that's what became so significant for the world, in terms of Gaia.

**JL**

It was luck once again. Since NASA had just been founded, everyone was working in trailers. There was no institution per se, hardly any security, hardly any bureaucrats, so you could move around and talk to anybody. I remember vividly one biologist who moonlighted as a stand-in for Tarzan in Hollywood!

**HUO**

A Johnny Weissmuller look-alike!

**JL**

It was in September 1965, so this year it will be fifty years from the inception of the idea. I was in a room with the philosopher Dian Hitchcock, who was one of the most intelligent people I have ever met. To give you an idea of how smart she was, she had done no science at all, but was employed by NASA to check the logical consistency of the experiments that were being sent to Mars.

In walks the astronomer Carl Sagan. Carl and I shared an office, and we talked a lot whenever we got a chance. Then in marches another astronomer, carrying sheets of paper, who announces that a complete analysis had been made of

the Martian and Venusian atmospheres, and that they are nearly all carbon dioxide with just traces of other things.

I knew instantly that there was almost certainly no life on either planet, and that suddenly made me think, well, what about the Earth? Why does it have an atmosphere so different from its two sister planets? And then, it came to my mind as a flash of enlightenment: we must be regulating the atmosphere. And then I thought, again almost instantly: where do the gases come from? We know that oxygen comes from plants, and methane, which it reacts with, comes from bacteria. Those are both living things.

I gave voice to my thoughts, and Carl Sagan's first remark was, "Oh Jim, it's nonsense to think that the Earth can regulate itself. Astronomical objects don't do that."

**HUO**

Was he dismissive?

**JL**

Yes. But then he said, "Hold on a minute, there's one thing that has puzzled us astronomers, and that is the 'cool sun problem.' At the Earth's birth, the sun was 30 percent cooler than it is now, so why aren't we boiling?"

**HUO**

And that guided your direction.

**JL**

I thought, if that's true, then all the biota have to do is regulate the $CO_2$ and they can control the temperature. And that's what they've been doing.

**HUO**

So you had this epiphany in 1965, but it wasn't yet called Gaia, it

was only later when you were speaking with your neighbor, the great writer William Golding, that the name came about.

**JL**

Carl Sagan had been married to the biologist Lynn Margulis, who became my colleague subsequently.

**HUO**

Lynn Margulis took Gaia into biology.

**JL**

Yes, she was the first biologist who took it to heart, and she contributed enormously, because although I was trained from the medical side in bacteriology, I tended to think of bacteria as pathogens. I hadn't thought of them as the great infrastructure that keeps the Earth going. It was Lynn who drove that home.

**HUO**

How was the theory received?

**JL**

The biologists hated it like poison. For instance John Maynard Smith, who was one of our senior biologists. He later became a close friend. That's what's been so wonderful about my life: the number of distinguished people that I've encountered, some in quite a hostile manner, who then became friends. William Hamilton was the same. He was another great biologist.

**HUO**

That leads us to Bruno Latour, the philosopher and historian of science who often quotes you. He sent me two questions for you. Actually, he wanted you to react to two passages from his Gifford Lecture,

# SARACENO'S
# MONADS AND SPIDERS

### Bruno Latour

TOMÁS SARACENO has a unique way of linking art, science, and philosophy. For me, the most striking discovery he has made is a powerful way to solve the conundrum of relations and essence, or to put it in less abstract terms, a way to thread habitats – spheres, globules, spaces – through extended networks. While everyday language distinguishes between entities (which have borders) and relations (which are then added to entities) – as if entities entered into relation only after being defined – Saraceno provides some very complex devices to show that it is possible to obtain locally habitable niches through relations.

This was clear both at the 2009 Venice Biennale, where I first encountered his work (*Galaxies Forming Along Filaments, Like Droplets Along the Strands of a Spider's Web*; see fig. 1), and in the piece he did for the 2014 *Anthropocène Monument* exhibition in Toulouse (*Museo Aero Solar*; see fig. 2): while the hot-air balloon on which the latter piece centers is indeed an enclosed space, it is one that is the result of an incredible extended network, including citizen organizations and activists, who have collected plastic bags and glued them together. Yes, it is local and could sail by itself, completely autonomously (if there were enough sun!), and yet it is made of something – plastic bags – that is simultaneously totally banal and omnipresent. One could see the same ability to obtain extreme

*For brief information on the author see* r·M!74.

individualization from an extremely extended collection in *On Space Time Foam* (see fig. 3), a marvelously clever (and also immensely complex) work shown at HangarBicocca in Milan in 2012. This time it is the visitors who are made to realize – because they cannot walk without taking into account their relations with other visitors trying to crawl along three layers of inflated plastic – that they are no longer autonomous entities but wholly dependent and fully *heteronomous* characters.

Saraceno, in my eyes, explores a sort of Leibnizian philosophy where the relation between the whole and its parts is replaced by a habitat produced by following proliferating vibrations. This is why he has been so attracted to spiderwebs (*Social … Quasi Social … Solitary … Spiders … On Hybrid Cosmic Webs*, 2013; see fig. 4). No wonder! It is impossible to durably separate the spider from its web, and yet there are endless ways in which you can focus either on one or on the other. His exploration has been so intense that he has had to produce new systems of visualization to follow the work of spiders. Rare are the artists who have published papers with scientists because the science they had to feed on was too limited! To extend the frontier

of art, Tómas first had to push the frontier of spider science.

How could vibrations through networks be an alternative to the part/whole relation? In that they offer the key to following, simultaneously, what makes the spider move and how the web reacts to its environment. It is in this sense that Saraceno's work can be roughly considered to be "ecological art": not at all because he popularizes some of the findings of environmental science, but because he has offered novel ways to represent – that is, to render visually discernible – what it is for any entity to have – no, I should say, to *be* its environment.

What renders his work so relevant for a set of exhibitions on the globe is that Saraceno never tries to get straight at the globe. When he produces local globes, arrays, webs, it is always by insisting on the extended network of which the globe is not just an element but a vibrating aspect, just like a spider in a spiderweb. In §67 of his "Monadology," Leibniz imagined the physical world as a pond full of fish, each fish made of many nested ponds full of fish (222). For Saraceno, a Leibnizian artist, it is "spiderwebs all the way down" and the spider itself another set of folded spiderwebs.

Works Cited

Leibniz, Gottfried Wilhelm. "The Principles of Philosophy, or, the Monadology." *Philosophical Essays*. Ed. and trans. Roger Ariew and Daniel Garber. Indianapolis: Hackett, 1989. 213–24. Print.

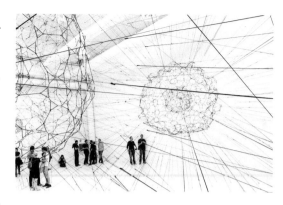

1   Tomás Saraceno. *Galaxies Forming Along Filaments, Like Droplets Along the Strands of a Spider's Web.* 53rd Venice Biennale, Palazzo delle Esposizioni. 7 June – 22 Nov. 2009.

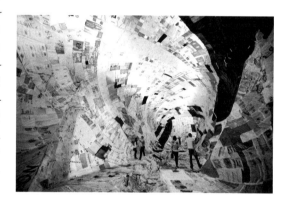

2   Tomás Saraceno. *Museo Aero Solar.* Exhibition view. *Anthropocene Monument.* Les Abattoirs, Toulouse. 3 Oct. 2014 – 4 Jan. 2015.

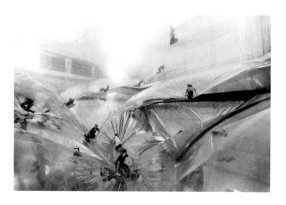

3   Tomás Saraceno. *On Space Time Foam.* Exhibition view. HangarBicocca, Milan. 26 Oct. 2012 – 3 Feb. 2013.

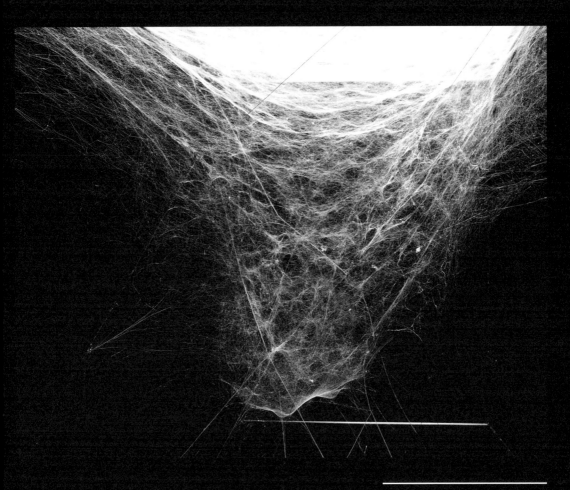

4  Tomás Saraceno. *Social ... Quasi Social ... Solitary ... Spiders ... On Hybrid Cosmic Webs.* Installation views. Esther Schipper, Berlin. 15 Mar. – 13 Apr. 2013.

# THE WORK TO BE MADE:
# THE ART OF TOUCHING

## Antoine Hennion

*Yes, in our private encounter with the work, we are not alone.*
### Étienne Souriau

THE GHOSTLY SHADES that go with each of us sustain our wanderings more staunchly than many visible beings do. For my part, one mask makes me a sociologist, another makes me a music lover, and yet another makes me ask myself what art wishes of us. When I write from behind the first mask, the two others over my shoulder evince perplexed, possibly mocking smiles. Admittedly, this dance of clashing masks makes a bit of a commotion, but it is what makes me write. Can this experience, curious and at the same time so ordinary, be taken seriously – this sense of an external call which, even as it demands our labors, relegates all of them to the rank of mere means, necessary but insufficient? Why is it always from *elsewhere* that the idea arrives, as though the interior of our discourses counted for less than the knock at the door that comes to disturb it? To put it like this is, of course, too simple. You have to have teased out the arguments, gone over every word again and unfurled their fabric: without that indispensable work, these ghosts would have no text to come and rumple up. For the music lover too (it would

ANTOINE HENNION *is a professor at* MINES *ParisTech and the former director of the Center for the Sociology of Innovation (*CSI*), where he developed a problematization of mediation that spans cultural sociology and science and technology studies. His main publications include* The Passion for Music *(2015) and* La grandeur de Bach *with Joël-Marie Fauquet (2000).*

1–4 African Masks.

be better to say the "experiencer" of music, the person whom music in its thousand guises has disturbed, transported, changed), no charmed moment is possible without his collections, his outings, his endless discussions, his books; and there is no singer without scales and exercises, without rehearsals and notes scribbled on scores – all that, sometimes, for music to seem to send out a sign and tell you it is right there beside you …

### CREATION?

YET I AM NOT going to throw myself into the hackneyed exercise of the author going back over his own writing. I shall launch, rather, on a hesitant revisiting

of the paradoxical idea of creation. Inquiring into the modes of existence provides a double orientation for such an endeavor. First, it extracts creation from the lead casing in which it has been immobilized by the many institutions concerned with regulating it – religion, art, space science, the life sciences, etc. But that isn't enough in itself. We also have to readdress the problem posed by creation in a lighter – and, particularly, more mobile – mode. How are we to think the emergence of previously unknown beings and objects, at the point where the existing modes join, at the places where they bleed into each other to open up – and sometimes instantiate – new realities?[1] What relation does this have to deliberate effort aimed at creating works?

If we suppose a stable world, a Euclidean space *within* which things obey their laws, then the elsewhere from which the new emerges can arise only out of the supernatural or from the genius of the modern artist, who is proclaimed a creator in place of the gods. The contradiction disappears if the world is not closed and finite: each reality, as it unfolds, becomes increasingly particular as it carves itself out. This is perhaps another way of expressing the project of pragmatism: going along with indefinite extensions as they occur.[2] If there are only flows and experiences that are always ongoing, in an open, indeterminate pluriverse, as William James argues in A *Pluralistic Universe*, and if those worlds "still in process of making"[3] are heterogeneous networks, with no exterior, expanded or contracted, then the problem of creation is reversed. Every act brings something into being, or fails to, and it is the maintenance of a small degree of stability that is the exception. Conversely, though it does not actually reduce to them, every act is itself supported on a stack of things that "make (something) happen": mediations,

habits, arrangements – so many "makings-happen" of every kind, without the support of which nothing is made (Hennion, "Vous"). In these conditions we must perhaps dare to forget the majestic opposition between between *poiein* and *prattein*. Creating is not grandiose; it is the most ordinary act there is. It is no less vital for all that, and no less risky. Quite the contrary, from the largest to the smallest, it can always succeed or fail. This is true of art and of love, but it is also the case with cooking, for example. There is no excess of lyricism or mysticism in all this; it is, in fact, very technical. What is involved here is something like the art of "making exist," an art that is, in the first place, manifested by beings and things themselves.[4] Everything happens *in between*; it operates without a clearly defined subject or object; it is neither in the brain nor in the work, but that doesn't mean its performance isn't entirely dependent on an unforeseen feature, a felicitous accent, a successful detail that changes everything. In each case, the extreme precision of what is in play is striking. The little difference counts more than what it stands out from. There lies the heart of the matter – in the crafting of an experience always in need of remaking, in contrast to the coarseness of fixed, already dead objects.

## ON THE SURFACE OF THINGS

IT IS THIS THREAD, the thread of the right gesture, that I'd like to follow, leaving the great stage of creation and placing myself, more modestly, at the level of an experience we all have as soon as we do something. Let's start from these contacts with my shades, for if I have relived this experience by thinking of the table I write at or the music stand I sing at, that's the same as what is felt by the craftsman

[1] Doubtless from those murky places where "the modes lend one another certain of their virtues" (Latour 249).

[2] See Hennion, "Enquêter."

[3] James, *Meaning* 226; elsewhere he writes: "What really *exists* is not things made but things in the making" (*Pluralistic* 263).

[4] This is the force of the [REP] mode proposed by Latour in the *Inquiry*.

or the wrestler, the orator, the surgeon, and many others. As soon as there is something to be done, a frontier looms, as uncertain as it is decisive, where everything is in the balance. We are talking about the climber's grip, the jazz player's blue note, the care worker's finely judged gesture, or, alternatively, the footballer's pass, to take some examples I have worked on before. Now all these words speak of touch, of contact. They refer us to brushing up against surfaces. To speak helpfully of what is created, do we not have to attend to these frictions? Might we not cleave to this strong impression and adopt an unorthodox watchword: to get into things, we have to stay on their surface?[5] Admittedly, we have so often been taught the opposite – to look behind appearances, to get to the bottom of things, to delve deeply into questions, etc. And, to make up what we thought might somehow be missing from the ponderousness of matter, the fixed nature of things, the rigor of objectivity, it seemed enough merely to add in their inverted doubles: the lightness of the idea, the fluidity of souls, the inventiveness of subjectivity. With things thus conveniently framed, why look any further? All we had to do was add the intention of a subject, the genius of a creator to the element of labor, and this business of shades knocking at our doors was settled ...

Well, it wasn't. And here we are bogged down again in the string of classic dualisms. Lethal dualisms, particularly as we are talking of aesthetics. Form versus content, matter versus ideas, objects versus subjects – is this really what it's about? Sociology, believing it is criticizing these dualisms, merely superadds an arrogant scientism to them, as loud in its criticism of the notions of gift, taste, and emotion as it is deafeningly silent when it comes to getting anywhere near the experience that arises, in infinitely varying forms and ways, *on contact with works of art* ... Causes, effects – these are just scaffolding, just crutches that have the bogus solidity of dead bodies. How could my discipline speak of that presence when all the words it uses separate, isolate, and reduce the living element of things, replacing it with a set of structures and rules, conventions, beliefs and determinations – when it does everything but attend to what is going on, which is irreducible to its enabling conditions? To speak of surfaces and touching, of variations and repetitions, is to argue against an always unilateral "deepening," whether that plunges down into the depths of being or ascends to the heights of the arbitrary nature of laws. We cannot touch either the law or being, and they do not touch us. On the other hand, the unfolding of contact gives us the feel of the world in ourselves and ourselves in the world – but the world as a new arrival, not as a given: scientism blocks off the path of experience and demands that we confine it within its "variables." What could be more fixed than a variable?

So a first, still inadequate formulation suggests itself: favoring the mobile over the fixed, or rather accepting this Jamesian flux of a world constantly making itself, and hence the idea that, to allow the experience in progress to play itself out, we must glide along with it, let ourselves be guided by its resistances, embrace its swirling eddies. It is at this point that the emphasis on touching surfaces assumes its full meaning, since the point is precisely not just to choose between the fixed and the variable, nor to aspire to say the unsayable, but rather to turn the call emitted by things-to-come into something tactile. Beyond the banal opposition between what we might think of as solid, firm, and measurable and what, by this very division, would be relegated to the evanescent, the transient, and the subjective, attention to experience shifts the problem *technically*, not towards an eternal plea to overcome dualism, but towards a new sensitivity to the surface of things: towards a contact with – a brushing against – what emerges from the passing moment. Dualism doesn't

[5]  Writing of Orpheus and his lyre in *The Five Senses*, Michel Serres has changed the impressive confrontation between subject and object into a furtive scraping of the fingertips on a taut string.

also said – that is simply pointless to string together into a superdualism that absorbs them all. Quite the contrary: they increase and unfurl themselves on contact with things.

## MAKING EXIST

HOW BETTER to describe the effect of presence of an *advenant*? I am going to highlight here the case of the art lover or *amateur*, understood as the person who makes an object exist for himself (cf. Hennion, "Those"). This is an inadequate formulation, of course, since it puts the emphasis on the amateur, while no one is more aware than he that it is equally the object that makes him exist. In artistic work, dance, singing, or athletic training, the way of it is always – for each after its own fashion – that you have to let things come, to allow the body, sounds, and gestures their space; aiming directly at the desired result prevents it from happening ("pace yourself!" says the coach to the sprinter; "careful, you're playing notes!" says the piano teacher, as if that were the worst thing to do!). The desired result comes as a bonus, whereas it is immediately stifled if you are bent on deciding it rather than simply *going with* it. All these practices work on "the moment"; they are experiments on experiences. To speak of the in-between and of how things "work out" does not imply artistic vagueness or an imprecise zone in which "anything goes" – far from it. A singer, for example, isn't just carried vaguely along with the stream. The painstaking process of learning to tame the voice is by no means one of cold technique with emotion grafted on later to add some warmth. Nor, from the body to the work being interpreted, is the singer carried along in some vital ferment with no base or boundaries to it. On the contrary, he speaks of nothing but the placing of the voice, of pressures and projection. He is confronted with extremely precise *surfaces*. Flux is not blur. But it is important that

so much ask to be overcome – a move that actually keeps it going indefinitely – as to be localized: it is a touching. To make aesthetics a technique of the tangible is to say that, as the two meanings of the verb "to touch" express so well, it is an art of caressing the *advenant*,[6] a rapprochement – which does indeed accept a host of practical dualisms, as James

[6]  Translator's note: I have retained Claude Romano's term *advenant* here, with its sense in recent French phenomenology of the person whom the (ontic) event comes to or is directed towards (Romano 52–55).

produce it and the sound emitted, but becomes a kind of cloth unfurled before you, which expands or contracts, which rolls back on itself or sweeps all before it. Are these imaginary formulas or palpable realities? How disappointingly reductive of what actually happens that would be! Admittedly, the teacher reflects such images back to the student, but he does so to help him in the constant back-and-forth in which he is constantly wavering between the sense of doing something and the contrary impression of being carried along through being possessed, as it were, by his own singing, which he "simply" has to maintain, to monitor without trying to control it – an action which, far from bolstering it, would immediately deprive it of its impetus.

I said that as soon as it comes to doing something, a frontier looms. But a frontier with what? Are we back with the artwork again? Yes, but not in the sense of a great leap into the sublime: what I described with regard to breathing or sound goes for each of the thresholds to be crossed. Music is no more given than is the body or the voice; it too takes the form of successive layers that have to be made to appear, one by one. The "same" notes on the same sheet of paper aren't the same when you have to sight-read them as when you have to attune your ear to them, combine them with words, or familiarize yourself with a piece of music – or when, subsequently, that music, which you still believe you are reading, is in reality already there, within you, and is, in that state, an entity of quite another order. Later, things will reverse even more radically between what seemed so firm – the score in front of you – and what seemed to veer off in all directions – your uncoordinated efforts to realize it by wrestling with the notes, your voice, your breathing, the sound, the expression. For as you get to know the score better, the work peels away from it. The flat surface of the paper is no longer a familiar indicator providing points of reference, and once again, everything remains to be done. It's less about "moving on" to the music once you've acquired the notes – as though

we are talking about surfaces – plural – here. Beneath one layer there is always another. The diaphragm, the stomach, the palate, the nasal cavities are things he gradually learns to *feel*: what's involved here is not physiological organs or mere mental images, but a layer of experience that acquires consistency. It is the same with breathing, sound, the voice: there is not one of these elements that does not appear in this way, as a zone of resistance that you have to have experienced – both emerging, affording one purchase and support, and at the same time referring to another layer. Each layer silences the previous one: once the sound has been better mastered by improving the breathing, for example, it no longer occupies the same place, in either the mind or the body. It is no longer that materiality of air, making the connection between the parts of the body that

an echo between words and music begins to sound right and an unknown emotion wells up in some area far beyond music; or, conversely, the song takes on body, timbre, vocality, and performance, and the notes on paper are now merely the support of such flights. In each case a new resistant surface takes shape, a surface you can lean on only by first constituting it, so that it will never be clear which one has created the other. This is that idea of layers I spoke of – provided that no cumulative progression is implied, nor even hierarchy. It is, rather, about the effects of successive veils, which are made to stand out one by one, as they might be picked out by the lighting in a theater, each seeming merely to lend its substance to the one that is removed ...

This is what Étienne Souriau calls "the work to be made": "It seems to say to us: And now, what are you going to do? By what action are you going to move me forward or knock me back?"[7] This is a work "to be made" – not in the contemporary sense of being an "open" work for the audience to rewrite as it pleases, nor simply reducible to the practice of those who make it what it is, but rather in the sense that, from the outside, this personage questions us with a fearsome precision, without ever supplying an answer. That there should be potential beings calling for the more intense existence that attention can give them is something better understood by calling to mind a jazz solo improvised in the night, the smile of a homeless person or caregiver, the performance of a sportsman, the despair of an Alzheimer's patient put in an institution, or the jubilation of an engineer who has solved a technical problem, than by confining ourselves to the false materiality of things present: all these experiences are about an interlacing of dependent, indefinable beings that "come together" to a greater or lesser degree, that are sometimes diluted or destroyed, that can neither be fixed in their identities nor reduced

there were technique on the one side and art on the other – and more about allowing what we call, out of convenience, a work (it's more like a series of openings) to gradually gain consistency. Sometimes the notes and chords assume a quasi-physical reality, like a statue one might be sculpting, and the words are merely the soil from which its substance comes; another day, a phrase begins to live, a phase that had previously been concealed by its own notes; or

---

[7]   "Elle semble nous dire : et maintenant, que vas-tu faire ? Par quelle action vas-tu me promouvoir ou me détériorer ?" (Souriau 208).

to external causes. Souriau spoke of uncertain be-
ings whose gradient of existence depends on the
relations they maintain, on which we ourselves rely
for our own existence.

If, literally, apparitions are what we make ap-
pear, then they are more real than reality, not less.
Decidedly, there was nothing exotic in conjuring up
shadows, ghosts, and masks. These are the faces of
what calls to us, from worlds yet to be made, from
worlds that are coming to pass, provided we lend
them our support.

*Translated from the French by Chris Turner.*

Souriau, Étienne. "Du mode d'existence de l'œuvre à
faire. [1956]" *Les différents modes d'existence.* Paris:
Presses Universitaires de France, 2009. 195–217,
here 215. Print.

---

*Works Cited*

Hennion, Antoine. "Enquêter sur nos attachements.
Comment hériter de William James ?" *SociologieS*
23 Feb. 2015: n. pag. Web. 26 Jan. 2016. Available at
<http://sociologies.revues.org/4953>.

———. "Those Things That Hold Us Together: Taste and
Sociology." *Cultural Sociology* 1.1 (2007): 97–114. Print.

———. "Vous avez dit attachements ? ..." *Débordements.
Mélanges offerts à Michel Callon.* Ed. Madeleine
Akrich et al. Paris: Presses des Mines, 2010. 179–90.
Print.

James, William. *The Meaning of Truth: A Sequel to
Pragmatism.* New York: Longmans, 1909. Print.

———. *A Pluralistic Universe: Hibbert Lectures at Manchester
College on the Present Situation in Philosophy.* New
York: Longmans, 1909. Print.

Latour, Bruno. *An Inquiry into Modes of Existence: An
Anthropology of the Moderns.* Trans. Catherine Porter.
Cambridge, MA: Harvard University Press, 2013.
Print.

Romano, Claude. *Event and World.* Trans. Shane
Mackinlay. New York: Fordham University Press,
2009. Print.

Serres, Michel. *The Five Senses: A Philosophy of Mingled
Bodies.* Trans. Margaret Sankey and Peter Cowley.
London: Continuum, 2009. Print.

# ON THE ODDNESS OF HABIT

## Michael Cuntz

To rid himself of all habits seems to be the nameless protagonist's project in Georges Perec's 1967 novel *Un homme qui dort*: "You have everything still to learn, everything that cannot be learnt: solitude, indifference, patience, silence. You must become unused to everything" ("Man Asleep" 162).

The habits given up by the young man, a student of sociology, are both social and vital: to be in company, to communicate, to act impatiently and directly, driven by needs and desires – the very things that make differences in the relation of a living being to his surroundings, structuring them and making them an environment, a habitat. What is at stake here is an attempt at a radical detachment from one's social and bodily existence in order to eradicate all the influences that affect and "alienate" the self. When he is not roaming the streets of Paris alone, *à la dérive*, the student withdraws into the refuge of his *chambre de bonne*, a minimal habitat and protective environment supposed to shield him from the outside world. But when the veil of habits is torn apart, what appears behind it is not the new, true self nor a new, true vision of the world; there are only more habits, past habits whose eradication is tantamount to the complete loss of memory, or new habits he cannot avoid acquiring,

**Michael Cuntz** *is a professor of media philosophy at Bauhaus-Universität Weimar. His main fields of research include the relations between humans and nonhumans as well as French theories of cultural technology and media anthropology. Recently he has published, together with Jörn Ahrens, Lars Koch, Marcus Krause, and Philipp Schulte,* The Wire: Analysen zur Kulturdiagnostik populärer Medien (2014).

like the constraints he imposes on himself as he organizes his strolls through the city or invents a game of solitaire based on a sorting algorithm, tying himself to a stack of cards worn by the endless repetition of the game. To lose the habit of appreciating food according to social connotations and gustatory

1–5 *Un homme qui dort*. Dirs. Georges Perec and Bernard Queysanne. Dovidis, Satpec, 1974. Film stills.

preferences, he forces himself to consume the same cheap meal each day. What must also be obliterated in the process is language itself, because naming means drawing distinctions, which means giving too much weight to the outside world. In mindless, amnesic routine and repetition, the student's world becomes uniformly grey.

Despite all his efforts, this exorcism of habit (a failure in any case) does not produce the desired result: instead of liberating the protagonist from the contingencies of mundane experiences and granting him autonomy, instead of providing a reliable foundation for his existence, it produces, first, a total standstill, then the breakdown of his existence and his refuge-habitat: shot through with cracks, the house literally threatens to come down.

But this strange experience, the self-experiment and exercise in solitude performed by this young man – into whose position we are projected by a narrative voice that speaks of the protagonist in the second person, thus addressing the reader as well – does not start as a voluntary decision; it is not a premeditated act, but rather an act that just happens not to occur. For all its destructive potential, it is not an existentialist *acte gratuit*. Something simply broke down, gave way – inside? around? – this young

student, who is more akin to Melville's Bartleby than to Sartre's or Camus's heroes. While he is preparing for an exam, his course of action comes to a halt for no particular reason; he remains in bed, and it is only in his mind that he executes all the small routines that would have led him to the seminar room, where he would have filled some sheets of paper with thoughts he does not have. What has been interrupted is the gearing, the infrastructure of habit itself, and this leaves the young man indisposed. Habit, as has been repeatedly stated by authors such as Aristotle, Félix Ravaisson, William James,[1] Arnold Gehlen, Michael Polanyi, and of course Bruno Latour himself, makes us do something, prepares us to do something, pushes us forward *before* there is any need for us to think, thus bridging (or smoothing) the gaps of the small discontinuities inherent in any course of action.

Ever since Aristotle – who sees the sphere of ethical virtues and the *aisthētikon*, the sensitive soul receptive to outward influences, as the sphere in which humans have to negotiate with their (animal) desires as well as the vicissitudes of life – philosophical reflection on habits and *hexis* as disposition has also been sounding the strange topology of habit(us) between the inside and the outside, as

[1]   "There is no more miserable human being than one in whom nothing is habitual but indecision, and for whom the lighting of every cigar, the drinking of every cup, the time of rising and going to bed every day, and the beginning of every bit of work, are subjects of express volitional deliberation" (James 80).

a *medium* between the self and the other, as something an entity owns and is owned by. Thus Perec's expression "become unused to everything" takes a clear stand regarding the actual mode of existence of habit/hexis/disposition: habits bind entities together, inevitably tie each and every entity to others – and ending these entanglements becomes the project this novel follows to its (almost) bitter end.

Written in the mid-sixties of the last century, Perec's novel is more than a curious case study of a bizarre dropout. It is certainly no mere coincidence that the young man who comes to "prefer not to" is a student of sociology. He finds he has not much to say about Marx, Weber, or Lukács; his studies are interrupted during the reading of Raymond Aron's *Eighteen Lectures on Industrial Society* and its analysis of that society's ever-faster quest for progress (and modernization).

Like others, Perec became disenchanted with Marxist and liberal progressivist narratives and with standard accounts of social relations that left no room for the appreciation of nonhuman entities; he was particularly dissatisfied that things were granted no other role than that of economic and semiotic carriers of values and connotations. He also became estranged from an avant-garde conception of art and literature that acknowledged only one habit: the utter contempt for any kind of habits and the iconoclastic wish to break them

– in other words, the belief that pushing the reset button again and again is a solution to anything. Due to an understanding of habit that reduces it to what just keeps us going on the same path as before, avant-gardism and the modernist front in general postulate the ideal of moving forward without availing themselves of the very thing that usually makes us move forward.

Almost parabolically, Perec's novel exposes the inherent schizophrenia of a modernist project that strives for a solution to a self-created problem. Social alienation, produced by a misconception of the social itself as an alienating force, takes as a remedy the actual cause of the problem: the belief that the self should immunize itself against all those "external" influences it was always already tied to by habit – via the body, sensual perception, experience, the social, tradition, education, institutions.

Consequently, the main protagonists of (at least a certain) modernity, the most prominent being Descartes and Kant, had to exclude habit completely from the foundations of modern thought – and this not, at least for Descartes, because habit was thought to be too rigid and inflexible, but rather because habits and customs were thought to be too volatile, too unreliable, a cumbersome bric-a-brac that had to be demolished to clear the field for pure reason. How can modernity be reset when Descartes

started the entire modernist project by resolutely pushing the reset button?

Significantly, even before the *Meditations* that provide a subtext for *A Man Asleep*, Descartes starts his very first text, the *Regulae ad directionem ingenii*, with a critique of a false habit: to trust experience means to confuse science with the arts, which are based on "a certain application and habituation of the body" (65) and therefore on the *hexis* of ethical virtues. In short, the false habit consists in referring to anything based on habit.

This strongly indicates that within a project like AIME that intends to reevaluate and even reset modernity, habit might be something more than just another of the moderns' modes of existence, since the core of the modernist project, as constituted during the seventeenth century, is based on the very exclusion of habit. It is not only that there was no room for it; it was actively fought because it was considered a producer not of essences, but of deceptive appearances resulting from untrustworthy and contingent experience, which impeded pure reason. Instead of negotiating diplomatically with the confusing variety of customs and habits, modernism declared war on those enemies. The careful rehabilitation of habit – well on its way in an important undercurrent of modernist thought at least since David Hume – is itself a significant readjustment of the parameters of mainstream modernity.

This might already suffice to make [HAB][2] something of a special case, but there is further evidence that habit, however inconspicuous, is nonetheless a key element, both in the architecture of the AIME project and for dealing with the moderns. With regard to the "specifications" for the modes of existence (Latour 182), habit thus appears to be charged with a particularly heavy load. But at the same time, it raises the question of whether [HAB] can be easily situated within the table of categories underpinning

AIME. Where to locate it? These aspects come into play once we shift our attention from the object of inquiry to the inquirers themselves, Bruno Latour and his fictional proxy, the young female ethnologist. First, one has to touch on the strategic value of habit in *An Inquiry Into Modes of Existence* to understand what is at stake when Latour, like Barbara Cassin, rehabilitates doxa against aletheia, sophism against Plato (268–69). In drawing on the concept of tacit or implicit knowledge, which is firmly connected with habit (e.g. by Polanyi, Maurice Merleau-Ponty, and Gilbert Ryle), Latour tries to cushion the sharp contradiction between what the moderns say and what they do, since there is a knowing by doing which, in contrast to explicit statements, cannot betray actual courses of action. What is reconciled here, too, is the methodological imperative to just follow the actors with the urge to correct the errors in the explicit self-accounts of the moderns. All explicit knowledge is, rightly or not, identified with [REF] and scientific truth, obviously the most ill-conceived mode in Latour's view (leaving aside for the moment the rightly ostracized, thoroughly malignant spirit [DC]).

Furthermore, one finds the architectural – or structural – hunch confirmed: from the start of the introduction, Latour makes explicit his book's therapeutic objective: to cure the moderns of their lack of space, and of their status as refugees without proper dwellings (and it is difficult not to be reminded here of Lukács's old concept of transcendental homelessness). The way to achieve this is by calling for the restoration of some of those scorned institutions and the construction of new ones. This seems to be the way to overcome the uncomfortable disorder the moderns live in. Although Latour refuses to believe in domains, he wants to believe in institutions revived or to come – provided each one finally manages to house a mode of existence properly.

[2]  For a brief explanation of these abbreviations, which refer to the modes explored in the AIME project, see the glossary in this volume (r·м! 543–47).

As we have already seen with Perec, it is more than a play on words that connects habit to habitat, a link Latour himself of course does not fail to underscore. Like Gehlen before him, Latour explicates the relation between habit and institution, framing his chapter on [HAB] with long opening and closing reflections that develop a plea for the necessity of rehonoring institutions: habits prepare the ground on which institutions are built (260–61, 280–81).

But even setting this aside, habit is linked in an even more fundamental way to AIME, and also to Actor-Network Theory: For what else do ethnologists do but observe and describe the habits and customs of the collectives they study? What is the project of *An Inquiry Into Modes of Existence* and, more generally, of Latour's work for more than thirty years now, if not genuine conversion, turning the fresh or wondering eyes of an ethnologist to our own customs and habits to see what they really are? And how better to achieve this than by a diffraction of perspective through the medium of the habits of others, of nonmoderns, thus modifying our habitual self-perception?

This is a project and a procedure, a method that can be traced back not only to Montesquieu's *Persian Letters* but at least to the Renaissance, and thus to the first (or even a counter-) modernity preceding the Cartesian-Galilean modernity that had to eliminate habit in what John Dewey and Stephen Toulmin described as a "quest for certainty." Perhaps nowhere is it more prominent than in Montaigne, especially in his essay "On the Cannibals," where the New World is also a fresher, maybe younger world not yet as corrupted by second nature as the old one, and Montaigne's defense of the American Indian's habits and customs functions at the same time as a denunciation of those of his own civilization. Montaigne, as a casuist and occasional diplomat who refuses to

be pinned down to a single position as the modern constitution demands, might make an excellent patron for the AIME project.

But then, one might ask, what is *not* a habit? What would rightly escape the jurisdiction and tyranny of this "schoolteacher," as Montaigne calls her ("On habit" 122)? The modernist habits of thought, sensation, perception, and action comprise not only all the "semantic" modes of existence Latour proposes to distinguish, but also that which is to be abolished: the distinction of form and matter, causing the unfortunate amalgam of [REP] and [REF]; the treatment of mental diseases as if they were an interior property of the mentally ill, thereby misjudging the true mode of existence of the beings of [MET]; and the institution of a discipline called economics, before whose unfathomable will and iron laws we all must genuflect.

If AIME's diplomacy succeeded in convincing a sufficient number of the moderns to recognize Latour's proposal for a more adequate ordering of the modes of existence and to act, perceive, feel, and think accordingly – as with Montaigne, this curious diplomacy imposes much more bothersome conditions on its own party than on the "opposing" side – then they/we would have to thoroughly revise the habits tying them/us to the old order and interrupt those self-reinforcing habits that have so far chained them/us to the disorders now revealed. Only then, once they/we had gotten accustomed to the model, would they/we be, once more, propelled in their/our collective existence by newly acquired and incorporated habits.

I therefore take it to be more than just a coincidence that it is exactly in the chapter on [HAB] that we find something close to the idea of a reset: the "manual restart"[3] that is required when there is major dysfunction that obliges us to go out of our

219

[3]  Latour 268. The term is curious insofar as one would consider implicit knowledge linked to habit to be situated precisely in the hands or other "subcenters" – as it has been by Bichat, Ravaisson, Dewey, Merleau-Ponty, and Polanyi, to name a few. Therefore, it would be more accurate to speak of a cerebral restart, since full consciousness is required where subception, to use one of Polanyi's terms, no longer does the trick.

routine ways. Needless to say, nothing has become more dysfunctional than the modernist worldview.

One might say that there is a certain tension between the need to reform modernist habits and reeducate the modernists – which indeed requires a profound manual override or reset – and the rehabilitation of habit as a genuine and respectable, even sacred mode of existence.

To clarify where to place habit, we have to consider how Latour understands the relation of [HAB] to other modes of existence. A key phrase reads: "Let us say that habit is the mode of existence that *veils* all modes of existence – *including its own*" (268).

Of course, Latour is perfectly aware of the fact that habit connects to all the semantic modes, and he enumerates several such crossings in the first part of the chapter (265). But unlike all the other modes, habit can never really take the [PRE]-position. What it does instead is suspend the prepositionality of whatever mode it combines with. Latour places great emphasis on the fact that the modes – and therefore their courses of action – are not forgotten (that's what [DC] would do) but rather remain presupposed by habit. Yet habit's crossings with other modes do not seem to bring out any contrast; on the contrary, due to habit's essential inconspicuousness, it desaturates whatever it encounters.

Interestingly, though, there is another crossing Latour addresses in his chapter on habit: [HAB·DC] (266–67). Habit, which should indeed be honored as a painstakingly built-up disposition, as the patient and strenuous exercise and experience of dealing with mediation and mediators ("bad habits" come at a price as well), collides head-on with the evil spirit of effortless and cost-free immediacy, although at first sight it resembles [DC] because it seems to forget or lose [PRE] where in fact it only veils the preposition. Should not [HAB], then, be classified among the "ancillary" or "grammatical" categories, exactly *between* [PRE] and [DC]? And could we therefore not think of it adverbially, as a certain mode-ification of

thinking, perceiving, feeling, doing, that we acquire no matter what mode of existence we are in?

However, how exactly habit works adverbially requires elaboration. If one is inclined to grant a productive and even innovative potential to habits, to the dispositions that enable us to think, sense, perceive, do something, then one might find Latour's characterization of habit as a mode that simply veils and pre-sub-poses the prepositions and keeps us running – as the patron of paved and well-worn ways – a bit too weak. Habit as a disposition is more than just something that keeps us on a network of familiar roads. Latour himself states that in good habits, which do not decline into dull routine, there is no inertia (269). As James and Dewey have argued, the disposition of habit is not stable but metastable. Dewey has defined habit as something that belongs just as much to the environment as to the individual, allowing him to interact and meet the challenges of an ever-changing environment. Habit is the disposition not only to maintain, but also to enlarge and reconstruct, if need be, one's road network.

More than just presupposing the prepositions, habit actively supports modes like [TEC], [FIC], and [REL], to name just those three. It collaborates with them as an *amplifier*, no matter whether you rely on practice and expertise for building sofas or playing the saxophone, or if the mediation of spiritual exercise brings you closer to illumination. But such exercise, according to such writers on habit as Hume, Ravaisson, and Dewey, is not something reserved to specialists, but part of every (human) being's everyday experience and psychophysiological development – even our anthropological condition, as Peter Sloterdijk claims: only through habit are we able to recognize things like objects – and then forget about them again in order to recognize other objects (Polanyi, Merleau-Ponty). [HAB], then, would also have us constantly shuttling between the modes in the first, pre-subject/object section of Latour's Pivot Table (488–89)

and (at least) those in the second section focusing on the quasi objects.

Habit has been described as a certain hue or coloration of what we experience or produce. If the AIME project is about adding colors to network analysis, then maybe [HAB] is a mixing and modification of the colors of a given mode of existence, or an intensifier that brings out those colors more vividly.

While we should carefully distinguish [HAB] from [DC], it is less obvious that [HAB], as a principle of association and linking, can really be distinguished properly from [ATT] and [REP] (and I am well aware that this amalgam cannot be dissolved by relocating [HAB] among the grammatical modes; here [HAB] is not presupposing the other modes, but is coincident or even coextensive with them).

As we have seen, Perec's young student, in his attempt to shake off his habits, tries to cut himself loose from all attachment, feeling the need to deaden all preferences, every kind of taste. He does eventually escape the dulling and maddening trap of autonomy, but to make clear how close this student comes to losing his ability to maintain his existence, Perec introduces his doppelgänger in *Life: A User's Manual*: a history student who, unable to stop the process, eventually vanishes without a trace.

This comes as no surprise, given that many of those among the moderns who have thoroughly investigated habit and habitus never managed – nor cared – to make a clear distinction between habit on the one hand and reproduction and attachments on the other. One could consider this to be the result of another unfortunate amalgam, such as matter (the failure to distinguish between [REP] and [REF]) or economics ([ATT], [ORG], and [MOR]). But it is exactly the most interesting description of habit, those posing the greatest challenge to the standard modernist accounts, that refuse to draw lines between [HAB], [REP], and [ATT].

Since Aristotle, hexis or disposition has been linked to desire, predilections, and taste, all of which require education, and thus to the very "essence" of attachments. The entire interplay between the active formation of a habitual disposition and its passive acquisition revolves around the education or corruption of tastes and preferences. Ravaisson, among others, even sketched out a brief explanation of addiction as the wish to repeat a pleasant sensation (tying us to whatever produces this sensation [69]). Therefore, habit always comes into play when we are interested in the pragmatics of taste – and we should remember that it is in this very context that Antoine Hennion has developed a whole theory of attachment – even at the most literal level, concerning food. Attachments do not simply rely on but *are* carefully cultivated habits. Or, to say it with Dewey: habits are the union of desires with propulsive powers.

(Nonidentical) repetition and (dis)continuity are among the most frequently named features and prerequisites of both habit *and* reproduction. At least since Xavier Bichat, habit has been defined, first, as the specific disposition of all animals, then of all living organisms. Combining the capacity for change with habit as disposition is merely "the primordial law and the most general form of being, the tendency to persevere in the very actuality [*acte*] that constitutes being" (Ravaisson 77). Thus fulfilling the definition of conatus given in Spinoza's *Ethics*, habit is the action required for every living being to reproduce itself in relation and interchange with its environment. Samuel Butler's entire *Life and Habit* is dedicated to the mystery of lineages, of how reproduction works from one generation to the next. Even more radically, Charles Sanders Peirce, Raymond Ruyer, and Gilles Deleuze considered habit to be the overall principle of association that constitutes and maintains all entities, including the *lignes de force* of inanimate objects. To pretend these authors committed category mistakes would only strengthen the modernist account, since their broad conceptualizations go against the grain of human exceptionalism and of a naturalism that both grants

spirituality only to humans and holds that nature – that is, inert matter – is governed by preestablished laws, whereas habit transforms matter into plastic materials with a history.

Habit thus presents a twofold difficulty. On the one hand, it is tricky to distinguish it specifically from other modes. On the other, it is not easy to say where to place it in the table of categories at all. Is it one of the twelve basic modes (and if so, exactly where does it belong)? Or would it be better to place it among the grammatical modes instead? And is it not the prerequisite for positioning all the modes of existence, given that they all need to be housed in a proper working institution and that institutions are founded upon habits? Or is it a trickster that we find now on one side, now on the other? If it is, on the one hand, a specific mode of existence, coinciding largely with [ATT] and even more with [REP], and on the other a necessary part of many modes of existence, does it not exceed the logic of the container and the contained? Especially if habit is the prerequisite for institutions, and all modes of existence should be housed in their own institutions?

Maybe it is even a bit of a relief to have found habit to be a mode of existence that, despite its reputation of being boring, inclined to compulsive ordering and arranging, seems to be more a mediator than an intermediate when it comes to tidying up the modern mess. Maybe it behaves like a Renaissance philosopher that simply cannot be pinned down to a single position.

Maybe, due to its Euclidean two-dimensionality, the Pivot Table cannot satisfactorily translate the multidimensional topology of the modes of existence (and would this be an example of the noncoincidence of [REF] and [REP]?). In any case, I would prefer to think of this table not as immutable but as a very mutable mobile – a disposition, so to speak, not a routine. And this is not only, nor even primarily, a bid to keep the list open to *add* more modes of existence.

It is extremely useful, inspiring, and even exciting to fan out all the modes of existence, but their hues, even their shapes, might vary from situation to situation. The best way of treating them – and the best way to escape the moderns' obsession with stability – might be to treat them casuistically, according to any given situation.

Montaigne, speaking about intolerance and the religious wars of his times, was very skeptical about replacing inveterate habits with new and better ones (though he was perfectly aware that habits' sole authority came from being traditional). One need not follow him in this prudent conservatism. But the suggestion he makes at the end of his essay about the difficulty of changing habits – or more precisely, customary laws – is worthy of consideration: if you wish to avoid breaking the law, then bend it, make it supple and pliable so that there is room to maneuver within it, even if that means displacing the tablets of law:

> And similar acuteness was shown by a
> Spartan ambassador who was dispatched
> to the Athenians to negotiate a change in
> one of their laws, only to find Pericles testifying that it was forbidden to remove a
> tablet once a law had been inscribed on it:
> he counselled him – since that was not forbidden – simply to turn the tablet round.
> ("On habit" 139)

*Works Cited*

Aristotle. *Nicomachean Ethics.* Trans. and ed. Roger Crisp. Rev. ed. Cambridge: Cambridge University Press, 2014. Print.

Bichat, Xavier. *Physiological Researches upon Life and Death.* Trans. Tobias Watkins. Philadelphia. 1809. Print.

Butler, Samuel. *Life and Habit.* London: Fifield, 1910. Print.

Cassin, Barbara. L'effet sophistique. Paris: Gallimard, 1995. Print.

Deleuze, Gilles. Difference and Repetition. Trans. Paul Patton. New York: Columbia University Press, 1994. Print.

Descartes, René. Regulae ad directionem ingenii / Rules for the Direction of the Natural Intelligence. Ed. and trans. George Heffernan. Amsterdam: Rodopi, 1998. Print.

Dewey, John. Human Nature and Conduct. John Dewey: The Middle Works, 1899–1924. Ed. Jo Ann Boydston. Vol. 14. Carbondale: Southern Illinois University Press, 1983. Print.

–––. The Quest for Certainty. John Dewey: The Later Works, 1925–1953. Ed. Jo Ann Boydston. Vol. 4. Carbondale: Southern Illinois University Press, 1984. Print.

Gehlen, Arnold. Urmensch und Spätkultur. Philosophische Ergebnisse und Aussagen. 6th ed. Frankfurt: Klostermann, 2004. Print.

Hennion, Antoine. "Pragmatics of Taste." The Blackwell Companion to the Sociology of Culture. Ed. Mark Jacobs and Nancy Hanrahan. Malden: Blackwell, 2005. 131–44. Print.

Hume, David. An Enquiry concerning Human Understanding. 1748. Ed. Tom L. Beauchamp. Oxford: Oxford University Press, 1999. Print.

–––. A Treatise of Human Nature. 1739. Ed. David Fate Norton and Mary J. Norton. Oxford: Oxford University Press, 2000. Print.

Latour, Bruno. An Inquiry Into Modes of Existence: An Anthropology of the Moderns. Trans. Catherine Porter. Cambridge, MA: Harvard University Press, 2013. Print.

James, William. The Principles of Psychology. Great Books of the Western World. Ed. Mortimer J. Adler. Vol. 53. Chicago: Encyclopaedia Britannica, 1996. Print.

Lukács, Georg. The Theory of the Novel: A Historico-Philosophical Essay on the Forms of Great Epic Literature. Trans. Anna Bostock. Cambridge, MA: The MIT Press, 1971. Print.

Merleau-Ponty, Maurice. Phenomenology of Perception. Trans. Colin Smith. London: Routledge & Kegan Paul, 1962. Print.

Montaigne, Michel de. The Complete Essays. Trans. and ed. M. A. Screech. London: Penguin, 1993. Print.

–––. "On the Cannibals." Complete Essays 228–41.

–––. "On habit: and on never easily changing a traditional law." Complete Essays 122–39.

Montesquieu, Charles de Secondat, Baron de. Persian Letters. Trans. Margaret Mauldon. Oxford: Oxford University Press, 2008. Print.

Peirce, Charles Sanders: "Design and Chance." The Essential Peirce: Selected Philosophical Writings. Ed. Nathan Houser and Christian Kloesel. Vol. 1. Bloomington: Indiana University Press, 1992. 215–24. Print.

Perec, Georges. Life: A User's Manual. Trans. David Bellos. London: Collins Harvill, 1987. Print.

–––. "A Man Asleep." Trans. Andrew Leak. Things: A Story of the Sixties / A Man Asleep. Boston: Godine, 1990. Print. Trans. of Un homme qui dort. Paris: Denoël, 1967.

Polanyi, Michael. Personal Knowledge: Towards a Post-Critical Philosophy. Chicago: University of Chicago Press, 1958. Print.

–––. The Tacit Dimension. 1966. Chicago: University of Chicago Press, 2009. Print.

Ruyer, Raymond. L'embryogenèse du monde et le Dieu silencieux. Paris: Klincksieck, 2013. Print.

Ryle, Gilbert. The Concept of Mind. Chicago: University of Chicago Press, 2002. Print.

Ravaisson, Félix. Of Habit. Trans. Clare Carlisle and Mark Sinclair. London: Continuum, 2008. Print.

Sloterdijk, Peter. Du musst Dein Leben ändern. Über Anthropotechnik. Frankfurt: Suhrkamp 2012.

Spinoza, Benedict de. The Ethics. A Spinoza Reader: The Ethics and Other Works. Ed. and trans. Edwin Curley. Princeton: Princeton University Press, 1994. Print.

Toulmin, Stephen. Cosmopolis: The Hidden Agenda of Modernity. Chicago: University of Chicago Press, 1990. Print.

# RECOMPOSING THE HUMANITIES

## Stephen Muecke

THE INTREPID and somewhat perplexed anthropologist of the moderns who carried out Bruno Latour's *Inquiry into Modes of Existence* for him was invited to Australia – of all places, the end of the world? – to prepare a similar report for the venerable peers of the Academy of the Humanities.[1] This august body, of which I happen to be a fellow, was concerned about the status of the humanities in universities in the traditional subjects of history, languages, archaeology, philosophy, and literature. They were also uneasy about the possibility of declining *relevance*, as indicated by the recently elected right-wing government's attacks on the "increasingly ridiculous research grants" awarded by the Australian Research Council. The chair of the Scrutiny of Government Waste Committee, Jamie Briggs, was sure he knew, just from the title, what a ridiculous grant application looked like, and he "singled out four projects, two involving philosophy and Hegel, one to do with 'urban media art' and adaptation to climate change, and an exercise in anthropology, 'Sexuality in Islamic interpretations of reproductive health technologies in Egypt'" (Lane).

This is the government that was elected after its party leader, Tony Abbott, had outraged the scientific community by saying that the "[climate change] argument is absolute crap" (qtd. in Wilson), and which,

STEPHEN MUECKE *is a professor of ethnography at the University of New South Wales, Sydney, where he is part of the Environmental Humanities Program. He has written extensively on indigenous Australia, especially in the Kimberley, and on the Indian Ocean. A recent book is* Contingency in Madagascar *with photographer Max Pam (2012). Muecke is a Fellow of the Australian Academy of the Humanities.*

once in power, had happily begun to dismantle the very scientific institutions that might have contradicted such a well-informed position. Without wondering too much what a government like this might have to fear from Hegel, the European anthropologist engaged to write the report on the humanities nevertheless took the idea of "relevance" as the brief for the inquiry that extended her earlier work with Latour on what such institutions might really care about. And there were certain other things about Australia that intrigued her: a huge, hot, dry, antipodal island which was not quite part of Asia; a nation founded in 1901 based on British colonies only one century old; dispossessed Aboriginal peoples of great interest to anthropology who were still struggling for survival and recognition – in other words, a young-old country that was confused about just

---

[1]  This report is in progress. However, a most informative report concluded that the sector is "strong and resilient"; see Turner and Brass.

what its heritage might be. A paradigmatic example, in the same class as Brazil, Canada, and South Africa, of a country to which European modernity had been exported in the colonial era, and which had already "reset" somewhat as it readapted to new local conditions.

Is it perhaps the case, she wondered, as she admired the faux-Gothic architecture of the University of Sydney, that *resetting* goes with *resettling*, that the civilizing missions of Oxford and Cambridge can't simply be planted here in this new environment and do exactly the same thing they have done for centuries beside the quietly flowing Rivers Thames and Cam? But that was precisely the message she got from talking to the older humanities instructors at the older universities: the life of the mind (*esprit, Geist*) does indeed have its origins in Europe (this is not something that concerns the scientists who experiment with much more material things) and has to be coaxed into life again on the barren soils of the colony.

Our anthropologist walked away disappointed from such initial discussions; she had been hoping, thinking of Anna Tsing, for more signs of cultural friction. Let's assume that, if the discipline of history can be transported to colonies like Australia (though not in chains like the convicts), and if it remains unmodified in its conceptual architecture and its methods, then European modernism will have triumphed without having to go to the trouble of negotiating with any of the denizens of the new colony. It would be as easy as the sun of the Enlightenment illuminating a new corner of the planet as it turned. As for history, so too for philosophy, English literature, and philology. So from this point of view (the migration of disciplines), the humanities can be understood quite materially as a *geophilosophical* project. And indeed the migration of concepts can be traced quite concretely, externally, as if they had nothing to do with the life of the mind at all. For instance, when women demanded, and were granted, the right to vote quite early in South Australia

in 1894, men might well have asked where such an "outlandish" idea had come from. And if they had wanted, they could have traced the connections.

## POSTCOLONIAL ADAPTATIONS

IT IS IN THIS SENSE that one can analyze the resetting of the modern humanities *postcolonially*: they will be the product of the adaptations of these disciplines to their new contexts. Let me pause for a moment on some of these changes (that deeper inquiries by the anthropologist have discovered) before having, in the end, to share her disappointment that the modernist "life of the mind" has survived pretty much unchanged.

The discipline of Australian history had always assumed that the historical clock started ticking at the moment of colonization at Sydney in 1788. It wasn't until the 1960s that archaeological discoveries demonstrated human occupation going back at least forty thousand years. At about the same time, oral histories were providing narratives about times before colonization and points of view that contested the legitimacy of the British imperial project. As, in the 1970s, a new wave of political protests demanded indigenous rights and recognition, a new subdiscipline of history emerged: Aboriginal history. Was history now thinking differently? It had looked up from its desk at what was going on around it, had made one method (oral history) work a little harder to accommodate Aboriginal accounts, and was accumulating more content. But essentially it remained the same in that it saw itself as *judging* (rather than, say, experimenting). The truth of the historical facts was determined by the *authority* of the historian and his methods, on the basis of the triangulation of sources; this was how historical truthfulness would be sustained across time.

When the anthropologist visited philosophy departments it was very hard to get the philosophers to look away from their screens. They too were in the business of determining the truth, they informed

her without blushing, and they did this quasimathematically, by judging (again!) whether propositions were logically ordered. And yes, some of them also made judgments about morality and ethics, and in some instances speculation was possible. This was in some way connected with a desirable attribute of the philosophical mind: it should be "open." This was explained as being the opposite of "dogmatic," apparently the worst sin for philosophical thought (just as only having one source would be a fatal weakness for history).

The anthropologist decided she would have to come back to this "openness" metaphor later. But when she asked them if it mattered *where* they were – that is, Australia – they looked at her like she was mad. Provincialism, like dogmatism, would be the death of philosophy. Its aspirations were universalist. Having read some of the more arcane anthropologies of Australian Aborigines, like T. G. H. Strehlow and W. E. H. Stanner, our anthropologist went away a little surprised. Were these philosophers saying that there was no "life of the mind" in the country before colonization? And could there ever be such a thing as Australian philosophy? Apparently not. The philosophers were glued to their computer screens, which were networked back to the centers of philosophy in Europe and North America. These were people who had cultivated a strange *persona* (and, the anthropologist asked herself, are they not the same where I come from?) that was supremely indifferent to its location. It was ungrounded, transcendent.

Passing by the offices of the modern language departments, with only one or two lecturers struggling to keep French and German programs alive, and only a bit of growth in Chinese because of direct Chinese government funding and control, she came to the English department, which was sustained because of the compulsory teaching of this subject in secondary schools. So this department was training teachers in the literary canon which many consider the backbone of education, if not civilization itself. The person who can refer to Shakespeare,

Jane Austen, etc. can "rise above" those plebs who merely have a thorough knowledge of the character traits, motivations, intrigues, and salaries of football stars and celebrities.

As she was about to knock on a door she overheard raised voices inside debating, it seemed, what grade a student should get for his honors thesis. He was accused of being "merely imitative" because he had produced a *new* "Henry James" story according to a set of stylistic rules he had formulated through statistical analysis of the Henry James corpus. One person was demanding "critical analysis," another "more theory." The student's supervisor was trying to defend him by saying that more theory would provide no greater "depth," that in fact it was a virtue to stick to the surface of the text, and that the student had a greater knowledge of Henry James through his meticulous application of stylistic rules. An attacker said this was "merely positivist empiricism." "Exactly what the English Department needs more of!" countered the supervisor.

The anthropologist would have a very interesting discussion with this man later, but her first meeting was with a "postcolonial theorist" who made a claim similar to the one made by the newer historians: that English in Australia had to accommodate more of the "great traditions" of Aboriginal epic song, love poetry, long narratives, and sacred verses. "These are the true voices of the country," she said, "but our literary choices still reflect our traditional ties with Britain." You will teach Aboriginal literature in classrooms? asked the anthropologist. "Of course," the theorist replied. With postcolonial theory attached? "I guess so ... it provides an explanatory framework."

The postcolonial theorist kindly provided some of her offprints, which the anthropologist read diligently over lunch, noting in passing that *reading and writing* are what humanities folk spend most of their time doing. Her analysis of these texts left her perplexed. How was the Derridean Gayatri Spivak the appropriate theorist to really "explain" Aboriginal

epic song? She needed a metatheorist to help her understand such strange amalgamations of discourses. Maybe she could take this question to her next appointment, with the man in the office dispute who had been the sole voice promoting empiricism in the humanities.

## EMPIRICISM
## AND TRANSCENDENCE

"YOUR FRIEND BRUNO LATOUR," said the born-again "empiricist," "really struck a chord with his article about critique running out of steam (Latour, "Steam"). I too had become tired of hearing the same critical moves; actually it's a bit of a complicated dance. With one step they promise emancipation (from the hegemons of class, patriarchy, etc.). The next step offers to reveal hidden truth, and then a head-spinning pirouette takes the reader to a higher level where contradictions might be resolved. For this exercise, the facts about Jane Austen's or J. M. Coetzee's books are as immaterial as the formal structure of the texts. What is important is to grapple with the powerful language of theory, as a kind of dancing partner. The exegetic work on arcane language puts the student in a state of spiritual anticipation ('openness') for the moment when the moral problems that they have learned to identify will finally be overcome.

The aim is a pedagogy of enlightened subjectivity, for those now liberated from 'mere objectivity.' This is what my friend Ian Hunter calls a 'spiritual exercise,' a manifestation of Kant's transposition of Christianity to the early modern confessional university. Today, the humanities are often defended as the set of disciplines that has the special capacity to deliver critical reason to society as a whole; these knowledges are not treated as instrumental or diverse, but as unified in the conception of the life of the mind. This singularity, argues Hunter, was made possible through Kant's 'preserving the idea of the divine mind as the source of all

thinkable things' (Hunter 16–17). It is this striving for unity that conjoins 'ever higher forms of philosophical abstraction and principle with ethical dispositions' (17), hence the emphasis on 'theory' in English departments, alongside the continued phenomenological orthodoxy that Quentin Meillassoux calls 'correlationism': how the mind relates to the world, that familiar subject-object dualism that obscures all kinds of other active relations that can make knowledge."

After this dizzying account, the anthropologist came away with a clearer idea about some of the battles in the humanities. There is hostility towards empiricism because staying "at that level" would impede the transcendental movement of the subject towards a higher unity that has a special vision of the future, propelled there by the dramatization of the "current crisis." No wonder the (Anglo-American) humanities are always in crisis and ridiculed in "culture wars" or "science wars" for using elitist language!

But this was a particular specialty in the humanities, this deployment of "critical theory" as fetishistic exercise. If we look at archaeology (for some reason classified in Australia with the humanities rather than the hard sciences), there are no battle lines drawn between empiricism and theory, because facts can be determined and knowledges developed without the elaborate theoretical dance. What about the "environmental humanities"–maybe this new subfield has some solutions for reconciling the sciences with the humanities, real-world experimentation with the "life of the mind"?

## NEW ECOLOGICAL SETTINGS

WHEN SHE MANAGED to track down an environmental humanities academic, he readily agreed that the field was beset by all sorts of crises: extinctions, global warming, pollution. But these were not used as pretexts for moral blackmail on the order of "we, the humans are responsible; therefore we

must act now." Rather, a new humility had been found for the humans whose arguments are "entangled" with those put by other, nonhuman agents. So human rationality or "critical reason" no longer occupied the elevated position it had in the quasi-theological corner of the humanities academy described by Hunter.

Not only were whales and Amazonian rainforests arguing, but the argument put by the Anthropocene was even more radical because it was a *hyperobject*, to use Timothy Morton's word: everywhere at once and infiltrating everything. Even the kinds of stories that were told about human destiny now had interesting contradictions: in an epoch named after the human, humans were losing their sovereignty, and key organizing concepts like "freedom" had hit an ecological wall. "Nature," in the context of this new interdiscipline, could no longer be a rallying point for puritanism or apocalypse, but there continued to be all sorts of surprises in store for those investigating the emerging natures which "we" will never have mastered. Human reason would now be localized and limited to the range of its methods, scientific as well as humanist, and in many cases occupying the same terrain. It would henceforth not be a matter of "facts first, values later," as it had been with the nuclear weapons invented in the last century by "disinterested" scientists.

So the environmental humanities academic was often doing philosophy "in the field," collaborating with real scientists, while inflecting their joint results with understandings that were not based on a singularized and objectified nature. Sometimes the results came out a bit queer, as in the work of Donna J. Haraway or Karen Barad, in which case the environmental humanities might indeed be experimental and compositional rather than judgmental. Starting from the plurality of a community, experiments are necessary in that we don't know a priori just what composition of agents will enhance the life of the system and propel it forwards.

## WHERE DO THE HUMANITIES REALLY RESIDE?

THE INVESTIGATING anthropologist was suddenly brought to a halt by a serious problem as she listened to the convincing words of the environmental humanities academic. It's only a tiny academic field; it's hardly going to change the world overnight, is it? Maybe she had been confining the scope of her inquiries too narrowly. What about the arts more generally, the massive productions of films, books, operas, festivals, ceremonies, and so on? How are they supposed to relate to the humanities? This brings us back to the problem of *relevance*. If arcane knowledge (on Hegel, or on reproductive health in Egypt) is produced within the confines of the universities, it nevertheless is supposed to be taken *outside* to be tested in some small or larger way in a public forum. It may look "ridiculous" to right-wing politicians, but it should look reasonable to someone.

Humanities academics can, and do, act as critics or arbiters of taste. This is well and good; they can judge, and yes, judgment does go on all the time. They can write well about these festivals, films, and books. But if there is a crossover from one set of institutions to another, and values are thus created and distributed, then this is a valuable experiment in the distribution of facts and values: Does this work aesthetically? Can a person really be like this? The most cherished values relating to beings as works in progress, and as organized in narrative, are thus empirically and experimentally distributed, tested, and reset if they don't work.

Ok, said the anthropologist, back to square one. I shall have to investigate all the humanities departments again, this time as they "test" themselves cross-institutionally. I shall have to think once again about even the most dubious critical moves, like the oft-repeated moments when theory is used allegorically as a "spiritual exercise." What part does it play in its culture? What has kept it alive for so

long as a critical technique? What will be my recommendations for recomposing the humanities (in Australia and elsewhere)? And she began to note on the back of an envelope:

1) Assess to what extent the indigenous cultures have "reset" the modernism of the colonizers.
2) Analyze each institutional organization in terms of the other institutions that test it with support or attacks.
3) Try to understand the real effects of the unrealistic (prophetic) use of theory.
4) Try to understand the current state of the disciplines in terms of the historical and geographical distribution of their ideas and methods.

---

Works Cited

Hunter, Ian. "The Mythos, Ethos, and Pathos of the Humanities." *History of European Ideas* 40.1 (2014): 11–36. Print.

Lane, Bernard. "Coalition Angers Research Community." *The Australian*. News Corp Australia, 6 Sept. 2013. Web. 3 Feb. 2016. Available at < http://www.theaustralian.com.au/higher-education/coalition-angers-research-community/story-e6frgcjx-1226712215714>

Latour, Bruno. *An Inquiry into Modes of Existence: An Anthropology of the Moderns.* Trans. Catherine Porter. Cambridge, MA: Harvard University Press, 2013. Print.

---. "Why Has Critique Run out of Steam? From Matters of Fact to Matters of Concern." *Critical Inquiry* 30. 2 (2004): 225–48. Print.

Meillassoux, Quentin. *After Finitude: An Essay on the Necessity of Contingency.* Trans. Ray Brassier. London: Continuum, 2008. Print.

Morton, Timothy. *Hyperobjects: Philosophy and Ecology after the End of the World.* Minneapolis: University of Minnesota Press, 2013. Print.

Tsing, Anna Lowenhaupt. *Friction: An Ethnography of Global Connection.* Princeton: Princeton University Press, 2004. Print.

Turner, Graeme, and Kylie Brass. *Mapping the Humanities, Arts and Social Sciences in Australia.* Canberra: Austral. Acad. of the Humanities, 2014. PDF file.

Wilson, Craig. "Tony Abbott Visits Beaufort." *Pyrenees Advocate* 2 Oct. 2009: 5. Print.

# RESET MODERNITY: AFTER HUMANISM

## Clive Hamilton

THE ARRIVAL OF THE NEW EPOCH provokes us to reconsider the essential commitments of modernity – the commitments to human autonomy, to humanism, and to the spoken and unspoken utopianism without which modern society could not exist, even if, after the collapse of socialism, the utopian promise of capitalism mutated into a banal expectation of an ever-expanding present.

It has often been said that the European Enlightenment represented the transition of humankind from the realm of necessity to the realm of freedom. Philosophies of social progress (Hegelian, Marxian, liberal, and neoliberal) have seen history as freedom unfolding under its own momentum. Now it seems that the flourishing of human freedoms has been at the same time eroding the foundations on which they were built; that is, the exceptional climatic stability and clemency provided by the Holocene allowing settled agriculture, and thus civilization, to flourish.

Perhaps the realm of necessity was not abolished but merely withdrew, and is now reasserting itself. In other words, if the essential motif of modernity has been relentless progress towards self-determination, a process posited by Enlightenment philosophies of the subject, faith in human agency becomes harder to defend in the Anthropocene, unless the modern agent was always bent on self-destruction. The shift out of the Holocene's sympathetic environment into an epoch that promises dangerous

CLIVE HAMILTON *is a professor of public ethics at Charles Sturt University in Canberra as well as the founder and former executive director of the Australia Institute.*
*The comprehensive list of his publications includes* Growth Fetish (2003), Requiem for a Species: Why We Resist the Truth About Climate Change (2010), *and, most recently,* Earthmasters: The Dawn of the Age of Climate Engineering (2014).

instability can be expected to limit progressively the scope for human freedom.

The reframing of modernity as the "risk society" (Beck 1992) is built on an implicit faith in our ability to recognize how our environment is changing and respond accordingly, guaranteeing our autonomous capacity to respond to the world as it is. Yet the most striking fact about the human response to climate change is the determination *not* to reflect, to deploy a range of psychological protections against the warnings of the scientists, and so to carry on as if nothing profound is happening.

All humanisms, secular and otherwise, agree on a conception of self-determining agents whose individual and collective future lies in *their* hands rather than supernatural ones. Repudiating all notions of fate, humanism imagines (in Peter E. Gordon's words) "a triumph of consciousness over its surroundings" (21). Yet now it seems that in its celebration of human powers something was missing from

humanism – it was silent on the fate of the earth itself. It is as if, after the earth's "disenchantment," the social defeated the natural so that the earth provided no more than the inert and passive stage on which the human drama would be played out.

With the advent of the Anthropocene, we are beginning to see the limits to human spontaneity and self-making. In the 1929 Davos debate between the Kantian philosopher Ernst Cassirer and Martin Heidegger, Cassirer defended an enlightened humanism and Heidegger argued for a darker vision of humans thrown into a destiny inscribed in being itself. The dispute revolved around the question of whether the human being is limited by its existence in a finite world or can break free of those constraints and create its own world; in other words, it was a debate that went to the heart of the claims of modernity.

Cassirer lost the debate at Davos but in the wider world his view prevailed. He spoke for the spirit of the times. Even the great iconoclast Nietzsche acceded to its core belief. "Inexorably, hesitantly, terrible as fate, the great task and question is approaching: How shall the earth as a whole be governed?" (501) he wrote, as if there were no questions over whether the earth as a whole *can* be governed.

One thing is now clear; striving for the perfectibility of humankind is a failed project. We now see that all Utopias take as given the natural conditions of the Holocene and imagine that, whatever social structures may delimit Utopia's pathway, continuing material advance faces no insuperable natural barrier. Yet, the ever more unsympathetic and irrepressible climate expected this century and beyond will consume a growing share of resources merely to defend the economic gains of the past. In the absence of self-delusion (admittedly a heroic condition to impose), a hard confrontation with the scientific warnings inevitably erodes the essential optimistic mood of late modernity, and replaces it with a kind of existential dread. Against Cassirer's sunny humanism, Heidegger's grim vision seems to be vindicated with every new paper published in a scientific journal.

It is true that the desire to resist the scientific facts has been expressed in several more-or-less ingenious reframings of the Anthropocene aimed at turning it back into the Holocene, or even to moulding it into a golden opportunity for human beings to achieve their full greatness. These evasions, warding off the future in the pretence of creating it, sustain modernity's essential mood of optimism.

Oddly, the relegation of the Holocene to the past also renders obsolete all eco-utopias; the "nature" with which some aspire to live harmoniously is no longer natural in the Anthropocene. We begin to suspect that instead of modern utopianism representing the secularization of divine transcendence (as Karl Löwith famously argued), the reality we have created more appropriately calls for the secularization of eschatology.

Walter Benjamin once wrote that the idea of the unstoppable advance of history – historical materialism of various kinds – secretly draws its power from "theology, which as everyone knows is small and ugly and must be kept out of sight." The Anthropocene demands the revisiting of all history with a view to excavating its buried parts, those that were deemed redundant to the triumphal march of progress. If history can no longer be thought of as an array of potential social creations, perhaps in the Anthropocene we will unearth some sense of a larger destiny.

The advent of the new epoch forces us to look into the future in a new way. No longer a speculative vista constructed by social beings – following "the break with nature caused by the awakening of consciousness" (Burckhardt 31) – the activation of the earth in the Anthropocene allows us to see, with more certitude, the changing constraints to which human actions will be responding. The hidden residue of Hegelian world history, that of the ineluctable advance of human freedom, has now been exposed as wishful thinking, not so much because human freedom may increasingly be limited by "geology," but because the unquestioned benefits of that freedom – freedom from want and opportunities for

self-expression – must now be confronted with their dark side, the use of freedom to ravage the earth.

If world history is the working out of "the progress of the consciousness of freedom" (54) – or, in its distorted practical expression two centuries after Hegel, as the progress of economic growth – then the Anthropocene has blown it up. The response is not to discard the idea that some kind of logic can be discerned in the unfolding of events. Instead, the disruption of Holocene stability and the reassertion of the earth's violent temperament prompt us to replace the social-only idea of world history with a social-geological idea of *planetary history*.

The arrival of the Anthropocene marks a new epoch in the geological history of the earth. Yet it is much more. It is a gathering together of all of the relationships of humans to the earth, the fullest expression of the consequences of the modern objectification of the earth and our dependence on it, a culmination of the struggle to find a way in which we can inhabit the planet. It is a disclosure of the inner relationship of humans and the earth, a forced and perilous reunification that spells the destiny of each. In other words, the Anthropocene fulfills Heidegger's conception of *Ereignis*, an "event," or of something coming into view.

The question of the survival of the human species is starting to move from the backwaters to the mainstream, from speculation to serious thought. While the "existential question" can be considered in physical terms, posing it also resurrects in a new way the oldest ontological conundrum: what are we doing on this planet? We are prompted to ask whether our response to the approach of the great disruption is the ultimate test we were sent to confront. If the history of *Homo sapiens* has a known beginning and a conceivable end, should our demise be regarded as a misfortune for the last generations or a tragic failure of cosmic purpose? Was the emergence of human consciousness a mere accident of evolution, or did it have significance for the universe? If our greatest triumph, modern science and

technology, cannot save us, was there something buried in technological society that prevented the world from being saved?

These kinds of grand questions have been rendered unaskable in the modern world. Perhaps the Holocaust debates over the nature of evil in the 1950s and 1960s were the swansong of grand questioning. The rise of analytical philosophy in the Anglosphere and Continental philosophy's preoccupation with epistemological questions, combined with the anti-intellectualism of neoliberal society where academics are judged by their contribution to the economy, has ruled them out, a silence deepened by the marginalization of theology, which remains small and ugly and kept out of sight.

So let us revive those big questions, not simply because they remain compelling for anyone concerned with what was once called the human condition, but because the arrival of the Anthropocene now demands it.

*Works Cited*

Beck, Ulrich. *The Risk Society: Towards a New Modernity.* London: Sage Publications, 1992. Print

Benjamin, Walter, *On the Concept of History.* Web. 16 Dec. 2015. Available at <http://members.efn.org/~dredmond/ThesesonHistory.html>.

Burckhardt, Jacob. *Reflections on History.* Indianapolis: Liberty Classics, 1979. Print.

Gordon, Peter E. *Continental Divide. Heidegger, Cassirer, Davos.* Cambridge, MA: Harvard University Press, 2010. Print.

Hegel, Georg Wilhem Friedrich. *Lectures on the Philosophy of World History. Introduction: Reason in History.* Cambridge: Cambridge University Press, 1975. Print.

Löwith, Karl. *Meaning in History,* Chicago: University of Chicago Press, 1949. Print.

Nietzsche, Friedrich. *The Will to Power.* Ed. Walter Kaufmann. New York: Vintage Books, 1968. Print.

# EARTH, ATMOSPHERE, AND ANOMIE IN DOUGLAS TRUMBULL'S SILENT RUNNING

## Philip Conway

*On this first day of a new century, we humbly beg forgiveness and dedicate
these last forests of our once beautiful nation, in the hope that they will one day return and grace our foul
earth. Until that day, may God bless these gardens and the brave men who care for them.*

**Commander Anderson**

IN THE HEADILY futuristic year of 2008, the Valley Forge approaches Saturn. Along with its fleet, this space-ark carries a precious cargo: the last of the earth's forests (see figs. 1 and 2).

The pyrrhic progress of mechanized modernity has produced a devastated, desiccated planet. The best that humans (or, rather, Americans) can accomplish is, out of the kindness of their hearts, to get these forests as far away from "our foul earth" as possible. But, after eight years, the millennial mission is on thin ice. Worse still, only one man in the universe seems to care. Freeman Lowell (performed by Bruce Dern), the nominal and physical embodiment of early 1970s hippy humanism, is these forests' caretaker – and later their partisan. We soon hear over a crackly radio:

> COMMANDER ANDERSON. Boys, I have to make an announcement. We have just received orders to abandon, then nuclear destruct all the forests and return our ships to commercial service. I have received no explanation, and we must begin at 09:00 in the morning. May God have mercy on us all.

PHILIP CONWAY *is a doctoral candidate in the Department of International Politics at Aberystwyth University, Wales. He previously studied at the Universities of Keele (BA) and Bristol (MSc). His PhD project "An Historical Ontology of Environmental Geopolitics" mobilizes a mixture of the history of science and contemporary speculative philosophy to engage with debates in political geography that are asking "what is the geo- in geopolitics?"*

The celebratory whoops and hollers of Lowell's laddish, obnoxious crewmates – Keenan, Wolf, and Barker – crash against Lowell's still-faced outpouring of dumbfounded, disconsolate despair (see fig. 3).

Later, their blithe, boorish carelessness provokes him into a rage:

> LOWELL. [In the past] there were flowers all over the earth! And there were valleys! And there were plains of tall, green grass that you could lie down in, that you could go to sleep in! And there were blue skies, and there was fresh air! And there were things growing all over the place, not just in domed enclosures blasted some

millions of miles out into space! ... On earth, everywhere you go, the temperature is 75 degrees. Everything is the same. All the people are exactly the same. What kind of life is that?

[...]

KEENAN. What do you want, Lowell? I mean, there's hardly any more disease. There's no more poverty. Nobody's out of a job.

LOWELL. That's right. Every time we have the argument, you give me the same three answers all the time! The same thing. 'Well, everybody has a job.' That's always the last one! But you know what else there's no more of, my friend? There is no more beauty, and there's no more imagination. And there are no frontiers left to conquer. And you know why? Only one reason why! One reason why! The same attitude that you three guys are giving me right here in this room today, and that is: nobody cares ...

(see fig. 4)

### TRAGEDY

THE DEEPEST HOPES and the deepest fears that the many moderns ever dreamed or dreaded have come to pass. In this vision of tragic modernism, rationality, mastery, and progress have been absolutely realized but at the cost of the world-soul: nature, murdered.

The earth's very temperature is a homeostatic 75 degrees Fahrenheit, plants and animals live only at the grace of man – even the valleys razed to nothing![1] Homogenized, standardized, rationalized, universalized. Quite a geo-ontology. Even for *Silent*

1–24    *Silent Running*. Dir. Douglas Trumbull. Universal Pictures, 1972. Film stills.

1

2

3

*Running*'s most enthusiastic advocate, the film critic Mark Kermode, these descriptions (never visually represented) "stretch the bounds of credibility" as they fail to account for the maintenance of a breathable atmosphere. Kermode equivocates that "clearly the script is aiming more for emotional resonance

[1]    "Every valley shall be exalted, and every mountain and hill shall be made low: and the crooked shall be made straight, and the rough places plain" (Isaiah 40:4). Thanks to Tim Howles for this reference.

4

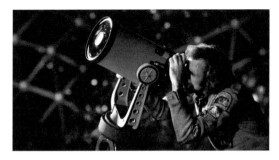

5

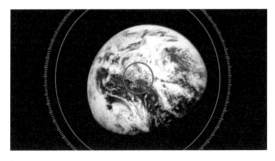

6

Douglas Trumbull made his name working as a special effects engineer on Stanley Kubrick's *2001: A Space Odyssey* (1968). Most notably, he was responsible for the slit-scan photography technique that produced the famous "Star Gate" sequence. When given the chance to make his directorial debut on a low-budget, no-strings deal with Universal Studios, he decided to make a science fiction picture that diverged from the bleak, glossy, magisterial soullessness of 2001. Having, as an inventor, none of Kubrick's disconcerted awe for the technological edifice, he wanted to make a film where humans were not dehumanized by their artificial interfacing – where machines were neither mere instruments nor sinister overlords-in-waiting. He wanted to make a film about emotion, passion, and heartbreak that happened to be set in space. He made *Silent Running* (1972).

optimistic Prometheans anticipate, as in Arthur C. Clarke's novel *The Fountains of Paradise* (1979), an earth perfected to the point of designer rain patterns and the elimination of floods, hurricanes, and other earthly undesirables.

The world presented in *Silent Running* simply anticipates this vision and takes it to its logical (if not plausible) conclusion: a dead, desiccated, animatronic earth, its every vital sign systematized (see figs. 5 and 6).

The delicate, pearly orb at which Lowell longingly gazes is, in fact, a meteorotechnic monstrosity – a machinated corpse lavished with dreams of resuscitation. A terraformed earth, *une terre terraformée*.

But we do not live on a planet susceptible to murder (Conway "Back Down to Earth"). Only nature, that infinite outside, could be so fragile. Gaia will have her revenge long, long before then (Lovelock *Revenge of Gaia*)! Lowell's earth is a tragedy, but it is an aesthetic, moral tragedy – endangered without endangering, acted upon without acting back. Nothing could be less true of that which we must now learn to dread. The geopolitical theology of Trumbull's secular celluloidal hymn jars with our

than for factual plausibility" (44); however, is the explanation not obvious?

We are, some say, on the cusp of an "age of geo-engineering" in which the paper-thin haze that bathes the earth's crust will become a technologically variable membrane; a sky-wide, planet-scale shell; a veritable cosmic fortress against "unbudgeted" solar radiation. Some of the more giddily

newfound sense of being in an atmosphere that is not ours and that will never again be lulled into passivity. Lowell bellows and thunders about frontiers lost and he mourns to his bones the consequence of man's destructive brilliance. We, on the contrary, do not have the luxury of such tragic, pyrrhic triumph.

### TERRITORY

AS HIS CREWMATES gleefully go about their assigned tasks, ejecting and obliterating one dome after the other, Lowell, seemingly in a daze, tends the garden he knows is about to be destroyed, shielding his eyes as the bleaching glare of nuclear detonations sear through the space above him (see fig. 7).

Convulsed and wounded by the pulsing immolations, he looks lost and helpless ... until he can take no more – fiery-eyed, square-jawed, and lion-maned, he looks up and pronounces: "No!" (see fig. 8).

When Keenan attempts to enter this garden to plant the last bomb, Lowell stands in his way, spade in hand, defiant (see fig. 9).

A struggle ensues and Lowell kills Keenan (see fig. 10).

Then, in what is gradually revealed to be a traumatized state, he ejects and destroys the dome containing the two remaining crewmen, covering his tracks with regard to the rest of the fleet by manufacturing a malfunction. He allows the ship to drift towards the outer rings of Saturn, and then, in submariner speak, puts the ship into "silent running" mode. The second half of the film consists of Lowell attempting to make a life for himself – to live with himself and the things that he has done – alone aboard the ship.

Faced with the gleeful slaughter of nature's last fading remnants, Lowell found himself channelling inner terrors. In a desperate act of homicidal territoriality, he drastically affirmed the spatial order without which he could not bear to live. In the terms of Carl Schmitt, through a violent land-appropriation [*Landnahme*], Lowell instituted a new legal-spatial order – a *nomos*, but not of this earth.

7

8

### ATMOSPHERE

EARLY ON IN the voyage of the spacecraft Endurance in Christopher Nolan's *Interstellar* (2014), protagonist Joseph Cooper finds physicist Nikolai Romilly in a state of anguish:

COOPER. Are you okay Rom?

ROM. This gets to me Cooper. This, this. Millimetres of aluminium protecting us and then nothing out there for millions of miles, [that] won't kill us in seconds.

For all Lowell's suffering, this is not an anxiety that he experiences. Even when the Valley Forge passes perilously through the outer rings of Saturn, the sense of impending implosion is minor. The only casualty of the transition is maintenance Drone #3, which finds itself stuck on the exterior of the ship at just the wrong moment. Lowell lives and

9

10

11

Geoengineering is the idea that, in the words of Clive Hamilton, "deliberate, large-scale intervention in the climate system" can counter or offset the effects of global warming. Carbon capture, ocean seeding, aerosol spraying – such technologies, while highly contentious, are being taken increasingly seriously. However, the vaulting ambition of would-be *über*-engineers goes beyond merely modifying the climate: "For the true Prometheans ... the goal is to take control of geological history itself" (201). At the root of this, for Hamilton, is an insatiable will to perpetuate the expansion of the frontier of empire and capitalism beyond the given boundaries of the biosphere. Out, perhaps, into the stars, as so many have boldly dreamed ...

Carl Schmitt (1888–1985) was a jurist, philosopher, and political thinker. He is infamously associated with the Nazi Party during the 1930s; however, his work remains highly influential within political philosophy to this day. In *The Nomos of the Earth* (1950), Schmitt insists that, contrary to linguistic convention, "one should not translate *nomos* as law (in German, *Gesetz*), regulation, norm, or any similar expression. *Nomos* comes from *nemein* – a [Greek] word that means both 'to divide' and 'to pasture.' Thus, *nomos* is the immediate form in which the political and social order of a people becomes spatially visible" (70). As Claudio Minca and Rory Rowan put it, geopolitical order is, for Schmitt, "not simply founded in space but through foundational acts of spatial differentiation" ("Question of Space" 281; *On Schmitt and Space*).

237

breathes in a technosphere that is imperturbably implicit; it is never *this* "outside" that is the issue. The looming void was a key element of Kubrick's 2001 and it is perhaps against that film's cold heart that Valley Forge's interiors were made so immune to the menace of puncture. And yet, these consummately habitable interiors did not assemble themselves.

Wounded from his fight with Keenan, Lowell reprograms the maintenance drones to perform surgery on his leg. Later, he names them Huey, Dewey, and Louie and teaches the two that survive Saturn to play cards and work in the gardens. They become companions on his lonely journey through space, replacing the crew of whose murders he has recurrent flashbacks (see fig. 11).

12

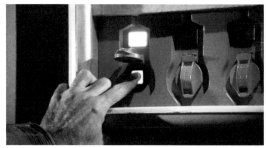

13

14

15

Even before his crewmates' demise, Lowell is shown constantly immersing himself into his nonhuman surroundings. For a time, during his silent desertion, it seems as though he may have approached a kind of psychological stasis, an even keel amidst the chaos. However, it does not last

Having already lost Louie in space, tragedy strikes again when Huey is damaged in an accident. Lowell's psyche gradually unravels, falling deeper and deeper into depression, eventually neglecting even his precious garden. When the fleet's rescue party finds him on the other side of Saturn, he is speechless, having seemingly forgotten that there might be anyone out there looking for him (see fig. 12).

With nowhere left to drift, we find ourselves at the film's poignant conclusion. Having made his peace, the camera pulls back from the interior to the exterior of the ship and, with a blinding flash of light, Lowell detonates the bomb (see figs. 13, 14 and 15).

The technosphere is, then, finally shattered by Lowell's own hand. Yet this final, absolute puncture is in no way a nihilistic gesture. However quaintly archaic and quirkily sentimental *Silent Running*'s tragic modernism may be, it retains a certain profundity. Because the film, like the more recent *Moon* (Duncan Jones, 2009), spends almost all its time with a single, solitary human character, it becomes exquisitely sensitive to that being's coexistential preconditions. It can, for these reasons, be understood as a case study in "atmosphere" – in the diffuse, multiplicitous, layered preconditions of life as lived. That is, not just of the biological functioning of the body – the oxygenated atmospheres that are so vividly explicitated aboard a spaceship are only one kind of atmosphere among others. All are preconditions of life as lived and much of this is taken away from Lowell at the moment that he "goes silent." Through such atmospheric constructivism, *Silent Running* explores the entropic unravelling a being suffers when cut out of its world.

For Peter Sloterdijk, the space station is paradigmatic of contemporary existence. It "signifies our lost innocence," making our atmospheric preconditions absolutely explicit, unfolding them to infinity. "We can't fool around with the artificial environment in the cosmic void, whereas ancient earthly nature let us get away with almost everything ... In the absolutely artificial environment, not even tiny mistakes are pardonable anymore" ("Foreword to the Theory of Spheres" 236–7). From the womb to the ark to the earth itself, in Sloterdijk's extrospective phenomenology, humans are the beings that existentially shroud themselves in endlessly evolving spheres, globes, bubbles, and foam. They achieve identity and security by formatting these worlds or, rather, *Umwelten* (bounded-worlds/environments), fortifying themselves against the fearful outside (*Globes* 897). Nebulous but not ethereal, indefinite but not ineffable, we swim in these precious spaces, emphatically and ecstatically at home in language, ritual, architecture, faciality. At home, that is, until the bubble bursts – until mistakes, tiny or otherwise.

## ANOMIE

As LOWELL'S WORLD decays, slowly eroding inside his technospheric citadel, the film's own sense of rhythm and consistency begin to fray. Time falls out of joint and space contracts, closing in, constricting Lowell's movements and worldly engagements. He is left doing little more than staring into the middle distance, lost to an asphyxiated "world-poverty," undone (Sloterdijk, *Globes* 584–587).

The film's climax is foreshadowed several times. For example, shortly before the fateful broadcast that informs the crew of their orders to return home, Lowell insists, with tangibly apprehensive optimism, that the coming communiqué would herald good news:

> I suggest that you reach deep down inside
> yourself there and try and find something

that will keep you awake a little while
longer because this transmission coming
up may just rekindle your will to live.

After the killings and shortly before "going silent," Anderson advises Lowell over the radio:

> We'll never be able to stop you before you
> hit the rings ... Freeman, you might want
> to consider ...

With a dazed, jaded stare and a knowing half-laugh, Lowell interrupts:

> Suicide, Sir? No ... I just don't think that I'd
> ever be able to do anything like that ...

Anomie, for Émile Durkheim, was a strictly "social" phenomenon, rigorously partitioned from the "cosmic" or "natural." This was in lockstep with the *nomos* of his time. For the moderns, geopolitical order was laid down over passive, static, prostrate earth. We find this same terrestrial inanimism in Lowell's description of the planetary monstrosity he calls home. His anomic suffering results from the humans around him being utterly, carelessly unconcerned with the spatial-ontological order that, for Lowell, was the whole world: "nobody cares ..." (see fig. 16).

Our world is no longer that of Durkheim, nor Schmitt, nor Freeman Lowell. The norm itself has become pathological. It is no longer a question of "is life worth living?" (James) but of "is this life liveable?" On our agentic earth, the air all around us, the soil beneath our feet: all are in motion – in *sensitive*, *reactive* motion. Scything the social from the natural was symptomatic of industrialized humanity's omni-exploitation. Moreover, Durkheim's organismic obsessions reflect the imperative of nationalism and the "balance of power" principles of the *ius publicum Europaeum* that endured, for Schmitt, up to that most catastrophic of years, 1914.

16

17

18

19

Durkheim's professional obsession was with carving out a sovereign ontological space over which sociology would have absolute authority. Alas, the social has evaporated; the Gaussian bell-tower is rubble. Anomie is not a pathology, *it is a project*. The very project of the moderns: to be free of all constraint, all limitation, all obligation. Society was the God of Durkheim's secular theology, anomie his version of sin. God is dead, derangement reigns! The social *katechon* (that which restrains) has folded in the face of post-War carboniferous capitalism and all its searing incandescence. The "morbid desire for the infinite" (Durkheim 234) knows no bounds. Wherever might we find, today, *ecological* solidarity?

### WILD

IN THE OPENING moments of *Silent Running*, a handheld camera tracks slowly, in extreme close-up, through foliage and wildlife, weaving a visual incantation of environmental bounteousness (see figs. 16 and 17).

The frame then dissolves and lifts, fading in to observe a male figure, swimming: "the focus pulling from the leaves toward his face, establishing him as part of the natural order of the sequence – another animal amidst the wilds of nature" (Kermode 25; see fig. 19)

Moments later, we see Freeman Lowell dressed in a heavy robe. Kermode notes the "intentional allusions towards St Francis of Assisi" but also, given the events soon to unfold, "a hint of Rasputin" (Kermode 63; see fig. 20).

The camera pans up to show a domed roof – beyond, the stars. We are revealed to be inhabiting an absolutely artificial nature (see fig. 21).

20

21

Émile Durkheim (1858–1917) was one of the founding figures of the science of sociology in the late nineteenth century. He conceived of society as an organism, the health of which could be represented by its relative statistical "normality" (Hacking). When healthy, the "bell curve" is symmetrical (a normal or Gaussian distribution). His concept of anomie (from Greek *anomia*: "lawlessness") signified a breakdown of the normative-appetitive restraints that a healthy, regulative social order imposes upon individuals – a deregulation or derangement [*dérèglement*] of social solidarity. Following Arthur Schopenhauer (1788–1860), Durkheim understood human nature in dualistic terms: to the bodily passions of the "will" were counterposed the rational restraints of "representation" [*Wille und Vorstellung*] (Meštrović). Durkheim transposed this distinction to the level of the social organism – individual wills corresponded to the bodily passions that, without superegoic regulation, resulted in self-destruction.

The film was scripted by Deric Washburn, Michael Cimino, and Steven Bochco. However, it was the former, according to Trumbull, who was responsible for "the whole environmental aspect of the story" (Kermode 14, 36). A few years later, Washburn would cowrite the screenplay for the Vietnam War epic *The Deer Hunter* (1978) with Cimino. Most tellingly, around the year 2000, he penned a screenplay (to date unmade) for Edward Abbey's novel *The Monkey Wrench Gang* (1975), which celebrates the use of sabotage in preserving wilderness spaces. Abbey's work was an important inspiration for the formation of the Earth First! group in 1979–1980. Cofounder Dave Foreman remains an outspoken voice for "deep ecology" and, in his own words, "wilderness fundamentalism." He urges a "return to being animal, to glorying in our sweat, hormones, tears, and blood" and derides "the modern compulsion to become dull, passionless androids." He sees himself as a "warrior" and Earth First! as a "warrior society" (Cronon 19–20).

Henry David Thoreau (1817–1862) famously wrote: "in Wildness is the preservation of the World." Equating wildness and wilderness with vitality, he continued that "the Wild" was "but another name" for "the West" – in other words, the Frontier. William Cronon has strongly criticized such crypto-imperialism, finding it also in Dave Foreman's deep ecologism; however, he affirms that "we can still join Thoreau" in celebrating "wildness (as opposed to wilderness)" because wilful wildness "can be found anywhere" (24) – in a suburban garden as much as the deepest forest.

22

23

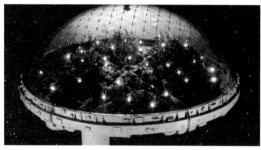

24

For all the beatific pastoralism, Lowell never makes any particular distinction between the monsters that he loves, and there is nothing either dull or passionless about his robotic companions. Indeed, it is the drones' exquisitely expressive performances, operating through subtle visual cues reminiscent of silent cinema, that bring the film to life. *Silent Running* is in no way a film about nature *against* technology but about a journey that mixes plants and animals, humans and machines seamlessly and unhesitatingly.

But what "wilds"? The forests or gardens (used interchangeably) for which this sweet, kind man will be driven to murder are almost obsessively well-kept and combed – tamed, dependent, without the slightest possibility of turning feral (Monbiot). This world-image is from another geo-ontological age altogether. As Isabelle Stengers writes, "Gaia cannot be domesticated." Nor, we might add, subjected to a *nomos*. Wildness is no longer a mere object of aesthetic or moral desire but the ontological precondition of all domesticity. From the will of the wild to the wildness of wills – forces that no frontier will ever tame.

However, the film does not end with Lowell's nuclear self-destruction. As the brilliant flash fades from the audience's eyes, the camera resolves to a heartfelt denouement: a battered watering can held in the mechanical claw of the one surviving crewmember of the Valley Forge (see fig. 22).

Having been ordered to tend the last remaining garden in the universe, an instruction accepted not without a hint of self-will, we see Dewey and the garden dome drifting off, free (see fig. 23).

Lowell's crimes and his suffering were, in the end, not for nothing. Undiscovered, his *nomos* endures (see fig. 24). Neither he nor his forests will ever "grace [the] foul earth" but nor would he be returned to "commercial service." Our own returns to earth, we might hope, will be less terrible – but who among us is confident of that anymore?

## Works Cited

2001: A Space Odyssey. Dir. Stanley Kubrick. MGM, 1969. Film.

Abbey, Edward. The Monkey Wrench Gang. Philadelphia: Lippincott Williams & Wilkins, 1975. Print.

Clarke, Arthur C. The Fountains of Paradise. New York: Harcourt Brace Jovanovich, 1979. Print.

Conway, Philip. "Back down to Earth: reassembling Latour's Anthropocenic geopolitics." Global Discourse 6.1–2 (2016): 43–71. Web. 24 Nov. 2015. Available at <http://dx.doi.org/10.1080/23269995.2015.1004247>.

Cronon, William. "The Trouble with Wilderness: Or, Getting Back to the Wrong Nature." Environmental History 1.1 (1996): 7–28. Print.

Durkheim, Émile. Suicide: A Study in Sociology. 1897. Ed. George Simpson. London: Routledge, 2005. Print.

Hacking, Ian. The Taming of Chance. Cambridge: Cambridge University Press, 1990. Print.

Hamilton, Clive. Earthmasters: Playing God with the Climate. Crows Nest, N.S.W.: Allen & Unwin, 2013. Print.

Interstellar. Dir. Christopher Nolan. Paramount Pictures, Warner Bros., 2014. Film.

James, William. Is Life Worth Living? Philadelphia, 1896. Print.

Kermode, Mark. Silent Running. London: Palgrave Macmillan, 2014. Print.

Lovelock, James. The Revenge of Gaia: Earth's Climate in Crisis and the Fate of Humanity. London: Penguin, 2007. Print.

Meštrović, Stjepan Gabriel. Emile Durkheim and the Reformation of Sociology. Totawa, NJ: Rowman & Littlefield, 1988. Print.

Minca, Claudio, and Rory Rowan. "The question of space in Carl Schmitt." Progress in Human Geography 39.3 (2015): 827–43. Print.

---. On Schmitt and Space. London: Routledge, 2015. Print.

Monbiot, George. Feral: Rewilding the Land, the Sea, and Human Life. Chicago: University of Chicago Press, 2014. Print.

Moon. Dir. Duncan Jones. Liberty Films, 2009. Film.

Schmitt, Carl. The Nomos of the Earth in the International Law of the Jus Publicum Europaeum. New York: Telos Press, 2003. Print.

Silent Running. Dir. Douglas Trumbull. Universal Pictures, 1972. Film.

Sloterdijk, Peter. "Foreword to the Theory of Spheres." Cosmograms. Ed. Melik Ohanian and Jean-Christophe Royoux. New York: Lukas and Sternberg, 2005. 223–40. Print.

---. Globes. Cambridge, MA: The MIT Press, 2014. Print.

Stengers, Isabelle. "History through the Middle: Between Macro and Mesopolitics." Interview by Brian Massumi and Erin Manning. INFLeXions 3 (2009): 183–275. Web. 24 Nov. 2015. Available at <http://www.inflexions.org/n3_stengershtml.html>.

The Deer Hunter. Dir. Michael Cimino. EMI, Universal Pictures, 1978. Film.

243

WITH THE THREE FIRST PROCEDURES, the moderns are beginning to land somewhere at last. Thanks to Procedure 1 of relocalizing the global (r·m!51–67) they have abandoned the view from nowhere; with Procedure 2 (r·m!91–103), they have shifted away from their obsession with the object/subject connection; and as to Procedure 3 (r·m!167–83), it led them to encounter the presence of many entities, that no longer resemble the "natural" and "material" world from which they had been requested to escape while being irreversibly reduced to it.

Fine, but *where* have they landed? What is this place that is neither outside nor inside? It is one thing to refuse to be imprisoned in "the cave," it is quite another to detect where you now reside. This is why we need a fourth procedure if we wish to reset our instruments and find our bearings.

## Procedure 4

# FROM LANDS TO DISPUTED TERRITORIES

Moderns invented a term to define the promised land to which they tried exiling themselves; it was called "the economy." Strangely enough, it had all the characteristics of an extraterrestrial utopia as well as those of being mundane, material, earthly, secular, and carnal. With "the economy," you could pretend that you had broken free of all the other earthly limits and attachments so as to benefit from an infinite cornucopia of goods, and simultaneously, without any contradiction being made apparent, that you had to submit yourself to the harsh conditions defined by the "laws of economic nature." Such was the "secular religion" or, rather, the odd "religion of secularization" described by Karl Polanyi.

Whereas "the economy" claims to be the "dismal science" of mundane matters of fact, obliging everyone to stay inside the strict limits of its laws, it also shifts attention to a transcendent world of infinite benefits (Mitchell). Such a contradiction is enough to push anyone to lose their bearings: how could you decide where to live if you were asked to be at once out of this earth and bound to its most sinister necessities?

Once the other procedures have been followed, "the economy" appears not as the universal horizon of the planet, but as an extraterrestrial body with the capacity of destroying the planet, just as *Melancholia* does in the magnificent film of Lars von Trier (see fig. 1). As soon as you relocalize the global pretence of "the economy,"[1] it appears as the most provincial definition of what it is to occupy a territory. One thing becomes clear: such a secular religion is not of this earth. It has to be fully reset.

[1]   See, for instance, the works *Situation Rooms* (2013) by Rimini Protokoll, on the rclocalization of the globalized world of weapons, and *The Forgotten Space* (2010), a film essay by Allan Sekula and Noël Burch, following container cargo and describing the "global" maritime transport system.

"The economy" now appears as an odd construction, mixing up the most transcendent and the most immanent visions of daily existence, without our having been able to explore the oddity of this construction. And a construction it certainly is. A "machinery of calculation" able to transform space into an apparently isotropic universal sensorium and time into the mere consequence of calculations and plans firmly situated in the past (Giraudeau, r·m!260–71; Graeber).

The result of such an odd machinery of hopelessly confused immanence and transcendence is a world of violent land grabs that have become strangely groundless as so magnificently portrayed by David Maisel (see fig. 7, r·m!253). Whereas the official version is that nothing is left but an isotropic space allowing for the smooth and uninterrupted transfer of calculations, everywhere it is interrupted (see fig. 3, r·m!249) and abruptly stitched together (see fig. 5, r·m!252) as if it had become a war zone, a vast landscape of front lines and trenches (Montebello, r·m!293–95).

That is the place where the moderns have landed, not because they were too greedy and too much attached to worldly profits but, on the contrary, because they were inventing on this earth something that had no plausible ground "on this earth." As if waking up from a dream, they look around utterly puzzled. It does not make for an easy morning when, having dreamed that you were soon to enter the promised land of endless frontiers, you wake up suddenly in the Anthropocene! What does it mean to be limited? And by which sorts of borders and fences?

What happens when you try to break free from the strange mixture of misplaced transcendence and misplaced immanence? You land on a territory that begins to take on a very different shape, atmosphere, thickness, density, and opacity. It is at once much more local, much more differentiated, and much more layered. It no longer resembles the surveyed land of most legal theory as it has long been defended by the older figures of the state and property rights (McGee, r·m! 272–77). Its boundaries have shifted.

To be sure territories gain in realism; they have a

1    *Melancholia*. Dir. Lars von Trier. 2011. Film still. Courtesy of Zentropa Entertainments27 ApS.

2    Otobong Nkanga. *Social Consequences I: Limits of Mapping*. 2009. Drawing, round stickers and acrylic on paper, 29 × 42 cm. Courtesy of the artist, Lumen Travo Gallery, Amsterdam and In Situ Fabienne Leclerc Gallery, Paris.

fragile soil to contend with, they have multiple ecosystems to be defended and cared for (Brantley, Lebedeva, and Hausrath). Their limits are difficult to trace on a map as if they had lost their "limes" (see figs. 4a–e, **r**·m! 250–51). They are discontinuous and when they connect with other territories, this is no longer through the mediation of any isotropic space: they have a complex geological history (Zalasiewicz) added to a highly complex set of agricultural practices that require attention and care – exactly the attention and care that was supposed to have been made useless by the advance of the modernizing front (Gouraud, **r**·m! 296–303).

Thanks to such a procedure, the landscape looks entirely different, as does first of all the very idea of what a landscape is (Olwig). The vast dispositif of cartography, survey, land rights, property laws, and perspective is being slowly replaced by another set of signposts and guiding trails. It becomes impossible to place territories side by side. They overlay, overlap, and dispute one another; new visualization tools and mapping principles are called for (Farinelli). Everything happened as though we had moved from a geopolitical map surveyed from above, to a great many trails through disputed territories. As though the land of the moderns had now all the characters of the older attitudes toward land that anthropologists have documented (Ingold). More exactly, as though the moderns ended up sharing the same tragic destruction of lands that they had imposed on the others (Martin). As though they all had to live in the same ruins (Tsing).

How strange is the shift for those who felt they could see "the globe" from above, as though from nowhere. Especially now because the temptation, everywhere on the fully "modernized" planet, is to shrink away from the utopia of "the economy" by receding beneath some well-entrenched border inside some closely knit identity. As though, to escape from the impossible move toward the great "outside of globalization," the only solution was indeed to accept being condemned to remain prisoners in "the cave."

Just at the moment when it becomes necessary to fathom the multiplicity of intertwining and overlapping territories, there now resonates the old nostalgic call for falling back on the lands of the (imaginary) past. How difficult it is to de-modernize oneself. To stop demonizing the thick, heavy, earthly, mundane soil on which we have to grow. To stop being nostalgic about the promised land as well as about the archaic ground left behind for good.

For this we need still another procedure, one that reconciles us with our ability to build fully artificial, or better, artifactual landscapes inside which to reside in common (Latour, "Procedure 5," **r**·m! 305–19).

Works Cited

Brantley, Susan L., Marina Lebedeva, and Elisabeth M. Hausrath. "A Geobiological View of Weathering and Erosion." *Fundamentals of Geobiology*. Ed. Andrew H. Knoll, Don E. Canfield, and Kurt O. Konhauser. Hoboken: John Wiley & Sons, 2012. 205–27. Print.

Farinelli, Franco. *L'invenzione della Terra*. Palermo. Sellerio Editore, 2007. Print.

Giraudeau, Martin. "The Business of Continuity." Latour, *Reset Modernity!* 278–85.

Gouraud, Sylvain. *"Shaping Sharing Agriculture (Letter to My Grandmother)."* Latour, *Reset Modernity!* 296–303.

Graeber, David. *Debt: The First 5,000 Years*. Brooklyn: Melville House, 2011. Print.

Ingold, Tim. *The Perception of the Environment: Essays on Livelihood, Dwelling and Skill*. London: Routledge, 2011. Print.

Latour, Bruno. "Procedure 1: Relocalizing the Global." Latour, *Reset Modernity!* 51–67.

---. "Procedure 2: Without the World or Within." Latour, *Reset Modernity!* 91–103.

---. "Procedure 3: Sharing Responsibility: Farewell to the Sublime." Latour, *Reset Modernity!* 167–83.

---. "Procedure 5: Innovation not Hype." Latour, *Reset Modernity!* 305–19.

---, ed. *Reset Modernity!* Cambridge, MA: The MIT Press, 2016. Print.

Martin, Nastassja. *Les âmes sauvages*. Paris: La Découverte, 2016. Print.

McGee, Kyle. "On the Grounds Quietly Opening beneath Our Feet." Latour, *Reset Modernity!* 272–77.

Mitchell, Timothy. *Carbon Democracy. Political Power in the Age of Oil*. New York: Verso, 2011. Print.

Montebello, Pierre. "Earth and War in the Inquiry." Latour, *Reset Modernity!* 293–95.

Olwig, Kenneth Robert. "All That Is Landscape Is Melted into Air: The 'Aerography' of Ethereal Space." *Environment and Planning D: Society and Space* 29 (2011): 519–32. Print.

Polanyi, Karl. *The Great Transformation*. Boston: Beacon Press, 1944. Print.

Tsing, Anna L. *The Mushroom at the End of the World: On the Possibility of Life in Capitalist Ruins*. Princeton: Princeton University Press, 2015. Print.

Zalasiewicz, Jan. *The Planet in a Pebble. A Journey into Earth's Deep History*. Oxford: Oxford University Press, 2012. Print.

**3** Sophie Ristelhueber. WB #6.
2005. Color photograph, digital
pigment print directly posted

**4a–e** *Italian Limes* (2014–16) is a project by Folder (Marco Ferrari, Elisa Pasqual), Pietro Leoni, Angelo Semeraro, Alessandro Mason, Delfino Sisto Legnani, Livia Shamir. Courtesy Folder.

252

**5** Ahmet Öğüt. *Pleasure Places of All Kinds. Fikirtepe Quarter.* 2014. Sculpture, 150cm × 150cm × 70cm. Private collection, Amsterdam.

**6** Ahmet Öğüt. *Pleasure Places of All Kinds. Zhejiang Province.* 2014. Sculpture, 150cm × 150cm × 70cm. Private collection, Amsterdam; *Pleasure Places of All Kinds. Fikirtepe Quarter.* 2014. Sculpture, 150cm × 150cm × 70cm. Courtesy of the artist.

**7** David Maisel. *The Lake Project 2.*
2001. Photograph, printed as
archival pigment print, 2015, 122
× 122 cm. Courtesy the artist,
Ivorypress Gallery, Madrid, and
Yancey Richardson Gallery, New
York.

8    Adam Lowe. *Littoral Deposits*.
     1994. Pigment transfer print
     (pigment and gelatine). Left: the
     bed of the river. Right: littoral
     deposits collected at the same
     point.

9    Adam Lowe. *Littoral Deposits*.
     1994. Pigment transfer print
     (pigment and gelatine). Left:
     the bed of the river. Right:
     littoral deposits collected at
     the same point.

**10**  Adam Lowe. *Littoral Deposits*. 1994. The slipcase, the 72 feet etching open
at one double page and the supplementary book containing additional self
representations by the river.

11   Adam Lowe. *Littoral Deposits.*
1994. Littoral deposits fixed in a
layer of resin.

12   Adam Lowe. *Littoral Deposits.* 1994. Another example of *Littoral Deposits* fixed in a layer of resin. The ability of the
river to represent itself was an integral part of this exercise.

**13** Bureau d'Études. Die Eroberung
des Hohen Nordens. Geopolitik der
Energie- und Bergbau-Ressourcen.
Map, size variable.

**14** Pierre Huyghe. *Nymphéas Transplant* (14–18).
2014. Live pond ecosystem. Courtesy of the
artist, Esther Schipper, Berlin, Hauser and
Wirth, London, Marian Goodman Gallery,
New York.

15r·m!

03

824846596979r·m!2

**OUR ECONOMY**

**Martin Giraudeau,
Antoine Hennion,
Vincent-Antonin Lépinay,
Cormac O'Keeffe,
and Consuelo Vásquez**

*For brief information on* **MARTIN GIRAUDEAU** *see* r·m!278.

*For brief information on* **ANTOINE HENNION** *see* r·m!208.

**VINCENT-ANTONIN LÉPINAY** *is an associate professor at the Department of Sociology at Sciences Po in Paris as well as head of the Center for Science and Technology Studies at the European University in St. Petersburg. He is the author of Codes of Finance (2014) and coauthor (with Bruno Latour) of The Science of Passionate Interests (2009). In the* AIME *project he has acted as a mediator.*

**CORMAC O'KEEFFE** *earned his PhD degree in education from Lancaster University's Centre for Technology Enhanced Learning. He is currently an executive director at* YES 'N' YOU *in Paris where he develops digital learning and assessment programs. His research interests are* STS, *digital methods, learning analytics, and education.*

**CONSUELO VÁSQUEZ** *is an associate professor in the Département de communication sociale et publique at the Université du Québec à Montréal in Canada. Her work has been published in numerous international peer-reviewed journals. Her current research focuses on the constitutive role of spacing and timing in project and volunteer organizations.*

Originally published on:
AIME. *The Blog.* FNSP, 28 Oct. 2015. Web.
8 Feb. 2016. Available at
<http://modesofexistence.org/our-economy/>.

# The blog

ÉVÉNEMENTS  |  DISCUSSIONS  |  RESSOURCES  |  PLATEFORME  |  TOUS

## *Our Economy*

28 OCTOBER 2015
catégorisé sous: ECONOMY SPECBOOK

Revised excerpt from:
"Specbook." AIME. The Blog. FNSP, 30 June 2015. Web. Available at
http://modesofexistence.org/specbook/.

**Foreword**

Among the various institutions that we submit to the inquiry, the
Economy is in a very particular situation. If it now seems to have taken
precedence over all other institutions to control our world, it is also the
most modest size, the one that does not claim to defend our values, enter
our anthropologies, do our politics. Minimalist in its claims, this institution
is at the same time voracious consumer of human and material resources. It
is the one that mobilizes an army of soldiers and displays a logistics at all
times. Taking stock of the Economy and putting it to debate was not a
trivial matter: we had to balance between not taking it too seriously
(believing in the laws of the market) and not taking it too casually
(denounce it as a vast illusion). Hence our hesitation to find the tone of our
own discussions, and especially situate ourselves with respect to the
economists, whom we never know if they do science or if they perform the
"real" economy.

Not without some hesitation, we chose to take the gamble of a somewhat
calculated ignorance. To forget for a moment the authors, leave out the
frontal critic of theories, assume some *naïveté*. This may be the key that
allows opening all issues, especially the ones that the economy prevents
the formulation other than in its own terms. Even if it means to say
thoughtless things here and there, this false innocence (or this real
incompetence) seemed the right way to avoid falling into the trap of the
economic evidence: "not considering what I say, is doing politics,
philosophy, sociality, whatever you want, but without taking into account
reality, and whatever you do, it will catch you! You cannot avoid me for a

long time!" To address the economy otherwise we somehow reversed this blackmail: we considered very real the work of the economy, its tools, its measurements, its effects; and we quickly passed over the way it presents itself. The kitchen, rather than the menu!

This gave an offhand tone to our conversations, to which we gave free rein. We preferred to keep this spirit also in the writing of this report, rather than hide it by stuffing it with explicit references and adopting a more balanced tone of a scientific debate: a bit of disrespect helps better unmask the blind spots of this discipline of evidence. It was also a way for us to inscribe our conversations directly in dialogue with the Inquiry by somehow presenting, on the one hand, the army of economists — all these professionals we refer to in the text —, and on the other hand, the modes of existence, Gaia's representatives, the non-moderns, and Gaia herself. We hope that by avoiding the rigidity and fixity of a certain writing style, the conversational tone adopted in the text will help to recreate this 'middle ground' and invite for contestation.

### Our "Economy"

1. We Moderns do not believe that we should have to economize on the economy. By this we do not wish to say that the economy is indispensable (maybe it is, maybe it isn't…) but that 'there will always be a price to pay' for all economization. 'You don't get something for nothing,' so the saying goes, and this applies to the economy too: Everything that goes into the economy is work; in other words, everything has a 'cost' – the quotation marks are here to show that prior to this work, these costs are only metaphorically economic: they are attachments that haven't yet been economized. That is, neither, calculated, evaluated nor managed, and this implies a lot of effort. So much the better, since it is these costs that reveal that there are choices, other possible paths, other winners and losers, and beings and potentialities that either flounder or flourish.

2. It is the existence of these choices, these other possibilities, that reveals that there is no Economy, in the sense of substance. There is only economizing, in the sense of existence. Up until now, we have had a tendency to privilege an economy-as-substance, formulated in terms of rules or laws. This obsession has led us astray, it has given rise to a confusion of categories and pathways, it has set us firmly, first on the path of productivity, then on the path of obesity (located in the forest of poverty). The argument for substance is though not a viable one … not until we have addressed the possibilities of destruction that weigh so heavily on Gaia. The substance-economy is a way of keeping everyone else at bay while the experts remain in charge.

3. We thus need to move on from an Economy seen as the Way the World

Works — as light and abstract as it is imperative, doing nothing yet still running everything — towards multiple tentative *economizations* that need to be revised and remade. Only then we can leave behind the image of a smooth economic space where articulations among orders of reality are neatly delineated in favour of a different kind of movement, like navigating among tectonic plates or polar ice floes. So the question that emerges here is the same as the one that concerns the other modes of existence: How do we 'institute' this way of letting the economy '*laissez-faire*,' but only on the condition of having concurrent experiments that are revised and debated? The answer is not simple. What we have is a tangle of scripts all piled up on one another belonging neither to a coherent whole nor a predefined, rational or planned organization. No question of a give and take around the table so that everyone gets something: Patching things together, with nothing between them but frictions, gaping holes, chasms and fractures, means nothing holds together for very long. Less metaphorically speaking, the economy is nothing other than a heterogeneous accumulation of statistics, accounting, industrial politics, businesses, fiscal legislation, the State, planning, markets, theoretical calculations and econometrics. It is a piling up of various devices [*dispositifs*] that are far from all pulling in the same direction. What kind of institutionalization do we need? There are any number of means available in all this mix to make them self-correct, once we stop thinking about these assemblages as a system (a system which collapses if just one piece is moved, like the game of Pick Up Sticks). These constructions, all with varying degrees of coherence, are not parts of a jigsaw laid out on an economic base framed by abstract laws. There is no base, just provisional stabilities as the experimentation proceeds.

4. So let's stop understanding the Economy as an incredibly efficient 'low cost' machine able to transform our problems into solutions with a simple price tag, and rather consider it as a conflicting and open plurality of economizations that are all, in their own way, 'costly.' Only then we will be able to keep whatever profits are made by having a discussion about what costs, what was lost, and what was damaged. Since these heterogeneous, poorly defined, ill-disciplined costs remain to be tested — precisely because they are attachments that have yet to be economized — there is no ready-made answer. The problem is not one of economizing them ever faster but rather to *slow down* the solutions, ask questions, evaluate the losses without necessarily knowing where it will lead. In other words, by increasing the level of care and attention given to each economization.

5. In the first instance, we do not mean by this that we should put into the economy what it had neglected until now. This would be to admit that everything is economizable with a profit margin, that it is only a matter of handing over everything to the economists who will then say, "All right, let us handle it, we'll calculate that for you." On the contrary, we could

consider economics as a pluralization of all those economizations that are possible or impossible, those that are doable or not, without knowing the stakes or repercussions. Then, in the second instance, it would be a question of accompanying all economizations with watchfulness, with care, with a vigilance that would live up to its promise: every economization comes at a price. How are we to do this? It is precisely because 'we do not know' that we propose to begin with those concerned with 'doing' things differently. Instead of sweeping bothersome questions under the carpet, we can then propose a variety of devices [*dispositifs*], inscribing into scripts possibilities for discussion and revision. To achieve this, we need to start listening again to strong discordant voices and deflate economics (for its own good). Both externally, by simultaneously applying pressure to "competing" institutions (law, politics, morality) and internally, by making sure scripts are revisable and self-limiting.

**1. Slowing down the Economy: The price of Attachment and Care**

1. If we understand the economy to be an operation that stabilizes and blackboxes solutions it is hardly sufficient that it can just work, that it is scientific or rational enough for us to consider it as acceptable — that we just leave the economy the keys even if this means taking away from it a few sacred domains. On the contrary, the economy needs to be usable everywhere and by everyone, yet always open to discussion, provisional, revisable, even if — especially if — the discussion itself is costly and slows things down. If it has *a* value then it also valu*able* (c.f. Dewey). And it is precisely this point that reveals and expresses attachments. If the economy can be dear (expensive) then it can also be dear *to us*.

2. **[ATT]** allows to us to encompass goods and people as a collective. Beyond "dazzling displays," institutions must maintain a thick **[ATT]**, not just a single thread, but a heavy weave, thus making it easier to decide in favor of some to the detriment of others. These attachments always turn out to be a test of what we hold dear and it is for this very reason, from the point of view of the economy, that they span the gap between the instantaneousness of impulse buying and the heaviness, the duration, the body and inertia that carry us. Let us note that in the word attachment there is both the passive (whatever attaches us), and the active (the '-ment' of attachment: what we attach ourselves to, and which determines us, thus strengthening, or undermining, our attachments — or that sometimes forces us to abandon them), both need to be taken seriously when considering the 'price' of economy.

3. We say 'YES' to any and all experimentation. This word must be heard outside of the confines of pre-established forms. It is for each of us to invent our own devices [*dispositifs*], our own evaluations, spaces and limits. Experimentation links collective action and the precautions and measures

that accompany it, even when this means delays: these experimental economizations need guards, spies, alerts, reminders, and thresholds that must not be crossed. All these beings are beings of exploration and *care*. In the manner of a "speculum", they are indicators, neither entirely on the inside nor the outside. If we are to install one of these economies *in the making*, we need a multitude of these little telltales signs to let us know where we are. There will be failures and rejections to cast aside, corrections to apply, some things exaggerated and others brutally destroyed ... because we constantly need to "watch over" our attachments, list and protect the experiments, sound the alarm in case of danger, even when it all looks too promising. All of this requires new skills and new sensitivities to learn how to take the time necessary for economization: to be watchful, alert, curious, and respectful. For this economization to be made possible we will require new roles (and professions?). This will involve a change of descriptive categories, a focus on the actors, collectives, things in the making and not only on numbers and ratios (industrial economy versus economic calculation). So as to avoid a reduction to the individual, this is all filled with collectives that are more or less attached, professions, businesses, social movements, organizations, etc. that are to varying degrees bound to one another. Bodies, in a general sense.

4. By the same token we say 'NO' to the economists' constant blackmail: "This is a great idea," they say, "But, sorry, a new world is quite impossible; it's far too risky and will only end up bringing down the system." There is no such thing as a system that needs to be protected for its own sake within the economy as if any attempt to monitor it would only break its irrepressible momentum. On the contrary, the more these problems show up, the more possibilities exist for 'care,' for inventions, for new starts – and possibly even for interesting economizations – but this time for everybody. We say 'YES' to an economy that both cares *for* and cares *about*. That is to say, an economization that experiments and brings with it promise and hope but all the while remaining costly and only on the condition of allowing a market to open with the cover of discussion, and the right to revision written into it. For the costs are also virtuous costs; they measure the effort required to consent to experimenting with new worlds (*commons* or alternative economies on the edges of the economy, but also at its center of gravity, by questioning currency, finance, companies etc.).

5. There is something to learn from Hayek's idea of a negative institution, understood as a series of "do not" imperatives, if we free it from its exclusively economic confines. However, as with slowing down, these 'do nots' are not in reality entirely negative but can be considered as time wasted only to be saved.

6. Just like Hayek (and a few others), we are convinced that time matters

centrally; just as Hayek (and a few others, including Israel Kirzner), we see that economizing is a dance with uncertainty; like Hayek, we look at experiments and experimentation with some interest. Have we simply become Hayekian? What unites us further is the avoidance of any master repartition. In the language of Hayek, the State plays the big bad wolf, endowed with special powers and entitled to stifle any experiment it would not fancy, for one (arbitrary) reason or another. So we do share with Hayek some caution against any hurried composition of the common good. With some relief, given the deadly track record of the Austrian schools of economics, there are also some salient differences. The background of Hayek and his disciples is both an aggressive Darwinism — experimentations will eliminate the weakest candidates and celebrate the fittest — coupled with a narrow definition of efficiency, crowned by "price." This couple is topped by a mobilization of the (rule of) law — also a long and wise outcome of a market mechanism — which would maintain a procedure and some order to the otherwise wild experiments that entrepreneurs entertain.

7. However, unlike Hayek, we are not attempting to defend a little enclosure where the economy, a minimalist institution not needing an institution, would be finally free to run without reins or brakes, protected by nothing other than negative institutions with instructions not to get in its way. The parallel with the image of the *middle ground* in its contrast with the image of the frontier is striking: it is, on the contrary at the heart (or the choir — in French, *coeur or choeur*) of the economy where the voices of the greatest possible number of institutions should rise, all provisional and none founded, each able to experiment with the means it has to hand, creating provisional zones of stabilization, under the pressure of others. Our barriers are internal. First we have to negotiate the time that needs to be set aside from them before destroying them.

## 2. Taking the Virtue of Transaction Costs seriously

1. How, though, to create some time? Or, referring to the terms of the *Inquiry*, what is the felicity condition for the economy? It certainly cannot be for it to work – on the contrary, this is precisely when we should call out, "Danger!" – but that it brings to light all the resistances, and the attachments left behind to be crushed. A very *Polyaniesque* idea is that the economy is impossible, (in the same way that we say that a small child is utterly impossible), that is it nothing more than the measurement of those oppositions that allow it to exist. This is what the kind of anti-instituting institution (à la Hayek) would be aiming for. More technically speaking, it would be a quasi-legal requirement for it to warn about any irreversibility. The problem of the size and duration of these experimental formations should not be solved in an absolute sense or with a rule; this would be

contradictory. Above all, we must free ourselves from the dictates of efficiency, by reinstating a new value – transaction costs – but taking it seriously this time.

2. The virtue of the economy is not its efficiency outside of the possible concerns of individuals, but rather its production of knowledge and preferences. Eliciting such preferences – what we hold to be good, not yet common, but at least consistent enough that we can formulate it and defend it – is not only the noisy chit-chat of the conversation dear to Tarde (AIME). It is the only solution to keep the experiences of the economic experimentations from becoming the chimera of disrespectful scientists. The new gesture of our economy is to question not only any free lunch, but to question the efficiency of economic institutions.

3. The recent vicissitudes of French bank BNP-Paribas will clarify the need not to rush towards a ready-made definition of transaction costs. National currencies have long been praised as vehicles of efficiency and low transaction costs. From the 1970s on, the US dollar impersonated this fiction of a global economy freed from currency uncertainty. In 2014, BNP-Paribas settled for a fine of 9 billion dollars so as to be allowed to continue operating transactions in US dollars. The reason for such a fine is a breach of an injunction by the State department outlawing economic transactions with enemy States (Cuba, Iran and Sudan). All of a sudden, the *transaction cost free* currency carries a huge cost and the French bank wishes it had another currency, another collective experiment, that would not tie it to the diplomatic policies of the current US administration. Incidentally, we can see just how swiftly and adroitly the Mighty know how to combine brute force with politics, law, and economics (if you want to be in the US market, then you agree to the fine) while profiting from their official status. The economy only cheats on those who believe in it.

4. People will object: but this is too costly; how can you want an increase in transaction costs?! There is an argument against this: the transaction costs have already exploded. The economy looks as though it reduces costs, by stabilizing calculation techniques and procedures – but they are constantly revised, adapted, twisted, etc., and at a huge cost. There is an entire army of economizers doing that: economists, but also and most importantly accountants, managers, etc. And not only is this costly in a monetary sense; it is also costly in the sense that this professionalisation of economizing prevents other participants from having their passionate interests taken into account. Economizing must be fully redistributed, by the abolition of the professional manager, the professional accountant, the professional economist. Management, accounting, economics are everyone's business. There is, we must admit, a danger of hegemonization in de-institutionalization and re-distribution of economics. How can we

preserve the deflation — slowing down — of economy without going back (or going forward) to another totalization? (Will [REL] help us?)

5. This attempt at a "deinstitutionalizing re-institution" must not be heard as having a social-democratic tone. Social democracy theoretically believes in realities as given (the market, the social, the legal, etc.) in practice puts them together by tinkering with them. We seek the opposite, by accepting, in a theoretical manner, the pluralism of a multimodal world in which no order is a given, and by confronting, in a practical manner, the violence of things, necessary choices that lack any basis, and fighting against other reductionist pretensions (even if they are our own). Most of all though, we fight *for* — without ever really knowing for what. Hence the urgency and the slowing-down, the necessity of combat and the uncertainty, commitment without guarantees, risk-taking and experimentation; these are stances that are far removed from perpetual compromises and indecision wrongly taken for open-mindedness.

6. The idea that we "we don't know" but that we will nevertheless try has nothing anecdotal about it but is at the heart of a pragmatic mix of commitment and incertitude that is our lot, confronted as we are, with worlds that are still to be made. Setting up institutions in a post-AIME pluriverse (ahem ...) is to insist on both of these terms at the same time: action *and* ignorance, commitment without a guarantee and neither reason nor a given order to rely upon. Just an assembly with a negotiable duration and held together by nothing other than the actions of those collectives involved (e.g., organic wines). Such an institution not only takes a "positively negative" turn, but also a tone that distances itself from what is hard to shake off, that of an order to be established. Rather, it should be to organize disorder, or to disorganize orders, or disorder organizations, all the while letting them go into battle...

### 3. Inscribing Disorder into Scripts or the Possibility of Revision

1. We are happy to debate the "profits" of the economy, the advantages that it can or cannot procure (the "receipt" once goods have been bought, circulation, innovation, the possibility of investment — to take Polanyi's list — everything to which economists quite properly concerned with the common good may care about). However, far from delegating the problem of the Economy, ("Don't you worry about anything, we'll take care of it"), how can we organize the debatability of this economization [*mise en économie*] without knowing the answers? It is not about making dynamic frameworks more dynamic, nor collecting the desires of consumers in increasingly inventive ways (this is a job for marketing) but to "contain" scripts, to let them hesitate and hold back with alerts, protests, and all manner of unpredictable forms that may or may not fit into a framework. To listen to discordant voices and not only to those that enter into the

framework and reinforce it. To try things out, to experiment and rely on those actors concerned — or rather, to inscribe this care into the very scripts of the economy. This does not mean giving carte blanche since all economization must be accompanied (thanks to law, politics, morality, family, religion, etc.,) by the right to revise, review deadlines or be accountable to itself as well as, when the state of affairs demands it, to have the possibility of questioning or changing the script without having to ask for permission (thank you Gaïa, if you prefer!). This way of putting it is important: we see that it is less about agreement and coordination (we can agree on nothing but disagreements) but about actions undertaken by those collectives concerned, and only through their own results will they will be able to be judged, estimated and appreciated (this is the Deweyian double meaning of the worth of things: to be valued and to have a value). The aim is not to compare goods in the same space and against a common standard, but to evaluate incommensurable experiences in action.

2. What could then be the possible conditions to put into place so as to ensure the reversibility of scripts? We have already said it: what motivates the keeping of scripts open is the need to turn the economy into a felicitous set of experiments. Against the temptation to blindly celebrate or reject the economy altogether, we look to the economy as a site where experiments should be tried out or at the very least be "triable." This is important to keep at bay the disillusionment (from Weber onwards) that some of the critiques of the economy force onto the revisions. However, this opening up to experimentation also has some limits. The strict requirement for the revisability of scripts has an implication: the need to avoid situations where scripts only go so far, or where so many scripts are interconnected that revising one of them puts the whole "system" at risk of collapse. Some form of protectionism must thus be constituted. However, it must not be a protectionism of stable or "external" frontiers: protecting national economies, certain industries, etc. It must be a protectionism of mobile barriers — "internal" frontiers that will be established and re-established constantly. And it must provide barriers against the extension of scripts or systems of scripts.

3. The goal is fairly clear: that no script begins to set itself up as the template for the others, with its path to realization being its own story, ready to digest all the others. We must recognize that these forms of vigilance, more or less proactive, that compel self-limitation, remain to be found by searching among one's neighbors (the other modes or institutions already mentioned, from the law to the family, etc. but also among protests, riots and uprisings, the slow "awareness" of the environment or the qualities of everyday things, the sudden breakdown of a way of working being turned off, etc.). There is, it would seem, a lot to be done: "les affaires restent à faire…"

4. Nonetheless, we do admit that the practicalities of this are problematic. There could be a requirement that no script be too extensive – with a size limit, preventing the excessive growth of certain entities, a bit along the lines of anti-trust laws. But things get much trickier as soon as the new constitution tries to tackle systems of scripts; how is the building up of systems prevented? One possible direction would consist in setting extension requirements regarding chains of scripts – e.g. no chain should be longer than so many elements, and each new script produced should list the chain of scripts it puts itself into or generates, to check that it follows this requirement. So instead of stress tests that have been devised by the infamous Bank of International Settlements, rather a disclosure of conflicts of confiscation of scripts, forcing scripts to be relatively autonomous. So one of the conditions in the rewriting of the script is the need for each script to be autonomous from other scripts, a form of modularity. Refusing the entanglement of many scripts allows for one script to be discarded and thus refuses the argument that one script is too central to the whole economic system for it to be allowed to fail – the 'too big to fail' argument. It is as important to define interruptions to experiments as it is to let the scripts be open and revisable. This stopping point is a way of rewriting the question of regulation and State that has long paralysed economic intervention and has always been mobilized by libertarian economists as a straw man. The deadly State/Market debate has missed the fact that the experiences of economic experimentations always take place elsewhere: nor on a generic market – as experimentations are only good to launch if they involve interests and attachments that can be voiced here and now, by individuals and groups who are going to be affected by their outcomes.

5. These forms of institution seeking to avoid institutionalization are somewhat oxymoronic (the theme of "deflation" is present in all of the modes), but we are not left completely disarmed and it is not a question of remaking the world from scratch; this idea has already been worked on in the past. Some experiments come to mind when we want to think about the forms of limitations that need to be put in place. Below, we have given some examples: anti-trust laws, nuclear waste legislation, bitcoin or local currencies, etc. There are others such as policies of innovation that consist in sustaining competition between many ideas by supporting the ones that struggle and not the ones that are winning.

6. For instance, the web-based currency *bitcoin* has built into its system the dual imperative of being directly attached to what is now the most pressing question of the Internet — security of transactions — as the mining mechanism is dependent on producing public encryption keys, and the designed lack of hegemony in the ecosystem of other moneys because the mining of hash is becoming increasingly difficult so that scarcity is also built-in. So a currency that works at maintaining the possibility of

transactions — monetary and other forms — while containing itself.

7. The recent legislation of nuclear waste in France has made it necessary to adopt solutions — bury, keep above ground, etc. ... — that are reversible, so that in NN years, the experiment of living with nuclear waste can be assessed and revised and new solutions adopted if the problems outnumber the envisioned risks: this is a legal invention, a law that enshrines not knowing the answer now and refusing to make an irreversible decision, thus deciding not to decide.

8. The Argentinean crisis in 2001 taught us that the state is not the only guarantor of financial transactions. Alternative currencies and barter allowed for these transactions to be replaced and saved! The national economy was not saved outside of the system but the setting up of scripts that resisted and contested the "State" of affairs.

9. Codification, legislation, experimentation are all forms that can inscribe the right to revise. The opening up of scripts is mainly due to the ability of economic beings – whatever their size, shape or duration – to place themselves "above" the script and change roles: to be author, follower or protestor, at any moment and in any place. This is where economization must be accompanied by the other modes of the Inquiry.

# ON THE GROUNDS
# QUIETLY OPENING BENEATH OUR FEET

## Kyle McGee

MODERNITY HAS LONG drilled the ground to extract precious substances: substances invisible to the surface dweller's naked eye, lodged in the very heart of nature itself. Not necessarily valuable for use, these substances provide both the framework for and the symbolic archetype of all value. Glimmering beneath the crust, which serves only to conceal, they reward careful scrutiny and painstaking extraction. Honoring the great classical traditions they constantly plunder and reinvent, the moderns sanctify these substances with Greek or Roman appellations (*eidos, res cogitans, res extensa*). Whereas, if the outer shell of accidental experience suggests the reality or the autonomy of its contents and constituents, it deceives, beneath it lies the true ground of all experience, the ground beneath the grounds: sub-stance become sub-ject. The latter has undergone continual revolution, traversing spirit, mind, consciousness, and finally information processor, but has never, within the brackets of modernity, lost its capacity to explain, justify, and stabilize whatever befalls it. Now, however, as the air thickens with toxins, as the waters encroach upon and consume the coasts, as droughts and wildfires, heat waves, floods, tremors, and tornadoes wreak havoc – in short, as weather patterns and rising seas disclose climate volatility and announce the retroactive advent of the Anthropocene, this ground is finally parting: fractures, breaks, extraction wounds

KYLE MCGEE *is an American lawyer practicing in the US, author of* Bruno Latour: The Normativity of Networks *(Routledge, 2014), and editor of* Latour and the Passage of Law *(Edinburgh University Press, 2015). In the course of the* AIME *project in Paris, he organized a workshop on law as a mode of existence, which took place in April 2014.*

materialize everywhere. Somehow, the cogitations of the *res cogitans*, individual or collective, no longer seem sufficient.

Despite first appearances, this does not merely stage the confrontation of a pliable, anthropic domain of value against the rigid, objective domain of fact. The "modern constitution," as dissected in Bruno Latour's *We Have Never Been Modern*, depends upon a metaphysical dualism generative of that dichotomy – the purified realms of nature and society. But the character of that dualism varies. Its core configuration in the present is the joint articulation of the market as site of truth, a translation of *res cogitans* and the subjective form of modernity, and the state as public body, a translation of *res extensa*.

Each at once facilitates and constrains the agency of the other, but in common they suppress all other agencies. Like classical mind-body dualism, the state/market ontology generates countless dead ends and aporias. And most of them have to do with causality: has the state, which enforces property

relations and contracts, founded the market, or has the market, which offers the form of the exchange of liberty for security that stands at the heart of the social contract, founded the state? Here is the root of the rotten tree from which all modern ideologies grow.

The state/market ontology at once violently reduces the scope of agency and certifies an epistemology consistent with its appropriation of being: beings have reality only to the extent that they are politically-economically measurable. The derided neoliberalization of society, evident in the relentless dissemination of market forms, the soft power of reactive governance in the management of all aspects of life, and the entrepreneurialization of human capital,[1] is nothing other than the public face of this epistemology. Noneconomic agency is, in short, impossible. By collapsing all practices and all modes of action into one form, the state/market ontology arrogates all agency to itself, rendering its metaphysical substances cause and ground, necessary and sufficient reason. That arch-modern abstraction, the economy, is the daunting offspring of this strange coupling – that is, it is what emerges from the coimplication of the state as that for which the market exists and the market as that for which the state exists.

To reset modernity is to reset the economy. As Latour argues in "On Some of the Affects of Capitalism," the economy is the benefactor of an unthinkable reversal of the transitory and the eternal: instead of the gritty, contingent materiality of labor and worldly goods we might invoke to define the economy, only the category of *necessity* suffices. The earth screams out in pain, but humanity's ability to relieve it is limited by the dictates of the economy's indisputable necessities. An unprecedented exchange of properties: the transcendence of nature has migrated from the inaccessible beyond of things-in-themselves to the immanent flow of things-in-commerce. The old domain of nature becomes suffused with moral discourse and political controversy, as well as constructs designed for economic application. Even the so-called natural sciences are, therefore, not immune to economization: research in those fields is increasingly submitted to the methods and standards of quantitative modeling disciplines like econometrics (ecolometrics?), in a shift from the empirical, experimental standards developed in the long span between the scientific revolution and the late twentieth century. And yet what remains constant in this exchange of properties is the element of exteriority itself – the constitution of a remote, untouchable, self-governing, self-reproducing locus from which all causality, all normativity, all agency derive. Formerly things were limited and measured by the laws of physics; now they are limited and measured by the laws of economics.

Unlike the "first Nature," the second is understood, in Latour's *Inquiry into the Modes of Existence*, and in practice, to be fully artificial. Creating and sustaining competition, for instance, is part and parcel of the art of government, and does not happen "automatically." (What happens "automatically," i.e. without regulation, is cartelization, monopolization, concentration of market power.) Yet our "second Nature" earns the name because it operates according to immutable laws beyond human control, interested not in mortal affairs but only in its own eternity in perpetual reproduction. There is no real opposition to this view; Marxists, utilitarians, neoclassical and neoliberal theorists have their varying accounts of *what* those laws are, from the tendency of the rate of profit to fall (Marx) to the tendency of the rate of return on capital to outpace the rate of economic growth (Thomas Piketty), but none challenges lawfulness or systematicity as such.

In light of the economy's metaphysic of necessity, some leap headlong into the opposing perspective

---

[1]    On which see Wendy Brown's *Undoing the Demos*, which draws on and modifies Foucault's influential *Birth of Biopolitics* lectures.

273

and cultivate pure contingency. That strategy is doomed: total necessity is indistinguishable from total contingency. Contingency, at this high level of abstraction, is merely a new name for complete determination. A more promising avenue would look to the production of contingency and necessity, recognizing that there are both *agents of contingency* and *agents of necessity*, and that these are variable local signifiers, so that what performs contingency in one sequence of events may perform necessity in another. Theories of metaphysical contingency merely restate the problem by displacing the function of what Latour calls a "dispatcher" (Inquiry 400). Regardless of whether contingency or necessity reigns supreme, some empty figure is deemed to govern things effortlessly and from a distance – making all action redundant and all mediators passive.

Discerning which agents are manufacturing contingency and which are manufacturing necessity is a delicate and challenging matter calling for nonmodern tools, but it is the surest path toward the sorely needed ecologization or reterrestrialization of the economy. It is not enough to deny the transcendence of its laws; they must be caught in the act, in association with all the other actors that they depend upon for their alleged effects. If we could manage this, we would learn that the state/market ontology succeeds in monopolizing agency only by systematically confusing a host of weaker entities with its own constructs. The way it achieves this miracle of subduing the cacophony of actors that give it life is a properly philosophical gesture: it reverses the logic of grounding that is familiar from the history of metaphysics.

According to tradition, from Cartesian mechanism to the Kantian problematic of the transcendental, the ground is an exteriority that (ontologically) precedes the grounded.[2] The substance is essential and prior to the accident, which is transient and finally unreal; only the substance has reality, and accordingly, it is not encountered as such in finite, phenomenal experience, but only indirectly and through ciphers. This logic no longer holds: it is the successor, the effect, the accident that establishes its ground precisely by mobilizing it as such, causing it as its cause.[3] This is the deepest secret of the principle of sufficient reason: the ground summoned and rendered succeeds the grounded, and does not resemble it. The genius of the economy is to have nominated itself cause of all effects by disseminating its forms far and wide, making it possible for any other actor to adequately explain itself (and others) by appealing to universal economic forms, laws, and forces, establishing a correlation and a resemblance that did not preexist that appeal. In doing so, in other words, they do not merely serve a preexisting thing called the economy, but *perform* its mechanisms and its laws, its indisputable necessities, construct and reify it, entrench it as a functional a priori condition. The economy is nothing outside these performances. Nevertheless, it is these performances that accomplish the reduction of being to information. Admitting this is a small but crucial step toward the discovery of an earthly, nonmodern economics.

A somewhat obscure treatise preceding the autonomization of economics may light the way down this alternative path. Published as *Legal Foundations of Capitalism* in 1924, its author, John R. Commons, has obvious sympathies with John Dewey's pragmatism, the politics of American progressivism, and the theories of law, economics, and sociology advanced by the likes of Wesley Hohfeld, Thorstein Veblen, and Dewey's student Robert Lee Hale. But its contribution is singular. When he is recognized by lawyers and economic historians, Commons's

[2]  For this reason, Heidegger wrote: "The question concerning the essence of ground becomes the *problem of transcendence*" (106).

[3]  Thus the Deleuzian formula, extracted from notes to an early seminar: "to ground is to *appeal* to a ground" (17; emphasis added).

signal achievement is usually taken to be his powerful reimagining of the *transaction* as the fundamental unit of economic analysis: for him, this relational notion replaces such outmoded concepts as "interaction" and "experience," in which economists and lawyers alike had till then been trafficking (and which were at the time very much de rigueur in philosophy and sociology). Leveraging this more granular, empirical, realistic starting point, Commons staked out an economic theory allied with neither the commodity theorists (from François Quesnay to Smith, Marx, and Proudhon) nor the hedonists (Jeremy Bentham and other utility-oriented economists), but with an evolutionary tradition starting with David Hume, passing through Darwin, and ending with Oliver Wendell Holmes and the pragmatic philosophers.

For Commons, the economy is an adaptive network of transactions. Economics, he claims, can learn from jurisprudence, which starts from neither commodity nor feeling, but from transaction, and places the conditions studied by economists on this new foundation of "two or more wills giving, taking, persuading, coercing, defrauding, commanding, obeying, competing, governing, in a world of scarcity, mechanism, and rules of conduct" (7). From this angle, the ultimate analytical unit is, Commons says, "not an atom but an electron, always in motion – not an individual but two or more individuals in action. ... Their motion is a transaction" (8; cf. 68). The transactional sociology of economy and law that Commons thereupon develops establishes the dense entanglement of actual markets – for example, commodities markets are "conducted at every store, every factory, every railroad..." (159) – with legal structures. All of this is interesting enough, but Commons also shows precisely how economic contrivances outstrip their transactional grounds and come thus to unground their own legal and political foundations – surpassing their conditions to radically exteriorize themselves and establish a new institutional a priori.

This extension of market devices, and the overcoming of their legal-political conditions, begins with the "reversal" of the meaning of property and liberty that occurs when production begins to depend on incorporeal variations (namely, expected market returns based on the fluctuations of prices), and ceases to depend on bodies (namely, the anticipated uses of goods) (21). The upshot is that liberty and property unite in a single concept, generating a host of hybrid legal-economic entities (encumbrances, obligations, opportunities, privileges, etc.) that are "more valuable than all physical things... for upon them are built both the credit system and the business initiative that have displaced feudalism by capitalism" (24). These invisible things have existence only in the future; their present value is simply the probability that they will come to pass. This is precisely how Commons defines capital: as "the present value of expected beneficial behavior of other people" (28). And that eventuality is of course uncertain. Every transaction is an alienation of liberty suffused with coercion on all sides, a mutually adverse transformation of liberty into property, and the risk that the two will fall out of joint is addressed by the civil and criminal law supported by the sovereign power.

But contingent market devices – including basic semiotic constructs like expected exchange values and, therefore, also more complex constructs like capital – exceed their legal-political foundations by transitioning into agents of necessity, in two precise ways: first, through the wholly economic intensification of coercive power crystallized in invisible entities existing only in the future, and second, through the legal figuration of that power, which gradually displaces the traditional sovereignty of the state. This crucial legal transformation first appears in the US Supreme Court's 1876 opinion in *Munn v. Illinois*. The decisive element of the *Munn* analysis is the legal reengineering of property as a power on the same scale as sovereign power: there, "for the first time, it came to be seen that this liberty of private

property [traditionally different in nature from the sovereignty of the state] meant also the economic power of private property. The power of sovereignty was the physical power to compel obedience; the power of property was the economic power to withhold from others what belongs to self but is needed by others" (Commons 32). In *Munn*, a grain elevator firm that had strategically inserted itself at a critical point in a nexus of grain distribution spanning several US states had come under regulation by the Illinois legislature and contested the latter's ability to restrict its private business practices. The court sustained the legislature's restrictions as a lawful exercise of the sovereign's police power because it found that the public interest was affected by the warehouse firm's business practices – an attempt by the court to enhance the powers of sovereignty – but it did so by constructing, in law, an extrajuridical figure (property as economic power) that would undermine sovereignty from within. Indeed, that legal *moyen* would constitute the death blow to the traditional sovereignty of the state, which would henceforth be fused with the vicissitudes of the market.[4] This legal convolution is an essential moment in the genealogy of the economy.

But the story does not end there. Capital, as agent of necessity, remains nothing more than the "present value of expected beneficial behavior of other people," even as it is black-boxed, formalized, and codified in institutional market devices. The juridical reinvention of the ground of property supplements that expectation with a virtual compulsion, on the part of those possessing only their liberty, to transact in a way consistent with the distribution of property relations – empirically realizing what I have elsewhere called a deontic modality of doing, a normative constraint (McGee xviii). Capital's necessity materializes in and through its diminution of the agency of other actors, which become passive, inert, mechanical. And yet the elementary point that such transactions not only constitute but continually reprise the economic "system" that they seem only to obey has the effect of upending the narrative of modern political economy and economics – especially the codification of economy as either a self-subsisting autonomous being or a transcendental condition of any society. It augurs a vision of economy as *explanandum*, not *explanans*. It raises with urgency the *materiological* problem of how the very forms of agency presupposed by the economy are sustained, and how their "evolution," in Commons's terms, transforms the entire ecology of practices. And it reintroduces the philosophical problem of future contingents under the aegis of necessity, sounding the metaphysical depths of modernity in a whole new key.

Resetting modernity means resituating the economy within the circuits of the associations that witnessably compose it, skirting the nation-based insularity that passes for internationalism while undoing its massive theft of agency.[5] Works like *Legal Foundations of Capitalism* have more than historical value, then, but also clear deficiencies. Even adopting that book's lessons, to recompose the economy means pushing further into its noneconomic foundations, calling for a new political theory of liberty and a new legal theory of property sensitive enough to register each filament in the tissue of relations

[4]  Analyses of *Munn* usually focus on the expansion of the police power, and thus of sovereignty, over private enterprise, but this focus neglects or denies that a new form of power was also acknowledged and adopted by the court. To expand the police power (an expansion that was later curtailed), the court had to elevate another, nonpublic brand of power to the status of sovereign power (which has never come into question again). This seemingly minor point is amplified in later constitutional and state powers jurisprudence, as it becomes increasingly detached from its conditions of enunciation in *Munn*.

[5]  Reviewing a draft of this text, Scott Veitch of the University of Hong Kong helpfully pointed out that, in Scottish criminal law, *reset* is the offense of receiving stolen goods: an apt metaphor here, then, as the economy has illegitimately represented itself as the source of all agency! But then "reset modernity" comes under a new light, too...

those sacred terms enclose and conceal, and teth-
ering economic abstractions to actually existing
collectives. And ontologically, Commons's "trans-
actional" monism obscures important differences
in concrete practices, in techniques and methods for
assembling coherence, and in projections of agency
(and passivity). Monism is a powerful answer to the
rigged state/market game, as the materialist tradi-
tion shows, but rather than helping us become sen-
sitive to the shifting grounds of veridiction, it only
amplifies the hum of the dispatching machine, now
renamed contingency. The challenge of pluralism,
by contrast, is to invent means of piercing the econ-
omy's fatal whirr that prevents us from noticing the
grounds quietly opening beneath our feet.

Munn v. Illinois, 94 US 113–54. Supreme Court of the
US. 1876. Print.

## Works Cited

Brown, Wendy. *Undoing the Demos: Neoliberalism's Stealth
Revolution*. New York: Zone, 2015. Print.

Commons, John R. *Legal Foundations of Capitalism*. New
York: Macmillan, 1924. Print.

Deleuze, Gilles. *What is Grounding?* Trans. Arjen Klein-
herenbrink. Grand Rapids: &&&, 2015. PDF file.

Heidegger, Martin. "On the Essence of Ground." Trans.
William McNeill. *Pathmarks*. Cambridge: Cam-
bridge University Press, 1998. 97–135. Print.

Latour, Bruno. *An Inquiry into Modes of Existence: An
Anthropology of the Moderns*. Trans. Catherine Porter.
Cambridge, MA: Harvard University Press, 2013.
Print.

———. "On Some of the Affects of Capitalism." *bruno-
latour.fr*. Bruno Latour, March 2014. Web. 23 Oct.
2015. Available at <http://www.bruno-latour.fr/
node/550>.

———. *We Have Never Been Modern*. Trans. Catherine Por-
ter. Cambridge, MA: Harvard University Press, 1993.
Print.

McGee, Kyle. *Bruno Latour: The Normativity of Networks*.
Abingdon: Routledge, 2014. Print. Nomikoi Crit-
ical Legal Thinkers.

# THE BUSINESS OF CONTINUITY

## Martin Giraudeau

WHAT IS IT THAT makes contemporary business organizations perdure? At first sight, they seem to be upheld by law. In most jurisdictions nowadays, organizations have legal personhood; they exist as legal entities. As such, they also own property rights over land, offices, plants, machines, materials, even over other organizations; and they are engaged through contracts with many other parties from lenders to employees, suppliers to customers.

The firm is in many respects this tight "nexus of contracts" that has been described by institutionalist economics (Coase), and thanks to this it does gain some durability. Incorporation, property ownership, and contract signature all come with their share of rights and duties over a certain – more or less long – term. The temporary contract with an employee or contractor can be valid for as short as a few hours; the warranty for one of the firm's products ties it to its customer for a few months, sometimes a few years; a long-term loan will bind it for an even longer period to its bank.

Yet the impression of unshakable durability given by the idea that the organization is cast in law as if in marble is misleading. Employees can be fired, debts be repaid, shares sold, machines disposed of, the corporation declared insolvent or bankrupt, even dissolved. The legal texts set how these different forms of termination may take place, but they rarely preclude them. The high failure rate of

MARTIN GIRAUDEAU is an assistant professor in accounting at the London School of Economics and Political Science. His research, standing at the crossroads of the history of capitalism, economic sociology, and science and technology studies, focuses on the history of management sciences and technologies. In his PhD thesis, he studied the history of business plans in the late modern period.

business organizations, and especially of young ones, is a hardly disputable proof of this.

As a legal entity, the contemporary business organization is in fact rather liquid. When it continues, when it persists in its being to the point of seeming solid, it is through other means than its sole legal constitution. The purpose of this brief essay is to review some of these other means.

### GOING CONCERNS

QUITE OBVIOUSLY, the business organization keeps itself going by doing one thing, and that is business. But what does it mean exactly for a firm to be in business, rather than out of it?

The ultimate criterion is for sure the legal one: an organization may eventually be declared insolvent, if it cannot pay back its debts; it may, relatedly, file for bankruptcy; it may finally be liquidated. But, as stated above, these are just procedures that

trigger and/or organize the termination of certain contracts, as well as transfers of property rights. Before they eventually kick in, other judgments are made that diagnose the propensity of the organization to persist.

An important one, among these, is the definition of the entity as a "going concern" by its accountant or auditor. Under the dominant sets of accounting norms, nowadays, the certification of the accounts is based on the assumption that the organization will live on, that it will not be liquidated, at least in the "foreseeable future" – generally understood as the next accounting period/year. This assumption is crucial for the calculation of numerous lines in the accounting tables: without it, there would be no balances brought forward; no postponing of the incurring of prepaid costs; no spreading of depreciation over a number of years; no fair value valuations factoring in expected future revenues; etc. Unless otherwise stated, today's accounts assume that the firm will live on.

Yet, beyond the two main adjudicators that are the judge and the accountant (Miller and Power), it is also the investors and the lenders, on financial markets, who make assumptions about the future of the business, its ability to eventually distribute dividends, to pay back debt. Ultimately, the customers themselves may refuse to commit to a product or service if they expect the firm to be discontinued some time soon. There is thus a broader social definition of the going concern assumption, which encompasses the diverse expectations of all the stakeholders of the firm. The assumption that the firm will live on is the basis of many a decision, beyond that of the accountant to certify the accounts.

It is a fair assumption: business organizations do not seem to be confronted with the risk of disappearing on an everyday basis. Through all sorts of more or less lawful and fair practices, some of them even end up in very secure positions, for instance, of monopoly, of rent extraction. It is especially the case of the largest ones, of the ones that make the headlines. Yet, even in such advantageous positions, business organizations are always grappling with the management of various kinds of passages, of transitions, in order to continue as going concerns, broadly defined. Caught in a more or less tight net of internal and external expectations, they usually put a lot of effort into keeping things going, and for that in preparing the next step(s).

These efforts are particularly visible when the organization is confronted with imposed discontinuities. The sustenance of business, its deliberate continuation, becomes most apparent when it is challenged: for instance, when a new accounting period is about to start; when certain risks are identified in the organization's environment; when the firm has to replace some of its workers; or, perhaps more frequently, when customers and suppliers, on the one hand, and investors and lenders, on the other hand, must be attracted or retained. I survey below five crucial areas , within contemporary business organizations, where these issues are addressed, and where institutionalized efforts to ensure the continuation of business are therefore observable: business planning; risk management; record keeping; relationship management; and financial capitalization.

## PROJECTS

PROJECTS, formulated into plans, are certainly the most pervasive modality through which organizations produce their own durability. This is particularly striking in the early stages of the emergence of new organizations. Of course, sometimes, or up to a point, new businesses are scrambled together on the basis of a first commercial transaction, through sheer opportunity: someone has something to sell, a buyer shows up, the transaction takes place, the seller buys a new good or offers a new service with the proceeds, and so on and so forth. This, however, is a very hypothetical case. The seller is likely to have had a purpose when acquiring the initial good

279

or service; and this is even more likely if she had to produce the good or service instead of acquiring it. Suppliers had to be found, as well as funders, employees, customers, etc. The good or service was designed, marketed, distributed, etc. These diverse tasks, however formally distinct from each other, however clearly identified under business lingo terms, are likely to have required some form of preliminary coordination, of thinking ahead, of agreeing ahead, of budgeting, of planning. Activities were organized, made into a joint project.

Yet there are many ways of putting a project together, and these ways are institutionalized. At a certain time, in a certain place, in a certain type of activity, there is a limited number of accepted practices and procedures for whoever wishes to launch a project. In early nineteenth century public works in France, for instance, a project for a bridge, for a road, had to be completed along certain given, established forms: a set of pre-specified documents was required; intellectual property was defined in such a way that it could not be attributed to anyone; the accepted division of labor circumscribed the status and power of the initiator of the project; the design of the project itself was subjected to the techniques in place for the optimization of public works (Graber). Similarly, there were identifiable, institutionalized project forms for the foundation of convents in early modern times; for improvement projects in seventeenth-century England; for railroad projects in nineteenth-century America; for filmmaking in the 1950s in the USA; for development projects since the 1980s around the world; for the yearly business planning of a financial institution in the early twenty-first century; etc. (Giraudeau and Graber). The production of duration takes place within the local and temporary frame of such project forms.

These forms differ in the types of continuity they bring forward. The early modern projector so despised by Adam Smith could openly propose a grand scheme without being required to establish the realism of his proposal, and by relying instead on his personal reputation and networks to guarantee the coming success of the venture. Today, some entrepreneurs and organizations do of course also sometimes get away with such plans, which they may even in some cases be encouraged to propose: in some circles, artists are expected to not consider the means of their desired ends; some Silicon Valley innovators are also pushed to conceive seemingly impossible ventures. Some projects are thus proposals for continuation of business that do not rest on an assumption of continuity with the present. To put it differently, they are pure futures, not extensions of the present.

Yet nowadays a plan is more often expected to derive linearly from the observed, present situation: it has to be "proven"; its realism demonstrated, to the point where the good plan tends to be the pre-realized one (Giraudeau). Researchers know it well who often ask for funding by promising results they have already obtained in their previous project, but it is also the case for all the small business entrepreneurs, who are often incited to proceed step-by-step, to start their business up and show its viability in practice before asking for further funding, in various rounds. We could contend that it is also the case of candidates to elected office, whose electoral platforms are expected to balance financially, and to fit within the limited remit of their political mandate. Strict continuity between the present and the future must be embedded in the projects to ensure that the available means will allow the attainment of the proposed goals. The future is entirely contained within the present.

Projects, as such, may therefore be seen as the core modality of business continuation (putting proposals forward allows to keep some activity going), but all projects do not relate similarly to continuity, to the production of a future that can be derived linearly from the present, continuous with it. Depending on the sociohistorical project form under consideration, specific forms of work and specific technologies for ensuring continuity are observable – or not.

## RESILIENCE

PROJECTS ARE NOT the only modality through which the continuity of organizations is forged. The world of business and management has indeed developed, over the past half-century, numerous techniques and tools, now used pervasively throughout the world, to both monitor and control the continuity in the shape and activities of a given organization. Known under the broad name of "risk management," these techniques and tools tend to focus on the dangers that the organization is confronted with, and that could impose discontinuities onto it – including the radical ones mentioned above: insolvency, bankruptcy, liquidation (Power).

"Risk maps" are, for instance, used to keep track, from period to period, of the different risks that an organization's management team identifies as real and potentially worrisome. The listed risks are positioned on the two-dimensional map based on their assumed probability of occurrence and on the seriousness of their expected consequences on the organization. For example, if a risk becomes more likely at some point, it is moved on the map. Such an apprehension of risk is designed to allow the organization to react in a timely manner to potential risks, by drawing up plans to avoid them or to cope with them if they appear unavoidable. Other techniques have a less discrete approach to risk: instead of identifying individual risks, and of dealing with them as separate phenomena, they see general patterns in their forecasts of the future. It is the case, for instance, of "scenario planning," a technique used to identify trends in the organization's context, broadly understood, and envisage the possible options for coping with them. Such techniques and tools serve as grounding for new projects.

Yet other approaches have gained popularity over the past couple of decades, which are less focused on the study of the exogenous shocks that may hit what is seen as the "organizational system," and instead concentrate on finding the ways to make the organization structurally "resilient" to a variety of potential and ill-tracked risks. These approaches relate to what is formally known as "business continuity management." Inspired by systems theory and developed initially in the realm of large energy and telecommunication infrastructures and networks, they bring forward their own definition of organizational continuity, understood chiefly as the maintenance of core service capabilities. Ensuring such continuity is less a matter of developing the right projects than of structuring the organization in a way that will facilitate its smooth reaction in otherwise threatening contexts.

## RECORDS

ANOTHER, often more internally focused modality through which the continuity of organizations is produced is their record keeping practices – the way they retain their past rather than relate to the future.

The way organizations survive the passing human actors that populate them has for a long time been said to be by relying on the formal order of their positions and hierarchies. When an employee leaves the firm – resigning, fired, dead... – a job ad is posted to replace him or her, which specifies the requirements of the position, sometimes with a slight change to the previous specifications, so as to adapt to new internal constraints, a new external environment, etc. Yet beyond this quasi-automatic placement/replacement of personnel by human resources managers, the issue of continuity is in the ability of the new employee to fulfill the departed one's tasks in a satisfying enough way. This is ensured by a number of devices. Outside of the organization itself, vocational training of the workforce ensures its transferability from one employing organization to another – continuity is not just a matter of individual organizations. Within the organization itself, on the job training, often by the departing employee in the last days or weeks of his or her tenure, is common practice. Yet, in many cases, such

human-to-human training is insufficient to ensure a smooth transition from one employee to another.

To sustain the – expectedly ongoing – activities of everyday life within the organization, the new employee has to have access to and understand the records of such activities from the past. The phone number of a customer, the log of exchanges with a supplier, the loan contract with a bank... all of these are important and sometimes necessary pieces for the carrying out of work that will be continuous with that of the previous holder of the post the new employee is now occupying. For this purpose, organizations maintain a record-keeping infrastructure made of various layers. Employees may keep local records of their activities, on individual hard drives, in cupboards; but data is increasingly uploaded, nowadays, onto network drives. A crucial dimension of such storage is the structure imposed onto the records that are to be kept. The network drives can take the shape of shared folders, for instance, inside a single team, but the shared digital data oftentimes takes the shape of entries within the organization's (or one of the organization's) information systems. The storage of this data – what parts of it, where, for how long, etc. – is a matter for "records management," an institutionalized practice often left in the hands of third parties, like "records management companies," which will inform the customer organization about the legal requirements in terms of data conservation, advise the organization regarding its own conservation needs, and sometimes put the data away in one of its own off-site storage facilities.

Here again, as we can see, continuity is an object of management, and it will take different shapes depending on the institutional setting observed. To understand this, it suffices to consider two organizations as different as a democratically elected government and a private business venture. The legal requirements and practical decisions in terms of record-keeping will vary to the extreme depending on whether you are a minister relinquishing her

computer, hard drives, and cupboards to a new officer after losing an election, or the resigning chief financial officer of a non-listed company. The procedures of record transmission between the two successive occupants of a post will differ between the two contexts, and with them the way the two organizations produce their own continuity beyond the passing humans who each inhabit them temporarily.

## RELATIONSHIPS

PROJECTS, risk apprehension, and recordkeeping are explicitly targeted at managing organizational continuities, and they tend to do so at the level of the organization as a whole. But organizations also cope with countless other continuity issues that tend to be more local, more scattered: the ones that arise in the relations with external partners, such as suppliers and customers on the one hand, and investors and lenders on the other hand. Here again, specific techniques and technologies are put to work to ensure that the organization keeps holding on to these third parties, however tenuous and temporary the resulting links may be in the end.

Supplier relationship management is an important area in this respect. Degrees of outsourcing vary across firms and industries, but so does the durability of the connection between a firm – or more generally an organization – and each of its suppliers. In many cases, however, transactions with suppliers are designed to last; spot supply chain transactions are not the norm. Many different reasons may justify this for the ordering firm: the absence of alternative suppliers for a given raw material or intermediary product; the unsuitability of quality and prices proposed by other suppliers; the cost savings from not having to search for another supplier; etc. Whatever the reasons, the relationship between an organization and its suppliers is an object of managerial attention.

It is crafted with the help of specific techniques and technologies. One can find a striking example

of this within just-in-time management systems, where the firm integrates its systems with that of its suppliers, whose departments get immediate electronic notifications, for instance, when stocks start shrinking at the ordering firm. The relationship is made more durable by its solidification through the sharing of a common information infrastructure between the two organizations. However, other seemingly less hard forms of integration of supplier relationships exist, which ensure their durable maintenance. A good example of this is "open-book accounting," whereby a supplier accepts to share (at least some of) its internal accounting data with the ordering firm, which can thus regularly check its supplier's performance levels, measured in varied ways. Such disclosure almost unavoidably implies a high degree of trust between the two sides of the supply relationship, who agree not to make unfair use of the data in exchange for an informal promise to keep the relationship going. Various other supplier relationship management technologies could be put forward here, from the use of supplier scorecards – made for assessing supplier performance – to that of industry roadmaps – used, for instance, to synchronize technological development with suppliers as well as with competitors and customers (Miller and O'Leary) –, which all strive to ensure commitment to the future of the relationship from both of its sides.

Customers (or users) are an even harder category to ensure continuous relationships with, especially in mass markets. Beyond the initial attraction of first-time customers through advertising, shop windows, etc., companies therefore draw on numerous techniques to ensure their durable retention with the aim of locking them in the relationship (Cochoy). The offered products or services may themselves have their own lock-in features (computer software and hardware users are more than familiar with that), reinforced by "value engineering" efforts aimed at satisfying assumed customer expectations in the design of the product or service

itself. Deliberately fostered network effects can also have the same consequences of tying customers to a given product or service. When the product or service itself doesn't ensure such capture, the retention of customers is tentatively fabricated through numerous customer relationship management (CRM) techniques and technologies. CRM software provides salespeople, in banks for instance, with customer profiles, as well as suggestions of potentially relevant products to offer them, based on their past purchases and personal profile (Vargha). But the loyalty of customers is also approached in a more holistic fashion through branding efforts, on the one hand, and various forms of loyalty programs, on the other. Complaints, returns, and warranty management (for instance, within a "product life cycle" approach) are also deployed to try to maintain the durability of the relationship between the customer and the organization when it appears to be threatened. The shopping must go on.

## CAPITALIZATION

COMPARABLE FORMS of striving for continuity can be found in the financial management of organizations. Earnings management is a case in point here, which generally presents itself, especially in publicly traded companies, as an effort to smooth earnings over time: low profits are pushed up as much as – and sometimes further than – accounting norms tolerate to avoid their drifting down from past profit levels; and the same goes for excessive profits, put aside into various types of reserves as a precaution for potentially worse times to come. Such practices are driven by the institutional context in which firms operate for most financial markets, and especially stock markets, are excessively reactive to change, be it upwards or downwards. Yet earnings management is limited by various instances of control, from standard setters and judicial courts to auditors and ratings agencies. The smoothing of earnings is therefore also an operational effort, whereby

companies strive, in every new accounting period, to generate – and consequently account for – just as much profit as in previous ones.

Corporations are wary of the evolutions of their capitalization, generally understood in finance as "market capitalization," or the product of share price by number of shares, and in accounting as the amount of "invested capital," composed of stock, long-term debt and retained earnings. Yet the continuity issues around capitalization go beyond such capital maintenance efforts. Another definition of capitalization illustrates this well. To capitalize, for the accountant, is indeed also sometimes to record an expense, such as the purchase or maintenance of a machine, as a capital expenditure rather than as an operating cost, and to thus make it figure (positively) in the balance sheet, rather than (negatively) on the income statement. To capitalize such an expense is to count it as a durable increase in the volume of "physical capital." It consists in transforming a pre-existing resource, like a machine or the cost of its maintenance, into capital. This definition of capitalization can in fact be extended to the previously mentioned ones: increases in market capitalization or in invested capital are indeed also the product of accounting inscriptions, whereby capital is made into capital by being recorded as such – be it as an asset, a debt, or retained earnings – rather than as plain cash, for instance. In doing so, organizations temporalize their resources in a specific way.

In making capital as capital, organizations indeed assign to some of their resources a specific destination, or temporal horizon. Capital is widely separated from operations: what comes about with the making of some resources into capital is a certain form of organizational thinking, which may be described as "thinking as an investor" (Muniesa et al.), and the technologies that allow it: discounted cash-flow calculation, scenario analysis, business modelling... The main implication of such thinking lies in its approach to time. While operations are from an accounting perspective contained within a single accounting period – typically: one year – investment is expected to generate returns over multiple future periods. A certain number of interrelations are, of course, observable between the two types of thinking through the accounting categories of "circulating capital" (spent and replenished in operations, such as inventory), depreciation (counted as an operating cost), or retained earnings (turned into financial capital). But outside of these points in the accounting tables, everything goes on as if there were two juxtaposed economies: an economy of capital and an economy of operations; or, to put it in a striking way, a capitalized, "upper-case" economy, and a "lower-case" economy focusing on operations within a given accounting period.

In many respects, this distinction overlaps with the one made by Fernand Braudel between a market economy and a capitalistic economy (Braudel). Capitalization can thus be seen and studied as a specific form of economization, the making and maintenance of a specific kind of economy (Mitchell). The risk, however, is to confuse capitalization with financialization, which, as it is (too) commonly used, refers to the colonizing of the social world by financial organizations and instruments. The specific requirements of the upper-case economy must instead be highlighted, and especially the promises and expectations that it brings about. In matters of capitalization, assurance about the future is essential. Paradoxically perhaps, capitalism thrives in the most certain, the most assured contexts: when insurance becomes available, when reliable statistical information is at hand, when regulations are least likely to change unexpectedly, when a strong state and/or army protect the continuity of business, when the access to new territories, to new reserves of workers, etc., are durably secured. The various forms of capitalism that have developed since the rise of early modern war capitalism (Beckert) can be seen as corresponding to the deployment of different means of economic assurance, without which no capitalization would have been possible.

## LIFE

THERE IS, AS WE CAN SEE, a whole business of continuity, or of continuities to be more accurate. It is to a large extent an actual, commercial business, all of the techniques and tools mentioned above being produced, advertised, and sold by countless consulting firms and business schools around the world. But the business of continuities is more extensive than that; it is also a business in a metaphorical sense, a set of activities involving countless actors that seem to be outside of the economy, starting with the legislators or state administrations, but who in fact also inform these efforts towards continuity. The ways in which organizations strive for continuity cannot be summarized in the generic notion of "the project." Organizations are constantly and diversely grappling with the issue of their continuity: they are busy self-preservationists, and they are both heavily and diversely equipped and framed for that purpose.

Hence the problem is to understand the multifarious and often conflicting ways in which they are doing it, and how these may eventually be changed – how, especially, we can reclaim the future by escaping the strict requirements that bear on our organizations in terms of continuity, that wrap them up into the present. One way forward in this respect may be to inquire into the vitalism that, from incubators and seed funds to notions of corporate life and survival, seems to inhabit the world of business and management. Debunking this pervasively performed vitalism would most likely facilitate the foundation of a more accurate approach to organizational continuities.

---

Works Cited

Beckert, Sven. *Empire of Cotton: A New History of Global Capitalism*. New York: Knopf, 2014. Print.

Braudel, Fernand. *Civilisation matérielle, économie et capitalisme (XVᵉ–XVIIIᵉ siècles)*. 2. *Les jeux de l'échange*. Paris: Librairie générale française, 1993. Print.

Coase, Ronald H. "The Nature of the Firm: Origin, Meaning, Influence." *Econometrica* 4 (1937): 386–405. Print.

Cochoy, Franck. "A Brief Theory of the 'Captation' of Publics: Understanding the market with Little Red Riding Hood." *Theory, Culture & Society* 24.7-8 (2007): 203–23. Print.

Giraudeau, Martin. "Proving the Future. Business Plans and the Rise of Capitalism." 2016. Print. Forthcoming.

Giraudeau, Martin, and Frédéric Graber, eds. *Les projets: une histoire politique (17ème–21ème siècles)*. Print. Forthcoming.

Graber, Frédéric. "Du faiseur de projet au projet régulier dans les Travaux Publics (XVIIIᵉ–XIXᵉ siècles): pour une histoire des projets." *Revue d'histoire moderne et contemporaine* 3 (2011): 7–33. Print.

Miller, Peter, and Ted O'Leary. "Mediating Instruments and Making Markets: Capital Budgeting, Science and the Economy." *Accounting, Organizations, and Society* 32.7/8 (2007): 701–34. Print.

Miller, Peter, and Michael Power. "Accounting, Organizing, and Economizing: Connecting Accounting Research and Organization Theory." *The Academy of Management Annals* 7.1 (2013): 557–605. Print.

Mitchell, Timothy. "Fixing the Economy." *Cultural Studies* 12.1 (1998): 82–101. Print.

Muniesa, Fabian, Liliana Doganova, Horacio Ortiz, Álvaro Pina-Stranger, Florence Paterson, Alaric Bourgoin, Véra Ehrenstein, Pierre-André Juven, Basak Sarac-Lesavre, and Guillaume Yon. "Elements for a Social Enquiry into Capitalization." 2016. Print. Forthcoming.

Power, Michael. *Organized Uncertainty: Designing a World of Risk Management*. Oxford: Oxford University Press, 2008. Print.

Vargha, Zsuzsanna. "From Long-term savings to Instant Mortgages: Financial Demonstration and the Role of Interaction in Markets." *Organization* 18.2 (2011): 215–35. Print.

# INCLINED PLANS:
# ON THE MECHANICS OF MODERN
# FUTURES

## Martin Giraudeau

THIS CHAPTER explores the mechanical founda-
tions of modern futures.[1] It does this by question-
ing the technologies through which the future has
been produced over the past four centuries, in the
world of business and, by extension, beyond. I wish
to follow three successive stages in this technology:
How the future was conceived in the early modern
period; how it has been conceived since the start
of the late modern period; and how it could be (re)
generated following a reset of modernity.

Inclined Plans is grounded in a core historical hy-
pothesis: that late modern business plans, these
peculiar technologies of the future, can be related
heuristically to the mechanics of deterministic sys-
tems, and more specifically to Galileo's illustrious
inclined plane (see figs. 1 and 2). It can indeed be
argued that, since the early nineteenth century,
entrepreneurs have tended to propose business
plans that "demonstrate" expected business evo-
lutions in the same way as Galileo's inclined plane
demonstrates uniformly accelerated movement in
the physical space.

> Galileo's inclined plane
>
> allows its author to withdraw, to let the
> motion testify in its place. It is the motion,
> staged by the apparatus, that will silence

*For brief information on the author see* **r·m!** 278.

> the other authors, who would like to
> understand it differently. The apparatus
> thus plays on a double register: it makes
> the phenomenon 'speak' in order to
> 'silence' the rivals (Stengers 83).

This is due to the way, in the inclined plane,

> the different falling motions that can be
> observed have given way to a motion that
> is both unique and decomposable in
> terms of *independent variables*, controllable
> by the operator and capable of forcing the
> skeptic to admit that there is only one
> legitimate way to articulate them (84).

Each possible objection can be tested; its result on
the observed system measured.

If, for instance, one takes the "Project for estab-
lishing a manufacture of war and sporting gun-
powder in the United States" (see fig. 3) written in
1800 by Éleuthère Irénée du Pont de Nemours, cir-
culated to financiers, and eventually founded as a
company which still exists today – DuPont – the

[1]    I am grateful to Katalin Hausel, Héloïse Lauraire, and Bess Williamson for their insightful suggestions.

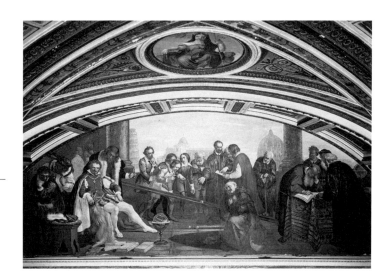

1    Giuseppe Bezzuoli. *Galileo Galilei shows the experience of falling bodies to Don Giovanni de' Medici.* 1841. Fresco. Museo di Fisica e Storia Naturale, Florence.

287

analyze is striking. Du Pont gives an accounting model of the proposed firm, that is, the expected profits and costs, which he uses to test various hypotheses: What will happen to the expected profits if another production technology is used? What if the price of gunpowder goes up? Or down? What if the price of raw materials goes up? And so on. Each of these hypotheses represents a possible objection to the project, but the production of a numerical result, that is, a figure of expected profits, allows each objection to be overruled. So much so, in fact, that the author of the plan can conclude: "One objection remains, we barely have the funds necessary for this establishment, and to this there is no answer."

In many ways, the "inclined plans" of late modern business people are mechanistic simulations of the future, in which a limited set of accounting variables can be played with to generate different measurable results, just as the descent of a ball along an inclined plane is determined by the height from which it descends or the inclination of the plane. This analogy is in fact grounded in some elements of genealogy, the mechanics of deterministic systems inaugurated by Galileo having had a crucial influence on certain developments in both accounting and economic methods from the end of the

eighteenth century (Giraudeau). This connection between the "scientific revolution" and the history of business practices is, for instance, visible in the accounting methods developed by Antoine-Laurent Lavoisier (Wise), or in the mechanical economics of Jean-Baptiste Say and some of his followers (Vatin).

Earlier and (potentially) later forms of planning can also be represented as mechanical devices, but the movement they generate differs from the one produced by inclined plan(e)s. This movement does not imply the same types of continuity and control, and therefore demands to be thought of through other kinds of devices. Pierre Samuel du Pont de Nemours' "Extract of a plan for an agricultural and commercial operation to be executed in the United States of America" (see fig. 4), written a couple of years before his son's, in 1797, and in Paris, is particularly telling in this respect. Comparing the two documents is like conducting a natural experiment, where the son's late modern forms of business planning can be strikingly contrasted with the father's.

Pierre Samuel, a leading Physiocratic economist and French civil servant under the *ancien régime*, was in many respects an early modern entrepreneur, envisioning business in an entirely political way in his plan, emphasizing his high-ranking personal

**2** Galileo Galilei. *Opera Galileo
Galilei.* 1608. MS Gal. 72.
Biblioteca Nazionale Centrale,
Florence. Fol. 116v.

**3** Éleuthère Irénée du Pont
de Nemours. "Project for
establishing a manufacture of
war and sporting gunpowder
in the United States." 1800. MS.
Hagley Museum and Library,
Eleutherian Mills Historical
Library, Wilmington.

# Extrait d'un Plan d'une Opération rurale et Commerciale, à exécuter dans les Etats-unis de l'Amérique

*formation de la société*

Une Société sera formée, qui doit avoir au moins deux cent action de dix mille francs chacune, & de servir par sa statut le plus actionnaire; la facilité ou le Procure de trop gros Bénéfices, par un Placement de leurs fonds

*But de la Société*

qui présente le avantages suivans

*la Société a fortune*

1° Votre d'danger, & Risque à Courir pour le Capitaux (Page M.r J. C. du Plan direy)

*ne traitera Paisible au besoin*

2° Certitude d'avoir, pour Chaque action, une Propriété Considérable, ou en un lieu où se trouvent véritablement la Liberté, la Sûreté, l'indépendance, sous un climat doux, sur un Sol agréable & fertile, dans la Riante Virginie & le Comté de Louis (86)

*intérêts annuels indépendant des Bénéfices & toute évènement humain*

3° Certitude d'un retour d'intérêts, d'abord à 4 p.r 6, puis à Six, puis à Huit (75, 74, 78).

*l'acquisition rapide des Bénéfices l'avenir*

4° Enfin, au bout de Douze années d'association, Certitude du quadruplement de Capitaux, Probabilité du Décuplement, Possibilité même de la Vingtuple (87)

*l'exemple, l'Essai de fortune rapide*

Ces espérances sont Garanties par une foule d'exemples récens; entre le Capitaine américain Williamson (118) & le ci-devant Larochefoucaud (119) Le dernier sans aucun soin a presque Doublé son Capitaux; le Premier avec quelque soin, les a aussitôt quadruplés dans Cinq ou Six ans, quoique tous deux eussent leurs Concessions très mal situées

*invention du projet, son exécution*

Le Plan a été Conçu, & va être exécuté par le s.r Dupont de Nemours jadis & suivant vingt-neuf ans, inspecteur général & Commissaire général de Commerce de France qui part avec un Million de Liberté national & l'approbation du gouvernement sur un Passeport Parlementaire, & sous la protection spéciale des nations

connections and status, as well as drawing on utopian narratives rather than on accounting models. Typically, he envisaged the long-term destiny of his project as the foundation of an entire American colony:

> Thus the principal Establishment of the Company will become (as if by accident) the capital of the county, perhaps some day of the State. The situation, its extent, the possible population and the laws of the country all permit that possibility; then the prosperity of the establishment would be incalculable.

## UP-SET

ONE COULD EASILY imagine an economic version of Galileo's inclined plane. It could be a long and flat device similar to Galileo's but articulated, held between, let's say, two rectangles of transparent Plexiglas and standing on top of a billard-like table. Holes in the Plexiglas, and a set of small handles protruding through it, allow the settings of the inclined plane to be modified: its height, its inclination, the place where the ball will start rolling, and so on (each setting corresponding to one of the cost and profits options in E.I. du Pont's plan). The direction of the device can also be changed by rotating it around a fixed point at the bottom end of the plane. Users could be invited to adjust the device so that the rolling ball ends its trajectory as far as possible on the measuring pattern (or profit targets) drawn on the felt of the table top, and eventually falls into one of the two pockets located opposite at the corners of the billiard table. The users of such a device would thus be made to experience a narrow, possibly unappealing, but efficiently controllable future. It is possible to master it, and it is likely to be performed successfully given its adaptability and grounding in methodical empirical observation.

## PRE-SET

IF, IN CONTRAST, we were to think of the early modern plan, that of a seventeenth or eighteenth century "projector" like P. S. du Pont de Nemours, as a mechanical device, it would be as a vortex, as a kind of funnel, or more precisely as a gravity well. The balls dropped (or invested!) into it would roll around in many directions before eventually falling into the predetermined destination right in the middle. The users of such a device would thus be made to experience a multidimensional and appealing, but pre-set future. It would be attractive, but impossible to modify or adapt to its evolving contexts, and therefore unlikely to be performed successfully.

## RE-SET

NOW, HOW WOULD you conceive of such a plan after the reset of modernity? It should be able to exhibit the unruly, ongoing, and revisable plans of committed collectives, which coordinate continuously, yielding uncertain results. One of the conditions for such a device is that the public needs to be competent to meditate on the practical consequences of fully renouncing late modern forms of planning, and to consider the possibility of forms of planning that would ensure the mastery over the future that is afforded by inclined plans while preventing the narrowing of perspectives that such late modern plans entail.

Overall, the issue is that of movement. Paul Virilio and Claude Parent identified it clearly in the late 1960s, when theorizing the "oblique function," which they saw as the quintessence of high modernity (Virilio and Parent; Parent). Breaking the distinction between verticality and horizontality, inclined planes can be used, in architecture, as substitutes for both walls and floors/ceilings, at the same time. With advanced ramps such as these, there are less interruptions in human trajectories,

5    Claude Parent. *Trajectoire*. N. d. Drawing, printed on
     tracing paper. 55.6 × 38 cm. Collection FRAC Centre-
     Val de Loire.

6    Claude Parent. IP 1, *Instabilisateur pendulaire*. 1968.
     Drawing, ink on tracing paper. 30.5 × 53.5 cm.
     Collection FRAC Centre-Val de Loire.

7    Claude Parent and Paul Virilio. *Maison Mariotti, Saint-
     Germain-en-Laye*. 1967. Drawing, ink on paper. 46.7 × 57.3
     cm. Collection FRAC Centre-Val de Loire.

less sharp turns – that is, more fluid, continuous movement, which they even initiate: gravity drives users downwards, but the slope also invites users upwards, stimulating their efforts, energizing them.

These so-called "pendular instabilizers" are thus mobilization devices, and late modern business plans are perhaps best seen as having the same effects in economic space, of facilitating and even encouraging movement in every specific locus of the business world. Contrary to business plans, however, the inclined planes of Virilio and Parent have seldom been used in practice. These "instabilizers" have too often been deemed to be mere tiring destabilizers – and have therefore been avoided. Similar prudence would perhaps have been welcome from the architects of our economies.

r·m!

## Works Cited

Du Pont de Nemours, Éleuthère Irénée. *Projet d'établissement d'une fabrique de Poudre de Guerre et de Chasse dans les Etats-Unis d'Amérique* [Project for establishing a manufacture of war and sporting gunpowder in the United States]. 1800. MS Longwood Manuscripts group III series B (box II). Hagley Museum and Library, Eleutherian Mills Historical Library, Wilmington.

Du Pont de Nemours, Pierre Samuel. *Extrait d'un plan d'une operation rurale et commerciale à exécuter dans les Etats-Unis de l'Amérique* [Extract of a plan for an agricultural and commercial operation to be executed in the United States of America]. 1797. MS Longwood Manuscripts group I series B (box 3). Hagley Museum and Library, Eleutherian Mills Historical Library, Wilmington.

Giraudeau, Martin. *Proving the Future. Business Plans and the Rise of Capitalism.* 2016. Forthcoming.

Parent, Claude. *Vivre à l'Oblique.* Paris: Nouvelles éditions Jean-Michel Place, 2012. Print.

Stengers, Isabelle. *The Invention of Modern Science.* Minneapolis: University of Minnesota Press, 2000. Print.

Vatin, François. *Le Travail. Économie et Physique (1780–1830).* Paris: Presses universitaires de France, 1993. Print.

Virilio, Paul, and Claude Parent. *Architecture Principe: La Fonction Oblique I* (1966). Print.

Wise, M. Norton. "Mediations: Enlightenment Balancing Acts, or the Technologies of Rationalism." *World Changes: Thomas Kuhn and the Nature of Science.* Ed. Paul Horwich. Pittsburgh: University of Pittsburgh Press, 1993. 207–58. Print.

# EARTH AND WAR IN THE INQUIRY

## Pierre Montebello

A CREPUSCULAR FOG is enveloping the earth. The earth, that "light one" of which Nietzsche spoke (154), is beginning to warp under the weight of great dangers, to acquire an unprecedented gravity. The backdrop to Bruno Latour's *Inquiry into Modes of Existence* is a situation of war that extends to every corner of the earth, one that calls for a new treatise on war, the earth, and salvation. The presence of war may not be apparent on every page of the *Inquiry*, nor is it always perceptible in the intensity of the book's tone. Yet war is there, in the layers of the book, just as it is in the layers of the earth.

The first layer is concerned with a programmatic shift: the earth of the moderns is characterized by a proliferation of extensions, institutions, domains, ecumenes: vast, fibrous, all-encompassing circles. The earth is subject to machines that are broadcasting the same monotonous song to its furthest reaches: everything is religion, everything is law, everything is politics, everything is economics, etc. When the economy is decoupled from its associations with terrestrial interests, attachments, and passions, it becomes "unchained" from sun, earth, and world, ultimately creating a monstrous, nonnegotiable, coldly optimal calculation. When science invents a universal material, it alienates us from the world. And when religion invents a transcendent God, we find that this source of everything ignores the faith we invest in it.

*For brief information on the author see* r · M! 105.

The *Inquiry* wages total war against every one of these institutional and domain-based appropriations; it attempts to wrest religions from religion, economies from the economy, the sciences from science. Our task is to rediscover the meaning of the earth, of religion, economics, politics, etc., so that we can oppose all such extensions – nature, language, society, God, the economy – and regain control of whatever we establish and whatever it is we cherish. The *Inquiry* deploys the ruses of a positioning strategy – a repositioning that extends to the very core of our modes of being – to mount a surprise attack on the forces that bind the earth. What exactly have we put in place (which then keeps us in place), which modes of existence?

Thus we embark upon an initial war, the war of nuances. Can we grasp the meaning of contrasts, of lightness, the meaning of what we have invented? Can we reassert control over our own inventions? The *Inquiry* draws its inspiration from a great philosophical tradition; it seeks a return to our immersion in things, to our participation in the earth and the structure of knowledge (Ruyer) in order to combat the most extreme transcendent programs and the most abstract axiomatic systems.

The second layer is concerned with diplomacy, since the war is global and therefore more visible. Western modernity is being submerged by an immense tectonic shift. The globalizing and globalized impetus of modernity is experiencing an immense backlash. The questions faced by modernity are becoming increasingly urgent. What does it espouse? What is the nature of its composition? Which of its modes of existence are indispensable? The impact of globalization has suddenly forced us to become cartographers of ourselves, explorers of ourselves, anthropologists of ourselves, in a movement that reverses our historical approach to the discovery and invention of others. Instead of imposing our will on others as before, we are now obliged to tell others what we are, to fully grasp the nature of our own composition. The time for comparative anthropology has arrived. If we accept that a war of globalization is under way, let each participant know the other's "war aims." Let us begin to map the modes of existence peculiar to each people or collective. Let us create ontological maps in every discipline, in philosophy, anthropology, sociology. Let strategists become ontologists as well, for the current war is ontological, and all the more violent for the silence that surrounds it.

The modes of existence mapped by the Inquiry are the keys to our salvation, part of our salvation but not its entirety. For us, the moderns, salvation is also a matter of creating a dialogue with every other collective, thus enabling people with radically different representations to come together and discuss the value of the modes of existence and beings to which they lay claim. The ontology of the Inquiry is a far-reaching endeavor. Cosmopolitanism is strongly emphasized in Bruno Latour's lecture "The Anthropocene and the Destruction of the Image of the Globe": if collectives seek contact with other collectives they must "a. specify what sort of people [they] are, b. state what is the entity ... that they hold as their supreme guarantee, and c. ... identify the principles by which they distribute agency throughout

the cosmos." We cannot wait for a salvation to be offered, to be prescribed, to be there waiting for us, to arrive from who knows where. We will be saved not only by taking clear control of our modes of being, but by creating potential discussion space with other collectives.

Ontology is undoubtedly the sole jurisdiction of the intercollective diplomacy the Inquiry emphasizes so strongly. Only ontology will save us – and then only if we succeed in creating an intercollective, transdisciplinary ontology that takes all the attachments of other collectives into consideration, thus regenerating a positive response to a diverse earth, a plurivocal cosmos.

But the third layer, the one concerned with the Anthropocene, is paramount, for its very urgency and the frightening possibilities it holds put everything at risk. In the light of this third relationship, we can no longer talk about using our modes of being to dismantle the programs that threaten the earth, or of employing diplomacy to usher in a plurivocal earth. On the contrary, the earth is trapped in the viselike grip of human violence, its surface becoming "hypersensitive" to human activity, its uniqueness suddenly, explosively apparent to all of us. There is only one earth. "If there is only one Earth and it is against us, what are we going to do?" (Latour, Inquiry 485). This is the supreme anxiety, and it exacerbates every other. We find ourselves engaged in a "phony war," a war without warfare, without a real enemy, a war we can only lose, for the more we strive to master the earth, the more it eludes our grasp, the more it tends to fight back.

Nature is no longer indifferent. It is abundantly clear that we are part of its composition, as it is part of ours, and that we are vulnerable to its reactions. The nature of the problem has indeed changed. The Inquiry, with its focus on the salvation of the moderns, must also face up to the reactions of Gaia. How do we prepare for the civilization of the future, for the collective dialogue that is crucial if we are to

tackle the problem of Gaia? How do we make possible a civilization capable of bearing the burden of an earth that is bearing the burden of us, that is buckling under our weight? "The modernizers knew how to survive a nature indifferent to their projects; but when Nature ceases to be indifferent, when the Nature of the Anthropocene becomes sensitive, even hypersensitive, to their weight, how is anyone to define what it is looking for, when in fact it is not even interested in us, but *in itself*?" (485).

In *Apocalypse*, D. H. Lawrence said: "When I hear modern people complain of being lonely then I know what has happened. They have lost the cosmos" (30). [1] Destruction of the pagan world, loss of the cosmos, dimming of the world's light. The revelation of biblical truth obscured the sun of ancient wisdom ("And the sun became black as sackcloth of hair" [*Bible*, Rev. 6:12]). The appeal to Gaia in the context of a devastated earth echoes that impassioned lament for a Helios obscured by the glacial pallor of the physical sun, or transformed into a black sun by the revelation of the light of an invisible God. In effect, another war is beginning, not against the cosmos but against earth itself. Having already lost the "vital cosmos" (Lawrence 28), we are in the process of losing the vital earth. This is the "strange war" we are embroiled in (Latour, *Inquiry* 485), and it explains the ultimate direction of our salvation. "If Gaia is against us, then *not much* is permitted any longer" (486).

The *Inquiry* examines three relationships to the earth, three forms of war, and three types of salvation. There is an extranational and participative earth, a plurivocal and diplomatic earth, and an earth that is both Anthropocene and Gaia. These three relationships set the terms for three forms of resistance to the incubation of war: the art of nuances versus programmatic monopolization, diplomacy versus tacit conflicts and the aims of undeclared war, and the collective invention of a civilization versus invisible phony war. The three types of salvation are ontological (we rediscover our modes of being), diplomatic (we invent a shared world), and terrestrial (we rediscover the meaning of the *only* vital world that exists).

The *Inquiry* is a book about the earth and the civilization of the future. It asks only one question: how do we recover the meaning of the earth; how do we avoid war if we do not rediscover the meaning of the earth?

*Translated from the French by Roger Leverdier.*

---

## Works Cited

*The Bible*. Ed. David Norton. London: Penguin, 2006. Print. Authorized King James Version.

Latour, Bruno. "The Anthropocene and the Destruction of the Image of the Globe." St. Cecilia's Hall, University of Edinburgh. 25 Feb. 2013. Lecture.

———. *An Inquiry into Modes of Existence: An Anthropology of the Moderns*. Trans. Catherine Porter. Cambridge, MA: Harvard University Press, 2013. Print.

Lawrence, D. H. *Apocalypse*. Harmondsworth: Penguin, 1980. Print.

Nietzsche, Friedrich. *Thus Spoke Zarathustra*. Ed. Adrian Del Caro and Robert B. Pippin. Trans. Adrian Del Caro. Cambridge: Cambridge University Press, 2006. Print.

Ruyer, Raymond. "La connaissance comme fait physique." *Revue philosophique de la France et de l'étranger* 114 (1932): 77–104. Print.

[1]    Lawrence 30. Another passage two pages earlier makes clear the significance of "the cosmos" for Lawrence: "An escape from the tight little cage of our universe; tight, in spite of all the astronomist's vast and unthinkable stretches of space; tight, because it is only a continuous extension, a dreary on and on, without any meaning; an escape from this into the vital cosmos."

# SHAPING SHARING AGRICULTURE (LETTER TO MY GRANDMOTHER)

## Sylvain Gouraud

DEAR GRANDMA,

I'm writing to you from the Ardèche where we're staying with Hélène and the children while we do a bit of WWOOFing.[1] WWOOF is an international network of organic farms that offer accommodation in exchange for working in the fields. I wanted a more direct experience of working the land, at dawn, in the cool morning air. So I got up at six this morning to do some watering. I'm not used to such time-consuming, repetitive work – I'm the sort of person who starts his machine with a single click. I'm always switching from one thing to another, but out here you have to linger over every shoot and make sure it's properly nourished. We work from 6 to 10 and then we're free, so I devote the rest of the day to my inquiry into agriculture.

But of course I haven't told you any of this before because it's been so long since I've been to see you. After Thelma was born we moved, together with Hélène, and settled in the countryside where urban Paris gives way to farmland. Shortly afterwards I began a photographic inquiry into agriculture. I wanted to understand how farmers produce the food that I – and you, too – will then eat. You and I are not on the same wavelength when it comes to

SYLVAIN GOURAUD *is a French artist who elaborates a practice based on inquiry at the intersection of artistic practices and social sciences using photography as his main tool. To construct an accurate representation of complex issues with the participants concerned, he immerses himself in different environments. His work is impactful both in museums and in civil society.*

what we eat, which is probably a generational thing: you went through the war, while I was born into the consumer society and the age of global warming. I was offered a residency at a nearby arts center soon after we settled in Essonne, so I began working locally. I started by going to see my neighbor Nicolas, who runs a farm. He's the same age as me and also has two children. I was immediately fascinated by all the high-tech stuff he uses. He's a member of EARL, along with his father, uncle, and cousin. If I remember right, at Saint-Hilaire you belonged to GAEC. Or was it SCEA?[2] I can't keep track of all these acronyms. His tractor is equipped with GPS, which means it can steer itself around the field (see fig. 1). Seriously, you can see the steering wheel turning by itself – it's magic! He can spray his crops with great precision and return to exactly the same

[1]    WWOOF stands for World Wide Opportunities on Organic Farms.

[2]    EARL, GAEC, and SCEA are farm management companies or cooperatives. EARL: Exploitation agricole à responsabilité limitée; GAEC: Groupement agricole d'exploitation en commun; SCEA: Société civile d'exploitation agricole.

1  Fendt 700 Vario. 2015. From the series *Shaping Sharing Agriculture*.

spot every year, give or take five centimeters. The cab's air-conditioned – when you're in it you don't smell the field at all. Nicolas paid a lot of money for it, 125,000 euros, which must seem like an astronomical sum to you, but it's an investment so he can lower his margins and pay less tax, and after seven years it'll be paid off. I often go back to see him. The way he farms is quite typical of the kind of intensive agriculture you see in my new region: monoculture with a high chemical input.

We haven't talked much about your rural roots. I have to admit that I wasn't all that interested before. I was born in Paris like my father, we lived apart from nature for so long, and since you'd stopped talking to Mom … . But eventually I took the opposite road from all those migrants headed for the capital, the people who left their rural communities to discover the big city, who turned their backs on their parents' or grandparents' farm. Me, I left the city to discover the countryside, a certain type of countryside. Maybe that's why I can look at it without feeling nostalgic, with a degree of objectivity and a curiosity about all the technical aspects.

Nicolas's tractor really fascinated me, and I wondered how it was made. I got permission to photograph the assembly line at the Massey Ferguson

plant in Beauvais. When the vehicle reaches the end of the line it has to be fitted with its massive wheels, which are stacked on enormous metal posts. The wheel I saw was so imposing, it seemed to be calling to me. Seriously! It was as if the object wanted to be photographed. I know you won't believe me – I'm sure you're as skeptical now as you have been on the rare occasions I've told you about my artistic choices. But I really did feel it calling to me, powerfully. I photographed it by itself, at an angle, but level with it. It's important to me to shoot at eye level, like you would with people, face to face. In a strange way, the tractor didn't seem all that imposing while they were still assembling it. In its unformed state it blends in with the charged atmosphere of the factory, while the wheel is a full and finished object. It stands out, and I'd never seen one as big as that before. Its size and the simplicity of its form say it all. I got the same feeling when I was choosing images from the contact sheet. The wheel emerged quite plainly.

The wheel became the project's dominant element, not least in terms of its size: 2.10 m across. It occurred to me that if I wanted to convey its scale, I'd have to make the print life-size: exactly 2.48 × 3.08 m. It was so big my lab could only do it on two separate sheets. So the print is in two pieces. Instead of trying to hide the join, I emphasized it with a strap, the same kind a farmer would use to strap the wheel onto his wheel changer. The picture became an object in its own right – you could feel its heaviness (see fig. 2). You see, it's actually the wheel that dictated the rules – all I did was adapt to the constraints, and it made the object stronger.

It's a pity you couldn't come and see the wheel when I exhibited it, it's a striking image. But I don't blame you, you live far away. I ask myself, what's the point of all this effort when the only people who see the images are the few who bother to visit the museum? And it's not easy to tell you about the pictures if you can't see them. I hope this letter will persuade you to come next time. Either that or I'll bring the pictures to you. Because it's much easier

2   *The wheel.* 2013. Inkjet print,
    framed, 248×308 cm. Exhibited
    at the Domaine de Chamarande,
    2012–2013.

3   *The Baulne Silo* 2012. From the series
    *Shaping Sharing Agriculture.*

to talk about them if they're there in front of you. That's why I was keen to start organizing events around the pictures right away, so the public and the people I've photographed could engage with them.

That worked quite well once, although it was entirely spontaneous. I was teaching a class and we were discussing a particular photograph, an agricultural landscape with a silo in the background. The earth-tone sheet metal created a break in the long lines of the landscape. The students disapproved of this human intrusion into the countryside. We discussed the aesthetic effects of such man-made structures on the so-called "natural beauty" of rural landscapes (see fig. 3). I showed them examples of classical landscape painting in which columns, bridges, and roads figured prominently. I hadn't noticed that a man was patiently listening to us as he looked at the pictures on the wall. The kids were sitting around the table. He began talking to us from where he was standing.

He was a farmer and wanted us to know why farming cooperatives put their silos "right in the middle of fields." He explained that "when you have blowers that run at night to blow the grain, the neighbors complain and you have to turn them off. That's why now they build the silos in the middle of a field, but maybe in ten years that'll be full of houses and people will say, well, it's his fault – and they'll push you out again. That's just the way it is." This testimony was fortuitous because it was triggered by a photograph and voiced by an expert, a professional, someone who was personally affected by the issue and eager to make his point. You would have been surprised by the lively debate it inspired (see fig. 4). Something really happened that time.

Would you have been against the silo? I wonder. Anyway, I'm trying to reproduce this "conversation model" in which a farmer and students discuss a photograph, but it doesn't really work at an arts center. We were lucky the farmer turned up, but not everyone is prepared to visit a museum – far from it. You can't deny it, you never go yourself. And I can't transport my big wheel picture to your place. The Essonne arts center, which bought the picture, tried hard. They're committed to exhibiting their collection across the department, and they suggested I show the wheel at the Potagers de Marcoussis,

an organization that helps the disabled find work on small organic farms. It's a bit like hanging a 2 × 3 m painting in your living room, if you can imagine that. There are so many constraints. I have to find a wall (preferably one that's clean and smooth), hang the picture without making too many marks, and either make sure it's far enough away from the viewers or explain at length why the work should not be touched. I need light, which is often no more than a fluorescent tube set in the ceiling tiles, not to mention the amateur photographs already hanging on the walls that I have to work around while still preserving some autonomy. And, as you might imagine, I have to renegotiate all this all over again whenever I show my pictures in a new venue.

I've become a familiar figure in Essonne since I started working on this subject there, and people are getting to know me. A journalist from Le Parisien came to interview me. I sent you the article, you said it was "impressive." Someone at Boutigny-sur-Essonne town hall saw it and invited me to the heritage festival to give a talk on agriculture, or rather the "culture of agriculture," as Norbert, the deputy head of culture, put it. I took a small camera on which I had recorded a series of images, which were then projected onto a big screen in the main hall (see fig. 5).

4   Discussing silos with a farmer.

5   A conference at Boutigny-sur-Essonne.

**6**  Macroaphotography apparatus.

Some of the pictures I showed at the festival illustrated problems arising from changes of scale. I used the example of tiny, misshapen beet seeds that would not pass through seed drills. The seeds used to be sown by hand, and sometimes two would be sown together, in which case someone had to go back to the field and thin the plants, allowing one to grow at the expense of the other. I'm sure you know all about thinning beets because every time I mention it, someone in the audience recalls the days when the whole family labored together in the fields. Once the companies came up with a way to wrap the

**7**  *Windmill in Beauce.* 2012. From the series *Shaping Sharing Agriculture.*

seeds in clay, they became round and big enough for mechanical sowing. The fields themselves were expanded by uprooting the hedges and combining the parcels. The landscape was transformed.

To photograph a seed, I had to improvise a camera using cardboard tubes. It was very difficult to photograph a tiny seed with a camera designed for portraits and landscapes. I needed a macro lens, but there's nothing wide enough on the market, and I didn't want to look down at the seed the way you would with a microscope. So I had to construct this monstrosity (see fig. 6) in order to get an eye-level shot and enlarge it sufficiently. That's kind of how my work goes: you think about the best way to approach the subject you want to represent, how to show it respect even though it's just an object, while at the same time capturing its essence. You have to juggle a lot of technical constraints.

It was the same when I screened the images at the hall in Boutigny-sur-Essonne where they were holding the heritage festival. The picture was fuzzy and the colors came out bad. Everybody has a video projector now, they're very useful for showing documents at work meetings, but

301

8    *Lettuce coated seed.* 2012. From the series *Shaping Sharing Agriculture.*

the image quality is rarely good unless the projector is quite large. I know you think I'm being too fussy here, nit-picking, but believe me, a lot of important details in my images got lost when I showed them. A wind turbine (see fig. 7) disappeared into the sky (they put them up in spots where the wind is strong and constant, especially in the open spaces that were created when all the hedges were removed and the fields were consolidated). The blue seed (see fig. 8) turned greyish (the wrapped seeds are colored to show they contain chemicals, and also to make them easier to find in the field when the farmer uses his seeder). The grain prices, written on cards (see fig. 9), were illegible (the cooperative fixes grain prices every day and displays them by the door; these cards are a kind of contract for the farmers).

That's why I decided to make my own projector. It's housed in a small box (see fig. 10a and b) and projects slides, kind of like the slide projectors people use to show their vacation photos. The enlargement is optical, not digital, and since there's no pixelation, there are no problems with definition. In other words, the colors aren't translated into pixels. To preserve the quality of the image, I print my photographs on medium-format slides, the same size as my negatives, 6 × 7 cm. My box holds lots of slides and I can show the whole set anywhere.

So that's my news, since you wanted to know what I've been doing. But the best thing would be for me to come show you one of these days and project my pictures for you – then you can tell me what's changed since your time. I suppose you'll be at Saint-Hilaire all summer. I'll try to find time for a visit before school starts.

With all my love,
Your grandson
Sylvain

*Translated from the French by Roger Leverdier.*

**9** *The rates.* 2012. From the series *Shaping Sharing Agriculture.*

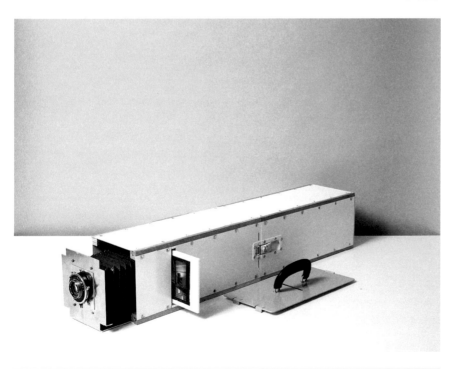

**10a–b**   V8 projector/case. 2016.

NOW THE TIME HAS COME to take up literally what has remained until now a metaphor: How to *reset* modernity? If the reader has followed the first four procedures, it must have become clear that we can always embed the global into the local so as not to be dazzled by the false promises of the globe (Latour, "Procedure 1," **r**·M! 51–67). That it is not so difficult to shift our attention to objects by ninety degrees so that we begin to move *within* the world and start to lose the strange asymmetrical quality of being mere subjects detached from nature (Latour, "Procedure 2," **r**·M! 91–103); which leads us to share agencies, potentialities, and "response abilities" with many other entities and to shift from an idealized notion of "matter" to this realistic form of "materiality" so typical of the Anthropocene (Latour, "Procedure 3," **r**·M! 167–83). This ends up making us feel that we inhabit new layered and overlapping sets of contrasting territories totally different from the 2-D color coded maps of older geopolitics (Latour, "Procedure 4," **r**·M! 245–59).

## Procedure 5

# INNOVATION NOT HYPE

Each procedure should allow us to register an experience that was hard to record before. That's what is meant by a reset: the possibility of rendering an instrument sensitive again to the signals it was meant to register. If there is one experience on which the moderns have never been able to report realistically, it is certainly that of the vast domain of what is called artifacts and techniques. If matter has become an idealized version of materiality, then technology is an even more idealized version of what it is to live through, with, and inside techniques.

Nothing is more hyped than technology, especially "new technologies," and nothing is further from the experience of inventing, developing, coping, and dealing with techniques. It is thus crucial to regain a handle on this experience just at the moment when, because of the Anthropocene, we have to redesign from top to bottom the new territories in which we are going to live – that is, to try to survive.

How to accept the artificiality of our built world and still resist the hype that comes with the strange idea that we could become masters of fully automatic, totally transparent, entirely rational, completely soulless pieces of mechanical and electronic stuff? How to deal positively with artificiality? Westerners have long recognized the problem through the ambiguous figure of Frankenstein, except they always misunderstood it as a retelling of the fable of the "sorcerer's apprentice" without realizing it offers exactly the opposite lesson: techniques are always born deficient and have to be cared for; if not, they become criminal or useless (Latour, "Cosmocolosse," **r**·M! 328–36). Technologies have to be loved – but loved for good, not for hype, denial, or pornography.

The problem is that techniques are always engulfed in a vast narrative that makes them part of an advancing modernizing frontier to the point that every little gadget, trick, stratagem, or machination is transmogrified into some irreversible and undisputable destiny that only irrational and archaic nitwits will resist. The problem is so pervasive that it has become impossible, when considering critiques of technologies, to figure out whether they are reacting to the modernizing fatality or if they are trying to prove, and with good reasons, that every set up could indeed be made different.

In the same way that we learned to relocalize the global, we have to learn to repopulate the deserted landscape of technical artifacts. A good way to resist the idealism of artifacts able to work in a "fully automatic" mode, is to look at how many earthly computers are necessary to keep the cloud up in the air.[1] This is still another rendering of Plato's allegory of the cave: the cloud is above, yes, but only as long as many antennas, computers, and refrigerating towers are using vast amounts of energy down below. Automatism never works automatically. As a rule of thumb, if some device is automatic, then the more engineers, programmers, lawyers, financiers, supervisors, and watchmen are necessary. Have a look at Armin Linke's workstation in a bank (see fig. 3, r·m! 310): what an infrastructure to generate the superstructure of finance and calculation! Are banks "dematerialized" and "delocalized"? Yes, but just as much as the cloud it is tied to its underworld: if you interrupt its massive set of material techniques, it dissipates quickly.

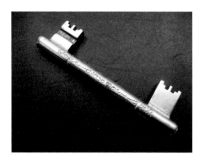

1    Berlin key. 2010.

2    Rufus Blacklock. *Evolution of the F1 Car.* Graphic.

And this is not a new phenomenon: Sophie Ristelhueber has shown in a stunning set of prints what is beneath the splendor of the fountains (see figs. 4 and 5, r·m! 311), facades and gardens of Versailles. Such is the underbelly of the Sun King's scenography of power and landscaping. In this perspective, there is probably not that much difference between this hidden infrastructure and the Pionen data center, built into the White Mountains, in Stockholm, Sweden, where WikiLeaks and Pirate Bay held their servers (see Emma Charles's *White Mountain*, figs. 6a–d, r·m! 312).

Just as the discontinuities of materiality have been smoothed over to produce the ideal imagination of a "material world," the many discontinuities necessary to generate functioning artifacts have been erased to give the impression of an overpowering machinery fully immersed in a sea of *res extensa*. What makes the case of technology even stranger is that technical drawings could have offered a striking portrait of those discontinuities. Any artifact viewed as an "exploded view" multiplies the gaps between each part and the next: the blanks on the page in between every line are crying out to be filled in by a large number of actors (workers, designers, engineers, and bureaucrats). And yet we keep fantasizing in our heads that devices assemble automatically without the aid of people. This is the dream of the posthuman, once again, as if adding prostheses to bodies would decrease instead of increase the number of engineers at work.

The exploded view may exist in two totally different kinds of space: one is the isotropic view of technical drawings erasing all traces of people, history, and institutions (except if you read the manual, follow the dotted lines, or try to fix it); the other is to offer a procedure to disentangle each part and bring it back to its conditions of production. No artist qua researcher has tried to explore that path more fully than Thomas Thwaites in his *Toaster Project* (**r**·M!354–61) (see fig. 7, **r**·M! 313). This is not the result of an iconoclastic gesture to make a toaster "explode," but a true example of how to love techniques by going all the way to the primary components and minerals heroically assembled by one single amateur. The result of that artwork is to show by contrast the immense social armament necessary to produce in the end a working toaster. This case of preemptive archeology gives another meaning to the notion of "reverse engineering"!

Such a reversal in the direction of our attention allows us to focus on the whole ecosystem necessary for innovations to withstand time. This is even more important in order to fathom the unintended consequences that the hyping of techniques generally trigger (Beck). This is movingly illustrated by Unknown Fields Division's (Liam Young and Kate Davies) work *Rare Earthenware* (see figs. 8a–e, **r**·M! 314–17) showing the production of earthenware with toxic material from Inner Mongolia. Techniques are so much a part of civilization that it comes to the same thing if you start with artifacts to describe the human machinery or if you start from human society to describe the material machinery. They are the two faces of the same coin.

Paradoxically, the most technically driven civilization has never found a way to be proud of its achievements without hyping it while at the same time denying its unintended consequences that are now visible on the entire planet. And to the point where

[1]   See the project New Cloud Atlas described as "a global effort to map each data place that makes up the cloud in an open and accountable way" (Dahmen, Frid-Jimenez, Dalton, and Waters).

geo-engineering can appear as the ultimate modernist solution to all the unintended consequences modernism itself has triggered (Hamilton, Morton). A nightmare built on a utopia pushed to its ultimate limits. A groundless world pushed totally offshore for good. As if Atlas himself had finally decided to shrug off his burden and dump the earth overboard!

It is because of the importance of techniques that reset, as we have seen above (Ricci, r·m! 24–41), should no longer remain a metaphor but a rich technical history so that we may escape from an idealized vision of technology. Could we finally become ready to innovate but freed from the modernizing hype? Is there a way to put our hands into the rich diversity of all the materiality needed to redesign a livable world? After all, as Henning Schmidgen reminds us, it is to try to capture the specific ontology of techniques, that the notion of *mode of existence* was explicitly proposed (r·m! 320–27).

It is hard to consider techniques separated from the rest of our earthly existence. If you begin to look at the geopolitics of oil, for instance, you end up describing the whole globe under one of its most sinister aspects. This is what Territorial Agency are showing through their clever fiction of a *Museum of Oil*, as though we could project ourselves ahead to a time when we will be able to look at our addiction to fossil fuel, as something of the past (r·m! 337–53).

For this we need to go one step further and free ourselves from mastery. We have to become grown up! That is, secular in a new and nonmodernist way.

Works Cited

Beck, Ulrich. *Risk Society. Towards a New Modernity.* London: Sage, 1992. Print.

Dahmen, Joe, Amber Frid-Jimenez, Ben Dalton, and Tim Waters, eds. *The New Cloud Atlas.* Web. 25 Jan. 2016. Available at <http://newcloudatlas.org/#3/41.51/-40.96>.

Hamilton, Clive. *Earthmasters. The Dawn of the Age of Climate Engineering.* New Haven: Yale University Press, 2013. Print.

Latour, Bruno. *Aramis or the Love of Technology.* Trans. Catherine Porter. Cambridge, MA: Harvard University Press, 1996. Print.

---. "Procedure 1: Relocalizing the Global." Latour, *Reset Modernity!* 51–67.

---. "Procedure 2: Without the World or Within." Latour, *Reset Modernity!* 91–103.

---. "Procedure 3: Sharing Responsibility: Farewell to the Sublime." Latour, *Reset Modernity!* 167–83.

---. "Procedure 4: From Lands to Disputed Territories." Latour, *Reset Modernity!* 245–71.

---, ed. *Reset Modernity!* Cambridge, MA: The MIT Press, 2016. Print.

---. "Cosmocolosse: Sequence 6: Viktor and Mary." Latour *Reset Modernity!* 328–36.

Morton, Oliver. *The Planet Remade. How Geoengineering Could Change the World.* Princeton: Princeton University Press, 2015. Print.

Ricci, Donato. "Don't Push That Button!" Latour, *Reset Modernity!* 24–41.

Schmidgen, Henning. "*Mode d'existence*: Memoirs of a Concept." Latour, *Reset Modernity!* 320–27.

Territorial Agency. "Radical Conservation: The *Museum of Oil.*" Latour, *Reset Modernity!* 337–53.

Thwaites, Thomas. "Construction." Latour, *Reset Modernity!* 354–61.

---. *The Toaster Project: Or a Heroic Attempt to Build a Simple Electric Appliance from Scratch.* New York: Princeton Architectural Press, 2011. Print.

**3** Armin Linke. BNP Paribas,
headquarters, trading floor, Paris
France. 2012. Photograph.

4    Sophie Ristelhueber. *Untitled #1.*
      2011. Color photograph, digital
      pigment print, framed and under
      glass, 100 × 150cm.

5    Sophie Ristelhueber. *Untitled #3.* 2011. Color photograph, digital pigment
      print, framed and under glass, 100 × 150cm.

**6a–d**   *White Mountain* Dir. Emma Charles. 2016. 16mm film. Film stills.

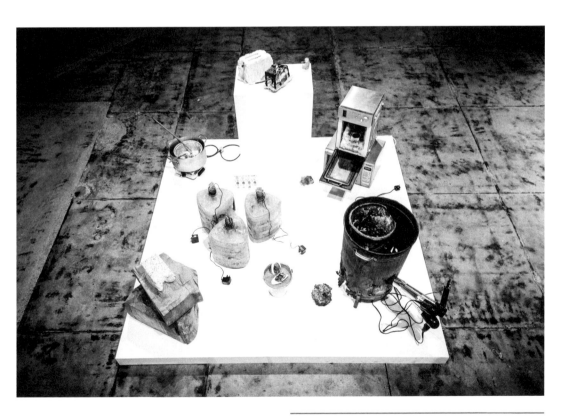

7    Thomas Thwaites. *The Toaster Project* (reproduction).
2011. As installed at the 2012 ZERO1 Biennial, California.

8a *Rare Earthenware*. 2015. Dir. Unknown Fields Division.
Black stoneware and radioactive mine tailings. Film
still.
This still depicts a Chinese worker assembling
electronics on a conveyor belt production line, mud
from the lake was used to craft a set of three ceramic
vessels. Each is sized in relation to the amount of
waste created in the production of three items of
technology – a smartphone, a featherweight laptop,
and the cell of a smart car battery.

**8b** *Rare Earthenware*. Dir. Unknown Fields Division.
2015. Black stoneware and radioactive mine
tailings. Film still.
Film still from *Rare Earthenware*, a film, developed
through a collaboration with Unknown Fields
and photographer Toby Smith, documents the
Unknown Fields voyage from container ships
and ports, wholesalers and factories, back to
the banks of a barely-liquid radioactive lake in
Inner Mongolia, where the refining process takes
place. The still shows Unknown Fields, collecting
radioactive mud from the tailings lake at the
outflow of Baogang Iron and Steel Corporation.
The mud was used to craft a set of three ceramic
vessels. Each is sized in relation to the amount of
waste created in the production of three items
of technology – a smartphone, a featherweight
laptop, and the cell of a smart car battery. The
full film and three finished vases produced from
this mud, produced by Unknown Fields Division
in collaboration with the London Sculpture
Workshop, were on display in the V and A Gallery.
The exhibition *What Is Luxury?* opened on 25 Apr.
and ran until 27 Sept. 2015.
Unknown Fields is a nomadic design studio that
develops work through expeditions across the
distant landscapes that lie behind the scenes of
modern cities. In this project they retrace rare
earth elements, which are widely used in high-
end electronics and green technologies, to their
origins.

**8c** Unknown Fields Division. *Rare Earthenware*. 2015. Black stoneware and radioactive mine tailings. Three vases. Three finished vases, produced by Unknown Fields Division in collaboration with the London Sculpture Workshop, were on display in the V and A Gallery. The exhibition *What Is Luxury?* opened on 25 Apr. and ran until 27 Sept. 2015. Photograph.

**8d** Unknown Fields Division. *Rare Earthenware*. 2015. Black stoneware and radioactive mine tailings. Photograph. University College London, Radiation Safety Services. Mud from a radioactive tailings lake in Inner Mongolia is tested for radiation by Michael Lockyer in UCL Radiation Protection Safety Services lab and found to be three times background.

**8e** Unknown Fields Division. *Rare Earthenware*. Dir.
Unknown Fields Division. 2015. Black stoneware and
radioactive mine tailings. Photograph.
London Sculpture Workshop, 11 February 2015.
Unknown Fields in collaboration with the London
Sculpture Workshop uses mud from a radioactive
tailings lake in Inner Mongolia to fashion a vase
inspired by highly valuable Ming dynasty porcelain.

318

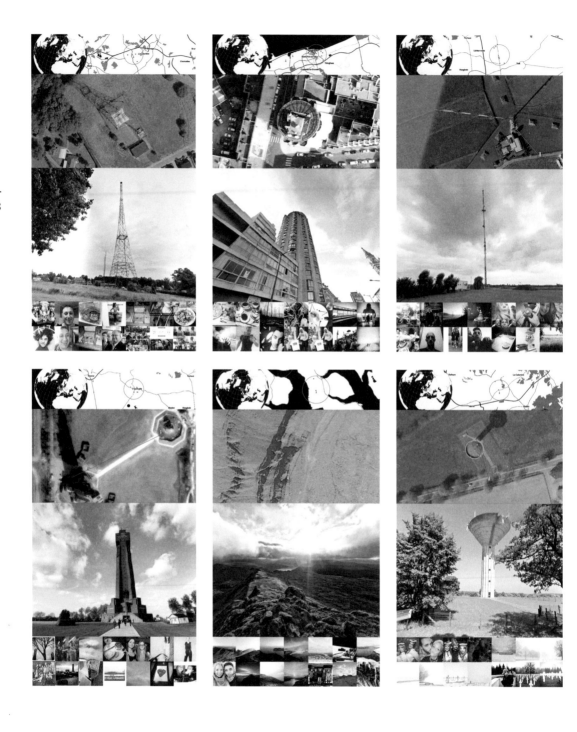

**9a–f**  A Network of Fragments / Fragments from Networks. 2016. Installation.

This installation aims to superpose antennas used for High Frequency Trading onto their immediate environment. For each antenna a map, a satellite image, a panoramic view, and Instagram pictures were collected and recomposed, in the same visual space, using mash-up technique.

These antennas are local fragments of large networks, studied by the anthropologist Alexandre Laumonier, that use multiple open-source intelligence such as company websites, government telecommunication institutions, or engineers' LinkedIn profiles (see http://sniperinmahwah.wordpress.com).

The stack of visual representations shows the idiosyncratic superimposition of a mysterious trading technique over the mundane and daily activity installed over a location.

Particularly interesting are the situations in which the technical infrastructural point became part of the landscape and was taken to be a point of interest by ordinary people.

319

**9g–k**  A Network of Fragments / Fragments from Networks. 2016. Installation. Instagram images in which the antennas become part of the landscape and an "object" worth to be pictured.

**9l**  A Network of Fragments / Fragments from Networks. 2016. Installation. Panoramas obtained by stitching Google street view tiles.

# MODE D'EXISTENCE:
# MEMOIRS OF A CONCEPT

## Henning Schmidgen

*Concepts have memories of events that we have forgotten.*
**Ian Hacking**

IN 1951, ÉTIENNE SOURIAU was selecting the texts for a special issue of a journal he coedited, *Revue d'esthétique*. It was devoted to "industrial aesthetics" – that is, to the relationship between art and technology. In his introductory essay, "Passé, présent, avenir du problème de l'esthétique industrielle," Souriau defined the topic by asking some representative questions: How does the predominance of machine work over handwork affect artistic production? What influence does the seemingly unlimited duplication of standardized objects have on our aesthetic experience? Should we view photography and film as technological procedures or artistic practices? He invited responses from art historians, literary scholars, sociologists, and psychoanalysts, as well as engineers, designers, and architects.[1]

In the face of the spectacular projects under way in cybernetics (artificial turtles, reflex conditioning devices, computers, etc.) and the increasing technologization of the world of work, the relationship between art and technology must have seemed as topical as it was relevant in the France of the 1950s. For Souriau, however, the industrial aesthetic was also of personal significance. As he explained, his father, the philosopher Paul Souriau, had noted the potential conflict between economic imperatives

HENNING SCHMIDGEN *is a professor of media studies at the Bauhaus-University in Weimar. He has worked extensively on Guattari's machines, Canguilhem's concepts, and the problem of living time in nineteenth-century physiology and psychology. He is a cofounder of The Virtual Laboratory, a widely used digital library and publication platform focusing on the history of the experimental life sciences.*

and aesthetic values as early as 1900. In *La beauté rationnelle*, Paul Souriau attempted to resolve this conflict by proposing an independent aesthetics of technology. His specific position, as summed up by his son, was "that the tremendously successful products of industry – including, above all, the machines – possess, in their perfection, a beauty that bears comparison with the best works of painting or sculpture."[2]

To Étienne Souriau, fifty years later, this thesis was a clear anticipation of the Futurist enthusiasm for the machine that would be so pithily expressed in Filippo Tommaso Marinetti's famous saying that a roaring car is more beautiful than the *Victory of Samothrace*. At the same time, he also saw it as defining the stance that would later lead modernist architects such as Henry van de Velde, Bruno Taut,

[1]  The issue included essays by Charles Lalo, Jacques Viénot, Pierre Guastalla, Jacques-G. Kraft, Paul Ginestier, and Ernest Fraenkel, among others.

[2]  Translated from É. Souriau, "Passé, présent, avenir" 231. Cf. P. Souriau 195, 198, 216.

Walter Gropius, and Le Corbusier to essentially equate functionality with beauty.

Étienne Souriau did not limit himself to addressing the problem of the industrial aesthetic from the point of view of his own family's history. With regard to film (an art form which with he had been intensely engaged since at least 1946, when he became a founding member of the Association française pour la recherche filmologique),[3] he referred to an "interesting article" that Walter Benjamin had published in the 1930s, most commonly known in English as "The Work of Art in the Age of Mechanical Reproduction." In fact, Souriau devoted quite a bit of attention to the way literature and art were influenced by reproduction technologies, from the "Rotaprint process" to the "Vari-Typer."[4]

On the final pages of his introduction, he outlined a "functional morphology" of the technological object, which would investigate not only the evolution of the external forms of such objects but also the redistribution of the separate "organs" inside them. In this connection he quoted Henri Foçillon, who had defined style as a "coherent ensemble of forms united by mutual suitability."[5] With the help of two photographs of a truck, presented as demonstrating the harmonization of its individual elements, Souriau showed how he imagined this concept of style might be applied to the phenomenon of technology (see fig. 1 and 2).

In 1958, Gilbert Simondon published a philosophical treatise on the mode of existence of technological objects, *Du mode d'existence des objets techniques*. While it went well beyond a journal article in scope, it can be read as a late contribution to Souriau's special issue. Indeed, Simondon refers not just to the philosophy of technology but also, and perhaps above all, to its aesthetics. It is true that on the first few pages he explicitly distances himself from a superficial consideration of technological objects. Taking the automobile and the telephone as examples (23, 39), he shows that there is a significant difference between a technology's external adaptation to its users and its internal evolution into a technologically coherent whole. The "technicity" of a telephone is not intensified by making its outer form more compact and easier to use.

It is for this reason that Simondon's study focuses on the *milieu intérieur* of technological objects. The central thread of his contemplation of this inner form is the "exchange of energy and information" that can be observed between an object's various components (48). From this perspective, a technological object evolves through the internal convergence of its functional structures. Although it may become the "venue of a certain number of relations of mutual causality" in the process (27), its morphological aspects do not disappear. On the contrary, that coherence of forms uniting through reciprocal adaptation that Foçillon described as "style" resurfaces here in terms of energy and information (19–23).

The aesthetic specific to this conception of the technological object can clearly be seen in the way Simondon describes the process of "concretization." He does not simply outline the development of the internal combustion engine and the vacuum tube (his main examples) in the text. Like Étienne Souriau, he documents it in photographs, which are reproduced in the book's appendix. Artfully arranged rows of machines and machine parts illustrate the morphological evolution of selected technological objects (see fig. 3).

321

[3]  On Souriau and filmology, see Lowry, Kessler, and Hediger.

[4]  "Passé, présent, avenir" 239, 248–49. Souriau is referring to Pierre Klossowski's French translation of Benjamin's essay, "L'œuvre d'art à l'époque de sa reproduction mécanisée." Benjamin is also cited in another article in the special issue, Ernest Fraenkel's "Esthétique industrielle et psychanalyse" (409–10).

[5]  "Un ensemble cohérent de formes unies par une convenance réciproque." Foçillon 10, qtd. in É. Souriau, "Passé, présent, avenir" 242.

It is therefore not surprising that Simondon attaches great importance to aesthetics. Within contemporary culture – which, he claims, is characterized by a hostile distancing from technology – aesthetics points the way toward reconciliation: "the aesthetic tendency is the ecumenical motion of thought" (181). Appreciating a machine as an aesthetic object would thus be a first step toward recognizing technology as an integral part of culture.

But is Simondon not relapsing, here, into the superficial view of technology he criticized at the beginning of his study? Not quite, since technological beauty is defined here in terms of insertion: "The overhead power line is beautiful when it spans a valley, the car when it speeds through a curve, the train when it departs or emerges from a tunnel" (185). In this way, aesthetic thought functions, for Simondon, as a "paradigm that directs and sustains the effort of philosophical thought" (201). It traces out that process that leads to a new cultural symmetry via a growing philosophical awareness of the meaning and value of technology.

It would be rash to infer a direct connection from these affinities. Although Simondon titled his treatise *Du mode d'existence des objets techniques*, it is not evident that he was referring to the book Étienne Souriau had published fifteen years earlier, *Les différents modes d'existence*. However, there is extensive overlap between the two texts. At first, the common ground would seem to be that in both instances aesthetics functions as the paradigm for philosophy. As Souriau states: "Each mode is an art of existing unto itself" (131). In fact, he frames the notion of "instauration" – a fundamental concept in his philosophy – in terms of the artistic process that leads from the lump of clay on the sculptor's bench to the simultaneous emergence of the work, on one hand, and the artist on the other (Stengers and Latour).

However, if one follows the thread of the term used by both authors, namely *mode d'existence*, it becomes clear that Souriau's path converges with the one taken by Simondon in another way, too. As different as they may be in their individual details, they both point back to a bifurcation that was decisively shaped by Edmund Husserl's phenomenology. Indeed, it was Husserl students such as Oskar Becker, Hedwig Conrad-Martius, and Roman Ingarden who, starting in the 1920s, helped make the concept of the *mode of existence* or *mode of being* so prominent in philosophical discourse.

Within this constellation, the phenomenologist appears in the guise of a modernist Descartes, arm in arm, as it were, with Gropius and Le Corbusier. In his studies of the intentionality of acts of consciousness (particularly his *Logical Investigations*), Husserl famously defined the group of "ideal objects" (numbers, triangles, etc.) in telling contrast to the then-dominant trend of psychologism. One result of this demarcation was the differentiation of "ideal objects" and "real objects." In this way, Husserl radically renewed the classic polarization of *res cogitans* and *res extensa*.

1   Apparatus for desinfection as used in South Algeria, ca. 1930. According to Souriau, in this case the form of the apparatus is not fully "integrated." Reproduction. Souriau, Étienne. "Passé, présent, avenir du problème de l'esthétique industrielle." *Revue d'esthétique* 4 (1951): 226–51, table III. Print

2    Apparatus for desinfection as used in South Algeria,
     ca. 1950. Souriau describe this version of the apparatus
     as a "complete integration of the form," leading to an
     "excellent aesthetics." Reproduction. Souriau, Étienne.
     "Passé, présent, avenir du problème de l'esthétique
     industrielle." *Revue d'esthétique* 4 (1951): 226–51, table IV.
     Print.

Another result was the question whether all objects can be accommodated in this new distinction between "ideal" and "real." With this question in mind, Becker, Conrad-Martius, Ingarden, and other Husserl students called attention to those objects that resist straightforward classification: works of literature, for example, or objects of scientific research. And unlike Husserl, in order to better appreciate such things and describe them with greater precision, they switched from phenomenology to ontology, attributing characteristic modes of existence or being to Goethe's *Faust* or the atom of contemporary physics.

In Étienne Souriau's book there is no lack of evidence for a connection to this construction of the problem. At the very beginning he juxtaposes "thinking" and "matter" in order to then raise questions about the mode of existence of objects that elude classification in terms of this opposition: "Does God exist? Did Hamlet, the *Primavera*, Peer Gynt exist, do they exist, and in what sense? Do the square roots of negative numbers exist? Does the blue rose exist?" (*Different Modes* 97). This is exactly the philosophical gesture that was characteristic of Husserl students such as Ingarden.

Simondon takes his cue from this gesture as well, but he executes it in a somewhat modified form consistent with a more advanced stage of reception. When he tries to grasp the specific mode of existence of the technological object, he not only considers the emergence and evolution of this particular kind of object but also derives it from repeated comparisons with other kinds of objects: the aesthetic object, the religious object, and the natural object. In the 1930s, Roman Ingarden had pursued a similarly comparative ontology based on his extensive study of the mode of being of the literary work of art. Taking literature as his starting point, he then differentiated the various modes of being of works of art in painting, music, architecture, and

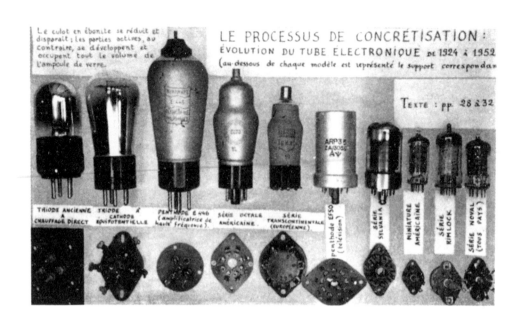

**3**  Simondon's illustration of the process of conretization in the vaccuum tube, 1924 to 1952. Reproduction. Simondon, Gilbert. *Du mode d'existence des objets techniques*. 1958. 3rd ed. Paris: Aubier, 1989. Table IV. Print.

film – the last, incidentally, in an article in another journal coedited by Étienne Souriau, the *Revue internationale de filmologie*.

Neither Souriau nor Simondon refer to Ingarden, although his writings on the ontology of art and science were known in France from the 1930s onwards.[6] By then the French expression *mode d'existence* was already established as the customary translation for the German *Seinsweise* – although (or because) Ingarden also used *Seinsmodus* (mode of being), *Existenzmodus* (mode of existence), and *Existenzweise* (way of existing) in his writings in German.

The key figure in the French reception of Ingarden's work was Mikel Dufrenne, who studied under Étienne Souriau, Gaston Bachelard, and Vladimir Jankélévitch. He was also a friend of Simondon – or at any rate, in 1958, in his preface to *Du mode d'existence des objets techniques*, Simondon thanked his "former colleague" Dufrenne for the "frequent encouragements he showered upon me," for the "advice he gave me," and for his "vigorous sympathy" when editing the volume (xv).

In the early 1950s, Dufrenne brought out an extensive *Phenomenology of Aesthetic Experience*. While the second part was devoted to aesthetic perception, the first dealt entirely with the aesthetic object. Dufrenne drew fruitfully on Souriau *and* Ingarden, structuring his analysis as a comparative analysis of different types of objects. Though he did not talk of modes of being, he did define the distinctive nature

[6]  In 1931, Souriau's friend and colleague Charles Lalo (another coeditor of the *Revue d'esthétique*) reviewed Ingarden's treatise on the literary work of art for the *Revue philosophique*. Soon thereafter, in a report on the 1934 International Congress of Philosophy in Prague, Jean Cavaillès mentioned Ingarden's criticisms of the Vienna Circle's attempts at logical formalization.

of aesthetic objects by comparing them to objects of nature (life), objects of use (technology), and objects of meaning (language) (72–146).

As noted above, the same approach can be found in Simondon's examination of the technological object. Some of the basic terms introduced by Ingarden in his analysis of the literary work of art reappear as well. For example, the distinctively Simondonian concept of the "concretization" of an object is also to be found in Ingarden's thought, as is discussion of the object's "edges" and/or "places of indeterminacy." Like Simondon, Ingarden also speaks of the "individuality" of the particular object (or work), the essence of which is defined by a "scheme." And, last but not least, Ingarden's book *The Literary Work of Art* contains the same analogy between the development of an object (or work) and "the life of a living being" (350) of which Simondon so often speaks.

Moreover, Simondon and Ingarden encounter similar difficulties in the course of their respective investigations. The rupture running through Simondon's treatise has been frequently noted: While the first two sections focus closely on the technological object, the third expands its perspective to include technology's "nonobjectivized realities" (154), embedding it in the greater totality of all relationships between humans and the world (magic, technology, religion, etc.).

This rupture changes the character of the referent of the term *mode d'existence*. In the first two sections, it refers to the distinctive properties of a specific type of object, but in the third it stands for different types of human-world relationships. Simondon describes these relationships, too, as "modes of existence," but he also calls them "modes of thought" and "forms of thought" (157–58); it is clear that he also has in mind here attitudes, mindsets, and values.

What emerges behind this vagueness is no longer a phenomenology, however, but a sociology. Or, to be more precise, it is the history-oriented categories

of a sociology of values that lead back via Georges Canguilhem (Simondon's second mentor, alongside Dufrenne) to Célestin Bouglé, Georg Simmel, and others. In fact, in his preface to *Du mode d'existence des objets techniques* Simondon also thanked Canguilhem for his "comments" and "suggestions" and underscored that the third part of his study owed "a great deal" to him (xv).

This acknowledgment should be seen as a reflection of the fact that Canguilhem, in his famous essay *The Normal and the Pathological*, relied on and referred to the philosophical school of axiology, or *Wertphilosophie* – in particular Wilhelm Windelband, Hugo Münsterberg, and Heinrich Rickert" (215) – when highlighting the different values of science on the one side and technology on the other. In a similar way, Canguilhem's teacher, the sociologist Bouglé, had construed the phenomenon of society as the result of an ongoing process of axiological differentiation which, starting from the original unity of magic, divided into spheres such as science, technology, economy, and aesthetics.

Ingarden, in his investigation of the modes of existence of the literary work of art, reaches a point similar as Simondon. Having exhaustively analyzed the different strata of the literary work and their polyphonic interplay, Ingarden finds himself forced to "bring the literary work back, so to speak, into contact with the reader and introduce it into concrete spiritual and cultural life" (331). The "mode of being" of the literary work suddenly turns out to be dependent on specific "modes of apprehending the world" that are in turn defined by "aesthetic and nonaesthetic values" (348). Here too, then, the concept of the mode of being is not limited to a phenomenological or ontological characterization of a specific type of object, but rather turns into a consideration – grounded, ultimately, in sociology and/or history – of how the object is embedded in particular modes of thought and action.

By this point at the latest, the Husserlian construction of the problem, to which the concepts

of "mode of being" and "mode of existence" were supposed to be a response, is itself revealed to be a problem. What it has always lacked is a critical understanding of the fact that objects' modes of existence cannot be separated from societies' historically specific modes of production and reproduction. Descartes and Gropius look on in astonishment: objects (*Gegenstände*) are object-ifications (*Ver-Gegenständlichungen*). But that was exactly the message conveyed by Benjamin when, in his famous essay, he spoke of the *Daseinsweise* of the work of art – or, quite literally, its *mode d'existence*.[7]

*Translated from the German by Jeremy Gaines.*

---

Works Cited

Benjamin, Walter. *Das Kunstwerk im Zeitalter seiner technischen Reproduzierbarkeit.* Ed. Burkhardt Lindner. *Werke und Nachlaß: Kritische Gesamtausgabe.* Vol. 16. Frankfurt am Main: Suhrkamp, 2013. Print.

---. "L'œuvre d'art à l'époque de sa reproduction mécanisée." Trans. Pierre Klossowski. *Zeitschrift für Sozialforschung* 5.1 (1936): 40–66. Print.

---. "The Work of Art in the Age of Mechanical Reproduction." Trans. Harry Zohn. *Illuminations.* Ed. Hannah Arendt. New York: Harcourt, 1968. 219–53. Print.

---. "The Work of Art in the Age of Its Technological Reproducibility." Trans. Edmund Jephcott and Harry Zohn. *Selected Writings.* Ed. Howard Eiland and Michael W. Jennings. Vol. 3. Cambridge, MA: Belknap, 2002. 101–33. Print.

Bouglé, Célestin. *Leçons de sociologie sur l'évolution des valeurs.* Paris: Colin, 1922. Print.

Canguilhem, Georges. *The Normal and the Pathological.* Trans. Carolyn R. Fawcett and Robert S. Cohen. New York: Zone, 1998. Print. Trans. of *Le normal et le pathologique.* Paris: Presses Universitaires de France, 1966.

Cavaillès, Jean. "L'école de Vienne au congrès de Prague." *Revue de métaphysique et de morale* 42.1 (1935): 137–49. Print.

Dufrenne, Mikel. *The Phenomenology of Aesthetic Experience.* Trans. Edward S. Casey et al. Evanston: Northwestern University Press, 1973. Print. Trans. of *Phénoménologie de l'expérience esthétique.* 2 vols. Paris: Presses Universitaires de France, 1953.

Focillon, Henri. *Vie des formes.* Paris: Leroux, 1934. Print.

Fraenkel, Ernest. "Esthétique industrielle et psychanalyse." *Revue d'esthétique* 4 (1951): 393–414. Print.

Hacking, Ian. "Vom Gedächtnis der Begriffe." *Was ist ein 'philosophisches' Problem?* Ed. Joachim Schulte and Uwe J. Wenzel. Frankfurt am Main: Fischer, 2001. 72–86, here 84. Print.

Hediger, Vinzenz. "'La science de l'image couvre et découvre tout l'esprit.' Das Projekt der Filmologie und der Beitrag der Psychologie." *montage AV* 12.1 (2003): 55–71. Print.

Husserl, Edmund. *Logical Investigations.* Trans. J. N. Findlay. 2 vols. London: Routledge, 2001. Print. Trans. of *Logische Untersuchungen.* 2nd. ed. 2 vols. Halle an der Saale: Niemeyer, 1913–21.

Ingarden, Roman. *The Literary Work of Art: An Investigation on the Borderlines of Ontology, Logic, and Theory of Literature.* Trans. George G. Grabowicz. Evanston: Northwestern University Press, 1973. Print. Trans. of *Das literarische Kunstwerk.* 3rd ed. Tübingen: Niemeyer, 1965.

---. "Le temps, l'espace et le sentiment de realité." *Revue internationale de filmologie* 1.2 (1947): 127–41. Print. Trans. of *Das literarische Kunstwerk.* 3rd ed. Tübingen: Niemeyer, 1965.

Kessler, Frank. "Etienne Souriau und das Vokabular der filmologischen Schule." *montage AV* 6.2 (1997): 132–39. Print.

[7] See *Kunstwerk* 169 (*mode d'existence*) and 216 (*Daseinsweise*). The term *auratische Daseinsweise* – rendered as "auratic mode of existence" in the 2002 revised English translation (105) – was essentially lost in the original 1968 translation, in which it appears as "the existence of the work of art with reference to its aura" (225–26).

Lalo, Charles. Rev. of *Das literarische Kunstwerk*, by Roman Ingarden. *Revue philosophique de la France et de l'étranger* 112 (1931): 308. Print.

Lowry, Edward. *The Filmology Movement and Film Study in France.* Ann Arbor: UMI Research Press, 1985. Print. Studies in Cinema 33.

Simondon, Gilbert. *Du mode d'existence des objets techniques.* 3rd ed. Paris: Aubier et Montaigne, 1958. Print.

Souriau, Étienne. *The Different Modes of Existence.* Trans. Erik Beranek and Tim Howles. Minneapolis: Univocal, 2015. Print. Trans. of *Les différents modes d'existence.* Paris: Presses Universitaires de France, 1943.

---. "Passé, présent, avenir du problème de l'esthétique industrielle." *Revue d'esthétique* 4 (1951): 226–51. Print.

Souriau, Paul. *La beauté rationnelle.* Paris: Alcan, 1904. Print.

Stengers, Isabelle, and Bruno Latour. "The Sphinx of the Work." Introduction. Souriau, *Different Modes* 11–90.

# COSMOCOLOSSE
# SEQUENCE 6: VIKTOR AND MARY

**Bruno Latour**

*For brief information on the author see* **r**·m!74.

Excerpt from:

Bruno Latour, Frédérique Aït-Touati,

and Chloé Latour. *Gaia: Global Climate Tragi-Comedy.*

Trans. Julie Rose. Version Four, May, 2011. 33–40. PDF.

### Sequence 6:  Viktor and Mary

*From this point on three very distinctive voices stand out from the chorus, the ones that played Mr Jolly, Mr Noah and Dr Lovelock, but without turning into simple silhouettes as in previous scenes. They are called Hamid, Christof and Lynn respectively. 'The Chorus' refers to the other actors.*

### Hamid (who played Mr Jolly)

I've had enough of being told the same old story about the sorcerer's apprentice.

### Lynn (who played the Foreman)

Except when it's told differently.

### The Chorus

What story? The one about Frankenstein, of course. Everybody knows that one. No, they don't, we don't know it. One more horror film, having got this far, that can't hurt us.

### Christof (who played Noah)

Yes, we may as well go the whole hog in this business, and be done with it.

### Hamid

Well then, wheel in Frankenstein!

*Horror film music. Gothic atmosphere in the style of Shelley. The actors change to play the rest of the scene.*

### The Chorus

Huh? Are you Frankenstein?

### Viktor

Yes, I am, of course, Dr Viktor Frankenstein, citizen of Geneva, founding member and president of the association of reformed innovators, C.A., *Creators Anonymous*. In other words, sobered up. You look surprised?

### The Chorus

Err, well, to tell you the truth, I imagined you... well, I mean. We were thinking of something else.

330

**Viktor**

It took time, but we got there, I'm properly reformed, you know. You mustn't hold
anything against me anymore. There wasn't an act I didn't commit. I paid. I did my time.
I almost froze to death in the Arctic, in the ice fields of the North Pole, but I ended up
killing the creature that I know, I know, I should never have brought into the world. I sort
of drowned it in the waters of a new flood. More precisely, it ended up killing itself. It's a
complicated story. But there is a statutory limitation. You didn't send for me to put me on
trial again, in front of all these fine people, I hope? I've already said everything. There
must be no, no, no more innovating, nor more pushing boundaries, no more wanting to
get beyond Hercule's columns. Hubris is finished, finished. Prometheus is behind the
times. But I've said everything already. I apologised in every possible way. I'll never do
the sorcerer's apprentice bit again. I'll never again play God. I promise, I swear.

**The Chorus**

I think we're a bit lost, Doctor. What exactly are you referring to? Actually, to be honest,
we were expecting the other Frankenstein.

**Viktor**

What other Frankenstein?

**The Chorus**

You know the... well...

*Gestures designating a monster criss-crossed with scars.*

**Viktor**

There is no other. My father is dead, my brother William too, alas, murdered by her, that
creature, that is, indirectly by me. There's only one Frankenstein now, Viktor, that's me.
Eternal witness offered to humanity in expiation by way of saying: no more innovating.
That you have to be careful of your own creations. Think before you act. Take
precautions. *Mea culpa, mea maxima culpa.* That's what you wanted to hear, wasn't it?

**The Chorus**

Not exactly, no. Actually, we didn't really know.

**Viktor**

Downsize, you have to downsize. Withdraw on tiptoe. I won't do it anymore. I promise I
won't do it anymore. No more laboratory, I've destroyed everything, burnt it. No more

patents. No more genetic engineering. Let's cultivate our garden. Switzerland, nothing but natural produce. A bit of green, you know? I've gone green. That's it.

## The Chorus

He's going to make me cry. What he says is frightening. He's right, he's right. We really shouldn't have. What have we done? Let's withdraw. For a start, let's begin by not having children; no more rich children anyway. We have to reduce our footprint. Turn out the lights. Curse Prometheus. All that $CO_2$ you give off when you breathe, it's horrible. Let's not breathe anymore. Nature, nothing but nature.

*Everyone is crying, the lights go out one after the other, the circus is plunged into darkness; it's all moaing and groaning.*

*Enter a little lady with an umbrella, Miss Marple style, played by Lynn.*

## Mary Shelley

Allow me, allow me. I'm Mary Shelley, the author of the book, 'Frankenstein, or the Modern Prometheus'. I think I sort of have the right to appear on stage, all the more so as, you know, if we wrote so much that summer, Percy Shelley and Byron – yes, Lord Byron himself, it was in 1815 in the Alps, we formed a sort of commune, very 70s, don't you think? they were great geniuses you know – it's because it rained, see, it rained all summer, impossible to do even the shortest ramble, and you know why? Because an Indonesian volcano, the Tambora, had erupted; we didn't know that at the time, of course, but it's not unrelated to your topic, it seems to me?

I'm not sure Viktor told you the story all that accurately.

## The Chorus

The author ought to know a bit about it in actual fact. An author, at least, controls his creatures.

## Mary Shelley

I see you have quite convenient means today. May I get you to witness something

*She grabs a remote control and sends Edison's film of Frankenstein to the screen.*

*First projected on the screen, the silent film is replayed by actors from the chorus in the fashion of Mnouchkine in* Fol Espoir: *it's the scene in which Viktor, initially enthusiastic about his success, sees that he's created a monster and flees the laboratory, shutting the door behind him and double-locking it and running out of his laboratory in pelting rain. The stage directions should of course recall the flight of Oedipus.*

**Mary Shelley**

Dear Viktor, do you remember?

**Viktor**

Mary, O Mary, you the author of my life, my progenitor, why do you torture me with such a recollection? I know very well that I shouldn't have. But Mary, I've expiated, I've paid. I've put all that in good order. I've put things right. I've made up for it. I've cleaned the place up. Down to the tiniest little bone. I incinerated it myself. Well almost. Why do you all keep tormenting me? I told you I'd never play the sorcerer's apprentice again. I'm finished with experiments – for good. 'Crossbreed and multiply', no! 'Decrease and escape', I've understood the lesson perfectly, believe me. Once bitten, twice shy, etcetera, etcetera, etcetera.

**Mary Shelley**

I'm not torturing you Viktor. I'm trying to refresh your memory.

**Viktor**

But I remember all too well, I've suffered enough. Doesn't a person have the right on this earth to expiate and be forgiven?

**Mary Shelley**

For sins committed and confessed, yes, not for those one has not committed or not confessed.

**Viktor**

I confessed everything.

*During this whole sequence, stage left, the Creature, stage right, gradually appears (on the screen or played by an actor) as if it were listening to what they are saying.*

*Viktor and the Creature spot each other, flee each other, catch up to each other again, all in silent film manner with exaggerated gestures.*

*At the end of the performance, The Creature grabs Viktor and holds him tight; if it is only appearing on the screen – in the Boris Karlov manner – we will hear everything it says as voice off.*

**The Creature**

Confessed everything?! Then why, why did you abandon me, you wretch?

**Viktor**

Demon, monster vomited out of my imagination, creature from hell, let go of me, go back to the nothingness you should never have emerged from.

**The Creature**

You're the doubly demonic monster who pulled me out of nothingness only to then flee shamefully. Ah, you thought you'd locked me up for ever in your alchimist's lair. But I got out, to take my revenge on you, and that's when I became worse, infinitely worse.

**Viktor**

You were already odious, vile, monstruous. Anybody would have fled in the face of such horror.

**The Creature**

Since you took yourself for God, why didn't you do what God would have done?

**Viktor**

Even God fled in the face of His Creation, he washed everything in the waters of the Flood. I did what He did, you horrible rough draft of an aborted experiment. The only thing I could do was try to drown you.

**The Creature**

Why run away, then? If you didn't know the secrets of Creation, why did you plunge into your laboratory only to give up after the initial results? I was born good, Viktor. It was only after being abandoned by you, yes, that I became loathesome. I'm the one who killed your brother William; on your wedding day, it was also I who murdered your wife; All over the Earth I've left a trail of blood caused by my jealousy at seeing them happy and beautiful, all these human beings.

**Viktor**

How dare you say you were born good? The opposite–horrible. Crazy, hideous, scarred, made of pieces and bits hastily stitched together.

**The Creature**

And whose fault is that? I was like anything that is born, anything that begins, anything that wails in the appalling pangs of childbirth. You ran away, Viktor, you ran away.

**Viktor**

I did not run away. I ran away?

**The Creature**

To atone for your crime, and for me to forgive you, there is just one thing I ask of you on bended knee, give me a companion, a monster in my own image, as badly designed as I am maybe, but someone I can at least gaze on with my eyes without her pushing me away, like the rest, screaming in terror.

**Viktor**

What! You want me to add to my folly in having made you, the folly of doubling you and – O atrocious thought – letting you reproduce! I'll destroy you, on the contrary. I'll plunge you into the waters of the Flood.

**The Creature**

What creature woudln't avenge themselves for such abandonment? O, I'll kill the lot of them, those that you love.

*The Creature runs away. Viktor falls into the arms of Mary Shelley, who has herself slumped a bit.*

**Viktor**

*Pulling himself together this time without tears, more assured and more grave, less of a wet rag.*

Mary, Mary, if I hadn't run away, if you hadn't made me run away that sinister night, what should I have done? Should I have, did you want me to abort that monster I'd made with my own hands? For me to imitate the God of revenge?

**Mary Shelley**

What God are you talking about? I'm lost now too. Poor sinners who no longer know what crimes we've committed. *You're* telling *me* about smothering one's own creatures in the cradle... Alas, alas. If only mine had survived. My little Hogg, how I would have loved you. Poor Clara, poor William, they were so delicate, and wrinkled, and ugly... so ugly. How I loved them. Who said anything about abortion? There are enough dead, already.

**Viktor**

Why didn't I understand, why don't you make me see? So, my tears of contrition were feined? O Mary, Mary, so aptly-named. That was the secret, then? Mary, what if we started the whole thing again from the beginning, from the laboratory scene.

**Mary Shelley**

I don't even know what I made you do anymore. This Flood sent to Earth to drown all creation, on the pretext that is sinful, what an abomination. You did, indeed, imitate that particular God, to the bitter end. I was wrong to blame you.

**Viktor**

No, Mary. I didn't imitate him since I ran away. It's not creating that is the crime, it's abandoning one's Creation.

**Mary Shelley**

But why then drown it? Never does a God abandon his creatures, no matter how sinful they've become. You're not a sorcerer's apprentice. Neither am I.

*From the wings.*

**The Creature**

Cursed be he who, in confessing a venial sin, hides another, this one mortal.

**Viktor**

*Addressing the Creature who has vanished into the wings.*

Come back, then, Creature, come back demon derived from my over-inventive imagination. No, alas, no, not inventive enough, not consistent enough, not obstinate, patient, loving enough, come back, let me remind you, console you, fashion your face anew...

**Mary Shelley**

Too late. The genie's out of the bottle.

**Viktor**

We must abandon everything, even abandonment.

*Darkness*

*The chorus reforms. Long pause.*

**Hamid**

We did need to do that scene again, actually. We are neither sorcerers, nor apprentices, nor gods.

**Christof**

What a novice He was, this God served by Mr Noah, like some cack-handed inventor who'd toss his drafts in the bin in a rage, one after the other. How pitiful the Flood is, and the Ark, which was too small and the ocean, which you had to bury yourself in in order to be able to float –there is no more shore, no more beyond to escape to.

**Lynn**

There is no Creator God at all, everything has to be started again, everything has to be gone back over. Even what it is to create.

**The Chorus**

There is no more outside, is there? We're heading nowhere, that's it. No more building work, then. No way out.

**Christof**

Yes there is, of course there is, it would be too awful otherwise.

**Hamid**

We have to get through this.

**The Chorus**

So what are we going to do? You didn't hear: we're starting everything again. We're taking everything in hand again.

*Darkness*

# RADICAL CONSERVATION: THE MUSEUM OF OIL

## John Palmesino and Ann-Sofi Rönnskog
### Territorial Agency

**0001**

WE SHALL NEED TO KEEP OIL in the ground. This is the simple gesture, the simple intimation that a growing and expanding knowledge event, the difficult understanding of the human impacts on the earth system, leads to. The mountainous efforts, the divisive politics, the reconceptualization of the separation (or lack of) lines between politics and science, the complicated efforts to make the earth system work as an analytical entity (NASA Advisory Council), the harsh historical mouldings of colonialism, imperialism, and industrialization, the inequalities of contemporary capitalism, the complex debates on the making of global circulation models and their supercomputers and national budgets, the contested legacy of the twentieth century, the work of the IPCC (Intergovernmental Panel on Climate Change), the UNFCCC (United Nations Framework Convention on Climate Change), all lead to a single action, or rather inaction. Keep oil in the ground, where it has been for millennia. Of course, this intimation seems to many unattainable. Firstly, who should keep it in the ground? We, or why not them?

*JOHN PALMESINO and ANN-SOFI RÖNNSKOG are architects and urbanists. They are the founders of Territorial Agency, an independent organization that combines architecture, analysis, advocacy, and action. They are directors of AA Territories, a think tank at the AA Architectural Association School of Architecture in London, where they are also unit masters. Together with Armin Linke and Anselm Franke, they have initiated the Anthropocene Observatory, a documentary practice combining photography, films, interviews, spatial analysis, and exhibitions to outline the development of the Anthropocene hypothesis.*

**0002**

CONSERVATION IS TO GUARD beforehand: the main activity of museums is a complex set of procedures to maintain and protect elements of specific interest, and to warn about their value and the consequences of their loss. It is an activity radically engaged with the future: it constantly reminds us of the possibility of future corruption, dismemberment, and collapse. It is in many ways a territorial practice: to warn off, to establish demarcations, and to deter. *Terrere*: territory is a concept enveloped in notions of terror and fright, where the procedures to hold onto the elements that we value and that sustain our lives are made explicit (*terrere* in Latin is to scare). Here conservation and

territory are looked at as procedures of investigation into what is to be maintained, and as objects of study. The inquiries of the *Museum of Oil* outlined here are all attempts to keep hold of, to outline, and to observe in detail the often violent elements of oil being exploited or being left in the ground.

### 0003

TERRITORIAL transformations are complex knowledge events which unfold over long periods of time and across wide spaces. They are knowledge events insofar as they involve learning the location, extent, intensity, and articulations of the pressures and forces encumbering our activities, the material and the energy flows that need to be kept open. They are a constructive process, where knowledge is produced and links between polities and material processes are reestablished, reevaluated, cut across, and torn apart, in order for a new semi-stable set of relations to emerge.

New procedures to steady, albeit temporarily, the vast dynamics that unsettle relations between the forms of institutional cohabitation, and their spaces of operation are queried, a rush to scour and order what appears to be upset, is what seems to be the main character of territorial changes. They are events which rearticulate figures and grounds, long processes of hard work to establish connections and delineations, where things are rearranged, recomposed, and polities are reassembled, compacted, and redistributed. Territories are conservation structures: they maintain and sustain relations to material and information processes that shape our lives.

### 0004

THE *Museum of Oil* is a new institution in the making. It is set amidst the making of the major knowledge event of our time, the difficult and unfolding capacity to understand the transformations of the earth, and it is amidst the making of a new field of work, research, projects, and activism. The two unfolding fields ahead of us are largely unknown in their connections, intersections, and interactions: the new institution sits on shaky grounds and is open to constant revisions, it needs to balance its proceedings against a growing number of institutions and fact-checking protocols. It is both frightening and reassuring that the object of study is equally fragile and unstable.

### 0005

THE *Museum of Oil's* aims are, on the other hand, rather solid: to put the oil industry into the museum. To make it a thing of the past. To make sure that oil is kept in the ground, the *Museum of Oil* sets out to register and outline how the oil industry has stretched itself so far that its territories have become fragile and untenable. The industry of oil is a specific one: oil power is not only an issue of energy sourcing, it infiltrates almost all realms of public knowledge and operations. Oil is power both in physics and in politics. Against such a powerful entity, the *Museum of Oil* works to indicate the specific procedures, the precise elements and protocols that guarantee entry into its rooms, the specific financial and technical risks that it has embarked on in its desperate attempt to remain powerful, the specific moments of infiltration and attempts to frame public debates on the environmental catastrophes, the unaccounted environmental and social costs it entails.

### 0006

THE *Museum of Oil* collects information, items, objects, and data about the different ways through which we have come closer to the decisions (it will have to be many) to keep oil in the ground, halting

its combustive so-called development sprees. It preserves this information and makes it available to the public through specific displays, and across detailed analysis of the fragile and dangerous territories that the oil industry, in all its ramifications, has carved out and cut across from pre-existing ones. While the amount of data and information is almost unmanageable, it is the very aim of the *Museum of Oil* to start a path across it, sorting things out and making them emerge from a muddy and obfuscating envelope that links oil to images of progress and wealth. Muck and oil, set against crude data: what is at stake is the establishment of new avenues of agency, of new sets of negotiating tools towards keeping oil in the ground.

### 0007

PETROLEUM is usually defined in a very simple way, as a mixture of different hydrocarbon molecules that have originated in high-temperature and pressure and low-oxygen geological processes of decomposition. It exists as a liquid in the form of crude oil and as a vapour: natural gas. This simple definition is expanded by oil being a source of power, physical and political, and wealth. Oil represents liquid wealth, both literally and economically: it enables and expands industry, transport, energy systems, and it sustains and articulates enormous sources of financial transactions. Petroleum is a connector, a dynamic vector that links the earth system to the world-system (Wallerstein). A vector of diffused and accumulated power, with leverage in both day-to-day activities of the world-economy and in the political circuits of many nation states (Wallerstein).

The specific ways through which petroleum operates as a liquid form of power have accelerated its disconnection from what is underfoot: the precise relations to forms of inhabitation, the long-term investments in organizing life and material flows. Oil has managed to become far more than

liquid, it has become ubiquitous. And it is exactly in this process to deterritorialization (Deleuze and Guattari) that it has become extremely successful, dominating narratives of progressive development, access to work and to the future.

### 0008

BROUGHT DOWN TO EARTH, literally in the ground, oil becomes a figure against a complex and noncontiguous background. Its coherence, what keeps it together, is registered and measured both geologically and in its multiple streams of influence. Oil marks in the ground are not only the results of spillages, extraction, pollution, and environmental catastrophe. Oil is registered in ways that far exceed its murky and black direct physical impact. It is registered in the absence of its name from any international negotiation document on climate change, it is marked in the growing influence of oil companies on the global financial markets, it is registered in the direct access to policy makers, it is in the missing and banned photographs of the impact of the BP Deepwater Horizon disaster in the Gulf of Mexico, and its traces are increasingly linked to the research on its consequences. It is in the civic enthusiasms of modern architecture and its development goals. It is in the rapid urbanization processes and it is in the growing corruption and violence that its extraction entails and facilitates (Amunwa; "Corporations"), it is in the militarization of global sea supply lines and choke points (Emmerson and Stevens), it is even registered directly in international law, with the extension of sovereign rights to mineral resources in submarine areas of the continental shelf (Anthropocene Observatory). The meter of this coherence needs to be assessed and reevaluated in relation to the emerging knowledge event of climate change and the Anthropocene. It is a complicated and double venture of conservation: the work of the *Museum of Oil* is both to outline the specific

339

Aerial photography of oil producing regions in the Permian Basin,
south of Odessa, and Midland, Texas, USA, 2014. United States Depart.
of Agriculture, NAIP National Agriculture Imagery Program.

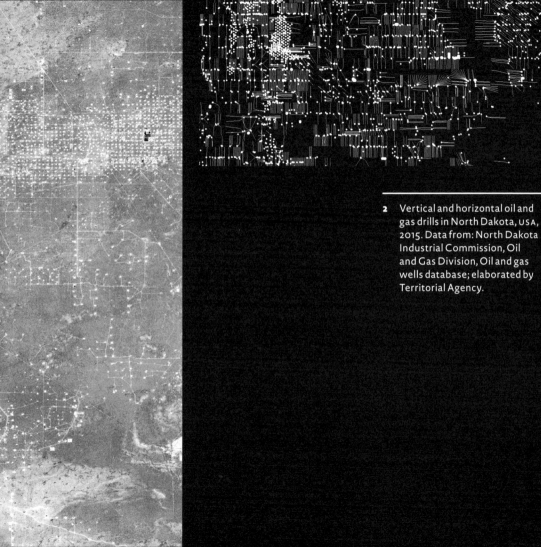

**2** Vertical and horizontal oil and gas drills in North Dakota, USA, 2015. Data from: North Dakota Industrial Commission, Oil and Gas Division, Oil and gas wells database; elaborated by Territorial Agency.

**3** Seismic lines, drilling pads, and pipelines cutting through the boreal forest in Northern Alberta, Canada. GIS data elaborated by Territorial Agency / Graham K. Smith.

**4** Multiyear multispectral analysis of the transformations of impervious surfaces at the Athabasca Oil Sands, Northern Alberta, Canada. Blue indicates transformations in the last ten years. Landsat data elaborated by Territorial Agency.

5   Multiyear multispectral analysis of the transformations of impervious
    surfaces in the Niger Delta region, West Africa. The bright blue areas
    indicate the rapid expansion of urbanization. The oil areas are in the
    delta and offshore, removed from the cities. Landsat data elaborated by
    Territorial Agency.

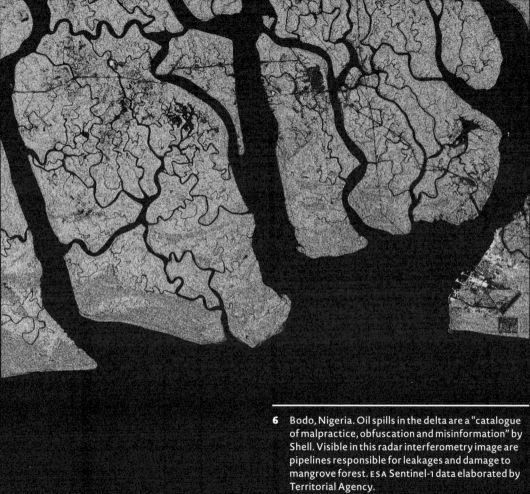

**6** Bodo, Nigeria. Oil spills in the delta are a "catalogue of malpractice, obfuscation and misinformation" by Shell. Visible in this radar interferometry image are pipelines responsible for leakages and damage to mangrove forest. ESA Sentinel-1 data elaborated by Territorial Agency.

territories, the specific groups and networks that the oil industry has shaped and cut across, and to indicate how they have become fragile and dangerously unstable on all sides. Conservation and territorial analysis are both the method to establish the elements of risk linked to oil, and the outline of the forms of life and cohabitation that need to be safeguarded from it. They are the preliminary elements of a plan to disentangle us from oil dependency.

### 0009

ENERGY TRANSITIONS are rare: they tend to last several decades and they are marked by one intensive use of a single energy source overlapping with a new one. In their historical succession, they have developed in parallel with modern institutions and their territorial forms. The exit from an energy system mainly dominated by agricultural work and draft animal power, which has lasted for the majority of the Holocene epoch, coincided with the formation process that led to the rise of city states and small republics in Western Europe between the thirteenth and fifteenth centuries (Global Energy Assessment). The exhaustion of wood energy led to the complex rearticulations of divisions of labor during the Industrial Revolution, linked to the complex rearticulation of city states dominating large world economies into colonial national parliamentary economies, bounded by new forms of representation, political, artistic, and scientific. The rapid rise of petroleum from being an exotic form of energy to the world's primary source of energy coincides largely with the demise of colonial empires and with the two World Wars. What emerges is the international: a vast new set of institutions to regulate, modulate, and govern a new set of energy flows, atomic and oil. The United Nations, I M F (International Monetary Fund), the O E C D (Organisation for Economic Co-operation and Development), the European Union, N A T O, the U S S R, the African Union, O P E C (Organization

of the Petroleum Exporting Countries), the Non-Aligned Movement: a new space of utilitarian negotiations geared towards governing an increasingly volatile and deterritorializing form of economy and energy. Each transition is linked to an expansion and extension of energy use, going from the 10–20 G J per capita of early agricultural societies to the 100 G J per year per capita during the industrial revolution in the U K and U S A (levels still well beyond the current per capita rate), to the staggering current global energy use of more than 600 G J, several orders of magnitude larger than at the outset of industrialization (Grubler et al.).

### 0010

RESERVE-REPLACEMENT RATIO (R R R) is the technical definition of a fundamental element of the oil economy: as resources of a specific oil company get extracted and start depleting, new assets need to be established in order to conserve and even augment investment flows. This leads to constant expansion of the material base of the oil industry, always geared to replacing the reserves that it has recently established, in a sort of explosive dynamic. Once a large part of these possible resources have been nationalized, as in the case of Nigeria and Brazil, it becomes more difficult to maintain the R R R at the necessary levels. This triggers the rush to ever more complicated, dangerous, and risky projects to secure new reserves: pre-salt explorations off the coast of West Africa and Brazil; in the Arctic Ocean extremely dangerous (Kronick) operations in Russia, Norway, and the U S A; shale gas investments in the U S A – investments in exploration for new fields has escalated in the last decade. The post-financial crisis low interest rates have engendered a growing search for financial yield, which has tended to focus on a large variety of funds specializing in high-yield corporate debt (International Energy Agency, Medium-Term Oil Market Report 2013).

#### 0011

THE RECENT American shale boom is a direct transformation of an entire material landscape, both above and below ground, as well as a human landscape directly linked to the 350 billion USD investments over the past six years. A rapid burst in activities, or rather a bubble of unprecedented impulse and dimensions. A Standard & Poor's analysis in late September 2015 indicates that half of the US energy junk bonds are at risk of default, resonating with the events of 2008, which triggered the biggest financial crisis in history. RRR is a triplet that indicates how the oil industry is a major risk; not only in terms of its impact on the earth system, but primarily because of its deep and ramified connections to the global financial system with a dangerous proportion of its transactions related directly to oil-linked investments and funds. The risks of oil to the world-system seem to equal those to the earth system. In the collection of the *Museum of Oil* are a series of detailed analysis of which fields are financially overexposed, which companies have operated them, and what is their publicized break-even point. Since the project started in spring 2014, the price of oil has plummeted, leaving most of these new developments exposed. The work of precise and articulated description of the material and immaterial impacts of the oil industry conducted for the *Museum of* Oil is one of conservation: to maintain the viability of our economies and ecologies, there needs to be experimentation with new tools and new forms of representation.

#### 0012

A FUNDAMENTAL element of the work is to separate, to carefully reallocate, to scale down, and to redistribute the material and immaterial elements of the oil economy that have been bracketed together and globalized. The Museum alerts us to the imperial growls of overview and control and modulation: it operates through border analysis, investigating the modes through which barriers are trespassed, reinforced, and reshaped. The tipping points of past energy transitions all reverberated through an expanding frontier line.[1] The energy transition equated a transition into a space where possibilities were augmented, including the possibility of destroying what was in the way: forms of life, environments, cultures, landscapes, economies. The new was always and systematically narrated as being better, larger, faster. The current energy transition, characterized by the shards of the spaces left behind from the previous impact waves of energy tipping points, is no longer a single and univocal vector of development and synchronized steps of connecting the world into a gigantic supply chain. The waves of this energy tipping point oscillate and multiply differences, they refract and brake: the waves of carbon fossil intensification, after having travelled around the deep surface of the earth, are now showing impetus that is coming back at us from all sides. The Anthropocene is a border condition, delineating differential strata, and demarcating multiple and overlapping flows and sedimentations, accelerations, and slow decays.

#### 0013

THE CURRENT decarbonization rate of the energy system is slower than global energy consumption growth. The energy transition out of oil and fossil fuels needs to be different from the modern tipping points that preceded it, all linked to the thirsty quest for further energy. It could be the first one where energy sources are changed because of a growing awareness of the negative effects of growth, rather than for furthering the expansions and ambitions linked to the increased

[1]    For the activities of Anthropocene Observatory (Territorial Agency, Armin Linke, and Anselm Franke), see for example the exhibtion #4 *The Dark Abyss of Time* at the HKW Haus der Kulturen der Welt, Berlin, 17 Oct. – 8 Dec. 2014.

capacity. Natural gases, renewables, and more efficient end-user technology and distribution technologies only account for 0.3% decarbonization rate, against 2% increase in global energy use annually (Global Energy Assessment). While the United Nations Climate Change Conference (COP21) Paris agreement is a fantastic new framework of reference for all working to keep oil in the ground because it provides for an unprecedented ethical push, new and sustained focus is required. The *Museum of Oil* operates along these lines; its focus is to narrate and make visible how oil is giving way to vast, complex, and systematically integrated and highly fragile human and material spaces: in order to better understand how to move beyond the dependency on oil, it is necessary to analyze and illustrate carefully the overarching structures it has built, the vast scale of the environmental, ethical, and economic devastation it has generated.

## 0014

THE CHALLENGES of climate change and the transition to a carbon-neutral economy require a rethink of the scale and dynamics of human activities on the planet. They require new forms of representation and new forms of government. The works of the *Museum* are aimed at linking the structures and forms of the oil industry and economy, with its many ramifications in political structures, institutional life, and society, to the structures and forms of the material spaces that it shapes.

The boundaries of the social, economic, and political spaces that the oil industry forms, the rules of legitimation, the members, the coherence of the human spaces it shapes are connected to the material and geographic structures, to the boundaries, urban and regional material flows and processes, to the procedures and ecologies that the oil industry encompasses at a global level. It identifies and makes visible and available to the wider public and specialized researchers the key elements of the vast

spaces that oil is shaping in our world. They are so extended that they have become risky and vulnerable.

The *Museum* is both a platform for the public display and debate of the elements that constitute the contemporary hard relationships between oil, politics, and economy, as well as a research platform that investigates in the unfolding environmental impacts of oil and produces elements for alternative narratives, representations, and forms of engagement with oil.

## 0015

AT THE Saint Petersburg G20 summit of September 2013, the then Prime Minister of Canada Stephen Harper and the then President of the European Commission José Manuel Barroso met to further discuss CETA (Comprehensive Economic and Trade Agreement), the trade agreement between the European Union and Canada. The meeting was at the height of the Syria civil war crisis, and passed largely unnoticed. Also largely unnoticed are the ways through which it has reshaped a space of law and intellectual property (IP). Integrating into a unified space the procedures for securing rights for exclusive economic usage of IP, the agreement is one of the major events in territorial transformation of the new century. At first sight CETA seems to be a purely administrative and juridical tool, acting upon an already intense and integrated economic space, yet its implications are far reaching and connected to resources extractions in the Canadian North.

Part of the integration and trade agreement is the dislocation of jurisdiction over IP and corporate activities, which results in a large removal of direct control over environmental impacts of industries from administrations directly affected territorially. CETA is an extremely sophisticated work of jurisdiction, a culmination of thousands of smaller negotiations and deployment of partial instruments. The shadow of the agreement is the

349

possibility of distribution of responsibility over environmental data, from environmental protection agencies to economic development agencies, de facto opening the way for an intensification of petrochemical operations across the continental forests of Canada.

Here, to conserve is to make visible what is unseen, to reveal structures and patterns of coherence, to highlight what has been disjoined, and to reassign agency to the levels of magnification it requires. While the Athabasca oil sands in Alberta are the largest single industrial operation on the planet, they are only the most evident and immediate element of the vast pattern of destruction that is linked to the oil industry in Canada. Thousands of miles of lines are cut across the boreal forest to expose the ground to direct surveys in the search for oil and gas: seismic soundings that create complex reverberation maps, extracted from the public realm through the complex intercontinental I P agreements, and severed from activists and researchers. The small width, large-scale continental grid of contemporary Canada is no longer a system of interconnection and links: it is a complicated and obscure system of invisibility and severance. What might an activist practice be in this fine network of dislocated and removed agency?

### 0016

MUSEUMS ARE repositories of both cultural heritage – native and foreign, indigenous and pillaged, as well as repositories of power and a projection of political and cultural intent. Oil and museums both "signify" – the words carry meaning and power beyond their definitions. In the context of climate change, oil is critical: it is responsible for 36% of global emissions from fossil fuel combustion (International Energy Agency, World Energy Outlook 2013) – but just as significant is its central role in both the global and national economy. Shell is the single biggest dividend payer in the U K; Exxon-Mobil is "the world's largest publicly traded international oil and gas company" – and until 2012 was the most valuable company in the world, now it has slipped to number three behind Apple and Google. In addition, oil companies occupy crucial cultural and political space – their relationships with key cultural institutions (The Tate Galleries, the Royal Opera at Covent Garden, the Science Museum, the National Portrait Gallery, the British Museum) as well as the political establishment (the Foreign Office, the Treasury and the Department of Business, as well as the No. 10 policy unit are some British examples) increase the leverage of the oil industry over the political actors that determine the outcomes of the multilateral political process driving (or not) the reduction of carbon emissions (U N F C C C, "Six Oil Majors").

Meanwhile museums aren't passive, if grand, high culture warehouses. They don't merely provide a platform for our collective cultural goods – they locate power as well as artefacts. They can retrospectively "retell" key stories, their conservation priorities subtly shading that narrative to suit the key commercial, financial sponsors as well as political champions of a given institution.

### 0017

THE OIL ECONOMY cuts through and wrests away territories and rearticulates social, industrial, and environmental relations. These transformations often move in slow-motion, at other times they flare up to reveal the extent of the damage all at once. Multiple lines of inquiry are necessary to counter the slow violence of environmental destruction, as Rob Nixon calls it. Inattention, neglect and negligence are difficult to counter and to outline, yet they are a fundamental element of the design and architecture of the territories of oil (Greenpeace). To sustain attention, to be able to conserve the drive to protect and preserve environments and not fall prey to the exhausted lines

of diffused violence, the *Museum of Oil* mobilizes technologies that have a dual origin. Landsat and other earth observation and monitoring systems have developed out of a common ground shared by the military and environmental practices.

### 0018

THE LONG-TERM changes sensed by the orbiting array of multispectral scanners reveal in a series of multi-year analyses the images of the grip of oil on vast parts of the planet. From the deforestation in Brazil and Peru to the constant oil spillage along the crumbling and rusty pipelines of Siberia; from the encrusted decades-long enormous spillage and pillaging of the Nigeria delta lands to the reshaping of migratory routes in Sub-Saharan Africa; from the reshaping of urbanization processes between the geologically symmetrical coasts of Brazil and Angola to the damage in the Arctic, remote sensing technologies reveal the transition at differentiated and syncopated rhythm of oil territories.

### 0019

A TWOFOLD movement: the atmosphere is getting older and also younger. In June 2015, Heather D. Graven, of the Department of Physics and Grantham Institute at Imperial College, London, published a surprising article in PNAS, the *Proceedings of the National Academy of Sciences of the United States of America*. She announced that strong practical implications were to be expected from her work on the impact of fossil fuel emissions on global carbon cycles, and in particular on atmospheric radiocarbon. Radiocarbon is widely used to date organic material, and many applications are sensitive to 14C in the atmosphere. The $CO_2$ produced by burning fossil fuels in the coming century will contain no 14C because of a million years of radioactive decay. The amounts of $CO_2$ emissions

will substantially impact the levels of 14C in the atmosphere: by 2050 fresh organic material could have the same ratio of 14C/C as samples from 1050, thus making new and ancient organic materials no longer distinguishable. In other words, the atmosphere will be getting older faster, and simultaneously we will not be able to date organic samples: one thousand years of ageing in less than a century. Surprisingly, the dismantlement of the oil industry might even be faster than that.

### 0020

OFFBEAT, asynchronous, and divergent change is mirrored in the differentiated speed and discontinuous understanding of the Anthropocene and its direct connections to oil, both in the form of carbon cycle modifications caused by combustion engines and in the nitrogen cycle perturbations caused by the Haber-Bosch process. The new intensifications reveal the reconnection of the earth system of multiple interactions, and the world-systems of dirty cosmopolitanization processes, across what Paul N. Edwards calls the vast machine of planetary sensors, climate models, and supercomputers. It is an event of complex making, the construction of which implies mountainous scientific achievements, multiple sources of development, and myriads of public debates and political negotiations in many different circuits and in different publics. Knowledge is an event of difficult making, and it seems that climate change knowledge and the Anthropocene are events unfolding along treacherous fronts, where time itself gets warped. We shall need to keep oil in the ground in order to stay alive on the planet, yet if we do our economies shall be mortally wounded. The oil industry is in this sense both a treath to the earth system and to the world-system. A radical conservation project is needed, to reshape the future connections between polities and material spaces and to negotiate our way out of these risky times, and make oil a thing of the past.

351

The *Museum of Oil* is a project by Territorial Agency and Greenpeace. An excerpt of the *Museum of Oil* is exhibited at Z K M | Karlsruhe from 15 Apr. to 4 Sept. 2016.

Team: John Palmesino, Ann-Sofi Rönnskog, Tom Fox, Graham K. Smith, Roland Shaw, Stavros Papavassiliou, Eleni Tzavellou Gavalla, and Maria Radjenovic.

---

## Works Cited

Anthropocene Observatory (Territorial Agency, Armin Linke, and Anselm Franke). Interview. "Anthropocene Observatory in conversation with Davor Vidas." Oslo: Fridtjof Nansen Institute, Nov. 2013.

"Corporations." *Amnesty.org.* Amnesty International. Web. 21 Feb. 2016. Available at <https://www.amnesty.org/en/what-we-do/corporate-accountability/>.

Amunwa, Ben. *Counting the Cost: Corporations and Human Rights Abuses in the Niger Delta.* London: Platform, 2011. Print.

Deleuze, Gilles, and Félix Guattari. *What is Philosophy?* Trans. Hugh Tomlinson. New York: Columbia University Press, 1994. Print.

Edwards, Paul N. *A Vast Machine: Computer Models, Climate Data, and the Politics of Global Warming.* Cambridge, MA: The MIT Press, 2010. Print.

Emmerson, Charles, and Paul Stevens. *Maritime Chokepoints and the Global Energy System: Charting a Way Forward.* London: Chatham House briefing paper, 2012. PDF file.

Global Energy Assessment (GEA). *Toward a Sustainable Future.* Vienna: International Institute for Applied Systems Analysis (IIASA), and Cambridge, MA: Cambridge University Press, 2012. Print.

Graven, Heather D. "Impact of Fossil Fuel Emissions on Atmospheric Radiocarbon and Various Applications of Radiocarbon over this Century." *Proceedings of the National Academy of Sciences of the United States of America*, 112.31 (2015): 9542–545. Print.

Greenpeace. "Fuelling climate crisis. How the oil industry seeks to distract from meaningful climate action while condemning millions to poverty." October 2015. PDF file.

Grubler, A., T. B. Johansson, L. Mundaca, N. Nakicenovic, S. Pachauri, K. Riahi, H.-H. Rogner, and L. Strupeit. "Energy Primer." Chapter I. *Toward a Sustainable Future.* Ed. GEA. Vienna: International Institute for Applied Systems Analysis (IIASA), and Cambridge, MA: Cambridge University Press, 2012. 99–150. Print.

International Energy Agency (IEA). *World Energy Outlook 2013.* Paris: IEA Publications, 2013. Print, PDF file.

International Energy Agency (IEA), *Medium-Term Oil Market Report 2013. Market Trends and Projections to 2018.* Paris: IEA Publications, 2013. Print, PDF file.

Kronick, Charlie, "Out in the Cold: Why Shell's Arctic Plans Are A Risky Investment." Greenpeace UK, 21 May 2012. Web. 23 Feb. 2016. Available at <http://www.greenpeace.org.uk/blog/climate/out-cold-why-shells-arctic-plans-are-risky-investment-20120521/>.

NASA Advisory Council, Earth System Sciences Committee. *Earth System Science Overview: A Program for Global Change. A report of the NASA Advisory Council with recommendations to National Aeronautics and Space Administration, NOAA, National Science Foundation.* 1986. Washington, D.C.: National Aeronautics and Space Administration. Print.

Nixon, Rob. *Slow Violence and the Environmentalism of the Poor.* Cambridge, MA: Harvard University Press, 2011. Print.

Standard and Poor's. *Credit Trends: Distressed Debt Monitor – Distress Ratio Nears A Four-Year High*. Report. 15 Sept. 2015. PDF file.

United Nations Framework Convention on Climate Change (UNFCCC). "Paris Agreement (as contained in the report of the Conference of the Parties on its twenty-first session, FCCC/CP/2015/10/Add.1)." UNFCCC secretariat, 12 Dec. 2015. Web. 25 Feb. 2016. Available at <http://unfccc.int/files/home/application/pdf/paris_agreement.pdf>.

United Nations Framework Convention on Climate Change (UNFCCC). "Six Oil Majors Say: We Will Act Faster with Stronger Carbon Pricing. 'Open Letter to UN and Governments.'" UNFCCC secretariat, 1 June 2015. Web. 21 Feb. 2016. Available at http://newsroom.unfccc.int/unfccc-newsroom/major-oil-companies-letter-to-un/.

Wallerstein, Immanuel Maurice. *The Modern World-System I.: Capitalist Agriculture and the Origins of the European World-Economy in the Sixteenth Century*. Berkeley: University of California Press, 2011. Print.

# THE TOASTER PROJECT: CONSTRUCTION

**Thomas Thwaites**

**THOMAS THWAITES** is a designer, interested in the societal impacts of science, technology, and economics. He holds a MA in Design Interactions from the Royal College of Art, and a BSC in Human Sciences from University College London. His work is exhibited internationally. The Toaster Project, his first book, was translated into Korean and Japanese.

Excerpt from:
Thomas Thwaites. *The Toaster Project: Or a Heroic Attempt to Build a Simple Electric Appliance from Scratch.* New York: Princeton Architectural Press, 2011. 168–85. Print.

1 top part of the plastic case
1 bottom part of the plastic case
1 top part of the plastic plug
1 bottom part of the plastic plug
1 short length of nickel-copper wire
3 copper pins for the electrical plug
3 copper wires for the electrical cord

Twenty-two parts. My toaster doesn't have a spring to pop up the toast when it's done, or an adjustable timer mechanism, or a cancel button. And it's questionable whether it's actually capable of toasting bread. At the time of writing, I've not plugged it into an electrical outlet, out of respect for the health and safety officer at the Royal College of Art and, if I'm honest, because I'm mildly scared of electrocuting myself or, worse, someone else.

I have plugged it into two twelve-volt batteries wired in series to make twenty-four volts, and the element does get hot. Too hot to touch, in fact (I have a burn on my finger to prove it). But my element doesn't glow red—possibly because the batteries provide ten times less power than the United Kingdom mains electrical supply. This means that, to a pedant, what I've made could at the moment be classified as a bread warmer rather than a bread toaster. I'm still hopeful that I'll see some toast when I up the voltage, or use white bread instead of the whole wheat I've tried so far.

Toast. Has that really been my goal for the last nine months? In one way, yes. But in another more accurate way, no.

I wanted to get under the skin of the slick-looking objects that surround us, but don't really come from

## Construction

Listening back to the recording of my first interview with Professor Cilliers, I'm slightly embarrassed at my naive optimism. "Yes, I'm going to make a steel spring to pop the toast up," and "Yep, I'm going to make all the electronics from scratch too... refining crude oil to make plastic? No problem, I'll just use a cooking pot." I can hear that while he didn't want to pour cold water on my ambition, he knew that the technical and scientific expertise assembled by countless people over centuries could not be replicated by me in the nine months that I had available.

That time is now up, and so I must take stock of the components that I've actually been able to make:

3 bits of iron internal toaster structure
4 iron grill bars
1 iron toast-raising lever
3 sheets of mica

anywhere (unless you work in supply chain management). To the average consumer (like me) a toaster begins its life on display in a shop, waiting for you or someone to buy it. To pay £3.94 for a toaster that's "from a shop" seems vaguely reasonable, but £3.94 for a toaster that is entirely made from stuff that a few months ago was rocks and sludge distributed in giant holes all over the world, then brought together in an elaborate series of processes and exchanges, gradually assembled by many people, wrapped, and boxed and then somehow shipped to that shop, which is heated and lit and has people being paid to assist you in your purchase: Somehow £3.94 for all of this doesn't seem to quite add up.

My attempt at making a toaster myself, from scratch, has been wildly, absurdly, outrageously "inefficient." My toaster cost 250 times more than the one from Argos, and that's just the money I spent on it directly (mostly travelling to mines). If I'd included all the food I ate, and the shoes I wore out, and so on, then its final price would be more. Much more. And its carbon footprint must be huge, at least a size 14 (European size 48).

And thus the miracle of modern capitalism is brought starkly into focus. As Jonathan Ive, senior vice president of industrial design at Apple Inc., said to me (well, me and the rest of the audience), "A complex product being made is like one of those films of a glass smashing that they play backwards—all the bits come together in the right place at exactly the right time to be assembled into this thing—it's amazing." I agree with Mr. Ive; it is amazing. I even have one of his iPhones, which at the moment I quite like (though

strangely it does make me feel like a bit of an idiot when everyone else in the room has one too—like going to a party and everyone's wearing the same "fashionable" top—but that's the point of fashion right?).

However, before we get too chummy with Adam Smith and his invisible hand, it seems that the need to buy more stuff to stimulate our economy, and the need to consume less to save our environment, are on a collision course. So while the £1187.54 price of my toaster doesn't really include all that it cost to make it, £3.94 isn't really what the Argos Value version cost either.

The real "cost" of products is hidden. We don't see (or smell) the pollution emitted when iron is smelted or plastics are made. You wouldn't want it happening in your back garden (though my neighbours have been quite nice about it). Equally we don't have to live with all the stuff we throw "away" (my neighbours I feel sure would complain about a personal garden rubbish dump, especially come the summer). But pollution and rubbish don't just disappear, they end up somewhere, and if not dealt with properly, are costing someone something (their health perhaps). At the moment there's lots of stuff not included in the price of the Value toaster—"externalities" that aren't included in the money economy.

For example, say the copper in the Value toaster was open-cast mined by copper miners in Chile. As we know, large holes in the ground tend to fill with water, which leaches out minerals from the exposed rocks, as happened at Rio Tinto and Parys Mountain. This water, acidified and contaminated with a whole load of heavy metals, such as arsenic, usually finds its way into the nearest river.

At the moment, no one "owns" the river, so the copper miners don't have to pay for stinking it up, and we all get cheap copper for our toasters. Except, of course, someone's paying a cost—like the people living along the river, or relying on it for water. We get the benefit of cheaper copper, but don't have to pay the costs—the costs are external (to us, anyway). However, if *I* owned that river, you can be damn sure that I'd demand a hefty sum from anyone who wanted to turn it into a blood-red home exclusively for acid-loving bacteria. Perhaps it would be so hefty that it wouldn't even be worth mining near my river. Or perhaps the copper miners could haggle me down by agreeing to certain conditions (like being extra careful to not stink up the river). They could then pass this slightly less hefty sum onto the wire manufacturers, who'd pass it onto the toaster manufacturers, who'd then undoubtedly pass it onto me and you—and, to be quite honest, fair enough.

But now imagine the river as the atmosphere, and the whole world's industry as the copper miners. I can imagine myself hypothetically owning a river, but even at my most delusional I can't see myself owning the entire atmosphere of planet Earth. So no one (not even hypothetically) owns the atmosphere, and industry, ourselves, cows, squirrels, etc., are all free to use the atmosphere as they wish, to add a bit of carbon dioxide, methane, sulphur dioxide, and so forth. If no one has to pay anyone to use the atmosphere, then there's no cost associated with polluting it. Environmental regulations are an attempt to impose a cost, but groups with different interests argue for different costs. The Emissions Trading System implemented by the

European Union is an attempt to let the free market in part determine the costs of polluting, but it has run into huge difficulties. In any case, it only applies in Europe.

If all the costs associated with their production were captured, well, toasters would cost a bit more, and perhaps we wouldn't buy and discard them so often, and of course not so many people would be able to afford them…

Here I am, yapping away about how things should be more expensive (well, technically that things *would* be more expensive if we were paying the right price for them). It seems a bit pious to be claiming that I want to pay more for stuff. Well, worse actually, it's hypocritical. Like lots of people, I generally buy the best stuff (that interests me) and that I can afford and probably go on just about as many holidays as I can afford, too (usually on the cheapest flights I can find).

I'm a willing beneficiary of the cheapness of things. When I go to buy my next computer (I'm interested in computers), I'll certainly be looking at the prices of all the different choices very carefully and will buy the fastest, newest one I can get at the best price I can find. I can say this with some certainty, because that's what I did the last time I bought a computer, and the time before that. My present computer is supposedly much better than my first computer, for all sorts of reasons, but the thing is, I don't feel *that* much better off—many of my friends *still* have better computers than me.

We compare what we have with what other people have. Poverty, then, is relative—that's not to say it isn't a very bad/uncomfortable/life-shortening/fatal position to be in, just that it's not an absolute. What it means to

be "poor" changes through time and across the world—as does what it means to be "rich," "well off," or merely "comfortable" (though what it means to be "starving" is flatly invariable). In terms of toasters, if everyone else has a toaster and I don't, well, I'll feel a bit deprived, and I'll go and buy a toaster if I can afford it. The fact that wealth is relative is, I think, one thing that drives the economy. It's not that people have "infinite wants" (as economists traditionally claim), just that no one wants to be at the poor end of the scale.

So, to expect people to stop wanting things when other people have more than them (and sometimes a lot more), because of costs that are difficult to even conceptualise, is I think a bit unrealistic. It's not that people are selfish and nasty—just that we're all constrained by lots of things, especially by what the people we're in contact with are doing, or have. It's a lot easier to give up smoking if the people you tend to smoke with are giving it up too (so far, so good anyway). People's attitudes to modern life won't *suddenly* change because of the (generally) slow and undramatic progression of climate change and environmental degradation—especially if the perspective they see "modern life" from is that of someone who's not currently living it. Developing countries are developing; what happens when every household in China can enjoy a toaster bought for only a few yuan? As a Chinese fashion designer told me while we were in wealthy and minimalist Stockholm, "Here, less is more. In China, more is more."

The collision of the economy with the environment is happening now… if it were a film of a car crash in slow motion, then I guess the front bumpers would be crumpling and bits of glass would be flying up as the

headlights smash. So how can we make the collision more of a glancing blow as opposed to a chaotic and bloody head-on pileup?

There's a whole battery of ways to make this come about—economic means like landfill taxes, giving pollutants the monetary cost they deserve, more and better consumer information. The answers, I think, already exist (lots of people, many of them more clever than I, have given it much thought), they just need to be implemented. Of course the implementation is the tricky part, especially if legislation is required, and legislation is where the big changes can be made. Differing legislative environments are why the same company can operate both the world's dirtiest nickel smelter in Siberia and one of the cleanest in Finland. We're just in need of politicians with the gumption to act.

Recently I heard this quote from the American environmentalist David Brower: "Politicians are like weather vanes. Our job is to make the wind blow." I'm not sure whose job he means specifically, but I think the analogy of culture as wind is a good one. And the direction the cultural wind blows is shaped by economics, fashion, science, literature, beliefs, technology, stories, news, events… all mixed up together. Right. So does that make it pretty much everyone's job to help keep the cultural winds blowing in the right direction? But many of us already have jobs, and don't want a second one if we can help it. Maybe more of a pastime then?

My attempt to make a toaster has shown me just how reliant we all are on everyone else in the world. Though there's romance in that idea of self-sufficiency and living off the land, there's also absurdity. There is no turning

back the clock to simpler times—not without mass starvation anyway. Besides, the majority of the world is still trying to turn the clock forward.

It also has brought into sharp focus the amount of history, struggle, thought, energy, and material that go into even something as mundane as an electric toaster. Even if we still don't have to directly pay what it costs, we can at least value it for what it's worth. Looking beyond just toasters, this means making sure the stuff we need to buy lasts longer, and investing as much ingenuity and money taking things apart as we do putting them together. My trip to Axion's polymer recycling factory was informative on this score. Perhaps there should be two instruction books with every product: one detailing how to set the product up and use it, and another detailing how to take the thing apart and separate it into the different components or materials from which it's made, ready to be fed back into other products without degrading the quality of the material. Is it unrealistic to imagine "the consumer" taking apart and sorting everything that they throw away? At the moment it seems completely so—who would spend an evening dismantling their old toaster or television? The health and safety issues would also be difficult. ("Step 1: Unplug your appliance. Dismantling your toaster while it's still connected to the power supply could be hazardous!")

But there's not much point in imagining futures that are the same as the present. For one, it's not very interesting, but it's also not very useful, and can be dangerous. For example, lots of banks made lots of loans because they assumed the future was going to be basically the same as the present, and look where it

got them (and us). The extent of the kind of change needed to avoid a nasty maiming collision can be summarised by many different statistics, one of which is that 60 percent or more of ecosystem "services" are being degraded or used unsustainably (ecosystem "services" are those important things we get from the environment—like fresh water, clean air, soil in which to grow things, and so on). Other statistics are available. The point is, big changes are needed, and big changes happen. Whether we end up dismantling our old TVs, or paying someone else whatever makes it worth their while to do it for us, doesn't really matter—what matters is that getting rid of stuff you no longer want has to become worth doing properly.

I've had rather a nice time visiting places as well as making my toaster. It's certainly something that I'll never throw away, because (to put it cornily) it embodies so many memories: walking the highlands of Scotland, clambering through the shafts of Parys Mountain in Wales, the Santa's grotto at Clearwell Caves. Companies spend a lot of money trying to invest their brands with emotion and meaning. For me, the stuff that really has emotion and meaning attached to it is stuff with a bit of history. The provenance of things is important. Maybe when we're in school each of us should assemble our own toaster, our own kettle, our own little microwave or something, then perhaps we'd be more likely to keep these things for longer, and repair and look after them. This would mean these products would be more than things that just come "from the shops."

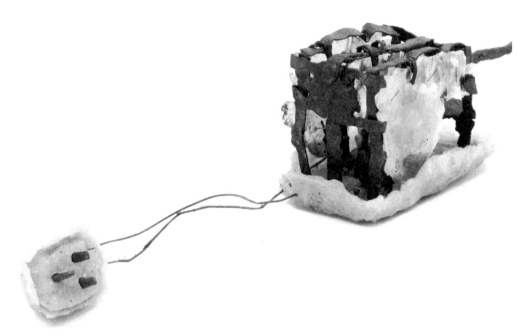

The toaster without its casing

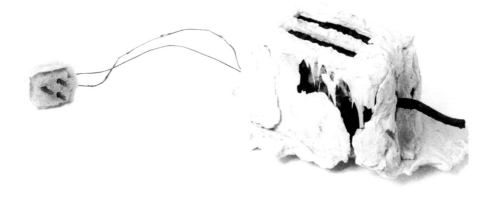

My toaster

THE PROCEDURES that have been introduced for the reset begin to resemble the Jesuit Ignatius of Loyola's Spiritual Exercises, which were indeed aimed at a reset, but the reset of the soul! Or maybe they become a habit like a philosophical form of Chinese gymnastics, a school of qigong; or perhaps like the training of commandos readying themselves for some strange sort of warfare. Anyway, it takes time to do the whole sequence correctly and to begin to feel in the pain of one's exercised muscles the new equilibrium it is leading to. But it is too late to go back: the new sensors are now in place to register signals to which earlier you could not make yourself sensitive enough.

## Procedure 6

# SECULAR AT LAST

One of the specific difficulties moderns have encountered is to deal with politics and religion simultaneously. If there is one topic where the exact distribution of immanence and transcendence has been thoroughly mixed up, it is the question of how "render therefore unto Caesar the things that are Caesar's; unto God the things that are God's" (Matt. 22:21). How can we expect former moderns, waking up from the utopia of modernism, to grasp what it is to be earthbound at last if when they turn to politics they mistake it for a form of transcendent religion, and when they turn to religion they accept an ersatz of immanent politics? How are they to remain attentive to the artificial construction of technical infrastructure (Latour, "Procedure 5," r·M!305–19) if it is constantly confused with a longing for supra-human mastery?

If it is so difficult to register the different wavelengths of politics and religion, it is because they are constantly mixed. One dramatic example is offered by Barack Obama's celebration of the memory of Reverend Clementa C. Pinckney in his moving "Amazing Grace Talk" as analyzed by Lorenza Mondada and her colleagues (r·M!395–403). It is clear from that example that it would make no sense to require Obama to distinguish clearly between what is a political speech against racism and a Christian sermon about grace and forgiveness. In this case, because Obama is the first black president of the United States and because the eulogy happened in a black church, the two are potentializing one another to the point where the oration ends up being a great conversion moment as well as the fiercest denunciation of racism that the president has ever voiced. And all of that through a well-known hymn that is at first recited and then literally *sung* in public with the audience.

In Jean-Michel Frodon's critical inquiry of the way cinema has always churned politics and religion together (r·M!370–80), Obama's "double talk" is not an isolated case. There is no way to separate the two because the creation of public works of art constantly uses themes from many traditions to devise versions of

1   Bruno Latour and Peter Weibel,
    eds. Iconoclash: Beyond the Image Wars
    in Science, Religion and Art. Cover.
    Cambridge, MA: The MIT Press, 2002.
    Print.

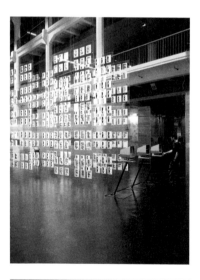

2   Ben Rubin. Dark Source. 2005.
    Interactive installation. Installation
    view Making Things Public: Atmospheres
    of Democracy. ZKM | Museum of
    Contemporary Art, 2005.

what it is to live outside of the theater, in the move-
ments and lights captured so rapturously by the cam-
era. And the great virtue of cinema is to build such a
public scene throughout the world by crossing the
boundaries imposed by theologies, cultures, and na-
tions as though the religion and politics amalgams
had become a question for every moviegoer under
the sun.

The problem is that the very notion of the political
public has a tradition that comes in part from religious
tradition as well (Dewey). Even though the official
narrative states that modernity is some irreversible
movement to render religion private because what
is common to all – politics – is the only thing that
should be public, it does not take much attention
to detect in political passions the presence of sever-
al versions of the absolute.

Nothing has been less secular, nothing has been
made more sacred than the political fights of recent
history. It is now clear that those who accept the "sep-
aration of church and state" are mostly Christians
who, after a long series of bloody alternatives, have
found no other makeshift solution to terminate the
religious wars of the sixteenth and seventeenth cen-
tury. If they feel at ease, it is probably because what
they ended up accepting in the secular public space
is another version of what they earlier meant by the
church. No wonder that they feel relatively comfort-
able in accepting this divide: they keep their religion
private and recognize in the public space (in the state,
in the nation, in the republic) another version of their
collective ideal.

But this is in no way a universal version of the di-
vide between religion and politics; it is rather one po-
litical theology the extension of which to the whole
planet seems highly unlikely (Voegelin). No other col-
lective feels much at ease under such an armistice –
and many movements are at work, everywhere, to
break it. Islam, for instance, has never been asked to

participate in such a divide and remains attached to a quite different form of political theology (Manent). Nor does it seem possible to shoehorn Russian Orthodoxy into such a modernizing version (Kharkhordin, r·m!381–86). Whatever the example, religion seems to always overflow the limits of the private sphere in which it is supposed to be contained so as not to explode in public. As for politics, it is even less freed from the poisons and virtues of various forms of spirituality when it has no clear roots in religious traditions.

One of the strange effects of such an impossible division (in fact a clever redistribution of the joint attributes of religion and politics) is that the specific tone, mode, and skills of political speech-acts have never been clearly highlighted. As shown by Gerard de Vries (r·m!387–94), what is meant most often by the political sphere is either a domain or a type of topic, but not the skills necessary to tie them together (de Vries "What Is Political"). This is what might explain the sudden reintroduction into revolutionary politics of a utopian desire that directs attention to a world of "beyond" which bears no clear connection with the skills proper to political practice and even less so with the various religious vocations of Jews, Protestants, and Catholics. The result of such a confusion in goals and vocations is a definition of politics that renders secularization impossible. As if it was impossible for the moderns to be mundane, profane, and secular when they deal with the earth.

Since secularization resembles so much a form of religion (a civic religion parading as secular), it is perfectly possible that there is still a long way to go before we can turn our eyes to the world without immediately framing it as if it lies between the "up" and the "down"; except the "up" is a world of "beyond" with no link with transcendence and the "down" another world of "beyond," a utopia with no link to immanence either.

Hence the complicated landscape the exhibition tries to unfold: a place which is neither up nor down. Secular at last? That remains to be seen. At any rate it is freed from the strange idea that there is an activity whereby a human could master mastery so thoroughly that it no longer depends on any other source of power. A good site to open up the possibility of *diplomacy*.

Works Cited

De Vries, Gerard. "What Are Politicians For?" Latour, *Reset Modernity!* 387–94.

———. "What is Political in Subpolitics? How Aristotle Might Help STS." *Social Studies of Science* 37 (2007): 781–809. Print.

Dewey, John. *The Public and Its Problems.* New York: H. Holt and Company, 1927. Print.

Frodon, Jean-Michel. "Religious Films Are Always Political." Latour, *Reset Modernity!* 370–80.

Kharkhordin, Oleg. "Resetting Modernity: A Russian Version." Latour, *Reset Modernity!* 381–86.

Latour, Bruno. "Procedure 5: Innovation not Hype." Latour, *Reset Modernity!* 305–19.

———, ed. *Reset Modernity!* Cambridge, MA: The MIT Press, 2016. Print.

Manent, Pierre. *Situation de la France.* Paris: Desclée De Brouwer, 2015. Print.

Mondada, Lorenza, et al. "Referring Grace, Performing Grace." Latour, *Reset Modernity!* 395–403.

Voegelin, Eric. *The New Science of Politics (new foreword by Dante Germino).* 1952. Chicago: The University of Chicago Press, 1987. Print.

Which means the people shall be activated

3a–f  Lisa Bergmann and Alina Schmuch. *Gnade üben (Performing Grace)*. 2016. Video stills.

and are able to change themselves trough the worship

4  *The Gospel According to St. Matthew*
   [*Il vangelo secondo Matteo*]. Dir. Pier
   Paolo Pasolini. Arco, Lux, 1964.
   Film still.

5   *The Trial of Joan of Arc.* Dir. Robert
    Bresson. Agnès Delahaie, 1962.
    Film still.

6   *Breaking the Waves.* Dir. Lars von Trier. Zentropa et al.,
    1996. Film still.

# RELIGIOUS FILMS ARE
# ALWAYS POLITICAL

## Jean-Michel Frodon

THE CINEMA INDUSTRY began representing the religious quite early on, producing films with "religious subjects" – more precisely, episodes from the Bible depicted with a predictably cloying piety – from its very first years. The presence of the religious on the screen was largely either a response to the initial hostility of the religious authorities towards the cinematographic, or initiated by such authorities – who were Christian, given the countries in which the new invention first developed.

In France, the first film magazine, Le Fascinateur, appeared in 1903. Created by the Catholic church, its aim was to alert the faithful to the dangers posed by certain films. But priests had long been using projected images to propagate the faith. The eminent seventeenth-century Jesuit scholar Athanasius Kircher, for example, was a leading propagator of the magic lantern. As the cinema historian Martin Barnier observes:

> We tend to believe that the Catholic
> church has always been opposed to
> cinema. In reality, through the tradition
> of magic-lantern shows, priests took
> advantage of cinema to propagate the
> faith. Assemblies at which slides and films
> were shown multiplied in the 1900s.
> Screenings in churches had stopped by
> 1912, but they continued in parish halls,

JEAN-MICHEL FRODON *is a professor at Sciences Po Paris, professorial fellow at the University of St. Andrews, Scotland, and lecturer at the Sarajevo Film Academy. He is the author of numerous books and has worked as a film critic, for example, for* Le Point *(1983–1990) and* Le Monde *(1990–2003). From 2003–2009 he was editorial director of* Cahiers du cinema. *Since 2010, he works for the online magazine* Slate.

and later in parish-run cinemas, until the 1950s.

The situation was broadly similar in Protestant societies, with some differences. Ministers and public-decency organizations monitored films to ensure they did not show or refer to anything that contradicted dogma or their own idea of Christian morality. This did nothing to hinder the film industry's astonishingly rapid development in Protestant countries, especially in the United States, of course, but also in Scandinavia, which proved to be very fertile soil for the "seventh art" from the outset, and later in Germany as well. And on the whole, the Orthodox church, although noted for its conservatism, did not display any opposition in principle. The current position of the Department for External Church Relations of the Moscow Patriarchate is unambiguous:

1   *Diary of a Country Priest* [*Journal d'un curé de campagne*]. Dir. Robert Bresson. UGC, 1951. Film still.

The secular culture can be a bearer of the good news. … This is true for various kinds of creativity, such as literature, representational arts, music, architecture, drama and cinematography. For the preaching of Christ any creative style is suitable if the artist is sincerely pious in his intentions and if he keeps faithful to the Lord.

It is not unreasonable to suggest that Christianity, built on the mystery of the incarnation, is the religion of the image par excellence; that its accommodation of cinema was a natural response; and that it in fact actively promoted the medium. On a more abstract level, we could even argue that it was responsible for the birth of cinema.[1]

The other two great monotheisms seem, in reality, just as tolerant, even though both are said to be hostile to the image. Ultra-Orthodox Jewish sects have condemned the medium, but it has encountered few difficulties in wider Jewish society. Indeed Hollywood, the world's greatest cinematographic empire, was a Jewish creation, as Neal Gabler has so eloquently documented. More surprisingly perhaps, attitudes to film in Islamic lands are also quite positive. Despite the predictable misgivings expressed by some religious authorities, both Shia and Sunni, cinema spread throughout

[1]   For a major study of the foundational link between Christianity and the image and the ways in which this connection influences contemporary practices, see Marie-José Mondzain's *Image, Icon, Economy*.

2    *Timbuktu*. Dir. Abderrahmane Sissako.
Worso, Dune Vision, 2014. Film still.

most Islamic countries between 1900 and 1920, doing especially well in Egypt and Iran. One notable exception to this trend, Saudi Arabia, remains hostile to the very existence of film, despite some signs of softening.[2]

The most interesting example, especially in terms of the links between religion and politics, is certainly that of Iran, where the advent of the Islamic Republic in 1979 marked a historical turning point in the reciprocal implication of the religious and the political in modern societies. On February 1 of that year, having just returned from exile to assume power, Ayatollah Khomeini delivered his first major speech on general policy, in which he outlined the framework he envisaged for all public bodies and for the organization of the lives, collective and individual, of all Iranians. Nobody expected to hear anything about cinema in a speech of such importance, except perhaps for a denunciation of it as one of the perverse, destructive factors imported from outside Iran.

(Khomeini's supporters had burned down half the country's cinemas during the preceding months of revolutionary turmoil.) But instead of condemning the medium, Khomeini announced his desire for an Islamic cinema that would shed its links to the West as the various sectors of Iranian society underwent Islamization.

What is Islamic cinema? Mullahs and *hojatoleslams* spent years puzzling over this question, for the Supreme Guide's injunction was taken very seriously. Numerous seminars, conferences, and working groups were organized in a voluntary attempt to create a cinema consistent with the message of Islam. Participants viewed the works of Carl Theodor Dreyer and Robert Bresson, rightly regarded as pinnacles of Christian cinema, to see if they could serve, mutatis mutandis, as models. These efforts were accompanied by the establishment of a meticulous system of censorship designed, as in other countries, to regulate so-called morals rather than the relationship of film to religion.[3] (The

[2]    The first Saudi feature film, *Wadjda*, directed by Haifaa al-Mansour, was released in 2012 to great international acclaim, although it could not be distributed in Saudi Arabia, which has no commercial cinemas.

[3]    For an overview of the relationship of religion and politics to Iranian cinema, see Agnès Devictor's *Politique du cinéma iranien*.

3   *Yeelen.* Dir. Souleymane Cissé.
    Atriascop et al., 1987. Film still.

4   *Come Come Come Upward* [Aje Aje Bara Aje]. Dir. Im Kwon-
    taek. Taehung, 1989. Film still.

very similar "Hays Code," a response to pressure from moral watchdogs, regulated Hollywood's output from the 1920s through the 1950s.)

Turning to other parts of the world, we find that neither Buddhists nor Hindus have voiced serious concerns about the film medium, although their attitudes towards it differ significantly. The many Buddhist sects have been unanimous in their indifference to cinema (which does not mean that cinema has been indifferent to Buddhist teachings and conceptions of the material and spiritual worlds). Hinduism, by contrast, has embraced film, as it has all the other arts, as a vehicle for the promotion of its narratives and representations, a goal which received a massive boost from India's emergence as the home of the world's most prolific film industry. Dadasaheb Phalke, the "father of Indian cinema," is said to have become attracted to the medium after watching a film depicting Christ. Wanting to show the gods of Hinduism on the screen, Phalke made the first full-length Indian feature film, *Raja Harishchandra* (1913), which was also the first of

countless mythological films made in that country. The unique and extremely strong link between cinema and Hinduism is actualized in the concept of *darshan*, the visual/spiritual relationship between the individual and the divine, something cinema can obviously facilitate once it gains acceptance. In this respect, the deification of movie stars is not dissimilar.[4]

In sketching out the relationship between cinema and religion, we have so far deliberately maintained the confusion between "religion," in the sense of an established body of doctrine supported by rituals and, usually, a clergy, and "the religious," in the sense of a structured relationship to invisible forces that are referred to as God, gods, "the spiritual," or "transcendence." In the context of this book, at least, and this exhibition, which have their origins in Bruno Latour's *An Inquiry into Modes of Existence*, such confusion is legitimate; it is the underlying principle of [REL], the religious mode of existence,[5] even if Latour's magnum opus privileges Christianity – which, to reiterate, is not what concerns us here, given that cinema, like the "moderns"

[3]   For an overview of the relationship of religion and politics to Iranian cinema, see Agnès Devictor's *Politique du cinéma iranien.*

[4]   On Indian cinema and religion, see Rachel Dwyer's *Filming the Gods.*

[5]   For a brief explanation of these abbreviations, which refer to the modes explored in the AIME project, see the glossary in this volume (r·m!543–47).

5   *La ricotta*. Dir. Pier Paolo Pasolini. Arco, Cineriz, 1962. Film still.

of whom it is a manifestation, enjoys a special relationship with Christianity.

But it is time to take a closer look at the spiritual, or metaphysical, dimension of cinema, at the cinematographic dispositif itself, in order to gain a better understanding of the way in which it can give rise to an exemplary tension in the register of the religious, and of the subsequent articulation-displacement wrought by [ POL ], the political mode of existence.

In fact it is a very old idea, long known to theorists and historians of cinema: the active tension between, on the one hand, the specific realism created by recording the four dimensions of the real world (the three spatial dimensions already allowed by photography, plus the temporal dimension, the prerogative of cinema) and, on the other, the invisible, all those perceptible absences which are nonetheless "there," summoned up by the

medium's power to preserve a vast quantity and diversity of traces of the real. Maxim Gorky's famous declaration – "Last night I was in the Kingdom of Shadows," written after viewing a Lumière presentation in Nizhny Novgorod in 1896[6] – leads us to an intertitle from F. W. Murnau's *Nosferatu* (1922): "And when he had crossed the bridge, the phantoms came to meet him." Crossing the bridge serves as a metaphor for the entry into cinema, or into the film. Early theorists formulated this primarily in terms of a relation to the disjunction and collision of two presents (the present of filming and the present of viewing), where the gulf between them is always that of aging, and potentially but in fact irrevocably that of death.

Among the many scholars of cinema, Jean Epstein, Siegfried Kracauer, and André Bazin have come closest to illuminating, in different ways depending on their approaches, the circumstances

[ 6 ]   Gorky 407. In "Gorki au cinématographe," Valérie Pozner has provided a remarkable explanation of the context in which Gorky wrote the article from which this sentence is extracted (used here more for its symbolic value than for the precise meaning the author intended at the time).

and implications of this relation. Although not as immediately apparent, the relation to space and the articulation of space and time are equally important, for while both are infinite, they are framed by the cinematic dispositif in a gesture that does not exclude the infinite, creating a relation to the world that opens up to the realm of the tangible a space of invisible heterogeneity. When Bazin invoked the biblical description of Christ's garment to argue that cinema can approach the "seamless robe of reality" ("la robe sans couture de la réalité"; 29), he summed up the definition of this asymptote of the world and of its representation, toward which cinema, as dispositif and as process, naturally tends, and which transcends, consciously or otherwise, the gap between the physical and the metaphysical, between immanence and transcendence, the opposition on which the entire system of Western religious representation and discourse is founded. But as long as Christians are responsive to cinema's unique powers, they should be able to see what it is doing, although they may have to adjust their religious vocabulary to name phenomena which neither exclude nor encapsulate it. Amédée Ayfre, for example, talks of "human events in which the whole mystery of the Universe is co-present" (185), going on to link this mystery to the message of Christianity.

What is important here is the potentiality, the capacity of the cinematographic dispositif to actualize this "co-presence," although the vast majority of films can at best only hint at its promise. That promise is deliberately and admirably fulfilled, by a filmmaker explicitly concerned with Catholicism,

Robert Bresson, as can be seen with particular clarity in A Man Escaped (1956). This film, inspired by real events, is a painstaking recreation of the concrete conditions of escape from Nazi jails. Bresson's fastidious materialism transforms it into a song of hope that invokes but does not name (other than indirectly, through its use of the Kyrie from Mozart's Mass in C minor) the highest spiritual aspirations.

Bresson was a true idealist in the sense that he wanted to film ideas, to locate the presence of ideas in the world as they exist in their most essential form. But as an idealist he only believed in the material presence of beings and things, in the spirit only as attested by the flesh, in the invisible as intensely inhabiting the visible. Bresson believed that cinematography, when used properly, was the perfect means by which to render perceptible the presence of the spirit in the real. In Notes on the Cinematographer he exhorts the filmmaker – in capital letters, no less – to capture "THE BONDS THAT BEINGS AND THINGS ARE WAITING FOR, IN ORDER TO LIVE" (80). This double involvement, in the quotidian and the spiritual, is also indicated in the film's French title: the first part, Un condamné à mort s'est échappé ("A man condemned to death has escaped"), has the factual tone of a police report or newspaper article, while the second, Le vent souffle où il veut ("The wind blows wherever it pleases"), is a quotation from the Gospel according to John.[7]

So far we have emphasized the situatedness – as established by the Abrahamic religions and Greek philosophy – of the dual conception which separates the physical from the metaphysical. In Beyond Nature and Culture, Philippe Descola

375

[7]    The passage describes an encounter between Christ and the Pharisee Nicodemus. "Jesus declared, 'I tell you the truth, unless a man is born again, he cannot see the kingdom of God.' 'How can a man be born when he is old?' Nicodemus asked. 'Surely he cannot enter a second time into his mother's womb to be born!' Jesus answered, 'I tell you the truth, unless a man is born of water and the Spirit, he cannot enter the kingdom of God. Flesh gives birth to flesh, but the Spirit gives birth to spirit. You should not be surprised at my saying, "You must be born again." The wind blows wherever it pleases. You hear its sound, but you cannot tell where it comes from or where it is going. So it is with everyone born of the Spirit'" (Holy Bible, John 3:3–8). It is not enough to be human and therefore capable of being saved, not enough to be born physically; one must be born a second time, spiritually. In Greek, the language of the Gospels, Spirit and wind are the same word, but all translators agree that the parable uses the physical phenomenon of wind to refer to the abstract idea of Spirit. These are Bresson's "flowing currents."

**6** *Timbuktu.* Dir. Abderrahmane Sissako. Worso, Dune Vision, 2014. Film still.

has systematically shown how this conception, in spite of its geopolitical dominance in modern times, is historically far from unique, given its reliance on alternatives that originated in supposedly "primitive" societies. François Jullien, too, has devoted himself to illuminating the possibilities offered by completely different approaches, focusing in his work on China: a different civilization, a different mode of thought and representation, developed by a society that can hardly be described as "primitive." Curiously, these different approaches almost mirror what Western theorists of cinema have been reaching for, though inevitably with the concepts and formulations of their "own" world (Christian, monotheistic, Platonic, Aristotelian).

For example, in *Vivre de paysage*, a book devoted to the critical difference between Western and Chinese conceptions of landscape, Jullien notes that "because China did not take the distinction between the sensory and the extrasensory to the point of metaphysical division, it could comfortably imagine the deployment of the spiritual *within the physical*" (120). This relationship to the world bears a striking similarity to the relationship Ayfre imagined cinema to create. And Bresson would surely have agreed that his "flowing currents"

operate on the same principle as qi, the "vital breath" that defines the Chinese conception of the world, a world that contains human beings but is by no means defined by or for them – qi blows wherever it pleases. Explicit examples of this can be found in those East Asian films inscribed most fully in their own traditions (those least contaminated by Western models of narration and representation): by Yasujirō Ozu, King Hu, Hou Hsiao-hsien, Jia Zhangke, Tsai Ming-liang, Im Kwon-taek, and Apichatpong Weerasethakul.

We can therefore see clearly the possibility of cinema's double relation to [REL], the intrinsic dimension that links the invisible and the cinematographic dispositif, and the possibility, in certain cases, of making a particular religious approach the "subject" of a film. This kind of doubling is not without consequences, however, for it inevitably mobilizes involvement from another mode of existence: the political. One could argue that good old [POL] is present in every mise-en-scène in any case, that every narrative and representative construct mobilizes questions of dominance, alliances, negotiation, distancing, community interests – and one would be right. Politics and the political are present, in one form or another, in

the cinematographic dispositif of every comedy, Western, or sentimental drama. Even so, something unique occurs in this doubling, or rather this particular echo effect that is activated when the means of cinema are mobilized and deployed to address situations involving (a) religion.

And this circulation, this tension which harbors both proximity and antinomy, produces the political as surely as rubbing two flints together produces a spark. In other words, a film with a religious subject will always ignite political issues, in the interaction of the spiritual element in the cinematographic process and the themes specific to it.

We can only verify this on a case-by-case basis, by a detailed analysis of each film. As a task of such magnitude is impossible here, we will simply appeal to the reader's memory by offering a list of titles and asking him or her to note the essentially political dimension that structures each of these films, since they all, despite their infinite diversity, have a "religious subject"; they all depict characters with priestly functions or situations inspired by religious texts.

- *Andrei Rublev* (Andrei Tarkovsky, 1966: Orthodox Christianity)
- *Breaking the Waves* (Lars von Trier, 1996: tension between Catholicism and Protestantism)
- *The Cardinal* (Otto Preminger, 1963: Catholicism)
- *Come, Come, Come Upward* (Aje Aje Bara Aje, Im Kwon-taek, 1989: Buddhism)
- *Day of Wrath* (*Vredens dag*, Carl Theodor Dreyer, 1943: Protestantism)
- *The Decalogue* (Dekalog, Krzysztof Kieslowski, 1989: Catholicism)
- *Dernier maquis* (Adhen, Rabah Ameur-Zaïmèche, 2008: Islam)
- *Destiny* (Al-massir, Youssef Chahine, 1997: Islam and Christianity)
- *Diary of a Country Priest* (*Journal d'un curé de campagne*, Robert Bresson, 1951: Catholicism)
- *The Flowers of St. Francis* (*Francesco, giullare di Dio*, Roberto Rossellini, 1950: Catholicism)
- *The Fugitive* (John Ford, 1947: Catholicism)
- *The Garden of Stones* (*Baghé sangui*, Parviz Kimiavi, 1976: Islam and animism)
- *Genesis* (*La genèse*, Cheick Oumar Sissoko, 1999: monotheism and animism)
- *The Gospel According to St. Matthew* (Il vangelo secondo Matteo, Pier Paolo Pasolini, 1964: Christianity)
- *Guelwaar* (Ousmane Sembene, 1992: Catholicism and Islam)
- *Hadewijch* (Bruno Dumont, 2009: Catholicism and Islam)
- *Intolerance* (D. W. Griffith, 1916: Christianity, religious war)
- *Kadosh* (Amos Gitai, 1999: Judaism)
- *The Last Temptation of Christ* (Martin Scorsese, 1988: Christianity)
- *Leaves from Satan's Book* (*Blade af Satans bog*, Carl Theodor Dreyer, 1920: Protestantism)
- *Mandala* (Im Kwon-taek, 1981: Buddhism)
- *A Man for All Seasons* (Fred Zinnemann, 1966: Catholicism)
- *Murder in the Cathedral* (George Hoellering, 1951: Catholicism and the Reformation)
- *Nazarin* (Nazarín, Luis Buñuel, 1959: Catholicism)
- *Of Gods and Men* (*Des hommes et des dieux*, Xavier Beauvois, 2010: Catholicism and Islam)
- *The Passion of Joan of Arc* (*La passion de Jeanne d'Arc*, Carl Theodor Dreyer, 1928: Christianity)
- *La ricotta* (Pier Paolo Pasolini, 1962: Christianity)
- *Rite of Spring* (*O Acto da Primavera*, Manoel de Oliveira, 1963: Catholicism)
- *The Seventh Seal* (*Det sjunde inseglet*, Ingmar Bergman, 1957: Protestantism)
- *Simon of the Desert* (*Simón del desierto*, Luis Buñuel, 1965: Christianity)
- *Story of Judas* (*Histoire de Judas*, Rabah Ameur-Zaïmèche, 2015: Christianity)
- *Thérèse* (Alain Cavalier, 1986: Catholicism)
- *Timbuktu* (Abderrahmane Sissako, 2014: Islam)

377

- A Touch of Zen (Xiá nǔ, King Hu, 1971, Buddhism)
- The Trial of Joan of Arc (Procès de Jeanne d'Arc, Robert Bresson, 1962: Christianity)
- Under Satan's Sun (Sous le soleil de Satan, Maurice Pialat, 1987: Catholicism)
- We Have a Pope (Habemus Papam, Nanni Moretti, 2011: Catholicism)
- Winter Light (Nattvardsgästerna, Ingmar Bergman, 1963: Protestantism)
- Word and Utopia (Palavra e Utopia, Manoel de Oliveira, 2000: Catholicism)
- Yeelen (Souleymane Cissé, 1987: animism)

These forty titles[8] appear in alphabetical order, creating a random mixture of religions, but the dominance of Christianity should come as no surprise. What is remarkable is the absence of American films dealing with Protestantism, given that this form of religion is predominant in the United States. It was a Frenchman, Raymond Rouleau, who eventually brought Arthur Miller's The Crucible to the screen, and a German director, Wim Wenders, who adapted Nathaniel Hawthorne's The Scarlet Letter. While the films of Terrence Malick are noted for their mysticism, they do not specifically engage with Protestantism. Similarly, Paul Schrader's screenplays reveal the powerful influence of that particular faith, but the films themselves do not deal with religious subjects. Preachers have featured in numerous American films, sometimes as eccentric characters (Jeremiah Johnson, 1972), sometimes as menacing figures (The Night of the Hunter, 1955), and frequently as harsh fundamentalists, but in most cases their role has been social rather than religious.

On the whole, American cinema seems to shun exactly those political issues that are likely to stimulate interaction between the religious and the political, although this is less true of filmmakers with a Catholic background, whether Irish (John Ford and, indirectly, Alfred Hitchcock) or Italian (Francis Ford Coppola, Martin Scorsese, Abel Ferrara). John Huston adapted several narratives with a religious element, such as Moby Dick (1956), a film with all the overtones of Herman Melville's novel, not to mention Orson Welles's unforgettable preacher. Others include Heaven Knows, Mr. Allison (1957), The Bible (1966), and A Walk with Love and Death (1969). Wise Blood (1979), with its crazed evangelist, and the James Joyce adaptation The Dead (1987) may be regarded as highlights, but we cannot claim that religion is the subject of any of Huston's films. The most memorable Protestant hero (or, shall we say, quasi-mythological Lutheran vision) to emerge from Hollywood is certainly the character created by Clint Eastwood in Pale Rider (1985): the same moralistic vigilante the actor-director has portrayed, in various guises less explicitly related to biblical myth, in a number of other films.

The list could be much longer than the forty titles chosen. It favors films of superior quality – where what we are calling "quality" signifies, in reality, a high concentration of cinema's unique powers, its capacity to invoke the invisible through the perceptible. The methods by which it does this are as varied as their realizations, but all engender a relationship thaat echoes what all religions seek to do, whatever their methods, dogmas, and rituals. The political also finds its way into vehicles for religious propaganda. Hollywood, for example, has churned out many spectaculars based on the Christian message: The Ten Commandments (1956), The Greatest Story Ever Told (1965), The Robe (1953), Ben-Hur (1959), The Bible (1966), The Passion of the Christ (2004), Noah (2014), etc. India's film industry does the same for Hinduism, while Muslim filmmakers, responding to contemporary Islamic politics, are beginning to follow suit with films such as Moustapha Akkad's The Message (1976) and Majid Majidi's Muhammad (2015).

[8]    We might also include Abbas Kiarostami's Looking at Tazieh (Shia Islam), which is not a film but a performance/installation that mobilizes the essential resources of cinema.

7   *Kadosh*. Dir. Amos Gitai. Agav
    Hafakot, MP, 1999. Film still.

8   *Andrei Rublev [Andrey Rublyov]*. Dir. Andrei Tarkovsky. Mosfilm, 1966. Film still.

But the films in the list above are – and why not put it simply? – very good. And by "good" we mean films that mobilize the unique resources of cinema. We could even argue that the better a film about religion is, the more political it is likely to be. This is precisely because by creating a tension between, on the one hand, that which is common to the cinematographic dispositif and sensitivity to active relations in the universe, and on the other, the materialization of the religious through its narratives, dogmas, clergy, rituals, prophets, and so on, it inevitably displaces its object – in the terminology of Latour's *Inquiry*, it modifies its "chains of reference" (77).

In effect, this strange linkage of religion and the religious, involving both a clash and a dialogue between two regimes of the religious, shifts our focus towards shared experience, towards relations of force and cooperation, towards the articulation of the individual and the collective, towards the private and the public. And in doing so it invokes the political mode of existence.

*Translated from the French by Roger Leverdier.*

Works Cited

Ayfre, Amédée. "Neo-Realism and Phenomenology."
Trans. Diana Matias. *Cahiers du Cinéma: The 1950s;
Neo-Realism, Hollywood, New Wave.* Ed. Jim Hillier.
Cambridge, MA: Harvard University Press, 1985.
182–91. Print.

Barnier, Martin. "Les prêtres en voix *off* au temps du
cinéma muet." *Le temps des médias* 17 (2011): 45–53.
Web. 13 Jan. 2016. Available at <http://www.cairn.
info/revue-le-temps-des-medias-2011-2-page-45.
htm>.

Bazin, André. "Renoir français." *Cahiers du cinéma* 8
(1952): 9–29. Print.

Bresson, Robert. *Notes on the Cinematographer.* Trans.
Jonathan Griffin. Copenhagen: Green Integer,
1997. Print.

Department for External Church Relations of
the Moscow Patriarchate. "Bases of the Social
Concept of the Russian Orthodox Church."
*OrthodoxEurope.org.* Dept. for External Church
Relations of the Moscow Patriarchate, n.d., Web.
13 Jan. 2016. Available at <http://orthodoxeurope.
org/page/3/14.aspx>.

Descola, Philippe. *Beyond Nature and Culture.* Trans.
Janet Lloyd. Chicago: University of Chicago Press,
2013. Print.

Devictor, Agnès. *Politique du cinéma iranien: De l'âya-
tollâh Khomeyni au président Khâtami.* Paris: CNRS,
2004. Print.

Dwyer, Rachel. *Filming the Gods: Religion and Indian Ci-
nema.* Abingdon: Routledge, 2006. Print.

Gabler, Neal. *An Empire of Their Own: How the Jews
Invented Hollywood.* New York: Crown, 1988. Print.

Gorky, Maxim. "Maxim Gorky on the Lumière
Programme, 1896." Trans. Leda Swan [Jay Leyda].
Appendix 2. *Kino: A History of the Russian and Soviet
Film.* By Leyda. London: Allen, 1960. 407–09. Print.

*The Holy Bible.* Grand Rapids: Zondervan, 1978. Print.
New Intl. Vers.

Jullien, François. *Vivre de paysage ou L'impensé de la raison.*
Paris: Gallimard, 2014. Print.

Latour, Bruno. *An Inquiry into Modes of Existence: An
Anthropology of the Moderns.* Trans. Catherine Porter.
Cambridge, MA: Harvard University Press, 2013.
Print.

*A Man Escaped* [*Un condamné à mort s'est échappé ou Le vent
souffle où il veut*]. Dir. Robert Bresson. Continental,
1956. Film.

Mondzain, Marie-José. *Image, Icon, Economy: The
Byzantine Origins of the Contemporary Imaginary.* Trans.
Rico Franses. Stanford: Stanford University Press,
2005. Print.

*Nosferatu.* Dir. F. W. Murnau. 1922. Film Arts Guild,
1929. Film.

Pozner, Valérie. "Gorki au cinématographe: 'J'étais hier
au royaume des ombres….'" *1895: Revue d'histoire du
cinéma* 50 (2006): 89–113. Print.

# RESETTING MODERNITY:
# A RUSSIAN VERSION

## Oleg Kharkhordin

RUSSIA HAS NEVER BEEN MODERN, but in another way than, say, France. That is, it was never completely and explicitly modern by conventional Western European standards. It lacked the rule of law and democratic politics. It developed powerful natural and exact sciences, but they were used to achieve a quasi religious, that is, charismatically conceived goal: to build a Communist paradise on earth. However, since at least the early eighteenth century, it always strove to be a modern European country. The last attempt coincided with the presidency of Dmitry Medvedev (2008–2012), whose speechwriters and advisors explicitly referred to reset and modernization as the primary goals of the country under a new, young, and seemingly energetic president. In this short essay I would like to test the high truths of Bruno Latour's *An Inquiry into Modes of Existence: An Anthropology of the Moderns* against this rather mundane reality – the third attempt to make Russia modern, to reset its modernity, that is, to reload it again, but with bugs and mistakes eliminated.

Medvedev used the term "modernization" to distance his agenda from Putin's, who was seen by many observers, including the heads of other states, as the author of a rather straightforward [ORG][1]

OLEG KHARKHORDIN *is a professor of political science at the European University at St. Petersburg, currently focusing on the political theory of republicanism. His main publications include* The Collective and the Individual in Russia: A Study of Practices (1999), Main Concepts of Russian Politics (2005), *and* Political Theory and Community-Building in Post-Soviet Russia (2011, *with Risto Alapuro*).

script "you'll sit for four years in this power seat and then you will give it back to me." In his September 2009 manifesto "Go, Russia!" Medvedev wrote:

> The impressive legacy of the two greatest modernisations in our country's history – that of Peter the Great (imperial) and the Soviet one – unleashed ruin, humiliation and resulted in the deaths of millions of our countrymen. … Today is the first time in our history that we have a chance to prove to ourselves and the world that Russia can develop in a democratic way. That a transition to the next, higher stage of civilization is possible. And this will be accomplished through non-violent methods.

[1] For a brief explanation of these abbreviations, which refer to the modes explored in the AIME project, see the glossary in this volume (r·m! 543–47).

The reset thus meant eliminating the bug called violence: persuade rather than coerce, rely on self-interest rather than on command. Modernization thus would mean Russia finally fully joining the club of the democratic countries of Western Europe and Northern America.

In international relations the novelty of the situation was also captured by the English term "reset." It was used by the Obama administration to describe the new effort to efface the pile of mounting conflicts between Russia and the West and to re-engage Russia in joint efforts of the civilized world to solve common problems. President Obama and his staff decided to treat Medvedev as if he not only really wanted to build a modern country based on the rule of law, but also as if he had realistic chances of circumventing Putin and achieving it. Vice President Joe Biden was the first to openly use the term, when at the Munich Security Conference in February 2009 he stated:

> The last few years have seen a dangerous
> drift in relations between Russia and the
> members of our Alliance. It is time – to
> paraphrase President Obama – it's time
> to press the reset button and to revisit the
> many areas where we can and should be
> working together with Russia. (Stent 217)

An era of this reset thus ignored the fallout from the 2008 Russian–Georgian war and ushered Russia back into the family of civilized states. The main achievements internationally that followed in its wake were the signing of the NEW START (Strategic Arms Reduction Treaty), reducing the number of nuclear warheads and launchers, and US–Russian cooperation on supplying NATO troops in Afghanistan. The term "reset" has become so popular in the parlance of the political class in Russia that the main Medvedev think tank named a section of its programmatic report, calling for a decisive budgetary reform as the main driver of renewal, "Reloading the

economic model." (*Obretenie budushchego. Strategiia 2012* 79; Trans. Kharkhordin)

But, a reader may interject now, the main tenets of the AIME project (An Inquiry into Modes of Existence) or the title of the exhibition at the ZKM | Center for Art and Media Karlsruhe (*Reset Modernity!*) are all about resetting modernity in the entire world, not about reforms to eschew the backwardness of Russian institutions and finally modernize them to this end, thus making Russia a copy of what has already been achieved in France, Germany, or America. Who cares that the Russian elite, together with their US counterparts, were using the words "reset," "modernity," and "modernization," when the goal is to reset that age-old modernist project rather than help someone finally fine-tune its previous version and make it accomplished! If we care about Gaia, if the key choice is "modernize or ecologize," then resetting modernity is not about helping countries like Russia or Brazil to finally get the old modernity right. The goal is to reset it anew, in full awareness of the multiplicity of modes of existence, some of which old modernity valorized too much and some of which it really tried to trample underfoot.

An answer to such an interjection would be: Listen, the experience of not-yet-modern countries is important because they might be closer to the new reset modernity than those that have it in the fully developed form. Those who have it in a well-developed form will have to reload all the software, so to speak, while the backward modernizers still have the vestiges of the premodern era flourishing as part of their life. For example, the modes of being of [MET] and [REL] are cherished and are not shied away from as nonscientific nonsense; [REP] and the audacity it takes for the stone to leap across the abyss of nonexistence to reproduce itself is not an exquisite philosophical truth discovered by Alfred North Whitehead in *The Concept of Nature* and metaphysically systematized by Latour in *Inquiry*, but an

1   US Secretary of State Hillary Clinton meets with
    Russian Foreign Minister Lavrov in Geneva on 6 March
    2009, where she handed a block with a red button
    marked "reset" in English and "overload" in Russian
    to him.

383

everyday perception, and so on. These vestiges will be then easier to integrate into the new reset modernity, because here some existence has never been modern even in its name. One is not calling upon others to go premodern, of course. Rather, one is saying that a full reload would not be necessary in these cases, or a different type of reload might be needed. For instance, if gift-giving and exchange of favors between friends are still central to these not-yet-fully-modernized bundles of humans and nonhumans, appeals to "diseconomize" the ongoing economization of the economy are easier to understand, because in such bundles one has never lived in the fully functioning allegedly self-regulating system where a meta-dispatcher called the market reigns over everything.

This statement (that modernity reload might be easier or different in not-yet-fully-modernized places) should come with a caveat, however. When one month after Biden's speech the US secretary of state Hillary Clinton met Russian foreign minister Sergey Lavrov in Geneva, she gave him a small gift box. It contained a red button emblazoned with the word "reset" on it, in both English and Russian (as she thought). Lavrov looked confused and then laughed: "You got it wrong!" ("Clinton Goofs on Russian Translation"). The Russian word on the button was *peregruzka*, not *perezagruzka* (what would have been the right term).[2] The Russian term engraved by Clinton's assistants meant "overload," "overcharge," or a g-force, say, that pilots feel in a too rapidly accelerating military jet. If we are too fast with the thesis stated above, we may get an overload of modernity, rather than its reload.

For example, some would say that after the second swap of places between Medvedev and Putin in 2012, Russia finally decided to abandon its attempts to become the West, that is, to catch up and finish modernization old-style, and instead it is trying now to reset the old modernity worldwide

2   The block with a red button marked "reset" in English
    and "overload" in Russian.

[2]   Please see also the video at https://www.youtube.com/watch?v=0GdLClHAMB0.

in its own fashion. After his return to power Putin has not only stopped the rhetoric of modernization-with-a-human-face, he also quickly cancelled many initiatives of the Medvedev era. Of course, his power moves might be taken as premodern politics in a postmodern world, rather than moves aimed at resetting the old rotten modernity. For example, even after the 2008 war in Georgia a popular suspicion was that Russia, with its stress on sovereignty, was within the nineteenth century agenda of leaders like Bismarck, and thus premodern. Astute commentators, like Václav Havel, Lech Wałęsa, and Alexander Kwaśniewski, however, noticed the novelty of this alleged return of sovereign Realpolitik. In their words, Russia was "pursuing a nineteenth century agenda with twenty-first century tactics and methods" (Stent 226).

Indeed, warfare in Ukraine in 2014 has been called "hybrid" by both journalists and scholars, and this hybrid character, many would argue, is a novelty rather than a return to worn-out and well-tried premodern tactics (Cullen Dunn and Bobick). Other measures of Putin are also nonmodern, one might argue. In 2013 the Russian state effectively introduced laws on the criminal prosecution of blasphemy, allegedly in the wake of the 2012 Pussy Riot trial when it had found serious difficulties in charging these punk rock (or performance art) ladies with "hooliganism motivated by religious hatred" (Elder). The Pussy Riot assault in February 2012 was itself a result of a widespread feeling that the state was going way too far in supporting official religion, with religion paying the government back with incantations of legitimacy of the powers that be. So, the issues of [REL] came to the fore of contemporary Russian politics, no matter how allegedly secular it is. Also, opinion polls during the arrest and trial of Pussy Riot, which revealed a clear conservative majority, gave Putin a gift, which he could have only dreamed about before, but did not have at hand. The state has discovered a silent majority,

which seemed absent during the street protests of 2011–2012, but which suddenly emerged on its own, and on which the state could now rely! The issue formed a public, but a clearly conservative and nondemocratic public that came out of its shadow existence. The tears of Putin during his speech to his supporters at a huge rally on the night of 4 March 2012, when preliminary results of the presidential elections were declared, could testify to the difficulty of forging this public. Since then, the Russian president masters the secrets of [POL] speech well, maintaining the ever-recurring circle in order to ingrain democracy as a habit (as the Inquiry would have it) (343). The fact that many observers would not take it to be democracy by Western standards at all, does not bother him.

And he ecologizes (in the conventional sense of the term)! If Medvedev rarely stressed ecology, Putin made it his trump card or a key political stunt. Thus, he directed the endangered rare cranes in their migration flight using a hang glider (Amos), helped release Amur tigers back into the wilderness (Reevell), and took care of whales (Parfitt). Please take a look at the official pictures offered by the Kremlin to get a feel for how the very vastness of Russia, and the diversity of its flora and fauna are enrolled by the current regime to vouch for it. Putin was also one of the first in Russia to state publicly the fact that oil and gas economics might be on the wane, and the real struggles of the twenty-first century will be over resources such as fresh water. Hence saving Lake Baikal, for example, with its huge reserves of potable water is of immense importance to Russia and perhaps to earth itself (Parfitt).

To repeat again: I am citing all these examples for one reason. Whether arguments for Vladimir Putin as a nonmodernizer (in the sense of Latour's Inquiry) are just a joke, and will be clearly knocked down like a straw man, or whether a serious argument could be built with time that he was part of a real movement to reset the old-type modernity, one should be

wary of such type of accounts for fear of ending up with an overload of modernity rather than with its reload. The reset of modernity should not suddenly be just a setback sending us to premodern condition of faith [REL], simple adulation of the possessed souls [MET], valorizing habit [HAB] and the silent reproduction of lineages and forces [REP].[3]

But if one does not want to be sent back to premodern [REL], for example, how could one ensure that one is getting out of the current predicament, without falling into the already tried and clearly dysfunctional condition? If Putin is a symbol of premodern life, rather than resetting modernity, as some would argue, how do we distinguish [REL] as part of the life to come from part of the life that was (and then it would be clear that Putin's use of [REL] is not what *Inquiry* wants)? Here a point about a recalling of modernity – a metaphor that was proposed in *Inquiry* (16) next to resetting it, could help us (and perhaps even save us). This image overtly suggests that one should recall modernity like a faulty car by the automobile industry, when producers or users have suddenly discovered a decisive deficiency, and some components of all cars of a particular model have to be replaced. What this image inadvertently implies, though, is that modernity is a machine that can be reset or recalled and refurbished; that is, that dealing with modernity relies primarily on the [TEC] mode of existence.

Reading about [TEC] in Chapter 8 of *Inquiry*, we learned that its decisive difference from reproduction [REP] is that a tree cannot start over again, its consecutive leaps across the hiatus of nonexistence are a one-way street, so to speak. By contrast, an engine can be reassembled, can jump back over this hiatus, or face it again, as it were. This starting all over again several times in a row, when an engineer tinkers and by groping tries to go from one obstacle to

the next one in order to resolve the issue, defines this mode of existence (215, 227). The chapter also says that modernity mistakenly takes technicians to be sort of lower-ranking scientists, as though technicians were only implementing ideas preconceived by scientists. So, if we are to restore ontological dignity to beings of technology [TEC], we should establish different transactions with them – only then will the verb "ecologize" become an alternative to "modernize." An example is given:

> … the Letter of Scripture remains inert
> without the Spirit that blows where it will.
> This is even truer of the bleached bones of
> the technical object that are waiting for
> the spirit of technique to raise them up, re-
> cover them with flesh, put them back to-
> gether, transfigure them – resuscitate
> them, if the word is not too strong. (231–32)

So resetting modernity, if one treats it in the [TEC] mode of being, is not just about changing some part in the machine, or resetting the software program that runs it, it is about resuscitating the machine, a clearly religious act. Because [REL], as we know from Chapter 11 of *Inquiry*, is about angels coming down during apparitions to say words that are capable of renewing those to whom they are addressed, to raise and transform them from the faltering into the supported and reinforced ones, to again and again tell them "I love you" and thus resuscitate and save. It is because of this that the [REL] mode of being transforms those addressed into persons. But these words need to be repeated incessantly, it is part of the endless reprise (303, 306–08).

If we follow this account of [TEC] and [REL], we arrive at the following: to reset modernity is to engage in the endless reprise of the words telling modernity that it is truly being loved, and thus – to

385

---

[3] The last three modes of existence mentioned are the three most ignored by modernity, as we know from *Inquiry* (288). Restoring ontological dignity to them, for example, should not be viewed as if from now on they should be practiced in premodern purity.

renew modernity. Of course, so far angels only came down to people and uttered words that transformed those addressed into persons – these very unique persons with proper names. The first attempt at such [REL] words, but addressed to modernity, not to individual human beings, was Latour's book. He told modernity it is loved. He sought to bring spirit to the bare bones of it, and to call it with a proper personal name: not modernity with a small *m*, but Gaia as a real person. The exhibition at the ZKM | Karlsruhe can be thought as one of the next steps in this endless reprise of addressing modernity with love and saving it as Gaia, which the *Inquiry* project is trying to unleash. But only life will tell whether the words of the *Inquiry* had enough angelic qualities; whether it carries *the* Word.

## Works Cited

"Action man Vladimir Putin shoots a whale (but only for scientific research) in latest macho photo opportunity." *MailOnline*. Associated Newspapers Ltd., 26 Aug. 2015. Web. 30. Sept. 2015. Available at <http://www.dailymail.co.uk/news/article-1306262/Vladimir-Putin-shoots-whale-scientific-research-macho-photo-opportunity.html>.

Amos, Howard. "Vladimir Putin leads endangered cranes on migration route in hang glider." *theguardian.com*. Guardian News and Media Limited, 6 Sept. 2012. Web. 30 Sept. 2015. Available at <http://www.theguardian.com/world/2012/sep/06/vladimir-putin-cranes-hang-glider>.

"Clinton Goofs on Russian Translation, Tells Diplomat She Wants to 'Overcharge' Ties." *Fox News.com*. FOX News Network, LLC, 6 Mar. 2009. Web. 30 Sept. 2015. Available at <http://www.foxnews.com/politics/2009/03/06/clinton-goofs-russian-translation-tells-diplomat-wants-overcharge-ties/>.

Cullen Dunn, Elizabeth, and Michael S. Bobick.

"The Empire Strikes Back: War without War and Occupation without Occupation in the Russian Sphere of Influence." *American Ethnologist* 41.3 (2014): 405–13. Print.

Elder, Miriam. "Pussy Riot sentenced to two years in prison colony for hooliganism." *theguardian.com*. Guardian News and Media Limited, 17 Aug. 2012. Web. 21 Feb. 2016 Available at <http://www.theguardian.com/music/2012/aug/17/pussy-riot-sentenced-two-years>.

Latour, Bruno. AIME: *An Inquiry into Modes of Existence: An Anthropology of the Moderns*. Trans. Catherine Porter. Cambridge, MA: Harvard University Press, 2013. Print.

---, ed. AIME: *An Inquiry into Modes of Existence*. FNSP, 2012–16. Web. 19 Feb. 2016. Available at <www.modesofexistence.org>.

Medvedev, Dmitry. "Go Russia!" *Official Internet Resources of the President of Russia*. Presidential Executive Office, 10 Sept. 2009. Web. 30 Sept. 2015. Available at <http://en.kremlin.ru/events/president/news/5413>.

Institute of Contemporary Development. *Obretenie budushchego. Strategiia 2012* [Finding the Future. The Strategy of 2012]. Moscow: INSOR, 2011. PDF file.

Parfitt, Tom. "Action man Vladimir Putin turns submariner at Lake Baikal." *theguardian.com*. Guardian News and Media Limited, 2 Aug. 2009. Web. 30. Sept. 2015. Available at <http://www.theguardian.com/world/2009/aug/02/russia-vladimir-putin-lake-baikal>.

Reevell, Patrick. "Vladimir 'Putin's Tiger' Devours a Bear in Russia." *ABCNews.com*. ABC News Internet Ventures, 15 July 2015. Web. 30 Sept. 2015. Available at <http://abcnews.go.com/International/vladimir-putins-tiger-devours-bear-russian/story?id=32462122>.

Stent, Angela E. *The Limits of Partnership: U.S.–Russian Relations in the Twenty-First Century*. Princeton: Princeton University Press, 2014. Print.

Whitehead, Alfred North. *The Concept of Nature*. 1920. Cambridge: Cambridge University Press, 1964.

# WHAT ARE POLITICIANS FOR?

## Gerard de Vries

POLITICS HAS a bad name. It's loathed for its endless disputes, rule-mania, and incompetence, its lack of transparency and rationality. We cherish democracy but complain about politics.

In the business world, middlemen are disappearing; organizations are becoming much flatter. So why don't we just remove politics, this irritant layer of mud, from society? Why don't we just take things into our own hands? With a few mouse clicks we will have established a citizen initiative on Facebook. We know best what is at stake and what has to be done: "We live here, okay?" Politicians, get out of our way. Spare us your politics.

Can one have a polis without politics, without politicians? What would we miss – apart from a topic we love to grumble endlessly about?

### 1.

FIRST, LET'S briefly review the function traditionally attributed to politics.

Established routines of living together fall short, problems emerge unexpectedly – or, even worse: "Things fall apart; the centre cannot hold." How to initiate appropriate policies, how to organize collective action? One option for rulers is to use force; another is to rely on the invisible hand of the market; a third is to turn to politics, the republican form of governing that explicitly acknowledges the existence of

GERARD DE VRIES *is an emeritus professor of philosophy of science at the University of Amsterdam. From 2006 to 2014 he served on the Scientific Council for Government Policy, the Dutch Government's think tank for long-term policy issues. His previous positions include professor of philosophy at Maastricht University and Dean of* WTMC, *the Netherlands Graduate School of Science, Technology and Modern Culture.*

a plurality of experiences, interests, and opinions, and that makes decisions on the basis of deliberation. Most likely, a compromise has to be reached; perhaps a more radical course of action is called for, something surprising no one has thought of before. In the republican tradition, politicians are viewed as innovators. They may have been selected by lot, be the heads of powerful families, or have been elected by citizens – but whatever brought them to politics, in dealing with the contingencies the community faces, they show civil virtues.

However, politicians also have to learn when *not* to be virtuous, Machiavelli taught. They must acquire the power not to be good and must understand when to use it as circumstances direct. So deliberation may turn into power struggle. There may be bloodshed. To prevent this horrible outcome, citizens should delegate a part of their power to the sovereign and consent to his rule, Hobbes argued. In return, citizens will receive a peaceful life. For

Hobbes, that was all that counted. Whether the sovereign was a monarch or a body elected by citizens was not his greatest worry. For practical reasons, he opted for monarchy.

In modern democracies both traditions have merged. We have representative democracy. In parliaments experiences, interests, and opinions are articulated, pros and cons weighed. But we also acknowledge that politics is not only a matter of deliberation, and that it may involve power. Enter Montesquieu, who taught that to secure freedom, separation of powers, a system of checks and balances, has to be introduced. All of that we now have in place. We are living in a state of law; we have democracy.

## 2.

SECOND, OBSERVE that the business of governing has changed in the past century. Politics has become what Bruno Latour has called *cosmopolitics* (*Politics of Nature*).

At the end of the nineteenth century the world learned – as Latour puts it – that "there are more of us than we thought" (*Pasteurization* 35). With Robert Koch and others, Louis Pasteur identified the existence of microbes and their role in the spreading of diseases. To prevent microbes from doing their deadly work, important parts of society had to be reorganized. The world had to be remade: waterworks and sewage installed as separate systems, hygienic measures introduced. It took some time before all of this was achieved. Koch had to fight long battles before the governors of cholera-stricken Hamburg were convinced. But once the measures were in place, life expectancy increased spectacularly. Humanity had come to take the existence of microbes into account and had learned how to live better with their presence.

We have to take much more into account than Machiavelli, Hobbes, and Montesquieu could ever have imagined. We are living with a lot more than we thought, indeed. Citizens can detect stench

themselves, but the facts that exposure to some chemical may cause cancer in the decades ahead and that current levels of $CO_2$ emissions will eventually cause climate change, with disastrous effects, are known only because of all the work scientists have invested in these matters in the relative seclusion of their laboratories.

So, to govern society, new powers have to be taken into account – not only the power of people, but also the power of microbes, noxious chemicals, ecosystems, the global climate. In cosmopolitics, we no longer have to deal with a community, but with collectives of humans and nonhumans. Can all of these powers fit into an ordered, collective, peaceful existence? As Koch and Pasteur showed, it may require quite a lot of reordering, a combination of technical, economic, social, and legal measures. Technical facilities have to be designed, rights and burdens distributed, new forms of behavior facilitated and stimulated.

New powers, new kinds of ordering, new questions: they demand new forms of deliberation. At the conference table, the politicians are already present. They represent their constituencies. Microbes, harmful chemicals, ecosystems, and the global climate are represented by scientists. Meanwhile, urban development experts, engineers, lawyers, and economists draw up their chairs as well, along with a few representatives of NGOs. Cosmopolitics takes place in hybrid assemblies – in and outside traditional political institutions, on municipal, national, supranational, and global levels.

So politics takes its course. There are public debates and debates among and with experts. All skills, competence, and expertise are needed. Compromises are negotiated and made law. We assess the results. Nobody has gotten what he wanted. Nobody recognizes himself fully in the outcomes of the political process. The nation is at peace, yes, but disappointment reigns.

Everybody's work is duly respected – that is, with the exception of the work of politicians. What do

they contribute to the cosmopolitical process, in which a multitude of others – scientists, engineers, lawyers, NGOs, you name it – are already involved?

### 3.

LET'S TAKE a closer look at the activities of politicians. What are their skills, what instruments do they have to offer that are unavailable to the experts already assembled around the table, or to a citizen with a Facebook account?

As to instruments, we will be ready soon. A notepad, a decent suit, an ear to pick up the latest rumors, and a good memory will do. Do politicians have a lot of friends who they can call for advice and support? Sure, they have fat address books – but nothing compared with what a little effort on Facebook can achieve.

Moreover, their contacts can hardly be called their friends. Politicians take to heart Cardinal Mazarin's advice, in his *Bréviaire des politiciens*: "Act with your friends as if they were to return one day as your enemies" (131; Trans. de Vries). If you want a friend, do not turn to a politician; buy a dog.

Skills, then? A politician needs the stamina to devour large stacks of papers and to listen to a wide variety of different voices, from both citizens and experts; the ability to weigh imponderables; the alertness and flexibility to react to contingencies; the awareness that at some time deliberation should lead to a decision; the endurance to sit through long, and boring meetings; some self-control (limit your greed and alcohol consumption, the cardinal advised); plus the courage to remain upright in a media storm.

But most if not all of these skills are also required these days for being a successful scientist, lawyer, or economist! So is a politician just a scientist without a laboratory, an economist without statistics, a lawyer without sufficient knowledge of administrative law? Is he the universal dilettante? What is there for this figure to do in contemporary cosmopolitics?

### 4.

WE NEED to change focus, Latour advises in his *Inquiry into Modes of Existence*. Stop talking *about* politics and *about* the skills of politicians. Try to display politics as a "mode of existence," as a specific "regime of enunciation" (375). Detect what it is to speak *politically*. Does this, as Latour suggests, involve "the Circle" that turns a multitude as yet unaware of what it wants into unity – a We who obey, distinct from the Them who are excluded – and then comes back and starts everything, *everything*, all over again in a different form – the Circle that traditionally has been celebrated under the name of autonomy (133–34, 342–43)?

Let's not jump to conclusions. Let's try to *empirically* detect what speaking politically means. Leave revolutions, demonstrations, strikes, and election campaigns for another occasion. Try to extract what political speech is from run-of-the-mill politics, i.e. the politics that goes on in assemblies that determine – together – the quality of people's lives as lived in the real world of safe food, clean water, decent housing, and breathable air, the future of the environment and eventually the planet.

What is the role of politicians in a cosmopolitical assembly – the kind of meeting where they confer with advisors? To what extent and how does their speech differ from the contributions of all the others – the scientists, lawyers, economists, etc. – that are also involved? What do they add to the discourse? Let's enter one of these meetings.

### 5.

IN THE CONFERENCE room are scientists, economists, lawyers, the representative of an NGO, and a few politicians. A discussion is needed. Why? Because there is an *issue* on which people take different sides; there is *uncertainty* as to what to do. The issue relates to public health, for example, or the environment, or the economy. But whatever it is, the

meeting will address the issue in the understanding that in some way, to some extent, what eventually will be decided will affect the order of things: to further the economy and to please motorists, a highway will be built in someone's backyard; to limit emissions of some chemical, the industry will have to redesign its production lines; next year, a new vaccination program will be started.

On the meeting table, in front of each participant, are notes written in advance by scientific experts, economists, lawyers, NGOs, perhaps a few newspaper reports as well. They bring the issue and the world outside into the meeting room. Are there also specifically "political" texts on the table? No. The politicians will have left their copies of their parties' latest manifestos at home. They know that when they cite those manifestos in the meeting, they will be bores.

The discussion is opened. Two key questions have to be answered: Which powers have to be taken into account? And how do all of those powers fit into a common, ordered, peaceful world? The chairman may suggest that for good order, separate slots of the meeting will be devoted to each question. It is unlikely that he will succeed. There will be two types of talk in the room; there will be speech in two different registers. A contribution in one register may immediately trigger discussions in the other. There will be a lively back-and-forth between the two. The chairman will have to let it happen.

The first register is *backward-looking talk*. Questions will be raised about how the notes and reports on the table refer to previous events, scientific results, laws, available budgets, and earlier decisions, i.e. to anything presented as "given" – which, however, may turn out on closer inspection to be quite disputable. Time and again, backward-looking questions will pop up. Is the available budget really set in stone, do the numbers add up, is this the outcome of really uncontroversial research, is that the only possible reading of the law or are there other interpretations, what exactly was decided

in a previous case? Eventually, the matters agreed upon will be cited in answering the first key question: what has to be taken into account?

Second, there is *forward-looking talk*. Time and again, the reasoning will take the form of little narratives. One participant may point out that "as we all know," because of A, we may expect B to happen. Someone else will interject that what will happen is certainly not B, but rather C, after which another participant may point out that if we also take D into consideration, C will not happen, and that it is thus indeed plausible that B is to occur, etc. The discussions linger on. By canvassing a wide range of alternative courses of action, in forward-looking narratives the future is *speculatively* probed. Discussants will cite their knowledge and previous experience to back up their narratives; economists may even refer to models that prove that something will happen – provided, of course, that people act "rationally" on the available information. But don't be fooled: everybody is fantasizing; everybody is suggesting contingencies, events, and causalities that may or may not happen. Don't expect this to be an orderly process. When backward-looking talk suggests another view on anything that was supposed to be "given," the forward-looking talk will take another turn. No, it's not certain that A is given, so we have to reconsider B, C, D, and E again. Talk, talk, endless talk.

No doubt the politicians will also take the floor; they too utter both backward- and forward-looking talk. They will bring their experience to the meeting; they know a lot of people and they may refer to them, calling them their friends. What do they have to offer, except amusing anecdotes and gossip? Should their input compete with the carefully prepared scientific evidence, the calculations and the legal scholarship on which the experts' contributions are based?

No. The anecdotes the politicians bring to the meeting should not be *compared* with the experts' contributions, but *contrasted* with them. They are spoken in a different key. The politicians are already

preparing the defense of the decision the assembly will make. Anticipating discussions that will come *after* the meeting, they assess the robustness of the basis on which the assembly's decision will be made and balance the pros and cons of the forward-looking narratives.

Look at their gestures in the meeting; they are old foxes who know many tricks. They may completely ignore someone's contribution. When X speaks, they will stir their coffee or check their iPhone for text messages; scientifically or juridically the guy may have a nice point, but politically it is irrelevant: it's unlikely that it will ever show up in a future meeting. At another moment, a politician may mumble, "I don't think the prime minister would be pleased with that," meaning that we don't need to travel that route, because any decision based on it will be discarded in a follow-up meeting. But he may passionately endorse a subsequent suggestion that he expects will help him convince the PM or any future audience to take his side.

Watch carefully what the politicians do. In their backward-looking talk and their reactions to the backward-looking talk of the others, they are probing whether what appears to be "given" will still hold water when they have to defend the assembly's decision – or their decision to take a minority view – in *future* discussions. Can they *trust* this research, the economists' calculations, the evidence the NGO representative cites, the interpretation of the law that is provided, or are other readings possible? Can they cite what is presented as "given" as a compelling reason, or will it collapse in the face of *future* opposition? In their forward-looking talk, they will speculate about what might happen and what the consequences of a proposed decision would be. They will specifically probe the distribution of rights and burdens that is implied, trying to detect who will be included in which role, who is left outside or downsized, which contingencies may happen. They want to get a clear view of what a decision will mean, concretely, for the lives of a

variety of publics, for the economy, the environment, the planet, because they know that they will have to defend the assembly's decision (or their minority view) before publics that will embrace, ridicule, or strongly oppose it. In the assembly's meeting, they are preparing for upcoming discussions. *They* will have to confront the general audience, their party members, and other politicians; *they* know that, given the system of checks and balances in place, whatever decision is made will be reconsidered again, in a different assembly or in a public meeting. It's a burden that none of the other participants has to carry.

On an upcoming Saturday afternoon, in a café in some backwater village, they will have to confront probably fifteen members of their party, ten of whom will accuse them of having compromised the party's principles and of being a hypocrite; the day after, on a late-night TV talk show, the host will publicly grill them; they will have to defend the decision of the majority in the assembly, or explain their own decision to take a minority view, in another meeting – in the cabinet, or in parliament.

And they will do so, arguing before the party members, on the TV show, or in some official body that the question is neither whether their constituency has gotten all it wanted nor whether everybody fully agrees, but whether *we can live with it* – that is, whether it is good enough, if not better. The party members, the television audience, or the politician's colleagues will be asked to look forward, to provide assent and *further* support.

Are the politicians anticipating the reaction of these future audiences because they are afraid of what the media will write or what their party members will say? Are they estimating their chances of not being reelected and thus losing their modest salary? Maybe they are, but their motives are not the point. They are speaking in another *key* because they know that whatever decision is reached, there will never be general approval. They are preparing for what comes next.

Late at night, the politicians will read what is posted on Twitter; the next morning, what's in the papers. It will not make them happy, but that's how it is. It's a dog's life, being a politician.

## 6.

OF COURSE, there is more to politics than cosmopolitical assemblies. But if this rough sketch is faithful to the role of politicians in run-of-the-mill cosmopolitics, can we detect more precisely what politics is as a mode of existence, i.e. [POL]?[1] Let's take stock.

Politics turns on an *issue*, something that provokes passions and controversy, a matter on which people take different sides. This is a necessary condition for any issue to be called a "political" one, but not a sufficient condition. It also applies to law, for example, and to science in the making. Moreover, like many other modes of existence, political action involves grappling with texts. Out of a large stack of notes and reports, some decision has to be brewed that will be registered in meeting notes that will probably land on other tables for further discussion, to be amended, discarded, or officially published in due course.

So, although the rule "no issue, no politics" holds, what is specifically passed in a political meeting must be something different. Grappling with texts, the discussants get involved in backward-looking and forward-looking talk. However, again, this is not specific to [POL]. We also find backward-looking talk in [REF] and in [LAW]. We find forward-looking talk in [TEC] and in [ORG] (plus quite dominantly in economics). So it's no great surprise that in a cosmopolitical assembly, where scientists, economists, lawyers, and other experts are present, both types of talk emerge. What we have to specify is a felicity condition that turns backward-looking and forward-looking talk into *political* talk.

As the above suggests, politicians are involved in both types of talk for *another* reason than other participants. They are involved in backward- and forward-looking talk because they know that at the end of the day, in a future meeting, they will be held accountable for the decision they agree upon (or for opting out by explicitly taking a minority view). The *continuity* they are trying to achieve is different from the ones in [REF] and [LAW], for example. They are trying to overcome another type of *hiatus*. Their concern is "the future."

Let's reflect on this for a moment. There is no doubt that time plays a role in politics. Circumstances may demand that a decision has to be made here and now, and an issue is discussed in the understanding that a decision will affect "the future." What does that mean? Distinguish between *time* and *history*. We sort events in time; we need clocks and calendars for that. History is something different; it situates events with respect to the extent to which they present *infringements*, i.e. affect one's existence. Use this distinction to distinguish between *future time* (the clock is ticking, a decision has to be made before tomorrow morning) and *future history* (the effects of a decision will *happen* to someone or something, i.e. affect their existence).

In the meeting, future time will be the chairman's responsibility (the clock is ticking, the meeting has to come to an end within an hour, the press is already waiting outside); but as we can detect from the questions they ask, the politicians' concern is future history. They speak in the awareness that they are discussing an issue that will affect the existence of human and nonhuman beings (a variety of publics, the presence of microbes, the environment, the global climate), and that it may also affect their own existence as politicians. Although a politician may use "time" as a resource to put pressure on others, both his backward-looking talk and his forward-looking talk are guided by a concern for

---

[1]    For a brief explanation of these abbreviations, which refer to the modes explored in the AIME project, see the glossary in this volume (**r**·M! 543–47).

future history. The future history of what or whom? Of the collective, or some part of it, a "public." What is at stake is how a decision on a concrete issue will affect (some) people's health, their employment, the national economy, the environment, or maybe even the planet.

The felicity conditions for someone engaging in *political* talk, then, are (1) that there is an issue that may affect the future history of a collective – or some part of it – and (2) that the speaker knows he will be held accountable for what he says in a *subsequent* meeting.

Or let's approach this from the negative side. When is political talk interrupted or void, i.e. what are [POL]'s infelicity conditions?

First, trivially, when talking ends and violence takes over, or when political talk is not deemed necessary because the market is supposed to take care of order. Yes, this has been part of the republican tradition's understanding of politics for a long time.

Second, again trivially, when the issue is not controversial, as nobody expects that whatever is discussed will affect future history, i.e. the existence of the collective or some part of it.

Third, when discussions are conducted without anyone present having the obligation to defend the decision *after* it has been made. Remove the politicians from the meeting and give the floor exclusively to scientists, and this will happen: they will question what's on the table for evidence. Or leave the discussion to lawyers: they will discuss jurisprudence. In both cases, backward-looking talk will predominate. Or, leave the discussion exclusively to economists: they will contribute forward-looking narratives (e.g. cost-benefit analyses) but will not question their textbook knowledge about how rational individuals act (perhaps someone else will do it at an academic conference, to no avail). All of the experts may have views about the decision of the assembly, but they don't have an obligation to defend it. If questioned after the meeting, they will declare that it was a political decision, not a scientific or legal one.

In *Antigone*, Haemon says to Creon: "You'd rule a desert beautifully alone" (184). But one cannot have a polis, a civil collective, when the felicity conditions for political speech are absent.

## 7.

IT'S A FRAGILE mode of existence, [POL]. To guarantee its continuity, institutions, the state of law – and thus another mode of existence, [LAW] – are required. Such interdependency of modes of existence is not uncommon. [REF] would lose its rationale without [REP]. As Ludwig Wittgenstein remarked in *Philosophical Investigations*, "the procedure of putting a lump of cheese on a balance and fixing the price by the turn of the scale would lose its point if it frequently happened for such lumps to suddenly grow or shrink for no obvious reason" (56e). "Autonomy" is not the value of [POL]. It's an outcome provided by [POL · LAW], a crucial crossing for rule of law and democracy. Montesquieu knew that already.

## 8.

IT'S A DOG'S LIFE, being a politician. We talk *about* them; we rate their results. Who has won, who has lost? The media report about politics as if it were a sport; easily, we copy their language. We completely neglect the fact that [POL] is a mode of existence, a regime with a rationality of its own. Talking about politics, we forget the *work* that politics requires, the preparation for what's next that is the rationale of the process, the specific rationality of political speech. Political speech: that's what politicians are for.

Works Cited

Hobbes, Thomas. *Leviathan*. Ed. J. C. A. Gaskin.
    Oxford: Oxford University Press, 1998. Print.

Latour, Bruno. *An Inquiry into Modes of Existence: An
    Anthropology of the Moderns*. Trans. Catherine
    Porter. Cambridge, M A : Harvard University
    Press, 2013. Print.

---. *The Pasteurization of France*. Trans. Alan Sheridan
    and John Law. Cambridge, M A : Harvard
    University Press, 1988. Print.

---. *Politics of Nature: How to Bring the Sciences into
    Democracy*. Trans. Catherine Porter. Cambridge,
    M A : Harvard University Press, 2004. Print.

Mazarin, Cardinal Jules. *Bréviaire des politiciens*. Trans.
    François Rosso. Paris: Arléa, 2007. Print.

Machiavelli, Niccoló. *The Prince*. Trans. Harvey
    C. Mansfield. 2nd ed. Chicago: University of
    Chicago Press, 1998. Print.

Montesquieu, Charles de Secondat, Baron de. *The
    Spirit of the Laws*. Trans. and ed. Anne M. Cohler,
    Basia Carolyn Miller, and Harold Samuel Stone.
    Cambridge: Cambridge University Press, 1989.
    Print.

Sophocles. *Antigone*. Trans. Elizabeth Wyckoff. *The
    Complete Greek Tragedies*. Ed. David Grene and
    Richmond Lattimore. Vol. 2. Chicago: University
    of Chicago Press, 1954. 158–204. Print.

Wittgenstein, Ludwig. *Philosophical Investigations*.
    Trans. G. E. M. Anscombe. 2nd ed. Oxford:
    Blackwell, 1986. Print.

# REFERRING TO GRACE, PERFORMING GRACE

## Lorenza Mondada, Sara Keel, Hanna Svensson, and Nynke van Schepen

## INTRODUCTION

ON 26 JUNE 2015, in the Arena of the College of Charleston, in front of 6000 people, Barack Obama pronounced a eulogy for Reverend Clementa C. Pinckney, senator of South Carolina and pastor of the Mother Emanuel African Methodist Episcopal church who had been killed together with eight other persons during a bible study session by a white supremacist, one week earlier.[1]

This much-commented speech represents an exemplary event for the analysis of crossing relations between politics and religion. Obama's eulogy has the character of both a political speech and a religious sermon. It appeals to political values and to the Grace of God. It represents a good example of overtaking the injunction to give back to Caesar what is Caesar's and to God what is God's, mobilizing God to promote political action and political history to encourage religion.

Political speeches, as well as sermons, are performed by a speaker addressing an audience. Both engage in quite distinct activities, and occupy specific spatial and bodily positions. As this paper will show, this asymmetry does not entail that the audience passively listens or mechanically responds – quite the opposite: we will demonstrate that the audience plays an active role in the delivery of the speech, and participates in choral moments in which

LORENZA MONDADA is a professor of French and general linguistics at the University of Basel and Finnish Distinguished Professor at the University of Helsinki. Her research focuses on social interaction in ordinary, professional, and institutional settings as well as the language of politics. In the latter context she directs the Swiss National Science Foundation (SNSF) project "Speaking in Public: Social Interactions in Large Groups."

SARA KEEL is a postdoctoral researcher at the French Seminar of the University of Basel and author of Socialization: Parent–Child Interaction in Everyday Life (2015). In addition to this research area, she currently focuses on patients' interactions with healthcare providers and their participation in discharge planning meetings, and public events organized and held by immigrants' protest movements.

HANNA SVENSSON is currently a PhD student at the University of Basel in the Swiss National Science Foundation (SNSF) project "Speaking in Public: Social Interactions in Large Groups." She engages with the interactional practice of other-initiated repair and how it is mobilized to manage and negotiate shared knowledge and public understanding in institutional multi-party interactions.

NYNKE VAN SCHEPEN is a PhD student at the University of Basel in the Swiss National Science Foundation (SNSF) project "Speaking in Public: Social interactions within large groups." In her dissertation, she focuses on the way citizens manage to speak in public, dealing with analytic issues concerning turn-taking, formulation and formation of actions, and participation as it is locally shaped and created by these practices.

the speaker merges with it. In this respect, the speech does not merely refer to and address a collectivity, but actually enacts and performs this collectivity. More profoundly, Obama's eulogy operates a political and religious transformation of all co-participants.

This study exploits current advances in conversation analysis: in this perspective, actions of the speaker are never considered independently of the responses they get, being conceived as interactive coproductions (Sacks; Schegloff); actions are interactively consequential in the way they are formatted within temporal arrangements of multimodal resources (like talk, gesture, gaze, body postures) (Goodwin); actions are specifically formatted in institutional settings (Drew and Heritage).

Our analysis of Obama's eulogy is based on the broadcasted event in several TV channels and Internet sites, and focuses on the reference to and, finally, achievement of "grace." This theological term is recurrently used during the eulogy; we demonstrate that the way it is mobilized is in service of different forms of interactivity as well as different hybridizations of religion and politics. In the first part, it is used thematically to describe an historical event, the shooting ("THEY"), and the way Obama ("I") reflects about it. In the second part, it is used politically to mobilize the collectivity of citizens ("WE") engaging in political actions. In the third, it is used religiously, being enacted by Obama and the ensemble of the participants engaging in a choral activity, singing the hymn "Amazing Grace."

Obama's eulogy massively uses classical rhetorical devices that have been described in the literature as very powerful to trigger audience's applauses (Atkinson). But he does more than that. His speech, built entirely on the idea of grace – first mentioned and finally performed – mixes rhetorical skills, politico-religious forms of action, argumentation, and

1 When Obama says "GRACE/" line 5. Video still.

passion. The aim of this analysis is to demonstrate some systematic practices transforming a discourse about grace into a collective state of grace.

## SETTING THE SCENE: TALKING ABOUT GRACE

AT THE BEGINNING of his eulogy, Obama sets the scene, referring both to the shooting and to himself reflecting upon it. In both cases, he refers to the notion of grace as an interpretive tool to describe, understand, and account for what has happened.

Since its very first mention, reference is not only made to the notion of grace, but elements of the hymn "Amazing Grace" are used to set up the contrast between the protagonists of the shooting: the killed group, surrounded by grace, and the killer, blind to it (see Extract I).[2]

[1]  The eulogy is available on the Internet in several versions. For the transcripts we have mainly worked on three sources. The first comes from the PBS NewsHour, an American daily evening television news program broadcasted on the Public Broadcasting Service. The second is provided by C-SPAN, a network specialized in U.S. political events, broadcasting most political and policy events in an unedited way. The third is an amateur video shot within the audience. For reasons of space, we cannot include an analysis of the footage itself, which deserves further studies.

Extract 1

```
 1  OBA   bl*inded by *ha:tre:d
    oba      *looks L--*looks down-->
 2         (.)
 3  OBA   th*e alle*ged kille:r*
    oba    ->*looks R*looks down*looks R->
 4         (.)
 5  OBA   could not see the $GRA#CE/$ $(0.3)$
    oba                     $parallel hands$nods$
    fig                         #fig.1
 6  AUD   *YEAH:::[:::::::]
 7  OBA          [surrou]:*nding reverend *pinckney
    oba    ->*looks down----*looks L--------*looks down-->
 8  AUD   *THAT'S RI::[:::GHT]
 9  OBA            [and th]at bible study gro†up*
    oba    ->*looks L----------------------------*looks down-->
    cle                                †...-->
10  AUD   [<(0.6) applause>† (0.5) applause† (.) applause* (0.7) applause>]
11  AUD   [<(1.9) YEA::::::::::::::::::::::::::::::::::::::::::::::::::::H>]
    cle   ..............†RH blesses----†,,,-->>
    oba                                      -->*looks R-->>
```



In describing the protagonists, Obama does not only use different words to characterize them, but also performs them in an asymmetrical way. While he describes the killer twice as blinded, Obama mainly looks down at his own text, in a way that does not invite any response – remarkably he also prevents negative responses – performing his speech in such a way that the audience does not respond at all to the first lines.

However, when he mentions the "GRACE/" (5, fig. 1), he mobilizes an array of multimodal resources: a louder and emphatic voice, a gesture done with two parallel hands locating and materializing grace, and a subsequent nod. All invite and encourage a positive response, coming in the form of a collective "YEAH::::" (6), and project further positive developments implemented in the next two units, referring to Reverend Pinckney (7) and to his group (9). While "GRACE" was the last word of the previous syntactical construction, these further units represent two increments to an already completed form: they are not projected as such, and thus susceptible to create an effect of surprise, mobilizing increasing responses: an upgraded response token ("THAT'S RI::[:::GHT]" 8), applauses (10), prolonged YEAHS (11), and a blessing gesture done by one of the clergymen besides the speaker. This episode introduces the idea of grace for the first time, and organizes the audience's response precisely on that item.

Another way Obama sets the scene is by situating himself in relation to what happened. This is again done by referring to grace, in several ways that will have structuring consequences for the unfolding of the speech (see Extract 2a).

Obama speaks about grace as a topic of reflection: he does this within a turn that constitutes an announcement and projects more about the results of this reflection. The reference to himself is self-repaired ("i'VE:-" suspended and then

[2]   Transcript conventions: Talk has been transcribed according to conventions developed by Gail Jefferson. Multimodal details have been transcribed according to Lorenza Mondada conventions (see <https://franz.unibas.ch/fileadmin/franz/user_upload/redaktion/Mondada_conv_multimodality.pdf>).

Extract 2a

```
1         (0.9)
2   OBA   °>eh<° this whole week i:'VE:- (0.2) i've been reflecting
3   OBA   on this idea of grace\
4   OBA   [-----------------------(11.3)----------------------------------]
5   CLE   [yes [haha]
6   AUD        [YEAH]
7   AUD            [YEA[H]
8   CLE                [ah]ah [ah ah]
9   AUD                    [YEA:[H]
10  AUD                         [appl APPL APPLAUSE APPLAU::SE [appl]
11  CLE                                                        [yeah]
```

restarted with "i've" 2) in a way that lowers the volume on the self-reference, making it more discrete, but also attracts the attention to it, by creating a discontinuity in the talk.

This announcement and self-disclosure are responded to by the audience in diverse manners (5–11): by acknowledgments, increasing applauses, and even by laughter (5, 8). These responses are quite personal and mundane, of encouragement, slight irony, and challenge. Obama goes on with an extended reference to the hymn (see Extract 2b).

This excerpt is structured as a very classical three-part list (12, 17, 21), in which each item begins with "the grace" as syntactical subject. These lists have been described as one practice "inviting applause" (Atkinson 57–72). It is noticeable that the first two elements (12, 17) are received with response particles (14–16; 19–20), and followed by a silence (13, 18) managed by the speaker. By contrast, the third item (21) is very differently formatted. It is expanded (23) and contains a reference to "my favorite hymnal" which is not immediately made explicit but rather projected, by "the one we all know/" – which operates the conjunction of Obama and the audience in a unique collectivity of practice. This conjunction is not only rhetorically stated, but also collectively performed within a distinct response by the audience: by saying "yeah" (25–26) they display a recognition of the hymn; more significantly, some participants already anticipate and pronounce the

name of the hymn (27–28) even before Obama tells it (29). In this way, the audience not only responds to Obama, but produces what Obama subsequently repeats with them.

The hymn is then fully quoted (28, 34, 37, 40, 43, 46, 49), each of its elements being responded (30, 32, 35, 38, 41, 44, 47, 48), applauded (33, 39, 45), and even anticipated (27, 28, 40) by the audience. The text is said in such a way that it permits the identification of Obama in/as the first person pronoun. In conformity with the beginning of this fragment (extract 2A), the hymn is used here in a descriptive way (reflecting, talking about grace) – which will contrast with it being sung at the end of the eulogy.

## A POLITICAL MOMENTUM: EXHORTING TO COLLECTIVE ENGAGEMENT, EXPRESSING GRACE

IN THE PREVIOUS fragment, Obama identifies himself with the story told in the hymn as a person – using the first person pronoun "I." He uses the hymn to identify with a trajectory of personal transformation, and in accord with the religious text. Later during his eulogy, he refers again to the hymn, but rather uses it in a political way. Thrice, he introduces points of political engagement – exhorting to take down the confederate flag, to create equal opportunities for all citizens, and to stop gun violence – and formulates these points systematically using the

Extract 2b

```
12 OBA   the GRAce of the FA:milieS:: who lo:st °loved ones/°
13 OBA   [----(1.0)----] (1.0)
14 CLE   yeah=
15 CLE       =yea[h]
16 CLE          [y]eah]
17 OBA   the gra:ce that (0.5) rev'rend pinckney would preach about in his sermons
18 OBA   [---(0.8)----] (1.2)
19 CLE   [ah[a/]
20 AUD     [°ye]ah:::°]
21 OBA   the grace descri:bed in (1.1) one of my favourite hymnals/
22 CLE   mhm/
23 OBA   the one we all know/
24 OBA   (0.3) [---------------(1.9)----------------]
25 AUD         [yea::[h   yea]::h yea::h [ yea::h]
26 CLE          [ yeah  ]
27 CLE                              [amazi[ng
28 CLE                                  [°°am[azing grace°°]
29 OBA                                       [aMAzing  gra][ce\]
30 CLE                                              [yea]::haha]
31 OBA   [---------(2.6)----------]
32 AUD   [yea:::::[::::::::[:::::::h>
33 AUD            [applause a[pplause applause applause]
34 OBA                      [how  sweet  the  sound\]
35 AUD   <(2.2) yea::::h yea::[:::>:[::h ]
36 CLE                        [oh my:
37 OBA                            [that] SA::ved a wretch like me\
38 AUD   [<(2.2) yea:::::::::::::::::::::h>]
39 AUD   [<(3.9) appLAU:::SE applause applau:::]::::::se>
40 OBA   i once was LO:[st/]
41 AUD                 [YEA]H/ <(1.4) yea::::h >
42 CLE   °°°b[ut now i'm found°°°]
43 OBA       [but now/ I'M found\]
44 CLE   [<(0.7) YEAH>
45 AUD   [<(1.6) YEAH applause>
46 OBA   w[as bli::nd/]
47 CLE    [was bli:nd]
48 AUD   <(0.5) yea:>[:::::::::::::]:::::::::h>
49 OBA              [but now/  I  see\]
50       (0.3)
```

same format that he uses for the second argument, which receives the biggest applauses (see Extract 3). Obama's political argument is developed within a three-part list, introduced with "by + a verb of political action" (1, 5, 21). While the first part is brief and receives, within the speaker's pause (2), minimal responses (3, 4), the second part (5–19) is rather complex, formatted as a proposition with several subordinate clauses. Its beginning (5) is received with some response tokens and incipient applauses

during a pause managed by the speaker (6) – but then the continuation is delivered in an accelerated pace during continuous applause (11–19). Here not only the talk engenders applauses, but applauses generate more talk, increments, and additions.

This prepares the third and final part (21), which equates the political actions as an expression of grace. The reception here is upgraded, with the audience not only applauding but standing up: interestingly, the first clergyman starts to stand up on the

2   Taken when Obama says "gr<u>a</u>ce" at the end of line 21.
    Video still.

Extract 3

```
 1 OBA    by re:cognizing our co:mmon (0.3) humanity
 2 OBA    (0.3) [---(0.8)---] (0.3)
 3 AUD         [yeah[::]
 4 AUD              [ye]ah\]
 5 OBA    by treating e:very chi:ld as important
 6 OBA    [------(1.6)------]
 7 AUD    [YEA[::H]
 8 AUD        [YEA:[:[[:::H]
 9 AUD           [appl. appl. appl. appl]
10 CLE            [that's] ri[ght/]
11 OBA                       [regA:r]dless of the color of their ski:n/
12 AUD    &[applause applause applause applause applause applause applause&
13 AUD     [YEA::[::::::::::::::::::::::::::::::::::::::::::::::H]
14 OBA         [or the sta:tion into which they were bo:rn]
15 AUD    &[applause applause applause applause applause applause applause&
16 CLE     [that's [right/]
17 OBA            [and to d]o: what's necessary/
18 AUD    &[applause applause applause applause applause applause applause&
19 OBA     [to make opportunity (0.4) rea:l (0.3) for e:very ame:rican
20 AUD    YEA$::[::::H]
21 OBA         [†by $do]ing $that/ $we$ °exp$ress$ god's grace #
   oba    $RH up--$stroke-$stroke$stroke$RH up$RH down$
   cle         †stands up-->
   aud                              °stands up-->>
   fig                                              #fig.2
22 AUD    &[APPLAUSE APPLAUSE APPLAUSE APPLAUSE APPLAUSE APPLAUSE APPLAUSE]
23 CLE     [YE[AH::]
24 CLE       [YEAH:[:]
25 AUD           [YEA:::::::::::::::::::::::::::::::::::::::::::::::::H]
```

very beginning of this third part (21), projecting and anticipating its gist, which is positioned at the very end of the turn. The three-part list thus prepares for the final climax, which is not just generated by the speaker but actively coproduced by the audience. This coproduction also responds to Obama's use of first person plural pronouns ("our" 1, "we" 21), to its reference to common human (1) and American values (19), as well as to equality (recurrence of "e:very" 5,19). More radically, the co-participants solicited by the use of "we" respond by collectively sustaining and even anticipating Obama's discourse, affiliating with its collective dimension. This collectivity will be enacted at the end of the speech within a truly collective action: singing the hymn.

## A RELIGIOUS MOMENTUM: PERFORMING COLLECTIVELY, ACHIEVING A STATE OF GRACE

AT THE END, the speech culminates again in the invocation of the grace, in a unique way (see Extract 4a)

In this segment, grace features in two very similar bipartite "if/then" constructions (1, 5; 12, 16). The first part of the first construction receives minimal responses (3–4, after a pause, 2). The second part gets increasing responses: after a pause (6), some response tokens (7–9) are followed by incipient applauses (10). The audience recognizes immediately the second construction, produced in a very similar way, with a strained voice, several beat gestures, and a panning gaze alternating between the right and the left – and responds with stronger applauses, which continue after the second part is produced (17). In this way, we can say that Obama prepares the reactiveness of the audience, which increases from the first to the second construction.

The next step is produced after a pause that corresponds with a silence of the audience (20), clearly waiting for something to happen (see Extract 4b).

The silence is stopped by a first "ama:zing/ grace\" (21) which gets some rare responses followed by a silence (22), only suspended by a second mention of it (27) again followed by a long silence (28). Clearly the audience is still waiting for something to happen.

What happens next are the first syllables of the hymn. The fact that the hymn is now sung, rather than mentioned, becomes recognizable after two stretched syllables also corresponding to the hymn's first tonal interval: at that point, one of the clergymen smiles and utters a response token (33); most significantly, the next syllables are produced first by the audience beginning to sing (34) rather than by Obama himself (36) who continues later, then in unison with the audience (37) – as the clergymen persons stand up (37). The entire arena joins in singing and in other responses as the song goes on.

Through the singing, rather than the mention, of the "sweet sound," Obama transforms the reflection about grace into a state of grace for himself and all his co-participants.

## CONCLUSION

THE SPEECH operates a progressive radical transformation in the way in which grace is mobilized: it is first descriptively referred to, then normatively attributed to wished for political actions, and finally collectively achieved by the choral singing of the hymn "Amazing Grace." Through this transformation Obama explores different uses of the word: talking about, exhorting, invoking, and finally being talked through. His words first just describe states of affairs, using the hymn as an intertextual resource; finally, his words achieve a state of grace, ceasing to mention the hymn in order to sing it. Reference to the hymn is addressed by the speaker to the audience, to construct a collectivity including the audience and all citizens; by contrast, the song of the hymn dissolves the difference between the speaker and the audience, the latter initiating more and more frequently turns before the

Extract 4a

```
 1 OBA   $*°°if we can f$i:nd/°° <((strained voice)) $°tha:t $gra*ce/°>$
   oba   $Lfist up-----$small strokes-------------$Lfist up$Lhand down$
   oba   >>*looks L-------------------------------------------*looks down-->
 2       (0.2)
 3 CLE   aha:/
 4 AUD   u:hm
 5 OBA   *anything is* possible\
   oba   *looks R, shakes head*looks down-->
 6 OBA   (0.2) [----------------------(2.2)------  -----------------]
 7 CLF         [ye[ah]
 8 CLE            [*>my] my[\<]
 9 AUD                     [y]eah:/]
10 AUD                        [app. app. app. [app. app. app. app. app.]
11 CLE                                         [my my\]
   oba         -->*looks L-->
12 OBA   $*[if we can $ta:p$ *(0.3) that (.) $gra$*ce$
   oba   $Lfist up----$beat$two small beats--$Lfist up$Lfist down$
   oba    ->*looks R---------*looks down----------*looks R-->
13 AUD      [applause applause applause applause applause applause applause
14 AUD   <(0.7) applause [applause> [applause applause applause applause
15 CLE                   [aha/]
16 OBA                            [EV:erything can cha*nge\
   oba                                       -->*looks down-->
17 AUD   [<2.2) appla[use applause] app*lause> [<(1.1) app.>
18 AUD   [u::hm]
19 CLE                [a:ll right\]
   oba                            -->*looks L-->
```

former, and both merging in a collective performance. Mentioning the hymn can be used to recognize Pinckney as a pastor and a senator, and to refer to political as well as religious concerns; producing it as "sweet sound" achieves the state of grace that was just evoked and referred to at the beginning. Within these transformations, Obama operates the definitive hybridization of religion and politics as well as the fusion of believers and (American) citizens.

Works Cited

Atkinson, Max. Our Masters' Voices: The Language and Body Language of Politics. London: Methuen, 1984. Print.

Drew, Paul, and John Heritage. Introduction. Talk at Work. Eds. Paul Drew and John Heritage. Cambridge: Cambridge University Press, 1992. 3–65. Print.

Goodwin, Charles. "Action and embodiment within situated human interaction." Journal of Pragmatics 32 (2000): 1489–1522. Print.

Obama, Barack. "Eulogy for Reverend Clementa C. Pinckney." PBS NewsHour. PBS. Washington, D.C., 26 June 2015. YouTube. Web. 17 Dec. 2015. Available at <https://www.youtube.com/watch?v=ZDXM0O9ABFE>.

---. "Eulogy for Reverend Clementa C. Pinckney." C-SPAN, 26 June 2015. YouTube. Web. 17 Dec. 2015. Available at <https://www.youtube.com/watch?v=Abc41Cd90qU>.

Peart, Brenda J. "My View – POTUS Obama singing Amazing Grace – Hon. Rev. Clementa C. Pinckney Funeral CHS." YouTube. YouTube, 26. June 2015. Web. 17 Dec. 2015. Available at <https://www.youtube.com/watch?v=W40q0KqL8P8>.

Sacks, Harvey. Lectures on Conversation. Oxford: Blackwell, 1992. Print.

Schegloff, Emanuel Abraham. Sequence Organization in Interaction. Cambridge: Cambridge University Press, 2007. Print.

Extract 4b

```
20        (2.8) *(1.6)
   oba      -->*looks down-->
21 OBA    ama:zing/ grace\
22 OBA    [--------------(1.7)-------------][--(2.7)--]*
23 CLE    [aha/
24 CLE        [xx/
25 AUD          [uhUm/
26 CLE                      [my my\]
   oba                            ->*looks R-->
27 OBA    ama:zing/ grace\
28 OBA    [----------(2.6)--------------][------(4.6)---*-----(5.5)----]
29 CLE    [uhu[:m/]
30 CLE      [x]xx/]
31 CLE                  [my my\]
   oba                          -->*looks down-->
32 OBA    ama::::[:]
33 CLE        [gh]aha[:\]
34 AUD          *[zi][:ng:  [gra*:ce]
35 AUD              [y:e:a::::::::::::::::::::::::::::h]
36 OBA              [zi::hi::]:hi:ng †[gra:::ce/ ]
37 AUD                      [grace::ce/]
   oba        -->*looks R--------*looks behind-->
   cle                              †stands up-->>
38 AUD    [who:::/ ha:lleluja:h\]
39 AUD    *[YEA:::::::::::::::::H]
   oba   ->*looks at audience-->>
```

3    Obama and the audience singing together.
Video still.

WHEN ENGLAND AND FRANCE began to extend some of their new-fangled administration to the vast expanses of America, they realized that it was impossible for them to include the powerful Native American nations they had encountered as though they were a part of Wales or Brittany, nor could they simply police them. For well over a century, they had to build what Richard White had called a "middle ground" (r·M! 420–25), a precarious series of diplomatic encounters. It was at those meeting points where all parties realized that everything had to be renegotiated – from the basic principles of law, to the gestures you had to make in order to express your peaceful intentions, all the way to how to offer gifts, wage a war, exchange prisoners, share tribute or smoke the peace calumet.

As White recounts, each middle ground acted as a way to reinvent anthropology since it was impossible to take anything for granted – at least as long as both sides remained of comparable strength. Later, once the First Nations had been decimated and the new kingdoms had seized their land, this testing ground for anthropology vanished. Native Americans were rendered thoroughly exotic. When they lost their power, they were unable to bring the "civilizing" nations back to the middle ground. The ground was fully occupied. First Nations had to be content with reservations. They had become "the other."

If this example is apt, it is because it introduces a wedge between two ways to build encounters with the other from the point of view of anthropology: the scientific and the diplomatic. In the scientific way, no matter how much you learn about yourself thanks to the contrast between the views of your societies and those of the culture you study, no surprise in what you encounter can jeopardize the solidity of the epistemological framework that has sent you into the field. No matter how deep your anxiety, science will always win. In the diplomatic situation, this is not the case. What you hold to, including your science, or the very idea of what a science is, might be jeopardized. You are never sure to survive the encounter. While epistemology always unfolds onto a solid ground, diplomacy, on the other hand, has to get by on a moving one.

This is why the metaphor of the middle ground is an apt one to designate what we are trying to draw with the expression "reset modernity." It has become literally true that the ground has shifted under our feet, or that it has been moving just as much as the history that used to take place on top of it. Such is the situation coded by the label "Anthropocene": the addition of history of unstable humans

**Procedure 7**

# IN SEARCH OF A DIPLOMATIC MIDDLE GROUND

on top of the history of an unstable earth system. Everything happens as though we had moved from a stable land to a moving sea. Geostory is history squared.

Middle ground also designates the atmosphere invented in the exhibition and in the layout of the catalog to get away from the impression that we are always sandwiched between two dimensions, what we have called the up and the down. Such is the scenography of Plato's cave, with a realm of light we should try to reach in order to avoid remaining prisoners of a realm of darkness – or the opposite (Latour, "Let's Touch Base!," r·m! 11–23). To be on moving ground, that is, to render oneself finally attentive to the specific features of the earth, requires a different feel for things in order to register what it is to be mundane, earthly, and secular (Allen, Mareis, and Bruder, r·m! 496–515). To be within the world is no longer to be torn between transcendence and immanence.

1a–c    *Make it Work / Théâtre des Négociations*. View from the top of negotiation room by 4 webcams. 26 May 2015. Scenography: raumlaborberlin. Image: Benoît Verjat.

Transcendence is nowhere but in the many discontinuities that are necessary for agencies to achieve their common existence. It does not constitute another world above and beyond this one, but is distributed deep inside the agencies themselves. As to immanence, it is never smooth and continuous enough so as to be simply there, offering nothing more than the strange shape of mere matters of fact. It does not make up a world of below, but it is just as much distributed throughout the agencies. "Dappled" would be a good adjective.

Middle ground also means what happens to the former moderns when they accept the resetting of what they had called the "modernity" that made them simultaneously proud and ashamed – ashamed of being proud and proud of being ashamed! When you are invited to find your way by stumbling in the dark toward the middle ground, it is superfluous to feel pride or shame. You have no time for that. You'd better look around for what could go wrong. Watch your step. Compose your demeanor. Turn your tongue seven times in your mouth. You are no longer sure of who you are.

To pursue the allusion to White's description, the whole idea of the procedures of reset is to prepare the former moderns to meet others in another way. It is to warn them: beware, those you are going to

encounter will no longer look like the other of the past when you believed you knew yourself to be superior to them. From now on they will appear as those who require you to deeply recompose what you hold to. You are not welcoming them to *your* space, inside your epistemological database. Space is being disputed, and time too, and the way to sit, to salute, to breathe, to exchange gifts, to wage war.

This is what the AIME project aims at in the end: moving you forward (that is backward!) to the sixteenth century! To reinvent a situation where you, the "discoverer" of foreign land, find yourself in a state of great weakness. Yes, this space is a fiction, an invention, but it is also the best way to test both what you hold to and what holds you (Stengers, **r**·M!426–32).

If it is so important to trace such a meeting place on the sand – or rather on the concrete floor of a museum devoted to media art – it is because it allows the former moderns (those who realize they have never been such) to reinterpret their history and to detect through what sort of strange transformation (mutation? metamorphosis?) they have ended up becoming naturalists for a while, to use Descola's term (**r**·M!121–28; Descola, *Beyond*). And then the tantalizing possibility opens up: through what small change, once they have been brought back to a sixteenth century atmosphere, could such naturalists turn back to analogism? Or at least, enter into all sorts of new possible propositions, like the "sylvan ontology" introduced by Eduardo Kohn (**r**·M!445–49; Kohn, *Forests*).

The diplomatic encounters have a strange capacity to modify the way philosophers define their task. Even the distinction between speech and being is unsettled. Such is Patrice Maniglier's attempt when he uses the occasion of the middle ground to give a new ontological status to the concept of sign (**r**·M!475–85). Because the others have stopped being exotic in the old ways, they gain the capacity to make the former moderns redefine what they are attached to in the end.

Such is the sort of risk you run when you begin to penetrate the middle ground. Suddenly you begin to realize that the instruments you previously used to record modes of existence now register signals you had never registered before. The dead, for instance, may have an agency for which there was no format when you thought of yourself as an enlightened modernizer.[1] But so, too, might there have been agencies that went undetected in the many day-to-day encounters firmly situated within the institutions of industrial societies (P3G, **r**·M!455–67). Since today every collective has been thoroughly modernized, the exchanges of properties are now heading in all sorts of directions. Thanks to the middle ground, we are all beginning to be equally nonmodern; that is, fumbling our way in the midst of equally fragile entities.

[1] See Despret, "Dead," (**r**·M!450–54) and Despret, *Au Bonheur*. The same thing will happen to animals without an artificial soul being added to them (Despret, *Que Diraient les animaux*).

There is clearly a vast distance between the experience moderns *have* and what they are *supposed* to experience – as if they could never focus on what is happening to them. Yes, as if moderns were constantly distracted, unable to give attention to their attachments (Karsenti, r·m! 433–44). Pragmatism as a philosophical school had attempted to direct our attention to experience ("we want nothing but experience, but we don't want *less* than experience"). Indeed, pragmatism also tried to reset the modernist project as it had developed from Kant onward through the industrial revolutions and colonization, but it failed to build any middle ground. Today, largely because of ecological mutations, moderns are trying to escape from the pseudo-problems they have multiplied to avoid being of this earth (Debaise, r·m! 486–90). So, in a sense, pragmatism comes to fruition a century late, when "the earth" begins to replace "the globe."

The universal ground of the globe and of globalization has very little to do with the middle ground of today. Obviously, once the moderns have reset their instruments and have become able to register their experience they look terribly clumsy. Such clumsiness is even more patent if you try to employ a diplomatic vocabulary through the use of an overly complex digital instrument (Ricci et al.), which will appear simultaneously much too open and much too dogmatic to those who look for the type of certainty proper to philosophical style (Blake, r·m! 468–74). When the reset moderns reintroduce themselves to the other collectives, they hesitate, they parley, they fight for the exact words. And they are open to ridicule in face of the others who, themselves in their turn, don't know how to address them (Viveiros de Castro, r·m! 491–95).

Works Cited

Allen, Jamie, Claudia Mareis, and Johannes Bruder. "Why Is It So Hard to Describe Experience? Why Is It So Hard to Experience Description? " Latour, *Reset Modernity!* 496–515.

Blake, Terence. "De-Briefing AIME Project: A Participant Perspective." Latour, *Reset Modernity!* 468–74.

Debaise, Didier. "The Celebration of False Problems." Latour, *Reset Modernity!* 486–90.

Descola, Philippe. *Beyond Nature and Culture.* Trans. Janet Lloyd. Chicago: Chicago University Press, 2013. Print.

---. "How We Became Modern: A View from Afar." Latour, *Reset Modernity!* 121–28.

Despret, Vinciane. *Au bonheur des morts: Récits de ceux qui restent.* Paris: Les Empêcheurs de penser en rond / La Découverte, 2015. Print.

---. "Bring the Dead into Ethology." Latour, *Reset Modernity!* 450–54.

---. *Que diraient les animaux si... on leur posait les bonnes questions?* Paris: Les Empêcheurs de penser en rond / La Découverte, 2012. Print.

Karsenti, Bruno. "A Philosophy of Attention." Latour, *Reset Modernity!* 433–44.

Kohn, Eduardo. *How Forests Think: Toward an Anthropology Beyond the Human.* Berkeley: University of California Press, 2013. Print.

---. "Modes That Move through Us." Latour, *Reset Modernity!* 445–49.

Latour, Bruno. "Let's Touch Base!" Latour, *Reset Modernity!* 11–23.

---, ed. *Reset Modernity!* Cambridge, MA: The MIT Press, 2016. Print.

Maniglier, Patrice. "The Embassy of Signs: An Essay on Diplomatic Metaphysics." Latour, *Reset Modernity!* 475–85.

P3G. "Reset Inquiry!" Latour, *Reset Modernity!* 167–83.

Ricci, Donato, et al. "Clues. Anomalies. Understanding. Detecting Underlying Assumptions and Expected Practices in the Digital Humanities Through the AIME Project." *Visible Language* 49.3 (December 2015): 34–61. PDF file.

Stengers, Isabelle. "Don't Shock Common Sense!" Latour, *Reset Modernity!* 426–32.

Viveiros de Castro, Eduardo. "On the Modes of Existence of the Extramoderns." Latour, *Reset Modernity!* 491–95.

White, Richard. *The Middle Ground: Indians, Empires and Republics in the Great Lakes Regions 1650–1815.* Cambridge: Cambridge University Press, 1991. Excerpts rpt. in Latour, *Reset Modernity!* 420–25.

2    The AIME team preparing
     the first AIME workshop with
     the GECO (Groupe d'études
     constructivistes) on the crossing
     [MET·REF]. Brussels, 29 June
     2012.

3    AIME workshop groups on the
     crossing [MET·REF]. Brussels, 29
     June 2012.

4  AIME Workshop on Armin Linke's photographic archive with the artist, Bruno Latour, Donato Ricci, Christophe Leclercq, Dorothea Heinz, Laure Giletti, and Sarah Poppel at Sciences Po, Paris, 18 Aug. 2012.

5  Antoine Hennion, Simon Ripoll-Hurier, Sylvain Gouraud, Bruno Latour, Jean-Michel Frodon, Armin Linke, and Lisa Bergmann at the AIME workshop on Fiction. IKKM, Bauhaus University, Weimar, 10–14 June 2013.

**6** Jean-Louis Missika (Deputy Mayor of Paris), Denis Bertrand (semiotician), and Bruno Latour at the AIME workshop on Politics. Sciences Po, Paris, 23 May 2013.

**7–8**   AIME workshop on Politics
organized by Noortje Marres.
Goldsmith University,
London, 31 Jan. 2014.

**9** AIME *Tiles* by Jamie Allen and Catherine Descure. 2014. The AIME modes of existence inspired their physicalization as a set of "tiles" that serve as a kind of reading aid; a sketch of tactile tools for scholarship; game pieces for playing with thought.

**10** Installation by Jamie Allen for the AIME Workshop on Economy. Copenhagen Business School, 25–26 Feb. 2014.

11  AIME Workshop on Economy organized by Vincent Lépinay. Copenhagen Business School, 25–26 Feb. 2014.

12 Katherine Lemons (Anthropology, McGill University) at the Diplomacy workshop on the anthropological dimension of AIME, on [LAW], [MET], [REP], and [REF], organized by Richard Janda, Eduardo Kohn, and Peter Skafish, final settlements. McGill University, Montreal, 25 Mar. 2014. Video still.

13 AIME workshop on Religion organized by Milad Doueihi. Sciences Po, Paris, 21–22 May 2014.

**14** Pierre-Laurent Boulanger, Pierre Sonigo, and Didier Debaise at the AIME workshop on Reproduction organized by GECO (Groupe d'études constructivistes). Porquerolles, 15–18 Apr. 2014.

**15** Patricia de Aquino at the AIME workshop on Religion organized by Milad Doueihi. Sciences Po, Paris, 21–22 May 2014.

16  Diplomatic Writing Week.
    École des Mines, Paris, July 2014.
    Video still.

to better represent themselves
to other non-modern collectives and Gaia.

17  Patrice Maniglier, Eduardo Viveiros de Castro, and Deborah Danowski at
    the Diplomatic Writing Week. École des Mines, Paris, July 2014. Video still.

**18** Exhibition Meeting at ZKM | Karlsruhe with the AIME
team, the CML (Critical Media Lab Basel), and the
artist Armin Linke. ZKM | Karlsruhe, 22 Oct. 2015.

# THE MIDDLE GROUND:
# THE CLASH OF EMPIRES

Richard White

RICHARD WHITE *is the Margaret Byrne Professor of
American History at Stanford University. He is the recipient
of a MacArthur Fellowship, a Guggenheim Fellowship, and
a Mellon Distinguished Achievement Award. He has twice
been a finalist for the Pulitzer Prize, and his books have won
numerous awards.*

Excerpt from:
Richard White. *The Middle Ground:
Indians, Empires, and Republics in
the Great Lakes Region,* 1650–1815.
Cambridge: Cambridge University
Press, 2011. 223–68. Here 256–60.
Print.

256                           The middle ground

would leave them no available counterweight to British power. When news of
the fall of Niagara and the abandonment of Fort Machault and Presque Isle
arrived, the Indians around Fort Pitt seemed sober and abandoned their
singing and dancing.[63]

V

The British victory over France allowed the British to think that the *pays d'en
haut* was ripe for the kind of imperialism that civilized men thought they
should by right exert over "savages." There was no longer a need to indulge
Tamaqua. General Amherst promised not to take Indian land, but he would
not withdraw from it. He would treat the Indians according to the services
they rendered, rewarding them when they were good, punishing them when
they were bad. In the kinship terms of the alliance, the Indians had always
been children, but now they were being infantilized.[64]

General Amherst's new vision of the *pays d'en haut* was a simple one:
the British were conquerors; the Indians were subjects. It was a view that
abolished the middle ground. The politics of villages no longer mattered.
Only the politics of empire counted. And they counted quite literally.
Imperial wars were expensive, and in the wake of victory, Amherst was under
heavy pressure to reduce expenditures.[65]

With the imperial struggle resolved by the conquest of Canada, Indians
no longer seemed of great significance to the British military. As General
Thomas Gage recognized, "All North America in the hands of a single
power robs them of their Consequence, presents, & pay." The mistake of
the Indian agents and superintendents like Croghan and Johnson, Amherst
confided to his officers, was that they thought the Indians of "more conse-
quence than they really are." It was a view the officers at the western posts
were prone, at least initially, to accept. With the fall of Niagara came an
eagerness to adopt a tougher policy toward the Indians. "We must," Colonel

---

[63] For Indian reaction, see "Journal of James Kenny," 437. After the fall of Niagara, Johnson
used a Chippewa prisoner to seek peace in the West and soon undertook negotiations
with the Ottawas, Chippewas, and Mississaugas, Johnson to Amherst, July 31, 1759, *JP*
3:115–18, Journal of Indian Affairs, Aug. 22, Aug. 29, 1759, *JP* 13:118–20, 128–29. For
French abandonment of forts at Venango and Presque Isle, see Croghan to Stanwix, Aug.
13, 1759, *Bouquet Papers*, 4:31. Some Ottawas who came to Fort Pitt to see the English killed
two soldiers on their departure, Mercer to Stanwix, Aug. 6, 1759, *Bouquet Papers*, 15:67.

[64] Amherst Policy, Amherst to Johnson, Sept. 11, 1759, *JP* 3:136; Johnson to Amherst, Dec. 8,
1759, *JP* 3:183, Amherst to Johnson, Dec. 18, 1759, Amherst Papers, reel 30. Conference
held by ... Moncton, Aug. 12, 1760, *PA* 3:744–52.

[65] For a detailed discussion of the enormous debts the British had accrued during the war, see
Gipson, *British Empire*, 10:1–222.

Bouquet wrote, "be brothers and friends, but not slaves." Similarly, Colonel Hugh Mercer, while promising to treat the Indians kindly, was relieved that we "can now speak to Indians in proper stile since services are not necessary." A worried George Croghan warned that although the military had conquered the French, they had "nothing to boast from the War with the natives" who must be conciliated.[66]

General Jeffrey Amherst was not interested in conciliation. He was a man who had little patience with Indians or with the limits negotiated on the middle ground. He thought categorically and universally. He had a soldier's veneration for obedience and a devotion to the standards of Englishmen that he regarded as decency and common sense writ large. Indians were savages who had to be brought to understand the necessity of obedience in their own particular relation to the British empire and who must conform to the universal laws of thrift, diligence, and trade. Before the fall of Niagara, Amherst was diffident. With Canada's soldiers still prepared to resist him, Sir Jeffrey tended to accept Sir William Johnson's advice in dealing with Indians. Experience, however, robbed Amherst of his diffidence in Indian affairs, and that diffidence unfortunately proved to have been his major asset. No longer deferring to William Johnson, Amherst had by 1761 blustered into Indian affairs with the moral vision of a shopkeeper and the arrogance of a victorious soldier. Years of experience in Indian affairs had taught Johnson and Croghan what weight the middle ground could bear; Amherst landed ponderously upon it and it cracked. The question would be, did it matter?[67]

At the center of Amherst's policy was a determination to eliminate the presents that served as a token of the entire middle ground. Amherst believed that presents were emblematic of the problems with existing relationships with the Indians. Presents cultivated the natural lassitude of savagery. If Indians got provisions by asking for them, they would "grow remiss in their hunting." Amherst had no objection to Indians receiving charity in cases of dire necessity, but regular presents would have to cease. Indians would have to support themselves by hunting. Amherst was prepared to pay for services rendered, but "purchasing the good behavior, either of

---

[66] For Gage quotation, see Gage to Gladwin, Feb. 19, 1762, Gage Letterbooks, Clements Library, University of Michigan. For Amherst quotation, see Amherst to Bouquet, June 7, 1762, Amherst Papers, Reel 33. For Bouquet quotation, see Bouquet to Croghan, Aug. 10, 1759, *Bouquet Papers*, 15:75–76. For Mercer quotation, see Mercer to Denny, Aug. 12, 1759, in Stevens and Kent, *Wilderness Chronicles*, 165. For not conquered, see Croghan to Johnson, Jan. 25, 1760, *JP* 10:134. For fear of Indians, see Croghan to Johnson, 22 Dec. 1759, *JP* 10:131. For tensions and theft and murder around Fort Pitt, see "Journal of James Kenny," 424–49.

[67] Amherst to Johnson, Dec. 18, 1762, Amherst Papers, reel 30; Amherst to Johnson, Mar. 16, 1760, *JP* 3:198–99.

Indians or any others is what I do not understand; when men of what race soever behave ill, they must be punished but not bribed."[68]

Johnson and Croghan recognized the magnitude of the change Amherst's new approach to Indian affairs involved. His rejection of the procedures of the middle ground served to increase astronomically the difficulties involved in settling all other outstanding differences. George Croghan wrote: "The British and French Colonies since the first Settling [of] America . . . have adopted the Indian Customs and manners by indulging them in Treaties and renewing friendships making them large Presents which I fear won't be so easey to break them of as the General may imagine." And Sir William Johnson warned:

> The French . . . spared no labor, or Expence to gain their friendship and Esteem, *which alone enabled them to support the War in these parts so long* whilst we, as either not thinking of them of sufficient Consequence, or that we had not so much occasion for their assistance not only fell infinitely short of the Enemy in our presents &ca to the Indians, but have of late I am apprehensive been rather premature in our sudden retrenchment of some necessary Expences, to which they have been always accustomed.[69]

Amherst dismissed such warnings. He remained remarkably sanguine about Algonquian and Iroquois resistance to unilateral changes in their relationships with Europeans. He believed that he had the power to demand "good behavior" of Indians because he was their conqueror. He dismissed their power to resist, and those of his officers who did not command posts in the Indian country shared his arrogance. When news of the first of several attempts to muster resistance to the British emerged, the General wrote Johnson that they "never gave me a moment's concern as I know their incapacity of attempting anything serious." Amherst was confident that he had the power to destroy the Indians totally "whenever any of them give me cause."[70]

---

[68] Amherst to Johnson, Dec. 18, 1762, Amherst Papers, reel 30; Amherst to Johnson, Mar. 16, 1760 *JP* 3:198–99. Johnson alone spent £17,072 on Indian presents between Nov. 1758 and Dec. 1759. For orders restricting presents, see Croghan to Hutchins, Oct. 25, 1761, *Bouquet Papers*, 15:166. Gage to Le Hunte?, Oct. 7, 1762, Gage Letterbooks, Clements Library; Croghan to Johnson, Oct. 8, 1762, *JP* 10:548–49. Amherst relented enough to allow "trifles" to be given away at the posts (Campbell to Bouquet, Oct. 27, 1762, *MPHC* 19:173), but he denied any system of regular presents, Amherst to Bouquet, Jan. 7, 1763, Amherst Papers, reel 33.

[69] Croghan to Bouquet, Mar. 27, 1762, *Bouquet Papers*, 15:183; Johnson to Earl of Egremont, May 1762, *JP* 10:461.

[70] Amherst to Johnson, Aug. 9, 1761, Amherst Papers, Reel 30; Amherst to Johnson, Dec. 20, 1761, *ibid.* For scorn among military, see Claus to Johnson, Dec. 3, 1761, *JP* 3:575–76. This picture of Amherst is very different from the oddly narrow one that is presented by Harry Kelsey in "The Amherst Plan: A Factor in the Pontiac Uprising," *Ontario History* 65

In the *pays d'en haut*, Amherst's increasingly direct role in Indian affairs gave British policy its particular form, but the specifics of British policy were not fully his doing. Decisions to occupy the posts formerly held by the French, demands for the return of all prisoners taken in the war, and the curtailment of expenditures in North America were part of larger government policies. And Amherst's decision to eliminate presents and to rely on trade as the sole mechanism for the exchange of goods between Indians and whites was only the means of implementing the new financial stringency.[71]

Despite their dismissal of the Indians and their insistence on dictating the future, the British did not seek conflict. Their policy, as Amherst repeatedly stated, was to guarantee the protection of Indian lands and to insure a regulated, fair, and abundant trade free of a reliance on rum. Their ways of dealing with the Indians might ignore French precedents, but, as they saw it, they asked little from the Indians that had not already been accorded the French. When, for example, the British demanded the return of all British prisoners, they saw themselves as led by both precedent and justice. And indeed, they did have a strong case. The Algonquians had at the conclusion of both the Iroquois wars and the first Fox war regarded the failure to return captives as a casus belli. Similarly, the British saw their occupation of the posts as merely a replacement of the French occupation. With the exception of Sandusky, the British asked for no new posts. The British instituted a policy of keeping the Indians deliberately short of powder, but although the Indians felt the result, they could only guess the intention. The British did not publicly proclaim this policy; they lied and denied it.[72]

Except for the elimination of presents and restrictions on the sale of gunpowder, Johnson and Croghan did not seriously question most British measures; they only criticized the speed with which they were taken and the failure to negotiate them according to the diplomatic procedures of the middle ground. Johnson thought denying the Indians powder caused unnecessary suffering and formed an obstacle to the very trade both he and

---

(Sept. 1973): 149–58. Kelsey basically blames the rebellion on Amherst's subordinates who were unable to provide the ships necessary to supply and reinforce the upper posts in accordance with Amherst's plans.

[71] For a discussion of the cession of Canada, see Guy Frégault, *Canada: The War of the Conquest* (Toronto: Oxford University Press, 1969), 296–340. Gipson, *British Empire*, 8:208, 216, 300, 309.

[72] For British assurances and policy, see Johnson to Amherst, Sept. 10, 1759, Amherst Papers, reel 31; Amherst to Johnson, Sept. 11, 1759, *JP* 3:136; Amherst to Hamilton, 30 Mar. 1760, *JP* 3:205; Amherst's Speech to the Western Indians, c. Apr. 24, 1760, *Bouquet Papers*, 15:90–93. At Detroit Campbell feared trouble if Indians knew of Amherst's intentions to keep them short of powder, Campbell to Bouquet, Oct. 12, 1761, *MPHC* 19:116; *ibid.*, 3 July 1762, *MPHC* 19:158. For scarcity and suffering, see Johnson, Private Journal, 19 Oct. 1761, *JP* 13:270. Croghan was denying to the Shawnees that such a policy existed as late as Dec. 1762, Report of Indian Conference at Fort Pitt, Dec. 8, 1762, *Bouquet Papers*, 15:194.

260          The middle ground

Amherst wanted to encourage. He and Croghan both regarded eventual subordination of the Indians as inevitable, but they thought it could be gradual and peaceful. In Johnson's words, there were "yet necessary Expences" that they "should be gradually weaned from, and that by a prudent Conduct, and due distribution of some little favours to them for a time, we may effect without much trouble, what we should find no small difficulty in compassing by force." For now, the precedents of the middle ground should be followed. Presents would serve to get prisoners returned and the posts occupied peacefully.[73]

Amherst's policies served both to validate the fears of the Ohio Indians that the British meant to subordinate – and, in their terms, enslave – them and to shatter the willingness of many other Algonquians to accept further extensions of the peace. The British had broken their original promise to evacuate the Ohio Valley after the defeat of the French, and they had also lied when they had claimed they would erect only a stronghouse at Pittsburgh to protect the trade. Instead they built and garrisoned a substantial fort at the forks of the Ohio. When they occupied the other posts of the *pays d'en haut* in 1760 and 1761, they surprised and alienated many of the Indians. The Detroit Indians told the French that they had been promised by the British at Niagara that a British garrison would not come to Detroit. When Robert Rogers's Rangers escorted such a garrison in the fall of 1760, the public welcome was cordial. The Detroit Indians confined themselves to reminding the British that "this country was given by God to the Indians." Privately, however, they told the deposed French commander, M. de Bellestre, that they had been betrayed.[74]

425

[73] For Johnson's position, see Johnson to Amherst, Mar. 21, 1761, *JP*, 10:244–47, *ibid.*, Apr. 23, 1761, *JP* 10:257–58. For quotations, see Johnson to Lords of Trade, Aug. 20, 1762, *JP* 3:866–67. For Johnson on present, see Johnson to Amherst, Dec. 6, 1761, *JP* 3:582; Johnson to Amherst, Jan. 1, 1762, Amherst Papers, reel 31; Johnson to Amherst, June 12, 1761, *JP* 10:286–87. Gives presents for prisoners, Croghan to Bouquet, Mar. 27, 1762, *Bouquet Papers*, 15:182–83. Croghan thought the posts would present no difficulty if presents were given, Croghan to Bouquet, Nov. 25, 1762, *Bouquet Papers*, 9:167.
    Amherst's position on powder was contradictory. He wanted Indians to hunt commercially, but he restricted their access to the powder necessary to do this. He asserted, however, that if they were "industrious" they could barter for powder. Under pressure from Johnson, he was allowing small gifts of powder by the fall of 1762 when there was a shortage in the upper country, Amherst to Johnson, Sept. 12, 1762, Amherst Papers, reel 30; Johnson to Amherst, Sept. 24, 1762, Amherst Papers reel 31.
[74] For Indian version of original promise, see Rapport fait à M. de Ligneris . . . 4 jan 1759 par Casteogain, chef de Loups . . . joint a la lettre de M. de Vaudreuil, 15 feb. 1759, AN, C11A, v. 104, f. 23. As late as Jan. 1759, the British were still indicating that they would return home following the defeat of the French, Indian Conference at Pittsburgh, Jan. 8, 1759, *Bouquet Papers*, 15:31. For Fort as stronghouse, see "Journal of James Kenny," 428. For fear of Fort Pitt, see Johnson to Gage, Mar. 17, 1760, *JP* 3:200–1.
    For Rogers at Detroit, see Howard Peckham (ed.), *Journals of Major Robert Rogers* (New York: Corinth Books, 1961), 157–67. For quotation, see Conference at Detroit, Dec. 3,

# DON'T SHOCK COMMON SENSE!

## Isabelle Stengers

AT THE BEGINNING of his book *An Inquiry into Modes of Existence*, Bruno Latour suggests taking a look at the example of the Greek agora:

> Discovering the right category, speaking in the right tonality, choosing the right interpretative key, understanding properly what we are going to say, all this is to prepare ourselves to speak well about something to those concerned by that thing – in front of everyone, before a plenary assembly, and not in a single key. (59)

The most important aspect of the agora is its situated character. Of course those concerned, those who take part in the assembly, have never really amounted to "everyone," but in this specific case this is not a flaw we could retrospectively hold against the Greek assembly. All too often the moderns tend to think that "everyone," whether or not they accept or even realize it, is concerned with their categories or with debating them – and in a way, this is clearly the case today. That is precisely where Bruno Latour calls on the moderns to "make room" for others and, above all, not to attribute a place to these others (which they have done far too much), nor to speculate on the relevance for them of the categories he proposes, or even of the notion of category. In other words, the

ISABELLE STENGERS *teaches philosophy at the Université libre de Bruxelles. Her work resists the model of objectivity that mimics the theoretico-experimental sciences and silences the diverging multiplicity of scientific practices. In this perspective she has developed the concept of an active ecology of practices, embedded within a democratic and demanding environment. As a philosopher she explores the possibility of a speculative, adventurous constructivism, which she relates to the philosophy of Gilles Deleuze, Alfred North Whitehead, and William James, as well as to the anthropology of Bruno Latour and the sci-fi thinking adventure of Donna J. Haraway.*

agora is no more bound to be jettisoned everywhere than are Peter Sloterdijk's pneumatic parliaments.

It should be stated at the outset that the agora Bruno Latour imagines is very particular, for the practical test of "speak[ing] well to someone about something that really matters to that person" (*Inquiry* 58) was probably no more of a rule in Athens than it is in our contemporary parliaments. This is the particularity that I would like to emphasize by distinguishing between three distinct modes of presence, three types of "roles" in a sense, among those assembled. First, there is the role of the initiator of the assembly, attempting the test of "speaking well to." Second, there are those I call the testators, because their role is similar to that of the protochemists who tested the gold that alchemists

claimed to have made. They would not assemble without the initiator who invited them and who claims to speak well to them about something that really matters to them, as they are rather accustomed to "speaking badly" of one another, with impunity, without this being of any consequence. Finally, there is what I call "the public," who is more used to being used as a witness, taken hostage, or blamed by the testators, who just about agree on that point only. Yet the public's presence here is crucial, for what causes the initiator to tremble and could well do likewise to the testators, "of course, is always, as Whitehead insisted, above all, not to shock common sense" (*Inquiry* 59).

To speed up the process, let's say that Bruno Latour is the initiator, as a "persona," role, or mask wearer, distinct from the other "persona" that is Bruno Latour the sociologist, who called on his colleagues to "follow-the actors-themselves" rather than making them bit players in their own theories. This distinction is not an opposition. Here again, with regard to the agora, he calls for an actor-centered approach. But in this case, he is not concerned with their practice, the way in which they engage in and are drawn to a situation. Rather, he is interested in the striking difference between their mode of engagement, which he has learned to be cognizant of through his contact with them, and the way in which they usually present it publicly. In other words, in the agora, the actors are separate from the specific, always particular situation which made them think and, for the sociologist, made them crucial *passeurs* or informants, dramatizing a particular aspect of the situation and contributing to making it a real intrigue (Latour *Aramis*). What the actors will have to take a stand on is a version of their practice which challenges the version that, often heedlessly, they would serve up to what we could call a "captive audience" – one that knows that if it refuses to be captivated, if it objects, it will bluntly be put in its place and reminded of its incompetence and/or irresponsibility.

Correlatively, anyone playing the role of testator, testing the proposal put to them, considering its implications and consequences, knows that they must speak as a member of an institution, and that, if they forget it, their peers will accuse them of betrayal, of having accepted a version of what matters to them that puts all of them in danger. For the way the testator customarily presented his/her practice to the "incompetents" is not informed by what she/he "does" tangibly, but by a "territorial defense" apparatus, defending boundaries in place against outsiders, always considered as threatening, as incapable of understanding. The testator's peers could disown their colleague – "you got played, you weakened us." The proposition made by the initiator does indeed emphasize what the testator has told to and shared with the initiator, glad and surprised to have met someone who is interested in the testator's concrete situation of quest, someone who does not arouse any defense reflexes or even skillfully disarm them. But what is at stake in the agora is the reproduction of the institution to which the testator belongs, the difference to be maintained and reproduced, between "the inside" and "the outside." Will this difference be safely respected if what the testator and his/her peers see as "gold" does not have the necessary shine to impress the "incompetents"?

Who are these disconcerted practitioners? The "categories" at play in the agora respond to a problem, not to an accurate empirical description of practices. This problem characterizes institutions which, in one way or another, endow the practitioners that belong to them with the power to claim indisputable legitimacy – which also means the power to get away with enforcing their right to disqualify other knowledge practices that could make them challengeable. The problem raised in the agora, therefore, does not concern all practitioners; many are prey to this predatory culture, accustomed to living on the fringes, in a situation of formal or effective dependence. Think, for example, of the relationship between those who know of the needs of the

427

animals they care for and the scientists who come to observe these animals "objectively." Or between peasant farmers and technicians of an increasingly streamlined agronomy. These practitioners are all too familiar with the experience of being described pejoratively, but do not feel empowered to present themselves as insulted or dissatisfied – which is why they cannot play the role of testators – and are therefore "in the public," to which I will return.

One of the singularities of the agora is that practitioners from "predatory" institutions mingle there, and each one of them has very good reasons to listen to the proposition made to another, and to the latter's response. They know that such others present themselves in a way which often involves them, explicitly or de facto, rather unflatteringly. Thus science is neither politics (disgusted tone) nor religion (idem), it is the only true (tremolo) source of technological innovation, and anyone who depicts it as fiction will be an enemy (exclamation). In normal situations this kind of presenting someone else as a foil is without consequences. Take, for example, the artificial courtesy that makes so-called "interdisciplinary" meetings sterile and boring. The "science wars" and the surprising atheist crusade led by scientists in English-speaking countries are exceptions. Normally, predators do not attack one another – too much to lose, too little to gain. But in the agora, the presence of a public interested in both their silences and their interventions means that each testator must pay attention to the way in which the other's argument involves or enrolls them. Tolerance does not work anymore; mutual ignorance is no longer an option. A choreographic mise-en-scène then unfolds, where the dancers, accustomed to bumping into one another and stepping on each other's toes, must learn the art of coming together and respecting distances.

Let us now turn to the public, which, in one way or another, embodies this "common sense" that is not to be "shocked," whereas its "incompetence" makes it all predators' designated prey. The reason

Latour cites Alfred North Whitehead here is probably because Whitehead identified the "bifurcation of nature" (*Concept of Nature*, ch.2) as an outrage against common sense, or because he followed in the footsteps of Gottfried Wilhelm Leibniz, for whom philosophy should not "collide with established sentiments" (Stengers 15). However, the agora demands that we go a bit further, as testator-actors will protest – *justifiably so* – if they see common sense suddenly take on the role of a referee or censor: I am shocked, therefore you are wrong. I therefore propose another Whiteheadian figure of common sense: "... common sense brooding over the aspects of existence hands [them] over to philosophy for elucidation into some coherence of understanding" (Whitehead, *Modes* 51).

Of course, "philosophy," which has blessed modernization since Immanuel Kant, is quite incapable of matching the trust of "brooding common sense." The initiator of the agora, however, for whom we have never been modern, could accept this trust, knowing that it is not blind but "probational," that it is testing the initiator himself or herself. For the figure of "common sense brooding" is not that of a crowd asking for a master to tell it how to think; there is brooding because there is resistance – dumb resistance, certainly, lacking the words to express itself, but resistance nevertheless that will not be satisfied with just anything, a resistance that seeks to elucidate and not, once again, to be enlightened.

The public that the agora needs would be a "concerned" public that the agora as a *dispositif* would address not as a judge, but as an entity which, through its brooding, is able to recognize an authoritarian blunder, a rash shortcut, a dogmatic estoppel, or a striking incoherence when uttered in its presence. This would shock this public, coming from those who claim to know, while they themselves brood. And this is how it sets a constraint, how it forces the speakers to "slow down" and not to use arguments involving a pejorative judgment insulting those listening.

A constraint is not a limit. It does not mean that the testators have to "remain polite." A constraint is what forces one to think, to imagine, to try – and to "mov[e] forward," as Leibniz wrote in a letter to Landgraf Ernst von Hessen-Rheinfels when he opposed "innovators" (81), who thrive on overturning well-established beliefs, to those who, like geometers, produce new truths without needing to destroy old ones. The constraint here is the presence of those who would be in a position to object to how what matters to them is treated. It involves the testators being forced to move "forward," in other words, to try to speak well, to describe as plainly as possible what their affiliation requires of them, the course they need to maintain, the way in which this situates them, and what this requires them not to take into account.

This is where the question of what we call "common" sense is at stake, along with what the constraint of not "shocking" it would mean. This does not just relate to the capacity to brood, and to object if what matters to common sense is dismissed in a way that shocks it. It is also about its capacity to consider the diversity of practices, what compels practitioners and makes them think, what matters to them, and what omissions this entails. We know that scientists, for example, often justify the need to present themselves in a somewhat deceitful way that silences the singularity of their questions, by claiming that "people" ask of science that it depict the world "as it is" (so-called "common sense" realism). They would turn away if they understood that researchers' knowledge is relative to the questions which they have made themselves capable of asking. But doesn't this demand, which justifies their "pious lies," rather "translate" the destruction of common sense, the way in which stupidity can result from answers with missing questions, or from "educational" questions designed to elicit "the right answer," the one that should get everyone to agree? The agora is betting on this hypothesis.

To bet on common sense – which Whitehead claimed philosophy had a duty of "welding" with imagination (*Process* 17) in order both to restrain specialists and to enlarge their imagination – is to bet on a capacity and an appetite. This requires a shift from "them," the people, to an inclusive "us" – the "us" of everyday experiences to whom their full value is thus granted. We are all capable, when we are not caught in a theory, of juggling with multiple contextual, practical, and semantic resources, according to the requirements of situations, and we are not distraught at the idea that these situations can matter to others in a different way. On the contrary, we find it interesting; it becomes part of our brooding and activates our imagination. And in this case the issue is not at all "respecting" common sense, but rather nurturing it properly. Participating in the agora, becoming an attentive witness of practitioners' passions, doubts, dreams, and fears, a bit like the chorus in ancient Greek plays, is something which any reader of detective novels and science fiction, or role-playing enthusiast is capable of. This is why history, ethnology, and ethology books are so popular, which explore the way in which both human and nonhuman others related or relate to their world. This is the imagination that we owe to fiction, which teaches us that one truth can always hide another, and that none is "only relative."

In 1993, *La clef de Berlin et autres leçons d'un amateur de sciences* [The Berlin Key and Other Lessons from a Science Connoisseur], republished under the more serious title *Petites leçons de sociologie des sciences* [Small Lessons in the Sociology of Science], made public what the Latourian sociologist and philosopher or anthropologist share. Irrespective of the persona, the mask, or the role, the relevance of a study will depend on curiosity, on the capacity to appreciate details that matter, to love not as a competent actor but as an amateur or a connoisseur. The study may then surprise those studied, but it will not insult them – except in situations of war, where all must pick a side, must "stand and be counted." It may even connect them to other possibilities to

appreciate what they themselves do. Are those who brood likely to appreciate as amateurs that which unfolds before them, to detect a certain "coherence of understanding" in the doubts, hesitations, and suspicions of those to whom they are listening? Both the public nature of the agora and the injunction not to "shock common sense" "translate" a trust, which we could call political, in this possibility.

In fact, Bruno Latour's harsh judgment of the (Platonic) Socrates of *Gorgias* in *Pandora's Hope* primarily relates to the removal from the dialog of debate-connoisseurs citizens, who would certainly have been shocked by the stupidity of the protagonists falling into Socrates's obvious trap. With total impunity, Plato pitched Socrates against a "straw Callicles" (Latour, *Pandora's Hope* 221) who seemed to announce the now routine way in which testators caricatured one another. Were the Athenians "torpedoed" stupid by Socrates? In Plato's writing they were. But, when in a time of war (of science), physicists and their allies started proposing jumping from the sixth (or eighteenth) floor of a building to those they suspected of relativism (specifically of doubting the reality of the law of universal gravitation), the full measure of what I have called the "destruction of common sense" became clear. Not only were the physicists not seen as amusing, they also did not think that they were running this risk, or that any individual, shocked, would blandly ask them whether people confused doors and windows before Galileo Galilei or Isaac Newton.

Political trust, I wrote; this is quite obvious since the agora is primarily the place of politics, and the way in which the testators gathered there usually present themselves conveys an active antipolitics of distrust of "incompetents." More specifically, I would call this infrapolitics, in the sense that politics is an institution and that the question raised is associated with all "predatory" institutions, which Latour claims cannot be "reformed" but must rather be "reset," or, it could be said, regenerated, thus enabling them to relate differently to their environment.

The Latourian agora is of course a fiction, a triple fiction in relations of mutual presuppositions. It seems particularly unlikely that the initiator would have the power to assemble, that the testators would agree to rub shoulders with one another, and that the public would be empowered to listen and appreciate as amateurs, as all three propositions seem radically undesirable in this day and age. Does the contempt for institutions with which Latour reproaches himself and his generation explain why they are so poorly defended against the fundamentalist attack we call neoliberalism? Or was this poison not already in this "hatred of the people" which, more than ever, makes Plato one of our contemporaries? Either way, convinced that they lack "flexibility," these institutions are now collapsing, powerless, under cynicism and dishonor. And all the "nonpredatory" practices, all the crafts that called for thinking, feeling, and brooding are systematically being destroyed.

However, the agora is not a chimera, nor the thought experiments that lend the experimental sciences their inventiveness. It does not resolve anything, but transforms the formulation of the question. A bit like Gilles Deleuze's idiot who accepts the urgency that everyone feels but cannot adhere to it because there is something "more urgent" (Deleuze 317), Bruno Latour does not deny the generalized ravage but cannot adhere to the economies of thought legitimated by urgency. The term *reprendre* [start over] is probably the most important in *Inquiry*. *Reprendre en mains* [to take in hand again], but also *se reprendre* [to get a grip on oneself], regenerate our "hands," our capacity to carefully handle modes of thought which at present possess and devour us. The moderns, he wrote, "are the people of Ideas; their dialect is philosophy" (*Inquiry* 22). This is not a compliment but primarily a description of what makes us a dangerous people for ourselves and for others. It draws on an idea formulated by Whitehead, for whom *The Symposium* by Plato, the father of philosophy, announces the birth of this "people of Ideas": the double introduction of the human soul and ideas,

the enjoyment of which brings life and movement to this soul, and makes it feel and think. Whitehead concluded, "It is obvious that he should have written a companion dialogue which might have been named The Furies" (*Adventures* 148), as this dialog would have discussed the horrors lurking within any "imperfect realization" of what we call "idea." Latour has first-hand experience of these Furies, as he had to resolve himself to giving up the term construction, for the difference between "well constructed" and "poorly constructed" was inaudible, drowned in the fury of the fights sparked by a slogan that doomed to imperfection any realization of ideas: if it is constructed, it should be deconstructed.

The agora is a construct, a fictive *dispositif* similar to thought experiments in physics, which serve to dramatize the risky consequences of an idea. This idea, through testator practitioners, is aimed at their institutions. What if, when your traditional allies betray and subjugate you, forcing you to dishonor what you were entrusted with protecting, you risked the challenge of "publicizing" the fragility and precariousness of your "reasons" and of their "conditions of felicity" (*Inquiry*)?

Those who see "the public" as exemplifying monstrous irrationality, to be kept at a distance at all cost, will call this idea fanciful. They will cite opinion polls, where "people," taken one by one and questioned on topics that do not concern them, kindly offer "proof" of their incompetence. And yet other *dispositifs* suggest that even people without particular competence or conviction – randomly selected – but sufficiently concerned to become engaged with something similar to the agora, seemingly "ignorant" people that the *dispositif* has empowered to thinking together, can become capable of listening to experts fighting without desperately seeking "the right answer," "the legitimate position," and are thus able to formulate questions and objections relevant enough to make these experts stutter.

What is called "citizens' conventions,"[1] amongst other denominations, gathered around questions relating to technoindustrial innovations, attest to the fact that "intelligence," in the sense of the capacity to think, to imagine, and to understand what matters to others, is not an attribute but something that is achieved through *dispositifs*. As such, this intelligence can be destroyed by a *dispositif* which, in one way or another, creates fear of mistakes and a lack of confidence. But it can also be regenerated – at least when the recalcitrant force of what I call "brooding" has not been eradicated.

It is possible to destroy unwittingly, whereas arousing, nurturing, and regenerating require a demanding and exacting culture regarding *dispositifs* and their effects. "Don't let anything go, don't let anything pass" (*Inquiry* 472) is the injunction that Bruno Latour associates with what would be true "liberalism." This challenge must be taken up by institutions that would foster an environment populated with *dispositifs* conducive to recalcitrance and imagination. These institutions should then learn to honor their commitments, the beings demanding instauration who Tobie Nathan calls "owners" (*Inquiry* 194), so that they may be nurtured by this environment, and so that this environment may allow for their actualization. If you do not feed your deities properly, they will devour you or turn you into a devouring power. Tobie Nathan, who taught me this, and Alfred North Whitehead, who saw it as philosophy's task to take care of our modes of abstraction, both forbid me to see Bruno Latour's agora as a chimera.

*Translated from the French by Liz Libbrecht.*

---

[1] The expression "citizens' convention" is promoted by Jacques Testart and the Fondation Sciences Citoyennes in France. The Fondation has proposed a precise protocol to respect scrupulously in order to prevent a jury, a consultation, or a citizens' conference from becoming an instrument designed to ensure the "acceptability" of an innovation by the public, as is often the case nowadays. See Fabien Piasecki and Jacques Testart's article "The Citizens Convention: A New Democratic Procedure for Decision-Making on Research and Innovation Issues." Available at <http://sciencescitoyennes.org/the-citizens-convention-a-new-democratic-procedure-for-decision-making-on-research-and-innovation-issues/>.

Works Cited

Deleuze, Gilles. "What is the Creative Act?" *Two Regimes of Madness: Texts and Interviews 1975–1995.* Trans. Ames Hodges and Mike Taormina. New York: Semiotext(e), 2006. 312–24. Print.

Latour, Bruno. *Aramis or the Love of Technology.* Trans. Catherine Porter. Cambridge, MA: Harvard University Press, 1996. Print.

———. *Petites leçons de sociologie des sciences.* Paris: Seuil, 1996. Print. Rpt. of *La clef de Berlin et autres leçons d'un amateur de sciences.* Paris: La Découverte, 1993.

———. "The Berlin Key or How to Do Words with Things." *Matter, Materiality and Modern Culture.* Ed. P. M. Graves-Brown. London: Routledge, 2000. 10–21. Print.

———. *An Inquiry into Modes of Existence: An Anthropology of the Moderns.* Trans. Catherine Porter. Cambridge, MA: Harvard University Press, 2013. Print.

———. "A Politics Freed from Science: The Body Cosmopolitics." *Pandora's Hope: Essays on the Reality of Science Studies.* Cambridge, MA: Harvard University Press, 1999. 236–65. Print.

Leibniz, Gottfried Wilhelm. "Leibniz to Count Ernst von Hessen-Rheinfels. 12 April 1686." *Discourse on Metaphysics: Correspondence with Arnauld, and Monadology.* Trans. George R. Montgomery. Chicago: Open Court, 1908. 74–82. Print. Trans. of "Leibniz an Landgraf Ernst von Hessen-Rheinfels [Hanover, 12 April 1686.] [4.6.]." *Sämtliche Schriften und Briefe.* Ed. Martin Schneider. Berlin: Akademie, 2009. 22–26. Print.

Piasecki, Fabien, and Jacques Testart. "The Citizens Convention: A New Democratic Procedure for Decision-Making on Research and Innovation Issues." *Fondation Sciences Citoyennes.* Fondation Sciences Citoyennes, 28 Oct. 2015. Web. 15 Jan. 2016. Available at <http://sciencescitoyennes. org/the-citizens-convention-a-new-democratic-procedure-for-decision-making-on-research-and-innovation-issues/>.

Plato. *The Banquet of Plato.* Trans. Percy B. Shelley. Chicago, 1895. Print.

———. *Gorgias.* Trans. Robin Waterfield. Oxford: Oxford University Press, 1994. Print.

Sloterdijk, Peter, and Gesa Mueller von der Haegen. "Instant Democracy: The Pneumatic Parliament®." *Making Things Public: Atmospheres of Democracy.* Eds. Bruno Latour and Peter Weibel. Cambridge, MA: The MIT Press, 2005. 952–57. Print.

Stengers, Isabelle. *The Invention of Modern Science.* Trans. Daniel W. Smith. Minneapolis: University of Minnesota Press, 2000. Print. Trans. of *L'invention des sciences modernes.* Paris: La Découverte, 1993.

Whitehead, Alfred North. *Adventures of Ideas.* 1933. New York: Free Press, 1967. Print.

———. *The Concept of Nature.* 1920. Cambridge: Cambridge University Press, 1964. Print.

———. *Modes of Thought.* 1938. New York: Free Press, 1968. Print.

———. *Process and Reality: An Essay in Cosmology.* 1929. Eds. David Ray Griffin and Donald W. Sherburne. New York: Free Press, 1978. Print.

# A PHILOSOPHY OF ATTENTION

## Bruno Karsenti

AN INQUIRY INTO MODES OF EXISTENCE, the book of philosophy and sociology written by Bruno Latour, requires a specific way of participating in the reading (as well as in the website and the face-to-face encounters). As the book itself makes clear, to interpret its meaning, readers must clarify the position they will take. Or to put it more precisely, using the Inquiry's own proposed vocabulary, they must "pre-position" themselves. Since the Inquiry, as I will argue, requires a specific sort of attention, it is important to calibrate the exact form of attention that it deserves. Without such a calibration, we risk committing what the author calls a "category mistake" – that is, reading the book in the wrong key. Obviously, such a reading would run counter to the argument of the book, which is to teach us how to avoid such mistakes. Yet I cannot offer such a reading without confessing to a certain feeling of anxiety: the Inquiry expects its readers to contribute to what is called an *instauration* – but will it accompany them all the way there?

Ultimately, this anxiety is rather banal: upon closer inspection it merges with the act of starting on any type of book whatsoever – be it a manual in geology, a mountaineering guide, a detective novel, or a philosophical treatise; whether it is supported by the paper we hold in our hands or by a window on the computer screen, opening virtually onto other windows where it becomes possible for us to insert our own comments, affecting

BRUNO KARSENTI *teaches at the EHESS in Paris. Based on his studies of the sociological and anthropological tradition, his research, for example, deals with defining a political collective identity from a psychoanalytical perspective. He has published books on Marcel Mauss, Émile Durkheim, and Auguste Comte, and edited some of the writings by Gabriel Tarde, Lucien Lévy-Bruhl, and Henri Bergson.*

the text in turn. The reader, any reader, starts wondering: How should I commence, will it commence for me, will my mind start wandering, will I quickly lose the thread, will the book close on itself, or, on the contrary, have I not already gotten hold of this thread as if it had been woven down my spine, to the point where I surprisingly find myself right in the middle of the plot without even noticing it, but with this ear or this gaze which has sharpened without my noticing it, and which makes me want to continue – this is a fact, the book doesn't close on itself, I want to know what follows, I am already in what follows, that which follows comes to me. And I want to finish it.

### AN ETHIC IMPLIED BY A PHILOSOPHY

THE CASE OF Inquiry, however, has a particularity in terms of this general situation which is valid for any book, whether one devours the book

or gives up on it in frustration. It's that it pursues a consequential work and pursues it by providing it with a fresh weft, it pushes it to a new level. The sociologist of assemblages demands from his readers something more than just following him in his exploration of networks. It requires them to feel it themselves, to experience a sort of *firmness*: a firmness which is as much his as it is theirs, to the extent that they accept to participate in an inquiry into the texture of the world which he, the author, and we, the readers, are supposed to hold on to *together*. "This, we will not give up on." This is the phrase resonating throughout this demonstration, and the ensuing *diplomacy*, which is all the more paradoxical. Ultimately, it would turn out to be the exact opposite of compromise, it would construct and justify itself by excluding any form of compromise about that which we hold on to. Does a diplomacy of intransigeance make any sense here?

This question arises especially because the inclination sought, the *penchant* of the book we are looking to examine, can be found here. We should declare this without hesitation: there is a conservatism on display here, even if it rejects all accusations of reaction or retrogression, as it still used to be called in the nineteenth century. Something like a forward-looking conservatism, a "forward conservatism," a tribute to the *coming* civilization. But regardless of the nuances, evoking conservatism raises a number of problems. In the current context it is granted that this is rather undiplomatic. Furthermore there is the concern that, having been misunderstood, the book could cause frustrations and even disappointment for all those who have followed Latour up to this point but who hesitate to follow him now, on a decidedly slippery slope. Here we consider the development as a whole, seeking to understand what might render this conservatism *necessary* in one form or another, what could necessitate it in the development of thought.

Naturally, we shall start by asking: what is Latour's firmness after all? And why does it accommodate itself to such variations, as demonstrated in his texts: variations of objects, of sites of investigation, of modes of writing, of tonalities or graphics, of supports and publication techniques? In this, Latour's method is faithful to the intention of the great pragmatists: it is reflected as a whole in this notion of inquiry, which John Dewey developed into a theory, and in the radical empiricism of William James. Nothing but experience, and nothing less than the *totality* of experience. It is in opening up to the *totality* of experience where the destitution which consisted in opening up to nothing but experience, without frameworks assignable a priori to conditions of its apprehension, reaches its turning point, revealing not just its richness but indeed its *rigor*.

Latour's sociology is known for Actor-Network Theory. The question that needs to be posed immediately is: what is philosophically entailed by the concept of the network, what is already entailed by the multiplicity of its usage in the various fields where it has been employed? Latour has expressed himself quite extensively on this issue. He has not ceased to show the displacement of sociology, which found itself involved in the tracing of networks, in the reconfiguration of social facts as phenomena of dynamic composition of variable textures, in a sociological inquiry which eludes in principle the hypostasis of the social *per se*, or of society in the singular – this is the hypostasis which Latour classically attributes to Émile Durkheim (Latour *Reassembling*).

In this respect, he has already set his philosophy in motion, and the recent book is not the exposition of a hidden foundation, a regression to the level of principles previously unstated, kept secret. Latour's ontology could be read even in his sociology, which did not hold any secrets. However, there is one point which remained in the shadows and is exhibited by his latest text: not so much what these networks are in themselves, but what makes them hold together, and, more precisely, that which allows the *passage* from one to the other. In other words, if the sociology of networks did not lack its own ontology, it lacked its own *cosmology*. It lacked an articulation

of networks among themselves and what sort of changes it made to compare them to one another. It is not sufficient to disentangle the pathways, to see each of the threads appearing and allowing for its own mode of displacement. One should also explain the fact that we have been able to disentangle them by disregarding not just their distinction, but also their real entanglement, the manner in which they really manage to compose a consistent fabric. The attention to distinctions is not reducible to a division into sectors or lines: all modes of existence are *incident* to the same point, and it is their incidence which needs to be understood.

Distinguishing is not the same as separating, it is rather to unfold a harmonic. Such is, in my opinion, the true anti-Durkheimian principle of Latour, and an authentic confrontation should take place at this point: Latour's attention to the salience and grasps, rather than to ruptures and discontinuities inscribed in experience, which for Durkheim are the formal operators of sociological conceptualization. We do nothing but displace the beings and displace ourselves in them using each network by which they alter themselves, that is to say, by which they constitute themselves in their being according to Latour's ontology of differentiation. We also displace ourselves among them, we pass from one to another, we take the junctions – sometimes accurately, sometimes falsely, sometimes fruitful, and sometimes disastrous. But how do we bring this about?

This question can be put differently: which is the world we hold on to and by which we are taken hold of? This cosmological question, it must be stressed, is a situated question. Latour knows too much anthropology to pose this question with the precipitation of a metaphysician who ignores the comparatism and believes himself capable of accessing directly the principles of all possible cosmology. He knows that his own questioning is the product of a unique history which could not have taken form otherwise than at the heart of an experience which is precisely that of the moderns and that of this

rationalism by which they represent themselves. Also the "we" in the question "Which is the world we hold on to?" is not a universal subject: this is precisely about us, the moderns, the Westerners, it concerns us, including in the movement through which we are led through anthropological paths to compare distinct cultural forms. But is this "we" relativized by being situated as such? Does the experience of unfolding which we intend to restore preclude a fallback position? And how do we pass from fallback to unfolding? Isn't it true that the "we" in question in *Inquiry* is actually in the process of becoming, that it even attempts to write the book, even its constitution and its operational mode using means provided to us by our own technical culture, its curvature? In terms of methodological considerations, it is our original problem which resurfaces once again. Ultimately, this concerns nothing but us, returning us to our instinct of conservation. And yet, appealing to the coming civilization, assumes that it concerns something else – that the "we" in question here has a status which is much more indeterminate.

In this case, it all depends on the type of comparatism we are discussing. If not a structuralist, Latour is at least an avid reader of *A World on the Wane* (French original 1955). Claude Lévi-Strauss pointed out there that, contrary to popular belief, the ethnologist is not the one who compares his or her society with that of others, but one who compares several *other* societies, from the society he or she has left and to which he or she must necessarily go back to in order to be a true ethnologist and not dissolve into a new indigenous identity. All things considered, the significant gap is not therefore the one between us and them, but the one duplicated on either side, in them and in us, and the relationship established between these two gaps. And it is exactly this gap in us which Latour has not ceased to scrutinize. So that it may initiate a reappropriation, so that it may result in praise of the coming civilization, as he enjoys pointing out, a praise where we could situate ourselves all the better vis-à-vis the others than

us – a certain firmness would finally be gained and this is the challenge of the demonstration.

We now understand the slope followed by Latour's book, that which we initially designated as its *inclination*, its *penchant*. Based on an in-depth work, which consists of an inquiry into the modes of existence, a relaunch of the whole project has been started. We can immediately provide the formula for this relaunching. it consists in the passage of a discourse on the manner in which the world holds, on its texture, on its fabric, to a discourse on the manner in which we hold on to the world, that is to say, the manner in which we must hold to it. In a word, this treatise on ontology, taken to its logical conclusion, leads to a practical philosophy – to philosophical ethics, which do not merge with the sole practice of sociology. To put it even more succinctly: from a philosophy implied by the social sciences we pass over to an ethic implied by a philosophy. In what follows, I have chosen to define this philosophy as a *philosophy of attention*. But it is still necessary to justify the purpose of traversing Latour's *Inquiry*.

## FROM NETWORKS
## TO HOW
## THEY ARE COMPOSED

LET US COMMENCE with the word "network" and simply ask ourselves why Latour likes this word, with the love of the philosopher and not simply with the technical concern of a prudent sociologist. Besides its illustrative ease, the term makes it possible to fulfill two requirements at once. First, it contains the distinction – and thus prevents the confusion – between two levels of reality: on the one hand, that which displaces itself and, on the other, that which allows the displacement. Second, it has the advantage of highlighting a constraint of *radical continuity*: an interruption at the slightest point of the network suffices to provoke its general collapse.

From here, from this double premise, it follows that the network has in fact three fundamental attributes: materiality, continuity, and fragility. More specifically, continuity is the opposite of fragility, both determining a materiality of a certain type. In other words: the network, due to its mode of being continuous, requires *care* and constant attention, wherein is reflected its intrinsic fragility, but where it also proves its own true material consistency, where the type of materiality it entails is specified. The smallest link has the same strength as the network, and its obstinate maintenance cannot mitigate a weakness, but rather acknowledges a specific potency which is that of the linkage itself, not in totality but in each of its points and therefore in its materiality of *connection*. The strength of the network lies, therefore, precisely *in* its fragility – such that we can also say that this fragility reverberates in us, provided that we follow it, nourish it, and maintain it. Provided that we pay *attention* to what we do. Thus, our attention is the combined expression of our fragility and our strength.

In the world that is taking shape, and based on a characterization of the nature of the networks, we see that there are different types of linkage which are so many ways of displacement –allowing anything to be displaced, or displacing something. The network does not have any a priori form, and this is proven first by the fact that if you look at it closely enough it is never separable from the way you engage into it. Above all, the fact that it is always a question of networks, in the plural, and thus empirically differentiated, even when we employ the general category, is due to the fact that here we cannot confuse anymore what displaces itself with what allows the displacement to take place. Because this latter, as we should emphasize, is the material requisite for the displacement of the former. In other words, it is a *means* and not a formal condition of possibility. To put it more precisely, "to speak the truth," we use the preposition "with" and not the conditionality of the "if."

This little word "means" is worthy of note. It is difficult to perceive the primacy, and yet this is what

Latour's philosophical inquiry builds on. Ultimately, the only mode of veridiction which manages to isolate it, to dissolve it, is the law. And it is here, no doubt, where we find the reason for its singular resistance to modern dissolutions. It is that the law has this singularity, not so much – as it is too often said – of being formal, but for resolving itself in the establishment of enunciatory passages, to ensure the transition from one statement to another statement without which the question of that which is transported from one to the other – morality, truth, objectivity – overdetermines the very fact of the *pouvoir passer*. In remaining in forms or procedures in this case is to remain attached to material thickness of the means, even if it is stated with all the abstraction of a "legal means." There is no doubt that if the law has been able to fascinate Latour at this point – he devoted one of his most beautiful books to it (*Making*) – it is also because it rendered a requirement more evident which is inherent to his own philosophy: that of remaining at the same level as the means, of seizing the means in themselves, of restoring to them their own weight, of recognizing the status of this transitional materiality without reducing or situating it on another plane.

Saying that a means is material seems merely to state a truism. But the remark is more important than it appears. Literally, one could say that means corresponds to the requisite displacement of a type of reality which is obviously never the same with respect to the object one is considering. Likewise, the care of continuity cannot be simply supported by a general form of attention. This form does not correspond in itself to anything real either. Properly understood, attention shirks the generic definition of a faculty. If it is really attention, care, maintenance, respect, or solicitude (to speak with Étienne Souriau), then it is also intrinsically modalized, in contact with that which it concerns, entirely occupied by that which it cares for, and therefore constituted by it in the very act by which it assumes responsibility for it (Souriau).

Let us note that by thus invoking attention we make it play a role opposite to that which Durkheim had in mind for it in his struggle against pragmatism in his lectures given in 1914 (166). For him, the attention was a sign of restraint, prohibiting the confusion of thought and action, and, more specifically, the thought with action as Dewey intended it. Here it is quite the opposite: the attention is full, filled, occupied. Such that it is never the same attention which turns towards different types of networks, dedicated to different displacements of different realities. The world is made up of these multiple paths, irreducible to each other, designating the attitudes themselves as irreducible. We do not live armed with a battery of faculties which would be sufficient to employ in our experience, to activate as the case may be, we rather live *in* experience, that is to say, in a plural universe of actual means which we make and maintain, as close to their layout as possible. For this it suffices that we remain *attentive*, oriented towards that which follows. Ultimately, such is the only equipment required by the Latourian actor. It may not seem much, but it is in fact enormous – and we would like to ask Latour the simple question of *fatigue*, the possibility of withdrawal, or repairing of attention itself.

Although Latour does not talk much about fatigue, he does speak a lot about our inattention, our errors due to lack of attention. And behold, as precious as this attention is, we simply do not accord it any attention, and this is what constitutes our blindness. Captivated by the end, such as we believe it to be, proud of the principles we believe to be holding, we too quickly disregard the richness and strength of the interlayer which is the means, where our experience is formed. Now, all that which merits the status of reality for Latour is precisely in the means and nowhere else. And if the attention is attention to the means, that is because the networks are just another name for the means.

From the question "What is a network?" we turn to the question of "What is a means?" A question all the

437

more difficult to address here as it resolutely reduces itself into two forms of treatment which the rationalism of the modern has applied to it. The means is not determined based on a set of rules, independent of its implementation. But neither is it determined in relation to the purpose that is also thought independently of it, projected in a beyond which it only aims to achieve. To think of what it means to live in the means, one must begin by smashing the means–end relationship (that which Karl Marx also attempted to do, quite precisely, by positing that humans are living creatures which produce their means of existence). The means is *alteration* and, in this sense, it is a construction of the unique reality which it brings about. It is the vector of constitution of being *as the other*. It is the touchstone of an ontology of differentiation, or alteration. But then the objection bursts forth: How to fix the definition of that which would be a good means as distinct from that which is a bad means? What sort of discrimination is a world susceptible to which is nothing but alteration of being, where the being of the phenomena is held to be entirely in their unique alteration?

Here is the challenge of restoration of rationalism beyond the rationalism claimed by the moderns. Each linking of means is a certain type of differentiation of the true and the false, or also of the rational and the irrational. In the opposition between a single and the same truth erected in its fixity, on the one hand, and the infinity of errors committed as so many travesties, deviations, or deformations of this primary truth, on the other, Latour substitutes the modes of differentiation of the true and the false where that which one calls truth is immersed in a process of transformation and where reason attempts to prove a certain type of reality. If the means are not neutral channels, instrumented in advance by a given ideology as required by critical sociology, if they are not deducible based on principles, they are not involved analytically in the prior fixation of an end. If we think and act *in* the plural and material reality of the means, then we must indeed

come to this: the true and the false are engaged in constant infighting, which never has the same scenography with respect to the reality which must be explored, that is to say, with respect to the mode of being which takes form and this forming of which we dispose ourselves. Substituting the truth in the singular for the multiple marriages of the true and the false, it is rather committing the greatest error, in other words, a *meta-error*: an error of attention. Moral fault or philosophical error? Are we not inclined to relate philosophy to a form of morality which would thus become at the same time a category apart for the philosopher, this detector and assembler of prepositions?

What has just been said is never only a consequence of the philosophy of attention, which lies at the foundations of Latour's thought. More precisely, it is the consequence of the philosophy of attention to which the theory of knowledge now subordinates itself, or that which is traditionally called epistemology. Can epistemology disentangle itself from a theory of truth in the singular, or at least from a theory of the concept – and, more precisely, can it disentangle itself without renouncing the rationalist object which commands its constitution? It all depends on the manner in which we understand this endeavor. By posing the idea that the true and the false result from their differentiation within the chain of the means, means which derive their value from the fact that they produce precisely this differentiation, one dooms the true to a process of transformation that is not distinct in nature from transformations which lead to the false. In other words, we do not have an "intransformable" (or an always falsely transformable) erected in absolute terms on one side, and deceptive distortions which divert us from this absolute on the other. We are rather in the presence of two types of transformation between which one must now distinguish as to which one we must turn to, and this in the interior of each particular system where something transforms. Plunged into the mediated and mediating

reality of the means, transfixed on their own level, and refraining from any stalling, one is engaged in discrimination of transformations taken in themselves, and without providing a reality in advance of which they would be the transformation.

But then the question is all the more insistent: How should one distinguish between the types of transformation? How do the transformations distinguish between themselves, if there is nothing but them, if they do not evaluate themselves in terms of an identity of which they would be the transformation, if they no longer depend on the prior existence of a model? It seems that the idea of knowledge we have established is incapable of discarding an ideal of access to the object, where the indirection of the means has abolished itself, where the transformation could be erased, where identity of that which one knows would be found through the innocent intervention of a third identity.

From an identity to an identity through an identity: this is the only linking that the consciousness of the moderns wants to retain, which challenges every real linking where the being of the phenomena constitutes itself only by altering itself, revealing at the same time that it is an alteration. There is, however, a tacit principle in this vision which suddenly becomes difficult to accept: it is that at each step no step is made, that each time knowledge finds the virginity which it leaves behind, since ultimately, it leans on nothing else but its own strength, and that it aims only at reunions with itself, reunions whose object has been at the most the occasion. What does it know then, if not itself? Moreover, what does it know of itself when it knows itself in this way? Certainly not the sequence of the steps through which the true has arrived just at the point where it can reclaim it, certainly not the sociohistorical movement of knowledge, considered as a practice. It seems that we end up with a dilemma: either knowledge is that which it claims to be, and history and sociology of science are nothing but the history and sociology of the insignificant conditions

of knowledge and, at best, a history and sociology of errors; or the practice of knowledge is reflected in its real movement, and this is the criterion of the truth which seems to elude us.

There is, however, a solution to this dilemma: making the *criterion* of truth play quite a different role than otherwise has been the case by denying knowledge its status as a practice, and, in addition, by opposing it to practices denounced as so many deformations. If there is a specificity of knowing, it should detach itself within the practices as so many modes of veridiction. To tell the truth, knowledge might seem privileged, but it is not. One must employ a particular mode of differentiation of the true and the false, which calibrates within its process, in situ, that which merits the name of scientific truth or error.

That may be, one might object, but then the thesis turns into a tautology. Because one has not yet answered the questions: How is this calibration evaluated, how to distinguish between good and bad transformation? If one wants to be a rationalist, one cannot avoid the question indefinitely. It is one thing to assert that there is no sovereign mode of veridiction in the activity of knowing which would apply to all other modes of veridiction (the others being its alleged inferiors), but it is quite another to renounce raising oneself to a philosophical level where one would be able to assert, in accepting the ontology of the networks – that is, in admitting a conception of being "as the other" – which means that in each path that we take we are, or at least we could be rational, that is to say, capable of pertinent differentiation of the true and the false relative to a determined mode of existence.

If Latour remains rationalist, it is precisely because he does not renounce. He even believes, at least that is what he claims, that by refusing to withdraw knowledge from the games of transformation, in immersing it at the level of practices, it is its own best servant – the servant of the servant that it is in reality, even though it believes itself to be sovereign.

439

But he also knows – and this book is not a new book but the first within a new system of thought from this point of view – that the criterion of the mode of veridiction cannot be merely an internal description, at each point closed to the interiority of the network in question. Consciousness exists, it defines a linkage, engages a concatenation of means, forms a singular access to being, a mode of speaking the truth. Religion is another mode, irreducible in turn. And likewise the law. However, we live in a world where the harmonics are intertwined: we distinguish, but all are incident to the same point, and that is precisely why we distinguish.

We see therefore that knowing does not, ipso facto, mean knowing oneself. It is for having confused the two that modernism crashed into a characteristic ignorance. If there is still a Platonism of Latour – it is true, Platonism expurgated of all that it contains from idealism, that which, to cite the opinion of Alfred North Whitehead (39), would still represent a very extensive footnote – it is precisely here where it is recognizable: knowing oneself (*se connaître*) is an exercise which, at least for the moderns, constitutes a properly philosophical task, which can and should be distinguished from knowing in general (*connaître*). A frontier runs between the simple form and the reflexive form of the same verb. This amounts to affirming loud and clear that philosophy is not science, including sociology. But this philosophy, geared towards self-knowledge and differentiated in this from knowledge in general, does not cease for this reason to bear the seal of rationalism: ultimately, that to which it attaches itself is to describe our manner of actually being rationals, our manner of acting in the world to which our attention is directed and whose real composition we do not cease to maintain. Rationalism, therefore, is first considered in the sense that the challenge is to account for ourselves and our world.

Whether there is a task which envelopes science, which understands it, and which precisely defines the superior level of rationalism which is to be established, that is what we are led to recognize here. But this has a remarkable theoretical consequence: we must now *get out of the networks*, or at least take a new look at their reality. For this rationalism, it is indeed no longer simply a matter of the distinction of the modes of veridiction which is important, it is their connections, their compossibility so that they get a world they can call "theirs" once they have abandoned the claim to be defined by an absolute reason.

We understand in what way the rationalism of Latour, to maintain itself, must pass over to that which we have designated above as the cosmological discourse. This is because it is an expanded rationalism, much broader than that employed in knowledge per se. The question, which it raises at a certain level of the inquiry, is knowing what still supports the unity of reason once the reasons have been deployed in the appropriate systems of veridiction. We know that Latour has often been accused of relativism. But the accusation really always proceeded from the hypostasis of knowing, of the imposition of a mode of veridiction on all others. In addition, as demonstrated by his sociology of science, the accusation rather proceeded from an erroneous idea of scientific veridiction, where reason excluded the networks through which one knows. Latour accepts the accusation to a certain degree, provided that by relativism we understand what Gilles Deleuze meant by it: not the variation of the truth, but rather the truth of the variation. The relationship, at every point where it is woven, is a mode of truth. Also, that which varies is not so much truth itself, but rather our access to it, the form which this access takes. But then what we understand now is that this relativism of the primary level is suspended at a determined philosophical position, escaping the alternative to relativism and universalism. Taken in its totality, this world, without having to be characterized as universal, no longer has to be relativized. It is *all* for us, and the "for us," far from being an amputation or an attenuation because it

is indeed the *whole*, is in fact reason itself. We hold on to it, we are held by it: it is the whole, not in the sense that it totalizes itself, but because in it there exists at each moment the requisite for our maintenance, or that of our collapse.

Do we safeguard or do we lose our *means*? Such is the ethical, political, and civilizational question in which Latour's research culminates. Of course, we know that other cosmologies are possible, we even know that they are real – we are the civilization which has given birth to ethnology – but this does not imply that we should relativize our commitment towards that which we hold on to and are held by. Knowing ourselves, finding our means without disregarding or blending them – without committing category mistakes – would be the prelude to a new self-confidence. Yet this new assurance is not the restoration of an absolute of knowledge which it delivers to us. It is the elevation to a new level of thought which turns the networks into the texture of a world where we do not cease to displace ourselves, even as we move from one network to another, where we know how to grasp that which allows us to perform these crossings.

This is because the networks are indeed not the *whole*. They are not the last word in cosmology, they do not recover our world in all its amplitude. Contrary to what one may believe, Latour has never celebrated their omnipotence, their indefinite capacity for expansion. He has never relied on their dynamic. The criterion of distinction between two modes of transformation where the differentiation of the true and the false in each system lies, is that of the *consistency* acquired, of the strengthening produced in our manner of taking hold of, that is to say, simultaneously, of attesting that the world is held together, at least through this channel, and thanks to the attention which we know to grant it. In attempting to separate the conditions of truth and the conditions of existence of things, the knowledge of the moderns renounced discerning the different manners of telling the truth as so many ways

for something to remain in existence, to continue to exist, by the care which we apply continuously to its maintenance. In doing so, by the power of our thought, or by the force of the things which would hold all alone and absolutely reveal themselves to us in their form, we believed ourselves to be stronger than we were in reality. But that was the opposite of a real self-confidence. Again, the strength of the network lies precisely in its fragility, and in fact this is the counterpart of *our* fragility, this fragility wherein our strength *also* resides if we know how to see it. Until now, its strength had only been envisaged in the interior of each network: the weakest link, the finest connection, one whose care is required at the risk of interruption pure and simple. But if the fragility is also that of *our attention*, if the slightest commitment is required in this holding, and if we ourselves do not hold the world but with this means, we have to be able to accommodate that which comes with the appropriate attention, that we know at each turn, for each mode of existence, how to place us on the right frequency.

## REVIVING THE OLD PROJECT OF SOCIAL THOUGHT

WE TOUCH ON the *necessity* of the move away from network. The cosmology cannot be deduced from the ontology of networks. It requires something else, it requires a different approach. We must now move on to the level where systems *contrast* with each other, where the frequencies are understood to be distinct, in short, where different routes are indicated to us, not statically as a map unfolded right before our eyes, but in the mode of a structure of multiple calls within which we are engulfed without being lost. To know oneself – always assuming that the Platonic injunction continues to be asserted in the pragmatist world and not the idealist one – is to know the different paths without confusing one with another. The networks are not all, not so much because there subsists so much emptiness

between them which risks foundering us, but because the movement which creates them has its vector in the junction which we know to take, in the exact articulation of that which precedes and that which will follow. The specific alteration of a mode of being, if it engages us, should be perceived as a significant contrast, distinguished from another type of alteration.

Latour thinks of this passage, which is not a network but that based on which networks can form themselves, in the prepositional mode, whose function in the natural languages was unveiled by James. [1] We have stated that the Latourian actor was only an intensely *attentive* being (and this is something exhausting): but it must be noted that its attention, if it is not a generic faculty, if it is attention to that which is approaching and is determined in relation to that which is approaching according to the inclination of that which precedes, is in fact the detection of contrasts. Such is his minimum equipment for speaking in the manner of sociologists of action. The preposition, in fact, does not establish anything, does not open up any worlds, it disposes, it establishes modes of grasping of that which follows, as it will follow. Likewise, it does not determine a priori a direction to follow, a meaning that regulates the action on the inside, but it rather *confers* action to that of its means, to a certain mode of actualization of the how.

Thus, between the networks, at their intersection, there are joints which the networks do not reduce, which do not belong to their own respective paths, but which articulate them and allow that something could be articulated by following each of them. These joints are the modes of engagement, but only in the sense that at their level distinct beings could be established, provided that we grant our active attention to this differentiated instauration

of each mode of being. In reaching this ontological level, it is the articulation of the world – of our world – which now becomes thinkable. In other words, it is at this exact point where the ontology of networks reveals its cosmology.

It is also at this point where we need to pay attention to the most imperative mode. The philosophy of attention cannot simply pay attention to what we do in each mode of doing, and doing it is always a "making-do" (*faire faire*) which is intrinsically mediated, immersed in the transitional reality of the means. It is also required that the contrasts between the mediating lines do not escape us, that we know which ones they are, that we are able to see them all together, of seeing them in a single view, making an exact table of the sort which could tell us globally attentive to that which we are, intensely attentive towards the world which is ours, and not simply being cautious within each channel that pierces through it. It is in this sense that the cosmology joins not simply the project of an anthropology of the modern, but that of a modern ethic. It ranges over a discourse on that which we must do, from the ensemble of contrasts which we must see, or which we must know how to see, in each singular trajectory which presents itself to us. This ethic could ultimately be put in the following manner: we are *responsible* for beings we establish, which are the result of an instauration by us, based on the decisive contrasts which engage us, such as the prepositions in the Jamesian syntax. We are responsible for it because, as moderns, certain beings call on us, need us, and because this structure of calling is the general articulation of the world which we hold on to and through which we are held.

Comparative anthropology certainly has not waited for Latour to affirm that every culture has its cosmology. But it may have had to wait for Latour

---

[1] "The conjunctions are as primordial elements of 'fact' as are the distinctions and disjunctions…Prepositions, copulas, and conjunctions, 'is,' 'isn't,' 'then,' 'before,' 'in,' 'on,' 'beside,' 'between,' 'next,' 'like,' 'unlike,' 'as,' 'but,' flower out of the stream of pure experience, the stream of concretes or the sensational stream, as naturally as nouns and adjectives do, and they melt into it again as fluidly" (James, *Essays in Radical Empiricism* 230).

to give to this affirmation the imperious sense of an ethical duty, or a political mission: that which the anthropology of the moderns has revealed is that this cosmology is neither a reservoir of beings in the world that are divided according to a determined social structure, nor is it a projection of this same structure onto a natural world indifferent in itself. It is an ensemble of articulated beings waiting to be established, that is to say, of beings altered according to the specific diet required by each of them, and we have revealed ourselves to be capable, existing as we exist, of altering as appropriate, that is to say, of *making exist* (*faire être*).

This is the "making exist of things in a certain manner" which has ultimately ordered our precious attention. And it is from this "making exist," the requirement for instauration which resides at the junction of each network, that an injunction is launched for us. Let us not be confused anymore, and let us commit ourselves to our own identity, which is our mode of differentiation of the real.

From this perspective, it seems that Latour revives the native project of social thought, such that it began to emerge in the early nineteenth century after the French Revolution had made society come face-to-face with itself, that is, facing this challenge of knowing itself to act on itself from its own interior, without delegating this action to an instance which would be alien to it. Indeed, it is difficult to imagine significant social thought, deployed in a real sociology, without ultimately involving a theory of values. From that which the sociological projects discusses in terms of values, often rapid condemnation either from the right or from the left has resulted. However, one can claim that, since its premises, since the postrevolutionary period, and therefore since the unfolding of the modern project, sociological thinking has been driven by a completely different intention: the intention of imagining a government of society by itself, in a world which it transforms and within which it can only subsist by transforming itself – in a world

where it is, and knows itself to be, devoted to movement. Finding the proper way of operating in modernity is what Auguste Comte was already looking for in the theory of ambulation of Paul-Joseph Barthez. Assessing human knowledge as an articulated plurality of speculative actions likely to orient and make us stand upright, not in immobility, but in the necessary movement from which we cannot escape in any manner: this can, after all, summarize the architecture of the course of positive philosophy where the word sociology appeared, let us remember, for the first time (Karsenti). Latour, as distant as he is from the positivist paradigm in terms of methodology and ontological presuppositions, is certainly not a stranger to this grand intention. Further, when he confesses that it is his aim to ultimately make us clear to ourselves, which should be called our values, it is for adding that values can only be maintained when they are manipulated, put at risk, that is, transformed. Indeed, what are they after all if not the actual contrast with the aid of which our progression is likely to continue, our transformation of ourselves and of the things that could take place? Starting out from a philosophy of alteration, one would be surprised to end up at a philosophy of values. But this is in fact a philosophy of *valences* of the world, this world which we hold on to and through which we are held. If one failed to understand it, it is because one unduly translates alteration by chaos or uncertainty. In fact, alteration has its rigor – what the table of modes of instauration is specifically intended to establish. In light of this study, the diagnosis is reversed. And we end up by admitting that it is in disregarding the alterations which we are capable of that the peril is actually the greatest.

*This text was first published in French as*
*"Tenir au monde, le faire tenir:*
*Linéaments pour une philosophie de l'attention."*
Archives de Philosophie 75.4 (2012): 567–86.
*Translated from the French by Translatetrade.com.*

## Works Cited

Comte, Auguste. *The Positive Philosophy of Auguste Comte.* Trans. and condensed by Harriet Martineau. London: Chapman, 1853. Print. Trans. of *Cours de philosophie positive.* Paris, 1830–42.

Durkheim, Émile. *Pragmatism and Sociology.* Trans. J. C. Whitehouse. Cambridge: Cambridge University Press, 1983. Print.

444

James, William. *Essays in Radical Empiricism.* New York: Longmans, Green, and Co, 1912. Print.

Karsenti, Bruno. *Politique de l'esprit: Auguste Comte et la naissance de la science sociale.* Paris: Hermann, 2006. Print.

Latour, Bruno. *An Inquiry into Modes of Existence: An Anthropology of the Moderns.* Trans. Catherine Porter. Cambridge, MA: Harvard University Press, 2013. Print.

---. *Politics of Nature: How to Bring the Sciences into Democracy.* Trans. Catherine Porter. Cambridge, MA: Harvard University Press, 2004. Print.

---. *Reassembling the Social: An Introduction to Actor-Network Theory.* Oxford: Oxford University Press, 2005. Print.

Lévi-Strauss, Claude. *A World on the Wane.* Trans. John Russell. New York: Atheneum, 1961, Print. Trans. of *Tristes tropiques.* Paris: Plon, 1955.

Souriau, Étienne. *The Different Modes of Existence.* Trans. Erik Beranek and Tim Howles. Minneapolis Univocal, 2015. Print. Trans. of *Les différents modes d'existence.* Paris: Presses Universitaires de France, 1943.

Whitehead, Alfred North. *Process and Reality: An Essay in Cosmology.* 1929. New York: Free Press, 1978. Print.

# MODES THAT MOVE THROUGH US

## Eduardo Kohn

*In memory of Alejandro Di Capua (28 November 1947–14 March 2014)*

I WOULD LIKE to consider the possibility that Bruno Latour's *Inquiry into Modes of Existence* is itself a mode of existence, and I want to chart the way in which this mode of existence has passed through my thinking about other modes of existence in ways that have transformed me. My engagement with the AIME project largely revolves around Latour's visit to McGill University in March 2014. Latour (along with a team he assembled that included Pierre-Laurent Boulanger, Christophe Leclercq, and Patrice Maniglier) visited us in Montreal for a public lecture and a workshop that I organized with my McGill colleagues Richard Janda and Peter Skafish.[1] As we drafted it, our proposal was to assemble a group of actual "diplomats" – scholars who had been made over by the worlds in which we had immersed ourselves to the extent that we had each come to "inhabit conceptual universes corresponding to different modes of existence." Furthermore, we had each "undertaken attempts at translating" such modes "into the terms

EDUARDO KOHN *is interested in capacitating sylvan thinking in all of its valences. He is the author of* How Forests Think: Toward an Anthropology Beyond the Human *(2013, University of California Press), which won the Society for Cultural Anthropology's 2014 Gregory Bateson Prize for Best Book in Anthropology. He teaches anthropology at McGill University in Montreal.*

of other universes and/or contesting the terms of the latter" (Skafish, Kohn, and Janda). Despite the different realities we as diplomats learned to inhabit, we shared in common the following:

1) We took the unprecedented global ecological crisis to be THE political (political-ethical-scientific-technical-etc., or, following Eduardo Viveiros de Castro, *metaphysical*) problem facing our times.

2) We felt that the ontological realms we inhabit could furnish unique conceptual tools that could be brought to bear on this problem.

[1] Participants in the workshop, followed by their affiliations and, in brackets, the modes of existence they represented, were as follows: Annalise Acorn (Faculty of Law, University of Alberta) [LAW], Peter Brown (School of Environment, McGill University) [LAW], Jay Ellis (Faculty of Law, McGill University) [LAW], Angela Fernandez (Faculty of Law, University of Toronto) [LAW], Vincent Forray (Faculty of Law, McGill University) [LAW], Kregg Hetherington (Department of Sociology & Anthropology, Concordia University) [LAW/POL/REF], Thomas Lamarre (Department of East Asian Studies, McGill University) [REF/REP], Katherine Lemons (Department of Anthropology, McGill University) [LAW], Setrag Manoukian (Department of Anthopology, Institute of Islamic Studies, McGill University) [REF/REP/FIC], Eric Méchoulan (Department of French Literature, Université de Montréal) [FIC], Ron Niezen (Department of Anthropology, Faculty of Law, McGill University) [LAW], V.K. Preston (Institute for the Public Life of Arts and Ideas, McGill University) [MET], Anne Saris (Department of Law, Université du Québec à Montréal) [LAW], Jeremy Stolow (Department of Communication Studies, Concordia University) [MET]

3) We recognized other modes of existence, capable of furnishing other conceptual tools, as well as the need to find ways to move among such disparate modes to establish a new form of collectivity able to face this crisis.

We took it upon ourselves to be thoroughly conversant with the framework provided by the AIME project and committed ourselves to exploring our ontological universe via it. We then, over a period of two intense days, each presented a proposal concerning how our mode of existence, now defamiliarized through AIME, could be reimagined in the Anthropocene. In particular we were interested in understanding "how living beings, ecosystems, and 'spirits' could intervene in our discussions as much as, say, (actual) scientists or the law." And we wanted to know "what kind of practice might allow for that to happen in fact and not just in principle or in the imagination" (Skafish, Kohn, and Janda).

This essay is a brief reflection that documents the history of this engagement. It begins with some comments I prepared in response to "Gaia, Anthropology and the Law," a public lecture given by Latour before the workshop, and then moves to a diplomatic engagement with the AIME project on behalf of the mode of existence that has forever changed my mode of existence. I call this mode "sylvan thinking." It is a way of being I learned to inhabit as a result of my ethnographic research in Ecuador's Upper Amazon among the Quichua-speaking Runa and the forest beings with whom they engage.

Latour's inquiry into the various modes of existence that make our world is concerned with recognizing the multiple kinds of beings these modes harbor, the ways in which we are made over by them, and our inability to recognize this if we persist in dividing up the world into (human) subjects and (nonhuman) objects. His call is urgent because of the ecological crisis that faces us today – a crisis that is forcing us to see ourselves, us humans, us moderns, as made by and dependent on these other beings, to whom we don't always know how to listen, but with whom we share a vested common interest as we search for ways to better inhabit this earth in the so-called Anthropocene. Latour's call is for an ontological exploration in order to understand how to face Gaia along with the many other kinds of beings that people our world.

Of course Latour's ontology is not so much concerned with *being* as it is with *being-as-other*. But back, for a moment, to being. It was exactly a week before his public lecture at McGill. It happened to be my birthday. What a wonderful day to think about *myself*. But that was interrupted by a phone call. I learned that Alejandro Di Capua, my uncle, who lived in Ecuador, and with whom I was very close, had died. Things suddenly got very complicated: morally (should I stay or should I go?), religiously (my uncle, the child of Roman Jews displaced by the Second World War to Ecuador, had inconveniently died on the eve of the Sabbath, which makes it very difficult to deal with a rapidly decaying body), and economically and technologically (last-minute tickets are expensive and hard to find). Torn against myself, not sure what to do, I managed to get myself on a plane to Quito, and to enter that dense tangle of attachments that was my uncle and which now has no center (the network is still there, albeit painfully resonating with the absence that still holds it together, an absence that now demands a different way for this network to pass through an-other to remain the same).

I went to Ecuador and managed to get back just in time for Latour's lecture. Without wallowing too much more in self-indulgence, the point I wish to make is that to take part in that conversation with Bruno Latour, a week after my uncle's death and my trip to Ecuador, I had to pass through many kinds of others. I could have stayed home and minimized some of these passes, to the point that I might have thought, narcissistically, and wrongly, that I really don't need any others to be me. But I went and allowed myself to be unmade and remade by these networks.

To make it back to Montreal I had to pass through all sorts of beings. Quito has a new airport out in the country (it used to be in the middle of the city); its landing strip, as it turns out, is situated along one of the original baselines that Charles-Marie de La Condamine used in the eighteenth century to calculate the meridian arc. The problem is that the road leading there had not yet been expanded, and everyone had to cross the narrow bridge over the Río Chiche to get to the airport. If you didn't cross this bridge before 5:30 a.m. you would not get across in time for any morning flight. This was, in the idiom of AIME, a very "material" pass through an other to remain the same. So, on the day before Latour's lecture, I got up at 4 a.m. and, as a result, got to the Quito airport in time to board an earlier flight.

On that flight I found myself sitting, improbably, next to an indigenous Quichua-speaking Runa man from the Andes (he was headed to Miami on business and also wanted to check out North Miami Beach and Disney World; at the end of the month he was traveling to China!). As we ate our breakfast – the standard stale airline fare but garnished with fried Amazonian manioc and Andean lupine beans – we started talking about those improbable networks that had brought us together on that plane, flying over the Andean snowcaps, sharing that equally improbable meal, chatting away, again improbably, in Quichua (that *yanga shimi*, or "plain speech," just about as underappreciated as that lowly lupine bean that is now served for breakfast on the American Airlines flight to Miami). And so I tried to explain to this man, Aurelio Maldonado, in that *yanga shimi*, and to the best of my ability, what I understood Bruno Latour's *Inquiry* to be about.

This is what I tried to tell him. For decades now Bruno Latour has been writing about the ecological crisis in which we find ourselves, a crisis that involves the problem of how best to "ecologize," how best to grasp the many kinds of relations that make us and our world, relations that we misrecognize and destroy when we focus on that one framework that promises to subsume all of our values – when we focus, that is, on the economy as the bedrock for our attempts to "modernize."

This made a lot of sense to Aurelio. In Quichua, the word for poverty is *huaccha*, which literally means orphaned – that is, relationless. As he explained it to me, *not* being poor means being able to be relational with others – with the earth, through planting and harvesting, and with other beings through the sharing of those fruits (none of this Pachamama talk, of course, kept him from wanting to visit Disney World, and it isn't stopping him from importing synthetic blankets from China).

And then I asked Aurelio, ethnographically, by which I mean diplomatically, what *he* thought might be a better way to live. This is, of course, something we both have to discover and invent (there is no room for retreating into tradition when you're headed, at five hundred miles per hour, for Miami). Aurelio had his own critique of modernizing and his own version of ecologizing. It was a complicated and subtle analysis that started with the observation that "being rich," *charij* in Quichua, from the verb "to have," is not a relational concept ("What are you going to do with all the money you accumulate?" he asked rhetorically), and it is therefore not really an antonym to *huaccha* (the lack of relationality that signals being destitute). And he concluded with the observation that "shuclla, mana ushanchi" – "alone, we won't be able to make it." I think Aurelio's words help us understand Latour's challenge. We inhabit a metaphysical framework that impoverishes us by collapsing all relationality into one kind, the kind that is all too human, in a way that makes us feel alone in the world – *shuclla, huaccha* – cut off from networks of relations among other kinds of beings.

So how can we open ourselves to relations with the other kinds of beings with whom we share our fate with Gaia? How can we learn to listen well in order to speak well? This is the empirical, ethnographic, and diplomatic challenge for which Bruno Latour is helping us prepare. And as an

447

anthropologist, my task is to find ways to open myself to it.

I do so by focusing on the mode of existence I call sylvan thinking – as in savage, sylvatic, *sauvage*, or wild. Sylvan thinking, as I outline in detail in *How Forests Think*, is the kind of thought done by forests and those beings – including humans, plants, animals, and spirits – that inhabit or engage with them. Although human language is the usual framework for how we think about thinking, sylvan thinking is a kind of thought that does not occur within it. Instead of relying on conventional, arbitrary signs, as human language does, sylvan modes of representation involve signs that point to and resemble their objects – we might say they are imagistic. All beings, human and nonhuman, as they engage with the forest, partake in this imagistic mode of communication. When, for example, a spot-winged antbird's alarm call points to a jaguar's presence, and a hunter simulates the call he hears, both partake in a form of sylvan thinking that is imagistic.

I think of sylvan thinking – very loosely – in terms of what Michel Foucault called an "analytics" (82). Sylvan thought, in this sense, is not a theory but a mode of existence that suggests its own way of thinking – one that can offer important theoretical purchase for facing today's ecological crisis. In this sense it is "ontological," by which I mean that sylvan thinking is a form of inquiry that can be made over by its object of inquiry. Sylvan thought has its own ability to move, to pass, to instantiate, to instaurate, as well as its own politics, its own ethics, and, via the spirits that can come to live in its tendrils, its own reflexive consciousness.

My work in Ecuador's Upper Amazon has been about ethnographically rediscovering (since it already exists in all of us) this fragile mode and finding ways of capacitating it. My goal is to continue to track sylvan thinking as an analytics as it takes on a new life in the face of new threats (such as the "neo-extractivist" policy adopted by the government of Rafael Correa) and new diplomatic opportunities (such as Ecuador's 2008 constitutional recognition of the rights of nature).

In the terminology of Latour's *Inquiry*, sylvan thought is intrinsic to that set of beings of reproduction that are characterized by "lineage" (110). I would suggest that sylvan thinking as a mode of existence could be called [REP].[2] [REP], however, in this sylvan reformulation of the AIME idiom, would no longer stand for reproduction (even though reproduction – albeit a kind that is not necessarily genetic, sexual, or filial – would be part of it). Rather, it would stand for representation or re-presentation. Sylvan thinking could be thought of as a mode of existence in proper Latourian terms in that it has its own kind of hiatus (a specific and unique constitutive relation to absence [Kohn 35–8]) and its own trajectory (it is uniquely telic; it involves means ends, purposes, functions, futures [72]), and this accounts for the ways in which it works in the world. It also has its own "truth conditions," as well as specific kinds of beings it institutes and particular ways in which it is in respect to the others it is not.

I think part of speaking well involves being ontologically honest to the various modes of existence. There are modes that seem to be fairly unique to humans, or even to moderns (e.g. [LAW]), there are modes that cut across all existents (e.g. [HAB]), and there are modes that are logically prior to all other modes (such as [NET] and [PRE]). But I think there are some things that are unique to *life* (wherever in the universe it may be and whatever substrate it may take and whatever other existents it may entangle), which I would subsume under this redefined [REP].

One thing that is unique about sylvan thinking is its capacity for intermodal movement. Whereas linguistic modes of thought require familiarity with the contexts that sustain them, sylvan modes

[2]   For a brief explanation of these abbreviations, which refer to the modes explored in the AIME project, see the glossary in this volume (*r*·M!543–47).

of thinking can cut across such contexts (Kohn 39). This has important diplomatic implications. However, sylvan thinking carries with it certain diplomatic risks because it asks us to think about the different modes of existence in terms of their nested and directional relationship with reference to each other (168–74), which requires one to make claims about other modes from within this one mode of existence. Rather than shying away from this problem, or fighting my way through it, I've chosen instead to try to learn to sit with it.

In sum, learning, with the help of Bruno Latour, to allow the AIME project, as its own mode of existence, to move through me has helped me see how thinking with forests can be mobilized as part of an ecological ethics for our times.

---

*Works Cited*

Foucault, Michel. *The History of Sexuality.* Vol. I. New York: Vintage, 1980. Print.

Kohn, Eduardo. *How Forests Think: Toward an Anthropology beyond the Human.* Berkeley: University of California Press, 2013. Print.

Latour, Bruno. *An Inquiry into Modes of Existence: An Anthropology of the Moderns.* Trans. Catherine Porter. Cambridge, MA: Harvard University Press, 2013. Print.

Skafish, Peter, Eduardo Kohn, and Richard Janda. "McGill Workshop on Diplomacy, 24–25 March 2014 – Schedule". AIME. *The Blog.* FNSP, 24 Mar. 2014. Web. 5 Feb. 2016. Available at <http://modesofexistence.org/mcgill-workshop-on-diplomacy-atelier-a-mcgill-sur-la-diplomatie/>.

# BRING THE DEAD INTO ETHOLOGY[1]

## Vinciane Despret

THE BODY OF LARS, a musician, is lying on the bed. His wife, Petra, is close by. With her is Heidi, a death midwife. Other people are moving about the house. One of them is Alexa Hagerty, who told this story ("Réenchanter la mort"). Everyone is talking softly, to each other, and to him. Lars's mouth is wide open. It has been like that since his death a few hours ago. It is a reminder of his illness and his agony, for Lars had a respiratory disorder.

The wife and midwife try to close his mouth, in vain. The scarf won't stay in place. After many frustrated attempts, everyone was called out of the room by a temporary distraction.

When they return, Lars's mouth is closed and he's smiling. Petra and Heidi agree that this is a sign he has left for them. He is no longer suffering and is now at peace.

The presence of the death midwife stems from a recent phenomenon that Alexa Hagerty studied for her master's thesis: home funerals. The home funeral movement was started by a handful of people in the United States, who mobilized collectively to denounce and protest about the way in which bodies of dead people are treated, the commercialization of this process by undertakers, the family's

VINCIANE DESPRET is a philosopher, psychologist, and teacher at the University of Liège and at the Free University of Brussels. Her research focuses on ethnopsychology and ethology. She has been interested for a long time in humans working on and with animals, and has also worked on a constructivist approach to emotions. Her current research deals with the relationship between the living and the dead.

exclusion, and the violence done to the corpse by the embalming techniques used. These collectives decided to relearn to care for their deceased and to pool their expertise. Counselors, called death midwives, are trained to solve administrative and legal problems, to help in taking care of the corpse and controlling its decomposition, and to organize the funeral vigil.

Home funerals put into practice an important dimension of the lives lived by the deceased: this type of funeral participates actively in the *instauration* of their existence.[A]

In this respect, the vigils that they organize with great care are particularly crucial. Here, the deceased retain their full relational capacity. The midwives stress that it is important to carry on talking to them, *with love, softly, carefully choosing one's words,*

[1] There are two types of notes in this paper. When the note is indicated by a number, it means the note provides additional information. When it is indicated by a letter, it signifies a direct reference to *An Inquiry into Modes of Existence*, from which it has either borrowed a tool, or in relation to which it differs slightly.

because, they say, while we have to get used to seeing them leave us, they have to get used to it, too, and we must help them. Although death is indeed a passage, which the anthropology of death never tires of theorizing as such, this passage is not one that goes from life to nothingness – as scientists and academics have defined it. On the contrary, it is the perilous moment of transition of a being towards a new way of being; a moment in which the living have work to do that has nothing to do with the work of mourning. Death is no longer inscribed within a medico-scientific time frame; it is no longer what happens at a determined moment in time (determined mainly by doctors). In fact, it becomes a long process in which what we call the person's agency, their ability to act, and where the body as "vibrant matter" (Bennet) remains, especially because communication is still possible.

This is the perspective from which Lars's smile was understood. The midwife and Petra agreed that it was a sign, a gift which comforts his wife and his family. Saying it like that means paying attention to effects; more precisely, it means taking care of events through their effects. There is no need to go any further by asking who (Lars) or what (the sign) does the comforting. But we could if we wished to. We could, for example, suggest that, by smiling, Lars intentionally gave his family a sign. Those who cultivate the practice of home funerals would readily accept this idea, or would even voice it themselves, because they believe that death is not an interruption in the process of life: cells carry on communicating for some time, hair carries on growing, and the

body undergoes transformations. What do we know about what the body continues to feel and causes the person to feel once it has stopped breathing?

Death midwives share the conviction that death is not a matter of all or nothing. The heart may have stopped beating, but there is still someone, a form of presence, albeit one that is certainly much weakened. They hypothesize that the dead continue to understand and even to respond to the words of the living, and that the question of concern not only applies to the latter. The deceased can respond by way of facial expressions, odors, or through signs in nature or the immediate environment. They can still talk to the living through memories or thoughts that come to them in the presence of the dead person (Hagerty, untitled 59). These are signs and, as such, they remain open to the possibility of being understood differently. Lars smiles to comfort his family and the midwife, which is how the widow interprets it.

But the midwife also adds that sometimes death affects the face muscles in such a way that it produces a post-mortem smile. Hagerty notes that one explanation does not preclude the other. The midwife adds a possibility, not in the sense of "either or," but of "or else, also" in the valuable grammatical register of conjunctions: and, and, and...

The outcome of this active conjunction of hypotheses is that the smile that comforts makes the deceased a particularly robust being for he unifies two ways of being: he becomes an expressive relational being, and his body becomes *matter for*

[A]   The term instauration proved to be crucial in this research. In the context we are concerned with here, the act of instauration means participating in a transformation that leads to a *certain existence*, that is, to *more existence* (in the case of the deceased, both a biographical supplement and the accomplishment of an existence in another realm of reality): an existence that, in the case of a particularly successful accomplishment, may manifest what Étienne Souriau calls its "brilliance of reality" (*éclat suffisant de réalité*) (10). For we can indeed talk of "reality" as regards the existence of the deceased, provided we agree on the right regime of reality that can be granted to them. By envisaging the definition of the mode of existence that enables us to account for what the deceased do and what they have others do – so that we can describe how they interfere in the lives of the living –, we avoid the trap in which our tradition captures and generally freezes the problem. This trap is that of separating the ways of being into two categories: that of physical existence, and that of psychological existence; either of the material world, or purely subjective productions. This ominous choice leaves only two possible fates for the deceased, and the one is as miserable as the other: either non-existence, or else fantasy, belief, and hallucinations.

*expression.* From this perspective, *that which* express-es and *that which* is expressed remain undetermined. We can, of course, determine them ourselves, but there is no guarantee that the one does not actually relate automatically to the other. As I have often heard said, why do the deceased not abide by the laws of biology (or physics?) when there is something they wish to communicate?[2] But these laws of physics (when objects fall or break spontaneously, or when electrical appliances seem to defy control), or of biology are not cited as evidence. In fact they prove nothing and nor do they give the phenome-non its scientific imprimatur.[B] These are expres-sive modes that require no explanation, only recip-ients. They simply call out to be taken into account.

This deliberate coexistence of two versions im-plements a particular type of epistemological en-gagement that home funerals practitioners refer to as the "threshold." Hagerty writes that the thresh-old is the space "in which the dead body is *both* bio-logical *and* sacred, object *and* subject, disenchanted *and* enchanted, inert *and* still offering its enspirited care" ("Réenchanter la mort" 135).

The disjunctive and controversial "or else" of the preferred conceptions are carefully replaced by "and," and it is these "ands" that challenge medical epistemology. For, unlike medical epistemology, the dispositif of home funerals considers that each ver-sion "adds" to the situation rather than requires the removal or substitution of a previous version. The fact that a smile can be a "natural" phenomenon does not prevent Lars from having wanted to com-fort his family. It is not the hypotheses of enchant-ment that challenge medical epistemology, but the

affirmation of the possibility that multiple and con-tradictory versions coexist. The "and" introduces a non-polemical challenge, I would say an *open* chal-lenge (insofar as it opens up to other narratives), in terms of "there is always something else." This is a commitment, in that it transforms ways of think-ing and of feeling.

Actively maintained, this coexistence signals the particular mode of existence of the deceased; not so much in the register of the occult – understood in the sense of alternation, although this register does also characterize them insofar as their "brilliance of reality" (*éclat de réalité*) is *à occultation*[C] – but, more precisely, according to what people report, in that of an oscillation. An oscillation that is active resis-tance to what can be termed, following Whitehead, as the "bifurcation of nature," which consists in di-viding reality in two: a causal realm of facts and an experiential realm of appearances (or subjective productions) (Savransky).

The deceased invite themselves into dreams, they make "presences of presence" felt[D], they pre-vent or activate through various stratagems, and they play on coincidences (as far as they are con-cerned, anything can be used to make a sign, for they are opportunists of enigma). In everything they im-plement or set in motion, they thwart all attempts to give meaning to the action.

But, fortunately, they do have regularity (albeit local and always in relation to a particular milieu) that we can rely on. It is therefore possible to con-stitute a science of the deceased that fits them: one that describes them, anticipates their behaviors, and can even interpret (in the sense of guiding a reply

[2]  The following theories that form this ethology of the dead draw on material from a study that I have been conducting since 2007, which consists in collecting accounts from people who experienced the death of someone close to them, and who continued to maintain relations with that person. See my book *Au bonheur des morts: Récits de ceux qui restent* (2015).

[B]  This means that the individuals who recount these events are attentive to use of the wrong category. For them, saying that the deceased can use the laws of physics to appear does not mean that the laws of physics will explain the event (on the contrary, were that the case, it would mean that these people would be doing something very different: rationalizing, with the aim of simplifying and de-animating the event or, in other words, changing categories along the way).

[C]  In the mode of appearance-disappearance.

[D]  As I have often heard or read, and that would in a sense be the semantic version of the redoubling of the action.

to) what they want or request. The deceased thus have an ecology (milieu is a crucial issue for them, and we sometimes witness real extinction in highly unfavorable niches) and, above all, an ethology – the science that hitherto studied the behavior of animals. Provided, however – and the same also applies to animals – that we are not referring to the traditional version of what is called classical ethology, otherwise known as behavioral biology and which primarily studies specific instincts and invariants.

The science of ethology is above all a practical science. It is the science of what beings do and get others to do, what they are capable of doing. Therefore, the facts that it describes should only be described using the infinitive.

This definition of ethology is actually the one proposed by Gilles Deleuze, in his lectures on Baruch Spinoza's *Ethics* (1677):

[E]thics is better known to us today under another name, the word ethology.
When one speaks of an ethology in connection with animals, or in connection with man, what is it a matter of? Ethology in the most rudimentary sense is a practical science, of what? A practical science of the manners of being. …
In what is called the animal classifications, one will define the animal above all, whenever possible, by its essence, i.e. by what it is. Imagine these sorts who arrive and who proceed completely otherwise: they are interested in what the thing or the animal can do. They are going to make a kind of register of the powers (pouvoirs) of the animal. Those there can fly, this here eats grass, that other eats meat. The alimentary regime, you sense that it is about the modes of existence. An inanimate thing too, what can it do, the diamond, what can it do? That is, of what tests is it capable? What does it support?

What does it do? A camel can go without drinking for a long time. It is a passion of the camel. We define things by what they can do, it opens up forms of experimentation.

Ethology thus defined meets the criteria proposed at the working seminar in July 2014 held at the École des Mines in Paris, "Reinstituting Nature: A Latourian Workshop":

Ethology is just beginning to accept the hard lesson that one does not learn from beings turned into zombies. The due attention demanded from ethologists thus requires addressing an animal defined as 'non-indifferent,' an animal for which the way it is addressed matters. (Debaise et al. 171)

Ethology reconfigured in this way becomes a practical science of the modes of interrogating and experimenting with ways of being, that is, for emphasizing the necessary redoubling of its definition: a practical science of the modes of attention that are required by the ways of being of those it aims to study.

*Translated from the French by Liz Libbrecht.*

## Works Cited

Bennet, Jane. *Vibrant Matter: A Political Ecology of Things.* Durham, NC: Duke University Press, 2010. Print.

Debaise, Didier, et al. "Reinstituting Nature: A Latourian Workshop." *Reset Modernity!* Ed. Bruno Latour. Cambridge, MA: The MIT Press, 2016. 104–13. Print.

Deleuze, Gilles. "On Spinoza." *Lectures by Gilles Deleuze.* Deleuzelectures.blogspot.com, 2007. Web. 20 Jan. 2016. Available at <http://deleuzelectures. blogspot.com/2007/02/on-spinoza.html>. Trans.

of "DELEUZE – SPINOZA: Cours 2." Rec. 9 Dec. 1980. *La voix de Gilles Deleuze en ligne.* University of Paris 8. Web. 20 Jan. 2015. Available at <http://www2.univ-paris8.fr/deleuze/article.php3?id_article=137>.

Despret, Vinciane. *Au bonheur des morts: Récits de ceux qui restent.* Paris: Les Empêcheurs de penser en rond / La Découverte, 2015. Print.

Hagerty, Alexa. "Réenchanter la mort: Les funérailles à domicile en Amérique du Nord." *Terrain* 62 (2014): 120–37. Print.

---. "Speak Softly to the Dead: The Uses of Enchantment in American Home Funerals." *Social Anthropology* 22.4 (2014): 428–42. Print.

---. Untitled. "Toward an Anthropological Theory of Mind." Ed. Tanya Marie Luhrmann. *Suomen Antropologi: Journal of the Finnish Anthropological Society* 36.4 (2011): 59–60. Print.

Latour, Bruno. *An Inquiry into Modes of Existence: An Anthropology of the Moderns.* Trans. Catherine Porter. Cambridge, MA: Harvard University Press, 2013. Print.

Savransky, Martin. *The Adventure of Relevance: An Ethics of Social Inquiry.* Basingstoke: Palgrave and MacMillan, forthcoming. Print.

Souriau, Étienne. *L'instauration philosophique.* Paris: Alcan, 1939. Print.

# "RESET INQUIRY!"

## P3G – Le Petit Groupe du Grand-Gagnage[1]

## TO HOLD INQUIRIES THAT HOLD US

WHY CARE ABOUT "inquiry"? And for whom might it matter? We are a small group of young researchers from Belgium from different disciplinary backgrounds in the arts, social and political sciences, philosophy, and architecture. Through this diversity, we share a common interest in *science studies* and a passion for empiricism as well as pragmatism (that is, authors who deal with practices, who look at experiences without separating them from their consequences). Pragmatism equips us with means of active thought, that is, the means of *engagement with* the situations which we explore and to which we belong as inquirers. Crafting inquiries along with questioning our crafting skills makes sense to us, insofar as it grounds our accounts in situated problems.[2]

In our view, inquiry has been (too) often practiced as an individual's quest, belonging to some scientific discipline, directed towards the "outer world" in order to generate knowledge for its own sake. We strive for another stance where inquiry is the collective elaboration of questions relevant to problems arising in a situation. We investigators share those

LE PETIT GROUPE DU GRAND GAGNAGE (P3G) *is a team of young academic scholars from Belgium, who mix a wide range of disciplines, such as philosophy, political science, architecture, sociology, and the arts. At the intersection of usual academic structures (faculties, departments, research centers), P3G institutes "horizontal" reading seminars, where the exploration of a text progresses jointly with established learning.*

problems at least to some extent. Our contribution rests with our ability to formulate them in a way relevant for those they concern – which does not necessarily imply their resolution.

This stance that we share stemmed and resulted from a collective and extensive reading seminar (held in 2013–2014) on Bruno Latour's *An Inquiry into Modes of Existence*. In this book, Latour identifies twelve modes of existence, distinct ways of consisting ontologically. He suggests different modalities through which various beings emerge, maintain themselves, and can deploy plural ontologies all at once. He looks at the trials those beings need to overcome, in order to gain consistency legally, politically,

---

[1]    P3G is a flexible collective that works by crossing readings and inquiries. This article comes from its first seminar, organized by François Thoreau and Ariane d'Hoop together with Amandine Amat, Jérémy Grosman, Giulietta Laki, Pauline Lefebvre, Elsa Maury, and Gert Meyers. All contributed to the writing of this text. P3G warmly thanks Benedikte Zitouni for her comments and suggestions on an earlier draft of the text.

[2]    For the reader interested in learning more about the situations we briefly outline in this chapter, see D'Hoop and Thoreau.

**1a** The seminar presentation in Brussels.

**1b** Collection of inquiries after a year of the seminar.

religiously – to name but a few of those modes of existence. Chapter after chapter, we inquired into the specificities of each with regard to problematic situations borrowed from our respective fieldwork (see figs. 1a and b).

Our aim was to experiment with the book and put it on trial in our own accounts of situations we cared about. Conversely, we wondered how this would affect the modes themselves. We wanted to avoid exemplifying the book's theories by juxtaposing or applying these theories to our fieldwork – a trap into which we were at risk of falling as soon as we were tempted to understand Inquiry as a closed system of thought. Hence, we hereby challenged both Inquiry and our fieldwork in their fragile encounter. No exegesis, only pragmatism!

2   A Google Image search for the "The Battle of Orgreave." The re-enactment pictures are featured as much as the images of the original battle. Google Image, 3 July 2015. Screenshot.

## RESISTING THE ENCLOSURE OF THINKING

EACH OF US CARRIES out fieldwork in a broad diversity of situations. Throughout our collective experimentation, we encountered a legal battlefield that opposed experts and an alleged "war criminal," all of them fighting to use images as evidence to make their case, but not only. We also encountered French winegrowers making interesting experiences while dealing with global warming consequences; architects striving to establish their own stories and who face so many constraints in doing so; a performer who set the reenactment of a historic strike and an epic battle between minors and policemen in 2001; a psychiatric institution moving out of its old premises and considering whether spaces had to be maintained or reinvented; ambiguous uses of scientific texts entangled with fictional narratives and, conversely, scientific references meshed into the plots of novels or theater plays; a European research project, where we witnessed engineers designing the architecture of highly protected perimeters and dramatizing algorithm's agency: how far could we take them seriously? And so on.

Such problematic situations demand adjusted thinking and cannot easily be reduced to some rough generalizations. Yet, at the end of the *Inquiry*,

the reader finds a table summarizing the different modes of existence. Does that make it a *systematic* approach to pluralist ontologies? This hypothesis was tested in a recent interview (Latour and Marinda) in which Latour is put on trial by a skeptical student. The latter wonders about the surprisingly round number of identified modes of existence: twelve. What a coincidence! So the *Inquiry* is a system of thought after all. The question matters because the history of ideas is full of such totalizing systems, which reduce the worlds we encounter into a handful of categories, and therefore sterilize the inquiry. All there is left to do is to pile up examples that illustrate the enclosed theory. Systems put the investigator at risk of getting detached from what is at stake – which incidentally often proves to be a fruitful way of getting academic recognition.

We have tried to resist this temptation by putting the book to work. Can a system of thought put the investigator at risk of being wrong with respect to the situation she or he cares for? This question calls for careful attention: to what extent can a "system" be considered as a set of tools which might *actually* be confronted with objects? The trial rests on its adjustability to the situations at stake. In our view,

there are no ready-made tools fit for everything. Each tool must tend towards adequacy; that is, it must adjust itself so as to *fit into* the situation, and not the other way round. The use of such tools requires constant reshaping. For instance, Latour characterizes the mode of the political [POL][3] with a diagram of drawing "circles" of inclusion and exclusion. It so happened that, in one of our situations, we witnessed powerful dynamics that, in our view, would considerably distort the very figure of a circle. When apprehending the re-enactment of the battle of Orgreave, which set minors against the police back in 1984 in the UK, a collective strength was spreading out that would impoverish, for a short while, any possible *form of representation*, which the very figure of a circle partly implies (see fig. 2).

So we see no point in resolving this question of the system's relevance "in general." To ascertain whether the *Inquiry* is a system of thought or not doesn't help much. In itself, such a question launches a quest for its essence and henceforth leads to reification of its propositions. Instead, our experiment with the *Inquiry* led us to reformulate the question: from within an empirical situation and its related problems, do the modes help us to better describe the contrasts that are at stake? Does it help us to see which mode of existence takes the upper hand, and at what point it does so? And which ones could be useful in providing better accounts of the situation, in opening up alternatives? We do not know if systems are good or bad, but we do know that words can make a difference.

Let's think of this architect who is fascinated with the contour lines of a map and who undertakes the modeling of the building-to-be based on them. This has consequences for the ground itself and for the actual execution of the work, but all of that rests on the inner consistency of this architect's vision – its ability to convince clients and win competitions. When architects construct

stories about their projects, are they planning an organizational script as in the [ORG] mode or are they taking the exercise of carrying forth a fiction [FIC] seriously? The question is problematic in itself and makes us hesitate. The choice between modes is not entrenched, and choosing to qualify the situation using one mode over another *does matter*. The contour lines themselves are different when deciding on the carving of the soil or when seducing aesthetically up to the point of enabling a decision (see figs. 3a–c).

In other words, we call for a pragmatic use of the modes of existence, answering William James's question: If it's true, why should it matter? The modes of existence are not so much about dealing with the truthfulness or falsity of a situation, but instead about trying to qualify it as accurately, as cautiously as possible, which sometimes implies distorting the conceptual tools we use to do so.

### SITUATED PRAGMATISMS ALL THE WAY THROUGH...

HENCE, PRAGMATISM is far from being only a philosophical notion. It also refers to a politics of inquiry. Surely, "following the actors" has been a long-standing commitment for Actor-Network Theory up to becoming some sort of caricature (Latour, *On the Modern Cult*). But "actors" experiment all the time with varied gestures or discourses in a situation which is also constantly evolving. In this way, situations themselves hold on to their own experimentations. Attention to significant experiences pervades the concrete pieces of worlds we have investigated. Empirical situations are not given as such. Instead, they show *attempts*: attempts to convince a judge, to design a building, to ecologize the grape-growing processes, etc. Through these attempts, hesitations about and attention to consequences lie foremost in the hands of practitioners.

[3]    For a brief explanation of these abbreviations, which refer to the modes explored in the AIME project, see the glossary in this volume (r·m!543–47).

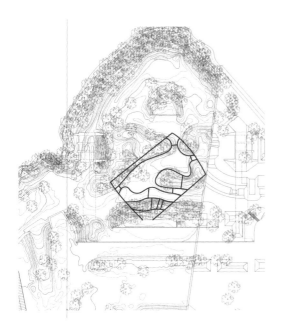

**3a–c** The trajectory of the curves during the design process: from contour lines on the plan given to the architect to poured concrete walls on the construction site.

Let us take another building as an example, a do-
mestic townhouse that was organized as a small-
scale psychiatric institution. Two years ago, this
center moved to a brand new building, designed
by architects for this therapeutic purpose. One of
the problems of this transition was "conviviality":
how to sustain it within the spatial arrangements
of the new building? Pragmatism would involve a
constant process of taking over the duplication of
some everyday care practice (such as daily team
debriefings and community meetings), which we
could term "retakes," but also some forms of "relays."
Relays would occur when caregivers bring back their
previous lived experience so as to convey, in this
new setting, their sense of their own practice to all
concerned third parties, such as building workers.
Conviviality fails or succeeds through the interplay
of such *retakes* and *relays* dynamics. Throughout this
experimental process, some features were secured,
adapted, challenged, or radically transformed. But
all raised the deployment of sensitive relations be-
tween people and things, and their importance in
the pursuit of care through its material configura-
tions. In here, the therapeutic practice [MET] seems
to rely on the attachment mode [ATT] (see figs. 4a–f).

While there is a kind of pragmatism at play that
belongs to the situation, we can still make a dif-
ference through our inquiry without crushing it.
It all starts with intuitions. At first, there is this
sense that *something matters here*, without being sure
what exactly. The modes of existence allow one to
embrace a broad diversity of *ways of mattering*. The
*Inquiry* throws us investigators into the necessary
speculative question of "what if…?" What if this algo-
rithm was *something more* than just technical? What
if climate change actually overreached the scientific
methods of our societies (along [REF] mode, that
of scientific reference)? What if…? Departing from
the initial troubles of the situation, the modes allow
us to widen the scope, to wonder whether it could
be characterized as this or that. They enable us to
identify a "plurifold" ontological register of what

4a–f    The center for psychiatry, in the original house and
in the new building. Important features that have
been taken over are the big living room that finds its
counterpart in a small one (a–b, c–d), and
the kitchen still opens on the dining room (e–f).

could count and how, and, *in the same move*, to oper-
ate differences – because we learned with Donna J.
Haraway that choosing one viewpoint instead of
another can never be a free exercise.

While exploring varied dimensions inherent to
a specific situation, some of these appear to be more
consistent than others. If *Inquiry* equips us to deploy
varieties of intuitions regarding a situation, it also
obliges us to *discern* which of them hold to that sit-
uation. After a situation has been qualified in a man-
ner or another, it must still be put on trial. Latour
sets up a vocabulary to test just that. In order to gain
consistency, each being goes through a series of
small discontinuities – "hiatuses" – that alter its
seemingly continuous trajectory into existence.
Along this trajectory emerges an entity which
passes through a certain mode of existence when it
is qualified by its own specific relation to truth and
falsity – its own "conditions of felicity".[4]

But each situation carries its own specificities.
If entities gain ontological weight through the
modes of existence, the modes themselves also gain
consistency through adjusting to situated specifi-
cations. This actually turns their allusiveness into
an interesting feature. However, it implies that a
trial must occur in order *to use* a particular mode,
under the tremendous penalty for it to remain an
immutable abstraction. Conversely, only through
a trial does this mode fit adequately to the situa-
tion at stake. Choosing one mode over another
does not go without saying; it necessarily results
from a process of explicitness. One needs good
reasons to assert that what is going on there could
be qualified under this or that mode. Only on that
condition can some of the modes, those relevant
to the situation, emerge through a series of active
frictions, problematic encounters. When psychi-
atric care is at stake, is it a problem of tastes and
interests [ATT], or is it about scripting a well-re-
fined organization [ORG]?

461

---

[4]   Drawing on Austin's pass/fail test for performative utterances, see Austin.

Starting from situated differences, an inquiry consists in following and intensifying some of them through the relevant modes so as to render them *significantly* different, which always depends on the problem at hand. For instance, one of our inquiries dealt with a sophisticated surveillance system called "virtual fences." Ideally, this system consists of cameras, radar, thermal and acoustic sensors, but also of wires, material hardware and software, data fluxes and algorithms. At first we wanted to use the script of technology [ORG] to make a problem out of its conflicting encounter with another script, namely, that of imprisoning felons. Prisons were one of the scenes of application envisioned for this technology. However, the ensuing discussion convinced us that using [ORG] in this sense would be premature because this problematic encounter was not actual enough yet. But above all, using [ORG] would not allow us to account for the singularity of the algorithm, even at the stage of a mere projection. We then focused on the way algorithms classify the images they receive to detect whether they are threatening or not. They incrementally perform a pattern of what a "threat" is or could be. Hence, we tentatively raised the idea that algorithms take "habits" [HAB] while discerning and classifying threatening and innocuous occurrences. But the argument matters because using [HAB] implies that, little by little, algorithms have the ability to secrete their own environment. All of a sudden, algorithms do not appear to be well-refined scripts anymore, but rather overflows engineer's vision by its own technical capabilities (as enacted in fig. 5).

The *way of crossing* different modes also matters for the inquiry. For instance, there is a very porous boundary between what belongs to the realm of scientific knowledge (reference) [REF] and what belongs to the realm of fiction [FIC]. In their incessant intertwining, the beings of the reference and those of the fiction never cease to find new ways of interacting, new modalities of encountering. In doing so, it may even turn out that their respective boundaries actually become barely distinguishable from one another. This is what we witnessed, for example, when inscriptions about knowledge in novels or in theater plays interrupt or intensify the vibrant attention of the reader. On the contrary, in scientific texts, one could wonder what space is devoted to touching sentences that might move the reader (see fig. 6).

The very configuration of *how* one mode of existence gets to bump into others affects our grasp on it.

### ...OUR COLLECTIVE EXPERIMENTATION WITH FRAGILE BEINGS

So PRAGMATISM IS AT STAKE. Any situation unfolds as a series of experiments and attempts. Any inquiry follows a speculative process – "what if...?" – before it may grant significance to a mode along the lines of empirical differences. But it is also crafted in a configuration that is collective and shared. *Collective* because, in our experimentation, the very use of the modes was constantly rendered problematic. Quite often, when we wanted to stick to a mode which we considered appropriate to speak well of a certain fieldwork, we would have to defend its (always contestable) relatedness to that situation. It was through the exchanges about our situations that the modes were tested, that their understanding was collectively fed and refined. Moreover, the configuration was also *shared*, because connecting a situation to one particular mode of existence enables connections to other inquiries that also set up, in the end, a more accurate image of this mode.[5]

For instance, in her film *Dust Breeding*, Sarah Vanagt follows the trial of Radovan Karadžić at

---

[5] This emphasizes the role of collecting, sharing, and browsing through diverse inquiry experiences, as the digital counterpart of Latour's book, even though the Internet can never afford the friendship we developed throughout the seminar.

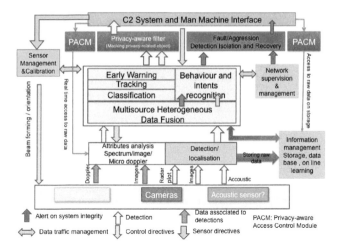

5    The envisioned system architecture for P5 *virtual fence* system. At its heart lies the "behavior and intents recognition" algorithm, which processes "multisource heterogeneous data fusion." Printscreen from the P5 project (Privacy Preserving Perimeter Protection Project).

To Mr. Manders, the cuffs, the stethoscope, and the Doppler with its strange sounds that shift in tune with every heartbeat are pretty impressive technologies. He observes the work of the technician as attentively as I do. If doctors need the outcomes of all this work and equipment in order to know about his disease, Mr. Manders can be proud of himself. Or so he jokes. He needs no equipment at all to have access to his leg arteries. He can feel them.

The technician, however, sees nothing special in Mr. Manders's ability to feel what she measures. Complaints simply correlate with a drop in pressure because they are both signs of a single disease, hidden deep inside the body: he feels it, she measures it. Inside the body the one causes the other. Thus, their correlation is self-evident. Or is it? Complaints and pressure drop often coincide, but not always. Here's a second scene.

vative force to the novel organization of the French health care system at the beginning of the nineteenth century. This generated the birth of the clinic. It was with the specific hospital organization that emerged at that time that it became possible and reasonable to open up corpses in order to find disease inside them. Speaking about the new hospital organization, Foucault remarks: "It so happened that it was on the basis of this tertiary spatialization that the whole of medical experience was overturned and defined for its most concrete perceptions, new dimensions, and a new foundation" (1973, 16). Medical knowledge,

medical perception itself, is as social in its origins as in its effects. And it is material as well: a *discourse* that structures buildings, instruments, gestures. That differentiates between normal and pathological organisms and thus mediates between the coherence of the body and the order of society.

*Associations and Multiplication*
The idea that medicine is not just a personal affair between a doctor and a patient has never left the literature since. It has become commonplace, something we all know, a truism: that medicine is as social

6    Ethnographical stories that overlay theoretical narratives: Annemarie Mol. *The Body Multiple: Ontology in Medical Practice.* Durham, NC: Duke University Press, 2003. Print.

the International Criminal Tribunal for the former Yugoslavia. She used video sequences of the trial, and she also recorded herself rubbing the surfaces of the furniture in the court. She made an artistic inquiry about the ways images can be used as proofs. Both the movie's and the trial's complexities are better grasped by looking at the several modes of existence. Some pictures, means of evidence [REF], must be put on trial, in the law sequence in order to become means of evidence [LAW]. Karadžić made a questioning use of fiction [DC·FIC] to demonstrate that these pictures would not prove anything. Sarah Vanagt, the artist and filmmaker, outlines how "we don't see anything" by rubbing and printing tracks from the material surfaces of the juridical institution (tables, chairs, etc.). But at the same time, she used the fiction mode [FIC] to question and disturb Karadžić's use of images (see figs. 7a–d).

The intelligence of this complex entanglement benefits from drawing on strains from other inquiries. The problem of pictures as proof in courts gets entangled with works on mediations in law (Claverie), on imagery and scientific objectivity (Daston and Galison), on revisionist rhetorics (Danblon and Nicolas), and even on archival movies about genocides (Didi-Huberman). All these works form knots around the modes [LAW], [FIC], or [REF], populate and ramify them.

Finally, experimenting with modes not only sheds light on unsuspected dimensions of a situation; it also sharpens the particular experiences that are going on there. It is a matter of "presencing," that is, putting different beings into presence while sensing whether (and how) this presence affects the situation or not. It requires very close attention to the multiple trials that entities endure. According to a winemaker from Alsace, France, the secret of a good wine is a fine and subtle balance between sugar and acidity. In his experience, over the last years climate change has affected this balance towards too much sweetness (see figs. 8a and b). To address

this problem, the wine estate decided to change over to biodynamic viticulture. It underwent a complete transformation of wine making and tasting, engaging in a determined *commerce* with forceful yet invisible beings [MET]. This turnaround could not take any shortcuts – like ready-made "climate change" models and projections for local small businesses do – because it involves experiments, doubt, and audacity through re-learning the practice of tasting wine. As difficult as this process might have been for the winegrowers, one needs the "beings of metamorphosis" to account properly for this re-conversion (where cynical economic or marketing arguments could so easily prevail).

Putting beings into presence echoes the process which Souriau calls "instauration." His philosophical take on the fragile emergence of an artwork – here, an upcoming situation as much as an investigative account – invites one to consider each instauration of a being as a tentative trajectory. The instauration is an experience which starts from a questioning situation, calling the person involved to feel that she or he is concerned by it, involving her or him in the *oeuvre-à-faire* throughout successive existential instances on its path to emergence. It compels us to feel all the uncertainties and the risks of failure all the way through. Our inquiries do not try to deal with strong entities in isolation, but instead they touch upon fragile beings-in-the-making, beings that maintain themselves through their multiple attachments to others, to borrow Hennion's words. Souriau's instauration is a vibrant call for discerning these emergent beings, as they come into existence in concrete situations. But this fragile birth is constantly exposed to abrupt abortion if the investigator remains deaf to the sacrifices and partiality that her or his choices entail.

**7a–d**  Rubbing and printing tracks from the material surfaces of the courtroom by the artist Sarah Vanagt in her film *Dust Breeding. Dust Breeding.* Dir. Sarah Vanagt. Balthasar Production, 2013. Film stills.

**8a** Vines in Alsace. The Vosges Mountains shape the microclimate of this region. But with climate change the wind now tends to come from the opposite direction, and pushes clouds against the mountains. Today, the climate is more unpredictable, and the increased number of sunny days has led to wines that are too sweet.

**8b** Bunches of Pinot Gris grapes with noble rot. Grapes with noble rot are traditionally picked during late harvests but these are now increasingly precocious. And noble rot is getting scarcer because of lack of moisture.

## RESET INQUIRIES!

HOW MIGHT all of that contribute to resetting inquiries? *Inquiry* provides us with a *politics of qualifying situations*. It forces us to operate differences, to enact them, while staying as close as possible to the stakes encountered in our fieldwork. While we seek to open up "plurifold" contrasts, these make the inquiry tentative, fragile, open to contestation. By rubbing modes of existence with situations through a coconstitutive trial, and doing it collectively, inquiry includes friction all along the way.

It matters because inquiry in this stance opens up a shareable space. Without the privileged positions of the nowhere or everywhere viewpoints, we need to come to terms with our situations from the middle. In this case, our perspective is by definition limited, we see what we see from where we stand, but our descriptions gain some steepness and sharpness. Using the modes of existence, all entities *are not* alike. Heterogeneity is not a slogan but denotes out actual ontological divergences. Equivalence or comparison may of course occur, but then it is an event that articulates entities successfully. It goes the same way with inquiry. The pieces of knowledge we produced are singular, different from the ones produced by and through the situation. Differences mark our potential relevance to the situation and its stakes. There we are, filled with the hope that inquiries open up new prospects for alliances with those who are struggling to make their world a more livable place.

### Works Cited

Austin, John L., *How to Do Things With Words*. Oxford: Clarendon Press, 1962. Print.

Claverie, Elisabeth. "Peace, War, Accusations and the Virgin." *The Vision Thing: Studying Devine Intervention*. Ed. William A. Christian, Jr., and Gábor Klaniszay. Budapest: Collegium Budapest, 2009. 225–44. Print.

D'Hoop, Ariane, and François Thoreau, eds. *L'appel des entités fragiles. Expérimenter, discerner et densifier les êtres de l'enquête, en compagnie des Modes d'existence de Bruno Latour*. Liège: Presses de l'Université de Liège. Print. Forthcoming.

Danblon, Emmanuelle, and Loïc Nicolas, eds. *Les Rhétoriques de la conspiration*. Paris: CNRS éditions, 2010. Print.

Daston, Lorraine, and Peter Galison. *Objectivity*. New York: Zone Books, 2007. Print.

Didi-Huberman, Georges. *Images in Spite of All*. Trans. Shane B. Lillis. Chicago: University of Chicago Press, 2008. Print.

Drumm, Thierry. "Si c'est vrai, qu'est-ce que ça change? William James: fabrique des savoirs, fabrique philosophique," *Thèse de doctorat défendue en vue de l'obtention du diplôme de Docteur en philosophie*, Université Libre de Bruxelles, 2014. Print.

*Dust Breeding*. Dir. Sarah Vanagt. Balthasar Production, 2013. Film.

Haraway, Donna J. "Situated Knowledges: The Science Question in Feminism and the Privilege of Partial Perspective." *Feminist Studies* 14.3 (1988): 575–99. Print.

Hennion, Antoine. "Enquêter sur nos attachements. Comment hériter de William James?" *SociologieS* [online], 23 Feb. 2015. Web. 2 March 2016. Available at <http://sociologies.revues.org/4953>.

Latour, Bruno. *An Inquiry into Modes of Existence: An Anthropology of the Moderns*, Trans. Catherine Porter, Cambridge, MA: Harvard University Press, 2013. Print.

Latour, Bruno, and Carolina Marinda. "À métaphysique, métaphysique et demie. L'enquête sur les modes d'existence forme-t-elle un système?" *Les Temps Modernes* 1.682 (2015): 72–85. Print.

Souriau, Étienne. "Du mode d'existence de l'œuvre à faire. [1956]" *Les différents modes d'existence*. Paris: Presses Universitaires de France, 2009. Print.

# DE-BRIEFING AIME PROJECT: A PARTICIPANT PERSPECTIVE

## Terence Blake

### INTRODUCTION

I HAVE BEEN actively engaged for many years with diverse projects aimed at elaborating a pluralist epistemology and metaphysics adapted to the modern world. I have also been involved in digital experiments in philosophical pedagogy and research. In particular, I took part in the *Second Life* discussion group and the blog preceding and accompanying Hubert Dreyfus's All *Things Shining* project, and in Bernard Stiegler's digital seminar. I founded a blog devoted to pluralist philosophy, called *Agent Swarm* (the subtitle of the blog is "Pluralism and Individuation in a World of Becoming"). I already knew and admired the work on science studies published by Bruno Latour, John Law, and Andrew Pickering. So I was very excited when I learned that Bruno Latour was going to publish a text on pluralist ontology accompanied by an innovative digital platform, and I did all that was within my power to participate in the initiative. I discuss AIME from the point of view of a participant, of someone who is neither an external observer nor an adherent, but an active coarticulator.

The AIME project is a game-changing speculative endeavor, providing one possible instantiation of the more general project of a pluralist epistemology and ontology. It proposes a radically new understanding of being in terms of being-as-other.

The AIME process is revolutionary in conception, as it involves not only an ontology based on a new

TERENCE BLAKE *is an Australian-born philosopher whose research concerns epistemological and ontological pluralism, recent and contemporary Continental philosophy, and the relations between philosophy and science fiction. He teaches at the Nice Faculty of Law and at the Lycée Léonard de Vinci in Antibes. His writings have been published in various journals including* Art & Text, Cycnos, *and* Screening The Past.

ontological hypothesis (being-as-other), but also a new way of doing ontology (empirical metaphysics), and a new means of organizing, promoting, and teaching ontological research (the AIME digital platform).

The AIME party line is rich, complex, and self-correcting, but it reintroduces an authoritarian tendency, a centralization, rigidity, and closure, that are not in harmony with the pluralist project, nor required by the digitally supported process.

### DIGITALITY

A FIRST CRITERION constitutes a threshold for entry into the AIME process: digitality. Latour proposes AIME as an exemplary contribution to the digital humanities. The old methods of research and exposition are quickly becoming antiquated in the light of the new digital technologies. The democratic demands of bringing education to a greater number of people and of making it more relevant are slowly making themselves felt. Bruno Latour talks a lot

about "digital humanities" yet he consistently undervalues blogs. In this he repeats habits belonging to the academy that he is trying to escape or transform. Despite his wariness of the "horrible things that people do at the end of your papers when they are on blogs," ("DH2014 Opening Plenary") his own AIME site is basically a heavily moderated blog, with the text of his book displayed in a searchable sidebar. Latour's site is no heuristic model for fundamental research in ontology, nor a pedagogical model for the teaching of the digital humanities. Given the stringent moderation process any potential "contribution" must go through in order to be published on the site, it is a much more authoritarian structure than a university seminar.

My involvement with the AIME project has been totally digitally based. I was enthusiastic about the project from the beginning, and I became one of the early adopters, and one of the early contributors to Latour's site, and an early reader of the book, which I bought when it first came out in French, and then again when it came out in English. I was an early commenter, both on my own blog and on a collective blog devoted to the book and project: https://aimegroup.wordpress.com. I was an early reviewer of the book, publishing a large number of analyses and discussions on my blog, and I posted one of the first full-length reviews ("On the Existence"). I have written a number of articles on AIME, all of which are assemblages of posts that were first published on my blog, *Agent Swarm*, then gathered together, rewritten, and posted on my academia.edu page.

My participation in the debate around Latour's book has been principally positive, and only secondarily negative or critical. Aside from the engagement with the book and a couple of contributions to the site, I defended Latour ("On the Realist Pluralism") from a series of ill-informed criticisms during the "Pluralism Wars," a controversy which flared up in January 2014 on various blogs associated with speculative realism, and which tried to present Latour's realist pluralism as a form of irrationalist antirealist

relativism. My own involvement with epistemological and ontological pluralism dates back to 1972 and my first encounter with Paul Feyerabend's works. I have long been not just a contributor but an independent coarticulator of pluralism, a fellow traveler to AIME, making common cause with its project of elaborating an ontological pluralism. But where is the place in Latour's paradigm of the digital humanities for such independent, participative work?

Latour has limited himself to describing the features and the advantages of this digital experiment, but has given no concrete example of the discoveries it has led to as far as the philosophical content of the book is concerned, which confirms my suspicion that the platform itself tends to become the message. Latour explicitly declared that he wants neither critique nor commentary, and advised one questioner (a woman who contrasted the inhumanity of the project with Latour's own very engaging humanity in presenting it): "contribute, don't comment." I fear this prefigures a model of digital humanities as composed of an array of mutually exclusive closed societies, juxtaposed without interacting (as interaction would be mere "commentary"). It also violates Latour's principle of anti-fundamentalism, where fundamentalism is defined as the "refusal of controversies."

Latour's site is philosophical in content; it develops and articulates an ontology. Its *results* as a contribution to pluralist ontology are to be evaluated principally in terms of philosophical criteria. Its *success* as a contribution to the digital humanities is to be measured in terms of the heuristic impulse it gives to ontological research and of the pedagogical articulation of pluralist ontology it permits. Not in terms of its contribution to the edification of a new paradigmatic dogma and of a confidential micro-sociological consensus. The initial democratic momentum of opening up access to the book and to the discussions it provokes by means of the digital platform tends to be lost under the authoritarian formatting and closure imposed by the rules of contribution adopted

for that platform. There is an unresolved tension, and the democracy tends to lose out to the digitality.

## DIPLOMACY

A SECOND CRITERION, that of "diplomacy," is ostentatiously advanced in the framing of the project, where one might have expected to see "democracy." Bruno Latour talks about diplomacy a lot in relation to AIME, and he gives it several incompatible meanings. However, despite the omnipresence of this rhetoric, there is not the slightest real diplomacy in Latour's work; all talk of it is metaphor and theater. Latour represents no one but himself and his project, and he speaks in the name of his own personal "modernity." He certainly does not speak in my name, or in the name of my modernity, or of that of many others. Latour's modernity, including his "religious mode of existence," is a biographically and intellectually motivated minority perspective rather than the result of empirical research or democratic consultation.

Latour's AIME is no longer simply a project but a self-organizing process, a digital performance converging towards an academic competence. The indicators of competence – technical jargon, one-dimensional timeline, academic diffusion, specialist applications – are increasing. AIME, which has already moved from project to process has been crystallizing as party line. I have come out in favor of the project of a pluralist ontology, which I support. I am also a fellow traveller of the AIME process, participating as I can. I am not, however, an adherent of the AIME party line. Who represents me and people like me in the diplomatic negotiation that is the framing metaphor for the AIME process? The question of *scale* has become important: What relation can there be between a potential contributor and the overarching process? What diplomacy is possible between David and Goliath? On the scale of the AIME process the question arises: Is diplomacy necessarily a synonym of assimilation, incorporation, or engulfment? Can

one be a dialogic partner without being engulfed? This question of scale in relation to democracy is the same as that posed by MOOCs [Massive Open Online Courses]: a laudable democratic gesture of the expansion of access to education is in danger of imposing an authoritarian model of learning, evaluation, and entitlement. As we have already seen for the problems of formatting, so too with the extended scale, the digital (technology) comes to prime over the human (democracy).

I have contributed to the AIME site, but I find its protocol far too constraining. Further, there is no interactivity – neither between contributors and the AIME team nor among contributors. The whole enterprise is quite frustrating. I have blogged about it critically, in terms of a deficit ("Aime Project") of democracy ("Towards a Democratic Semiotics"). But there is no interlocutor to whom to address such complaints. Latour usually dismisses such critiques as irrelevant, and highlights the value of his four-year experiment in close reading. It functions more as a very interesting experiment in digitally assisted cognitive teamwork, and its most revolutionary, but also most problematic, aspect is the system of management necessitated by its scale. "Diplomacy" is the name for this transformation of democracy into management, of open exchange into closed moderation. On the positive side, this appeal to diplomacy is a constant reminder to struggle against any tendency to impose the hegemony of one particular mode.

## RELIGIOSITY

ON THE QUESTION of religion, it cannot be a criterion in the contemporary world. Both Badiou and Latour observe that religion as "truth procedure" (Badiou) or as "mode of veridiction" (Latour) is dead in the society at large. I have no objection in principle to Latour's personal Catholicism. If his religious affiliation gives him the perspective and the strength to contest scientism, economism, and other reductionisms, this is a very considerable heuristic advantage

and should be valued as such. However, I do object to Latour's inscribing a form of Catholicism, however refined, into the purportedly empirical description of the moderns, that is, to his imposing Catholicism on us all, as part of our very definition. The idea that we are all ontologically Catholic is unacceptable and anachronistic. It violates Latour's own diplomatic principle of anti-hegemony. I find Latour's refined theology both too aristocratic and not poetic enough. It seems to be an arbitrary boundary condition imposed on the system from outside.

I have no hostility to religion as such, and I think that there is much to learn from the way Latour takes it out of the mode of [ REF ][1] and of belief. However, I do not think that enshrining religion in a separate mode [ REL ] is the best way to do justice to religion historically, sociologically, and anthropologically. Also, I disapprove of smuggling assumptions into a text that is not supposed to be a theological treatise, but an empirical ontology. A philosophical text that is far more widely welcomed by priests and theologians than by philosophers raises many doubts and questions as to its impartiality and representativity.

Latour wishes to avoid "fundamentalism" in questions of religion and also of science and politics. He defines this fundamentalism as "the refusal of controversies" (i.e., of dialogs where there is no pregiven arbiter) and as "the attempted exercise of hegemony of one mode of existence over the others" ("L'universel," 953; Trans. Blake). This hegemony is what many pluralists have fought under the name of reductionism. Reduction lies in treating religion as a matter of belief, and as submitted to the same truth-regime as referential domains like science. Latour is quite explicit that for him religion is not a question of belief at all, not a question of reference to the physical world, but one of a transformative message. One can find this symbolic, existential, nonreferential view of religion in the movement of demythologization and in post-Wittgensteinian philosophies of religion.

Slavoj Žižek also propounds this as a possible use of religion. In the English-speaking world the "refined" approach to religion has frequently involved turning towards Eastern religions (a phenomenon that Žižek discusses under the name of "Western Buddhism"). It may be a minority position compared to the number of fundamentalists, but it is one contemporary possibility for the religious form of life.

I don't think that the reserves that have been expressed on the treatment of religion in AIME are due to dusty abstract philosophers being unable to cope with empirical investigation, but rather they are due to people finding that the Inquiry is not empirical enough. For those who are Christians, the reduction of religion to [REL] has potentially devastating consequences. Not only does God not exist in a referential sense, but neither does Jesus (or if it could be shown that he did, it would be irrelevant). The Gospels on this view describe no empirical historical facts, as they are not at all referential texts but propose the symbolic wisdom or "poetry" of [REL]. With Jesus nonexistent or irrelevant, we have [REL] as a Christ-without-Jesus mode, that very few Christians would recognize as the essence of their faith. So treating [REL] as mode is doing no service to Christianity, except for those who already embrace the refined, or symbolic, Christ-without-Jesus version.

Convincing arguments can be given in favor of classifying religion as a meta-mode providing a new image of truth and veridiction to rival that imposed by philosophy (this is Badiou's preferred solution), or as mode (Latour's preferred solution), or as sub-mode of [MET] (this is the solution I favor). One could argue for the same ambivalence (meta-mode, mode, or sub-mode) in relation to other modes, such as [MET], or even [REP]. I think this *ambiguity* of categorization could be seen as a positive feature of Latour's ontology: its categories exist to expand and to free the range of experience taken into consideration, not to reduce and confine it.

[1]   For a brief explanation of these abbreviations, which refer to the modes explored in the AIME project, see the glossary in this volume (r·m!543–47).

## TESTABILITY

PACKED AMPHITHEATERS and multiple work-shops have no necessary connection with confirming such an ontology. Theoretically Latour is "Popperian," as he emphasizes the necessity for "trials" or what Popper called "tests" (this verbal difference between Latour and Popper does not exist in French, where both words are translated by *épreuve*). However, Latour's practice in AIME is often "Kuhnian," since he also talks about the necessity and value of team-work for research, of a shared vocabulary and endur-ing commitment, and of collective close reading. His model for AIME is normal science in Kuhn's sense, where he first provides the framing paradigm, and then calls for "contributions," that is, for puzzle-solv-ing activities that never question the fundamental assumptions of the paradigm.

Popper seeks to encourage bold speculative con-jectures and equally bold attempts at refutation; Kuhn seeks to maintain the paradigm and to turn puzzles into confirmations. Critical discussion and the demand for testability are refutation-oriented. Amphitheaters, workshops, closed teams, collective close readings, and modest contributions are con-firmation-oriented. AIME's digital platform allows only "contributions," that is, confirming instances. There is no room for trials that end up disconfirm-ing or profoundly modifying the paradigm's major theses. The Popperian democratic call for trials and dissensus tends to succumb to the Kuhnian empha-sis on confirmations and consensus.

This is bound up with the basic rule for a contri-bution: no commentary, no critique, no debate over the foundational hypotheses, just a brief discussion that confirms or extends the paradigm and that pro-vides a confirming document or reference as proof. In this way, all strong critique is blocked or discouraged: minor revisions are welcomed, but major trials are excluded. The time frame of the digital platform (the long delay while a contribution is awaiting modera-tion) and the invisibility to others of a contribution

before it is published preclude any authentic dis-cussion, except between the AIME moderator and the candidate contributor. AIME is not a discus-sion platform but a director's cut. Disconfirming in-stances and critical analyses are simply not published, and there is no agora for freer form of discussion.

The AIME site actively excludes fundamental dis-cussion, and to that extent its pedagogical model is anachronistic and faulty. Pedagogy is not confined just to magisterial exposition, but also involves trial and error, inviting and dealing with objections, which is a far messier but more democratic business than the aseptic process of approving or disapproving "contributions." The site's function here is ambiva-lent: it both democratically invites participation and authoritarianly constrains it.

## DEMOCRACY

MY PROBLEM with AIME is not its supposed "rel-ativism." I have argued that it is in fact what it claims to be: a pluralist and realist project. That is why I have been enthusiastic about it, and why I defended it during the Pluralism Wars. Rather, my problem is that even though it is pluralist, it is still not pluralist enough. Unfortunately, its pluralism is incomplete, and this flaw is tied to its perpetuation of a closed and nondemocratic academic habitus.

Latour likes to give the impression that all the crit-ics of his project are monists and reductionists. This is not my case. My objections are pluralistic. I am a fel-low traveller with AIME in defense of pluralism and in the struggle against scientism and other reduction-isms. The big problem here is that Latour's modes are elitist, whereas the domains he derives them from are, at least potentially, democratic. For example, [REL] as defined in AIME is élitist, while religion is democrat-ic; that is, "gnostic" in Latour's terminology.

The only trial that Latour allows for his descrip-tions of modes is the intuition of the relevant ex-perts. The only protest of experience that he allows is the protest of the experts. Protest by competent

authorities must be converted into acceptance, so Latour's conceptual radicalism is finalized by his aim of obtaining expert consensus and specialist consent. The modal authorities are defined as the only legitimate protestors.

In the case of religion, priests and pastors are defined as the relevant experts on [REL], those who need to be convinced. Ordinary people who practice a religion must accept their judgement, or be regarded as "gnostics." Only the religious experts can protest, the testimony of the gnostics (i.e., virtually everybody else) is rejected as resulting from the "wrong" apocalypse. Latour applies the same elitist grid that he uses for science (experts vs. laypeople, modes vs. domains) to religion.

This antidemocratic elitism is written into the very terms of the system, for instance, in the difference posited between mode and domain. Latour extracts an essence out of a domain in which people of many different types participate, and elevates this essence to the status of a "mode" of existence presided over by experts. Latour's thought here is extremely bifurcationist: modes are bifurcated from domains, experts from citizens. Yet AIME is constantly shuttling back and forth between modes and domains. It could not arouse and maintain any interest without this constant exchange and interference that it is obliged to label as confusion when found in rival perspectives.

The distinction between a mode and its domain can only be local, temporary, and controversial. It cannot be decreed once and for all. In everyday life, domains interfere constantly in the modes and transform them; this is both legitimate and necessary, not only for progress but for the very content of the discourses and the practices in play. A mode is a political selection of one particular current amongst many others within a domain, it is not a static universal essence.

Latour's system is not as empirical as he would have us believe. "Experience" should mean everyone's experience, not just that of experts as related to their special subjects and interests. The very naming of the modes is oriented towards differing a priori requirements. Why, for example, is the scientific mode called [REF] and the psychological mode [MET], but the religious mode [REL]? Calling the scientific mode [REF] is a democratic move, subsuming specialist science under the more general category of referential knowledge that is open to everybody. Similarly, in another democratic move, the psyche is taken from the exclusive hands of the experts (psychoanalysts, psychologists, and psychiatrists) and subsumed under a more general category – [MET], the beings of metamorphosis, and of their psychogenic networks. This is AIME at its strongest, combining conceptual invention and democratic inclusion.

So why is the mode corresponding to religion called [REL]? Why isn't religion treated like these other domains, and subsumed in a more general and more democratic category, such as "attention" or "care"? The religious mode is called [REL] because Latour has already decided on its role and content in advance. He is very attached to having religion as a mode, this is not at all an empirical finding but an ideological requirement. This ontological legitimation of religion goes together with the abandon of all empirical description of real religious practice and communities of faith, and the promotion of an elitist abstraction, the refined nonreferential interpretation of religion. To enter the religious mode you must undergo a conversion, a semiotic apocalypse, or stay outside as a "gnostic" or a fundamentalist. Thus [REL], as defined by AIME, is both nonempirical and antidemocratic.

More generally, this reduction of experience to expert opinion shows a residual elitism of AIME: it is not an anthropology of the experiences and perspectives of all practitioners equally, but only of the ideological consensus of certain privileged groups and representatives.

473

## CONCLUSION

RATHER THAN treating Latour's system as a new paradigm, one might better conceive of AIME as a preliminary experiment aimed at arousing interest in the project of an anthropological description of the moderns. The description finally adopted should not consist in a preexistent system presented in a monologue to the other-than-moderns, in view of subsequently initiating dialog, but should itself emerge out of an open dialog. Latour is contradictory in that he both outsources and wants to keep centralized control of the descriptive process. He thus imposes convergence on the "best" description, rather than allowing for dissensus, divergence, and multiple descriptions.

The aim of my remarks is not to offer a critique of AIME insofar as it is a pluralist project, but to help Bruno Latour to detect and eliminate the nonpluralistic, nonempirical, and nondemocratic aspects of his system, which are incompatible with its explicit goals. This text and this project are transformative. But are we talking about the transformation operated by the religious point of view, or that operated by the perspective of a pluralist ontology? Latour's speculative hypothesis is one of ontological pluralism: being-as-other is the principle of metamorphic abundance. All talk of "modes" and of "prepositions" are stuttering attempts to awaken us to this abundant world. The categories posited by AIME are provisional: transitory, local and contingent means of calling us to attend to, and to care for, the vastness of our experience and of the pluriverse.

Works Cited

Blake, Terence. *Agent Swarm*. Terence Blake, n.d. Web. 17 Nov. 2015. Available at <https://terenceblake.wordpress.com/>.
———. "Aime Project: Democratic Diplomacy or Elitist Business as Usual?" *Agent Swarm*. Terence Blake, 30 June 2014. Web. 17 Nov. 2015. Available at <https://terenceblake.wordpress.com/2014/06/30/aime-project-democratic-diplomacy-or-elitist-business-as-usual/>.
———. "On the Existence of Bruno Latour's Modes: From Pluralist Ontology to Ontological Pluralism." Rev. of *An Inquiry into Modes of Existence* by Bruno Latour. *Academia.edu*. Academia, n.d. Web. 17 Nov. 2015. Available at <https://www.academia.edu/7453695/Essay_Review_of_Bruno_Latours_AN_INQUIRY_INTO_MODES_OF_EXISTENCE>.
———. "On the Realist Pluralism of Bruno Latour." *Academia.edu*. Academia, n.d. Web. 17 Nov. 2015. Available at <https://www.academia.edu/5861379/ON_THE_REALIST_PLURALISM_OF_BRUNO_LATOUR>.
———. "Towards a Democratic Semiotics of Latour's Diplomatic Process." *Agent Swarm*. Terence Blake, 3 July 2014. Web. 17 Nov. 2015. Available at <https://terenceblake.wordpress.com/2014/07/03/towards-a-democratic-semiotics-of-latours-diplomatic-process/>.
Dreyfus, Hubert, and Sean Dorrance Kelly. *All Things Shining: Reading the Western Classics to Find Meaning in a Secular Age*. New York: Simon Spotlight Entertainment, 2010. Print.
Latour, Bruno, ed. AIME: *An Inquiry into Modes of Existence*. FNSP, 2012-16. Web. 17 Jan. 2016. Available at <www.modesofexistence.org>.
———. *An Inquiry into Modes of Existence: An Anthropology of the Moderns*. Trans. Catherine Porter. Cambridge, MA: Harvard University Press, 2013. Print. Trans. of *Enquête sur les modes d'existence: Une anthropologie des Modernes*. Paris: Découverte, 2012.
———. "L'universel, il faut le faire." CRITIQUE 786 (2012): 949–962. Print.
———. "DH2014 Opening Plenary." DH2014, Université de Lausanne, 8 July 2014. Address. Web. 24 Feb. 2016. Available at <http://dh2014.org/videos/opening-night-bruno-latour/>.

# THE EMBASSY OF SIGNS:
# AN ESSAY
# IN DIPLOMATIC METAPHYSICS

## Patrice Maniglier

I AM NOT HERE to defend a thesis. I come here humbly, on the mandate of a being that is all too often unrecognized, ignored, and despised by the long centuries of our intellectual tradition. I come because I have heard that there is an intention here to settle metaphysical disagreements, to hear the ontological outcast, to arrange a place for those beings previously crushed by the law of mono-ontism. This being that has sent me is the sign. You may be surprised that I consider it to be forgotten, unknown, scorned. Admittedly, it has often been mobilized with regard to matters of being, but that was to examine whether we could access being directly, or if we had to be content to analyze our ways of signifying. Rarely have we studied the actual being of the sign. It was taken to be a very ordinary material reality, to which only a "signification" would be added. The nature of this relationship, and especially of the metaphysical status of this signification, has been discussed extensively. Some saw ideal beings whose existence disqualified that of sensible beings, others saw mental representations, and others still saw mere effects of consensus between human actors. But who doubted that the sign itself could be stranger, more enigmatic, and even more ideal than

PATRICE MANIGLIER is Maître de Conférences at the philosophy department of Paris Ouest Nanterre University; he studied at the Ecole Normale Supérieure in Paris and he was a lecturer at the University of Essex. He has written numerous books and articles on Saussure, Lévi-Strauss, Sartre, Merleau-Ponty, Foucault, Deleuze, Derrida, Badiou, and Latour, and is one of the coeditors of the series Métaphysiques.

this famous "signification"?

Actually, we have a prophet. His name is Ferdinand de Saussure. He was the first to have had the revelation of what we could call l'être du signe – that is, the being of the sign.[1] He may not have been the first (for, as with all revelations, precursors can be found, and in this case there are many, some of whom can be traced back as far as ancient India), but it was indeed he who most systematically expressed the metaphysical intoxication that the sign inspires in those who see it: "We are quite convinced that whoever enters the realm of language may as well abandon all hope of finding a fitting analogy, earthly or otherwise" (Writings 154). Those among you who, like me, have come here to humbly testify in support of beings who are often poorly understood,

---

[1] I owe it to the memory of matters academic to state at the outset that I myself endeavored to repeat Saussure's words, so poorly understood, in a text with precisely that title – L'être du signe – which was my PhD thesis in philosophy (presented at Nanterre University in 2002). It has since been published as a book under the title La Vie énigmatique des signes: Saussure et la naissance du structuralisme. However, I do not have the impression that the message has been heard any better.

will easily recognize in these words the symptom of all metaphysical crises: it is never anything but a crisis of all analogies, the experience of a datum that finds no place in the categorical network available to us.[2]

I therefore propose, in all good faith and total charity, an examination. I would like to know whether this singular being of whom I am particularly fond (and whom I probably also know in a particular way, as love is a form of knowledge) – that is, the sign – can find a place in the house that Bruno Latour's *Inquiry into Modes of Existence* has proposed to build for all beings. I will examine what may need to be modified in this building for my being to be welcomed without crushing others (in other words, by respecting the diplomatic terms of reference proposed to us). Or else whether I must resign myself, yet again, to seeing my being chased from the common house, condemned to roaming, spectral, in the far reaches of what is called reality, even of the generously multiplied reality the *Inquiry* proposes to us.

To accomplish this task, one has to recognize above all that, in the *Inquiry*, the notion of the sign occupies a complex position, for it denotes both a particular case within a certain mode of existence, namely, a particular form of "fiction" [**FIC**],[3] and at the same time a concept of metalanguage, denoting something belonging to all existence (for all beings are expressive) – in short, another name for being. At these two levels (the latter of which is, moreover, essentially a conflation of levels), we need to ask whether our being has been saved. This sets the terms of reference that will occupy us. I admit that this is sometimes a thankless task, with a somewhat difficult technical aspect, despite the efforts I will make to ease it. But I hope, dear delegates, that,

like me, you will consider this long examination not to be in vain. And as for me, not only has it taught me things about the very beings that occupy me and have carried me for so many years, I believe I have also gained insight into what *being* actually means.

## 1. THE SIGN AND THE FIGURE

I HAVE TO ADMIT that my prophet is not treated very well in the *Inquiry*.[4] But that is of little importance. My question is not scientific. It is not intended to assess the degree of truth of this text with regard to the subject matter. It is diplomatic and concerns the survival of my beings in the common articulation. I will therefore endeavor only to verify whether this protocol ensures the singularity, at once admirable and worrying, of these beings that signs are. One has to acknowledge that things are not terribly engaged. The *Inquiry* seems, at first glance, to contrive to humiliate my beings, since it simply makes them a particular case of what it calls "fictions." Yet we know that, by contrast, the "structuralist" tradition, which has reportedly claimed Saussure as its founder, seemed to redefine narrative entities like signs. Not, contrary to received opinion, because it attributed to them a communicative function, but because it (correctly) recognized in them an ontological singularity. Thus Claude Lévi-Strauss explained that the analogy of a fictional character with a phoneme was justified in that one could not be assured of the character's identity solely on the basis of its apparent properties. What appeared to be a porcupine in one context might simply be a variant of what elsewhere was a bird – for the identity of a mythical object stems essentially from the system of differences to which it belongs (200–01). Now, the

---

[2] On this notion, permit me to refer the reader to another of my own texts, my "Manifeste pour un comparatisme supérieur en philosophie."

[3] For a brief explanation of these abbreviations, which refer to the modes explored in the AIME project, see the glossary in this volume (r·m!543–47).

[4] It is never cited by name but is easily recognized in a passage (254–57) where the "arbitrariness of signs," the notion of "structure," and the opposition between "signifier" and "signified" are all derided simultaneously.

*Inquiry* affirms, on the contrary, that from the point of view of its ontology, the sign is a particular case of fiction. But that is not a reason not to ratify this proposition. It is not my intention to ensure the preeminence of my beings. I merely wish them to be respected in their singularity. And from this point of view, as we will see, the peace protocol that the *Inquiry* has put forward is far more satisfactory than what tradition has proposed. We will see, however, that it also remains problematic.

By making the sign a particular case of "fiction," the *Inquiry* at least avoids committing the most common offense to which my being has been subjected, which is its reduction to a relationship between two terms: one material, the other ideal. Here is what is written there:

> The famous distinction between the "sig-
> nifier" and the "signified" – the anode and
> the cathode, they say, of all our symbolic
> energies – amounts to repeating with re-
> spect to signs what we have already said
> about the beings of fiction. We find the
> same vibration between raw material and
> figure, and the same impossibility of de-
> taching them from one another. The dis-
> tinction is important, to be sure, but be-
> cause it designates the particular case of
> the being of fiction whose vibration al-
> lows it to be always graspable – or rath-
> er ungraspable, by definition – either as
> raw material twisted toward form – the
> signifier – or as form inseparable from
> the material – the signified – without di-
> rect contact with the referent, which is
> not the "real world" but the result, merely
> glimpsed, of the proliferation of the *other*
> modes of existence – which fiction indeed
> always takes on obliquely. (254–55)

By interpreting the distinction between signifier and signified as that of matter and form, the *Inquiry*

avoids what Saussure called the conception of language as nomenclature – a conception that reduces the duality of the sign to the distinction between "form" and "meaning." Saussure countered this with a fact whose full potential has rarely been highlighted: even the so-called "material" part of the sign is "entirely psychological," so that the sign is a "dual entity" and not the combination of two terms. Fortunately, this aspect seems to be preserved in the interpretation of signs as *fictions*. These beings are effectively characterized by the *inseparability* of two elements: a fiction always *tends towards a form*, but we can never find a preexisting form in the "matter," nor can we separate it completely from this matter.

> This happens every time a little cluster of
> words makes a character *stand out*; every
> time someone *also* makes a sound from
> skin stretched over a drum; every time a
> figure is *in addition* extracted from a line
> drawn on canvas; every time a gesture
> on stage engenders a character *as a bonus*;
> every time a lump of clay gives rise *by ad-
> dition* to the rough form of a statue. But it
> is a vacillating presence. If we attach our-
> selves to the raw material alone, the fig-
> ure disappears, the sound becomes noise,
> the statue becomes clay, the painting is
> no more than a scribble, the words are re-
> duced to flyspecks. The sense has disap-
> peared, or rather *this particular sense*, that
> of fiction, has disappeared. But – and this
> is its essential feature – the figure can
> never actually *detach* itself, either, from
> the raw material. It always remains held
> there. Since the dawn of time, no one has
> ever managed to *summarize* a work with-
> out making it vanish at once. Summarize
> *La Recherche du temps perdu?* (Latour 244)

To affirm that language is a particular case of fiction in the sense thus defined is therefore to affirm that

477

the most modest words spoken at a bend in the road ("Bonjour, Monsieur Courbet!") engage the same dialectic between matter and form as the most subtle works of art. This dialectic is the following: the greatest painting is *merely* a heap of pigmented glue on a stretched canvas, and one only has to move too close to it to see this form to which we attach such value disappear into the chaos of its matter. Yet, on the other hand, the painting is prized precisely because the complexity of this form is schemed, so to speak, to infinity in the dense layers of pigments and brushstrokes. A dialectic of this nature should not be confused with that of form and meaning. It is not a question of saying that the Vatican Museum's *Laocoön*, in addition to being a volume of stone in space, is also a complex discourse from which it cannot be separated. It is a question of saying that the *Laocoön* as a real object cannot be reduced to its marble reality, that it actually exists only in its extension in reception, which is not at all to say that it is nothing but a "representation" projected onto inert matter. Latour's theory of what he calls "fictions" basically corresponds to the problems of what the psychologies of form called gestalt, and, more generally, what are known as "emergent" forms: Kanizsa's triangle is neither *on* the sheet of paper nor simply *in* my mind; it is both inseparable from "matter" and irreducible to it.

I do not wish to discuss the validity of this description of "fiction" in general, only its application to language. First of all, it must be stated that this type of understanding of natural language captures something absolutely essential: the fact that the learning of a language is always the acquisition of an ability to grasp emergent forms. Speech is not calculation, as the Chomsky-inspired cognitive scientists argue. Nor is it understanding, as the hermeneutic tradition claims. Speech is *perception*. As Saussure pointed out, he who is unfamiliar with a foreign language finds it difficult not only to *understand* what is said but also, above all, to *perceive* the "words." Language is a training in sensibility.

The linguists who invented the very word "structuralism" (namely the phonologists, starting with those of the Prague school – really Roman Jakobson) invented an essential distinction to describe this: the distinction between *phonetics*, the science of "matter" in Latour's sense, or what Saussure called "substance," and *phonology*, the science of "form" in Latour's sense – and Saussure's as well! Defining language as *one* dimension of the emergence of form in general is an act that inspires great recognition in us, the partisans of the sign, for it means starting to take into account the ontological originality of our entities.

But against the background of this recognition, we can define our discomfort even more clearly. The matter/form (or substance/form) opposition is indeed essential, but we should not reduce it to the opposition between signifier and signified. What the structuralist linguists have taught us is that, on the contrary, it is valid for both signifier and signified. The forms of the signifier, the "phonemes," are not the signified of the phonetic substance, even if they are made only of phonic variations that entail semantic variations. And conversely, the signified is also inseparable from some matter, one which Saussure calls the psychological substance, even though it is irreducible to the ideas that we have when we speak. In fact it consists of a form that emerges out of this substance by retaining only the "conceptual" features regularly associated (that is, associated in language) with phonetic variations. Thus it may very well be that, when a speaker of English reproaches her friends for eating "mutton," she also thinks of woolly animals in the pastures, yet the signified of this word does not contain this idea, for that would entail a variation in signification, the shift from "mutton" to "sheep." We must therefore understand that the dialectic of matter and form goes *both ways*, and not only from the signifier to the signified. Reducing the opposition between signifier and signified to that of matter and form risks repeating the ancestral *wrong* which

the being of the sign has always been inflicted to the being of the sign, that of reducing the sign to "matter" and the dual being that is the sign to only one of its dimensions.[5]

We are led here to choose between two ways of amending the "provisional report" put forward by the *Inquiry*. We can propose the introduction of a new mode of existence, which could be called [ sɪɢ ] and would correspond to a *dual fiction*. Unlike the fiction that Latour describes, the linguistic sign goes *both ways*. It is always at the intersection where two substances are shaping and being shaped by each other – which is exactly the image of the wave that Saussure takes to illustrate the formation of the linguistic sign (*Course* 112). Just as the mode of existence of fiction is based on that of technology, like a second disengagement, so too the mode of existence of the sign may be built on fictions, like a third disengagement, on a scale of increasing complexity.

But we can also reverse the proposition and recognize in "fictions" a particular case of "signs." We would obtain the former by amputation or simplification of the latter, rather than constructing the latter by making the former more complex. This would bring us back to the orthodox "structuralist" thesis, which sought to generalize the mode of existence of the sign to all beings treated as fictions – including, of course, the things that illustrate this concept in the *Inquiry*: works of art such as Hector Berlioz's *Les Troyens*, or Rembrandt's *Night Watch*. The question is indisputably empirical: to establish whether we can settle for a single plane of emergence to describe a being like the *Laocoön*. Is it possible that the figure emerges from matter only if the formal entities are drawn from a plane other than the marble? Does what there is to *see* in the *Laocoön* not depend on what there is to *read*? Is this an old man that I see, whom I could then relate to Virgil's text, or not, depending on my degree of culture? Or am I going to *see* something else if what I *directly* see is the honorable

Trojan persecuted by the goddess for his steadfast attempts to warn his people? Is the very perception of an entity from fiction, its release from matter, not gravid with work on *another* material? This brings to mind Antoine Hennion's work on music, which shows that the extraction of the musical *percept* is accompanied by protocols that regularly associate it with other things, such as a man who learns to perceive classical music by taking the train, in a fusion of music and landscape in which what is extracted is probably as much the units of landscape as those of the music. I would therefore personally contend that, for empirical reasons, we must rather think that it is the "figures," in the sense of "simple fictions," so to speak, that are an especially simple particular case of signs, dual fictions. We would thus need to replace [ fɪc ] with [ sɪɢ ].

But this first generalization of the concept of the sign leads us to question another occurrence of the notion of the sign in the *Inquiry* – in a more fundamental position, since it is essentially another name for being, as every mode of existence is also a certain regime of enunciation and vice versa. In effect, things proceed as if, once the sign had been recognized as a certain *type of being* (and not something that would bear no relation to being, because it would relate only to our ways of accessing it), we would wonder whether all reality must be understood as a semiotic reality, though this would not relieve it of its ontological weight. After the ontologization of the sign we have the semiotization of being, which we see moving towards an increasingly emphatic equivalence between *being* and *signifying* – an equivalence that necessarily goes both ways.

[5] In a manuscript entitled "On the Dual Essence of Language," published in *Writings in General Linguistics*, Saussure constantly warned against this tendency.

## 2. BEING AND MEANING: INSTAURATION AND ENUNCIATION

TO BE IS TO MAKE SENSE - How is such equivalence possible?

The author of the Inquiry is at the heart of a small historical paradox. With a background in the semiotic analysis of scientific texts, he is currently considered one of the most characteristic representatives of what is known as the "ontological turn" in anthropology. This turn, moreover, goes far beyond anthropology, extending into all disciplines and all traditions, and reflects, in some respects, an essential aspect of our "air du temps" ("current climate"), to take an expression that Gilles Deleuze used on the eve of May 1968 in a conversation about structuralism ("Sur Nietzsche" 196). From sign to being – yet the path is by no means self-evident. The ontological turn is often justified by opposition to the "linguistic turn" (this is particularly clear in the "neodogmatic" orientations of Alain Badiou and Quentin Meillassoux). Whereas the linguistic turn seems to have endeavored to stop trying to state what is, reflecting instead on the ways in which we talk about it (thus extending the Kantian gesture into language), the ontological turn seems to go in the opposite direction, disqualifying notions such as "representation," "languages," "cultures," and, of course, "signs." Its slogan might be: "Enough talk about ways of talking, let's talk about things themselves!" Symmetrically, some of the most eminent contemporary representatives of semiology also maintain this incompatibility between being and sign. An example is François Rastier, when he talks about "deontology" in reference to the singularities of the Saussurean sign (32–37). Of course, with deontology, Rastier intends, first and foremost, to oppose any way of anchoring semiotic processes in any given outside reality, in order to maintain the prerogatives of an immanent analysis. I agree on this point. However, not only does this allow us to identify what type of reality the semiotic process

is in and of itself, it also demands that we do so. We thus see that understanding what is in play here invites us to free the notion of ontology from the obsession with reference.

In such a context, the proposition of the Inquiry must necessarily appear very strange, since it amounts to a confusion of semiotics and ontology. This point is very clear in the first chapter of the book, with the shift from the notion of language to that of a mode of existence. How is such confusion possible? Should we not choose between talking about what exists and talking about ways of talking about it? Is the semiotic approach not known to sever the text from its context and uses, to then propose an "immanent" analysis? Is there not a contradiction between the "principle of immanence" and "ontological commitment"? Is the analysis of a scientific discovery in terms of an actor network not the exact opposite of the semiotic analysis of a text, which – as Françoise Bastide wrote in an unpublished typescript that Bruno Latour kindly shared with me – has to stick to the text and not stray from it? How does semiotics link up with ontology?

Reading Bastide's text, "The Semiotic Analysis of Discourse," enables us to answer this question with particular clarity: thanks to the concept of the *actant*, it is possible in semiotic analysis to refrain from reserving the capacity for speech to beings determined in advance, thus giving the word back to being rather than confining it to humans and conscious entities. In short, the version of the ontological turn put forward in the Inquiry is characterized by an unbinding of the domain of language, which it owes precisely to semiotics. This unbinding signifies, first, that we do not know *which is the subject and which is the object*. What the analysis of scientific texts receives from the semiotics of A. J. Greimas, by way of Bastide's work, is above all this suspension of the great bifurcation of human subject and nonhuman object. It enables us to spread out all these beings, thanks to the notion of the actant. Subject, object, cause, effect, etc.: it no longer depends on the

nature of beings, but on their shared position in a process of differentiation – that is, in the course of a *difference to be made*, which is the minimal definition of both action and meaning. A human being (for example, a princess) can be in the *object* position, and a material reality (for example, a golden cup or a quantum particle) can be in the *subject* position. The important thing is the way they contribute to the difference to be made, which is why we call them actants. This difference is meaning itself: to make sense means to make a difference and nothing else, which is perfectly Saussurean (as well as Bergsonian, not to mention Jamesian). But this difference has an internal architecture, which is expressed through notions such as subject, object, subject-operator, and passive subject, as well as sender, sent, helper, opponent, etc.

This is, however, only half of the liberation of speech that semiotics allows. The other half follows, but by a subtle and complex unhinging which the notion of *enunciation* enables us to grasp, and which is Greimas's specific contribution (for what we have said up to now remains basically Saussurean).[6] Indeed, the actant concept relates not only to the "content" of a statement but also to the protagonists of the enunciation itself. The one *who* talks is as much an actant of the sign as the characters *about whom* he or she talks. And just as the latter do not need humans to be in the position of subjects, so too the subject of the enunciation does not need to be human. Thus the quantum particle can itself be in a position to answer the questions put to it. Discourse not only makes all sorts of beings speak, it is also spoken by all sorts of beings; in fact it is that which *makes itself speak*. This is how semiotics liberates the ontology of speech: by liberating the actants not only from the enunciated, but also from the enunciation. The concept of the sign found in the *Inquiry* is defined

by the notion of enunciation, which itself is understood to mean a certain ontological regime. This means two things. First, the sign is defined in terms of action – that is, of production of a difference. Next, and more fundamentally, this action is itself dual, as every sign always does two things at once: it puts forward the enunciated, and it transforms the situation of enunciation. There is thus a twofold difference, which is not the same duality as that of dual fictions (signifier and signified), nor of substance and form. The concept of enunciation encompasses this duality of the enunciated and the enunciation. This is very clear in Greimas's definition (reproduced on the AIME website) of the semiotic term *enunciation* as

> one of the constitutive aspects of the primordial language act ... inaugurating the utterance by articulating at the same time and as an implicit consequence the domain of the enunciation itself. The language act thus appears as a split which creates, on the one hand, the subject, the place, and the time of the enunciation and, on the other, the actantial, spatial, and temporal representation of the utterance.[7]

If Greimassian semiotics proposed something like a dramaturgical conception of meaning, this is because, for it, speaking always consists of doing something that is both *in* language and *with* language: enunciation is an act, distributed between actants, that simultaneously instaurates the drama of its own enunciation. Meaning is a dramaturgy of itself. Speaking is always *making oneself do* the very thing that one does. The actants of a statement do things only because we make them do them: the princess weds the prince only because the storyteller delights

[6]  Indeed this idea already appears very clearly in Saussure's thinking: "In each series the speaker knows what he must vary in order to produce the differentiation that fits the desired unit" (*Course* 130).

[7]  Greimas 88, qtd. in the "Shifting Out" entry on the AIME website. Both "disengagement" and "shifting out" are translations of the word *débrayage*.

the children. But this other actantial drama, this making-oneself-do of enunciation, is not simply outside and prior to the enunciation, for it would not exist without it. It is the tale that makes an individual a storyteller. Hence, there is not a "reality," on the one hand, "within which" discourses are delivered (this would be called *context*), and fictive "worlds," on the other, that exist only because we represent them to ourselves (this would be called *content*). The "reality" is posed by the enunciated itself – without, however, being *represented* in the enunciated. We can therefore neither say that the enunciated is "in" reality as in a context, nor that reality is "in" the enunciated as intentional content in the Husserlian sense. The genius of Greimassian "pragmatics" stems precisely from the fact that, unlike other "pragmatics," it does not refer the action of the discourse to a world completely outside the discourse ("context," "form of life," "power relations," etc.), yet at the same time it also avoids reducing this situation of enunciation to a term represented by and in the statement.

We therefore understand better why this concept becomes another name for being: this is what enables it to avoid the dilemma in which the very problematic of ontology is caught. We often believe, in effect, that being is *either constructed*, in which case it loses the weight of reality, and the emphasis shifts towards what constructs it (the body that talks is supposed to be more real than the body it describes in its talks), *or else it is given*, in which case, as Kant pointed out in his *Critique of Pure Reason*, it seems by definition to transcend all access (the thing about which we are talking cannot be represented in its being as a thing). The notion of enunciation enables us to resolve this dilemma by making, of the act through which a being is made, an action of that being itself, although on a different plane from the one on which it deploys the action defining it. To say that every being is a sign is to say not only that *every being is made* (there is no statement without an enunciator), but also that *every being is itself an act of making* (the enunciated is an

actantial process), and that *every being determines, prescribes, and mobilizes the very beings that make it* (the enunciation is an actantial process of the sign).

In this ontological proposition we recognize the one for which the *Inquiry* mobilizes the concept of *instauration* found in the work of Étienne Souriau. Souriau argued that "the work to-be-made" could neither be reduced to its creator's "project" (to the representation that a being already currently there can have of the anticipated realization of another being, like an individual human envisaging the construction of a palace) nor the future state of the thing of which it is the final outcome (like a final cause pulling towards it the practical forces creating it). I will cite only two of his arguments: the representations of what we want to do can vary widely, but may nevertheless all be evaluated as moments in the work to be made, which shows that it cannot be reduced to the representations of its author. Likewise, the work to be made can *fail*, never actually coming into being, yet nonetheless it has been active, which shows that it is not a current future state drawing towards itself, in a teleological mode, the beings that contribute to its realization. There is thus a being specific to the work to be made, a being on the basis of which the "creators" are defined as the actants of this being itself, to use Greimas's vocabulary. To say of all beings that they are instaurated is to say that they all demand that we *do* something for them, without this meaning that they are only the results of a heterogeneous action.

The idea that what exists is inherently *to be made* is already a partial way out of the dilemma of constructivism. Beings are not functions of practical powers' actions, because these powers are themselves, rather, functions of the becoming of these beings. What Souriau called "the existential incompletion of every thing" (220) provides an ontological basis for the laws of pragmatics. Yet this pragmatic ontology (corresponding to that of Henri Bergson, William James, Alfred North Whitehead, and many others), which is also processual, risks

overemphasizing the work-to-be-made aspect by being guilty, essentially, of a new reduction in which the actants become *internal* functions of the being to be made. The semiotic conception enables us to avoid this new reduction in that it gives equal treatment, though at the cost of a division, to the *made* (the enunciated) and the *making* (the enunciation). Neither one is ontologically antecedent or prior to the other. Speaking is neither something that beings would do in a reality altogether indifferent to that which is posed by speech, nor something determined by the very content of a discourse; it is precisely doing both things at once. The notion of enunciation must therefore be understood here in the ontological sense, as the concept of a certain way of being in general, which we subsequently notice is valid for all beings simply because it solves the fundamental problem of ontology, which is nothing other than the eternal problem of idealism or, more generally, as it is frequently put these days, of "correlationism."

Thus everything that exists speaks. It speaks not in addition to existing, but in its very existence, and because being, as such, declares itself, enunciates itself, coming forth only in that enunciation. *Being* and *saying oneself* are synonymous. To be is to talk oneself into existence. In this sense, every existent functions as a sort of sign. Being is structured as a language.

### TO CONCLUDE …

PARTISANS OF THE SIGN that we are, we should, it seems, be flattered: here are our beings, elevated to the signal honor of functioning as another name for being. The main thing to remember from this analysis is that we have finally gotten past the unbearable dilemma of being and saying. Ever since the origins of the thinking of being, perhaps, we have been told to choose between being and saying: either we take the side of saying, *logos*, in which case being dissolves, leaving only the eternal power of the word (reread Plato's *Gorgias*, and also Barbara Cassin's *L'effet sophistique*); or else we stick to being – in which case, however, being seems by nature to be beyond all discourse, transcendent, inaccessible. We have to get out of this deadly quandary for once and for all. If the sign is concerned with the being, it is not because it refers to it, but because it itself exists. Being is not only that mute datum lurking on the other side of appearances, indifferent as to whether we apprehend or disregard it. It also reveals itself through signs, precisely as they exist, for we have at least one piece of information on what it is to be, through the very fact that signs *are* … To be sure, this means that the only being is the sign; but it also means that being is to be sought not in *that to which* the sign refers, but rather in the way in which entities can be said to exist, even if this way cannot be reduced to signs – in other words, in the other ways in which being reveals itself though existents, as it does through signs: in the plurality of modes of existence. In any case, Being *says itself*; it is not withdrawn in speechless impassivity; it *passes* through that which exists. From this point of view, we can say that the *Inquiry* is part of the tradition of *ontologies of expression* – in other words, ontologies that do not separate being and meaning – even though it does not make the slightest concession to any form of idealism (in other words, to the idea that the faculties of representation are the measure of all existence). Deleuze traced the genealogy of this tradition: Duns Scotus, Spinoza, Nietzsche, himself (*Difference* 35–42). This lineage refuses to see being as something that thought would have to represent (yet it is this presupposition that we find in the contemporary currents of the return to "realism"), and it proposes both to put the mechanism of "representation" back into being itself (the sentence in which I say that the cat is on the mat exists as much as the cat does) and to redefine them as the extensions of that being, which thus "expresses itself" through them (Einstein's physics expressed the reality even before representing it). When Nietzsche said "there

are only interpretations" (139), he did not mean that nothing exists, but that existing meant interpreting! The *Inquiry* proposes the same kind of inversion, but it says, rather (following Greimas): *there are only presuppositions*. Everything that exists is a sign of the self, is enunciated, because it simultaneously creates the measure of what existing means.

Are we taking a step backwards, in relation to the *Inquiry*, by reducing *modes of existence* to *regimes of enunciation* when, as the introduction to that "provisional report" explains, the *Inquiry* was born when its author understood the need to go the opposite way (20–22)? No, for the motive of this jump into ontology, of which I fully approve, was so that multiplicity would not be left only to "ways of speaking" – so that being itself would also be multiplied. To maintain that being says itself is not to maintain that it is *only* what is said. It is to refuse the disjunction implied by, on the one hand, a mute being, absolutely withdrawn and indifferent, and on the other, a talkative subject constantly projecting significations onto a blind and silent world. The fantasy of the mute being is the modernist fantasy par excellence, the one that existentialism will merely popularize and push to the extreme, shoving all the immense responsibility for meaning over onto the subject. As if meaning were necessarily a subjective effect! As if it were not the effect of a set of signs running through us and constituting us!

So, must we revive a very old idea, that of a being that speaks, resulting in a sort of world prose? Most certainly. If being speaks, however, it is not entirely in the sense of the "prose of the world" that Maurice Merleau-Ponty spoke of, and that Michel Foucault saw at work at the heart of the European Renaissance. The idea is not to anchor the significations that we pronounce in the world, nor to cause the *logos* of existence to emerge. It is not to ground our significations, but to render the being of the sign comparable to other forms of being, and to establish ontology only in this comparability (diplomatic hypothesis). To hold that being enunciates itself is to hold that our understanding of the simple fact of existing is revealed through existents themselves. Being is not decided outside them. The saying of being is the task of beings: being is not a passive property, but something that one does, and that is why *being* necessarily means *making sense*. For a long time we wondered what the names of being were, and whether their functioning was the same as that of the other names. I believe we can now answer this question: the best name of being is *saying*.

*Translated from the French by Liz Libbrecht.*

## Works Cited

Bastide, Françoise. "The Semiotic Analysis of Discourse." 1981. TS. Centro Internazionale di Scienze Semiotiche, Urbino. PDF file.

Cassin, Barbara. *L'effet sophistique*. Paris: Gallimard, 1995. Print.

Deleuze, Gilles. *Difference and Repetition*. Trans. Paul Patton. New York: Columbia University Press, 1994. Print.

---. "Sur Nietzsche et l'image de la pensée." *L'Île déserte: Textes et entretiens 1953–1974*. Ed. David Lapoujade. Paris: Minuit, 2002. Print.

Foucault, Michel. *The Order of Things: An Archaeology of the Human Sciences*. Trans. Alan Sheridan. London: Routledge, 2004. Print.

Greimas, Algirdas Julien, and Joseph Courtés. *Semiotics and Language: An Analytical Dictionary*. Trans. Larry Crist et al. Bloomington: Indiana University Press, 1982. Print.

Hennion, Antoine. "Une sociologie des attachements: D'une sociologie de la culture à une pragmatique de l'amateur." *Sociétés* 85 (2004): 9–24. Print.

Kant, Immanuel. *Critique of Pure Reason*. Trans. Werner S. Pluhar. Indianapolis: Hackett, 1996. Print.

Latour, Bruno. *An Inquiry into Modes of Existence: An Anthropology of the Moderns*. Trans. Catherine Porter. Cambridge, MA: Harvard University Press, 2013. Print.

---. "Shifting Out." AIME. FNSP, 19. Aug. 2013. Web. 1 Feb.

2016. Available at <http://modesofexistence.org/aime/voc/93>.

Lévi-Strauss, Claude. *The Origin of Table Manners.* Trans. John and Doreen Weightman. New York: Harper & Row, 1977.

Maniglier, Patrice. "Manifeste pour un comparatisme supérieur en philosophie." *Les temps modernes* 682 (2015): 86–145. Print.

---. *La vie énigmatique des signes: Saussure et la naissance du structuralisme.* Paris: Scheer, 2006. Print.

Merleau-Ponty, Maurice. *The Prose of the World.* Ed. Claude Lefort. Trans. John O'Neill. Evanston: Northwestern University Press, 1973. Print.

Nietzsche, Friedrich. *Writings from the Late Notebooks.* Ed. Rüdiger Bittner. Trans. Kate Sturge. Cambridge: Cambridge University Press, 2003. Print.

Rastier, François. "Ontologie(s)." *Revue d'intelligence artificielle* 18.1 (2004): 15–40. Print.

Saussure, Ferdinand de. *Course in General Linguistics.* Ed. Perry Meisel and Haun Saussy. Trans. Wade Baskin. New York: Columbia University Press, 2011. Print.

---. *Writings in General Linguistics.* Trans. Carol Sanders and Matthew Pires. Oxford: Oxford University Press, 2006. Print.

Souriau, Étienne. "Of the Mode of Existence of the Work-to-Be-Made." *The Different Modes of Existence.* Trans. Erik Beranek and Tim Howles. Minneapolis: Univocal, 2015. 219–40. Print.

485

# THE CELEBRATION OF FALSE PROBLEMS

## Didier Debaise

I SHALL BEGIN with an observation and propose a possible reading of Bruno Latour's *An Inquiry into Modes of Existence: An Anthology of the Moderns*: the moderns have been inordinately fascinated with false problems. They have celebrated the ones they inherited, invented a whole raft of multifarious new ones, and have tried to impose them on everyone they have encountered. Admittedly, every age has its share of false problems, but rarely have they been taken so seriously: they have involved controversies, oppositions, and exclusions from the public arena, been identified with the very exercise of thought, and have established the general forms of legitimate knowledge. Nothing has seemed more serious to the moderns than the great questions – the mise-en-scène of these false problems – in which dual forms of experience were ranged against each other: How could knowledge match up with the forms of existence of the world, that "famous *adequatio rei et intellectus*, at best good enough to serve as a crutch for an elementary philosophy exam" (Latour 71)? How could constructed, heteronomous beings acquire a life of their own, actual autonomy? What might the conditions for free action be in a universe with deterministic laws? These questions, repeated endlessly as a kind of refrain, though risible because of the scholarly seriousness surrounding them, have shaped modern experience.

I take this notion of a false problem from Henri Bergson who defined it as a badly analyzed

*For brief information on the author see* r·m! 104.

composite or, in the terms of *Inquiry*, an amalgam ("Amalgam"). A false problem is always a confusion between two orders of reality, between two categories, between heterogeneous qualities. Bergson gives an example which he regards as paradigmatic: the problem of freedom. This is the typical case of a false problem that obsesses the moderns. We ask how an action could really be free when it takes place within the laws of nature. How could it be indeterminate if, at the same time, it may be subject to forms of physical determinism? Bergson's answer, which in the form of its argument parallels what is at issue in *Inquiry*, is that there is implicit confusion in these questions – an amalgam, which is all the more operative for never having been cast into doubt. In the very last lines of *Time and Free Will: An Essay on the Immediate Data of Consciousness*, Bergson writes:

> The problem of freedom has thus sprung from a misunderstanding: it has been to the moderns what the paradoxes of the Eleatics were to the ancients, and, like these paradoxes, it has its origin in the illusion through which we confuse succession and simultaneity, duration and extensity, quality and quantity. (240)

We enquire into free action as though it had the same substance and the same qualities as spatial, extended action and, in so doing, we translate it into a mode that is alien to it. But where Bergson tended to describe false problems as illusions inherent to intelligence, *Inquiry* helps us to define them as historical events and make them tools of an anthropology of the moderns. Thus we find them in place everywhere the moderns are, as constant variations on a single theme: in theories of knowledge, in ways of envisaging political action, in aesthetic conceptions. Are these not false problems, embodied in questions so badly posed that they can lead only to absurdities, merely a veil, a representation, which, though admittedly bizarre, has no serious influence on the moderns' practices? Are they not merely representations that might suggest to us that the moderns have found it difficult to present – and hence represent – to themselves what they were really doing?

It is time to ask ourselves what they really found in these problems, what the higher interest was that lay in their attachment to them, beyond mere mental play and a mere illusion of representation. If the moderns celebrated false problems so much, they certainly did not do so on account of the image of themselves they found in them, nor out of a purely theoretical liking: it is because they found in them unprecedented conditions for action. False problems have nothing exclusively theoretical about them and they are, in no sense, of the order of epistemology, unless we see the latter as a political activity. This is the essential point for understanding their status: behind the questions that celebrate those problems – and which seem to us, retrospectively, so starchily schoolish – real "war machines" (Deleuze and Guattari) are now in place. To understand the reasons for the moderns' attachment to false problems, we have to ask some essentially pragmatic questions, such as "What were the practical effects?" "What did they produce in experience?" "What differences did they introduce?"

What Latour's *Inquiry* shows us is that the false problems were instruments for domesticating the heterogeneous and minority knowledges which, for a time, accompanied the constitution of modern experience. This is what Isabelle Stengers states in *Cosmopolitics I* with regard to the means and tools of disqualification that are brought into play in modern science:

> The contemporary scene is literally saturated with the "modern" heirs of Plato. Each of these heirs denounces his "other," just as the philosopher denounced the sophists, accused them of exploiting that which he himself had triumphed over. They include not only the heirs of Plato, but those philosophers who, following the sophists, were used as an argument to demonstrate the need for a foundation. What, in Plato's text, can be read as a network of analogies isolating the terrible instability of the sophist-*pharmakon* has today split into a number of "modern practices" (scientific, medical, political, technological, psychoanalytic, pedagogical) that have been introduced, just as Platonic philosophy in its time, as disqualifying their other – charlatan, populist, ideologue, astrologer, magician, hypnotist, charismatic teacher. (29–30)

Within the very constitution of the experience of the moderns, false problems were simultaneously extraordinary processes of simplification and formidable tools for ordering knowledge. But *Inquiry* shows that it was not only on that trajectory that they had their most influential effects. These false problems were, at the same time, decisive tools of destruction of all attachments in the encounter with other collectives. We shall return to this point. False problems, these badly analyzed composites, these amalgams, as Bruno Latour calls them, are

487

not merely effective tools for simplifying the representation of experience – permanent double clicks – but genuine instruments of capture, appropriation, and translation.

Let us read *Inquiry* as an enormous exercise in problematization. The questions asked in it, with the aim of interpreting the experience of the moderns, are of a new type: What are the genetic features of a false problem? What local effectiveness did such-and-such a false problem have? How was it possible for it to be transposed from experimental practices [REP·REF][1] to the political scene [REF·POL]? How did it become a crucial weapon against all psychical attachments [MET·REF], etc.? This is one of the first aspects of *Inquiry* – establishing an ethology of false problems. Admittedly, we shall never arrive at an exhaustive catalog of them: such a quest would, by definition, be both endless – a false problem has countless variants – and relatively pointless, since it will not enable us to grasp the inherent attractiveness of the constitution of a false problem. This is why *Inquiry*, even though it is presented as case studies and documents, is essentially a study on the logic immanent in a false problem or amalgam. These are, essentially, plural logics, which are historically situated and can even be dated in some cases, such as the invention of the "bifurcation of nature." (Whitehead, ch. 2) In no sense does Latour's *Inquiry* say why a particular amalgam had to emerge, but once an amalgam has been invented, we have to develop the means to analyze its terms, to distinguish what is being confused within it, to establish the interests that were combined in it, and, where appropriate, to propose a new articulation, a new "crossing." This is because there is a central empirical and historical dimension to understanding the genesis of false problems.

The second key aspect of *Inquiry* is that these false problems or amalgams produce a variety of monstrous entities that will crystallize all questions and shape the general frameworks for experiencing them: matter, belief, reason, symbolism, and so on. This is how it is with matter, for example, which is the product of an amalgam "between two modes [REP·REF] that everything should have encouraged them to distinguish carefully" (Latour 98). The most precise name for this amalgam is "material world," or, more simply, "matter." The idealism of this materialism – to use outdated terms – is the main feature of their anthropology and the first result of this inquiry, the one that governs all the others (98).

The constitution of this entity, which is purely abstract and derives from a poorly established crossing, is crucial to all the other aspects of the experience. It is the amalgam between chains of reference and trajectories of reproduction that will establish the stage on which all the other modes will be able to deploy themselves, since it is at the origin of the difference between "the world and statements about the world" (71). Once the amalgam has been established, this monstrous entity acquires a life of its own and imposes itself as primary reality, making it possible to differentiate and rank knowledges in terms of their degree of adequacy. This is a strange operation, in which an abstraction derived from a crossing sees itself reified – "thingified" – to become the central term of any experience and come to define the real. We could say the same of those other entities that are belief, reason, or the symbolic; we would find a similar logic in them, despite it being established within other trajectories and other necessities. A reified composite or a "thingified" abstraction that present themselves as natural and spread to all levels of experience of the moderns. These are pure abstractions, the product of amalgams, but their effects will be formidable because they will become generalized instruments for the domestication of practices and will bring about homogenization of the experience of nature. It is

---

[1] For a brief explanation of these abbreviations, which refer to the modes explored in the AIME project, see the glossary in this volume (**r·m!**543–47).

this strange series of inventions that has made the Moderns opaque to themselves, and, what is more serious, it has left them unable to grasp the "other cultures," which had been getting along perfectly well without either the "material worlds" or "subjects. (98)

To sum this up, we are speaking of a badly analyzed composite – [REP·REF] or [REF·POL] – that gives rise to a monstrous entity (matter or reason) that acquires a generalized effectiveness (double click).

This brings us to a third aspect of Latour's Inquiry, which should enable us to grasp even better the pragmatic effects of the false problems and the reasons why moderns celebrated them so much. Equipped with these monstrous entities, it was the encounter with other collectives that was to suffer profoundly. The moderns would be able to foist devilish alternatives on all the other collectives (belief or reason, real or symbolic, matter or minds), alternatives which they have invented from scratch and which do not give the multiplicity of attachments animating those collectives a chance. For example, matter becomes a weapon to be used against all forms of spiritual attachment, and the notion of belief will enable "illusions" and "idols" to be destroyed "in the name of anti-fetishism. 'Believing that others believe' becomes one of the traits that defines the Moderns' relationship with other collectives …" ("Belief").

Why present Inquiry as an enormous exercise in problematization? Isn't there a danger that stressing the false problems will cause us to miss the point of this enterprise which Latour repeatedly presents in terms of a series of oxymorons, such as an "[e]xperimental metaphysics" (481)? Might we not be said to be reducing to a minimum the aspirations driving the inquiry by granting so little significance to the question of metaphysics, ontological pluralism, and modes of existence? With its new tables of categories, its pared-down formalism (through the use of abbreviations), and its numerous combinations, there is a real danger of seeing Inquiry as a general metaphysics of beings. The underlying project is undoubtedly much more serious than this, and the sense of the metaphysics animating it is profoundly operational. There is no general worldview here. Time and again Latour stresses this: "the question of modes of existence has to do with metaphysics or, better, ontology – regional matters to be sure, since the question concerns only the Moderns and their peregrinations" (19). We are dealing, then, with an – always situated – local metaphysics, a metaphysics that deals with the false problems as near as possible to the point of their constitution. If metaphysics becomes operational at this point, that is because it provides unprecedented instruments for diplomatic activity by civilizing the abstractions that have transformed themselves into war machines.

*Translated from the French by Chris Turner.*

Works Cited

Bergson, Henri. *Time and Free Will: An Essay on the Immediate Data of Consciousness.* 1889. Trans. F. L. Pogson. Mineola: Dover, 2001. Print.

Deleuze, Gilles, and Félix Guattari. *Nomadology: The War Machine.* Trans. Brian Massumi. New York: Semiotext(e), 1986. 434–527. Print.

Latour, Bruno. *An Inquiry into Modes of Existence: An Anthropology of the Moderns.* Trans. Catherine Porter. Cambridge, MA: Harvard University Press, 2013. Print.

———. "Amalgam." AIME. FNSP, 19 Aug. 2013. Web. 22 Jan. 2016. Available at <http://modesofexistence.org/aime/voc/5>.

———. "Belief." AIME. FNSP, 19 Aug. 2013. Web. 22 Jan. 2016. Available at <http://modesofexistence.org/aime/voc/85>.

Stengers, Isabelle. *Cosmopolitics I: 1. The Science Wars. 2. The Invention of Mechanics. 3. Thermodynamics.* Trans. Robert Bonnono. Minneapolis: University of Minnesota Press, 2010. Print. Posthumanities 9.

Whitehead, Alfred North. *The Concept of Nature.* Cambridge: Cambridge University Press, 1964. Print.

# ON THE MODES OF EXISTENCE
# OF THE EXTRAMODERNS

## Eduardo Viveiros de Castro

AS AN ANTHROPOLOGIST who studies extra-modern collectives, where the prefix "extra" signifies the mark of exteriority, not superlativity, in relation to the peoples who live under the ontological dispensation (re)described by Bruno Latour in his book *An Inquiry into Modes of Existence: An Anthropology of the Moderns*, I am particularly interested in the bearers of what Robert Redfield called "little traditions," the *ethnoi* and other collectives who insist on existing, and who in no way feel represented by any of the nation states which subjected them to political-cultural hegemony and to economic and ideological "rationalization," usually imposed by fire and sword. These *minor* peoples – minor in the sense used by Gilles Deleuze and Félix Guattari in their *A Thousand Plateaus* (French original 1980) – witness with an anxiety not entirely free from contempt the agonized death throes of European *nomos* and the handover of the modernization offensive to the "great traditions" at the other end of the Eurasian continent. Moreover, these peoples now see themselves, suddenly and rather surprisingly, called upon to *assist* the old moderns who are at the end of their tether (à bout de *souffle*), harassed as they think they are, on the one hand, by the new moderns, who apply lessons learnt from Europe literally with no holds barred, and, on the other, by "the intrusion of Gaia," that strange power which has changed from being passively indifferent when confronted with the thaumaturgic *pavanerie* of the

EDUARDO VIVEIROS DE CASTRO *is a professor of anthropology at the National Museum of Rio de Janeiro. He has worked mainly on indigenous Amazonia cosmological ideas and speculative thought, and on the philosophical implications of the full acknowledgment of extramodern modes of existence. His publications include* From the Enemy's Point of View *(1992) and* Métaphysiques cannibales *(2009).*

"humans" (the moderns) into an ominous protagonist. And she is all the more mortally unpredictable, the more *actively* indifferent towards us she shows herself to be.

It is on the basis of such reflections that *Inquiry* ends, with an exhortation that the West should take steps "to seek the help of the other collectives whose competencies we had rejected in the belief that our first duty was to bring them out of their archaism by modernizing them" (482–83). And this must be done "before it is too late, before modernization has struck equally everywhere" (483). All this before the world comes to an end, and Gaia descends on us all – French and Chinese, Yanomami and Maori – including all the other living beings we have so far not succeeded in eliminating from the face of the planet.

Thus we obey *Inquiry's* exhortation in *extremis* and ask ourselves what the implications of the ontological reforms of modernity are that this extraordinary book explores. *Inquiry* is for a redefinition of the terms of negotiation between the ancient lords

of the earth and all the peoples excluded on their account; the peoples of the earth who never left her in their search for a particular theological or anthropological transcendence or condition of exception, who never had any need to "return to the Earth" (Latour, "A Fully Anthropocenic Approach").

The first thing of note is that the book ends *before* tackling head-on the crucial question of the project: the problem of *diplomacy*, the "foreign affairs" of the moderns. *Inquiry* devotes nearly all of its almost five hundred pages to reviewing internal diplomacy, the pacification of civil war between the modes of existence that are recognized within the practical and institutional space of the West. That is, recognized de facto rather than officially established, because the author's entire endeavor is precisely to reinstate the ontological requirements of each mode of existence in its adequate form. It is as if the fictional anthropologist [FIC·REF][1] who drives the narrative of *Inquiry* deemed his work done by writing an anthropology of the moderns, and thus left to the actual anthropologists (those observers situated in human bodies [REP·REF]) of extramodern peoples the task of investigating the adequacy of the modes of existence which constitute modern ontology – its variable universality, its more or less direct exportability, its sufficient or excessive specificity, and so forth – to other collectives, those, who have not yet been irreversibly infected by modernization. Therefore, there is a need to begin to begin, so to speak, a "collective inquiry" into a type of comparative anthropology whose possibilities were revealed to us by the "provisional report" (476) that *Inquiry* is. An anthropology of the moderns as outlined by *Inquiry* employs a variety of descriptive methodology which propounds a new form of comparison for anthropology in general.

The question to be formulated at the outset, then, is the question of the heuristic and, ultimately, the empirical value – at least in some instances – of the famous table of fifteen modes of existence at the end of the book from a strictly comparative point of view. Here I am referring equally to the twelve object-modes (listed in four groups of three modes each) and to the three meta-modes which, consolidating abstract axiomatics, a pre-ontological formalism of a quasi-mathematical nature reflexively applicable to themselves (vectors, hiatuses, surprises, passes, felicity conditions, etc.), provide the building blocks of object-modes.

There are several possible ways of becoming intrigued by such a neatly arranged ontological pluralism, this architectonic modularity of the moderns with an almost Kantian allure. For example, one could speculate that the first three modes ([REP], [MET], [HAB]) are "successors" to the old notion of nature; that the subsequent three ([TEC], [FIC], [REF]) replace the traditional notion of culture; and that the next three ([POL], [LAW], [REL]) refer to something like the old society; and we know that the last object-modes explicitly unpack the confused concept of economy, giving rise to a triad that echoes, in its quality as the moderns' "second nature," the first "nature" of the triad at the top of the table. Nor would it be absurd to suggest that the resonance between the condition of "brute existence," ingenuously reformulated as the mode [REP] (at the top of the table) and the moral world ([MOR], the last and in some way the supreme object-mode), cannot fail to evoke the classical dualism between the *is* and the *ought to be*. Or observing that the twelve mode-objects of *Inquiry* are like an explosion of the original triad, three "regional ontologies," whose conflicting relations are at the center of Latour's project of pacification, namely: science, politics, and religion (nature, culture, and supernature?), the objects prioritized in his previous investigations.

None of this should serve as a disqualifying argument; to a great extent, the modes of existence described in *Inquiry* are constructed exactly as

[1]    For a brief explanation of these abbreviations, which refer to the modes explored in the AIME project, see the glossary in this volume (r·m!543–47).

reformulations or redeterminations, according to the rigorous analytical criteria of old categories (including category mistakes) or dualities with which the moderns misled the world. As to the number of modes, and the suspect (and familiar) symmetry of its architectonics, our anthropologist of the moderns insists, not without a little embarrassment, that it is merely a matter of historical contingency, as much in relation to the indigenous as to the researcher (479); that the issue as to the number of actual or virtual modes remains an open one; and that in any case these various crossings of modes (curiously, always binary ones) are able to describe an indefinite quantity of institutions, agencies, or dispositifs – call them what you will – appertaining to the moderns.

But let us now return to the question of what to say regarding the others' modes of existence. If our modern dozen is contingent, as much regarding its number as its identity, we can imagine that other collectives have at their disposal, in the double sense of having and arranging, unsuspected modes of existence: "there have been and still are dead or pale or obscure moons in the firmament of reason," according to Marcel Mauss (32), who did not yet possess instruments to apprehend the ontological otherness, except via a mirror, as an enigma. Many such "dark moons" may yet be revealed as far distant stars, of the same or greater size than our modest provincial street lights.

So it amounts to more than an act of imagination: it is theoretically indispensable to determine modes of existence other than our own, consistently following the formal language and analytical methods proposed by Inquiry, which offer a remarkably powerful instrument for general anthropology or comparative metaphysics, concepts which, as Patrice Maniglier (r·m!475–85) demonstrates, work towards the close convergence of synonymy. I believe that the three meta-modes provided by the descriptive framework of Inquiry are fundamental gains, permitting a new definition of the object and of the main objective in anthropological research. So, on the one hand,

ontological pluralism as opened up by the [PRE] mode can be seen to balance the excessive generality or "planitude" of the mode so famously elaborated in Actor-Network Theory, [NET], and, on the other hand, the dangerously seductive "double click." [DC] signals the main epistemological obstacle (if the expression can be used without creating a scandal) to/for the proper declination of different modes of existence. Indeed, [DC] is the very figure of modern *hubris*, in affirming the immediate identity of being and identity, and all that follows from it (starting with the promise of a "reality" given a priori and freely accessible). But as regards the twelve object-modes, which resemble the rooms of the comfortable mansion the moderns proudly constructed upon the ruins of innumerable settlements, I understand that the suggestions provided by Inquiry on its validity (or not) elsewhere are still insufficient, hesitant, and at times inconsistent. Everything appears as though the demon of [DC] had never been wholly exorcised, particularly in the strategic passage from inside to outside in the multiverse of the moderns – the cost of this passage, the extent of the hiatus, or its surprising nature, the alteration required for us to be able to specify to our own satisfaction the felicity conditions of the modes of existence of others are not sufficiently *evaluated* in order to satisfy an anthropologist of the extramoderns.

Let us rapidly take stock. It is not enough to observe how the degree of elaboration or ontological priority of the modes of existence as described by Inquiry are not the same for other collectives; for example, that the [MET] mode is the recipient of more institutional investment and cognitive elaboration among extramoderns than amongst ourselves, where it has been reduced to the phantasm of interiority. At very least, one could say in passing, this would imply that the hierarchy introduced nolens volens in the course of the exposition (and the table) of Inquiry between [REP] and [MET] should be reversed when applied to the case of extramoderns. It is therefore necessary for us to ask ourselves

whether it makes sense to differentiate between these two modes in certain exotic ontological ecologies, such as the so-called "animist" collectives (for which, paradoxically, corporeality, that is, "somatism," is the true operator of *alteration*). Even in the case of the moderns, a definition of all modes of existence constituting "a version of being-as-other" (Latour 183) – a concept that is at the root of "the central hypothesis of our inquiry" (163) – demands an inversion in the order between [REP] and [MET]. Starting with the first of these seems to us a remainder of the substantivist preconception from which Latour's project actually seeks to liberate us: is it not a little contradictory to define the "beings" of [REP] as coming first and to situate the "becomings" of the [MET] as coming afterwards? It isn't enough for us either to say/state that other collectives value the first three modes ([REP], [MET], [HAB]) more intensely than we do – which, as a matter of fact, would explain why we used to designate them as *Naturvölker* [indigenous peoples]... The evolutionist notion of an order of precedence that "ascends" from universal modes to panhuman modes and from these to exclusively modern modes seems only possible to us from the perspective of a *unre-formed* ontology of the moderns (292–93). In addition to this, the possibility of others' modes of existence, shared by humans and nonhumans, or even exclusively by nonhumans – setting aside the dubious pertinence of the simple distinction between "humans" and "nonhumans" for other humans, that is, the extramoderns – is not considered.

What would modes of existence not referenced in *Inquiry* be if we limited ourselves to the multiplicities we designate with the label "humans"? For example, does *kinship*, that fetish-object of anthropologists of the extramoderns, constitute a mode *sui generis*, or is it reducible to [REP] – interestingly named after a master metaphor of Western origin (David M. Schneider) – or, perhaps, in the case of extra-state collectives, a crossing of [REP·POL] (Meyer Fortes and E. E. Evans-Pritchard)? But how

should kinship be conceptualized in a world affectively (in Spinoza's sense) centered on the [MET] mode? How to separate, in the transformational world of peoples such as the indigenous peoples of the Americas, for example, kinship from *witchcraft*, two sides of the same ontology of *influence* (E. R. Leach, Roy Wagner, and Marshall Sahlins)? How to conceptualize a mode of existence of kinship which links, rather than separates, "humans" and "nonhumans" (most famously in animism)? Or what can be said of a way of applying the [POL] mode in a society "against the State" (cf. Pierre Clastres, *Society*), or where nonhuman subjectivities become political collectives in the same way as "us" ("For us, politics is something else," Kopenawa 313)? Or, to take another example, does ritual cannibalism – this very particular form of articulating [POL], [MET], [REP], and, given its powerful mythic references, [FIC] – constitute a fully articulated mode of existence? Is Claude Lévi-Strauss's "science of the concrete" just the [REF] mode in a "savage" register, or does it open up to another ontological multiplicity as yet not mapped in *Inquiry*?

After reading *Inquiry*, one is left with the discomforting sensation that extramoderns possess *fewer* modes of existence than moderns, those who configure the world of whom Martin Heidegger was thinking (the extramoderns being the "quasi-poor-in-world," for all the philosophy of history of late modernity). One is left, a fortiori, with the impression that nonhumans possess even fewer modes of existence than extramoderns and that, in the end, the moderns continue to benefit from supplementary modes of existence in the style of what is called in French a *supplement d'âme*. Which brings us, by way of conclusion, to the vexed question of constructing [REL] in a radically Christian language. Are the moderns the only happy possessors of *persons*? Can only they dispose of, or need, an experience of proximity and presence of the divine (poisonous?) chalice of salvation? What are we to make of the dreams experienced by peoples, such as the Yanomami, as

described by Davi Kopenawa, shaman and political leader, which introduce us to a "phenomenology" in which sensitivity to other people's (or extra-human's) word, the reconstitution of the person, and the politics of nature are inextricably interwoven? Or of the Dinkas's experience of the divine, as magnificently described by Godfrey Lienhardt? Are there so many more unexpected varieties of [REL], or does the "catch-all mode" adopted by [MET] hold sway, to which we moderns relegate everything we cannot comprehend?

Finally, there is a lot of work still to be done in order to build a diplomatic bridge between the intra-ontological pluralism of the moderns as described by *Inquiry* and the meta-plural ontologies, plurally plural, of those who, as Clastres said of savages, "want the multiplication of the multiple" (*Archeology* 165). At least, if the challenge is, as Latour succinctly formulated it, to leave off modernizing in favor of ecologizing, it is highly likely that we must *adopt*, in the affectively and legally complex sense in which one adopts a child [REP·LAW], some of the modes of existence of other collectives, from among those that, *in reality*, have never been modern. The way out is via the other; via the being-as-other-of-others.

*Translated from the Portuguese by Amanda Hopkinson.*

Works Cited

Clastres, Pierre. *Archeology of Violence*. Trans. Jeanine Herman. Los Angeles: Semiotext(e), 1994. Print.

---. *Society against the State: The Leader as Servant and the Humane Uses of Power among the Indians of the Americas*. Trans. Robert Hurley, in collaboration with Abe Stein. New York: Urizen, 1977. Print.

Deleuze, Gilles, and Félix Guattari. *A Thousand Plateaus: Capitalism and Schizophrenia*. Trans. and foreword by Brian Massumi. Minneapolis: University of Minneapolis Press, 1987. Print.

Fortes, Meyer, and E. E. Evans-Pritchard. *African Political Systems*. Oxford: Oxford University Press, 1940. Print.

Kopenawa, Davi, and Bruce Albert. *The Falling Sky: Words of a Yanomami Shaman*. Trans. Nicholas Elliott and Alison Dundy. Cambridge, MA: Harvard University Press, 2013. Print.

Latour, Bruno. *An Inquiry into Modes of Existence: An Anthropology of the Moderns*. Trans. Catherine Porter. Cambridge, MA: Harvard University Press, 2013. Print.

---. "A Fully Anthropocenic Approach." AIME. FNSP, 14 Mar. 2014. Web. 29 Feb. 2016. Available at <http://modesofexistence.org/aime/doc/137>.

Leach, E. R. *Rethinking Anthropology*. London: Athlone, 1961. Print.

Lévi-Strauss, Claude. *The Savage Mind*. London: Weidenfeld & Nicolson, 1962. Print.

---. "The Science of the Concrete." *The Savage Mind*. London: Weidenfeld & Nicolson, 1962. 1–33. Print.

Lienhardt, Godfrey. *Divinity and Experience: The Religion of the Dinka*. Oxford: Clarendon, 1961. Print.

Maniglier, Patrice. "The Embassy of Signs: An Essay on Diplomatic Metaphysics." Latour, *r·m!* 475–85.

Mauss, Marcel. *Sociology and Psychology: Essays*. Trans. Ben Brewster. London: Routledge & Kegan Paul, 1979. Print.

Redfield, Robert. *The Little Community: Viewpoints for the Study of a Human Whole*. Chicago: University of Chicago Press, 1955. Print.

---. *Peasant Society and Culture: An Anthropological Approach to Civilization*. Chicago: University of Chicago Press, 1956. Print.

Sahlins, Marshall. *Culture and Practical Reason*. Chicago: University of Chicago Press, 1976. Print.

---. *What Kinship Is – and Is Not*. Chicago: University of Chicago Press, 2013. Print.

Schneider, David M. *American Kinship: A Cultural Account*. Englewood Cliffs: Prentice-Hall, 1968, Print.

Wagner, Roy. *The Invention of Culture*. Rev. ed. Chicago: University of Chicago Press, 1981. Print.

# WHY IS IT SO HARD TO DESCRIBE EXPERIENCE? WHY IS IT SO HARD TO EXPERIENCE DESCRIPTION?

Jamie Allen, Claudia Mareis, and Johannes Bruder

*[W]hat is given in experience*
*and what renders experience possible correspond to one another in an endless oscillation.*
**Michel Foucault**

**JAMIE ALLEN** is a Canada-born researcher, artist, designer, and teacher, interested in what experimental technologies teach us about who we are as individuals, cultures, and societies. He has been an electronics engineer, a polymer chemist, and a designer with the American Museum of Natural History. He has lectured, published, and exhibited projects extensively, worldwide. Allen is a senior researcher at the Critical Media Lab Basel.

**CLAUDIA MAREIS** is a professor of design studies at the Academy of Art and Design FHNW Basel. She heads the Institute of Experimental Design and Media Cultures and the Critical Media Lab Basel. Her research includes the history of design and design epistemology as well as the intersections of design, media technologies, and STS studies.

**JOHANNES BRUDER** is a post-doctoral researcher at the Institute for Experimental Design and Media Cultures and the Critical Media Lab of the Academy of Art and Design FHNW in Basel. His research revolves around experimental subcultures, critical media technologies, design thinking, and knowledge practices.

A BOOK, an exhibition, an artwork – objects, things – is always paradoxical, self-contradictorily allowing the energies and agencies responsible for their arrival to disappear. Each of these forms is assumed to be an evidential *return of experiences of the world*, whereas they are but momentary detents in *experience with the world*. Still, we conceive of knowledge *production* as the swing of an imagined pendulum in this way, as we try to render explicit an inframince[1] distance between analysis and synthesis, research and development, backstage and the stage itself. The edited publication, the designed exhibition, and the *objet d'art* swing out of the open doors of the writing room or studio, immediately becoming closed systems. "Hiding Making – Showing Creation" is the leitmotif of the researcher, the designer, the artist, the creator, just as it is for the reader, the viewer, or the audience (Esner, Kisters, and Lehmann). The forming of forms and the production of products wraps us all up in this most hermetic of affairs. We are all always on the outside, at the end, trying to look inwards. The word "form" goes from verb to noun (*to form* becomes *a form*), and the messy prehensions of actual, real materials, methods, and interactions are transformed into "the hegemonic and dominatory pretensions of certain versions or *accounts* of method" (Law, *After Method* 4). Finalized ideas, designs, and artworks hide (in plain sight) the means and methods that bring about and sustain them as *things*; objects, as results of informing activities, always warrant still further in*forming*. But how might we avoid pretensions and attempt to explain *what is really going on*? How do we bear witness to *what has happened*? Surely, we must try.

The physicist Léon Foucault wanted people to know what was going on. In 1851, the 32-year-old hung a twenty-eight kilogram bob at the end of a sixty-seven meter wire from the apex of a former

The *Reset Modernity!* exhibition was collaboratively designed and curated by a group consisting of people from the AIME Research Team, the Critical Media Lab of the Academy of Art and Design FHNW in Basel, and the ZKM | Center for Art and Media Karlsruhe. Invited to contribute their thoughts on this process to this catalogue, Jamie Allen, Claudia Mareis, and Johannes Bruder of the Critical Media Lab have opted to trace and reflect on the far from equilibrium entanglements that emerge between the various modes of history and tradition, scholarly inscription and description, experimental design practices, and impossible scenographies in such processes.
The authors describe the practice and thinking of the Critical Media Lab (Basel), dedicated to continuous questioning and critique that is "associated with more, not with less, with multiplication, not subtraction" (Latour, "Why Has Critique" 248), intertwining praxis-led art and design research with historical and theoretical reflection.

church turned mausoleum for distinguished French citizens, the Paris Panthéon. The bob, pulled taut to the outside of the spectators' ring, was attached by a short linen cord to the railing there. This cord was then burned through with a candle flame; cutting it in this ingenious way ensured that no manual forcing would induce lateral oscillations in the pendulum's main swing line. Instead, lateral oscillation would come from the uneven angular momentum of the earth, increasingly detectable as we move away from either pole and, luckily for Léon, entirely detectable at 48.8462218 longitude and 2.3442251 latitude, between the fifth and sixth *arrondissements* in his hometown Paris. There, as in every place nonpolar on earth, planetary rotation entrains the earth at a rate slightly ahead of the

[1]    "Inframince" is a notion developed by Marcel Duchamp that refers to an inseparable duality or intimate closeness, a kind of infinitely close separation or "unmediation." Duchamp coined this term and worked on the notion, asserting that it was impossible to conceptually define it. Instead, he gave examples of things inframince: the infinitesimal separation between the fired bullet and the noise of the gun or the disappearing warmth of a seat that has just been left by a sitter.

entrainment of a protracted pendular plumb line, causing the latter to trace the path of elongated ellipses on the plane or platform beneath it. It is a phenomenon astronomers call "precession."

In the mid-nineteenth century, Léon Foucault contrived for the world a first and primary, popular, and public exhibition of a scientific "fact" – specifically, he transformed the known, mathematical descriptive reality of the rotation of the earth *into an experiential thing* through an instrumental dispositif and performed architecture. *Putnam's Magazine* described the "pendulum mania" (Conlin 181) that ensued immediately afterwards, when popular and scientific reports and copies of Foucault's pendulum caused a sensation worldwide. It is a mania that has not yet abated – one can visit Foucault pendulums in present-day science museums, planetariums, and vestibules of higher education from London to Istanbul, and Vancouver to Bogotá. Some time after the fumes from the burned-through length of string had dissipated, Léon's presentation of the rotation of the earth took on a singular form as a quintessential mathematico-scientific fact; rendered, once and for all, palpable and exhibitable. It is a form that is as simple, elegant, repeatable, and determined as we might expect to be installed beneath the Panthéon's dome, authorized by the two primary demiurges resident there: the transcendent deities of the church and the Enlightenment heroes of France entombed in what is now a secular mausoleum. Léon's juggernaut of a contribution to the history of public exposition of scientific knowledge is an apparatus that, perhaps more than any other, continues to contribute to the popular conception of a universal reality that is formal, formed, and harmoniously tuned by divinity. The pendulum remains "celebrated as the ascent of truth and reason over falsity and superstition" (Tresch 17).

Taking this ragtag assemblage only as a finely tuned instrument, which renders the large-scale reality of earth's spinning momentum directly perceptible to our senses, demonstrates one of modernity's perennial mistakes or misgivings. Léon Foucault's pendulum is, of course, no more an *experience of what is really going on*, cosmologically, than Magritte's famous painting of a pipe can be smoked. What is witnessed in Foucault's 1851 installation is a constellation of artifacts, architectures, assemblies, and environments that are, in actuality, a sort of *mess*: a sixty-seven-meters long wire and a twenty-eight-kilograms bob purchased at some expense from a metalsmith; the charred remains of a burnt length of linen cord; the the unusual construction of a church-cum-site of public honor forged from lead, iron, and stone; a city and the people of Paris still trembling from the street violence of the 1848 *révolution de Février* in the nation of France spinning with all the rest of the globe at about four hundred meters per second.

> Through this remarkable artifice the skilled experimenter rendered sensible to all eyes the invariable meaning according to which the movement of the earth occurs. (Figuier 28; Trans. the authors)

Léon's pendulum is a medium of apparent use in representing the rotation of earth, a *demonstration* for the *demos* who call it home. It is an installation-as-instrument that exhibits and imparts scales and forces which leap over innumerable hiatuses and discontinuities to arrive into human experience – operating as a technological *translator*, "completely original every time … [as a] perpendicular movement of rummaging around, exploring, undulating, kneading, which so obstinately misses the relation between form and function and the relation between ends and means" (Latour, *Inquiry* 227). These often missed and misinterpreted means of conscripting phenomena into acting themselves out is often part of what an exhibition designer is supposed to do, along with curators and science communicators. Such roles and activities are linked genealogically to the moment of Léon's not-so-subtle

1    Illustration of Léon Foucault's 1851 scenography
     for the Paris Panthéon, in: Louis Figuier. *Les nouvelles
     conquêtes de la science. L'électricité.* Paris, 1883: 29.

nineteenth-century exhibit design for the Panthéon (to say nothing of his more theatrical endeavors).[2]

Just how invested we remain in the illusory clarity of old Léon's smoothly folding epistemology is told and retold by the ubiquity of clocks, "seconds pendulums"[3], radio frequency sweeps, the cyclical scan of tunneling microscopes, the periodic raster rhythm of digital displays – and in the production of smoothed over histories, airtight published methods sections, and time-lined, linear histories. For the mountaineer, a "pendulum traverse" is the act of swinging out on a taut rope in order to reach securely a hold or precipice. Christian Kassung's book *Das Pendel. Eine Wissensgeschichte* [The Pendulum: A History of Knowledge] outlines the centrality of the pendulum as a classical image of closure and finality in research and knowledge production. It is a figure that alleges undulating continuity between a clearly defined question, on the one hand, and a just as well defined answer on the other. Yet, "the more precise a question is formulated, the less space remains

for answers" (Kassung 7; Trans. the authors). The pendulum's closure begets a monologic reading of how knowing *works,* as the presupposed precision of scientific questioning wrung through well-defined categories of knowledge. This image of knowledge as a smooth pendulum always falls short, because it forces us toward understandings that block out the frictions, disruptions, and messes intrinsic to all research and all experience. In this there is a danger of neutralizing the scope and specificity of epistemic attention and alertness, forecasting in advance what is to be found, or found out.

What if we were to attempt an experimental *Gedankenausstellung* [thought exhibition] that not only showcased placid, perfect, sweeping ellipses – the ends always produced by representational, mathematical, and algorithmic epistemes? What if we were to veer instead toward the conceit of spaces and media to think with that tended to slightly skew perspectives, vaguely constrict visibilities, and render things just a little bit claustrophobic? Could we construct a human formicary that would seek not to constitute, but to dissolve modernity, toward effecting its careful, attentive recrystallization?

In a similar vein, Michel Serres asks us to "overturn old images" as perhaps "the search for truth follow[s] the path of shadows" (Serres, *Eyes* 69). To serve and protect "the lowly darkness which is less peremptory, less arrogant, less harrying than invasive brilliant lights" (69) would give way to scenographies that are much more murky and manifold – the lights kept always just a bit too low for enlightenment.

And I count as an aesthete since Sartre applies this term to anyone purporting to

499

[2]    John Tresch sounds "the subterranean links between the positive sciences and fantastic mass spectacle" (20) through the person of Léon Foucault, who was otherwise gainfully employed throughout the mid-nineteenth century creating special effects for the Paris opera.

[3]    A one-second half-period pendulum, that is, a rod 0.994 meters long at standard gravity. An early act of the newly formed French National Assembly in 1790 was to specify by decree the "seconds pendulum" as metrological default for linear measurement.

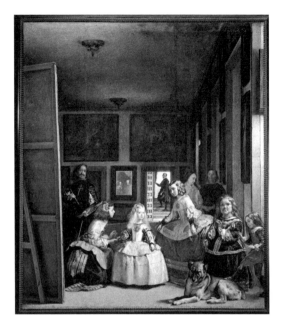

2   Diego Velázquez's 1656 perspectival portrait of portraiture. Diego Velázquez. *Las Meninas*. 1656. Oil on canvas, 318 × 276 cm. Museo Nacional del Prado, Madrid.

3   Central exhibition room of the *Exposition Internationale du Surréalisme*. 1938. 1200 coal sWacks hung from the ceiling above an art installation. Galerie Beaux-Arts, Paris.

study men as if they were ants.... But apart from the fact that this seems to me just the attitude of any scientist who is an agnostic, there is nothing very compromising about it, for ants with their artificial tunnels, their social life and their chemical messages, already present a sufficiently tough resistance to the enterprises of analytical reason ... So I accept the characterization of aesthete in so far as I believe the ultimate goal of the human sciences to be not to constitute, but to dissolve man. (Lévi-Strauss 246–47)

The painter is observing a place which, from moment to moment, never ceases to change its content, its form, its face, its identity. (Foucault 5)

In his lecture "Information and Thinking," reading from *The Star of the South* by Jules Verne, a passage that also complements Bruno Latour's essay in this book ("Let's Touch Base!", *r*·M! II–23), gives us the image of an epistemology that inverts the emancipatory clarity of Plato's cave allegory:

They were in the center of an immense grotto. The ground was covered with fine sand bespangled with gold. The vault was as high as that of a Gothic cathedral, and stretched away out of sight into the distant darkness. The walls were covered with stalactites of varied hue and wondrous richness, and from them the light of the torches was reflected, flashing back with all the colors of the rainbow, with the glow of a furnace fire and the wealth of the aurora. (Verne, "Star" 276)

Equating light as the tyranny of the "yellow dwarf" (the sun), Serres speaks of a knowledge that is clandestine, streaked, and striated:

> Verne's cave reverses the Platonic one. The latter sings the glory of one sun, discovered in the daylight, as one emerges from the shadow, while the former is an invitation to penetrate under a vault that is so deep that one's gaze is as lost as if it stared at a starry sky: here, in this cave, a thousand lights dazzle the thinker. (Serres, "Information and Thinking")

Serres's geo-epistemology eschews the ascetic, divisive knowledge offered by Plato's hollow, monologic derivations, throwing a reticular wet blanket over the traditionally Platonic urge to escape the confines of earth. Serres denies to us the pursuit of unmediated knowledge through the supposed transcendent emancipation of blazing sunlight. We are not *chained* underground in need of light, but are in fact rather deftly able in our negotiations, scurrying and scampering about, gathering up the multiple, parallel, and simultaneous interpretations offered below, above, and here, on the ground. Freedom, if it must come, comes through attachment, as investigation and inquiry *into* the specificities of the illusory "surfaces" that appear to separate, but are better thought as zones of interchange between scales (e.g.: of energy), phases (e.g.: of matter), and rates (e.g.: of individuation). The "surface" of the earth is no boundary at all, but a transitional detent – a state of non-rest marking dynamic equilibrium, as in the low point of a pendulum's swing. How might we render an experience of "modern knowledge" that swings through this space, this non-surface, dipping into the dark mantle below? Deep in Verne's cave (not Plato's), we can imagine equipping ourselves for a probing inquiry, gathering samples for later demonstration, demos for the *demos*. The dark technical arts of instrumentation – electron micrography, digital video, gas chromatography, photography, illustration, satellite imaging, and sculpture – actively equip this inquiry, scaffolding and highlighting knowledge (as a) *production*, urging (re)composition and the performance of a *reset*.

Imperatively, we might imagine an entirely *other* pendulum, named for that non-native Parisian who was also a creator of scenes (also linking him to that so well-named French museological practice *scénographie*). Michel Foucault was a writer and thinker who engaged with the scaffolding, staging, and infrastructuring of thought, words, and things. A pendulum named for Michel Foucault would be different, altogether subaltern, and much more *eccentric*. It would be a pendulum for driving thought through and into the stuff of dirty, telluric life, registering not just the rotation of the earth but its microtremors and tectonic creeps. It would be an exhibition of scuttles and scratches, of the finer delicacies of phenomena, of frustrated translations of information, and of incomplete, inefficient, and devastating transductions of energy, knowledge, and power. It is a pendulum we would hesitate to call a pendulum at all for its lack of superterranean periodicity, clear symmetry, and smooth tracing out of parametric lines.[4]

Michel Foucault's treatise on the history and development of modern epistemology, *The Order*

[4]  Unsurprisingly, this metonymic play has its precursors. After the publication of his mystery-conspiracy novel *Foucault's Pendulum*, Umberto Eco commented, with characteristically ambiguous wit: "As an empirical author I was not so happy about such a possible connection [between Léon Foucault and Michel Foucault]. It sounds like a joke and not a clever one, indeed. ... maybe I am responsible for a superficial joke; maybe the joke is not that superficial. I do not know. The whole affair is by now out of my control" (Eco, *Interpretation* 82–83). We agree with Eco's modulation of Foucault's "epistemes" – no complete epistemic breaks are possible. For Foucault, relations of sympathy, resemblance, and hermetic semiosis are historically delimited, whereas Eco notes how these "premodern" tendencies persist in the hermetic, Baroque writings, in parallel to the development of quantitative science (Hutcheon, "Irony-Clad Foucault" 312–27). Of course, we also agree with Eco that "maybe the joke is not that superficial."

*of Things*, begins in scenography. Like that of Léon's pendulum, it is a scenography that is apparently but deceptively simple – the famed mise-en-scène (and mise en abyme) painting of classical portraiture, *Las Meninas* (1656) by Diego Velázquez. Foucault describes this painting *of painting*, first, in terms that seem to perform a smooth swing between research and creation, observation and inscription, representation and sensation. Foucault's portrayal of the artist in Velázquez's painting is, at the outset, an almost symmetric motion – from analysis to synthesis and back again. The artist is placed "at the neutral centre of this oscillation" (Foucault 4), between world and representation. Satisfying our moderns' desire for simple, geometric explication, Foucault's pendular tracing notes, at first, how the "painter's sovereign gaze commands a virtual triangle whose outline defines this picture of a picture: at the top – the only visible corner – the painter's eyes; at one of the base angles, the invisible place occupied by the model; at the other base angle, the figure probably sketched out on the invisible surface of the canvas" (5). The artist in Velázquez's painting is, for a moment, something of a functionary, transporting light between two kinds of visible objects. Foucault speaks indeed of the painter *ruling* at the precipice between these two scopic regimes, "at the threshold of those two incompatible visibilities" (4).

Yet Foucault does not leave us for long in the comfort zone of this oversimple description. This fallacy of a static world transported to the canvas is swiftly swept away. In place of such a static world is installed "a place which, from moment to moment, never ceases to change its content, its form, its face, its identity" (5), even as the self-assured painter, "standing a little back from his canvas" (3), poises himself for the next mark to be made. The pendulum of observation and reproduction, observing and *acting in the world*, is quickly disturbed under scrutiny, transforming itself into a more complex scene

of *acting with the world* not in it, as interlocking and dynamic frames and focuses, gazes and reflections, and ambiguous swirls – a "spiral [that] is closed, or rather, … [that] is opened" (12).

Oblique rays of illumination and dark, enigmatic shadowy figures begin to (over)populate Foucault's description, as he stirs up an aesthetic-epistemic cyclone. The full text of Michel Foucault's essay on *Las Meninas*, comprising 6,845 words in its English translation, is at pains to describe the parallel, recursive, folded networks of relations – a set, perhaps, of micropendula – constituting the composition (of composition) in the painted *Las Meninas*. It is a painting that Velázquez himself seems to have produced in order to recompose, reset, and put on display the illusion of sovereign points of view or reflected perspectives popularized in medieval painting (today we could call it "glitching"). Full of impossible baroque convolution, as well as impossible perspectives and lines of sight, no amount of words have been able to provide an interpretation of this painting that is clear or satisfactorily diagrammatic. What is the baroque after all, if not an art and science in service of presenting overwhelming meshes and infinite connections, of exhibiting the unknowable, resonant relationality of the world. This is the baroque that John Law has explored in relation to Actor-Network Theory, that "[i]nstead of looking up, this looks down and discovers limitless internal complexity within, which is materially heterogeneous, specific, and sensuous" (Law, "And if the Global" 13).

The romantic art historian remains frustrated that we can draw no definitive, singular point of view regarding the points of view in Velázquez's painting.[5] *Las Meninas* by both Foucault and Velázquez are contradictory depictions of the impossibility of depiction, impossible scenographies, constantly in flux, exhibiting unsimply that the oscillations between objects, ideas, and their framing as exhibition

[5]  John Searle opens his own essay on *Las Meninas* with the line "Why after over three centuries does *Las Meninas* continue to bother us?" (477). "maybe the joke is not that superficial."

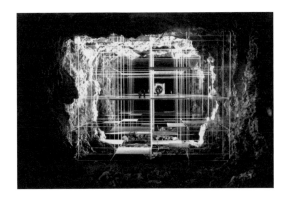

4    Frei Otto. *Vorgespanntes Raumseilnetz i.d. Kiste* [Pre-taut wire net space in a box]. Ca. 1964. Model.

and Nandita Biswas Mellamphy have called, after Benjamin, the "messy antics" of materialist reality: the interactions of objects and subjects acting together *with the world*. It is a linguistically dowsing[6] of what might light up beyond the painting's surface. Seeking out transversal, subterranean resonances, the probing insurrection of a Foucault's pendulum named for Michel Foucault sketches out its alternate lines. What truths might be found, recalling Serres versus Plato, in the dusky storm of ceiling shadows that dominate *Las Meninas*, a Muslim architectural interior in the Royal Alcázar of Madrid that so often, if inadvertently, replaced the backdrop for Velázquez's scenographies.

503

does not take sinusoidal shape; they do not fit the form of Léon's famous pendulum. These are the characteristics of a "pendulum" that is never simple to describe; one that recomposes the undeniably heaving mess of things; one that helps "tie a complex, reticular knowledge net" (Kassung 390; Trans. the authors) where the romance of scientific and artistic modernism would have us install yet another smooth, hyperbolic ellipse.

> [W]hat can be studied is always a relationship or an infinite regress of relationships. Never a "thing." (Bateson 246)

Foucault's intention in his *Las Meninas* essay is apparent and explicit: to "preserve the infinity of the task" (10) of both study and description, freeing representation from the simplistic relation impeding it; manumitting words, things, theories, practices, descriptions, and experience. "Las Meninas" the essay translates into text, dissolves, resets, and recomposes the complex undergirding of lines of sight and plays of shadow in *Las Meninas* the painting. Foucault's linguistic gesture is not smooth, but the erratic zigzagging and scuttled procedure of an infinite and interminable attempt. Invoked in "Las Meninas," the essay, just as spending time with the painting itself reveals, is what Dan Mellamphy

Through Léon's and Michel's pendulums, we outline divergent types of hermetic, hermeneutic "swings" – these are divergent aesthetics and imaginaries of knowledge, the mythologies of methodologies which subtend research, practice, evidence, and exhibition. We admit preference for the infinite recurrence of a pendulum named for Michel Foucault – found in the asymmetries and heterogeneousness of the "reset" and linked to the occasions precipitating these writings: a research project undertaking an anthropology of modernity entitled *An Inquiry Into Modes of Existence* (AIME), published in book form; an exhibition project, *Reset Modernity!*, at the ZKM | Center for Art and Media Karlsruhe; the fruitful collaboration between researchers at the Critical Media Lab in Basel, Bruno Latour and the team behind the European research endeavors AIME at Sciences Po, Paris, and the minds, bodies, and edifices of ZKM | Karlsruhe, Germany's foremost media arts institution; a scenography designed and developed at the Critical Media Lab in Basel by a loose amalgam of

[6]    A "dowsing pendulum" is an apocryphal technology – a weight hung from a string – that is used to locate ("divine") the subterranean water, petroleum, and metal deposits.

5   The "verbose" console output for the incremental, sequential process
    of initiation processes that take place each time a computer is "reset."
    Screenshot.

```
MAC Framework successfully initialized
using 10485 buffer headers and 7290 cluster IO buffer headers
FakeSMCKeyStore: started
DirectHW: Driver v1.3 (compiled on Jun  8 2012) loaded. Visit http://www.coresystems.de/ for more information.
AppleKeyStore starting (BUILT: Sep 19 2013 22:20:34)
FakeSMC v6.0.1018 Copyright 2013 netkas, slice, usr-sse2, kozlek, navi, THe KiNG, RehabMan. All rights reserved.
IOAPIC: Version 0x11 Vectors 64:87
FakeSMC: 10 preconfigured keys added
ACPI: System State [S0 S3] (S0)
pci (build 22:16:29 Sep 19 2013), flags 0x61008, pfm64 (36 cpu) 0xf80000000, 0x80000000
[ PCI configuration begin ]
console relocated to 0xe0000000
[ PCI configuration end, bridges 3, devices 8 ]
RTC: Only single RAM bank (128 bytes)
USBF:    0.205    We could not find a corresponding USB EHCI controller for our OHCI controller at PCI device number31
SMC: successfully initialized
acache: 1 CPU(s), 64 bytes CPU cache line size
mbinit: done [64 MB total pool size, (42/21) split]
Pthread support ABORTS when sync kernel primitives misused
rooting via boot-uuid from /chosen: 9073466E-1B60-34E7-BABA-30B94065C3F4
Waiting on <dict ID="0"><key>IOProviderClass</key><string ID="1">IOResources</string><key>IOResourceMatch</key><string ID="2">boot-uuid-media</string></dict>
com.apple.AppleFSCompressionTypeZlib kmod start
com.apple.AppleFSCompressionTypeDataless kmod start
com.apple.AppleFSCompressionTypeZlib load succeeded
com.apple.AppleFSCompressionTypeDataless load succeeded
USBF:    0.256    AppleUSBOHCI::CheckSleepCapability - controller will be unloaded across sleep
USBF:    0.260    AppleUSBOHCI::CheckSleepCapability - controller will be unloaded across sleep
Got boot device = IOService:/AppleACPIPlatformExpert/PCI0@1e0000/AppleACPIPCI/pci8086,2829@1F,2/AppleICH8AHCI/PRT000/IOAHCIDevice@0/AppleAHCIDiskDriver/IOAHCIB
lockStorageDevice/IOBlockStorageDriver/VBOX HARDDISK Media/IOGUIDPartitio
BSD root: disk0s2, major 1, minor 2
jnl: b(1, 2): replay_journal: from: 935936 to: 2162688 (joffset 0xa0000)
jnl: b(1, 2): journal replay done.
hfs: mounted Stuff on device root_device
com.apple.launchd          1          com.apple.launchd                                          1    *** launchd[1] has started up. ***
com.apple.launchd          1          com.apple.launchd                                          1    *** Verbose boot, will log to /dev/console
  ***
com.apple.launchd          1          com.apple.launchd                                          1    *** Shutdown logging is enabled. ***
** /dev/rdisk0s2 (NO WRITE)
```

6   The irregular networks, apocalyptic geology and chromatic "reset" of:
    Alberto Burri. *Grande cretto nero.* 1977. Masonite, soil, and vinyl. 149.5 × 249.5
    cm. Centre Pompidou-CNAC-MNAM, Paris.

researchers, students, independent designers, artists, and architects, knit together in a manner that parallels the messy prehensions and articulations we have just described: the practices of scholarship, research, exhibition design, art, and media. A description of these latter processes is not attempted here, as this kind of didacticism would no doubt tend toward those unfortunately pretentious accounts designers often use to productize what they do as "design methods." We conclude, as John Law does:

> If much of the world is vague, diffuse or unspecific, slippery, emotional, ephemeral, elusive or indistinct, changes like a kaleidoscope, or doesn't really have much of a pattern at all, then where does this leave social science? (Law, *After Method* 2)

We ask instead: Where does this leave the methods of design? Of artistic practice? Of exhibition-making?

The "reset" of *Reset Modernity!* is a pendular gesture, instituted as it is by that word-forming prefix "re." It never returns precisely to a point of origin, that impossible point that always long since dissipated. Like its syllabic cousins "return," "review," and "restart," it instigates a movement done again, once more or in turn, but with just a hint of undoing, decortication, of "peeling back the surface to see what the planetary reality is" (Woods n. pag.), followed by a call for recapitulation or recomposition. As Donato Ricci's contribution to this volume attests ("Don't Push That Button!" *r·m!* 24–41), resets are applied variously to alarms and scoreboards, rings and bones, and video games – the stuff of the earth, as usual, offering up its own highly articulate enunciation[7] that is also a declination of the possibility of "starting all over again." Practically absurd, yet still part of modernist eco-pastoral fantasies of the re-turn,

and extraplanetary fantasy of re-birth, "starting all over again" seems to besiege thinking as a kind of "necrophilosophical drive for eternity through extension" (MacCormack 11). There is, for example, certainly no pretechnological condition to which "we" could re-turn, as "technologies *precede* humans by hundreds of thousands of years" (Latour, *Inquiry* 223). But the slate can never be completely wiped clean, and backward compatibility[8] is, broadly speaking, always a necessity and never a feature. A "reset" never presumes the wholesale, conclusive violence of a clear-cutting, or the clean, ahistoric sanitation of purification, but instead speaks to the conditions for the possibility of renewal that acknowledge themselves as tautological.

The reset's pendular gesture is then of a kind we have now named for Michel Foucault, just as the reset of a computer or Internet browser, which does the good work of clearing out log files, dumping bungled memory allocations, and erasing "cookies," all in expectancy of a recomposition, bit by bit. We should not mistake these for "smooth" processes: a computer's reset sequence – ever so slightly *different every time* – gives us a reconstitution that is the same *but not*, rigorously tautologically. An infinite, differential task, the reset links operations of re-production and re-newal, as the re-initiation of a series of phenomena linked in a chain, that one by one, little by little, effect microtranscendental recompositions. Why else would our everyday be so full of this infinite task – this unquestioned, techno-ritual of "turning it on and off again"? *Things*, and technologies in particular, *like* being reset.

The "reset" is a pendular path that stutters and cracks our modern imaginaries, all the while attempting to log the enunciations of our archival world, dragging along with it an earthly, historical ballast, never naively trying to escape what has come before: "There is always something that exists first as

---

[7]   "Language is well articulated like the world with which it is charged" (Latour, *Inquiry* 144).

[8]   Technical culture gives us "backward compatibility" as the ability of a contemporary model apparatus or system to function in concert with legacy systems, that is, older products or technologies.

a given, as an issue, as a problem" (Latour, "Cautious Prometheus" 4). The artistic practices, mediations, and exhibitions of modernity are shot through with the rebar of indentured labor and the vulgarities of rare earth and strip mining; the boundless industry of science and computation are grounded by the historic materialities of an earthly finitude with which *everything* must necessarily be "backwardly compatible." Just as design is "never a process that begins from scratch: to design is always to redesign" (4), all architectures (including our osseous skeletons[9]) are backwardly compatible with the ever spinning globe; the most cutting-edge, high-fidelity digital media are ineluctably backwardly compatible with the properties of atomic silicon. Only that which has been built can be reset, and only by those with enough access, and power, to know where the "reset button" is, and push it.

Never the impossible apocalypse of a complete "re-start," the "reset" gives up on the idea of entirely *clearing ground*. It avoids creating yet another, apocryphal *Lichtung* – that delusion of Western philosophical thought we humans have long congratulated ourselves for being singularly capable of. Instead, we return to the description of experience, and the experience of description – both "ours" and "yours." A reset of modernity does not *clear the ground* so much as it *grounds the clearing*. If our relatively small, impressively brutal human scratchings on the surface of earth show us anything, it is that overtures toward *Lichtungen* come only via incommodious and involved zoning authorization meetings, legislative permission tribunals, mass land redistributions, and landscape geoengineering projects.

*Reset Modernity!* is a scenography of resituated, grounded bodies; an immersion into the cumbersome "realities" constituting Western culture; a simultaneous recomposition and description (Law, *After Method* 13); a set of philosophical *and ambulatory* "turns" where multiple entrances and exits fold into and onto one another. From above we should deny ourselves a view of what we descend below to better experience. As with Vernes's "cave streamed with light," it is a scenography of knowledge as attachment, as grounded – not a "clearing," or even a "clearing up," but the attempt to jostle and reset the jumbled museum of the earth. It is the exhibition of a Foucault pendulum named for Michel, oscillating through the fissured and cracked surface of the earth.

### GRATITUDES

THE AUTHORS wish to extend their heartfelt thanks for the enthusiasm and commitment of the project team linked to Critical Media Lab, Basel: Flavia Caviezel, Moritz Greiner-Petter, Paolo Patelli (independent designer and researcher), Carola Giannone, Martin Siegler (Bauhaus-University Weimar), and Deborah Tchoudjinoff (Royal College of Art, London). Further gratitudes are extended to FHNW student collaborators Ephraim Ebertshäuser, Dan Kray, Josefine Krebs, Mirko Mertens, Yunhyun Park, Felipe Schwager, Esther Stute, and Jil Wiesner for their time and generosity. Thanks to Bronwyn Lay, Orit Halpern, Garance Malivel, and Nina Jäger for their insightful reviews of early versions of this essay.

---

*Works Cited*

Bateson, Gregory. *Steps to an Ecology of Mind: Collected Essays in Anthropology, Psychiatry, Evolution, and Epistemology*. 1972. Chicago: University of Chicago Press, 2000. Print.

Conlin, Michael F. "The Popular and Scientific Reception of the Foucault Pendulum in the United States." *Isis* 90.2 (1999): 181–204. Print.

Eco, Umberto. *Foucault's Pendulum*. Trans. William Weaver. San Diego: Harcourt Brace Jovanovich,

[9] A cosmo-pathological example, "spaceflight osteopenia," names a condition wherein prolonged absence from our home planet results in decreased bone mass.

1989. Print.

---. *Interpretation and Overinterpretation.* Ed. Stefan Collini. Cambridge: Cambridge University Press, 1992. Print.

Esner, Rachel, Sandra Kisters, and Ann-Sophie Lehmann. *Hiding Making – Showing Creation: The Studio from Turner to Tacita Dean.* Amsterdam: Amsterdam University Press, 2013. Print.

Figuier, Louis. Trans. of *Les nouvelles conquêtes de la science: L'électricité.* Paris: Librairie illustrée, 1883. Print.

Foucault, Michel. *The Order of Things: An Archaeology of the Human Sciences.* 1970. London: Routledge, 2005. Here 366. Print.

Hutcheon, Linda. "Irony-Clad Foucault." *Reading Eco: An Anthology.* Ed. Rocco Capozzi. Bloomington: Indiana University Press, 1997. 312–27. Print.

Kassung, Christian. *Das Pendel. Eine Wissensgeschichte.* Paderborn: Fink, 2007. Print.

Latour, Bruno. "A Cautious Prometheus? A Few Steps toward a Philosophy of Design (with Special Attention to Peter Sloterdijk)." *Networks of Design: Proceedings of the 2008 Annual International Conference of the Design History Society (UK).* Eds. Jonathan Glynne, Fiona Hackney, and Viv Minton. Boca Raton: Universal, 2009. 2–11. Print.

---. *An Inquiry into Modes of Existence: An Anthropology of the Moderns.* Trans. Catherine Porter. Cambridge, MA: Harvard University Press, 2013. Print.

---. "Let's Touch Base!" Latour, *Reset Modernity!* 11–23.

---, ed. *Reset Modernity!* Cambridge, MA: The MIT Press, 2016. Print.

---. "Why Has Critique Run out of Steam? From Matters of Fact to Matters of Concern." *Critical Inquiry* 30.2 (2004): 225–48. Print.

Law, John. *After Method: Mess in Social Science Research.* London: Routledge, 2004. Print.

---. "And if the Global Were Small and Noncoherent? Method, Complexity, and the Baroque." *Environment and Planning D: Society and Space* 22.1 (2004): 13–26. Print.

Lévi-Strauss, Claude. *The Savage Mind.* Chicago: University of Chicago Press, 1966. Print.

MacCormack, Patricia. *The Animal Catalyst: Towards Ahuman Theory.* London: Bloomsbury, 2014. Print.

Magritte, René. *The Treachery of Images (This Is Not a Pipe)* [*La trahison des images (Ceci n'est pas une pipe)*]. 1929. Oil on canvas. Los Angeles County Museum of Art, Los Angeles.

Mellamphy, Dan, and Nandita Biswas Mellamphy. "What's the 'Matter' with Materialism? Walter Benjamin and the New Janitocracy." *Janus Head: Journal of Interdisciplinary Studies in Literature, Continental Philosophy, Phenomenological Psychology, and the Arts* 11.1–2 (2009): 163–82. Print.

Ricci, Donato. "Don't Push That Button!" Latour, *Reset Modernity!* 24–41.

Searle, John R. "'Las Meninas' and the Paradoxes of Pictorial Representation." *Critical Inquiry* 6.3 (1980): 477–88. Print.

Serres, Michel. *Eyes.* Trans. Anne-Marie Feenberg-Dibon. London: Bloomsbury, 2015. Print.

---. "Information and Thinking / L'information et la pensée." The Society for European Philosophy and Forum for European Philosophy Joint Annual Conference *Philosophy After Nature.* Centre for the Humanities, Utrecht University. St. Martin's Cathedral, Utrecht. 3 Sept. 2014. Video address.

Tresch, John. "The Prophet and the Pendulum: Popular Science and Audiovisual Phantasmagoria around 1848." *Grey Room Quarterly* 43 (2011): 16–42. Print.

Vélazquez, Diego. *Las Meninas.* 1656. Oil on canvas. Museo del Prado, Madrid.

Verne, Jules. "The Star of the South." *Works of Jules Verne.* Ed. Charles F. Horne. Vol. 13. New York: V. Parke, 1911. 208–308. Print.

Woods, Lebbeus. "Without Walls: An Interview with Lebbeus Woods." By Geoff Maunaugh. BLDGBLOG. 3 Oct. 2007. Web. 19 Feb. 2016. Available at <http://www.bldgblog.com/2007/10/without-walls-an-interview-with-lebbeus-woods/>.

**7**   BGL. *Domaine de l'angle I*. 2006. Installation. Saint Charles de Bellechasse.

**8**   Paolo Patelli, Moritz Greiner-Petter, Jamie Allen, Dan Kray, and Mirko Mertens. RM! *exhibition earth/grounding scenography concept*. 2015. A photograph of a physical model of ZKM at Critical Media Lab Basel, showing part of the earth/grounding scenography concept for the *Reset Modernity!* exhibition. Special thanks to Inbal Lieblich.

The Critical Media Lab, part of the Institute of Experimental Design and Media Cultures at the Academy of Art and Design in Basel, was as a research and relay partner for the development of the AIME exhibition at ZKM | Karlsruhe. Researchers acted as curatorial and scenography advisors during exhibition development, and undertook sketching and prototyping sessions amongst interdisciplinary researchers and students, taught a shortcourse on AIME topics and themes, held reading groups, and advised on material and curatorial selections, exhibition development and visitor flow.

**9a** Roof parts of the cardboard model. 2015. Photograph.

**9b** "Re: [RM!] RM wall." E-mail from Donato Ricci to Bruno Latour, Martin Guinard-Terrin, Christophe Leclercq, and Jamie Allen. 30 July 2015. Screenshot.

**9c** Jamie Allen. Sketch of the visitor's movement in the exhibition. 2015. Drawing.

**9d** Moritz Greiner-Petter's image folder for the exhibition. 2015. Screenshot.

9e   Photo of a construction site in
     Basel during the summer of 2015.

9f   Jamie Allen and Johannes Bruder develop AIME exhibition ideas with
     students of the Academy of Art and Design FHNW in Basel. Oct. 2015.

**9g** Paolo Patelli's floor plans for the exhibition. 2015. Screenshot.

**9h** "Fwd: [RM!] Skype demain avec Bruno?" E-mail on material propositions for the exhibition scenography. 2015. Screenshot.

**9i** Material sample of a perforated metal plate for the exhibition scenography. 2015. Photograph.

**9j**  Mosaic floor, inspiration for the
exhibition scenography taken in
Paris. 2015. Photograph.

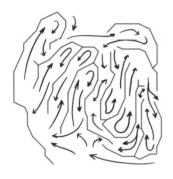

**9k** Jamie Allen. Sketch of the visitor's movement in the exhibition, including the walls. 2015. Drawing.

**9l** Bruno Latour presenting the exhibition scenography at Louvre Museum Auditorium. Paris, 25 Sept. 2015. Video still.

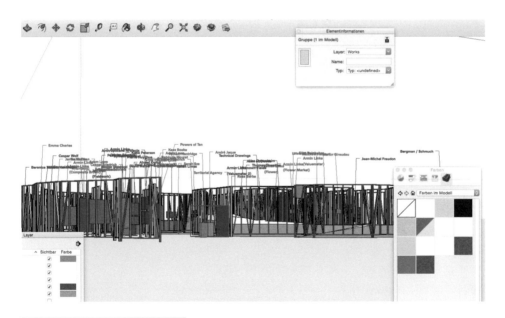

**9m** Moritz Greiner-Petter's rendering of the exhibition scenography. 2015. Screenshot.

**9n** Sketch of a topview of the proposed exhibition
scenography. 2015. Drawing.

**9o** "Re: [RM!] RM wall." E-mail from
Donato Ricci to Jamie Allen,
Bruno Latour, Martin Guinard-
Terrin, Christophe Leclercq,
Moritz Greiner-Petter, and Paolo
Patelli. 31 July 2015. Screenshot.

# FOR ANOTHER RESET: RENAISSANCE 2.0

## Peter Weibel

THE ADVANTAGE of the notion of reset is that many other wavelengths may be registered, once the procedures described in this book have been carried out. In what follows, I wish to offer an alternative trajectory of modernity by tracing what has happened to the relations between art and technology.

When we consider the modern art movement it seems that the observers have been too much a part of the systems they were observing, and therefore did not gain enough critical distance. Instead of being critics they have been partisans, or even outright aficionados of modern art. Let's therefore try to take a closer look at the fundamental changes caused by the links between modern art, science, and technology in a new way.

### MODERN ART: THE SUBVERSION OF REPRESENTATION BY REALITY

FOR MANY CENTURIES, up until 1900, the art of painting, which together with sculpture was held to be the primary medium of art, was grounded on a theoretical program that can be summed up by Leonardo da Vinci's words about painting. In his renowned treatise on painting (*Trattato della pittura*, written ca. 1490) Leonardo stated:

> The science of painting begins with
> the point, then comes the line, the plane

PETER WEIBEL, *Chairman and CEO of the ZKM | Center for Art and Media Karlsruhe and professor of media theory at the University of Applied Arts in Vienna, is considered a central figure in European media art on account of his various activities as artist, theoretician, and curator at biennials in Venice, Seville, and Moscow. He publishes prolifically on the intersecting fields of art and science.*

> comes third, and the fourth the body
> in its vesture of planes. This is as far as
> the representation of objects goes.
> For painting does not, as a matter of fact,
> extend beyond the surface; and it is
> by its surface that the body of any visible
> thing is represented. (119)

Painting is a science claimed Leonardo. And the aim of this science is to represent the shapes of visible things. As the means of this representation he defines point, line, plane, and volume. The classical program of painting is here formulated: The visual representation of the world of visible things with the painterly means of representation like point, line, plane, and volume. Classical art was defined as the art of representation, the representation of visible reality.

The breach between the classical program of art and the program of modern art is obvious from

REPRESENTATION

Representation of Things with the painterly Means of Representation

ABSTRACTION                    1913                    REALITY

Self-Representation of the                        Self-Representation
Means of Representation                              of Things

Kazimir Malevich, *Black Square*, 1913

Marcel Duchamp, *Bicycle Wheel*, 1913

the title of a seminal book by one of the founding fathers of abstract modern art, Wassily Kandinsky's *Point and Line to Plane*, published in 1926. Like Leonardo, Kandinsky also cites point, line, and plane as the painterly means of representation, prominently, in his book's title. But he discards the second half of Leonardo's paragraph that links these means of representation to reality. Kandinsky stops at the means of representation. He only considers point, line, and plane. Evidently, he does not want these means of representation to represent something. He denies the representation of the world and focuses only on the means of representation themselves. That is the reason for the book's subtitle: *Contribution to the Analysis of the Pictorial Elements*. The subtitle is an echo of nineteenth-century experimental psychology, for example *Contributions to the Analysis of Sensations* (1886) by Ernst Mach. Modern painting has cut the reference to the world of things. Modern painting has reduced itself to representing the painterly means of representation alone.

> It is the first stage on the road by which painting will, according to her own possibilities, grow in an abstract sense and, finally, reach a purely artistic composition. (Kandinsky and Rebay 45)

The modern painter limited himself to analyzing the available painterly means of representation. Instead of representation of the world of objects as in classical art, modern painting aims only at the *self-referential representation of the means of representation*. Kazimir Malevich, for instance, even made this the title of his book on Suprematism published in 1927: *The Non-Objective World*.

Alexander Rodchenko declared "the end of representation" in 1921 and produced the first monochrome paintings in history, which featured only

1  Pablo Picasso. *Mandolin and Clarinet*. 1913. Wood construction, pencil strokes.

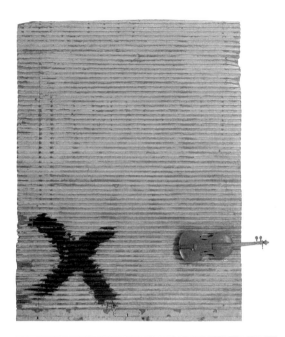

2  Antoni Tàpies. *Metal Shutter and Violin*. 1956. Assemblage.

the colors red, yellow, and blue. The colors no longer represented visual things. Yellow did not represent the sun nor blue the sky. The colors represented nothing but themselves, from Alexander Rodchenko to Gerhard Richter (Six Yellows, 1966). Things were banned from painting. This act of nonrepresentation of reality was called abstract art. Abstract art is nothing other than the self-representation of the means of representation: radical reductionism.

When we reset modernity we have to ask, *how great was the loss by this reduction and how far will we maintain this reduction in the future?* The question becomes more evident, when we discover that from the beginning this reduction to the self-representation of the means of representation was just half the story, because simultaneously and parallel to this self-dissolution of painting, parallel to the prohibition of representing things, real things entered the art world. Art was divided. On one side the artists said: no representation of reality, only abstraction. On the other side artists welcomed reality in a way that had never been allowed before.

The self-representation of things, which was formerly prohibited in the classical arts, was the answer to the prohibition of modern painting to represent things. On one side we had pure colors – red, yellow, blue, and so on – with no reference to reality, and on the other side we had pure reality, that is, the self-representation of things as things. In the same year, 1913, when Malevich painted his famous black square, Marcel Duchamp presented his first ready-made: *Bicycle Wheel*. Duchamp declared an object, without any transformation, to be a work of art. This was the beginning of reality art instead of the art of representation. The object was enough just as the color was enough. A strange situation has occurred at the beginning of modern art: some modern artists banned the object world entirely, and other modern artists introduced the object world like never before. The twentieth century was nothing else than the evolution of these two conflicting tendencies. In the first half of the century abstract art was dominant, in the second half

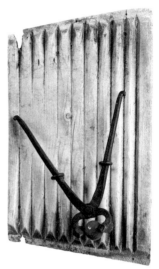

**3**   Alberto Burri. *Wheat*. 1956. Sackcloth and acrylic on canvas. 150 × 250 cm. Kunstsammlung Nordrhein-Westfalen, Düsseldorf.

**4**   Ivan Puni. *Relief with Pincers*. 1915. Wooden washboard, metal pincers, and red ball.

of the century the art of reality was dominant. Everything that had been representation in former times, was substituted with reality at the end of the twentieth century. Instead of paintings that represent the natural light of the sun through colors, today we have works using real artificial light, so called light art. Instead of painted fire, today we have real fire as part of an installation. Instead of painted clouds we have real clouds (ZKM). Instead of portrait painting we have real bodies (body art). Instead of landscape painting we have land art. Painted hair, pianos, animals, bricks – all are substituted by real hair, real pianos, real animals. Painted waterfalls are substituted with real waterfalls, and so on. Even painting began to substitute its means of representation with real things. From Pablo Picasso and Francis Picabia to Ivan Puni and Kurt Schwitters, real materials like newspaper (*papiers déchirés*), wood, or rubber replaced color. From these collages

of paint and real materials in the first half of twentieth century arose in the second half material painting with, for example, iron, concrete, and wood, that culminated in assemblages, a closed ensemble of real objects, and environments, a situation constructed from real objects.

The use of pure color, of "absolute color," of color that did not represent real things, was indeed nothing else than the introduction of color itself as real object: color as color. Abstract art used color as a concrete element. Thus in 1924 the movement called *concrete painting* or *concrete art* arose. Abstract art was already the beginning of substituting representation with reality because it substituted color that represents things with colors that are simply real colors without any representation.

In his *Manifesto of Art Concrete* Theo van Doesburg said in 1930 that we speak of "concrete and not abstract painting because nothing is more concrete,

**REPRESENTATION**

**REALITY**

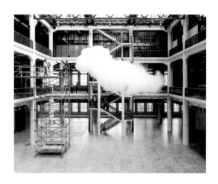

**5**    René Magritte. *Les Nuages.* 1939. Gouache. 34.3 × 33 cm.

**6**    Transsolar + Tetsuo Kondo. *Cloudscapes.* 2015. Installation. Installation view ZKM | Karlsruhe 2015.

**7**    Thomas Ender. *Blick auf Gastein.* 1830. Oil on drill. 78.5 × 58 cm. Neue Galerie Graz.

**8**    Olafur Eliasson. *Waterfall.* 1998. Installation view *Surroundings Surrounded.* Neue Galerie Graz 2000.

**9**    Johann Kniep. *Ideale Landschaft.* 1806. Oil on canvas. 95.5 × 121 cm. Neue Galerie Graz.

**10**    Dan Flavin. o. T. (*To Bob and Pat Rohm*), 1969. 6 fluorescent lamps (2 red, 2 green, 2 yellow). 244 × 244 × 25 cm. Sammlung FER.

REPRESENTATION

REALITY

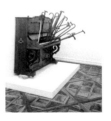

**11**  Karl Friedrich Gsur. *Dr. Sepp Rosegger und Frau am Klavier.* 1920. Oil on cardboard. 45.3 × 54.1 cm. Neue Galerie Graz.

**12**  Dragoljub Rasa Todosijević. *My second fluxus piano.* 2002. Piano, walking sticks. 120 × 150 × 70 cm. Neue Galerie Graz.

**13**  Egon Schiele. *Mime van Osen.* 1910. Charcoal, watercolors on paper. 38 × 29.6 cm. Neue Galerie Graz.

**14**  Günter Brus. *Selbstbemalung I.* 1964. 4 b/w photographs, series of 15, each 48.7 × 39 cm. Neue Galerie Graz.

**15**  Giacomo Balla. *Velocità d'automobile.* 1913. Tempera on paper, 70 × 100 cm. Stedelijk Museum, Amsterdam.

**16**  Jean Tinguely. *Méta-Taxi.* 1986. Mixed-media installation. Installation view *just what is it...* ZKM | Karlsruhe 2010. Daimler Art Collection.

**17** Jan Christiaensz Micker. *Bird's-eye View of Amsterdam.*
1652–1660. Oil on canvas. 100 × 137 cm. Amsterdam
Museum.

more real than a line, a color, a surface" (Van Does-
burg 2; trans. Weibel).

Here we find Leonardo being cited, but once again
line, color, and surface do not represent visible things,
they are themselves considered as real things.

### THE IRRUPTION OF MEDIA ART THROUGH A NEW CONNECTION WITH SCIENCE

Suppressed by the art market and marginalized
by art history, which has modeled its conception of
the image on the art of painting, two new tendencies
appeared between abstract art and reality art in the
twentieth century: media art and action art. Art
historians date the beginning of machine-based
production of images with photography to around
1824 (Joseph Nicéphore Niépce). However, in actu-
al fact, from the renaissance to the seventeenth
century – the golden age of painting, from Velázquez
to Vermeer – paintings had been produced with the
help of drawing aids.

Seventeenth-century landscape painting in par-
ticular was the culmination of a great deal of knowl-
edge. Geometry, cartographic projections, mathe-
matics, surveying instruments, systematic

triangulation, artillery instruments for measuring
and sighting – all worked together to create views
of landscapes, which would not have been possible
in reality. In the Netherlands, for example, there are
no hills, so an aerial perspective, a bird's eye view,
was impossible for contemporary artists.

Neither did the painters have access to flying ob-
jects. Their views of cities and landscapes from
above were the result of geometrical and mathe-
matical models constructed with the help of cer-
tain instruments. Painting was the product of math-
ematics, geometry, navigation, and the military.
When media theorists like Friedrich Kittler and
Paul Virilio describe media art as a by-product, as
an offspring of military technology, this is
shortsighted.

Paintings had already been created within the gun
smoke from military technology. From fortifications
to battlefields extended the terrain of painting.

The ZKM book *Mapping Spaces* provides a wealth
of detail on how mathematical and geometrical
theories as well as instruments have been used by
painters to construct images of landscapes, towns,
and battles, for example.

**18** Levin Hulsius. *Erster Tractat Der
Mechanischen Instrumenten [...]
Grundtlicher/Augenscheinlicher
Bericht deß newen Geometrischen
Gruntreissenden Instruments/
Planimetra genandt/mit seinem
Inductorio und Rahmen [...].*
Engraving. Reprinted in
Levin Hulsius, Frankfurt/M.,
1604, 114, Sächsische
Landesbibliothek – Staats-
und Universitätsbibliothek
Dresden.

**19**  Pieter Snayers. *Siege of Gravelines, 1652. 1652.* Oil on canvas. 188 × 260 cm. Installation view *Mapping Spaces: Netzwerke des Wissens in der Landschaftsmalerei des 17. Jahrhunderts.* Z K M | Karlsruhe 2014. Museo Nacional del Prado, Madrid.

Painters from the eighteenth to the mid nineteenth century, from Caspar David Friedrich to William Turner, still profited from the scientific achievements of Spanish and Dutch painters of the seventeenth century. A network of knowledge, from cartographic instruments to geometrical and mathematical methods and military technology, created the golden age of painting. These paintings were machine-based and tool-based to a greater or lesser extent. Therefore in a certain sense media art has taken on and continued the heritage of classical painting. Painting as a practice of knowledge, as a tool-based skill, was still linked to other tool-based practices like science.

The critical point was precisely this use of tools or how the technology of a practice was developed.

Until the seventeenth century science and art shared common knowledge and technology. But from then onward painting regressed and used less and less technology, whereas science invented more and more technology. In the seventeenth century a vast culture of engineering emerged. With the advent of viewing instruments like the microscope and perspective machines the geometrization of space began, and in general mechanization and mathematization of vision that for the next centuries would separate the evolution of art and science.

The main problem with painting after the seventeenth century is that its visual practices only followed natural perception and used only organic tools like eye or hand. The representation of the visual world was constrained by the artist's eye and hand. Science instead starts where (natural) perception ends.

During the last three centuries scientists have explored an extended frequency range with the help of machines and gone far beyond the limited scope of natural organs. This is the triumph of science over art. Art paused within the range of natural vision; science passed beyond natural vision. Art is defined as aesthetics, which is the Greek word for perception (aísthēsis). But precisely where art seemed dominant, calling itself the visual arts, just the opposite was taking place: science is a far superior art of vision, because it delivers more images of the unseen world than art. Let's take electromagnetic waves as an example.

Evolution has not equipped humankind with a natural organ to receive electromagnetic waves. The eye only reacts to a very small spectrum of the sun's electromagnetic waves and also, very feebly, the skin. Although the earth has been surrounded by an electromagnetic field ever since its formation, it was only around 1600 that it was discovered that the earth itself is a magnet (William Gilbert).

Classical art worked within the limited range of frequencies or wavelengths capable of being processed by natural organs. But because we know that electromagnetic waves exist and since we have instruments that use these electromagnetic waves, from radio to television, nonclassical art can work with an expanded range of frequencies. Therefore, in the mid nineteenth century a new technical art appeared, beginning with photography, and fol-

lowed quickly by film. From the camera obscura to *Man with a Movie Camera* (Dzlga Vertov, 1929) we see the rise of media art.

Thus media art is the third way between abstract art and reality art. It changes and challenges the ontological assumptions of both. Media art is not about depiction, but about construction. It is not about mimesis of the real, but about simulation. Classical media art is photo, film, and video because of the chemicomagnetic storage of information. New electronic and digital art forms, from computers to the Internet, that use the extended spectrum of electromagnetic waves conquered by humans 130 years ago, store information electronically. This means that information can be distributed in real time and appear simultaneously around the globe as a consequence of separating the message and the messenger.

Media art gave rise to a generation of artists who shared some of their tools with scientists. Indeed, why should the new field of apparatus-based perception remain the exclusive domain of the sciences? With the advent of photography and its use by artists as the first machine-based vision some artists started to overcome the constraints and borders drawn by painters and the art market. Naturally the price was very high, the art system denied for a hundred years that photography can be art, even when to the present-day painters from Gerhard Richter to Andy Warhol have used photography as sources for their paintings. As late as 1937 one of the best photographers of the twentieth century, Man Ray, published an edition of his photographs with the title *La Photographie n'est pas l'art* because he was so tired of accusations that his work was not art. With media art, art began to reach beyond the limits of the visible defined by the natural sensory organ, the eye. By including motion, color, and sound in cinema, for example, the representation of reality came closer to reality than ever before. Much more than painting could ever accomplish. As Leonardo wrote, painting was only capable of representing the shapes of visible things; but cinema could also represent the sound and the motion of visible things. With the aid of computers viewers could even interact with the shapes, sound, images, and motion of visible things. Leonardo's program was vindicated, paradoxically, not by the painters, but by the media

525

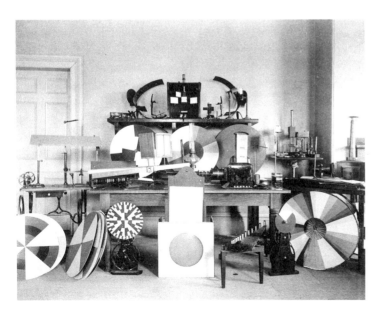

**20** Anonymous. Harvard Psychological Laboratory in Dane Hall: Instruments for Experiments on Sight. 1892. Photograph.

artists. The sources of media art are less the history of painting, and more the history of machine-based vision since the seventeenth century, especially the achievements of nineteenth-century experimental psychology. All the research conducted in experimental psychology, physiology, and physics on vision, illusions and delusions of vision served the future generations of artists as their theoretical basis. Therefore, the relationship between art and science has changed. What had previously been the domain of science, technology-based perception, now also entered the ambit of the field of art. A standard work on the relationship between scientific and artistic aesthetics is *The New Landscape in Art and Science* by György Kepes published in 1956. The advent of apparatus-based media art since the invention of photography around 1824 marked the beginning of a new artistic direction and trajectory that reached beyond the bifurcation of abstract art and reality art.

Media are not merely image and sound machines, they are also interfaces for constructing new realities and new communication forms. Now that artists and scientists have a certain range of tools in common, the studios of artists occasionally look like the laboratories of science, and vice versa. Modern-day artists are less focused on seeking subjective expression; their frames of reference are social systems, as well as the structures and methods of the sciences. Against this background, new research methods and perspectives such as art-based research (AR) and art and science labs are evolving. I call this movement *Renaissance* 2.0, the retooling of art. This retooling of art is especially amplified and magnified by the advent of digital machines and methods.

The fourth way between abstraction and real objects is the art of action. With Jackson Pollock "action painting" began, with Georges Mathieu and Yves Klein painting on a stage in front of an audience. After action on the screen and in front of the screen or with the screen, ultimately there began action without a screen: happenings, performances, and events with real people (artist or audience) and real objects. The self-representation of the means of representation turned into the self-destruction of the means of representation (Lucio Fontana) and ended with the self-destruction of real objects and bodies (Jean Tinguely, Günter Brus). After painting music also became a form of action (John Cage) as well as sculpture (Joseph Beuys) and poetry (Peter Weibel). Painted movement became kinetic art (real movement) etc. The avant-gardes before World War II had been responsible for abstract art and reality art. The neo-avant-gardes after World War II were responsible for developing media art and action art.

## FROM ART TO EXO-EVOLUTION THROUGH TECHNOLOGY

WITH THE SCIENTIFIC revolution of the modern age and the subsequent industrial revolution, for which the equation "Machinery, Materials, and Men" (F. L. Wright, 1930) holds, humankind has created an entire universe of tools, from the microscope to the railway. These tools have both facilitated humans' reach beyond the constraints of their natural organs, and even enabled them to extend their perception of the world into hitherto invisible zones.

The machine-based industrial revolution and the information-based postindustrial revolution have created the technical prerequisites for a development we may call *exo-evolution*.

As early as 1791, Johann Gottfried Herder presented a vision of the impact of the industrial revolution as a turn in the history of ideas:

> Man is the first of the creation left free: he stands erect. He holds the balance of good and evil, of truth and falsehood: he can examine, and is to choose. As Nature has given him two free hands as instruments, and an inspecting eye to guide him, she

has given him the power, not only of placing the weights in the balance, but of being, as I may say, himself a weight in the scale. (Book IV, 92)

Herder's metaphor "Our Earth is a Star among Stars" (Book I, 1) prefigures Richard Buckminster Fuller's idea that the earth is a spaceship with limited resources and lacking an operating manual: "So, planners, architects, and engineers take the initiative. Go to work, and above all cooperate and don't hold back on one another or try to gain at the expense of another." (132)

It is not only the modern era that is an unfinished project – the human being, the earth, and the world are unfinished, open projects, too, that will be transformed by further revolutions. We currently find ourselves at the beginning of the digital revolution. Herder indicates the key idea, that bipedal locomotion was nature's way of freeing two of humans' feet to become hands. Nature gave humankind two free hands as tools and with these tools humans got free of nature. Because with hands used as tools they could create new tools. With hands they created handicrafts. They could make a hammer and with the hammer and fire, they made swords. Gradually, natural organs were substituted with technical tools. This pre-formulates the development of humans during the industrial revolution; that is, the transition from organs to tools; from natural sensory organs to machines, media, and apparatuses; from nature to technology. Herder defines this transition positively, as a moment of freedom. Released from the prison of nature, human beings end up as "freehanded cultural beings" (Bayertz). Yet this freedom of choice inevitably entails human beings submitting themselves to choice – and facing choices. Herder's metaphor, that the human being not only has the power to place the weights, but is also a weight on the scale, highlights the idea of reset, of going back – human beings are part of the system they observe, within which they select and weigh.

Due to the technical and industrial revolution, humans have once again become beings let free, namely, let free from evolution. This process, this stepping out of the process of natural evolution, I call *exo-evolution*. From exo-biology to exo-planet, from exo-skeleton to exo-pregnancies – the increasingly differentiated contours of a new world appear.

The term *exo-evolution* is a neologism coined by me as a variation of Michel Serres' term *exo-Darwinism*:

> But what is true of purely physical functions – with regard, for example, to hammer, wheel, etc. – is also true of intellectual functions (fonctions intellectuelles), and indeed you can clearly see that memory has become materialized: in writing, in printing, in computer science. The body actually loses – it loses these objects, which become conveyors of an evolution that we call technical evolution, scientific evolution, etc. I call this exo-Darwinism. (Serres)

In his book *Principles of a Philosophy of Technology* (1877) Ernst Kapp develops his organ projection theory, which states that, in the final analysis, all technical artifacts are reproductions and projections of organs; for example, the hammer reproduces the fist, the saw reproduces incisors, telegraphy reproduces the nervous system, and so on. Therefore, technical evolution is a multiple exteriorization, an outsourcing of natural physical organs and functions, as well as mental functions, to technical machines: human arms to bow and arrow, memory to clay tablets and computers, and so on. The media theory that follows this paradigm of extending bodily functions is thus an "organology," describing the transformation from natural organs to technical tools. The particular technology of an era is thus understood as the outsourcing – exteriorization and externalization – of

527

already existing organic and intellectual human properties. At the same time, this understanding of technology and media is based on an anthropology that defines the human being as a deficient creature being improved by technology. In 1930 Sigmund Freud explains:

> These things that, by his science and technology, man has brought about on this Earth, on which he first appeared as a feeble animal organism and on which each individual of his species must once more make its entry ("oh inch of nature!") as a helpless suckling – these things do not only sound like a fairy tale, they are an actual fulfillment of every – or of almost every – fairy-tail wish. All these assets he may lay claim to as his cultural acquisition. Long ago he formed an ideal conception of omnipotence and omniscience which he embodies in his gods. To these gods he attributed everything that seemed unattainable to his wishes, or that was forbidden to him. One may say, therefore, that these gods were cultural ideals. Today he has come very close to the attainment of this ideal, he has almost become a god himself. Only, it is true, in the fashion in which ideals are usually attained according to the general judgment of humanity.... Man has, as it were, become a kind of prosthetic God. When he puts on all his auxiliary organs he is truly magnificent; but those organs have not grown on to him and they still give him much trouble at times. Nevertheless, he is entitled to console himself with the thought that this development will not come to an end precisely with the year 1930 A. D. Future ages will bring with them new and probably unimaginably great advances in this field of civilization

and will increase man's likeness to God still more. (38–39)

Thus, every technology is tele-technology, the overcoming of temporal and spatial distances: telefax, telephone, television ("tele" in Greek *far*). And every tele-technology is a theo-technology; a technology, that makes humans godlike in their imagination.

Marshall McLuhan laid out his understanding of media as an extension of the human sensory organs (an understanding that is quite similar to Freud's) in 1964, in his *Understanding Media: The Extensions of Men*. Earlier, in a 1956 essay, he had written, "Each new technology is a reprogramming of sensory life" (McLuhan and Carson 162). What he meant was, firstly, that the relationships between the sensory organs are reprogrammed; and secondly, that the relationship of the sensory organs to their surroundings is reprogrammed. To put it in a nutshell, our entire sensory life is reprogrammed by the media, the machines, and technology.

Accordingly, from manual to mental tools, over the course of millennia human beings have evolved a tool culture, an engineering culture, extending the boundaries of perception and of the world. The technologies of perception in science have advanced, from microscope to computerized tomography. Objects undetectable by the naked eye were made visible by means of apparatuses.

With the arrival of the mechanical revolution natural functions and organs were increasingly "outsourced" and externalized: the hand to the hammer, the foot to the wheel, the eye to the microscope or telescope, the voice to the microphone, and so on.

Since the digital revolution, an increasing range of mental processes have also been outsourced, for example, neuronal networks in calculating machines, thought processes in algorithms. By means of machines and media, humans create artificial organs which compensate for the shortcomings of their natural organs: from eyeglasses as exo-lenses,

from hearing aids as exo-ears through to exo-skel-etons which help the disabled to move, we are witnessing the emergence of an ever increasing number of exo-organs – the exteriorization of natural organs. In addition, humans also create new technical organs or tools. Exteriorization has now gone so far as to search for life outside the earth (exo-biology, exo-planets). Ultimately, the aim is to exteriorize life itself, for example, the exteriorization of human reproduction: life artificially and technically manufactured in the laboratory. The sum of all tools, machines, and media is what constitutes exo-evolution: a human-made and controlled exo-evolution of artificial organs or tools. The contours of this development we are only just vaguely beginning to perceive since their timescale is not even the blink of an eye compared with the billions of years of natural evolution.

One of the fundamental evolutionary principles of biological systems is the natural and random creation of diversity through cell division. This principle is of key significance to the resistive powers of life. The installation *Retooling Evolution: Nature at Work* (2015), a collaboration between Karlsruhe Institute of Technology (KIT), ZKM | Center for Art and Media Karlsruhe, and the commercial company Heurisko, makes the process of cultivating microorganisms visible to exhibition visitors. The displayed "evolution machine" is able to select from a pool those microorganisms which are able to metabolize not only sugar as food but also other carbon compounds. This experiment in real time is an example of human-controlled evolution designed to optimize an organism for a technical application, for example, to eliminate problematic chemicals from the environment.

Ideas of human-controlled evolution have a long history. In 1911 French biologist Stéphane Leduc published *The Mechanisms of Life* in which he tried to prove that life was merely a chemical process. With the advent of synthetic biology these ideas are back, including the concept of creating the cell, the basic

unit of life, out of nonliving materials, the so-called "protocell." In the installation a custom-made rapid prototyping printer is used to create protocells, paving the way towards being able to print actual life.

The exhibition *Exo-Evolution* (31 Oct. 2015 to 28 Feb. 2016 at ZKM) set its focus on the artistic application of new technologies, offering views of the future and the past with its modules. It showed us a new reality formed by 3-D printers and robots, cyborgs and chimeras, molecules and gene pools; by wearable technologies and medical miracles; by synthetic beings, bionic suits and silicon retinas, artificial tissue and biotechnical repairing methods; by findings from aerospace research, molecular biology, neurology, genetics, and quantum computing. And it showed us visions for problems of the

529

**21** *Retooling Evolution: Nature at Work.* 2015. Mixed-media installation. A cooperation of Heurisko Gesellschaft für Biologische Technologien mbH, Institute for Biological Interfaces I at Karlsruhe Institute of Technology, and ZKM | Karlsruhe. Installation view *Exo-Evolution.* ZKM | Karlsruhe 2015.

twenty-first century; for example, splitting off oxygen from $CO_2$ (carbon dioxide) to cope with the climate crisis.

Material scientist and nanotechnology pioneer Geoffrey A. Ozin and his University of Toronto team were seeking solutions for sustainable energy production and storage to address the problems of global climate change. Inspired by photosynthesis, their "solar refinery" is designed to use solar energy and recapture atmospheric carbon dioxide to produce synthetic fuels. These offer the potential, with regard to storability, distribution, and processability, of supplanting fossil fuels, without emitting new $CO_2$ into the atmosphere. In this sense, this visionary approach is modeled on the earth's natural carbon cycle.

Natural evolution relies – according to Koen Vanmechelen – on two principles: First, each organism is looking for another organism to survive. Second, fertility comes from outside. Since humankind in the age of the Anthropocene is disrupting natural evolution, in the late 1990s Vanmechelen started his multidisciplinary science-based art project *The Cosmopolitan Chicken*. By crossbreeding "national" chickens for many years he was able to create new and never before existing chickens. Koen Vanmechelen believes that hard scientific data and artistic

**23** Koen Vanmechelen. *La Biomista – Cosmopolitan Chicken Project*. 2015. Mixed-media installation.

creativity can work together to reveal the vicissitudes of nature and of human life. *La Biomista* (Mixed Life) is Vanmechelen's new studio, situated in the multicultural Belgian city of Genk. *La Biomista* serves as a breeding station for the artist's crossbreeds of chickens and other animals. Last but not least, *La Biomista* is also a laboratory and a library of bio-cultural diversity.

Within the *Great Chain of Being* (Arthur O. Lovejoy, 1936) humankind disrupted the evolution of animals by turning wild animals into pets. Therefore it is necessary to reconsider our relations with animals as a history of others.

*The History of Others* is an art and research project by visual artist Terike Haapoja and writer Laura Gustafsson. It's focus is an exploration into the lives and experiences of animals and an investigation of their history. *The Museum of the History of Cattle* is the first part of the ongoing project. The large-scale installation exhibits world history as seen through the eyes of cattle, one of the most important species for the development of human culture. The exhibit

## Solar Refinery

ambient air

CO₂ capture plant

CO₂-free air

synfuels

fuel synthesis plant

renewable energies

www.climeworks.com

**22** Geoffrey A. Ozin. *Draft of a solar refinery*. Figure.

is divided into parts: "Time Before History" addresses the history of cattle before their domestication by humans. This is followed by "Time of History," which for many cattle began about 10,000 years ago, when bovine culture became intertwined with that of humans. "Time of History" ended one hundred years ago, when human industrial society made it impossible for cattle to pass on their heritage to later generations.

Exo-evolution deals with the exteriorization of human organs into artificial tools, for example, a natural arm can be substituted by a robotic arm and the natural eye can be substituted by a camera, and finally the planet Earth can be substituted by the planet Mars.

With the help of a mast camera in the robot "Curiosity Mars Rover," in 2013 NASA took pictures of the surface of Mars. These pictures were broadcast wireless to the earth, stored digitally, and made available on the Internet. Robotlab, an artist group working at ZKM, has taken this pictorial data and programmed an industrial robot to use this data for redrawing the surface of Mars. In a process taking five months, this robot draws the landscape of Mars – with just a single line. *The big picture* is a creative process, surpassing the possibilities of human creativity. In the installation the robot is given the role of a landscape draftsman – the big picture thus refers to traditional art forms based on human perception. This drawn landscape has never been seen before by a human eye, though – only by a Mars robot. Through algorithmic operations, the robot artist converts visual data into a single uninterrupted path, consisting of more than 900 million movements. The line, stretching for hundreds of kilometers on the surface of the drawing, forms an abstract structure that gradually approximates a photorealistic image.

Here we learn the radical innovation introduced by exo-evolution and infosphere. Things can be turned into words, but words cannot be turned into things. Things could be turned into images, but not

24  History of Others (Laura Gustafsson and Terike Haapoja). *The Museum of the History of Cattle.* 2013. Mixed-media installation. Installation view *Exo-Evolution.* ZKM | Karlsruhe 2015.

images into things. Therefore we have this famous painting by René Magritte *Ceci n'est pas une pipe* (1929). In the digital age words, images, sounds, and things are turned into data (into the digits 0 and 1). In the analog world words and images could not be turned into things. These relations were irreversible. In the digital world data can be turned back into words, images, sounds, and things. The relation is reversible. This is the beginning of "industry 4.0": This is when you don't order things anymore, just data and the 3-D printer at home turns your data into things.

Another example for this reversible process from things to data and back again is a kinetic sculpture by David Bowen. It appears to be a mobile controlled by a steering mechanism. It is controlled by a sophisticated mechanism suspended from the ceiling of the exhibition space. The undulating movement exactly replicates the swell in the middle of the Pacific: A buoy sends data on water height and intensity of movement to the National Oceanic and Atmospheric Administration in the USA. Bowen uses this data for his project – the wave behavior is scaled to fit the installation space, but all other data is unchanged. Yet this access to detailed information about a remote place also demonstrates the snippety

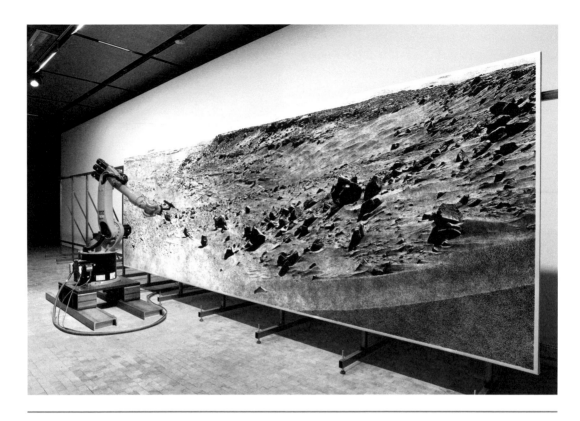

**25** robotlab (Matthias Gommel, Martina Haitz, and Jan Zappe). *the big picture*. 2014. Robot installation. Installation view *Exo-Evolution*. ZKM | Karlsruhe 2015.

**27** STRATASYS. *Magic Arms*. 2012. 1-channel video (color, sound, 3:56 min.) and 3-D printed exoskeleton. Installation view *Exo-Evolution*. ZKM | Karlsruhe 2015.

**26** David Bowen. *tele-present water*. 2011. Aluminum, plastic, electronics, water data. Installation view *Infosphere*. ZKM | Karlsruhe 2015.

nature of our knowledge: The buoy's precise geographic position is unknown since it went adrift from its mooring. Still: the waves of the ocean, a moving surface, are turned into data and sent across the globe. Receiving the data a computer controls the movement of a wooden grid surface, imitating the Cartesian grid, which replicates the waves of the ocean.

The future role of 3-D printing is dramatically exemplified by an exo-skeleton. The STRATASYS company can produce very large 3-D prints. These prints can replicate the anatomy of human beings, for example, an exo-skeleton. Such an exo-skeleton can help disabled persons to control the movements of their limbs. A child, who is partially paralyzed, can play with objects with the help of the skeleton and computer-controlled devices. For many decades the famous physicist Stephen Hawking has been in a similar situation. He is almost completely surrounded by exo-evolutionary machines and media. He says: "Medicine has not been able to cure me, so I rely on technology to help me communicate and live." (Connor)

## MODERNITY RESET: RENAISSANCE 2.0

ACCORDING TO HEGEL, religion was the first system that claimed to be a medium of knowledge and to explain the world from the beginning. Religion was followed in this claim by art. But confronted by the contemporary art movement called Romanticism and its anti-scientific monarchist religious agenda Hegel declared the end of art. Philosophy followed religion and art in the search for the absolute. In the modern age, natural sciences and engineering were added to the classic systems for explaining and transforming the world. *Politics as a Vocation* (Max Weber, 1918) was in fact for all decades the decisive power to change the world. The sciences of the modern age have prepared a new approach to explain and change the world: By means of experimental systems (theory, experiment, proof) and a noetic turn – a shift from language to tool-based culture – science had no qualms about increasing its scope of enquiry to atoms and molecules in order to change the world. Art has limited

533

**28** Reconstruction of the Banū Mūsā's music automaton according to their description. Exhibition view *Allah's Automata.* ZKM | Karlsruhe 2015.

**29**  Marc Lee. *Pic-Me*. 2015. Web-based artwork.
Installation view *Global Control and Censorship*. ZKM |
Karlsruhe 2015.

itself to the constraints of natural perception for far too long. While science has penetrated into hitherto invisible zones with the aid of apparatuses and devices, art has remained on the surface of the visible spectrum. Today, art and science are drawing closer together for they both use the same or similar technologies. This new interlacing of art and science is very reminiscent of the seventeenth century, the Siècle d'or, and the Renaissance. Hence, we may well refer to a Renaissance 2.0, which includes an extension to Arab and Asian sources. Therefore, we speak of an Arab renaissance, the golden age of Arab science from 800 to 1200, when Baghdad was the Florence of the first renaissance.

Contemporary performative media art has not the slightest intention of being excluded from the transformation of the world, like modern art reduced itself just to analyze the means of representation. The performative turn in philosophy around 1960 tried to reclaim the power of action for the realm of words: *How to Do Things with Words* (J.L. Austin). The speech-act theory already in its terminology sought to prove that interpretation is also action. Marx ended his *Thesis on Feuerbach* (published 1888): "Philosophers have hitherto only *interpreted* the world in various ways; the point is to *change* it." Austin wanted to demonstrate that any

utterance, within the context of an institution has the power to change the situation. A judge can sentence (!) somebody to imprisonment by speaking a sentence. A priest can declare two humans husband and wife and they act like a married couple. The power of the word, of verbal utterances, changes people and the world. This performative turn also occurred in the 1950s in the visual arts. The artist became performer and action artist. Artists did not represent the world visually, but made actions to change the world. With media art and its technology of participation and interactivity the public became the central player. Without the participation of the viewer, pressing a button or acting in front of a camera, the artwork would neither function nor exist. Media changed the focus from the artist as actor to the audience as actor. The action of the audience became central in media art: the viewer turned into user. Media art is an art to be used. Therefore, media are performative. This is the reason why we do not speak of visual media anymore but of social media. Media art not only depicts the world, it wants to contribute to the construction of the world. Such art opens up new perspectives and options for the digital society of the twenty-first century, for which the equation "media, data, and men" (Peter Weibel) holds.

### INFOSPHERE:
### THE TRANSFORMATION OF THINGS
### INTO DATA AND BACK

IN THE TWENTIETH century, art responded to the stress of the massive flood of stimuli caused by big data environments with a program of reduction: silence in music, monochromatic paintings. In the twenty-first century artists abandoned subjective expression, and began processing with scientific methods the noise of data and generating with algorithms acoustic and visual works of art with outstandingly innovative aesthetics. The digital revolution changes the notion of art by liberating its

components. With the emergence of photography, painters forfeited their monopoly on the production of images, and, similarly, with the introduction of digital technology, artists are obliged to yield up their monopoly on creativity. Not only is everybody an artist, but, through the social media, everyone has become a transmitter and a receiver. In this way, new political forms of action emerge, which empower and support the emancipation of the individual and foster civic participation. They warn against the negative effects of globalization and digitization, namely, that the liberated member of nature is now rapidly becoming the hostage of a security junta: the danger of pollution holds good for the infosphere no less than it does for the atmosphere. Freedom for the infosphere is law, and an eleventh biblical commandment is now called for: "Thou shalt not covet thy neighbor's data."

Thus many artists engage with the problem of data surveillance. Marc Lee shows with his work *Pic-Me* (2015) the fate of photography in the age of data administration. Taking Instagram as an example, he demonstrates how any photograph shot at any place in the world and communicated and distributed by Instagram allows the photographer to be located with the aid of Google Earth.

We thus discover a new meaning in the old photographic motto "to be on the spot." Each photographer of today is spotted, is located. Photographic activity is controlled globally. Not only each photograph but also every photographer is located, observed, and controlled. From the "viewing business" (Darius Kinsey) photography has turned into data business, into control business. Exposure, originally a technical term, has become a social term. In the age of data administration formerly called photography everything and everybody is exposed and wants to be exposed.

A similar project is 24 H R S *of Photos* (2012) by Erik Kessels. Kessels printed out all images uploaded to the platform Flickr over the course of one day and filled a real space with these 350,000 images to

**30** Erik Kessels. 24 HRS *of Photos*. 2012. Installation with 350.000 photographs from Flickr.

535

demonstrate the overpowering digital flood of images. Digital society produces countless memories where photographs are no longer the monopoly of professional artists and photographers. Photographs become a penny in the bazaar of image-sharing sites. Photographs on social platforms serve to observe each other, to watch each other, to control each other, to expose to each other. Social platforms do not need a Big Brother, because the participants are all little brothers to each other.

The Software Studies Initiative (Lev Manovich, Nadav Hochman, Jay Chow, Damon Crockett) created with the work *Instagram Cities* (2013–2015) a graphic about the data on the social media platform Instagram. For this purpose, 2.3 million photographs from 13 major cities worldwide were downloaded and evaluated. These info-graphics delivered metadata, which allowed conclusions to be drawn about the cultural and social life in these cities. Not only data but also metadata can help to focus observation for multiple aims.

How did it come about that things, images, and words became data? It took an infinite number of theories and inventions to bring about this transition from things to data. I shall single out only a few.

Numbers created an abstract realm that transcended the existence of things, that is, the existence

of *sensua* (sensual data). You can express all the numbers in the world with ten figures. Gottfried Wilhelm Leibniz's 1697 invention of the binary number system, the expression of all numbers by combining just two digits, 0 and 1, constitutes one of the decisive axioms for the mathematization of the world.

Numbers can represent images, words and things, but also numbers, for example, the digits 1 and 0 can represent all numbers. This gives rise to a new form of ontology, whose contours are only beginning to dawn on us. In the old analog world we have defined relations between things and words, between words and images (cf. Quine; Foucault). In the new digital world we define relations between numbers only, but these relations can replace the old analog relations. It is clear that not everything that exists can be thought. The horizon of things, partially unknown and invisible, is bigger than the horizon of ideas. The ontological scope is bigger than the scope of the known universe. It is also clear that not everything that can be thought can be said. There exists more than a human being can say. Human beings think and feel more than they can express. So there is more than we can think and say. But that part of being that can be thought and that part of thinking that can be said can be formalized and ultimately mechanized. In other words, if computation is an element of thought, thought can be formalized: computation is the mechanization of the formalization of thought. The extended Church-Turing thesis asserts precisely this: Anything that can be formalized can be computed. And anything that can be computed can be mechanized. One is tempted to speak of an operative ontology. We have only limited access to the universe. This access is defined by our tools, that is, from words to things. Only by the mathematization and finally mechanization of theories about electromagnetic waves was the existence of electric light and of telephone, etc., created by humankind. It is precisely our attempt to formalize, to compute, and to mechanize, it is precisely our

passion – to follow the path of truth, provability, and computability – which extends the horizon of what there is, that extends ontology. Digital philosophy doesn't claim that everything can be formalized, on the contrary (Gödel). It realizes that more exists than we can express in language. Nor can everything that we think be formalized. Yet human beings increasingly try to grasp with their thoughts what is or could be. So the world of data doesn't complete the world of things, words, and images; on the contrary, it transforms them into an open system. Infinity turned from a philosophical and theological concept into a number theoretical axiom by Georg Cantor.

Cantor proved that real numbers are more numerous than natural numbers. This theorem implies the existence of an "infinity of infinities." Even if his theory of transfinite numbers was counter-intuitive, it defined the concept of the infinite very clearly, which is why the eminent mathematician David Hilbert defended it by declaring: "No one shall expel us from the paradise that Cantor has created." (170; trans. Weibel) The realm of numbers is infinite. Therefore mathematics is not a closed system. Undecidability, incompleteness, are theorems of mathematics. With the mathematization of the world we create a world as an open system.

It seems the universe only reveals to us its formal, mechanical, digital side. Our minds and our tools grant us access only to the digital side of the universe, but to an increasing extent. This explains why, in physics, mathematics is, apparently inexplicably, so effective (Wigner). In the age of transformation of things into data we operate with data as if they were something existential. But strangely enough these operations have real effects. We discover a new law: a word could not transform into a thing, nor could an image (Magritte, *Ceci n'est pas une pipe*, 1928), but today, with 3-D printers, data can turn into things.

In the twentieth century, building on the technical innovations of radio waves and combined with computer technology based on mathematical and logical research, a closely interconnected communications and information network of mobile media evolved – the infosphere: an envelope of radio and other electromagnetic waves covering the planet. By means of artificial, technical organs, for the first time human beings can use electromagnetic waves, for which humans had no natural sensorium, for the wireless transmission of words, images, and other data. The social media, which have changed our everyday life, are part of these technical networks. Since the replacement of the alphabetic code by the numeric code, algorithms – from stock exchange to airport – have become a fundamental element of our social order. Today, people live in a globally interconnected society, in which biosphere and infosphere are interpenetrating and interdependent.

The question as to why nature has not equipped us with the kind of organs capable of perceiving a larger spectrum of electromagnetic waves continues to be one of the enigmas of evolution. Thus humans were obliged to construct artificial and technical organs themselves, such as radio, telephone, television, radar, satellite, global positioning systems, and smartphones, in order to extend the spectrum of electromagnetic waves accessible to them. Hence, after the atmosphere, an increasingly expanding and dense infosphere began to emerge; a canopy of radio waves enveloping the earth for the wireless transmission of language, images, and other data. We thus live in a new sphere, the so-called infosphere, and the infosphere has meanwhile become as necessary as the atmosphere for the lives of the over seven billion human beings inhabiting the earth.

Media art is a way out of the antinomies of modern art. By being apparatus-based like science, technological art has become part of that movement which seeks to change and to create the world.

When I described two of the most fundamental changes of the contemporary world with the terms *infosphere* and *exo-evolution* it is evident that media art in all its scope, from techno art to bio art, is part of these changes. As a product of the reset of modernity this new art could become an alternative to modern art. Artists throughout history have always been able to get a grasp on the world by simultaneously reconnecting with science and technology. Only when artists engaged with the practice of science did the range of formats they used undergo profound modification. Once we reset modernity, we shall be able to register many alternatives to the usual divides between arts, media, evolution and data. In that sense, a reset brings us closer to what used to be called Renaissance. Expect it is Renaissance 2.0!

REMOTEWORDS is a long-term project launched in 2007 by the artist duo Achim Mohné and Uta Kopp. The project understands the globe itself as an expanded art territory. Messages are written on the rooftops of five cultural institutions on five continents: in Taipei at Taipei Artist village, in Port-au-Prince, Haiti, in Kliptown, Johannesburg at SKY, in Auckland at MIT, Manuka Institute of Technology, and in Karlsruhe at ZKM. The letters are so huge that the messages are only legible on satellite views of our planet provided by Google Earth and Bing Maps. The message of five words on five continents is authored by Peter Weibel, the curator of the GLOBALE, "ONE EARTH UNITES MANY WORLDS."

537

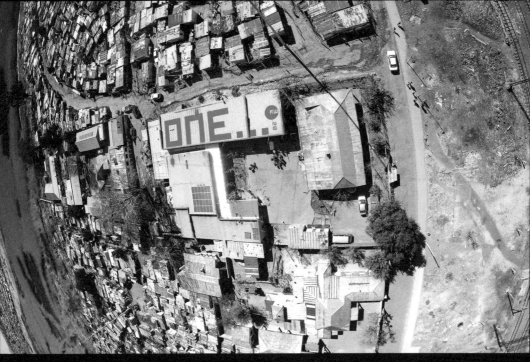

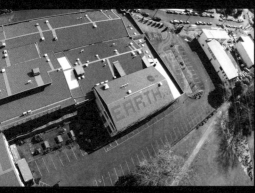

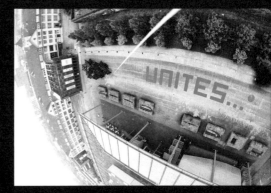

**31** REMOTEWORDS (Achim Mohné and Uta Kopp). RW.26. Part of the artwork ONE EARTH UNITES MANY WORLDS. Words: Peter Weibel. 2015. Lettering "ONE" on the rooftop of Soweto Kliptown Youth Centre, Johannesburg, ZA. In cooperation with Sylt Foundation.

**32** REMOTEWORDS (Achim Mohné and Uta Kopp). RW.29. Part of the artwork ONE EARTH UNITES MANY WORLDS. Words: Peter Weibel. 2015. Lettering "EARTH" on the rooftop of Manukau Institute of Technology, Faculty of Creative Arts, Auckland, NZ.

**33** REMOTEWORDS (Achim Mohné and Uta Kopp). RW.30. Part of the artwork ONE EARTH UNITES MANY WORLDS. Words: Peter Weibel. 2015. Lettering "UNITES" on the forecourt of ZKM | Karlsruhe, DE.

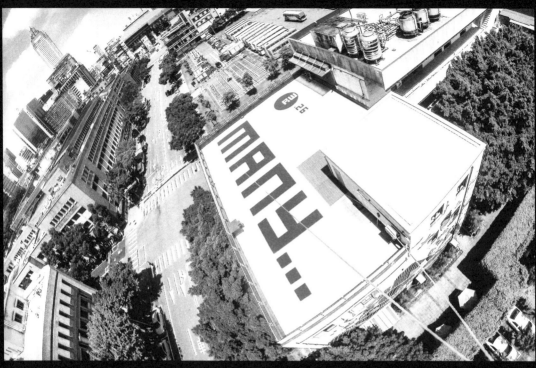

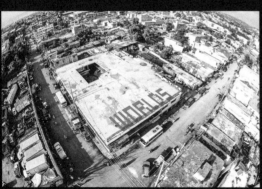

**34** REMOTEWORDS (Achim Mohné and Uta Kopp). RW.30. Part of the artwork ONE EARTH UNITES MANY WORLDS. Words: *Peter Weibel.* 2015. Lettering "MANY" on the rooftop of Taipei Artist Village, TW.

**35** REMOTEWORDS (Achim Mohné and Uta Kopp). RW.30. Part of the artwork ONE EARTH UNITES MANY WORLDS. Words: *Peter Weibel.* 2015. Lettering "WORLDS" on the rooftop of Ghetto Biennale, Port-au-Prince, HT.

Works Cited

Austin, J. L. *How to Do Things with Words*. Cambridge, MA: Harvard University Press, 1962. Print.

Bayertz, Kurt. *Der aufrechte Gang: eine Geschichte des anthropologischen Denkens*. Munich: C.H. Beck, 2012. Print.

Connor, Steve. "Stephen Hawking gets synthesiser upgrade to help him speak faster." *Independent*. Independent.co.uk, 2 Dec. 2014. Web. 9 Mar. 2016. Available at <http://www.independent.co.uk/news/people/stephen-hawking-gets-synthesiser-upgrade-to-help-him-speak-faster-9898581.html>.

Da Vinci, Leonardo. *Notebooks*. Compiled by Irma A. Richter. New York: Oxford University Press, 2008, Print.

Doesburg, Theo van. "Commentaires sur la base de la peinture concrete." *Art Concret* I (1930): 2–4. Print.

Foucault, Michel. *The Order of Things: An Archaeology of the Human Sciences*. Trans. Alan Sheridan. London: Routledge, 2004. Print. Trans of *Les Mots et les choses. Une archéologie des sciences humaines*. Paris, 1966.

Freud, Sigmund. *Civilization and Its Discontents*. New York: W.W. Norton, 1962. Print.

Fuller, Richard Buckminster. *Operating Manual for Spaceship Earth*. New York: Simon and Schuster, 1969. Print.

Gehring, Ulrike, and Peter Weibel, eds. *Mapping Spaces*. Munich: Hirmer, 2014. Print.

Gilbert, William. *On the magnet, magnetick bodies also, and on the great magnet the earth*. 1600. London, 1900. Print.

Gödel, Kurt. "Über formal unentscheidbare Sätze der Principia Mathematica und verwandter Systeme I." *Monatshefte für Mathematik und Physik* 38.1 (1931): 173–98. Print.

Herder, Johann Gottfried. *Outlines of a Philosophy of the History of Man*. New York: Bergman, 1800. Print.

Hilbert, David. "Über das Unendliche." *Mathematische Annalen* 95.1 (1926): 161–90. PDF file.

Kandinsky, Wassily, and Hilla Rebay. "On The Spiritual in Art." *Archive.org*. Internet Archive, 2011. Web. 3 Mar. 2016. Available at <https://archive.org/stream/onspiritualinartookand/onspiritualinartookand_djvu.txt>.

Kandinsky, Wassily. *Point and Line to Plane*. 1926. Ed. Hilla Rebay. New York: Solomon R. Guggenheim Foundation, 1947. Print.

Kapp, Ernst. *Grundlinien einer Philosophie der Technik. Zur Entstehungsgeschichte der Cultur aus neuen Gesichtspunkten*. Braunschweig: George Westermann, 1877. Print.

Kepes, György. *The New Landscape in Art and Science*. Chicago: P. Theobald, 1956. Print.

Kittler, Friedrich. "Medientechnologien sind Kriegstechnologien." *Die Weltwoche* 29 (1994): 34. Print.

Leduc, Stéphane. *The Mechanisms of Life*. New York: Rebman, 1911. Print.

Mach, Ernst. *Contributions to the Analysis of the Sensations*. Chicago: The Open Court Publishing Company, 1897. Print.

Malevich, Kazimir Severinovich. *The Non-Objective World*. Chicago: P. Theobald, 1959. Print.

Man Ray. *La Photographie n'est pas l'art*, 12 *Photographies avant-propos de André Breton*. Paris: Guy Levis-Mano, 1937. Print.

Marx, Karl. "Theses on Feuerbach." *Marxists.org*. Marxist Internet Archive, 2002. Web. 3 Mar. 2016. Available at <https://www.marxists.org/archive/marx/works/1845/theses/>.

McLuhan, Marshall, and David Carson. *The Book of Probes*. Corte Madera: Gingko Press, 2003. Print.

McLuhan, Marshall. *Understanding Media: The Extensions of Man*. New York: McGraw-Hill, 1964. Print.

Quine, Willard Van Orman. *Word and object*. Cambridge, MA: The MIT Press, 1960. Print.

Serres, Michel. *Regards Sur Le Sport. Michel Serres, Philosophe Images. Une Documentaire de Benjamin Pichery*. Paris: Insep, 2009. DVD.

Turing, Alan. "On Computable Numbers, with an Application to the Entscheidungsproblem." *Proceedings of the London Mathematical Society* 2.42 (1936–37): 230–65. Print.

Virilio, Paul. *War and Cinema. The Logistics of Perception*.

London: Verso, 1989. Print.

Wigner, Eugene. "The Unreasonable Effectiveness of Mathematics in the Natural Sciences." *Communications in Pure and Applied Mathematics* 13.1 (2016): 1–14. Print.

Wright, F. L. "Machinery, Materials, and Men." *Modern Architecture: Being the Kahn Lectures for 1930*. 1931. Facsim. ed. Princeton: Princeton University Press, 2008. Print.

Reset Modernity! builds in part upon *An Inquiry into Modes of Existence* (AIME), a book project as well as a website (www.modesofexistence.org) that has gathered documents, critiques, and contributions from a sizeable number of people. Inevitably, such a collective project has generated a number of technical terms to facilitate the conversations among many co-inquirers from different backgrounds. In this book a few authors have used some of those technical terms, which always consist of three-letter abbreviations in square brackets, for instance [REP] or [FIC].

# GLOSSARY OF [MODES]

When you encounter these somewhat mysterious terms and wish to have a complete definition of them, it is best of course to go to the "Vocabulary column" (labeled VOC) of the AIME website. But should you want a quick definition, here is a summary written for the catalog: The principle of the AIME project is that there is an implicit pluralism in what we call "modes of existence" even though moderns (a conceptual rather than a geographical delineation) would be adamant in claiming that there exist only two types of entities: objects and subjects. Such a plurality of modes has been unearthed by paying close attention to the difficulties the moderns have in recording their experience when only objects and subjects are supposed to have an official existence.

Here are the fifthteen modes with their abbreviations:

[REP] for "reproduction" highlights the originality of how entities prolong their existence – whatever the nature of those entities and the ways chosen to keep existing. Such a mode was difficult to highlight in modernism because of its amalgam with "nature," "matter," and "object."

[MET] for "metamorphosis" refers to the ability of entities (again, whatever they are) to transform themselves in order to continue existing. The modernist tradition had enormous difficulty eliciting such a mode because it was often simplified as a form of psychology and not seen as an ontology.

[HAB] for "habit" underlines a very important mode that has the peculiarity of smoothing over the many discontinuities through which all the other modes have to go through in order, so to speak, to gain their existence. It has been poorly articulated by the moderns.

Interestingly, the preceding three modes are in no way captured by any notion derived from objectivity or subjectivity.

[TEC] for "techniques" underlines the many innovative ways in which materials might be modified to generate tools, tricks, and later technologies. It is simultaneously celebrated by the moderns – to the point of being hyped – and neglected philosophically (Simondon took up the phrase "mode of existence" in his book *Du mode d'existence des objets techniques*).

[FIC] for "fiction" stands for an ubiquitous mode, somewhat badly recognized as "art," that imposes another transformation upon any entity, thereby producing a sort of dissonance between forms and matter. Most notions of meaning, language, or sense turn on the recognition of this mode. It is Étienne Souriau's preferred topic of study in his book on the plurality of modes of existence.

[REF] for "reference" is a central mode since it underpins the process through which it is possible to generate verifiable instrumented knowledge about distant states of affairs. However, the moderns' celebration of science has hidden reference as a specific mode. Its redefinition as a mode among others is the key to the whole project: knowledge is a mode; the world is not made "in knowledge."

Together these three modes account for the polarization of the moderns around the notion of objects, contrary to the next three, which explain why so much energy has been invested in the ideas of subjects and subjectivities.

[POL] for "politics" refers to the totally original way in which it is possible to produce assemblages of entities recognizing themselves as forming groups with some sort of limits or borders. Although it has been valorized by the moderns, its definition as a mode has been left in the dark.

[LAW] for "law" underlines another type of connector which aims at stitching together entities that are constantly and inevitably spread apart because of the continuing gaps they have to go through in order to subsist. Highly valorized by the modernist tradition it is also the one that is easiest to specify as an original and totally specific mode.

[REL] for "religion" tries to capture the strange emergence in the modernist tradition of an ability to obtain the apparently contradictory goal of ending the passage of time while simultaneously continuing to live in time. This mode is highly controversial and the modern project constantly tries to act as if it did not exist or as if it could be replaced by definitions of religion based on other modes ([MET] as well as [POL]).

Three other modes have been recognized that have the peculiarity of connecting all the other modes together without the distinction between objects and subjects being recognizable, even as relics.

[ATT] for "attachment" captures the ways in which entities simultaneously feel passions and interests for one another, creating a maelstrom of constantly modified connections. Curiously, it is a mode that has been valorized by the moderns and yet because of its violence and irrationality economists seem afraid of considering it.

[ORG] for "organization" should be the mode most easily figured out by the moderns given the immense investment they have made in vast organizations and in the mass of instruments devised to maintain them. And yet its way of defining courses of action is just as paradoxical as all the others and just as little studied.

[MOR] for "morality" refers to the ways entities constantly try to judge who is means and who is an end for the continuation of their existence. Even though it is supposed to have no relevance except for human subjective assessment, the logic of the inquiry is on the contrary to give it a material and even a cosmic grasp.

Together those three modes redefine something that has been called the "economic infrastructure."

Two modes are necessary to make the inquiry feasible:

[NET] for "networks" is a way to consider any set of entities struggling for their existence in terms of a network of associations when the type of those associations is not qualified further. It is an exact equivalent of what has been attempted earlier as Actor-Network Theory.

[PRE] for "prepositions" is the mode that allows all the other modes to appear as a plurality without immediately being squashed by the modernist pincer of object and subject. It borrows from William James the philosophical notion of something which does not act as a foundation but as something simply positioned before and which gives meaning to what comes next.

Finally, there is a sort of anti-mode, which is defined precisely because it is unable to recognize that it is necessary for any entity to go through discontinuities in order to maintain its existence.

[dc]  for "double-click" is the villain of the piece, so to speak; the one that is never prepared to pay the price of the transformations that bridge discontinuities (hence the metaphor of double-click as the symbol of quick, easy, and unmediated access to any kind of information).

When there is a crossing, that is, a tension or an amalgam or a contradiction between two modes, they are both included in the one set of square brackets and separated by a period – for example, [rep·ref]). For further details and another presentation see the "Crossings" section on the aime website.

---

*Works Cited*

"Access the Crossings." aime. fnsp, 19 Aug. 2013. Web. 9 Feb. 2016. Available at <http://modesofexistence.org/crossings/#/en>.

aime: *An Inquiry into Modes of Existence.* fnsp, 19 Aug. 2013. Web. 9 Feb. 2016. Available at <http://modesofexistence.org>.

Latour, Bruno. *An Inquiry into Modes of Existence: An Anthropology of the Moderns.* Cambridge, ma: Harvard University Press, 2013. Print.

Simondon, Gilbert. *Du mode d'existence des objets techniques.* Paris: Aubier, 1958. Print.

Souriau, Étienne. *The Different Modes of Existence.* Trans. Erik Beranek and Tim Howles. Minneapolis: Univocal, 2015. Print.

# INDEX OF NAMES

# *reset* MODERNITY!

CURATED BY
**Bruno Latour, Martin Guinard-Terrin,
Christophe Leclercq, and Donato Ricci**

16 Apr. to 21 Aug. 2016
Location: **ZKM_Atrium 8+9, ground floor**

*The exhibition is part of* GLOBALE

---

GLOBALE CONCEPT
**Peter Weibel**

GLOBALE PROJECT MANAGER
**Andrea Buddensieg**

RESET MODERNITY!
PROJECT MANAGER
**Daria Mille**

PERFORMANCE BY ANDRÉS JAQUE /
OFFICE FOR POLITICAL INNOVATION
SUPERPOWERS OF TEN PROJECT
MANAGER
**Lívia Nolasco-Rózsás**

SYMPOSIUM CONCEPT
NEXT SOCIETY – FACING GAIA
**Bruno Latour**

SYMPOSIUM PROJECT MANAGER
**Lívia Nolasco-Rózsás**

PROJECT TEAM
**Beatrice Hilke**

TEXTS
**Bruno Latour**

TRANSLATIONS
**Christiansen & Plischke**

COPY EDITING
**Sylee Gore, ZKM | Publications**

DESIGN DIRECTION
**Donato Ricci**

CONCEPT OF SCENOGRAPHY
AND DESIGN RESEARCH
**the Critical Media Lab
Institute of Experimental
Design and Media Cultures
Academy of Art and Design
FHNW Basel (Jamie Allen,
Claudia Mareis, Paolo Patelli,
Moritz Greiner-Petter,
Johannes Bruder,
Flavia Caviezel,
Carola Giannone,
Deborah Tchoudjinoff)**

LOGISTICS, REGISTRAR
**Regina Linder**

HEAD OF ZKM | TECHNICAL MUSEUM
AND EXHIBITION SERVICES
**Martin Mangold**

TECHNICAL PROJECT MANAGER
**Anne Däuper**

CONSTRUCTION TEAM
**Volker Becker, Claudius Böhm,
Mirco Fraß, Rainer Gabler,
Gregor Gaissmaier,
Ronny Haas, Dirk Heesakker,
Christof Hierholzer,
Werner Hutzenlaub,
Gisbert Laaber,
Marco Preitschopf,
Marc Schütze,
Martin Schlaefke,
Karl Wedemeyer**

TRAVEL COORDINATOR
**Silke Sutter, Elke Cordell**

EXTERNAL COMPANIES
**Artinate; COMYK,
Roland Merz, Karlsruhe**

CONSERVATION TEAM
**Nahid Matin Pour,
Katrin Abromeit,
Jonathan Debik**

PUBLIC RELATIONS AND MARKETING
**Dominika Szope,
Regina Hock, Verena Noack,
Stefanie Strigl, Harald Völkl,
Sophia Wulle, Andre Thielen**

MUSEUM COMMUNICATION
**Janine Burger, Banu Beyer,
Regine Frisch, Maxie Götze,
Kristina Sinn**

EVENT MANAGERS
**Viola Gaiser, Johannes Sturm,
Wolfgang Knapp**

TECHNICAL EVENT PRODUCTION
**Manuel Becker, Hartmut
Bruckner, Hans Gass,
Victor Heckle, Manuel Weber**

Special thanks to the artists, the lenders, Kathy Alliou, Barbara Bender, Adeline Blanchard, Dorothée Charles, Maciej Fiszer, Jacob Friesen, Frith Street Gallery (notably Dale McFarland), Hauser & Wirth, Institut français, Ivorypress (notably Josechu Carreras), Biljana Jankovic, Timo Kappeller, Ferial Nadja Karrasch, Margaret K. Koerner, Anton Kossjanenko, Ivanhoé Kruger, Monica Lebrao Sendra, Anna Maganuco, Thomas Michelon, Max Moulin, Pia Müller-Tamm, òbelo, Hans Ulrich Obrist, Léonor Rey, Margit Rosen, Joachim Schütze, Sciences Po médialab, SPEAP students and pedagogical committee, Anne Stenne, Mathieu Szeradzki, Ingrid Truxa, Olivier Varenne, Benoît Verjat, and Cleo Walker

For further information on the exhibition see:
<http://www.zkm.de>

For further information on the works of the exhibition see:
<http://www.modesofexistence.org/field-book>

Unless otherwise noted, all works are solely the property of the artists.

The AIME research has received funding from the European Research Council under the European Union's Seventh Framework Programme (FP7/2007-2013) / ERC Grant 'IDEAS' 2010 n° 269567

IN COOPERATION WITH

## SciencesPo

SUPPORTED BY

HAUSER & WIRTH

THE GLOBALE IS A PROJECT IN THE CONTEXT OF THE CITY ANNIVERSARY – 300 YEARS KARLSRUHE

SPONSORED BY

PATRON OF ZKM

MEDIA PARTNER

THE BOOK

# *reset* MODERNITY!

EDITORS
**Bruno Latour with Christophe Leclercq**

EDITORIAL STAFF

HEAD OF ZKM | PUBLICATIONS
**Jens Lutz**

EDITORS
**Christophe Leclercq
(Sciences Po); Miriam Stürner,
Claudia Voigtländer,
Caroline Jansky, Jens Lutz
(ZKM | Publications)**

ASSISTANT EDITORS
**Martina Hofmann, Ulrike
Havemann, Greta Garle
(ZKM | Publications)**

COPY EDITING
**Patrick Hubenthal,
Gloria Custance,
Katharina Holas,
ZKM | Publications**

TRANSLATIONS
**Jeremy Gaines,
Amanda Hopkinson,
Roger Leverdier, Liz Libbrecht,
Chris Turner,
TranslateTrade.com**

DESIGN DIRECTION
**Donato Ricci**

LAYOUT
**Tommaso Trojani,
Francesco Villa**

LITHOGRAPHY
**COMYK Roland Merz,
Karlsruhe**

PRINTED BY
**EBERL PRINT,
Immenstadt i. A., Germany**

PAPER
**115 g/m2 Lessebo Smooth
natural**

THIS BOOK WAS SET IN
**Novel Pro, Sans Pro, Mono Pro
(christoph dunst | büro dunst)**

THANKS TO
*the co-inquirers who participated
in the AIME project. Special thanks
to Michael Flower, the Sciences Po
médialab (and especially Gabriel
Varela and Barbara Bender),
Clément Layet, Karin Buol, Ernst
Gärtner*

ZKM CEO AND CHAIRMAN
**Peter Weibel**

ZKM GENERAL MANAGER
**Christiane Riedel**

ZKM HEAD OF ADMINISTRATION
**Boris Kirchner**

Printed and bound in Germany

ISBN 978-0-262-03459-3

Library of Congress Control Number 2016936332

Founders

Baden-Württemberg

MINISTERIUM FÜR WISSENSCHAFT, FORSCHUNG UND KUNST

Karlsruhe

Partner

Mobility Partner

# PHOTO CREDITS

27–31/figs. 3a–c: data visualization by Donato Ricci. 37/fig. 16: data visualization by Donato Ricci. 38–39/fig. 19: © Science Museum / Science & Society Picture Library. 43/fig. 2: © VG Bild-Kunst, Bonn 2016. 44/fig. 3: © VG Bild-Kunst, Bonn 2016. 45–49/figs. 4–15: photos: Marco Menghi.

52/fig. 1: © bpk / RMN-Grand Palais (Musée du Louvre) / Daniel Arnaudet. 56/fig. 3: © Eames Office LLC. 57/fig. 4: photo: Miguel de Guzmán. © VG Bild-Kunst, Bonn 2016. 57/fig. 5: photo © Futurefarmers. 58/fig. 6: © Eames Office LLC. 60/fig. 9: © Eames Office LLC. 61/fig. 11: photo: Stephen White. 66/fig. 15: © Private Collection. 66–67/fig. 16: © Galerie Neue Meister, Staatliche Kunstsammlungen Dresden, photo: Jürgen Karpinski. 71/figs. 1–2: © Goodman Gallery. 71/fig. 3: © bpk / Bayerische Staatsgemäldesammlungen / Elke Estel / Hans-Peter Klut. 72/fig. 4: © David Hall – ARTOTHEK. 79–88/figs. 1–8: photos: Jorge López Conde.

96/fig. 3: photo: Gerald Raab. © Staatsbibliothek Bamberg. Universitätsbibliothek Freiburg / Historische Sammlungen, Sign.: R A 4.75/31. 100/fig. 7: © ZKM | Center for Art and Media Karlsruhe. 101/figs. 8a–d: © United Talent Agency. 102–03/figs. 9: © Véréna Paravel and Lucien Castaing-Taylor. 140/figs. 2–3: photos: Rodger Bosch.

170/fig. 1: © VG Bild-Kunst, Bonn 2016. 173/fig. 4: © bpk / Staatliche Kunsthalle Karlsruhe / Wolfgang Pankoke. 174–75/fig. 5: Installation view Marian Goodman Gallery, Paris. Courtesy the artist, Marian Goodman Gallery New York / Paris, photo: Marc Domage. 176/fig. 7: photo: José Luis Gutiérrez. 177/fig. 9: © VG Bild-Kunst, Bonn 2016. 206/fig. 1: photo: Alessandro Coco. © Studio Tómas Saraceno 2009. 206/fig. 2: © Studio Tómas Saraceno 2014. 206/fig. 3: © Studio Tómas Saraceno 2013. 207/figs. 4–5: © Andrea Rossetti 2012. 208–13/figs. 1–4: photos: Antoine Hennion. 215–17/figs. 1–5: © La vie est belle Film Associés 2007. 234–42/figs. 1–24: © Universal Pictures.

249/fig. 3: © VG Bild-Kunst, Bonn 2016. 250–51/figs. 4a–e: photos: Delfino Sisto Legnani. 259/fig. 14: photo: Ola Rindal. © VG Bild-Kunst, Bonn 2016. 297–303/figs. 1–10: photos: Sylvain Gouraud.

306/fig. 1: photo: Karlheinz Pape. 311/figs. 4–5: © VG Bild-Kunst, Bonn 2016. 313/fig. 7: photo: Patrick M. Lydon / ZERO1 Biennial. 314–317/figs. 8a–8e: © Unknown Fields / Toby Smith.

364/fig. 2: photo: Franz Wamhof. 368/fig. 4: © VG Bild-Kunst, Bonn 2016. 369/fig. 5: © VG Bild-Kunst, Bonn 2016. 368–69/fig. 6: © TrustNordisk ApS. 371/fig. 1: © VG Bild-Kunst, Bonn 2016. 372/fig. 2: © Les Films Du Worso, Paris. 373/fig. 3: © trigon film, Ennetbaden. 374/fig. 5: © VG Bild-Kunst, Bonn 2016. 37G/fig. 6: © Les Films Du Worso, Paris. 379/fig. 8: © Mosfilm Cinema Concern, Moscow. 383/figs. 1–2: © FABRICE COFFRINI / AFP / Getty Images. 396–403/figs. 1–3: © PBS News Hour.

410/figs. 2–3: photo: Christophe Leclercq. 411/fig. 4: © Armin Linke. 411/fig. 5: photo: Christophe Leclercq. 412/fig. 6: photo: Christophe Leclercq. 412–13/fig. 8: photo: Alex Wilkie. 413/fig. 7: photo: Alex Wilkie. 414/fig. 9: photo: Jamie Allen. 414/fig. 10: photo: Jamie Allen and Sara Krugman. 414–15/fig. 11: photo: Jamie Allen and Sara Krugman. 416/fig. 13: photo: Robin de Mourat. 417/fig. 14: photo: Christophe Leclercq. 417/fig. 15: photo: Robin de Mourat. 418/fig. 16: © Agathe Nieto. 418/fig. 17: © Agathe Nieto. 419/fig. 18: photo: Bruno Latour. 456/fig. 1a: photo: Jullian De La Fuente. 456/fig. 1b: photo: Pauline Lefebvre, P3G. 459/figs. 3a–c: © Anne Holtrop, Museum Fort Vechten, Bunnik NL, 2011–2015. 460–61/figs. 4a–f: photos: Ariane d'Hoop, 2013 and 2014. 466/fig. 8b: photo: Amandine Amat. 500/fig. 2: © bpk / Alfredo Dagli Orti. 500/fig. 3: photo: Denise Bellon. © Les films de l'équinoxe – Fonds photographique Denise Bellon. 503/fig. 4: photo: Frei Otto. © saai | Südwestdeutsches Archiv für Architektur und Ingenieurbau, Karlsruher Institut für Technologie, Werkarchiv Frei Otto. 504/fig. 6: © Fondazione Palazzo Albizzini Collezione Burri, Città di Castello. © VG Bild-Kunst, Bonn 2016. © bpk / CNAC-MNAM / Bertrand Prévost. 508/fig. 7: photo: Mathieu Doyon. © BGL. 510/fig. 9c: © Jamie Allen, Critical Media Lab Basel. 510/fig. 9d: © Moritz GreinerPetter, Critical Media Lab Basel. 510–11/fig. 9e: photo: Jamie Allen, Critical Media Lab Basel. 510–11/fig. 9f: photo: Johannes Bruder, Critical Media Lab Basel. 512/fig. 9g: © Paolo Patelli, Critical Media Lab Basel. 512/fig. 9h: © Jamie Allen, Critical Media Lab Basel. 512/fig. 9i: photo: Jamie Allen, Critical Media Lab Basel. 513/fig. 9j: photo: Jamie Allen, Critical Media Lab Basel. 514/fig. 9k: © Jamie Allen, Critical Media Lab Basel. 514/fig. 9l: photo: Christophe Leclercq. 514/fig. 9m: © Moritz Greiner-Petter, Critical Media Lab Basel. 514/fig. 9n: © Paolo Patelli, Critical Media Lab Basel. 517/Duchamp: © Succession Marcel Duchamp / VG Bild-Kunst, Bonn 2016. 518/fig. 1: © Succession Picasso / VG Bild-Kunst, Bonn 2016. 518/fig. 2: © Fondation Antoni Tapies Barcelona / VG Bild-Kunst, Bonn 2016. 519/fig. 3: © VG Bild-Kunst, Bonn 2016. 519/fig. 4: © VG Bild-Kunst, Bonn 2016. 520/fig. 5: © VG Bild-Kunst, Bonn 2016. 520/fig. 6: photo: Harald Völkl. © ZKM | Karlsruhe. 520/fig. 7: © Neue Galerie Graz. 520/fig. 8: © Neue Galerie Graz. 520/fig. 9: © Neue Galerie Graz. 520/fig. 10: photo: Christof Hierholzer, Karlsruhe. © Estate of Dan Flavin / VG Bild-Kunst, Bonn 2016. 521/figs. 11–14: © Neue Galerie Graz. 521/fig. 15: © VG Bild-Kunst, Bonn 2016. 521/fig. 16: photo: ONUK. © ZKM | Karlsruhe; © VG Bild-Kunst, Bonn 2016. 522/fig. 17: © Amsterdam Museum. 522–23/fig. 18: © SLUB Dresden, http://digital.slub-dresden.de/id272646202/121. 523/fig. 19: photo: Tobias Wootton. © ZKM | Karlsruhe. 525/fig. 20: © Harvard University Archives – HUPSF Psychological Laboratories. 529/fig. 21: photo: Jonas Zilius. © ZKM | Karlsruhe. 530/fig. 22: © Climeworks and G. A. Ozin. 530/fig. 23: © Koen Vanmechelen. 531/fig. 24: photo: Jonas Zilius. © ZKM | Karlsruhe. 532/fig. 25: photo: Matthias Gommel. 532/fig. 26: photo: Anatole Serexhe. © ZKM | Karlsruhe. 532/fig. 27: photo: Jonas Zilius. © ZKM | Karlsruhe. 533/fig. 28: photo: Harald Völkl. © ZKM | Karlsruhe. 534/fig. 29: © Marc Lee. 535/fig. 30: © Erik Kessels. 538–39/figs. 31–35: © VG Bild-Kunst, Bonn 2016.